MW00806056

STUDIES IN THE HISTORY OF ART · 83 ·

Center for Advanced Study in the Visual Arts

Symposium Papers LX

Edited by Jeffrey C. Stewart

NATIONAL GALLERY OF ART, WASHINGTON
Distributed by Yale University Press
New Haven and London

BEAUTY BORN OF STRUGGLE

THE ART OF BLACK WASHINGTON

Copyright © 2023 Board of Trustees, National Gallery of Art, Washington. All rights reserved. This book may not be reproduced, in whole or in part (beyond that copying permitted by Sections 107 and 108 of the U.S. Copyright Law, and except by reviewers from the public press), without written permission from the publishers.

This volume was produced by the Center for Advanced Study in the Visual Arts and the Office of Content Strategy, Publishing, and Branding, National Gallery of Art, Washington
nga.gov

Series Editor
Steven Nelson

Program Assistants
Annie Miller
Jen Rokoski

Design and Production
Peggy Martin
Mariah Shay
Christina Wiginton

Editors
Elizabeth Franzen
Lisa Shea
Cynthia Ware
Emily Zoss

Design and layout by Jeff Wincapaw
Proofreading by Magda Nakassis
Indexing by Kate Mertes

Typeset in Minion Pro and Source Sans Pro
Printed on GardaPat Kiara by Friesens, Canada

Distributed by Yale University Press, New Haven and London
yalebooks.com/art

Abstracted and indexed in BHA (Bibliography of the History of Art) and Art Index

This volume includes proceedings of the symposium "The African American Art World in Twentieth-Century Washington, DC," organized by the Center for Advanced Study in the Visual Arts, National Gallery of Art, and sponsored by the Wyeth Foundation for American Art and the Arthur Vining Davis Foundations. The symposium was held March 16–17, 2017, in Washington.

The Center for Advanced Study in the Visual Arts, founded in 1979, is a research institute that fosters study of the production, use, and cultural meaning of art, artifacts, architecture, urbanism, photography, and film worldwide from prehistoric times to the present. The Center's programs include fellowships, internships, meetings, research, and publications.

Library of Congress Control Number: 2022948353
ISBN 978-0-300-26710-5
ISSN 0091-7338

To David C. Driskell

CONTENTS

ARTISTS SPEAK

INSTITUTIONALIZING MODERNISM

THE ART OF BLACK BEAUTY

FOREWORD

This volume records an important event in the history of the Center for Advanced Study in the Visual Arts at the National Gallery of Art. The date of the meeting itself was auspicious. The National Gallery opened on March 17, 1941, and the Wyeth Foundation for American Art Symposium provided a crowning event at the very end of its seventy-fifth year. In 2017 we also celebrated the thirty-fifth anniversary of the Center and the previous year's renovation and reinstallation of the East Building in which the Center is housed. Looking beyond our own institutional history, other milestones presented even more compelling reasons for the meeting. Twice as old as the National Gallery, Howard University, nationally recognized for its arts programs and its collections of African and African American art, celebrated its sesquicentennial that year. At the same time, the epochal opening of the National Museum of African American History and Culture (NMAAHC) on the National Mall late in 2016 was a special occasion for celebration, demanding recognition from its neighboring colleagues.

Of even deeper significance than such anniversaries was the decision to dedicate this expanded Wyeth biennial symposium to the topic of "The African American Art World in Twentieth-Century Washington, DC," and to collaborate in its planning with the Howard University Gallery of Art. The first ideas out of which this collaboration grew date to the moment of the National Gallery's acquisition of the Corcoran Gallery of Art collection in 2014. With that set of artworks came nearly two hundred examples by African American artists, including work by some thirty-three artists not yet represented in the National Gallery's collection. And within the group of newly accessioned works were over thirty given to the Corcoran by Thurlow Evans Tibbs Jr. in 1996, the year before his untimely death. Educated at Dartmouth and Harvard, this young Washington collector and dealer was the grandson of Lillian Evans Tibbs, a Howard music graduate known by her operatic stage name, "Madame Evanti." Thurlow grew up in his grandmother's house at 1910 Vermont Avenue NW, and upon her death this family property, listed in the National Register of Historic Places for its cultural significance, became his home and gallery. When we learned that the Evans-Tibbs archive, so vital to the cultural history of African American artists, especially in DC, would also be in the National Gallery's safekeeping, we realized that this transfer presented both an extraordinary opportunity and a responsibility. Working closely with the National Gallery of Art Library, we wanted to let it be known that these materials were available for research. During the symposium, a sampling of archival materials was displayed outside the auditorium. Since then, the library staff has produced a finding guide for the archive and sponsored a Wikipedia edit-a-thon to promote knowledge of its contents.

The choice of Washington, DC, as our focus in 2017 was also determined by a related commitment to showcase the riches of the nation's capital for such research into African American history and culture. Among these resources are the Library of Congress, the Archives of American Art (which in 2018 appointed a curator of African American manuscripts and an

archivist for the African American Collecting Initiative), and other Smithsonian institutions, in addition to Howard and NMAAHC. Support for original research and the diffusion of new ideas are at the heart of the Center's mission, and the choice of this topic was also strongly motivated by a desire to capture the history of a moment. The mid-twentieth century is not so far away, but much knowledge of the history of art and culture in African American Washington in the twentieth century will be lost if we fail to register its importance now. Thurlow Evans Tibbs Jr. understood that in making his collection and in preserving its future through his gift. The living presence of so many artists who have considered DC an artistic home inspired the inclusion of an artist panel in the symposium. The video of this extraordinary event has enjoyed a wide circulation; an edited transcript of the panel is included here for the historical record. We deeply mourn the loss of Floyd Coleman, David C. Driskell, and Sam Gilliam, artists, teachers, and senior figures in the field, since the meeting, and we treasure this record of their conversation. The volume also preserves a contribution from Michael D. Harris—noted scholar, curator, and artist—who passed away during the final stages of the book's production. We lament his loss and are grateful to include his essay herein.

The impact of the Wyeth symposium was profound, helping to make possible the realization of a wider set of hoped-for initiatives in African American art. Too many years had passed since the landmark exhibition at the National Gallery of *The Art of Romare Bearden* (2003–2004), organized by Ruth Fine, followed by the publication of the Center's companion symposium volume, *Romare Bearden, American Modernist* (2011). At a gathering of colleagues from around the United States at the Center in fall 2017, convened to reflect on future developments, the consensus was that the spirit engendered by the symposium must be sustained and strengthened if it was to be meaningful. Important milestones to date include several distinguished professorial appointments, the endowment of visiting senior fellowships for scholars in underrepresented fields, and the development of a Seminar Papers volume, *Black Modernisms in the Transatlantic World*. None of this would have been possible without the support of the trustees of the National Gallery and of many colleagues throughout the institution. In addition to thanking all those involved in the production of this volume recording the Wyeth Foundation for American Art Symposium, I welcome the opportunity to give special personal thanks to Kinshasha Holman Conwill, Huey Copeland, the late David C. Driskell, Gwendolyn H. Everett, Jacqueline Francis, Carmenita Higginbotham, Steven Nelson, Richard J. Powell, Jeffrey C. Stewart, Lou Stovall, and Mabel O. Wilson for guaranteeing that the Center's initiatives in African American art will persist and flourish.

Elizabeth Cropper
Dean Emerita, Center for Advanced Study in the Visual Arts

PREFACE

On April 2, 1985, the exhibition *Art in Washington and Its Afro-American Presence: 1940–1970* opened at the Washington Project for the Arts. Curated by artist Keith Morrison, the exhibition and its accompanying catalog focused on the artists and institutions that created and sustained an extensive ecosystem of Black art in Washington during the twentieth century. Though this world permeated much of the city throughout the period, its history was little understood. *Art in Washington and Its Afro-American Presence* brought it into plain view. Morrison didn't consider Black art in a vacuum; he insisted on the interconnection between Black artists and non-Black institutions and individuals. He followed artists and explored museums, galleries, and universities with an eye toward understanding the myriad ways that Black art flourished.

Some thirty years later, in anticipation of the 150th anniversary of Howard University and the opening of the National Museum of African American History and Culture (NMAAHC), architectural historian Mabel O. Wilson, former Center for Advanced Study in the Visual Arts Ailsa Mellon Bruce Senior Fellow, and my predecessor, dean emerita Elizabeth Cropper, began a conversation about a symposium to mark these landmark events. Mabel introduced Elizabeth to Kinshasha Holman Conwill, deputy director of NMAAHC, and together the three laid the groundwork for the Center's 2017 Wyeth Foundation for American Art Symposium, "The African American Art World in Twentieth-Century Washington, DC." Taking place on March 16–17, 2017, this event brought together artists, scholars, curators, and administrators to revisit and to expand the themes examined in the 1985 exhibition, highlighting the rich and complex history of Black art in this city. In a wonderful closing of the circle, several of the artists included in *Art in Washington and Its Afro-American Presence*, including Morrison, participated in the Wyeth symposium's artist panel, giving a personal, firsthand account of their experiences in Washington from the 1940s to the present.

Beauty Born of Struggle: The Art of Black Washington is the fruit of the 2017 Wyeth symposium and those earlier conversations among Mabel, Elizabeth, and Kinshasha. It is also the result of years of collaboration between the Center and colleagues at Howard University and NMAAHC. The symposium and this book would never have been possible without the unwavering support of Kinshasha as well as Gwendolyn H. Everett, associate professor of art history at Howard University and one of the volume's contributors. Including essays by twelve of the symposium's participants and a transcript of the artist panel, the volume deepens our understanding of the issues at play in the making and sustaining of Black art worlds in Washington throughout the twentieth century. The Center commissioned additional essays by Adrienne Edwards, Michael D. Harris, and me to expand the volume's intellectual and institutional breadth. *Beauty Born of Struggle*, in the deft hands of scholarly editor Jeffrey C. Stewart, MacArthur Foundation Chair and Distinguished Professor of Black Studies at the University of California, Santa Barbara, shares Morrison's intersectional lens to explore the

crossings and clashes that enriched and enlivened the Black arts scene in Washington over the twentieth century.

Many helped bring *Beauty Born of Struggle* to fruition. Former Center associate dean Therese O'Malley beautifully created the symposium program and supervised the book's planning and early editing. She was supported by Catherine Southwick and Annie Miller, who expertly communicated with authors and the scholarly editor through the many parts of this process. Jen Rokoski coordinated with several of the book's authors to secure numerous image permissions, and Frances Grant provided additional assistance. Megan Driscoll contributed to the early editorial process and helped secure image permissions. Cynthia Ware was the project's original managing editor, setting a high standard for us to follow. Emily Zoss, Lisa Shea, and Magda Nakassis expertly completed what Cynthia had begun. Helen Tangires, Jeannette Ibarra Shindell, and Nathalie Meza managed the budget and administration. John Hagood, Yuri Long, and Anne H. Simmons provided critical support from the National Gallery of Art Library. The publication was supported by an endowment for scholarly publications from the Mellon Foundation.

Over the course of planning and editing *Beauty Born of Struggle*, four of the book's contributors—Floyd Coleman, David C. Driskell, Sam Gilliam, and Michael D. Harris—passed away. Though we feel their loss deeply, their spirits and great contributions remain in our hearts and in the pages of this book. It is to their memory that I dedicate this preface.

Steven Nelson
Dean, Center for Advanced Study in the Visual Arts

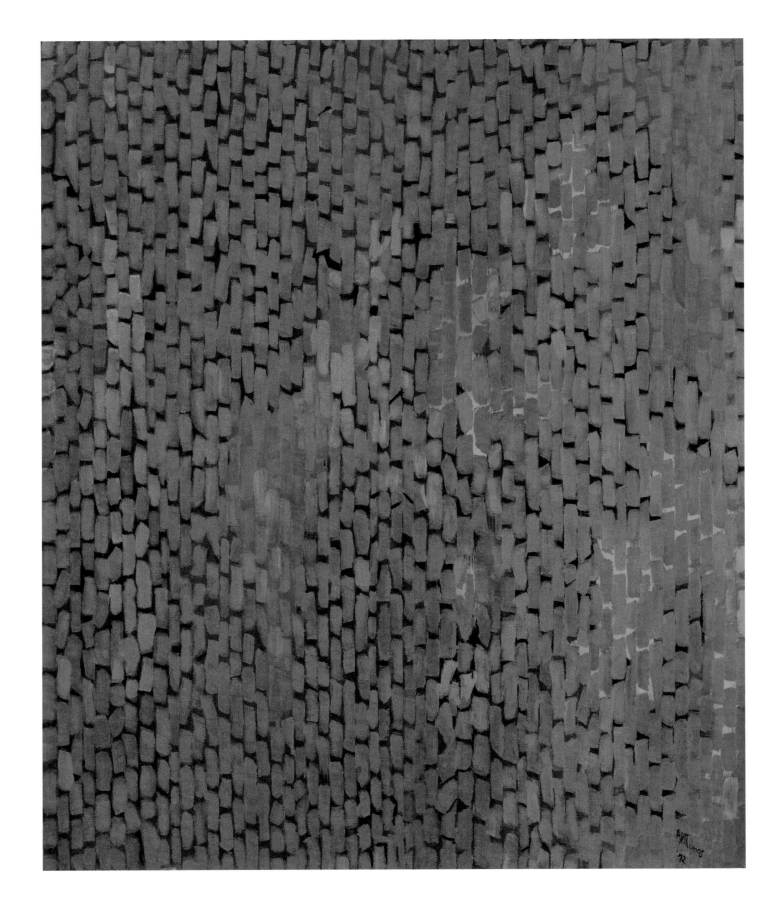

INTRODUCTION

Jeffrey C. Stewart

In a twentieth century during which modern art largely abandoned beauty as its imperative, a little-known intergenerational group of Black artists from Washington, DC, made beauty the raison d'être not only of their art making but also of their lives. In 2017, eight legacy artists and fourteen eager scholars gathered at the National Gallery of Art under the auspices of the Center for Advanced Study in the Visual Arts to discuss what it meant for a group of Black artists to devote their lives to the pursuit of perfection in form in a city devoted politically and socially to the compromise and the deal. What emerged was recollection, laughter, a few tears, and most importantly, a recognition that this little-known band of aesthetic warriors made beauty the centerpiece of their lives and by doing so redefined what it means. For in a nation and a Western culture that routinely excludes Black people from any discussion of beauty, whether in the fine arts or popular culture, it remains an irony that it was Black people beginning in the 1920s who sought to make loveliness the pivot of their art and lives, despite or perhaps because they lived under the ugliness of Jim Crow segregation, political disfranchisement, and domestic terrorism in the nation's capital.[1]

In 1928, Alain Locke published an article entitled "Beauty Instead of Ashes" in *The Nation*. Locke, a little-known but increasingly assertive African American philosopher from Howard University in Washington, DC, argued that beauty was the weltanschauung for a generation of young Black artists during what he called the Negro Renaissance.[2] Locke borrowed the line "beauty instead of ashes" from Isaiah 61—"[The Lord] has sent me to bind up the brokenhearted, to proclaim freedom for the captives . . . to comfort all who mourn . . . to bestow on them a crown of beauty instead of ashes, the oil of joy instead of mourning, and a garment of praise instead of a spirit of despair"—to suggest that art by Blacks had a deeper role to play than simply being an arm of the civil rights movement of the 1920s.[3] The article was defending the right of Black artists to choose something other than protest as the rationale of their art, since W. E. B. Du Bois, the editor of *The Crisis*, the magazine of the National Association for the Advancement of Colored People, seemed to suggest it was the only valid purpose of Black art in a racist America.[4] To Du Bois, all art was propaganda for or against the race, and allowing Black artists to devote themselves solely to the creation of beauty was a luxury an embattled people could ill afford. For Locke, however, beauty was deeper than propaganda—a spiritual

1. Alma Thomas, *Mars Dust*, 1972, acrylic on canvas

Whitney Museum of American Art, purchase, with funds from The Hament Corporation

Digital image © Whitney Museum of American Art / Licensed by Scala / Art Resource, NY

reward, as the biblical passage suggested, that transcended discursive retaliation. Beauty was a gift from God that inaugurated a catharsis by which a degraded people might be lifted up and a rended soul made whole. Most importantly, Locke suggested that Black people in America were particularly gifted in this alchemy, by which the particular struggle for dignity and humanity among Black people had yielded works of art of spectacular beauty. Was this not the case with the African American spirituals, those Black versions of Anglican hymns, born of the Black experience of slavery but almost universally praised as original American music and some of the world's most inspired religious song? As post-slavery offered more lessons in the meaning of struggle, African Americans created the blues during the Jim Crow period of sharecropping, disenfranchisement, and lynching in the South, giving rise to some of the most enduring and profitable anthems of the wounded soul the world has heard. Jazz emerged from the ghettoes and red-light districts of Black New Orleans to become the soundtrack of the 1920s, as F. Scott Fitzgerald, a known racist, acknowledged when he called the decade the Jazz Age. With Black-authored poetry, short fiction, novels, drama, and even visual art beginning to flourish in what became the Harlem Renaissance, Locke argued, a distinctive contribution to beauty was born of Black people's struggle to express their deeper humanity in an inhumane and tragic world.

Tragedy was aplenty for African Americans in twentieth-century America, even in Washington, DC. In 1919, as the city celebrated the end of World War I—which Woodrow Wilson had declared would make the world safe for democracy—Whites intent on showing that the fabric of segregation remained intact terrorized the city's up-and-coming Black citizens and neighborhoods in two days of rioting, during which even Black intellectuals like Locke feared for their lives.[5] But here is the thing: two years after the most horrific attack on Black neighborhoods in the capital city's history, a Black landscape painter named James Herring walked into the offices of the White president of Howard University and secured permission to start an art department at the historically Black university, created during Reconstruction to educate ex-slaves in civilization and culture. Success followed. In 1924, the art department graduated its first student, Alma Thomas, who went on to become one of Washington's most original abstract expressionists. Later in life, she added her statement on her preference for beauty instead of ashes to that made by Locke and embodied by Herring: "Through color I have sought to concentrate on beauty and happiness, rather than on man's inhumanity to man."[6] Herring continued to create institutions devoted to the appreciation of beauty by founding the Howard University Gallery of Art in 1928 and the private Barnett-Aden Gallery—established with his life partner Alonzo Aden in the home they shared on Randolph Place NW—in 1943. Herring's institutional innovations created spaces of interracial gathering, as well as spaces of art exhibition by Black and White artists at a time when Black and even international modern artists were not welcomed into galleries in downtown Washington.

But even in the 1920s, sharp differences emerged among Washington's Black aesthetes as to the beauty Black artists should offer and the visual language they should use to convey that beauty in an art world still dominated by anti-Blackness. Some like Herring, Thomas, and another Herring protégé, James A. Porter, saw a commitment to beauty as art for art's sake and asserted that the Black artist must be absolutely free in terms of subject matter or aesthetic tradition. They rejected not only Du Bois's call for Black artists to create counter-propaganda art, but also Locke's notion that the path to beauty went through a cathartic engagement with the Black face and form, or an openness to explore African art, to develop a uniquely African American visual language. No, Herring declared, and his academic department, the Gallery of Art, and Barnett-Aden followed suit.

For Locke, however, a problem loomed. How does one create beauty—really, fashion a life of beauty that honors the beautiful in oneself and one's surroundings—when the narrative of your nation is that you should not bother, since you yourself can never be beautiful in others' eyes? From its earliest efforts at self-definition, America has been called the land of the beautiful, and Blacks have been defined as the people who were not. For the ancient Greeks like Plato, beauty was an anchor of an ideal society along with truth and justice. Thus, to lack beauty in Western culture was tantamount to lacking humanity—which, in the American context, meant to lack citizenship. Thomas Jefferson codified this attitude in his book of American self-definition, *Notes on the State of Virginia* (1785), where, after detailing the beauty of America's flora, fauna, and institutions, he argued that following their eventual emancipation Blacks should be shipped out of the country. As justification, he noted that "ten thousand recollections, by the blacks, of the injuries they have sustained" might lead to unending conflict and violence between the races, but he added that the key was the real differences between the peoples—in particular, that Blacks were neither beautiful nor capable of creating beauty. This was not unimportant. "Are not the fine mixtures of red and white, the expressions of every passion by greater or less suffusions of colour in the one, preferable to that eternal monotony, which reigns in the countenances, that immoveable veil of black which covers all the emotions of the other race? . . . The circumstance of superior beauty, is thought worthy [of] attention in the propagation of our horses, dogs, and other domestic animals; why not in that of man?"[7] Such exclusion of Black people from the realm of beauty was not peculiar to Jefferson. During the Enlightenment, one only had to read the other thinkers—Hume, Voltaire, and Kant—to see the idea maintained that Black people lacked the capacity to express the beautiful and the sublime. Jefferson, of course, was the most direct, calling Phillis Wheatley's poems "below the dignity of criticism."

How then, Locke queried, was the African American artist to create beauty by referring only to Euro-American traditions, if the notion they advanced was that beauty was everything that Black people were not? While an embrace of Henry Ossawa Tanner's success in France was nice—he received the Legion of Honor from the French government in 1923 for his work as an artist—that same French government in 1931 dedicated part of its International Exposition to show the total French exploitation and domination of its African colonies.[8] As the artist Vince Johnson states, we have to acknowledge the European tradition as one that enables and erases us.[9] Locke's suggestion was that the visual arts created by African Americans should embody a confrontation with the aesthetic consequence of racism in the mind of the Negro. In essence, beauty needed to be decolonized by artists willing to reconstruct their image and the world based on a unique theory of beauty—and that by focusing on the artistic, a social transformation would occur in America. As he put it,

> The social promise of our recent art is as great as the artistic. It has brought with it, first of all, that wholesome, welcome virtue of finding beauty in oneself; the younger generation can no longer be twitted as "cultural nondescripts" or accused of "being out of love with their own nativity." They have instinctive love and pride of race, and, spiritually compensating for the present lacks of America, ardent respect and love for Africa, the motherland. Gradually too under some spiritualizing reaction, the brands and wounds of social persecution are becoming the proud stigmata of spiritual immunity and moral victory. Already enough progress has been made in this direction so that it is no longer true that the Negro mind is too engulfed in its own social dilemmas for control of the necessary perspective of art, or too depressed to attain the full horizons of self and social criticism. Indeed, by the evidence and promise of the cultured few, we are at last spiritually free, and offer through art an emancipating vision to America.[10]

As the conflict between these two divergent theories of beauty raged at Howard, some like Lois Mailou Jones straddled the line and others, like James Lesesne Wells, ignored it altogether by creating an entirely new signature that fused otherworldly fantasy with spectacular design innovations. Indeed, design was the highlight of the Howard University art department, laying the groundwork for a new visual language of abstraction that Thomas and Sam Gilliam would innovate in the 1960s, producing what was arguably the Washington Black Renaissance's most original contributions to American art. While abstract expressionism has been historically narrated as a "White" phenomenon, Keith Morrison suggests that abstraction is fundamentally a Pan-African visual tradition, a point of view reinforced by manuel arturo abreu.[11] Then, in the 1970s, the pendulum swung completely to Locke's side of the argument, as the arrival of Ed Love and Jeff Donaldson in the Howard University department of art (as sculptor and chair/ painter, respectively) suggested that the only relevant art that could be created in Washington, DC, was unapologetically Black and African inspired.

The essays collected in this volume explore the challenges and evolution of this aesthetic dialectic that unfolded from the 1920s up to the present period, as different generations of Washington Black artists embraced or rejected academic, Afrocentric, abstract expressionist, or photographic realism traditions. Among those interpreters of this evolving Washington Black Renaissance, one deserves special mention—David C. Driskell, to whom this volume is dedicated. David was part of the artist panel at the 2017 symposium but passed away in 2020 from COVID-19. While he was a superb artist, he was also so much more—a counselor to younger Black artists and art historians, a curator, the department chair at Howard, and the founder of the David C. Driskell Center for the Study of the Visual Arts and Culture of African Americans and the African Diaspora at the University of Maryland. Perhaps his most important contribution was the national touring exhibition he curated, *Two Centuries of Black American Art, 1750–1950* (1976–1977). Indeed, the catalog for that exhibition remains one of the best interpretations of African American art in America, in part because it sutured together the competing traditions of beauty he had inherited from Herring and Porter on the one hand, and Locke on the other, as a student and teacher in the Howard University department of art. In other words, David used the internal tension over the nature of beauty in the Howard situation as an explanatory frame for understanding the fundamental tension that runs throughout African American art—between the struggle for freedom of expression on the part of Black artists and the search for an enabling tradition and visual language that will not erase the beauty that has emerged from the Black experience, however tragic that experience has been. The essays offered in this volume stand on the shoulders of this giant of interpretation, reminding us that one of the central features of the African American art tradition is that it often has been written, curated, and institutionalized by the artists themselves.

This symposium's gifts reach us at the intersection of several trends in the art and social world that make these intellectual offerings especially important. First, in contemporary art circles, there has been renewed interest in the subject of beauty in art at the end of the twentieth century, in part as a reaction to the work of Dave Hickey, who critiqued the turn toward conceptualism in contemporary art and made a claim for renewed engagement with the pleasure conveyed by the image, whether figurative or abstract.[12] The controversies generated by that critique have awakened attention to those artists pursuing the power of the image to stimulate pleasure in the viewer or community. This line of thinking—that the function of art is to produce pleasure in the viewer—was implicit in the art-for-art's-sake approach toward art training at Howard. Paint something beautiful, not propaganda for the race. Avoid essentialism. In that sense, Du Bois's argument that all art is propaganda was an early example of institutional

critique. What is the value of beauty in a century like the twentieth in which, as Theodor Adorno believed, there could be no poetry after Auschwitz? What is the role of beauty in an American century defined by segregation, lynching, and human rights violations? Unlike Adorno, Locke believed beauty was a possible weapon against the mindset at the root of man's inhumanity to man. Today, we might find the debate about beauty reflected in a film such as *Moonlight* (2016), which is unflinching in its portrayal of systemic racism and homophobia, but renders it like poetry for all its pain, a beautifully made thing that culminates in Black Joy. Can beauty work in the world to form a new community? These questions animate our current American awakening to systemic problems of racism and injustice garnered by the Black Lives Matter movement. Hickey's argument implies the visual pleasure of beauty can go beyond the individual viewer to activate a community. Might a focus on beauty take us from the demand for social justice to a demand for social transformation, to the beauty of justice, to the "immaterial visible only to the mind's eye?"[13] These trends and debates were all anticipated and engaged vigorously in the Washington Black Renaissance, as the papers in this volume show.

The second trend is the recent emergence of the narrative of Black Joy, announced for me in the article by David Dennis Jr., "The Defiance of Black Joy in an Especially Anti-Black Year" (2020), which argues Black Joy is an act of resistance—a refusal, really, to give into the despair of seemingly overwhelming emotional, epidemiological, and social forces by improvising self-love.[14] That joy is evident in our contemporary moment by the improvisational genius by which hip-hop, among other contemporary Black iterations, adapted almost seamlessly to the pandemic by moving from shared space to the virtual space of Twitter, Instagram, and TikTok to carry on critique, interrogation, and music production. But Black Joy goes deeper to claim moments of happiness in the midst of whatever horror the American experience delivers. It manifests in interdisciplinary oases of creativity, epitomized by Howard University as a site of production, not simply of fine art but also the fine music of Donald Byrd, who joined the music faculty when Donaldson was chair of the department of art. He inspired the Blackbyrds, a student music group that recorded "Rock Creek Park," a celebration of the elysian joy of sexuality "after dark." Not accidentally, this anthem to Black love in DC was released in 1975, during a period that Tate Modern called the *Soul of a Nation: Art in the Age of Black Power*.[15]

That's what was working for young Black artists of the '70s and '80s in the District—the beauty of living.[16] Despite the palpably hierarchical nature of Washington, more colonial in feel than any other city in the United States, an incredible sense of joy among Black people suffused it. This was expressed in street concerts and sidewalk dancing, but also in Washington's lush neighborhoods, where even the slums are flush with trees. That Black Joy is the *bluency* that Robert G. O'Meally writes about elsewhere in this volume, experienced in basements in Northeast Washington, where the buoyant dance parties create a sense of community despite the faux competition Washington set up between classes and colors of Black people. It is the dancing, the grinding, the dissolution of despair in a sea of rhythms that come out in Gilliam's abstractions, which carry energy into spectacular, undulating color. Gilliam's drapery paintings are the real flag of Black Washington because here all of the colors are absorbed and unfurled as signs of transcendent subjectivities husbanded by the wonderful superiority of number and love that Black people in Washington, at times, achieve and perform. That Black Joy asserts something like this: that despite what we are experiencing in the cauldron of a Black city in which many of the conflicts around race, class, gender, and sexuality are amplified, Black Joy is here, in Washington, and distilled into the alchemy of the art of Thomas, Gilliam, and Donaldson, but especially the Scurlocks, whose art conveys something subtle in the midst of that joy. It is that a "Black interior" exists, as Elizabeth Alexander suggests, a reflection of the deeper sources

of self-invention and self-regeneration that occur in private places away from what Cornel West called the White normative gaze.[17] In the blues, jazz, and spirituals; the canvases of Thomas, Gilliam, and Donaldson; the photographs of Addison Scurlock and the sculpture of Ed Love—it is because of that deep interiority of joy that they can *dance*! Such works convey a deep sense of belonging to a place like Washington as a cauldron of creative living. That's the Chocolate City that Richard J. Powell is talking about—freedom up on the hill at Howard or in the blue-light basements to create some art that will shock the rest of Washington, because we don't care anyway. Lilian Thomas Burwell said it in the panel discussion preserved here: being ignored by the White art world, so to speak, of Washington, was a blessing. It gave freedom. And use that freedom is what Washington artists did in all venues to create a vision of perfection in Black life that endures. For in the end, the lacks, the absences, were where something new, unexpected, and magical could occur, because Black art was not policed by the otherwise maudlin aesthetic taste of the art world of Washington—one that could never compete with New York's.

The third trend implicates the question of space and how Black artists colonized public and private space during the twentieth century in Washington for their aesthetic politics. In a social and political environment overdetermined by space—as the Jim Crow spatial segregation of Black bodies was in Washington at the birth of the Howard University art department in 1921—space functions on many psychic levels in the following discussions. In Thomas's life, for example, there is the tension between the impulse to access public exhibition spaces and the benefits of reclusion, a kind of strategic retreat to her backyard for inspiration that suggests a new paradigm—that nature was the infrastructure of abstraction. She retreated to her backyard to avoid engaging race and found an expanded territory to colonize with her brush, not just on earth but literally in space, producing stunning abstractions such as *Mars Dust* (1972; fig. 1) and *Apollo 12 "Splash Down"* (1970) that evince a pithy humor as well as deep mystery about the universe. Her accomplishment leads one to wonder how the restricted space of segregation produced in her a deeper sensitivity and courage to stop engaging with the material world on the ground and to look up, to explore the space that transcends. Race led to a new exploration of space. Because in her own private Eden, she was able to plan her takeover of public space, as when she became the first Black woman to have a one-woman show at the Whitney Museum of American Art in New York, but also the first Black woman to have a painting in the White House. Might *Resurrection* (1966) have been planned to hang in the White House during the first Black presidency, as art that invaded and now colonized the White House as a space of *color*?

The dialectic of private and public space operated to create the Barnett-Aden Gallery in the 1940s as a queer space for beauty in response to the exclusion of Black bodies and Black art from downtown Washington. The racial and sexual freedom of that space also opened into an international space in which all the expatriates from empire could convene and turn a private home into a leading public space for modernism in the nation's capital. Here is made visible what benefits came to those artists working in Washington—they had homes! Washington had an economic network of employment in public sector jobs or service jobs to the Washington political elite that created enough capital for Black folk to own their own homes and use those private spaces to create new public spaces that violated the norms of Southern-thinking Washington, DC, welcoming White artists and patrons into Black spaces. These house galleries functioned as house museums under Herring and Aden, and later with Adolphus Ealey. They were also gendered and queer spaces of beauty, where women like Jones, Thomas, and Irene Rice Pereira could exhibit their work and be taken seriously as artists, and where alternative lifestyles could flourish despite the bourgeois heteronormativity that reigned even in official Black Washington. Black, White, woman, gay, foreigner, expatriate, runaway—all found a place in Black art spaces

in Washington that made room for a universalism claimed by the Western art world but seldom extended to outsiders.

With the transition to the Black Arts Movement in the 1970s, space was also the place of revelation, a different kind of coming out in the public sphere, as asserted by the 2017 Tate Modern exhibition *Soul of a Nation: Art in the Age of Black Power* and the 2018–2019 Museum of Contemporary Art North Miami exhibition *AfriCOBRA: Messages to the People.* Ed Love putting up giant sculptures on Georgia Avenue symbolized locally that Black people's art would no longer confine its voice to the backyards of Thomas's day, while AfriCOBRA championed a global sensibility, as Jeffreen M. Hayes puts it, of "Blk Space as Home."[18] Here we see the historical narrative coming full circle—Herring along with his allies created a space for aesthetics in his home, whether up at Howard or in the Barnett-Aden Gallery, and Donaldson and his allies created an international home for Black aesthetics. Beauty for Black Washington was not simply a commitment to art, but a commitment to the beauty of living together.

A synopsis of the essays collected in this volume will highlight the richness of the beauty created by Black Washington artists and the promise of future research that builds on this initial foundation. Following the artist panel and its revelations from Washington art heroes of what it meant to choose a life in art during the twentieth century is Gwendolyn H. Everett's institutional history of the Howard University Gallery of Art and department of art. This essay makes visible the institutional ingenuity Black artists and curators exhibited in making room for the pursuit of the visual arts at a Black institution of higher learning originally devoted to educating the freedmen and women. Everett establishes that artist-created institutions were a critical pillar for advancing art careers in Washington under segregation, nowhere more dramatically than in the case of Thomas, whose one-woman show at the Howard University Gallery of Art launched her national recognition as an art star. Tobias Wofford's following essay shows how dialectical Howard's gallery and collecting strategies really were. Wofford reveals that despite the hostility of Herring and Porter to the notion that African art should be a central tradition for African American visual artists, Howard's art gallery pioneered the exhibition of traditional African art and contemporary African artists in the United States at a time when other arts institutions, like the Museum of Modern Art, resisted exhibiting African artists as anything more than "sociological" curiosities. The donation of the Alain Locke collection of African art transformed the modest art collection Herring had begun in the 1930s and set the stage for an Afrocentric turn in the exhibition strategies of the gallery under the leadership of department chair Donaldson in the 1970s. These first two essays show the importance of art institutions at Howard University—they established a tradition of Black exhibition aesthetics that allowed for perpetual update of what was beautiful and how it should be portrayed. As Wofford notes, the arrival of Locke's massive collection allowed Howard to maintain "a constant conversation among Black American artists, contemporary African artists, and traditional African art" in the Howard art department that fulfilled Locke's legacy. Once Donaldson arrived, he and other collectors added significantly to Locke's collection, such that today Howard has one of the richest but least studied collections of African art in the United States.

Elsa Smithgall shows that Howard had an ally in establishing its art exhibitionary legacy. Her essay reveals a hidden history of collaboration and intellectual kinship between Duncan Phillips and Herring in the fashioning of an integrated exhibition complex in the 1940s and 1950s. Phillips purchased a considerable number of artworks by African Americans, exhibited their work at The Phillips Collection, lent art to Howard University Gallery of Art exhibitions, and was a regular attendee and supporter of the Barnett-Aden Gallery, which Smithgall asserts was modeled on the Phillips. Her essay revises our notion of the Howard University Gallery

of Art as a segregated institution, showing that a mutually beneficial alliance existed between the gallery and the Phillips, driven by the shared commitment to furthering a "universalist aesthetics" and a personal compatibility between Herring and Phillips, who even attended art sales in New York together. Phillips's support helped make creditable Herring's claim that the gallery was an American rather than a Negro art institution. After Phillips lent art by Louis Eilshemius, Marjorie Phillips, Eugene Speicher, and Hunt Diederich to Howard's tenth-anniversary exhibit, *Contemporary American Art*, in 1940, the exhibition catalog asserted, "Our policy has been to leave the discovery of racial and nationalistic artists to our chauvinistic friends. We have preferred to exhibit the works of all schools and trends regardless of ideology or any designated sphere"—a swipe at the previous year's *Contemporary Negro Art* exhibit at the Baltimore Museum of Art, which Locke had helped to fruition. Smithgall's essay is especially helpful in detailing the support of Black artists by The Phillips Collection after Duncan Phillips's death, with an important note on the role played by his wife, Marjorie Phillips, in curating the first one-man museum show for Gilliam.

In his essay, John A. Tyson offers an intriguing pairing of Jones, an artist who taught in the Howard University department of art, with Porter, an artist who chaired that department for many years. Tyson's essay is as remarkable for its detailed revision of the history of modernism in the visual arts during the early twentieth century as it is helpful in ferreting out the similarities and differences in Jones's and Porter's approaches to modernism. He situates Porter's paintings in a tradition of the American Scene as well as postimpressionism, whereas Jones's work began in postimpressionism and transitioned into a postmodernist design aesthetic that was more daring and more abstract than Porter's. With careful attention to the subtle innovations of Porter's art, Tyson shows that modernism for Porter meant inclusion in "a longer Euro-American art-historical tradition," rather than a radical break from it. Tyson's detailed analysis of Jones's iconic works of the 1930s—*The Ascent of Ethiopia*, *Africa*, and *Les Fétiches*—shows how Jones reworked the Parisian appropriation of the African art object into her own innovative design signature. While Porter was inspired by his exposure to African art to develop a body of work that referenced Africa, it was Jones who read the African tradition as an aesthetic and had the artistic ability to translate it into works of art that became icons of Black consciousness in the 1960s and 1970s.

Steven Nelson's essay continues to expose that even among Washingtonians who agreed on the significance of the African art tradition and the people who created it, inherent tensions nonetheless remained over how to use the African art tradition to create a community around Black beauty in Washington. Warren Robbins, the central figure in this story's drama, emerges as the psychological opposite of Phillips—a driven enthusiast with outsized and unrealistic dreams about what a museum centered on the genius of African art could do for race relations in the city, if not the nation. Well-meaning, energetic, and racially liberal as he was, Robbins lacked the art-historical knowledge and the social tact to partner successfully with a Howard University used to more arm's-length dealings with liberal White Washingtonians. Nelson's essay reveals how attitudes toward African art, African American art, and racial pride were jumbled together in the minds of Black radicals and White liberals during the 1960s and 1970s, when the possibility that greater knowledge of the heritage and culture of African-descended people would transform American race relations seemed real. Robbins's indefatigable resourcefulness made his Museum of African Art one of the more popular integrated settings for the exhibition of African art—or any art—in Washington. Its exhibition receptions were a collage of diverse Washington personalities, art enthusiasts, and curious young people. Nelson concludes, however, that a litany of missteps and misunderstandings doomed the effort to link the museum to

Howard University. Ultimately, while the museum's stellar collection remained, Robbins died disappointed that his larger vision of the transformative effect of African aesthetics on American social consciousness was not taken up by the Smithsonian when it acquired the collection. His failure to cement an alliance with Howard had another, more subtle consequence: an opportunity was lost to link Howard's half-century-long art programs to downtown mass consumption.

Jacquelyn Serwer's essay reminds us that Black art was being exhibited in Washington even before the creation of the art department at Howard University. Moving out from educational institutions, the exhibition and purchase of art in the nation's capital became an important stimulus for recognition and livelihoods for those who chose art as a career, not simply a vocation. Interestingly, an explosion of Black art entrepreneurship led to a flourishing of many Black-owned galleries that mastered marketing to the city's professional classes in the vacuum created by White gallery disdain for Black art. And when White galleries did sell Black art, they felt as if they were shunned by the media for crossing the art gallery color line.

Jacqueline Francis's revelatory essay on the Evans-Tibbs Collection shows how Thurlow Evans Tibbs Jr. was the culmination of the curatorial tradition in art laid down by elite Black Washington from the second decade of the twentieth century forward. Though not an artist, Tibbs embodied the Black aesthete's faith that appreciation and dissemination of art gave one's life a meaning that transcended the social degradation of Black people in America. Less combative than Herring, Locke, and Porter, and less tactless than Robbins, Tibbs was able to take the culture of beauty he inherited, along with its curatorial strategies, and externalize it, nationalize it, and carry that sense of beauty into a larger national space through his partnership with the Smithsonian Institution Traveling Exhibition Service program. Less ideologically driven than his forebearers, Tibbs was able to get a mainstream, historically White institution such as the Smithsonian to do his bidding and fulfill his dream in ways his forerunners could not. That dream was to bring the beauty of cultivated Black Washington into homes, schools, and nonprofit public spaces across the country, throughout the South as well as the North, and to elevate the reputation of Black art for thousands of visitors to his traveling exhibition. With Tibbs, the beauty culture of Washington found its best ambassador: an aesthete who worked with outsiders to that culture to communicate the beauty of living for art, engaging not simply visitors to his home, but also a nation.

Robert G. O'Meally explores Black beauty in Washington as an interdisciplinary underground "where a democratic sense of community shone and sounded 'underneath' (and in defiance of) the White community's me-first violence." While avoiding the traps of essentialism, Duke Ellington was a New Negro who believed the folk were his inspiration and primary audience, and he created music for stage and film in which "a deep sense of love is celebrated." In Ellington's music, the aural environment allows glimpses of a vision in which Black people don't have to be banished in order for America to reach for perfection. Here, beauty is achieved not through a tight-knit, insular, heavily policed Black community, but through a dialogue with the Black citizens whose participation is the ground from which sprouts the greatness of Ellington's music. In essence, O'Meally suggests that whatever the mask worn by elite Black artists to show their acceptance of the dominance of White culture as the basis of Black art, the Duke drops that mask in his music and films to produce sounds of outrageous beauty. Unabashedly, O'Meally suggests Black beauty is fundamentally interdisciplinary and locates its most transcendent expression in the dynamism of communal striving. Key to this sense of beauty is the "coordination of strongly diverse individual voices" and a refusal of the sameness and uniformity of Western notions that emphasize beauty as a harmonious whole. Dissonant, clashing, discordant meshing of difference in forms represents the conflict and contradiction of the American experience

that reaches resolution in the beauty of Ellington's experimental sound of the 1930s and 1940s, or the collages of Romare Bearden's paintings of the 1950s and 1960s.

Adrienne Edwards extends this notion of Black art as a dialogue with the unseen other in her essay on Sam Gilliam, whose abstractions emerge from a kind of meditative discourse—a ferocious beauty that nonetheless dances in his canvases and his post-canvases, which revolutionized painting through drapelike breaks with the notion of the picture as frame. Abstraction in Gilliam's practice, Edwards's incisive analysis suggests, is not an escape from a torturous Black reality or maligned subjectivity, but rather a translation of the multiplicities of the Black experience in spectacular color and form. In effect, abstraction here is really the abstracting of the Black subject into a play of forms that dances, from the perspective of the African tradition, such that the interdisciplinarity that O'Meally announces plays out in how Gilliam conjures the ineffable without leaving the Black subject behind. Spirit speaks in his practice, which takes the love of forms that attracted Herring to the academic tradition, the American innovations of abstract expressionism, and the longing for deliverance in America, and produces an art that shows Blackness is as much the mastery of forms as the liberation of image. Gilliam emerges here as America's postmodern master in Washington.

A distinctively Black Washington abstraction was inaugurated, of course, by Alma Thomas, who rejected the nomenclature of Blackness and the politics of Locke's African-centered New Negro art practice to avoid the limiting essentialism of a Negro art formalism. Lauren Haynes's essay suggests that the roots—literally—of Thomas's private renaissance as Washington's breakout painter of the sixties and seventies lay in her private garden, where her eye transformed nature into abstract art. Haynes shows that Thomas was able to see the structure of the world abstractly because she found that structure in the backyard of her Washington home. Thomas's now-famous statement that she turned to color and beauty instead of man's inhumanity to man as her artistic focus becomes here something more than a dismissal of Du Bois's demand that Black artists create counter-propaganda to racism. Thomas's genius rests on a different kind of refusal from that announced by O'Meally. Hers rests on a demand that we not confine our looking at one another to answer the racists but allow ourselves to look out into the world of nature and up into the heavens of the cosmos for the meaning of our existence. Color and beauty are a visual language of transcendence, embedded in which is the Black longing for something more than a life spent fighting over property, truth, and even justice. Time itself seems to stand still in her luminous paintings, suggesting that we focus too much on the here and now as well as the problems of race.

The dialogue that O'Meally hears in the basements of Black Washington dancing to the beat of Ellingtonian elegance can be found in the studio of Addison Scurlock, who, as a commercial photographer, found a way to represent the need and desire of the Black Washington community for portraits of beauty they could embrace as their own. Rhea L. Combs and Paul Gardullo's essay shows that the mirror of art that Locke and Du Bois sought from Black fine artists was actually being held up to the Black community by Addison and his two sons, Robert and George. This was in part because the Scurlocks were running a business that had to appeal to a Black clientele to survive. Despite being born, as the authors note, six years after the end of Reconstruction, during the setback and terror of the Jim Crow period, Addison found a way to make a living as an artist—educating himself through an apprenticeship with a White photographer in Washington. This relationship highlights the complexity of the New Negro period, during which some Whites violated the codes of segregation and shared an aesthetic technology that Black artists like Scurlock used to create an oeuvre of racial pride and Black accomplishment. The vision of art that Du Bois and Locke looked for can perhaps best be seen

in Addison's double portrait photograph of a Black soldier and his wife in 1944, looking up and at us with the hope that they will have the opportunity for a beautiful life in Washington after the gift of military service to the nation. That image is followed by another—of what could be called the second New Negro—this time of two Negro boys running outside in 1951. The essay shows how the Scurlock Studio photographically captured the changing times of Black life in Washington, not simply by securing commissions and forging contracts with institutions like Howard University, but also by moving their practice outdoors, to capture Black youth asserting mobility in public space. These boys are not sequestered away in basements or cloistered studios but run free—almost—at a turning point in Washington race relations, when segregation is waning but not yet gone.

The essay is valuable as an economic history of how an artist dependent on market forces survived in Black Washington, from working with Howard University to protecting a business through robust Black self-identification during the 1968 riot in Washington after the assassination of Rev. Dr. Martin Luther King Jr. However, that nexus of respectability and economic ingenuity should not distract us from the central fact that Addison Scurlock was one of the great photographers of the first half of the twentieth century, certainly a rival if not the superior of the much better-known New York photographer James Van Der Zee. Addison's mastery of posing, lighting, and retouching to create mood, as exemplified in his portraits of Du Bois and Lillian Evans Tibbs, was peerless. What distinguished the Scurlock Studio was not only its subject matter, Combs and Gardullo suggest, but rather a commitment to bringing the artistry of photography to a community that embraced them, setting the Scurlocks off as perhaps the most important artists with whom Washingtonians engaged.

What did this mean? I myself remember walking by the Custom Craft Studios (the later name for the Scurlock enterprise) on 18th Street in the 1980s and seeing a stunning portrait photograph of King in the window. I went in and inquired how much a copy would cost me. Fifty dollars, the proprietor, who might have been Robert Scurlock, told me. I kick myself now that I did not get the photograph, although at that point in my career as an adrift assistant professor in town on research leave, fifty dollars was a lot of money. But I had stopped in to Custom Craft because of the effect that this unique photograph of King as America's luminous star had had on me. Beaten down by frustrations in my research and my personal life, seeing that glowing photograph of King as I trudged home from the Dupont Circle Metro station lifted me, doused beauty on the ashes of my hurts and disappointments, and transformed my mood every time I saw it. Scurlock photographs did similar work in the Black community for decades, establishing a tradition of catharsis through photography that Addison inaugurated. As Combs and Gardullo note, Addison fused a sense of Black beauty with a strong business acumen, respectability, and feeling for the psychic needs of his community that literally began at home. Here is the dynamic of the Washington Black Renaissance—an aesthetic that began in the homes of Washington and spilled out onto the streets of the city in images that could uplift even a visitor to the city trudging his way homeward.

My essay explores the armor that the steel sculptures of Ed Love, the master sculptor at Howard University, supplied to Black aspirations for agency in the 1970s. Ed's work, which was introduced to me by Marta Reid Stewart, engaged with what Thomas wished to avoid in her art—"man's inhumanity to man"—and the notion that art by African-descended people ought to provide them the psychic resources to combat that inhumanity. Ed welded sculptures that fused African traditions and repurposed objects of a dying American industrialism into giant shining totems he stationed out on Georgia Avenue to communicate the possibility of a triumphant Black subjectivity to a Black public. He developed a new visual language that advanced

beauty as sculptural armor to protect gifted Black people on their spiritual journey, resembling huge Egyptian gods on the one hand, and futurist characters like the Mandalorian on the other.

Michael D. Harris's essay shows us how the arrival of Donaldson as chair initiated a revolution in a Howard University art department struggling to emancipate itself from the academic tradition epitomized by Herring and Porter, and to embrace the new militant notion of art as social sculpture against racism that was being crafted by Ed Love. Harris captures the sense in which the art department under Donaldson created a fine art program that was simpatico to the Scurlocks' program in photography—capturing and advancing a positive Black subjectivity through mastery of aesthetic form. He shows how Donaldson added a global perspective to the department that was not European but rather African, Caribbean, and Black American, with Washington as its new Black epicenter. Here was a renaissance built on the shreds of Locke's negritude in art advocacy, but expanded with a Black visual populism and internationalism that drew dozens of new Black consciousness–oriented faculty to the department. It also responded favorably to the activism of Howard art students such as Joyce Owens, who wanted an art education relevant to what was going on in the streets during the Black sixties. Beauty, for Donaldson, was not an alternative to racial struggle, as it had been for the department and its most famous student, but a new, powerful tool to address racial struggle through the lens of an African-centered aesthetic tradition. What emerges from Harris's essay is the sense of community that Pan-African perspectives on art produced under Donaldson's leadership—not just in teaching and exhibition, but also in the festivals with which Donaldson connected the students, giving students and artists a sense of being part of something larger and more capacious than a university-based movement.

The infectious energy of this Black awakening was not walled up simply at Howard, as Richard J. Powell's concluding essay shows us. By the mid-1970s, Washington had a new anthem—"Chocolate City," written and performed by the George Clinton–led group Parliament, a kind of coming-out song for the race-identified Black residents to celebrate Washington as their city. "Chocolate City" encapsulated the feeling that while denial of representation in the Senate for DC residents was a scandal and a continuing sign of domestic colonialism in the nation's capital, it could not stop Washington from being the capital of Black Joy in America. That's because in DC the real representation was in the culture of Black beauty sustained by its residents in the blue-light basements and The Phillips Collection; on Georgia Avenue and the campus of Howard University; and under the viaducts in Southwest. And it was sustained even by those who were not Black but who understood, as the star-crossed Warren Robbins did, that the spirit of African-derived aesthetics created a culture of beauty where it landed, Mothership-like, in America, and especially in Washington, DC.

ARTISTS SPEAK

Left to right: David C. Driskell, Floyd Coleman, Sylvia Snowden, Lilian Thomas Burwell, and Ruth Fine

Courtesy National Gallery of Art Archives

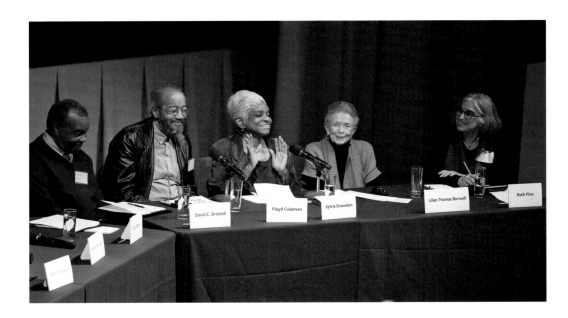

Left to right: Lou Stovall, Martin Puryear, Keith Morrison, Sam Gilliam, and David C. Driskell

Courtesy National Gallery of Art Archives

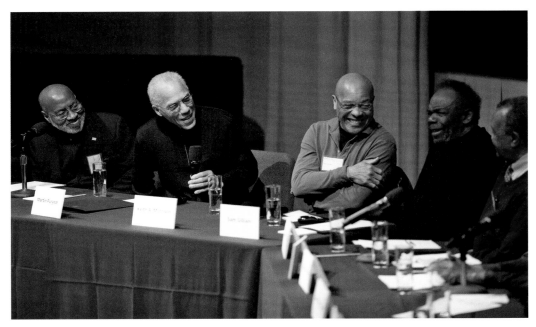

ARTIST PANEL:
THE AFRICAN AMERICAN ART WORLD IN
TWENTIETH-CENTURY WASHINGTON, DC

March 17, 2017

Τhe eight artists who assembled at the National Gallery of Art, Washington, DC, on March 17, 2017, to explore the Washington associations that had an impact on their lives and highly developed artistic practices were a powerful and diverse group, all of them above the age of seventy: Lilian Thomas Burwell, Floyd Coleman, David C. Driskell, Sam Gilliam, Keith Morrison, Martin Puryear, Sylvia Snowden, and Lou Stovall. A New York-based collector friend of mine referred to them as a "talent-heavy" gathering, which is confirmed by the following edited transcription of the program. Readers will note that no formal introductions were given for individual speakers because printed biographical data were available to the audience, and they are appended to this transcription in abbreviated form.

An overview of the speakers' combined experiences reveals that as a group these artists have not only participated in hundreds, if not thousands, of solo and group exhibitions but also taught in public schools and universities, thereby keeping art alive for younger generations. They have served as art department deans and in other arts administration positions, and they have written influential texts on art and art history as well as art criticism. They founded important annual conferences on art-based subjects and received grants from the National Endowment for the Arts and the Danforth, Ford, John Simon Guggenheim Memorial, John D. and Catherine T. MacArthur, and Rockefeller Foundations. They are also recipients of numerous honorary doctorate degrees and of citations from the DC Commission on the Arts and Humanities, the National Medal of Arts, the National Humanities Medal, and the Jamaican Order of Distinction. A talent-heavy group of people indeed.

The program's structure invited each panelist to speak briefly—some showed images and some did not—followed by a conversation among the participants, all of whom knew each other, some very well, others less so. Their combined presentations are warm and humorous, documenting the strength of community and family relationships; the artists' shared histories, particularly regarding Howard University and the interracial and forward-looking Washington-based Barnett-Aden Gallery; and the availability of great historical and contemporary art at the National Gallery of Art and other of the city's many museums, as well as their

welcoming atmosphere. Issues of exclusion and racial discrimination are apparent throughout the conversation, but they are overridden by what Lou Stovall refers to in his presentation as a "spirit of possibility." This phrase could serve as an apt title for this panel discussion overall, as was pointed out by Joseph Rishel, Philadelphia Museum of Art curator emeritus, after he read a draft of this transcription.

As it turned out, my role as moderator required little more than introducing each speaker by name, acting as timekeeper, and offering an occasional comment or question. It was, however, an honor and a privilege to be at the table with so many imaginative and profound speakers and to learn about their artistic encounters with each other and with Washington, DC.

—Ruth Fine

RUTH FINE (RF): Our initial speaker will be Lilian Thomas Burwell.

LILIAN THOMAS BURWELL (LTB): Well, good morning. When guidelines were suggested for this panel, it was suggested that we tell about one person, one piece of art, or one event that made a deep impression on us as artists. Indeed, influence is a factor, there is no doubt about that.

But my perception is that the primary and strongest contribution of African American artists in Washington has been anything and everything except the usual external influences. In my case, trying my best to even avoid them. Indeed, we really are taller than the shoulders upon which we stand. But those shoulders have allowed us to see light from a different space. I therefore see our strongest artistic expressions to be those of innovation, quite subjectively and introspectively singular—in other words, not influenced by others but coming from inside as an expression of the self and of the spirit.

I see my work particularly to be about the result of a channeling of my convictions, my life experiences, and what I personally am convinced of, made of, and of what I express. The art itself is a means of channeling spirit itself, always without conscious effort. Now, that said, my conviction is that for many of us it's been our differences—both point of view and of expression—that's given us the strength witnessed by originality. And most of us may have started with an academic background that formed a firm classical base, but what has morphed is emphatically our own.

Both negative and positive feelings and everything in-between seem to automatically present themselves in my work. I've also found freedom in the lack of opportunity that a broader acceptance of our people might have offered and the connectivity that acceptance might have fostered. Given that open inclusion has not been an accepted factor among the African Americans (not just artists), I experienced no need to conform to established expectations or trends. However, not many of us choose to blow our trumpets in an empty room; therefore, I know without question that I want to share my work by communicating with you. It's often there that I feel the sharing of our basic humanitarianism.

At one point a young friend of intelligence, whose judgment I valued, reneged on offering an opinion of my work by saying she knew me well enough to believe there was more to me than what she saw in my work. That's when I went underground, avoiding exposure to anything in the art world. I stopped seeing exhibits, and that's when I really learned why the caged bird sings.

Even as late as the mid-twentieth century, the best minds of the country found huge concentration right here and around Howard University, because of their denied acceptance as faculty of other universities. We were therefore privy to their availability. Artists also thrived in the support of other artists in the community. We may well work in the solitude necessary for spirit to enter without distraction, but we're able to maintain that necessity because of our

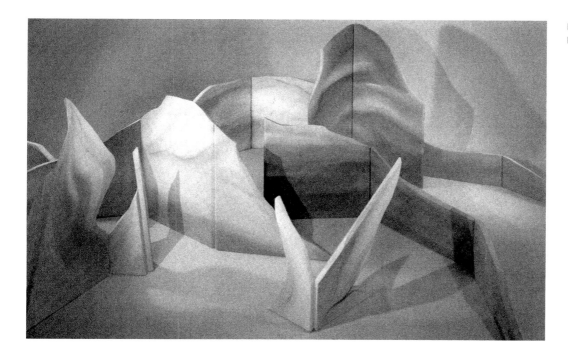

Installation view, Lilian Thomas
Burwell, *Orison Piece*, 1994–1995

knowledge of the strong community of connections and invisible hands and arms around us. We work together to earn so much not otherwise available to us.

It's seldom, if ever, simply one person, one piece of anything that is responsible for our development. We were more like family than anything else. And I will give you a few examples of how that worked in my life, multidimensionally. The first person that had a great effect on me was not just family in the sense of family, but actual family. This was the work of Hilda Wilkinson Brown, who was my mother's eldest sister. She was also an educator, also an artist, who convinced my parents, when I told them I wanted to be an artist, that I had not lost my mind completely, but that I should go into art education so that the students could be the patrons that fed me. Then I would have absolute freedom to work in whatever medium or whatever direction I wanted.

That was one of the greatest imaginable gifts because it gave me wings. And I've always told my students to find something to support your passion. And I say that to you as an audience because I really believe we're all artists to some degree. So, having that advantage of a blood relationship was a tremendous gift to me in the beginning. But then a very interesting thing happened. Years ago I visited Chicago, where I met a young man who, when I told him about an exhibit that I had curated of Hilda's work, told me that not only had Hilda taught him but also his mother. And that was Martin Puryear. There was another bit of family.

There was also Alma Thomas. Alma and her sisters—I don't believe there were any brothers—and my mother and her sisters grew up within two blocks of each other. So, they knew and supported each other. The part that Alma formed in my family was that she gave me advice about not being so social at parties. And she talked about how Alonso Aden, for example, and James V. Herring had suggested the same thing to her, that she just concentrate on her work. So, here again, it's family coming together, community support.

Sam Gilliam told me the very first time that I met him—he didn't know me from Adam— that if I was going to be taken seriously by artists, that I should have my own studio space. I don't know if he remembers that or not. But all of these influences, they affected my life and we

affected the lives of each other because of the fact that doors were closed in other directions, the result being that it brought us together even more closely.

Sylvia Snowden lived a couple of blocks away from me and got very upset with me one day when she found out that it was her studio assistant whom I had called upon to deliver a prescription to me in the middle of the night. I didn't even think I knew Sylvia that well, but she appeared on my doorstep upset and said, "I just live two blocks away, why didn't you call on me?" There again, extended family operating.

David Driskell gave me the tremendously important imprimatur of his sensitivity in how he wrote in my book, which was about my work, an autobiography of sorts. Someone that we've lost only in actual physical presence, but not in spirit, Felrath Hines, was my spirit brother in many ways, who called me almost daily when he knew and respected the fact that I was in my studio working, expressing feelings that he had about the art world in general, about exclusion or inclusion. How should he be considered, as an African American artist or just an artist? Which is part of what all of us concern ourselves with. But he is the one also who gave me tremendous confidence in my own way of working and seeing.

I hope Martha Jackson Jarvis is here today. We have her here in Washington, DC, and she was conscripted when I was head of the art department at Duke Ellington School of the Arts to teach ceramics. She simultaneously affected all of us as artists and as family, while she was still working on her additional degree in art.

And it goes on and on and on. There's Yvonne Pickering Carter. She took me in physically when I was building another house. As did Renée Stout. I don't know whether they were daughters or sisters or whatever, but we were all family. And this is part and much of everything that we are together. Michael Platt is a genius with a gift that keeps on giving. He has taken students in his own studio and guided them constantly. He's been a brother and a friend to me, with his brilliant ideas. I remember when he was at another school, he came to my studio one day when I had done my first freestanding piece of work that was somewhere between painting and sculpture, and asked, "Hey, Burwell, can you make a whole room full of these things? I've got an exhibit to curate." And that was the beginning—my first freestanding painting that took up an entire gallery. So, when you walk into the room, you walked into the painting itself.

It was a fact that we are an intrinsic part of one humanhood that brought me to unexplained tears when I sat on a bench inside of a one-story, one-room exhibition space, in front of three huge paintings that looked to me just like uninterrupted black. And it was only when I left that space and looked at a podium that had a pamphlet on it that I realized I was looking at a Russian Jew's depiction of a crucifixion—does anybody else know what I was looking at? Someone else told me that they had the same reaction. And that has convinced me that I had not seen flat empty canvases, but a painting by Mark Rothko that made me never again doubt how the power of spirit can be manifested through visual experience. It certainly has given dominance to my determination to continue to learn to allow spirit to rule and to channel, and that's certainly a dominant personal experience.

I do believe that you may well discover that the characteristic most prevalent in the work of African American artists in DC is certainly in large part our originality, our inventiveness, both in content and in means—the visual manifestation of finding a way out of no way, our way.

Finally, I have to add—the ego does this, you know, we all have some of it—that as I age, I'm proud to announce how old I am in case you want to know. I was born in the '20s, and when physically I wasn't able to continue cutting and carving large shapes out of wood, and covering them in canvas, and painting them so they were sculptural paintings, I started adding Plexiglas shapes, which I cut and then put into an oven until they're malleable. So, it is an example of

Sylvia Snowden, *Feel of Paint 16*, 2006, mixed media

Artist's collection

why my own mantra these days is "Find that life itself is a process of living for possibility. Don't ever give up, just keep on keepin' on."

RF: With thanks to Lilian we now will move on to Sylvia Snowden, please.

Cover of Lila Oliver Asher, *Men I Have Met in Bed* (2002)

SYLVIA SNOWDEN (SS): Hi. I'm Sylvia Snowden and I paint pictures. Lilian, I do remember that experience of being upset that you contacted my assistant and not me when you needed help. I do, I do. For a minute I didn't, but I do now.

I graduated from Howard University in 1965. At that time, I was taught by five people who really excelled in their choice of expression in art. They excelled. And they also kept an even temper. Their desire to educate us, their desire for us to learn, that was instilled in us. Their appreciation and knowledge of art was instilled in us. And it was a very pleasant experience for me, of learning—hard experience, but a learning experience.

These five people not only knew art but they understood art. A lot of people can say, "Well, this is done by that person, and this is done by this person," but they don't really know the art. But these five people did. They knew the art. And they were very supportive, very supportive. All five were supportive, it's almost as though we were their children. And they really taught us to have pride, and take pride in our work. And that art is not a game. Making art is not a game. It's not a simple thing to do, but it's something that you take seriously, that you do seriously.

The first person that I want to talk about, and these are just in alphabetical order, is Lila Oliver Asher. Lila Asher is alive now, and I believe she's in her nineties. She is still printmaking, and she shows in Silver Spring. I had a show recently at American University, and she came to see it. And she taught the life drawing class at Howard, which then was six hours a week. And I learned a lot about drawing the figure. I'm a figure painter, and I learned a lot about the figure from Lila Asher. And many people who do the figure and are very well known need to take Lila Asher's course. There were no mittens, no mittens, do you understand? You had to learn to draw hands. Now, I need to retake that course. What Lila Asher did and can still do with just the line, the simple line is really beautiful, the way she uses the line. And she was very patient, very patient. We had these large newsprint pads and you had to draw the figure from the model, and my figure would be tiny on this huge page. You know, she would encourage me gently to get larger. And I did, I did. Let me tell you, she wrote a book, *Men I Have Met in Bed*. Now that's tricky. But this is what she did, she worked for the USO, and she drew pictures of male soldiers who were ill, who were in the hospital, and that's where she met the men she knew in bed. That's why it's so tricky. It's a beautiful book, it is.

Now the next person I want to talk about is David C. Driskell. I thought that we had to talk today about the history of art, and I went to the library and I looked up everything I could. David Driskell is everywhere, I mean everywhere. And it was a pleasure to read that. He has been involved with art on all levels since the 1940s, all levels. And he realized, as Black people do, that we don't have a space to show our work. So instead of just complaining about it, he worked to change things and eventually became the namesake for the David C. Driskell Center at the University of Maryland that shows work of African American artists and African artists. That's quite a tribute to a man who writes books, who lectures, who is known around the world. I have a great deal of pride because I studied with Mr. Driskell.

I have remembered this for fifty years—that Mr. Driskell had a book where he kept formulas for glazes on ceramic pieces. And for some reason, it was either stolen or lost, but that book was gone. I remember that, and I also remember that he is an expert at color. He understands color. And he taught me things about color that I still remember, like a formula for flesh is to use white, to use cobalt violet, and cadmium orange. You know what they call flesh, not me, not describing mine. Okay, anyway, he also taught me that the use of one color, and putting

Floyd Coleman, *Shango's Helper*, 1972, acrylic on canvas

Collection of the Smithsonian National Museum of African American History and Culture, Gift of Kera and Bennie F. Johnson

the complement of that color near it, makes that color expand. I don't want to use this word, but it makes it pop. It does.

Mr. Driskell was and still is extremely supportive, extremely supportive. Lois Mailou Jones got me my first job, at Delaware State College, and I had my first show there. And Mr. Driskell came to it. He came to that first show; and he also came to my recent show, at American University, so that's a lot of support there.

And next is Lois Mailou Jones. Lois Mailou Jones drilled the elements and principles of design into you so much that when I teach today—well, I've stopped now—but when I used to teach, I would use the elements and principles of design, even in art history, to allow people to see the art.

RF: You are out of time, but you can talk more later. This is just an introductory statement.

SS: But I want to talk about James A. Porter, and James Wells. James A. Porter got an award from the National Gallery of Art for being one of twenty-six educators in the country, for being a good educator. 1965, was it? And I have so much more to say.

RF: Not to worry. We will come back to you with more time later. But now we have Dr. Floyd Coleman.

FLOYD COLEMAN (FC): Well, it's a pleasure to be here. I want to thank everyone here at the National Gallery of Art, at the Center for Advanced Study in the Visual Arts and at the museum,

Felrath Hines, *Midnight Garden*, 1991, oil on linen

Art collection of David C. Driskell Center at the University of Maryland, College Park, Gift of Dorothy C. Fisher, wife of the artist. © Dorothy C. Fisher, 2016

Image courtesy the David C. Driskell Center at the University of Maryland, College Park. Photography by Greg Staley, 2017

and of course at Howard University for this fabulous program. And it's an honor for me to be here with these distinguished artists, these fantastic individuals whom I've known for a long time.

I am going to speak about *Midnight Garden* by Samuel Felrath Hines, an artist who I got to know very well. Lilian talked about Fel a few minutes ago. But from 1987 until he passed in 1993, I had a great deal of contact with Fel. And the last six months of his life I saw him at least every week, if not two times a week. We would spend a lot of time in the studio talking about art, talking about painting and the like. *Midnight Garden* was painted in 1991. I feel that this work is a virtual portrait of Samuel Felrath Hines, a work that shows he had explored many different idioms, including various types of abstractions. He dealt with gestural abstraction, biomorphic abstraction, lyrical abstraction. He did a wide range of geometric, hard-edge-type iterations, as well as op-inspired works. I feel *Midnight Garden* also reflects something of Fel's sense of what an artist should be about.

Sylvia and others have spoken about color, and Fel was very much interested in color. He said he wanted, in a way, to speak in color. He would talk about color, space, and design structure. Those were the things that he built his works on. *Midnight Garden* is also a jazz moment. Fel was an aficionado of music, especially jazz. I feel that this work is very much like a late 1950s–early 1960s composition by Miles Davis. Fel responded to sound; he knew how to translate sound into color among his many different kinds of abstractions. He was not interested in mimesis, the imitation of nature. But with investigation, invention, and the creative imagination. I learned about art, I learned about being an artist, and I learned about life during the time that I spent with Samuel Felrath Hines. Thank you.

RF: Sylvia said she wants Floyd's leftover minutes because he didn't use them all. But I think we shall keep moving forward for now, with our next speaker—David C. Driskell.

DAVID C. DRISKELL (DCD): I have no images. You will have to look at me. I guess one of my claims to fame would be that I studied life drawing with Lila Asher before Sylvia did, in 1952. I also want to say a few words about the Howard experience through James V. Herring, the founder of the art department at Howard University, and James A. Porter, who succeeded him in that position. Now much has been said about these two gentlemen, but I think that Sam Gilliam would back me up on what I'm about to say, in the sense that they had a spirit about them of inclusion, of wanting all of us to understand the true meaning of art, and that it wasn't just something that was academic. That it was communal, that it was something that was spiritual, and that it was something that we should have a lifetime commitment to.

There were two different perspectives as to how you would see these people. James Herring was no-nonsense, and yet he kind of taught by parables and playing around, telling you things. I remember the first time I encountered him in Thirkield Hall, where the art department was located at Howard University in the 1950s. It was in a painting class, and he came up to me and

David C. Driskell, *Self Portrait as Beni ("I Dream Again of Benin")*, 1974, egg tempera, gouache, and collage on paper

Courtesy High Museum of Art, Atlanta/ DC Moore, New York

looked at my painting—I was doing a portrait of a young lady wearing a blue sweater—and without introducing himself to me, this cantankerous old man who would just say anything, and embarrass you and what have you, said, "Oh, you're a new art student, right?" And I said, "Yes." And he said, "Well, I'm looking at that painting you're doing," and he looked at the arm of the young lady who was wearing a blue sweater, and he said, "you will never paint a better seascape in your whole life." That was my introduction to James V. Herring. When we were in his class and we wanted to get even with him, and that was often, we would call his entire name: Professor James Vernon Lee Alfonso Joseph Augustus Herring. And he didn't like that. But that was our comeback.

James Amos Porter, *Self-Portrait*, 1957, oil on canvas

National Portrait Gallery, Smithsonian Institution, Gift of Dorothy Porter Wesley

Herring presented a contrast to James A. Porter, James Amos Porter, although they were all Howard University people in those days—the whole department was. Which meant you must dress well, you must speak well, you must act well. And all of that was part of the whole atmosphere of art. Professor Porter kind of dressed like an Englishman. He was never there without cuff links and tie and tiepin, all of that. And yet, he taught. But during his introduction to me, in Thirkield Hall in Professor Wells's drawing class in 1951, he stood behind me and watched me draw for a moment. And then he asked, "What is your name?" And I told him, and he said, "Well, I don't think I know you. You're an art major?" And I said, "No, I'm a history major." And he looked at my drawing, and he said, "Well, you don't belong over there, you belong here." So, I went and changed my major. That was my introduction to Porter.

And he then became my mentor. And I thought, well, I'm going to be a painter and will change the outlook of the world. I'm going to be a social commentary artist. The summer of 1953 I went up to the art program at Skowhegan, Maine, and had Jack Levine as my teacher. Jack Levine being a social commentary artist, I thought, "Well I'm going to change the world by showing him that I can be a critic and can do this and that." Well, that didn't last very long. Then I came back from Maine, and Porter said that we had a new person in the faculty and that he wanted me to take a class with him. And by that time Herring was retiring and Porter was chair of the department. And I asked, "Who is this person?" And he said, "Morris Louis."

Now, Morris was very quiet. He was just entering into that period of getting involved with the stripes and the strips of paint and what have you. He didn't speak very much, he just encouraged you: if you drew a line with color and placed another line against it, he would encourage you. And I said, "I don't want to study with this man, I'm going to be a social realist." And Porter said, "No, you will be studying with him." And, of course, I did.

Well, there were these different levels. As Sylvia said, there was Lois, who was no-nonsense when it came to learning color, design, theories of art, etc. And Professor Wells, who was so kind you could, kind of, walk over him; he just kind of let you keep moving along. But then he would say, "No, no, no, that's not the way it's done." So, you learn from all of these people.

But I wanted to say all of that in order now to say that Howard had an atmosphere about it of encouragement in the arts. And it was communal in the sense of the universe in Washington. Everybody knew the faculty, and they knew everybody. I met Mr. Duncan Phillips through Professor Herring, in the Barnett-Aden Gallery in 1952, when I was working there. I mean you got a chance to meet people there. I met Langston Hughes at the Barnett-Aden Gallery, and Romare Bearden, and people like that. So the Howard faculty had a sense of community that went beyond Washington, and they tried to introduce you to that, not just in the classroom. Howard was really at the center of art production in those days. I mean, everybody outside of the Washington community knew about art at Howard University. In the summer, Jones would

take students to Paris. Sylvia went with her to Paris. I was too poor to go when I was a student.

I came to Howard University in 1949, eight years after this National Gallery of Art was established; and I say this to the credit of this institution because this was one of three places in Washington, DC—it was still a segregated city in 1949—this was one of three places where African Americans could come and feel at home, three places in Washington where you could eat without the police coming to lock you up: the National Gallery of Art's cafeteria, the United Methodist Building cafeteria over near the House of Representatives, and the Savarin's Restaurant in Union Station.

And so Washington has changed over the years. The fare on the streetcar at that time was thirteen cents. And I came here with the notion that I was going to go to Howard University even though I hadn't made an application. I showed up after school had been in session for three weeks and they kind of looked at me strangely. I had my report card, I had been valedictorian in my little four-room segregated high school in Appalachia, in western North Carolina. And they told me that I couldn't just walk in and go to college. I had no money. And I asked, "But what do I need?" And they said, "Well, you complete an application," and I said "Well, I'm here, give me one." And so we went through this process, and I got into college.

Then I went through the program of becoming a historian and eventually an artist, and one of the things that changed my perspective of how I look at art, and eventually the world, was to go to the Andrew Rankin Memorial Chapel, where Howard's old art gallery had been. They had moved it to Founders Library by the time I had got there. But I went to chapel one Sunday morning and Dr. Howard Thurman was speaking. And I think I got religion. I had had it all the time, of course, because my father was a Baptist preacher. Anyway, Dr. Thurman based his sermon on service and dedication to your craft, whatever it is that you do. And he advised the audience that, "Some of your parents have labored to get you here to work, so that you would have this opportunity." And he said, "You've been up all night partying, not studying, not doing the thing that you should be doing. But let me tell you something. If you are one of those students, go thy own way and do thy own thing so God won't have to forgive you for being born."

And that kind of shook me up. I took my art more seriously thereafter. I became a scholarship student. And these people that Sylvia talked about— James Wells, Lila Asher, James Porter, Lois Mailou Jones, James V. Herring—they ushered me into a sense of commitment to my artistry, to my craft. And James Porter said to me, "You're a pretty good painter, but you've got a good mind so you can't just spend your time painting. You've got to help us define the field." So that's why I felt that I had to pick up the mantle and go forth. Thank you.

RF: Sam Gilliam is our next speaker.

SAM GILLIAM (SG): I came to Washington in 1962. I knew that the head of my department at the University of Louisville and the head of the art department at Howard were classmates at Harvard. So, through Sterling Brown and a *Washington Post* photographer who knew Sterling Brown, we chose to invite Dr. Porter over for an afternoon of drinks. And I had my sketchbook. I had gone through academic things, but I was just at the beginning, about to discover Paul Klee. It was just after military service and graduate school and having taught the sixth grade; and I was certain that I was ready for success. And success in that sense meant that I would teach college not the sixth grade. Dr. Porter said, "Well, you're passionate, aren't you?" And I said, "Yes." And he said, "Well, you'll make more money teaching high school." And he was right.

I didn't go to Howard, but I was never far from Howard once I got to Washington. But more essential was that I was not very far from those products of Howard. I knew everybody

Sam Gilliam, *Shoot Six*,
1965, acrylic on canvas

National Gallery of Art, Corcoran
Collection (Gift of Walter Hopps
in memory of Bradley Pischel).
© Sam Gilliam / Artists Rights
Society (ARS), New York

at this table. But when David came back from Fisk and became head of the department at the University of Maryland, almost everyone here was at the University of Maryland. I met Keith Morrison. I knew about Martin Puryear. And Lou Stovall and I worked together making prints. Lou gave me a test one day and asked me if I knew anything about silk-screening, and I said of course. So, I filled the screen up with paint and said, "Hand me the squeegee." And I made my mark. And that's like the idea that you're going to play basketball just by putting the basketball in your hand. There are a lot of techniques and a lot of other energies.

I did become sort of very close to Tom Downing, who only talked about Morris Louis. But the real event was the time that Kenneth Noland had his retrospective in Washington, at both the Hirshhorn Museum and Sculpture Garden and the Corcoran Gallery of Art. We were standing in line just to greet him. And at the end of the line was Alma Thomas. She was in a wheelchair at the time. And when Ken got in the door, he looked at the end of the line, and he started to run. And he ran and spoke first to Alma Thomas. Well, Alma and I were kind of buddies because she was painting flowers on one side of a sheet of paper, and she would switch it over and do these little abstract puzzle parts on the other side; but mostly because she would invite you by to talk art because under the kitchen cabinet she had a bottle of Johnnie Walker.

And sort of in an inward way, from deep inside, whether knowing Tom, knowing Keith, and knowing the very rapidly excelling and growing very famous, smart Martin Puryear, or working with Lou, I always felt that Washington was the best place to be, if for no other reason than for Rock Creek Park. And when my daughter, my middle daughter, Melissa, was going into medicine and she was a Rhodes Scholar, and she came home in her last year when she was to go to Harvard, and said to me, "Dad, I think I want to follow in the family tradition." And I asked, "What's that?" And she said, "I want to be an artist." And I said, "Whoa." I said, "You have two sisters. One wants to be a filmmaker, one wants to be an architect. I want to be an artist. We need support."

Upon her graduation from medical school and her working in a hospital in Chicago, I visited her apartment, and she had more African sculpture, more quilts, more color, more photographs, and I asked myself, "Did I do the wrong thing?" But of course, if you're not an artist, be a collector.

Well, it's the mistakes that count and it's also the winning that counts, which comes through diligence, learning, and innocence. I always say I'm a Washington artist because that's where it is. And if I had more time, I could fill in all about that. Thank you.

RF: And now Keith Morrison.

KEITH MORRISON (KM): I lived in Washington for, let's see, about eleven years, essentially the decade of the '80s. And Sam forgets I met Sam not in Washington but in Chicago. In fact, I met Martin [Puryear] in Chicago as well. And Sam visited my Chicago studio; we spent a lot of time drinking. And I remember driving down the Dan Ryan Expressway in my silly little sports car; we almost crashed. And David, whom I've known for so long, was kind enough to invite me to come to the University of Maryland, so it was like a reunion for me.

I can't say I was influenced by anyone in Washington, but my life as an artist was very much affected by Washington. And I really found a comfortable level to engage myself with the things I wanted to do in Washington. Actually, I had come to Washington long before I moved here. I first came to Washington in 1967 to meet Dr. James Porter. I was only a little baby boy then. And Dr. Porter introduced me to Dr. Jones. And he wheeled out my crib and introduced me to David. So, David and I have been brothers since my babyhood. We've been brothers for fifty years now.

But I've never taught at Howard, and I don't think I've even exhibited at Howard, but Howard has been really very important to my grounding as an artist, my finding a better understanding of why I was doing what I did. And the people who've been mentioned here for the last two days are people that I have really found very important to me as an artist: James Herring, Dr. Porter; and people have mentioned Alain Locke. And the many exhibitions, the wonderful exhibitions that they did at Howard since the inception of the Howard gallery in 1928 through today. When I lived in Washington and did some work studying the artists at Howard and the makers of art and the people that they were hiring at Howard—Porter and so on, including David—I was struck by how wide a field they were looking at, and the kinds of exhibitions they had, featuring artists from all over: Theodoros Stamos, Irene Rice Pereira; they brought Picasso prints from New York, and they brought Matisse.

At first it was tempting to think that they were being integrationists and expanding the art world to find a place for themselves as Black people, integrated into a greater world. But as I studied more, I realized they were doing that, but they were also doing something else. They were forging a world vision of art from an African American perspective. Porter got Candido

Keith Morrison, *Zombie Jamboree*, 1988, oil on canvas

Smithsonian American Art Museum, Museum purchase through the Catherine Walden Myer Fund and the Director's Discretionary Fund

Portinari from Brazil to show here, he got Wilson Bigaud from Haiti, somebody mentioned yesterday that Ben Enwonwu from Nigeria got his first US solo show here. And the Harmon Foundation's exhibition of contemporary African art, which they had difficulty placing in New York, as I recall, they brought to Howard in 1951. So what the gallery, what Porter and Herring—and Locke's ideas as well—created was a worldview of art from an African American perspective, and that really stuck with me.

You have to remember that in the mid-1980s even, the idea of African American art or Black art was still very controversial, and a lot of people—Black people, white people—would spend time debating the merits of that. So to find some grounding about that was very important for me. And what I found grounding was not a definition of what the art should look like, but rather a global perspective that included experiences of people of African descent, looking at art worldwide and making a whole composite of it.

But, I would be remiss if I also didn't mention the importance to me of Jeff Donaldson and AfriCOBRA, because I think in some ways, in many ways, they followed that expansive tradition. I should also point out that people like Herring and Locke, like a lot of brilliant people, didn't necessarily agree on anything. But the composite of their ideas created a lot of energy and a worldview. Jeff Donaldson was important to me in that arena as well, and not just Jeff but the AfriCOBRA members. I knew the AfriCOBRA members of the Howard faculty and Jeff from Chicago—in fact, I knew them before they became AfriCOBRA. I went to school with some

of them. And I went to one of their formative meetings before they defined themselves as AfriCOBRA.

And for me, one of the interesting things that Jeff and the AfriCOBRA faculty brought to Howard to augment what Herring and Porter and Locke had done was to bring in the importance of ideas carried by people who were slaves, people who were not necessarily formally educated, the vernacular ideas, ideas of people who've been left out in many ways, and street art, street ideas. In some ways they picked up on something Langston Hughes had promoted. We all know of course W. E. B. Du Bois was a great sociologist and that he promoted what he called the "Talented Tenth." I can't say that Howard really promoted the Talented Tenth, but by being a university you promote a diverse array of ideas. Langston Hughes, for example, always picked up

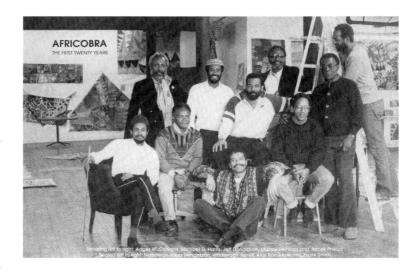

the vernacular in his portraits, the ordinary people. Jeff Donaldson would talk about that. We knew he studied African art. He studied with Frank Willard at Northwestern, I believe, and got a PhD. But Jeff's focus was less on the formally accepted African art than on the transmittal of ideas from people of African descent. And I think AfriCOBRA really did that, picking up on the Langston Hughes idea to really add to the mix. And I think it was really important to me to understand that.

Postcard for *AFRICOBRA: The First Twenty Years* at Nexus Contemporary Art Center, Atlanta, 1990

Archives of American Art, Smithsonian Institution

We look at people like Jacob Lawrence, and even before him, Horace Pippin in the 1940s, who have been included in African American art. But I don't think we ever really quite found, at least from my perspective, a full grounding of how their work fit. People talk about them as outsiders, especially Pippin, primitive or whatever it is. But if you look from an AfriCOBRA perspective, it's the ideas of the unschooled people who were part of the African American family. And I think this creates a whole arena of things.

What I got from Howard, Barnett-Aden, from David, from other people, was first of all, a sense of history. And I was a very history-conscious person. But more than that, they told a story, they were great storytellers. And their vision was a story of people of African descent, and for me that was very important. Thank you so much.

RF: Martin Puryear will speak next.

MARTIN PURYEAR (MP): I was born in Washington. And as many people probably know, Washington is a very transient city, but I'm a third-generation Washingtonian. So, I'm really from Washington. But my life as an artist didn't really happen here, I never maintained a studio here. After I finished my college years I moved away, and I would come back. With lots of family here, I have come back repeatedly to visit and also to exhibit in different capacities.

But I was little hesitant about speaking today because in a certain sense I'm not really a Washington artist. I didn't make my career in Washington. As soon as I left college I started to travel and lived in different places. I went in the Peace Corps in Sierra Leone in West Africa, then I studied in Sweden, then I lived in New Haven for the time I got my graduate degree at Yale. And then I was hired by David Driskell to go to Fisk University, where I taught for two years and got to know David, although I had met him in my undergraduate years at Catholic University. He was a graduate student working on his MFA, and I was an undergraduate when

we first made contact there. So, there's lot of history at this table, even though, like I said, I'm a dubious Washington artist in the sense of not being somebody who's lived here all these years. But I feel very close to this city.

I can echo what David is saying about what Washington offered, especially what the National Gallery offered. I was taken here as a child by my parents. I was introduced to all the museums on the Mall as a very young child. It's one of the formative influences in my life, being taken to the National Gallery. And I was young enough when I first came here to be absolutely in awe of all the carved marble statues of naked people. That really, to a little child, was one of the strongest memories I had, suddenly seeing people with no clothes being depicted. That's how young I was.

My parents were very encouraging to all of us, to just get out of our neighborhood. We grew up in Southwest Washington, the old Southwest, which was an urban renewal site back in the '50s. We lived in a block of apartments at the time—and the building is still there. A lot of what was around it was razed and new housing built around it, but that building is still there. Our neighbors in the block were professional people, government employees, teachers, surrounded by pretty rough neighborhoods. I went to William Syphax School, which is now a condominium, but it's right next to the big stadium off the South Capitol Street thruway, the brand new athletic stadium. That was where I was born and grew up.

As to my education as an artist, we were encouraged to talk today about an influence or a person or something. I don't know if I can talk about one single thing. One of my strongest memories is being encouraged by my parents when I was very small. I drew and they took note of it. And I had a bachelor uncle who also noted it. He had gone overseas in the army, came back, and had a little touch of Europe, speaking a bit of French. I was one of seven kids. I was the oldest, so there weren't seven to start with, but my parents were not wealthy at all. My father was a postal clerk; my mother was a schoolteacher. And this uncle, Uncle Emmitt, who is dear to me, learned of an art school for children in Washington. And he investigated it, and he took me with some of my drawings to the school. It was in Foggy Bottom, a part of town I had no knowledge of at all. I was in the fifth or sixth grade or so.

He took me there to meet this woman, whose name was Cornelia Yuditsky. David and I spoke about her because when David was going to Howard, I think, he was delivering art supplies, including to Mrs. Yuditsky's school for young people. She told my uncle that I definitely should be coming to her school. And she made an arrangement so the fees were affordable for my uncle, who paid for my youngest experience of taking myself seriously as an artist. I always thought Cornelia Yuditsky was some European person because of her name, and also because her school was open racially, which was atypical from the prevailing pattern in the United States. I mean, I was the only Black kid there. But there was no question once I showed my work that she said, "He needs to come here and I would love to work with him." That was a complete aberration to what was the general attitude at the time in Washington. Like David said, it was a completely segregated city, completely segregated. But Mrs. Yuditsky was an extraordinary open door for me. And what I got from her most strongly was that she conducted this art school in a way that was so serious. You come in, you get your paints, you get your easel, and you go to work. There's no gossip, chattering, playing, you take your work seriously. And that was an extremely crucial experience for me.

Actually, I started my college years at the District of Columbia Teachers College, for two years. And that's where I think I had a course with Hilda Brown. Also, that's the first time that I heard of the Barnett-Aden Gallery, and shortly after that transferred to Catholic University and I made David's acquaintance. I think I met James Porter at the Barnett-Aden Gallery once,

Martin Puryear, *Lever No. 3*, 1989, carved and painted wood

National Gallery of Art, Gift of the Collectors Committee

so I had a little bit of contact with that. And I realized that the Barnett-Aden Gallery was a real cutting-edge gallery in Washington. There were very few galleries that were showing what would be called today cutting-edge art. At the time it was the Washington Color School painting.

Kenneth Noland was on the faculty at Catholic University when I was a student there. I never had a course with him, but he was on the faculty and he showed work at the Barnett-Aden Gallery. It wasn't simply limited to showing the work of African American artists. So, there's so much complexity to the background of this city that I think is, in a way, varied. And this is such a good occasion to be able to make these connections and bring these things out.

After the Peace Corps years in Sierra Leone, I went to Sweden for two years to study art at the Royal Swedish Academy of Arts in Stockholm. I was away for four years, and then I came back to Washington and had heard this name: "You've got to meet Sam Gilliam; he's the new artist in Washington." Sam may not remember that, but that's when I met Sam Gilliam, and we have been in some kind of contact in the years since. So, I've had a sort of hit-and-run relationship with Washington, but every time I come back it's been just an amazingly rich and powerful experience, largely because this is where I started. I live now in upstate New York and have been there for twenty-five years. Before that I was for fifteen years in Chicago where I met Keith at the University of Illinois, Chicago. It's just a great experience to be back. Thank you.

RF: And our final speaker is Lou Stovall.

LOU STOVALL (LS): When James L. Wells came to Washington from New York City in 1929 to teach printmaking at Howard University, he brought with him some of the dynamic

initiatives which caused the Harlem Renaissance as we know it. Wells was an active artist in Harlem during that period of amazing aesthetic thought and creativity. And Wells became my mentor at Howard University in the 1960s.

What he brought to Washington was a system of values based upon community input and outreach. Wells involved himself in printmaking as a means to join a world of artists who he identified as a vehicle for his participation. He led workshops with Charles Alston in Harlem, where Jacob Lawrence was a student assistant, and together they shared their knowledge of making art as young men. James Amos Porter hired Wells for Howard University's fine art department. There, he joined what became a continuing tradition of young artists striving to infuse a spirit of possibility in this art world.

Thinking back to my discussions of possibility with Mr. Wells, I'm amazed to have been part of a tradition of sharing and participation. I did not know at that particular time when I began making silkscreen prints that I was continuing the dream of Mr. Wells and his early entrance into printmaking. At Howard I was exposed to some of the most inclusive thinkers of the time, and in that period when ambition to succeed prevailed we came to an understanding.

Perhaps a sharing of ideas has always been a path to involvement in the new. Even as I revisit these ideas of how sharing impacted and persuaded young thinkers to get involved in order to work on a higher plane, I cannot help but think of the many creators, such as the three Black women [Mary Jackson, Katherine Johnson, and Dorothy Vaughan] of whom we have only recently learned, who made space travel plausible and who contributed to a larger intelligence in their workplace. The film *Hidden Figures* reminded me of other contributors to a wide range of intelligence, including medicine, science, agriculture, literature, and, of course, art and so much more, who have only occasionally come to broader attention over the years.

I knew that if I wanted to become the significant silkscreen printmaker that I envisioned for myself in high school, it would mean working with a lot of people and sharing the medium of silkscreen printmaking by learning and sharing. Mr. Wells recognized in my statement of purpose that I was a kindred spirit and that we both thought of printmaking as our life pursuit. Though he engaged himself with relief printmaking and I pursued silkscreen, we both embraced craft as our God-given direction.

Wells was a master craftsman continually pushing the limit of existing traditions as he sought to extend the possibilities of the medium to match the challenging demands of his artistic vision. That also became my mantra. In my talks with him I shared my thoughts to accomplish silkscreen printmaking as the best medium with which to make art because it had the possibility of clarity, brightness, and the strength of modern art. It was all about making beautiful images, beautiful pieces which could be affordable at a time when it seemed that the ever-increasing prices of art would be out of reach for young collectors.

It was necessary, and it has always been necessary, to establish an accessible market. In 1985–1986, Wells came to my studio to observe and help as I made a silkscreen print of his original painting, *Still Life with Violin*. Wells was curious about my experiments in liquid mediums, of stop-out, with which I could replicate brushstrokes. He was impressed with the results of my experimentation and the prints I made for other artists. Wells and I had become friends, a distinction which I cherished. He came to all of my exhibitions. At that time, there was a growing number of opportunities to exhibit the work of new artists. Small and recently opened commercial galleries were seeking different cutting-edge works of art. Washington was coming into its own as an art market.

In 1987 I invited my friends who knew of my work with Mr. Wells to contribute funds to travel Mr. Wells's exhibition, *Sixty Years in Art*, from the Washington Project for the Arts to the

Studio Museum in Harlem. Wells had enjoyed a presence in New York early on in his career, but when he came to Washington, teaching at Howard absorbed him. Somehow going full circle by taking his work back to New York City was as important to Mr. Wells as it was to me. We collected over $13,000, all of which went to Mr. Wells for his travel, for packing and shipping, and for the final return of his exhibition. I was proud of the Washington Project for the Arts and its director Jock Reynolds for mounting the exhibition and publishing a very meaningful catalog to document the work of a man who was so consummately involved with Washington, and whose friendship, scholarship, and art added greatly to the sum of cultural life here.

Lou Stovall, *Breathing Hope*, 1996, color screenprint on wove paper

National Gallery of Art, Gift of Lou, Di Bagley, and Will Stovall

James Lesesne Wells, *Still Life with Violin*, 1987, silkscreen

DC Commission on the Arts and Humanities Art Bank Collection

In my own way, I feel that I have come full circle again by serving as a printmaker for Mr. Wells, Jacob Lawrence, Elizabeth Catlett, Lois Mailou Jones, David Driskell, and Sam Gilliam, and so many others who were not directly connected to either Howard University or the Harlem Renaissance, but who benefited from the flow of participation. So many artists who have come through Washington, DC, contributed to the city's various significant creativity, like the Washington Color School. Mr. Wells once said that he takes only credit for introducing me to the printmaking medium, but I also credit Wells for sharing with me his sense of community and the possibilities for participation. As he shared with me so he touched the artistic community of Washington, DC. I am grateful to the Center for Advanced Study in the Visual Arts at the National Gallery of Art for bringing this subject and all of us together, including James Wells's daughter-in-law, Linda Grant-Wells, who is with us today. Thank you, all.

Lilian Thomas Burwell

Courtesy National Gallery of Art Archives

Martin Puryear

Courtesy National Gallery of Art Archives

RF: What an extraordinary recounting of recent history we have just heard. I have many questions, but I would rather continue with questions the panelists have for each other.

LTB: I for one am very curious of how other artists feel about what the primary importance and impact of the Washington scene is. I hope that I made the point that my belief is that as innovators we are the initiators of ways of thinking and producing in our art. I think about Martin Puryear's work. No one has ever seen anything like that before. It came from Martin, it didn't come from Washington. But he was one of the contributors of the type of thing I'm talking about. I'm curious about whether you agree with me, that our greatest contribution has been about being inventive, of being creative? Responses, please.

RF: One thing about Washington is that it is one the great museum cities in the country, and I think that has something to do with this creativity, as well. And, Martin, you grew up here.

MP: I think of inventiveness as something that all artists should claim for themselves. That's what it means. And part of it is, in a way, inventing yourself.

LTB: Do you see that as one of our greatest contributions, though, as a group? And I see it as an example of denial making the space for making something happen which is much greater than otherwise might have occurred.

MP: I don't want to speak for everybody. And I will say at the outset, when I first was approached about this program, I gave a little feedback to the organizers: I had a little bit of an issue with something that was in the title: "The African American Art World." I think I wrote back and said, from the beginning of our presence, Black artists in this country—and I used the example of Joshua Johnson as one of the earliest Black artists who was a portraitist in the 1700s, a free Black man who was an extraordinary artist—I said that in my conception of art you want to be an artist in the world and not just in the African American art world. And one of my strongest feelings is that being an artist gives you an opportunity, and in a sense a duty, to invent. That's what I mean when I say it's inherent in every artist, and that it gives you the opportunity and the possibility and the duty to invent. And part of it is inventing yourself, because there's been a denial that we have a history in some ways.

Floyd Coleman and Sam Gilliam

Courtesy National Gallery of Art Archives

I spent yesterday trying to take in as much as I could of the new museum, designed by David Adjaye—the National Museum of African American History and Culture—quite a mouthful and also quite a volume of truth to try to absorb and take in. It's overwhelming. I don't know that this inventiveness is something that Washington has a monopoly on, or Black artists have a monopoly on. I think it's something that humanity needs to embrace more as a goal.

RF: Does someone else want to pick up on that? Sam?

LTB: I mean, who else does draped canvases across spaces but Sam Gilliam? That came out of Sam, that didn't come out of influence.

SG: I think that we learn from David to concentrate on the previous generation and from Floyd to concentrate on the Spiral group and from Ruth, who had a choice of writing about anyone and chose Romare Bearden. And during the time the Bearden show was at the National Gallery, I met a person who said, "I've been here eight times." That's more times than some people have gone to see *Star Wars*. And I think that Washington is an important place, because Jacob Lawrence was here to print with Lou and did perhaps one of his most central print projects with Lou [*The Migration Series* (1940–1941)]. I think it takes a very small place with a lot of close contacts. I guess, like the Paris of cubism. You don't always have that positive sense that you're doing the right thing. But sometimes you're doing the wrong thing that leads to exactly the right thing.

I remember that during the time at Yale that the Black Panther flag flew over the architectural building and classes were scrambling, and people were arguing. Martin invited Rockne Krebs and me to come to Yale to show our slides. And the fight increased because the concentration was on a writer mostly, Jack Burnham, who taught at Maryland. But also, the consensus was that Burnham was really writing about magic.

I think that one of the things is that it's not just Washington or New York, it's America.

And I don't necessarily agree with the term Black Art. I really don't. I've always known that there was an ocean not a pond. And even with Henry Louis Gates and David Bindman now bringing the history of the great eras of African diasporic art in *The Image of the Black in Western Art* series [Harvard University Press], you realize what a tremendous past that collectively people have put together.

Donald Trump's budget does not contain art. And art is the essential thing that caused all of us to know each other, to respect each other. And I'll tell you there's some famous people at this table. And there are always inquiries as to who is Felrath Hines? Are there shows about what comes from Indiana? David Smith. Or even when the curator of the Indianapolis museum talks about Felrath Hines being a Color Field painter, she says, "No, he's Felrath Hines."

The thinking that comes from this country leads to essential things that are a part of what is called universalism. And that's the most important thing. Right now, I find it impossible to be sad because I've gone back to Yale, I see the number of Black students. I know that the Calhoun College window is gone. I know that Thomas Jefferson's Monticello is now rebuilding the Sally Hemings room. I've read *The State of Jones: The Small Southern County that Seceded from the Confederacy* by Sally Jenkins and John Stauffer. I know Houston Conwill. I know Kinshasha

Holman Conwill. And I had to inform her this morning that Houston's mother and my mother were good friends. Collectively sometimes you're blessed to know people, have friendships and programs like this, and live in a good place where there's The Phillips Collection, the Hirshhorn Museum and Sculpture Garden, the National Gallery of Art, and now the new Smithsonian National Museum of African American History and Culture. And Mel Edwards reminded me that Smith means Blacksmith. Thank you.

RF: Does anyone want to respond to that?

FC: I would just like to say that we've been talking about influences, and I can say that I've been influenced by all of these people here. When I look to my far right, and I see Lou Stovall, it was in the early '60s when I first met Lou. And he confirmed some of the things that I had read about, particularly about printmaking and James Wells. And also, he confirmed another thing that I had learned from reading James A. Porter's *Modern Negro Art* and other things by Porter—that Howard was indeed an important place for us. Lou was a recent MFA graduate of Howard.

And then when I look to my left, I knew of Lilian, and I knew of Sylvia from the '70s forward. I knew their work. And then, when I was teaching at Southern Illinois University, I taught both studio art, graduate painting, as well as contemporary seminars in art history and criticism there. And I talked about the work of Sam Gilliam and Martin Puryear in those classes. Some of my students didn't know who they were, but I said that they belonged with all the other contemporary artists I'm talking about, whether it may be Lichtenstein or Pollock or whomever. That Gilliam and Puryear were in that category. And I've been saying this since the '70s.

I met Sam in 1968 when he gave a brilliant lecture at Atlanta's High Museum. And from that point on, he was part of my seminar discussions in my contemporary art classes along with Howardena Pindell and a lot of others. David Driskell and I go back to 1956. I was a freshman at Alabama State College, now University. And, David was at a little place called Talladega College, and they were writing about him in the white newspaper there. Let's face it, we've lived in an apartheid society in this country, particularly in the South; a little bit better in the North, but still apartheid. Still racism, segregation, and all those sorts of things. But David, in Alabama, in Klan country, David was doing all sorts of things and they were writing about him in the local white newspaper. They only wrote about Black people when they were in jail or stole a chicken or something. But they were writing about David, an artist.

And in 1958 or '59, I traveled to Atlanta, Georgia, to see an exhibition that the Atlanta University Center had sponsored. Really, it was the Atlanta Life Insurance Company that sponsored it, but it was held at Atlanta University—it was the annual National Exhibition of Negro Artists. It had paintings, prints, sculptures, and so forth. And I stood in front of a painting called *Young Pines Growing* by David. I remember that painting, and I stood there looking at that work. I knew Howard University, and David was a graduate of Howard, and so forth. Later I got to meet Keith.

So, my point here is that I've greatly admired and respected all of these individuals, and I've talked about them in classes and seminars and some of the conferences I've tried to sponsor over the years and the like. And then also I was so pleased to hear about Ruth being here. I knew of Ruth being given the distinguished Alfred H. Barr Jr. Award by the College Art Association, recognizing the work that Ruth did for the Norman Lewis exhibition, which was just a fantastic exhibition, and some of you got a chance to see it. I must also say that Howard University honored Ruth at the Porter Colloquium prior to the CAA award.

RF: What an honor that was, indeed.

I have a question for David. In 1976, you wrote the exhibition catalog *Two Centuries of Black American Art* for the Los Angeles County Museum of Art. I'm wondering what kind of things you've seen change since 1976 in terms of how African American art is viewed by and included within a broader community?

DCD: Well, hmm. First of all, I always say in my art sermons, which are very often that more than anything else, that we didn't ask to be called Negro artists or Black artists or whatever. We just wanted to be artists. But, because of the peculiar, and very often inhumane, insensitive, sociological nomenclature that is so evident in classifying and naming people in this country, we all but decided, accepted, and became involved with dispensing with this broader definition of humanity. And talking about, you know, Black artists, etc. I remember it was always the wish of Lois Jones. She said, "I'd just like to be called an artist. I'd like to be called an American artist." And hopefully one day that will happen.

And I very often get questions as I move around the country, "You still doin' those Black shows?" Well, you know, I'm doing shows. I'm often inclined to say as Tuliza Fleming said over in Paris back in January—at the symposium there dealing with *The Color Line* exhibition—she said, "I'm just tired of this term Black Art and if you're not talking about black on the canvas, I don't want to address it anymore." So, we get caught up with many of those labels out of the character of being named and nomenclature of who we are. I think everybody here today knows you have artists who are of the finest caliber sitting here at this table.

And Washington is blessed, as has been said on numerous occasions, with being a center for this kind of thought, this kind of process, in creativity. And I very often say segments of the community will be left out. You know, as I approach my eighty-sixth birthday, I am delighted to see this event happening at our nation's premier gallery and museum, along with the notion that the Howard University gallery and community has made a contribution.

And it takes that kind of forward thinking, that kind of forward looking, because as Sam mentioned these are critical times now. The arts are really in for a shock if we haven't already gotten shocked. And we must stand tall. The divisions, gender, race, etc., they're not a part of art. Art is a spiritual definition of who we are. And it gives us the sense of the best that there is in the human spirit. And we must embrace the notion that we are under attack, and that we must be willing to make the sacrifices of creative intervention, innovation—whatever is necessary to see to it that the blight of discontent, of unkindness that is before us in the world, in this particular city in general, is not what we spend our time involved with. We must go on with the creative spirit, we must keep on with the sense of keeping on until such time that we are above and beyond with the nonsense that is attacking us as artists. I don't think I answered your question, but I decided that at my age I'll say what I want to.

RF: Keith wants to say something. But before he does, I think I want to comment that I think we're all in the same category as David, at an age to say what we want to.

KM: Going back to Lilian's question about artists, the character of the artists and the potential of the artists in Washington. I'll only try to answer a part it. When I lived in Washington, I was always struck by the fact that so many artists in Washington were not from Washington. Washington was like a watering hole, a lot of people from different places around the table.

Lois Mailou Jones, *The Green Door*, 1981, watercolor over graphite on wove paper

National Gallery of Art, Corcoran Collection (Museum Purchase, William A. Clark Fund)

Martin, you're probably the only person here who's actually from Washington. Sam's from Louisville, he and Muhammad Ali, I think. I'm not even from the United States. Don't tell Donald Trump, I have a green card. My country is not even privileged enough to be on any-body's list of countries whose citizens are not welcome in the US. I think I'm going to propose that Jamaica gets on that list. I think that's a status symbol.

The thing is that I met David and Dr. Porter in 1967, and one of the things that struck me, coming from Jamaica, is that there was no line of demarcation in their thinking between the US and other people of African descent. And I've known David now for fifty-one years. And I've never heard David make a distinction about African American artists, Caribbean artists, African artists. He sees them as a whole, as a totality. And I think that was in the vision of James Herring and Dr. Porter and indeed Alain Locke. They had that whole vision of a global sense. And that global sense included people of African American descent, but everybody else as well. It's how they saw the world from their experiences.

And I think Washington, in my experience during my years here, was a bit like that. There were people from all over who came. Floyd, where are you from? From LA. They came from

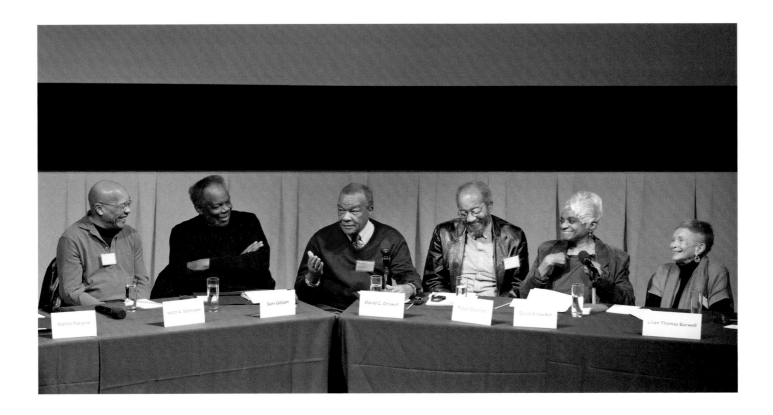

Left to right: Keith Morrison, Sam Gilliam, David C. Driskell, Floyd Coleman, Sylvia Snowden, and Lilian Thomas Burwell

Courtesy National Gallery of Art Archives

different places and made Washington the strength that it is, at least that was in my experience. Thank you.

LTB: I think I need to add a little bit of preaching to this. We have a tendency in this country to put everything into a category. We have sort of a file cabinet mentality. It's not just in races and occupations, but in thinking. It seems to make things more manageable if you can put someone or something into a category. There's an analogy that I love to use that helps us all in our thinking, whether it's about art or anything else.

I see all humanity the way a person would see a giant crystal ball. A diamond cutter cuts one stone into different facets. And I see each of us being a different facet of the same humanity. And light hits us all from a different angle because of that. It doesn't mean that we're separated from each other, but that we have that much more need of each other, and that need to contribute to how other people think and are. If we could just sort of use our differences as an additional thing instead of as a way to separate us, then we won't end up with a crystal ball falling as dust to the ground.

SS: I think that we need to examine what part of European art is African. That's the crux there. And when you examine that, I haven't closely enough, but when you examine that, we're not copying them, we're not. It's the other way around, it's completely the other way around.

And I wanted to say this, too, about Sam. Sam influenced me. This was a long time ago. I was nineteen or twenty and he came to my parents' house and I asked him to look at my work and he did. And I'm a figurative painter, and Sam said, "You can't see the penis. There's no penis. You know, like Cézanne's work." And so, it takes a while to go from being shy of showing

the penis to actually showing, painting, it. And my penises became large, but they were not pornographic. And there's more interest in the space, the negative space around them.

RF: It looks like Lou wants to say something from his end of the table.

LS: I think it's important for us to acknowledge our incredible audience, the friendship that has been bestowed upon all the artists here. I certainly feel it. There was something about Washington, there was a spirit of possibility. And there was a spirit of—even though we didn't feel it all the time because we did have all these social problems having to do with color and gender and all that—but the fact that you are all here, and that you're loving what's going on here. And I think this is one great city, and we have all enjoyed the National Gallery of Art. I'm especially, as I've said before, grateful to the Center for Advanced Study in the Visual Arts. I mean, imagine, being part of advanced spiritual education.

So, to my friends Elizabeth Cropper, dean of CASVA, and Therese O'Malley, associate dean of CASVA, who have put all of this together with the help of their incredible staff, I say that I think we all are very fortunate. And hopefully this will go on. As director Rusty Powell said at dinner last night, he wants this to be a continuation, a fellowship of participation. And I think that's a wonderful thing. And I'm going to say that you're welcome constantly and you're always welcome back to the National Gallery of Art, and don't ever leave it.

RF: That sounds like the perfect ending for this morning's discussion. Thank you, Lou, for doing closing remarks on my behalf.

ARTISTS' BIOGRAPHIES

LILIAN THOMAS BURWELL

Lilian Thomas Burwell (1927–) received an MFA at the Catholic University of America. Over the course of her career she served as publication and exhibits specialist for the Department of Commerce, master teacher of art in DC Public Schools, member of the Duke Ellington School of the Arts faculty, and panelist for the DC Commission on the Arts and Humanities. Burwell served on the board of directors of the Arlington Arts Center and the Smithsonian Institution's Renwick Alliance. Among her several awards is the Excellence in Arts/DC Commission on the Arts Individual Artist Award in 1998.

Burwell's work is included in public and private collections around the world, and she has participated in numerous solo and group shows in the United States and abroad. Selected recent exhibitions in the Washington, DC, area include *Circle of Friends* (American University Museum at the Katzen Arts Center, 2016); *Finding a Way Out of No Way* (Banneker-Douglass Museum, 2015–2016); *Saving the Legacy* (Corcoran Gallery of Art, 2013); *Rivers and Memories* (Brentwood Arts Exchange, 2012); and *I Am the Mother Nile* (Howard University, 2012). Burwell has contributed essays to *Renwick Quarterly, Washington History*, and the *International Review of African American Art*. Her book *From Painting to Painting as Sculpture: The Journey of Lilian Thomas Burwell* was published in conjunction with her 1997 retrospective exhibition at Hampton University Museum.

FLOYD COLEMAN

Floyd Coleman (1939–2018), professor emeritus of art at Howard University, received his BA from Alabama State University, MS from the University of Wisconsin, and PhD from the University of Georgia. Prior to joining the faculty at Howard University in 1987, he taught at Clark College, Southern Illinois University at Edwardsville, and Jackson State University. Dr. Coleman lectured widely and was the author of numerous publications, including, most recently, "Explorations of Identity and Cultural Memory: The Art and Life of Evangeline Juliet Montgomery" in *Callaloo* (2015); "African American Art Then and Now: Some Personal Reflections" in *American Art* (2003); "Legacy of Struggle and Triumph: Icons of *An Inside View*" in *An Inside View: Highlights from the Howard University Collection* (2003); and "Reading and Writing about Art: IRAAA and the Development of African American Art, 1976–2001" in the *International Review of African American Art* (2001). In 1990, as chair of Howard University's department of art, he founded the annual James A. Porter Colloquium on African American Art, the leading forum for scholars, artists, curators, and individuals in the field of African American art and visual culture.

Coleman was a well-known artist as well as a scholar. His work has been featured in solo and group exhibitions, including *Form and Content: Selected Works by Floyd Coleman* (Historical Society of Washington, DC, 2009–2010); *Bodyscapes* (Mechanical Hall Gallery, University of Delaware, 2011); and *FreshPAINT: African American Art at UD* (Mechanical Hall Gallery, University of Delaware, 2014).

DAVID C. DRISKELL

David C. Driskell (1931–2020), Distinguished University Professor of Art, Emeritus, University of Maryland, received degrees from Howard University and the Catholic University of America and pursued postgraduate study at the Netherlands Institute for Art History, The Hague.

He was the recipient of thirteen honorary doctorates and many lifetime achievement awards. In 2000 he was awarded the National Humanities Medal by President Clinton. The University of Maryland established the David C. Driskell Center for the Study of the Visual Arts and Culture of African Americans and the African Diaspora; the High Museum of Art, Atlanta, annually awards the David C. Driskell Prize in African American Art and Art History; and the Skowhegan School of Painting and Sculpture, Maine, created the Lifetime Legacy Award to honor Driskell for his support of that institution.

Driskell was the author of more than fifty books and exhibition catalogs, including *Two Centuries of Black American Art, 1750–1950* (1975); *Hidden Heritage: Afro-American Art, 1800–1950* (1985); *Harlem Renaissance: Art of Black America* (1987); *African American Visual Aesthetics: A Postmodernist View* (1995); and *The Other Side of Color: African American Art in the Collection of Camille O. and William H. Cosby Jr.* (2001). Before joining the University of Maryland he was director of University Galleries and chairman of the department of art at Fisk University. His paintings and prints are represented in the National Gallery of Art and the National Museum of African American History and Culture, among many other museums.

SAM GILLIAM

Sam Gilliam (1933–2022) earned BA and MFA degrees from the University of Louisville and received seven honorary doctorates. Gilliam was the recipient of multiple grants from the National Endowment for the Arts, a Guggenheim Memorial Foundation Fellowship, the Mississippi Governor's Award for Excellence in the Arts, and a US Department of State Medal of Arts; and his work welcomed visitors to the Giardini installation at the 2017 Venice Biennale.

After moving to Washington in 1962, Gilliam taught in DC Public Schools and at the Corcoran School of Art and exhibited at Jefferson Place Gallery. Early solo exhibitions at The Phillips Collection and the Corcoran Gallery of Art helped establish his reputation, and his art has since been exhibited internationally. *Sam Gilliam: A Retrospective* was organized by the Corcoran in 2005.

Washington solo and group exhibitions include *African American Art: Harlem Renaissance, Civil Rights Era, and Beyond* (Smithsonian American Art Museum, 2012); *African American Art Since 1950: Perspectives from the David C. Driskell Center* (University of Maryland, 2012); *Sam Gilliam: Close to Trees* (American University Museum at the Katzen Arts Center, 2011); *Sam Gilliam: Flour Mill* (The Phillips Collection, 2011); and *Washington Color and Light* (Corcoran Gallery of Art, 2010–2011). Gilliam's work is in museum collections internationally, including the National Gallery, London, and Tate Modern. His commissions include *From a Model to a Rainbow* (2011), an Italian glass mosaic at the Takoma Metro Station in Washington, DC, and *Construction Aviation Potomac* (1997) at Ronald Reagan Washington National Airport.

KEITH MORRISON

Keith Morrison (1942–), professor at the Tyler School of Art and Architecture, Temple University, received his BFA and MFA degrees from the School of the Art Institute of Chicago. His numerous honors include Ford and Danforth Foundation Fellowships; the Bicentennial Award for Painting from the City of Chicago; the Organization of African Unity Award for Painting; the National Foundation of Art Educators Award; and a Fulbright Senior Fellowship. In 2017 he was named Commander of the Order of Distinction by the parliament and prime minister of his native Jamaica, which he represented at the Venice Biennale in 2001, the only time Jamaica has been included. In 2008 Morrison represented the United States as cultural envoy to the Shanghai Biennale.

Morrison's many curated exhibitions include *Magical Visions: 10 Contemporary African American Artists* (University of Delaware, 2012); *Metaphors/Commentaries: Contemporary Artists in Cuba* (Ludwig Foundation of Cuba, Havana, and San Francisco State University Gallery, 1999); and *Art in Washington and Its Afro-American Presence: 1940–1970* (Washington Project for the Arts, 1985).

Morrison has exhibited internationally and held many academic positions, including several university deanships. Recent exhibitions in Washington include *Conversations: African and African American Artworks in Dialogue* (Museum of African Art, Smithsonian Institution, 2015–2016); *FLOW: Economies of the Look and Creativity in Contemporary Art from the Caribbean* (IDB Cultural Center Art Gallery, 2014); *African American Art: Harlem Renaissance, Civil Rights Era, and Beyond* (Smithsonian American Art Museum, 2012); and *African American Art Since 1950: Perspectives from the David C. Driskell Center* (University of Maryland, 2012).

MARTIN PURYEAR

Martin Puryear (1941–) earned his undergraduate degree from the Catholic University of America and studied at the Royal Swedish Academy of Arts, Stockholm, before receiving his MFA in sculpture from Yale University in 1971. He has taught at Fisk University, the University of Maryland, College Park, and the University of Illinois, Chicago. Puryear is a member of the American Academy of Arts and Letters; and the recipient of numerous awards, including fellowships from the National Endowment for the Arts and the John D. and Catherine T. MacArthur Foundation; the Skowhegan Medal for Sculpture; the National Medal of Arts in 2011; and the Yaddo Artist Medal. Puryear's work is in museums and galleries internationally, and his public art projects include the *River Road Ring* of the Chicago Transit Authority; Chevy Chase Garden Plaza, Maryland; Belvedere Plaza, Battery Park City, New York; and the National Oceanic and Atmospheric Administration, Seattle.

Puryear was the grand prize recipient in the Bienal de São Paulo in 1989. Major retrospectives of his have been seen in Washington at the Corcoran Gallery of Art, Hirshhorn Museum and Sculpture Garden, National Gallery of Art, and Smithsonian American Art Museum. Among the group shows in which he has been included are *African American Art Since 1950: Perspectives from the David C. Driskell Center* (University of Maryland, 2012) and *Selections from the Collection of Edward R. Broida* (National Gallery of Art, 2006).

SYLVIA SNOWDEN

Sylvia Snowden (1942–) earned her BA and MFA degrees from Howard University and holds a certificate from the Académie de la Grande Chaumière in Paris. She also studied at the Skowhegan School of Painting and Sculpture, Maine. Snowden has taught at Howard University, Cornell University, the University of the District of Columbia, and Yale University, among other institutions. She has been artist-in-residence at the University of Sydney, California Institute of the Arts, University of Colorado at Boulder, Cornell University, the Corcoran Gallery of Art, Howard University, and the Brandywine Workshop. She received the Lois M. Jones Award from the Fondo del Sol Visual Arts Center in Washington, DC, and several grants from the DC Commission on the Arts and Humanities.

Snowden's artwork has been widely exhibited internationally. A solo exhibition, *Sylvia Snowden*, was held at the National Museum of Women in the Arts in 1992, and recent group exhibitions in the Washington area include *Circle of Friends* (American University Museum at the Katzen Arts Center, 2016); *Washington Art Matters: 1940s–1980s* (American University Museum at the Katzen Arts Center, 2014); *Artistic Reflections: An Exhibition Celebrating the*

Life and Legacy of David C. Driskell (Brentwood Arts Exchange, 2011); *Catalyst* (American University Museum at the Katzen Arts Center, 2010); *Black Is a Color: African American Art from the Corcoran Gallery of Art* (Taft Museum of Art, 2005); *Malik, Farewell 'til We Meet Again* (Corcoran Gallery of Art, 2000); *Sense of Place* (Fannie Mae American Communities Fund, 1997); and *Evans-Tibbs Collection* (Corcoran Gallery of Art, 1996).

LOU STOVALL

Lou Stovall (1937–) earned his BFA degree from Howard University. In 1968 Stovall founded Workshop, Inc., in Washington, DC, where he has printed with many artists, including Sam Gilliam and Jacob Lawrence. In 1979 Stovall was named a Washingtonian of the Year by *Washingtonian* magazine. His other awards and honors include the Washington, DC, Mayor's Art Award for Excellence in an Artistic Discipline; an Alumni Achievement Award from Howard University; grants from the National Endowment for the Arts and the Stern Family Fund; and an honorary doctorate from the Corcoran College of Art and Design.

Stovall's art is in public and private collections throughout the world, including the National Gallery of Art. In the Washington, DC, area, his work has been exhibited most recently at the American University Museum at the Katzen Arts Center, the Washington Printmakers Gallery, Howard University, the Mansion at Strathmore, and the Harmony Hall Regional Center, among other venues. Stovall's silkscreen prints have been commissioned by the Washington Concert Opera, Howard University, the American Red Cross, Amnesty International, WAMU, the United States Holocaust Memorial Council, and the AFL-CIO George Meany Center. Stovall's artwork has been featured in the *New York Times*, the *Washington Post*, and a 2002 essay "Double Vision" by Ruth Fine in the *International Review of African American Art*.

INSTITUTIONALIZING MODERNISM

VISUALIZING A LEGACY, CURATING A VISION: THE HISTORY OF THE HOWARD UNIVERSITY GALLERY OF ART

Gwendolyn H. Everett

The history of the Washington art community has always been an elusive one. Its diverse and often contradictory nature makes definitive analysis a most difficult task. . . . It remains, however, that seminal influences in the arts have been born and nurtured in Washington. . . . Less well-known, though more historically complex and intriguing, are the contributions made by black artists and institutions.

—Jock Reynolds, Executive Director, Washington Project for the Arts

In 1966 a momentous art exhibition took place in Washington—an event of which most in the downtown arts community were unaware. On a hill in Northwest Washington, in a new fine arts complex on the Howard University campus, Howard's Gallery of Art hosted the first solo exhibition of work by Alma W. Thomas, a Black artist who would go on to become one of the most important African American contributors to the celebrated Washington Color School. Thomas, the first graduate (in 1924) of the Howard University department of art, had been an active participant in the local art community but was unable to attain wider recognition as a professional artist until her retirement in 1960, because a thirty-eight-year career as an art teacher in the DC public schools had consumed most of her time. But when she was invited by then gallery director James A. Porter to put together paintings for a solo show at Howard, she jumped at the chance. She produced a flurry of new works using strokes of color based on abstracted, reduced patterns related to plants, flowers, and landscapes she had observed and meditated on for years in Washington's lush parks and in her home garden (fig. 1).[1] These "color-filled" paintings associated her work with that of an emerging group of Washington artists who were using color to redefine visual forms in new and adventurous ways. Some, like Gene Davis, applied color using hard-edged stripes; others, such as Morris Louis, created washes of color by allowing the paint to stain untreated canvases; still others, like Kenneth Noland, used combinations of strokes and target patterns of color to create their distinctive paintings. Thomas was perhaps most adept of all at turning her meditations on the natural world into abstractions. She found inspiration in the play of light against moving trees, water, blooming

Detail, fig. 10

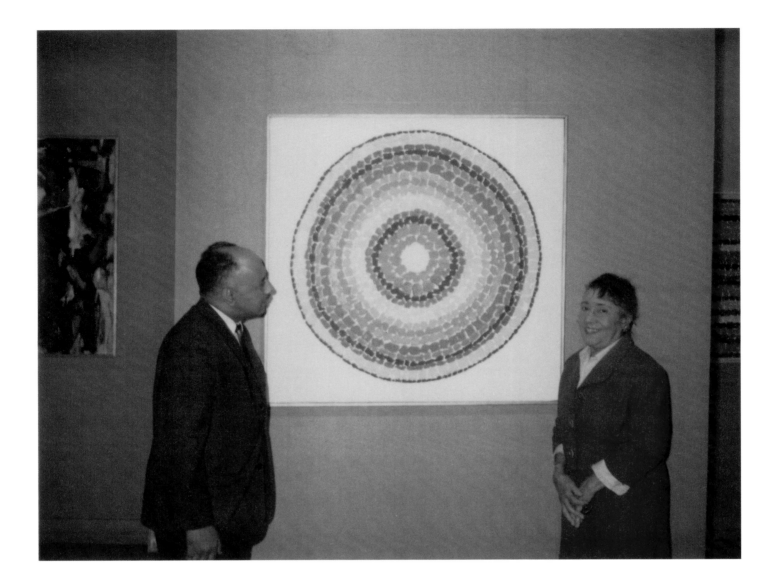

1. Alma W. Thomas with Albert Carter, curator, Howard University Gallery of Art, in the exhibition *Alma W. Thomas: A Retrospective Exhibition (1959–1966)*, 1966

Alma W. Thomas Papers, Archives of American Art, Smithsonian Institution

shrubs, and flowers, and even created a series influenced by space travel and the moon landing in 1969. For Thomas, color was liberating. "Through color," she was quoted as saying, "I have sought to concentrate on beauty and happiness, rather than on man's inhumanity to man."[2] No statement better defines the visual legacy and curatorial vision that animated Howard University's Gallery of Art in Washington's art world.

Thomas went on to become the first African American woman to have exhibitions at the Whitney Museum of American Art (1972) and, later that year, at the Corcoran Gallery of Art. Major museums and galleries then featured and purchased her works, but the acquisition of her painting *Resurrection* (1966) for the permanent collection at the White House during the Obama administration and the retrospective exhibition organized by the Studio Museum in Harlem garnered more widespread recognition.[3] Yet it was the Howard University Gallery of Art that launched her career as a professional artist and introduced African American abstraction onto the Washington art scene.

The Howard University Gallery of Art, at the center of the campus, has been a crucible of talent and an incubator of the special contributions of Black artists and institutions to the city's

art scene. This is not an accident: the visual legacy of the gallery, though it has shifted over the decades, has always coalesced around an enduring conviction that African Americans would refuse to accept the fate of second-class education and marginalized expression in the wider culture. Instead, Howard University generally and its Gallery of Art specifically would be an incubator and space of creativity that went beyond racial identities and allowed the complexity of Black humanity to be expressed and seen.

Some of this visualizing humanism can be seen in the meaningful contributions, legacies, and lineages of individuals whose work was key to the growth and development of the Howard University Gallery of Art.[4] Early exhibition catalog essays describe how the gallery worked to create a storied legacy of institution building and art making by African Americans in the city at large.[5] Never accepting a segregated or narrow view of the cultural work the gallery could offer the larger Washington community, its stewards worked quietly, but sometimes more vociferously, to call for inclusiveness in art and taste making.

Among the figures in this history was Keith Morrison, acclaimed Jamaican-born artist and critic, who served as curator and catalog writer for the seminal exhibition *Art in Washington and Its Afro-American Presence: 1940–1970* (1985). His essay concluded that both the department of art and the Gallery of Art played major roles in the establishment in 1943 of the Barnett-Aden Gallery, the first Black-owned art gallery in the United States. It was also the first gallery in Washington in which white and Black and national and international artists exhibited together—almost twenty years before Thomas's epochal exhibition at Howard. Morrison proposed that "this focus [cross-cultural modernism] evolved from the modest beginning of first establishing a place for Afro-American artists to show and grew into a gallery open to all artists. . . . A new idea emerged that set in motion new issues in what was then contemporary art."[6] These institutions and the individuals who established them "provided the catalyst for a wider association and cross-cultural freedom in the visual arts in Washington."[7]

The history of the Howard University Gallery of Art remains not only complex, as Jock Reynolds asserts in the preface to Morrison's catalog, but also largely invisible. The following overview sheds light on a history as elusive as the pursuit of the arts as a vocation in the nation's capital, by exploring something rather subtle: the relationship between creating space on a university campus for the display of art and creating an African American art collection as a treasure of learning in a university. Such exploration will yield something quite important, I argue, in thinking about the politics of creating space for the arts on a historically Black university campus—that the formation of a permanent collection and a gallery experience on campus is not a culturally neutral act. Rather, *creating room*, if you will, for the display and nurture of the visual arts is politically and ideologically linked to the mission rooted in the founding of the 155-year-old institution that has become Howard University.

Finding a Focus for a Gallery of Fine Art

Chartered by Congress on March 2, 1867, as a "university for the education of youth in the Liberal Arts and Sciences," Howard was named for General Oliver Otis Howard, one of its founders and its third president (1869–1873). Its first schools were a preparatory school, a liberal arts college, a teachers college, a theological school, a law school, and a medical school. Howard accepted women at its founding, a time when they were excluded from most liberal arts colleges and professional schools.[8] The coeducational student body was also racially and ethnically diverse. In addition to whites and freeborn and freed people of African descent, it included African, Asian, Caribbean, and Native American students.[9] Howard was perhaps the

2. Original seal, Howard University, 1867–1910

Courtesy Moorland-Spingarn Research Center, Howard University Archives

most integrated university at the time in the United States. Its original seal is emblematic of this democratic concept in visualizing different races above the motto "Equal rights and knowledge for all" (fig. 2).[10]

Shortly after the founding of the university, a committee was established to build a library collection. Danforth B. Nichols—a member of the committee who moved his private library to the school and the university's first librarian—created a model that foregrounded the visual and the curatorial in his scheme for an innovative knowledge center on campus. He divided the building into a library proper, a reading room, a museum and mineral cabinet, and a picture gallery.[11] As described in a history of the university published in 1941,

> The Mineral Cabinet . . . included a varied and valuable collection of fossils, minerals, rocks, including fine specimens of American and foreign metals. The entire collection contains over 3,000 specimens. One case in this room is devoted to coins, medals and curious notes. The collection of coins is quite extensive. This cabinet, already so fine, is due to the generosity and assiduity of its custodian, Rev. D. B. Nichols, and to a large donation by Mr. J. W. Vandeburg.
>
> The Museum, in another room, contains various articles illustrative of foreign and American history, of the latter, particularly during the recent Civil War, it presents many curious objects of interest. . . . We notice a good beginning in these important divisions, and it is believed that with the help of those of our friends who take an interest in such matters, they will soon reach a high degree of excellence, contributing largely to scientific and historic research among our students.[12]

It is worth noting that for Howard, the divisions between natural history and fine art were not barriers but opportunities to spark students' wonder and curiosity about the world beyond racial categories, which later would also be inherent in the curatorial vision and collecting mission of the Gallery of Art. In that sense, the Museum and Mineral Cabinet functioned as a quasi-Smithsonian for Black folk in Northwest Washington, who could see and experience the world from their backyards just as Thomas did when she studied her garden, neighborhood, and the skies as inspirations for her abstract paintings.

The Museum and the Picture Gallery occupied separate rooms on the upper floors in the Main Building on campus (fig. 3). The Main Building was the first constructed on campus, and it housed most of the academic units as well. The high regard for the gallery is represented in President Howard's description: "The Picture Gallery embraces portraits of many distinguished men and women, steel plate engravings of flora and fauna, and photographic views of ruins of Roman antiquity. Also there is a splendid collection of 100 photographic views of the late war generously given by Alexander Gardner."[13] The Picture Gallery functioned, therefore, as a mini–National Portrait Gallery, where students could study pictures of significant individuals assembled to reflect merit and greatness. This display furthered the mission of the gallery as a center of knowledge and inspiration.

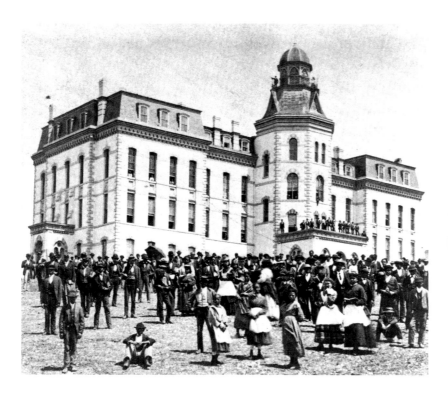

The Picture Gallery set the tone and tenor of what would become the mission of the Howard University Gallery of Art. It would be nearly sixty years before the Gallery of Art officially opened on campus and ninety-four years later when a designated space was built. The route was circuitous, probably owing to the many challenges the fledgling institution faced during its early years—fluctuating student enrollment, financial difficulties, and revolving revenue-generating projects and curricular strategies designed to meet the needs of Howard's diverse students.[14] Federal and private funding supported the erection of instructional and residential buildings on the new campus. The university trustees repeatedly asked Congress for funding to build an "adequate" library as the university's enrollment grew. Congress refused to make the appropriations, though private funds from the namesake's widow became available to complete the Andrew Rankin Memorial Chapel in 1895.

The red brick chapel, with its Gothic revival design and beautiful leaded stained-glass windows, still commands its site near the Sixth Street gate to the campus (fig. 4).[15] Registered as a National Historic Landmark, the chapel is built into the side of a hill and appears as two stories on the west side and one on the east. As distinctive as its asymmetrical design are its thirty-three stained-glass windows that commemorate aspects of Howard's history. James Porter and Lois Mailou Jones, eminent artists and Howard University faculty members, designed two sets of windows. The chapel continues to serve as a cultural and spiritual center of the university for religious activities and as a place of assembly.[16]

In spite of early difficulties, circumstances on campus during the "New Negro" period of the 1920s advanced the establishment of the Howard University Gallery of Art. The increased enrollment of students in the department of architecture in 1920 made it necessary to find an assistant to teach in the program. The department hired James V. Herring, a graduate of Syracuse University, as instructor in architecture to teach the subjects in the field most closely related to the fine arts. Herring gave the university's first illustrated lectures in the history of

3. Students on the lawn in front of the Main Building, Howard University, c. 1870

Courtesy Moorland-Spingarn Research Center, Howard University Archives

4. Andrew Rankin Memorial Chapel, Sixth Street entrance to the Howard University Gallery of Art

Courtesy Howard University Gallery of Art Archives

architecture, sculpture, and painting and added new courses to the curriculum, such as water-color, painting, and drawing from life. By the autumn of 1921, Herring organized these subjects into the first official department of art at the university, initially offering courses in design, freehand drawing, composition, watercolor painting, and life sketching. Over the next decade, he assembled faculty members that included Porter, a graduate of the department of art, who taught drawing and painting; James Lesesne Wells, graduate of Teachers College, Columbia University (graphic arts); Jones, of the Boston School and Museum of Fine Arts (design); and Alice E. Bailey, University of Chicago (history of fine arts).[17]

In an undated and unpublished manuscript in the gallery's archives, Porter, who became the second director of the gallery, described the kind of tactical ability to make use of small advantages that marched the university toward a gallery of art:

> The sum of $1000 was made available to the University by the Coonley family of this city to open a Gallery in the basement of the Chapel. The University matched this gift with an equal sum; and in 1929 the Howard University Gallery of Art became a reality. Its director at that time was Professor James V. Herring . . . who was also head of the Department of Art.[18]

In an article for *Southern Workman*, Alonzo J. Aden, the gallery's first curator, provides some insight into the role students played in this history. He attributed the gallery's development to the success of a traveling exhibition of student works: "So impressive was this collection that it gave rise to an Art Gallery as a permanent home on the campus." He continued:

> By means of an initial donation from Avery Coonley, an art patron in Washington, funds were made available to remodel the ground floor of Andrew Rankin Memorial Chapel for art col-lections and for the exhibit of the products of artists of this and of foreign countries. The Art Gallery was formally opened on the evening of April 7, 1930, with a distinguished assembly of art patrons. During the year 1931–1932 sixteen exhibitions were shown at the Gallery. Many of these exhibitions were circulated by nationally known organizations and institutions such as the College Art Association, the American Federation of Arts, and Roerich Museum. The exhibits of these art treasures at the University made the fine arts a living reality in the University life and added to the cultural and educational environment of the entire community.[19]

As was consistent with this period of "New Negro" student activism at Howard and other histor-ically Black colleges and universities (HBCUs), students created "room" for new institutions to emerge. Their explosive creativity drew the attention and support of Avery Coonley, mentioned above as a Washington art patron. Coonley, a philanthropist, progressive educator, and patron of architecture who commissioned works from noted American architects Frank Lloyd Wright and William E. Drummond, made a way for pupils to express and experience art on campus in a more permanent institutional space.[20]

The choice of the chapel as the site of an art gallery on a campus may seem unusual, but it was appropriate. Andrew Rankin Memorial Chapel was an architecturally significant edi-fice and a symbol of the aesthetic standard to which the early curatorial vision and collection strategy of the gallery aspired.[21] Putting an art gallery in a Gothic revival building also followed the common "signifier" in the nineteenth century for academic buildings associated with the earliest centers of learning in Europe: monastic establishments. The Smithsonian Institution's first building, known as the Castle, illustrates this association. The resemblance museums have architecturally to religious structures is not accidental. As Carol Duncan notes in the essay

"Art Museums and the Ritual of Citizenship," museums are "traditional ritual sites," and these spaces "can operate as culturally designated, special, and reserved for a particular kind of contemplation and learning experience and demanding a special quality of attention."[22]

The special significance of this contemplative space on campus was acknowledged in an article for *The Crisis*. "Art at Howard University has passed the stage of experimentation and is designed to make the University one of the distinguished centers of the country."[23] The increasing number of visitors also was a measure of the gallery's success. Attendance was recorded at 17,576 during the first year of its existence, and 19,520 was noted the second year. The author described the exhibitions as "diversified in character," listing watercolors and lithographs, oil paintings, sculpture, and prints as works shown in the first season. The second season featured exhibitions of seventeenth-century Dutch paintings, Spanish paintings, Italian prints from the Library of Congress, and three exhibitions of works by African American artists.[24]

As founding director, Herring decided that the gallery should have a collection and outlined its objectives: "to make good works of art available on a permanent basis to the university community; to establish, at least, the nucleus of a loan collection to be made available for use by reputable cultural and university centers; and to gather into the collection, whenever possible, significant works by contemporary artists without reference to the race, color, or creed of the individual artist."[25] This initial focus on contemporary art helped shape the collection as Herring and his successors encouraged patronage and sought financial gifts and partnerships that could enable the acquisition of major works by living artists.

Herring relied upon the generous help of alumni and friends of the university and of some public organizations that donated funds and works of art or made extended loans to the gallery. This strategy proved fruitful, and the first work to enter the collection, thanks to donated funds, was Henry Ossawa Tanner's *Return from the Crucifixion* (fig. 5), an oil and tempera painting, the last work the artist completed before his death in 1937.[26] In his essay "The American Negro as Craftsman and Artist," published in *The Crisis* in 1942, Herring discusses Tanner and the painting:

> He is represented in the Howard University Gallery of Art by one of his latest paintings, "The Return from Calvary" [*sic*]. . . . His paintings are owned by all the great museums of the United States, as well as the Luxembourg in France. His prizes, medals, and awards are too numerous to mention; he is one of our few American artists to receive the coveted Legion of Honor of France. . . . His whole career . . . is an inspiration and a challenge to aspiring painters, and his work a monument to sturdy endeavor and exalted achievement.[27]

That Herring would select Tanner's painting as the first acquisition for the Gallery of Art is noteworthy but not surprising. Tanner was the most celebrated African American artist at the turn of the twentieth century. His formal education at the Pennsylvania Academy of the Fine Arts, further study in Paris, and his access to museum exhibitions and cultural circles in Europe established him as an exemplar. Herring's appreciation of European modernist aesthetics in American art aligned Tanner's art with Herring's collection and exhibition practices. Furthermore, Tanner was well known in Washington through the Tanner Art League, an organized group of artists and art teachers who held exhibitions in the studios of Dunbar High School. Their 1922 exhibition featured work by Tanner.[28]

Tanner and Porter also had a personal acquaintance. The two had met while Porter was studying at the Sorbonne. Porter refers to their conversations and correspondence as an example of what an African American artist should do: "suggest infinite meaning with a reduced palette."

5. Henry Ossawa Tanner, *Return from the Crucifixion*, 1936, oil and tempera on board

Howard University Gallery of Art

Photo: Gregory R. Staley

Tanner's later paintings exemplified the mastery of his art. The relief effects of his half-tempera, half-oil paintings are evident in his final work, which was bought through subscription for the Howard University Gallery of Art, and for which Tanner was paid two months before his death on May 25, 1937.[29] Correspondence between Porter and Tanner documents the purchase of the painting. Tanner wrote to Porter, "The figure groups have from the first gone rather well, except the Mary and St. John, these I have painted over several times—what you say about the landscape is I hope true, Palestine always impressed me as the background for a great tragedy."[30] Like Porter, Anna O. Marley, in her introduction to the Pennsylvania Academy of the Fine Arts exhibition catalog, observed that the mixture of tempera and oil in Tanner's late works was experimental and "allowed him to create rough, highly built-up landscapes . . . a hybrid of modern technique and traditional subject matter."[31]

In the catalog for the Philadelphia Museum of Art Tanner retrospective in 1991, Tanner scholar Dewey F. Mosby acknowledges the significance of this acquisition, "purchased through public subscription . . . just two months before the artist's death. It is altogether fitting that Tanner should be so honored and that an African American institution on whose board his

father served should acquire his last work."[32] Mosby further notes that the painting's format, composition, and luminous color might be the artist's commentary on "his hopes and fears for humanity."[33] The Howard University Gallery of Art had reached a stage in its development where it could, if only months before the passing of the most important Black painter, marshal the funds needed to acquire a signature painting of "the master," as Herring called Tanner.

That purchase stimulated a surge in the gallery's collecting of African American art during the 1940s and 1950s, under Herring's directorship. Known for his connoisseurship, refined taste, and cosmopolitan style, Herring also, with Aden, cofounded the Barnett-Aden Gallery in 1943, in the home where the two lived. The Barnett-Aden Gallery was a step forward in the universalist vision of the Howard University Gallery of Art, exhibiting work not shown in downtown galleries and presenting it in an intimate setting in Northwest Washington.[34] The Barnett-Aden Gallery was the first integrated and thoroughly cosmopolitan private gallery in Washington, showing the works of contemporary American, European, African, and African American artists along with traditional academic artists.[35]

Herring continued to work assiduously to build the collection at Howard while using contacts with respected dealers, collectors, and donors to grow the gallery's collection in innovative ways. Friends and associates were influential in having allocated federally owned works of art to Howard following the liquidation of certain army posts throughout the country at the end of World War II. Congress's ending of the Works Progress Administration and the Federal Art Project led to the dispersal, in the late 1940s, of art from Fort Huachuca, Arizona, a segregated US Army post. The Howard University Gallery of Art received nearly forty works that included prints by Dox Thrash; sculpture by Sargent Claude Johnson; a mural, *Progress of the American Negro* (1939–1940), by Charles White; and paintings by Archibald Motley—five of which (*Barbecue, Saturday Night, The Liar, The Picnic,* and *Carnival*) were part of his Bronzeville series of approximately twenty paintings created from 1930 to 1937. According to Richard J. Powell, a Motley scholar, these works document and take "visual license" with the lives and activities of Chicagoans residing in the largely African American neighborhood of Bronzeville.[36] As a decidedly conservative collector, it is a testament not only to Herring's growth as a gallery director but also to his adherence to the objective of collecting significant works by contemporary artists that he chose Motley's "modernist" rendering of the Black urban experience.

Space in the chapel was tight, and in 1941 the gallery relocated to the east wing, ground floor, of Founders Library. The larger space made it possible for Herring to hold classes in the gallery, which for two decades would remain a venue for many important traveling exhibitions as well as exhibitions by faculty and students (fig. 6). The space also included the Art Seminar, one of two library rooms set aside for the study of art that alternatively served as classrooms. In the spring semester, the Art Seminar became the space where annual student art exhibitions were held.[37]

The African American and African art collection expanded dramatically under Porter after he was appointed second chair of the department of art and director of the Gallery of

6. Augusta Savage (right) with *Head of a Negro Woman* and Howard president Mordecai Wyatt Johnson at an exhibition in Founders Library, January 19, 1940

Courtesy Moorland-Spingarn Research Center, Howard University Archives

7. James A. Porter, the second director of the Howard University Gallery of Art; Norma Nabrit; Howard president James Nabrit; Meta Vaux Warrick Fuller; Warner Lawson, dean of the College of Fine Arts; and Dorothy Porter

Courtesy Howard University Gallery of Art Archives

Art. Like Herring, Porter, who served from 1953 to 1970, lectured widely on African and African American art. He traveled to conduct research for his publications, lectures, and classes. His book *Modern Negro Art* (1943) is still recognized as the foundational history of artists of African descent in America. Armed with the benefit of years of research on African and African American art and artists, Porter proceeded to choose acquisitions that would expand the gallery's collecting objective to approach the sweep of history.

In 1955 the gallery received into the collection the estate of Alain LeRoy Locke, who had died in 1954. Locke, professor of philosophy at Howard, was the first African American Rhodes Scholar. His anthology *The New Negro* (1925) was influential in the development of the Harlem Renaissance and the cultural and critical aesthetics associated with the New Negro Movement in the 1920s and 1930s. Locke facilitated contacts among artists, writers, and collectors and was a patron and benefactor of several aspiring and established artists. The bequest of paintings, sculpture, books, and memorabilia included many works by African American artists and increased representation in the collection of artists active in the 1930s and 1940s.[38] The core of the collection comprised approximately three hundred pieces of African sculpture and handicraft. That Locke's bequest entered the collection under Porter's watch is noteworthy, as the two men publicly disagreed on the aesthetic, social, and political directions of African American art and artists.[39]

It was during Porter's term that the gallery moved to what Porter termed the first "autonomously built complex on an HBCU campus."[40] The Fine Arts Complex opened to the public in 1961. The spaces included Cramton Auditorium, Ira Aldridge Theater, and Lulu Vere Childers Hall, where the new gallery finally had "spacious new quarters" with three interconnecting galleries.[41] The opening and dedication ceremonies celebrated this milestone (fig. 7). The inaugural exhibition, *New Vistas in American Art*, seemed to echo this spirit of optimism and to express a sense of triumph. Porter affirmed in the foreword to the exhibition catalog: "*New Vistas in American Art . . .* incontestably proves that, regardless of racial and cultural bias, there is a vigorous unifying current of creativity in American art today."[42] The juried exhibition provided monetary awards, and medals were given to artists in several categories. Works by award-winning artists, Black and white, were acquired for the gallery's permanent collection with a grant from the Eugene and Agnes Meyer Foundation. The artists who were represented included Meta Vaux Warrick Fuller, James Weeks, and Alma Thomas (fig. 8).[43]

In 1967, for the university's centennial, Porter purchased Edmonia Lewis's neoclassical marble sculptural group *Forever Free* (1867; fig. 9). The iconic work on the theme of emancipation seems to have problematized the subject, as seen in the sculptor's distinctly gendered responses to emancipation, the racial ambiguity of her subjects, and the proportion and scale disparities between the two figures. While some might attribute these problems in form and interpretation to an overt display of nineteenth-century sexual and racial mores, as well as to Lewis's inexperience at this stage in her development as a sculptor, one could also argue that throughout her career (and in her public persona) Lewis often defied the representational conventions of her

8. Alma Thomas, *Blue Abstraction*, 1961, oil on canvas

Howard University Gallery of Art, Courtesy Charles Thomas Lewis

Photo: Gregory R. Staley

day. In the case of *Forever Free*, the political and psychological phenomenon of emancipation was a vehicle upon which she could impose issues of racial difference, contradictory reactions based on gender, and even questions of decorum and competency.[44]

Porter's impact on the collection extended to exhibitions of his own work in the gallery. David C. Driskell's *Chieftain's Chair* (1966; fig. 10) was apparently inspired by an exhibition of paintings Porter organized following a research year in Nigeria. The exhibition was held in January 1965 and included eighteen oil paintings, among them a depiction of Shango, the Yoruba god of thunder and war. Art historian and Driskell biographer Julie McGee recounts that Driskell also drew inspiration from African art found in the Locke bequest in the permanent collection.[45] In his interpretation, Driskell presents a high-backed chair with molded feet that materializes from lush brushstrokes, ornamental scrolls, and collage elements. McGee suggests that *Chieftain's Chair* is as much a "nod to West African forms as it is to Queen Anne or Chippendale designs."[46] Driskell's colorful abstraction creates a visual rhythm that artist Floyd Coleman considered equal to examples by midcentury contemporaries.[47]

Driskell served as acting chair of the department when Porter was on sabbatical leave in 1963–1964. An internationally recognized artist, curator, scholar, professor, and art connoisseur, Driskell brought to his tenure a passion for the preservation, conservation, and documentation of African American art and artists that resulted in the publication of numerous exhibition catalogs, books, magazine articles, and film documentaries. He was the recipient of the National Humanities Medal, and in 2001, the University of Maryland established the David C. Driskell Center for the Study of Visual Arts and Culture of African Americans and the African Diaspora.

9. Edmonia Lewis, *Forever Free*, 1867, marble

Howard University Gallery of Art

Photo: Gregory R. Staley

10. David C. Driskell, *Chieftain's Chair*, 1966, oil and collage on canvas

Howard University Gallery of Art, Courtesy David C. Driskell

Photo: Gregory R. Staley

By the time Jeff Donaldson became chair of the department and the third director of the gallery in 1970, much had changed on campus and in Washington. While vestiges of the destruction from the riots that followed the assassination of Rev. Dr. Martin Luther King Jr. in 1968 were visible in prominent sections of the city, the election of Black officials seemed to usher in the promise of "self-determination." In the arts, the Black Arts Movement, the Black Power Movement, and Black Aesthetics were dominant.

Donaldson had helped to create the mural *Wall of Respect* in Chicago in 1967. The work was associated with Black pride and community involvement in the arts. Later, he founded AfriCOBRA (African Commune of Bad Relevant Artists), an artists' collaborative "committed to making art understandable, relevant and accessible to ordinary people."[48] On campus, President James E. Cheek's recruitment of new faculty to engineer curricular changes was recounted in an *Ebony* magazine article in 1971, "Howard University: Onetime 'Negro' school shifts emphasis to black curriculum."[49]

As director of the gallery, Donaldson made changes there as well. On December 4, 1970, he named the second gallery, initially called Gallery B, the James A. Porter Gallery of African

11. Skunder Boghossian, *DMZ*, 1975, oil on canvas

Howard University Gallery of Art, Courtesy Aida Boghossian

Photo: Gregory R. Staley

American Art. In April 1971, the first gallery, or Gallery A, was dedicated as the James V. Herring Heritage Gallery.[50] Donaldson expanded the curriculum in African and African American art and recruited new faculty. Appointments under his leadership as chair of the department of art included Ethiopian artist Skunder Boghossian and AfriCOBRA members Wadsworth Jarrell and Frank Smith.[51] Today, AfriCOBRA artists James Phillips and Akili Ron Anderson continue to play an active role in the development of studio artists at Howard. While AfriCOBRA artists have remained committed to engagement of their works through shared aesthetics and African visual references, they are more diverse in individual philosophies. Phillips, for example, uses zigzag forms and rhythmic patterning with bursts of colors that "shine," and Anderson creates stained-glass and monumental mixed-media sculpture pieces that pay homage to historical figures and cultural pride.

Skunder Boghossian was born in Addis Ababa. He attended the Slade School of Fine Art in London on a scholarship from the Ethiopian government. He later moved to Paris and studied at the Académie de la Grande Chaumière. In Paris, he became associated with the Senegalese philosopher Cheikh Anta Diop and other figures in the Pan-African and negritude movements. His abstract compositions often combine European and Coptic influences and offer commentaries on modern culture and social interactions. He taught at Howard from 1974 to 2000.[52]

12. Peter L. Robinson Jr., *Candy Cane Highway*, 2000, oil on canvas

Howard University Gallery of Art

Photo: Gregory R. Staley

Donaldson's directorship also left an impact on the gallery's collecting practices. However, unlike his predecessors' acquisitions, many of the works that entered the collection under his stewardship were bold abstractions that resonate with Black activism, memory, and cultural pride. Boghossian's *DMZ* (1975; fig. 11) is an example. This intricately constructed image, with veil-like orange washes, interrogates the political movements of the 1970s, particularly protest and activism related to the Vietnam War. Boghossian's powerful painting denounces the military actions of the day by reference to the demilitarized zone (DMZ), the official demarcation line that split North and South Vietnam in the 1960s and 1970s. In the context of social protest art, Boghossian's figures resemble human and skeletal forms. Using shifting dynamics of patterning and flattened spatial relationships, the visual complexities raise questions about human behavior and political agency.

In 1988 another shift occurred. From the department's founding, the chair of the department of art held the position of director of the Gallery of Art. Floyd Coleman, the department's sixth chair, recommended a change in the gallery's governance that resulted in the separation of the gallery from the department, and a gallery director was appointed with an independent administrative structure. Tritobia Hayes Benjamin, art historian and faculty member in the department and an alumna, was selected. Benjamin named the third gallery for the revered professors Lois Mailou Jones and James Lesesne Wells in a dedication ceremony on April 2, 1990.[53]

During Benjamin's tenure as gallery director, the Gallery of Art became an academic unit in the College of Arts and Sciences as the College of Fine Arts merged with the College of Liberal Arts in 1997.[54] Benjamin established an endowment for the permanent collection and continued

to expand the collection through gifts and donations.[55] She also managed a renovation project to improve the flooring and lighting in the gallery.[56]

The realization of Herring's initial programmatic vision of loan exhibitions and student, faculty, and alumni shows continued into the new millennium. The theme of continuity over decades is fundamental to the gallery's mission and sense of legacy. One of the most remarkable examples of the history of exhibitions and collecting was the presentation of works by 122 artists in the exhibition *A Proud Continuum: Eight Decades of Art at Howard University*, which was presented in 2005 during the centennial of Porter's birth.[57] Upon her retirement in 2012, Benjamin, the gallery's seventh director, had transformed the gallery into an independent force for learning and exhibitions on campus and in the Washington community.

My appointment from 2012 to 2019 focused on maintaining this legacy while continuing efforts to expand and exhibit the collections, updating access by developing the first systematic appraisal and database catalog of the collection, along with improvements to the physical structure of the Howard University Gallery of Art. The gallery continues to serve as a study and research facility of the university and scholarly communities, offering rotating exhibitions of national and international artists. The collections are available to the general public, students, faculty, and visiting scholars. The gallery's sustained excellence has been recognized by its listing as the only HBCU on the CollegeRank list of the Fifty Most Amazing College Museums in 2018 and its ranking as number nine among the top twenty best college museums in the country in 2013.[58]

The gallery has continued to present exhibitions of works by alumni and artist-scholars to celebrate their exemplary accomplishments, and the collection continues to be enriched through the generosity of friends of the gallery, alumni, and former faculty. Major donations have flowed into the gallery, notable acquisitions being the bequests from the estates of Warren M. Robbins and Lois Mailou Jones, works transferred from the Corcoran Gallery of Art after its closure, and a collection of paintings by alumnus Peter L. Robinson Jr.

Especially interesting are the works of Robinson, an award-winning painter, illustrator, and graphic designer whose colorful abstractions of horizons, landscapes, trees, outer space, still lifes, and figural forms reflect his fascination with nature and its magnificence. The retrospective exhibition *Peter L. Robinson, Jr.: An American Colorist,* presented in 2016, honored his life and career. With works selected from a donation of fifty-nine paintings, the exhibition was dedicated to Robinson's memory and his lifelong support of the department of art and the Howard University Gallery of Art.

Whether imagining whimsical compositions of enchanted forests or curving horizon lines and galaxies floating as if viewed from miles above the earth (fig. 12), Robinson's paintings demonstrate an understanding of early and mid-twentieth-century modernism, particularly the movements that embraced color and abstract forms: fauvism, pointillism, and abstract expressionism.[59] Robinson's work follows in the footsteps of Alma Thomas and may indicate a thematic contribution of the Howard University Gallery of Art to American art history—a continued interest in and support of Black abstraction, whether based in African or folk African American forms or in observations of nature. This nature-based Black abstraction may have sources in the natural environment of Washington as observed by some of its native inhabitants.

Robinson received early art training in the DC public schools. He attended Armstrong High School and then matriculated at Howard University. World War II interrupted his education at Howard. After a three-year tour of duty in the Army Air Force, he returned to Howard to graduate with a BA in 1949. Robinson honed his skills as an artist and learned the language of color under the tutelage of Lila O. Asher, Lois Mailou Jones, James Porter, and James Lesesne

Wells in the department of art at Howard. The teachings of E. Franklin Frazier, Alain Locke, Rayford Logan, and other Black intellectuals were also part of his experiences on campus at the time.

Following graduation in 1949, Robinson worked at the National Aeronautics and Space Administration (NASA) for more than fourteen years. In his capacity as director of the graphics and management presentation division, he was responsible for directing the visual information program including art and graphic design requirements at NASA headquarters. In 1973 he received the NASA medal of excellence for his work on the Apollo moon shot program. In 1975 he received the NASA Spaceship Earth Award for making art a more meaningful force in the community. In addition, in 1976 he received the NASA group achievement award for the graphics and management presentation division. He served as president of the DC Art Association and vice president of the Federal Design Council and of the Society of Federal Artists and Designers.[60] As was the case with some of Alma Thomas's paintings from 1969, space was thematically important to Robinson and was another anchor of the abstraction seen in the work of several Black Washington painters collected by and exhibited at the Howard University Gallery of Art.

A Collection with a Purpose

Although the first presence of a gallery on campus can be traced to General Oliver Otis Howard, founder and third president, as a "necessary part of the mission to enrich the lives of students,"[61] it was the collecting interests of the early directors and benefactors, along with private and public partnerships, that succeeded in forming the institution's art collections. In the course of more than 150 years, the Howard University Gallery of Art's collection has grown to over four thousand works representing a full range of artists and movements in Western art, from the Italian Renaissance, to American modernism, to contemporary art.[62] The collection has gained a reputation, however, for the depth of its African American and African art collections. This essay, in keeping with the theme of the symposium on which this volume is based, has been focused on twentieth-century works from the African American collection. It considers these works within the conceptual framework of intentionality in shaping the African American art collection to represent a collective visual legacy of the Black experience in twentieth-century America.[63]

Howard's history of cosmopolitanism and enlightenment in collecting and exhibiting is a visualization of the legacy of General Howard's "Picture Gallery." Through pictures, sculpture, and artifacts, the vision of a gallery of art responsive to changing times as well as its enduring legacy persists not only on campus but also in the wider Washington, DC, community. The steadfastness of scholars and benefactors, of Herring and Porter, along with the creativity of subsequent directors like Donaldson and Benjamin, have helped Howard fulfill a vision that most of America has never known but that Washington-area African Americans have enjoyed for more than a century and a half.

ADAPTABLE LEGACIES: ALAIN LOCKE'S AFRICAN ART COLLECTION AT HOWARD UNIVERSITY

Tobias Wofford

One of the many historical gems on the campus of Howard University in Washington is currently hidden in plain sight in the Lulu Vere Childers Hall on the northern side of the campus's upper quad. A visitor entering the hallways of this modernist building will immediately stumble upon an impressive collection of traditional African art (figs. 1 and 2). Displayed in cases along the main ground-floor corridor, the works are on permanent exhibition for students and visitors—a seemingly natural presence in the building that also houses the art department and the Howard University Gallery of Art. In fact, this collection remains a sort of cornerstone of the arts at Howard, a witness and a foil to the artistic and aesthetic philosophies of Black art that were born at the university and have been nurtured there since the early twentieth century.

The core of Howard's collection of traditional African art was amassed by Alain LeRoy Locke—one of the most important theorists of African American art and a professor in the philosophy department at Howard from 1912 to 1953.[1] His bequest of more than 350 works represented traditional African art from across the continent, ranging from masks and sculpture to textiles and household wares, as well as a particularly fine selection of Akan brass gold weights.[2] Works include the intricately patterned cosmetic box made by a Kuba artist from a region of the present-day Democratic Republic of Congo (fig. 3). The rhythmic carvings, playful symmetry, and deep wooden finish of the semicircular box reflect the dynamism of Kuba aesthetics and the tastes of Western collectors in the early twentieth century. Over the years, the Howard collection has grown, as patrons and faculty contributed their own objects and perspectives to the collection. Yet the current display of Locke's collection of African art at Howard reflects not only the genius of the African artists who created the pieces, or the astute tastes of Locke as a collector, but ultimately the layered and significant role African art has played in the history and pedagogy of arguably the most significant art program among the nation's historically Black colleges and universities (HBCUs).

The significance of Howard's collection of African art is inseparable from Locke's stature as a great American philosopher of aesthetics who was among the vanguard of writers to introduce serious scholarship on African art in the United States. Beginning in the early 1920s, Locke placed himself in close dialogue with other early collectors and scholars of African art, such as American collector and philanthropist Albert Barnes and French collector Paul Guillaume. As

1. Installation of traditional African art collection, Howard University Gallery of Art, Lulu Vere Childers Hall

2. Installation of traditional African art collection, Howard University Gallery of Art, Lulu Vere Childers Hall

3. Kuba artist, *Carved Cosmetic Box*, 19th–early 20th century (before 1926), wood

Howard University Gallery of Art

Mark Helbling has argued, the friendship and exchange of ideas between Locke, Barnes, and Guillaume was foundational in establishing and framing the discourse about African art in the United States.[3] Their connection resulted in a 1924 special issue of *Opportunity* dedicated to African art and continued into Locke's well-known tome *The New Negro* (first released in 1925 as a special issue of *Survey Graphic* titled "Harlem: Mecca of the New Negro").[4] Locke also engaged with theorists of African and diaspora aesthetics, including anthropologist Melville J. Herskovits, who had an early appointment at Howard University.[5] Through these connections Locke performed a major role in developing the discourse on African art in the United States just as he played a critical role in African American modernism of the early twentieth century.

For Locke, the two were intertwined, as he saw the potential for African art to serve as a wellspring of inspiration for Black artists and audiences—what he famously refers to as "ancestral legacies."[6]

One key example of Locke's early contribution and approach to the field of African art in the United States was his organization of the exhibition of the *Blondiau–Theatre Arts Collection of Primitive African Art* in 1927 (fig. 4). The effort was a substantial one in which Locke contrived with Edith Isaacs, publisher of *Theatre Arts* magazine, to establish a museum of African art in Harlem. In working toward this goal, Isaacs funded the purchase of approximately one thousand objects at a price of $5,700 from Belgian photographer Raoul Blondiau, whom Locke and Isaacs met while researching African art in Europe.[7] Blondiau had amassed the collection from 1900 to 1925. Once in the United States, the collection was placed on display in New York at the New Art Circle Gallery from February 7 through March 5, 1927.[8]

For Locke, the exhibition of the Blondiau–Theatre Arts Collection fulfilled a serious desire to introduce African art to the Black artists and audiences of New York in a way that resisted the two dominant paradigms of the era, in which such work was either justified only as a sounding board for the European and Euro-American avant-garde or was framed merely as an ethnographic curiosity. As art historian Helen M. Shannon describes it, "Locke's intellectual approach to the work followed neither the modernist's interest in abstraction nor the ethnographer's focus on documentation."[9] Locke sought this middle way by pursuing a better understanding of the history and culture of African art while also thinking of its potential inspiration for American audiences, and Black American audiences in particular. In defense of the exhibition against critics in the pages of *The Nation*, Locke proclaims, "Certainly it is at least as legitimate a modern use of African art to promote it as a key to African culture and as a stimulus to the development of Negro art as to promote it as a side exhibit to modernist painting and to use it as a stalking-horse for a particular school of aesthetics."[10]

Although the plans for a museum of African art in Harlem never came to fruition, the collection's sponsors did manage to reach a broad audience. As Shannon has explored, some five thousand visitors viewed the initial New Art Circle installation from 1927 to 1929, and parts of the collection traveled extensively to art institutions in Buffalo, Chicago, Milwaukee, and Rochester, as well as to several HBCUs, such as Hampton Institute, Fisk University, and Howard.[11] Eventually, approximately half of the collection was dispersed to private collectors and museums, including what is now the Hampton University Museum.[12] The other half of the Blondiau–Theatre Arts Collection was placed on exhibition at Harlem's 135th Street branch of the New York Public Library, now the Schomburg Center for Research in Black Culture, where many of the works remain today.[13] Locke himself acquired objects from the collection, among them a striking head-shaped Kuba cup (*mbwoong ntai*) that is now in the Howard collection (fig. 5). The bowl of this finely carved prestige cup takes the form of a stylized rendition of a woman's head that breaks the patterned bands encircling the curving cylinder at the base and lip of the cup.

THEATRE ARTS, INC.

Announces
an
EXHIBITION OF

PRIMITIVE AFRICAN SCULPTURE

Masks, Fetishes, Ivory and Wood Sculptures, Musical Instruments, Tissues, Objects of Decorative Art, Etc.

at the

New Art Circle
35 West 57th Street
New York, N. Y.

February 7th to March 5th

IF you are interested in further details of this Exhibition, send us your name and address. An illustrated brochure and photographs of some of the special objects will soon be ready.

Theatre Arts, Inc.

119 West 57th Street New York, N. Y.

4. Cover of *Blondiau–Theatre Arts Collection of Primitive African Art* (1927)

Papers of Alain Locke, Moorland-Spingarn Research Center, Howard University

5. Kuba artist, *Head-Shaped Cup*
(*mbwoong ntai*), 19th–early 20th
century (before 1926), wood

Howard University Gallery of Art

The Kuba cup, along with the rest of the collection, was enveloped in the debates about Black culture and identity in the early decades of the twentieth century. Consider, for example, the portrait by Harlem Renaissance photographer James Latimer Allen depicting Howard University art professor James Lesesne Wells holding the cup (fig. 6). The photograph has been featured in exhibitions examining the relationship of African art to the early twentieth-century American avant-garde.[14] As Yaëlle Birro described the image, "The anthropomorphic nature of the prestige cup and Wells's attentive gaze convey to this image a sense of tête-à-tête and silent intimate conversation."[15] In this sense, Allen's photograph embodies the interpellation with African art imagined in Locke's notion of ancestral legacies. In both his writing and teaching, Locke was most interested in African art as always tied to the immediate context of its collection and viewing—rendered powerful not only because of the history of its original production and use but also because of its potential to inspire Black artists and audiences experiencing the work in the United States. This perspective lends particular significance to the fact that Locke's museum project was destined for Harlem and much of his writing on African art appeared in the pages of Black publications like *Opportunity*. For Locke, African art was a useful key to developing Black modernism. As he wrote in 1939,

> Too, I have heard Negro artists and critics in some strange befuddlement question the relevance of African art to our cultural tradition. . . . Question, if you must quibble on something, the

6. James Latimer Allen, *Portrait of James Lesesne Wells*, c. 1930, gelatin silver print, sepia toned

Papers of Alain Locke, Moorland-Spingarn Research Center, Howard University

relevance of the African art in the imperial museums and colonial expositions the world over or the often concealed transfusion of African style in contemporary modernist art. Art belongs where it is claimed most or where it functions best.[16]

In some ways this emphasis on the utility of the "ancestral arts" for modern viewers and artists has led many to assume that his interest in African art merely extended to its applicability

7. Howard president Mordecai Wyatt Johnson escorts His Imperial Majesty Haile Selassie, Emperor of Ethiopia, to a special convocation during which the emperor received the honorary degree of doctor of laws, May 28, 1954

University Archives, Moorland-Spingarn Research Center, Howard University

to the work of Black American artists. However, it is worth noting that Locke arrived at his theorization in an international context. As art historian Richard J. Powell has reminded us, the Harlem Renaissance was not geographically limited to Harlem.[17] Scholars such as Theresa A. Leininger-Miller and Brent Hayes Edwards have all pointed out the internationalist interests of many Black writers and artists during this time.[18] Often the networks of Black culture in the early twentieth century extended through the centers of New York, London, and Paris to other areas of the diaspora, as well as to the African continent. In fact, Locke collected many African objects in Paris while scouring galleries and bazaars with artists and thinkers of the Harlem Renaissance like Hale Woodruff.[19] Just as Locke's Kuba cup moved through Europe on its way between Howard and its original Central African creator, Locke and his ideas circulated among an international network of Black writers and artists navigating and often resisting the global contexts of racial inequality and colonialism. Thus Locke's interpretation of traditional African art concerned not only the cultural and political interests of African Americans but also the cultural ascendance of modern Africa.

In fact, Locke traveled to Africa as well as Europe, first going to Egypt and the Sudan in 1923 and 1924 (before the publication of *The New Negro* and the Blondiau–Theatre Arts exhibition). He recalled these travels for the Howard University community in *Howard Alumnus*.[20] In Egypt, Locke visited Tutankhamen's tomb, an important touchstone of the 1920s, sparking the Egyptomania that infected American culture and feeding the African American tradition of Ethiopianism.[21] According to Robert Vitalis, Locke was one of the first among a mere handful of American intellectuals who actually traveled to the continent in that era, having made the trip a few months before the more famous visits of W. E. B. Du Bois.[22] While in Cairo, Locke met the young Haile Selassie (known as Ras Tafari Makonnen before assuming the throne as emperor of Ethiopia). Locke took the encounter as an opportunity to foster connections between Howard and the African continent. In correspondence, Locke encouraged a cultural and educational exchange between Howard and Ethiopia, eventually resulting in the choice of relatives of the royal family to attend Howard to study.[23] In many ways, the exchange foreshadowed Selassie's eventual visit to Howard almost thirty years later, in 1954 (fig. 7). In this manner, Locke participated in the conceiving of Howard University as an international center for Black culture.

One of Locke's principal interests at Howard was establishing an African studies department, one that would have a global reach and cement Howard's reputation as an international center. He proposed such a department in 1924, then again in 1928 (though the department of African studies was not established until 1953). In both of his proposals, Locke asserted that the study of African art would be a necessary cornerstone to the program.[24] Later, in the early 1930s, he proposed that Howard establish a museum of African art (which, like the museum in Harlem, never came to fruition). Notably, Locke framed his argument as an international one, writing, "As the leading institution in the world for the Liberal Education of Negroes, Howard University has a mission and influence of international as well as national scope"; and after laying out the nuances of this grand vision, he continued, "No single feature is more vital to

74

this project than the acquisition of a collection of African art, illustrating the native ability of the race in its original forms of culture."[25]

Thus, Locke clearly saw great potential in placing his own collection of African art at Howard University. More than simply a gesture of generosity from a donor with close ties to the institution, it was deeply rooted in a concept of Howard that Locke himself had already been long invested in constructing. Of course, HBCUs have been conceived of as places for this sort of intervention by many more than Locke. HBCUs functioned as a pragmatic solution to exclusion within a segregated educational system, but they also served to promote and define notions of Black community, a project in which African art often played a role. For example, Hampton University has one of the oldest collections of African art in the United States, which the African American missionary, educator, and explorer William Sheppard amassed during his travels to Central Africa and his extended stay in the Kuba Kingdom in the 1890s. Sheppard's materials wound up at Hampton partially because of typical networks of patronage and education (Sheppard was a Hampton alumnus), but Hampton was also a repository for African art as a node of diasporic connection similar to Locke's ancestral legacies. When the collection was acquired by the Hampton University Museum in 1911, the director, Cora Mae Folsom, proclaimed that "the African . . . collections should and do have a large mission in stimulating race pride."[26] However, the artistic model as imagined by Locke was not realized in this instance because the collection at the Hampton museum was initially framed as a cultural and ethnographic display akin to Western cabinets of curiosities. Further, as Mary Lou Hultgren has pointed out, Hampton lacked a fine art department until 1941.[27]

In contrast to Hampton, Howard during Locke's tenure was home to an active and growing art department, established in 1921 under the guidance of James V. Herring. Further, the Howard University Gallery of Art opened under Herring's direction in 1930 and maintained a robust exhibition schedule featuring a wide range of important local and national artists, Black and White alike. In his book *Art in Washington and Its Afro-American Presence: 1940–1970*, Keith Morrison offered an excellent description of the gallery's important position under Herring in the life of not only Howard but also the whole of Washington's art scene.[28]

However, despite his prominence in advocating for Black art on the national stage, Locke was largely detached from Howard's art department and gallery during his lifetime. As Richard Long recalled,

> There is also a notion . . . that Alain Locke, since he was at Howard, was involved in the establishment of that gallery, and that is absolutely untrue, largely because Professor Locke and Professor Herring hardly ever spoke to each other. There was a considerable antipathy between the two of them.[29]

The cool relations between Herring and Locke may have been tied in part to the dynamics of these two strong personalities within the university. Yet it was also true that Herring was not an enthusiastic advocate of Locke's notion of looking to African art as a model for African American modernism, and Locke found an outright critic in the young James A. Porter, who became chair after Herring's retirement in 1952.[30] Porter considered Locke's concept of ancestral legacies too racially prescriptive and believed that African American artists should engage with broader American aesthetic debates.

It seems that Herring's attitude toward such Black aesthetic debates was best described as an eclectic agnosticism. As Morrison noted, Herring purposely avoided debates regarding racial nationalism in his oversight of Howard's art gallery. Instead, he chose to exhibit as many

schools and styles of art as possible.[31] Thus, while he was not an advocate of Locke's notion of ancestral legacies, he did incorporate traditional African art into his exhibition program, including a 1935 exhibition of South African rock paintings. Perhaps the most significant exhibition of traditional African art at Howard during Locke's lifetime was the *Exhibition of African Negro Art* in May 1953. Organized by Herring, the show was something of a swan song, as he had retired from chairmanship of the department a year earlier. It consisted of more than two hundred works of art borrowed from major American institutions, such as the Smithsonian Institution, the University of Pennsylvania, and the Brooklyn Museum. Two of the objects from Locke's personal collection appeared in the exhibition, including the Kuba cosmetic box (see fig. 3). The small catalog contains essays by Porter and William Leo Hansberry, a professor of African history at Howard.[32]

While it featured exhibitions of traditional African art, the Howard University gallery under Herring's directorship is perhaps most notable for its early promotion of contemporary African artists. In fall 1950, the gallery featured an exhibition of Nigerian artist Ben Enwonwu, which was not only Enwonwu's first solo show in the United States but also one of the first major shows of any contemporary African artist in the United States (fig. 8). Bringing Enwonwu and his work to DC was not a simple undertaking. Correspondence between Herring and Mary Beattie Brady of the Harmon Foundation reflects the ways in which Herring's embrace of Enwonwu surpassed the imaginations of other curators such as the Museum of Modern Art's director, René d'Harnoncourt. Brady complained of d'Harnoncourt: "He feels that the Museum of Modern Art can only show the highly sophisticated and the type of art that they are sure will be accepted by the critics. He feels Africa is in a state of flux and that, while the material should definitely be shown, it should be shown more from the sociological basis."[33] Herring's art gallery did not shy away from incorporating Enwonwu into its aesthetic worldview, and, in the following decades, the Howard gallery presented a number of notable exhibitions of contemporary artists from the continent.

In this manner, though some distance existed between Locke and Howard's art department, the department's activities and the gallery's range of exhibitions provided fruitful ground for the consideration of Locke's concepts. Locke clearly followed the gallery's programs and must have seen promise for his vision in exhibitions like that of Enwonwu's. Consider, for example, Locke's late essay "The Negro and His Art," written in 1953, just a year before his death. Jeffrey C. Stewart has highlighted the optimism through which Locke reassessed his long-standing belief in the inspirational utility of traditional African art.[34] Notably, Locke rooted his optimism in Enwonwu, whose work he would have seen in Howard's art gallery:

> At the height of the New Negro phase, there was promise that African art would exert a special influence on the work of Negro American artists. After some experimental flurries, this did not fully blossom. The contacts with African sculpture were not as direct as they could and should have been; and there is no doubt that a more informed development in this direction could still be fruitful. The possibilities, especially in sculpture, are revealed by modern African sculptors themselves, notably Ben Enwonwu.[35]

Following Herring's retirement, Porter assumed the role of running the art department. In his early years, Porter was a well-noted skeptic of Locke's notion of ancestral legacies, which Porter saw as a part of a problematic racial essentialism. Most famously, in a 1937 essay, Porter expressed extreme objection to Locke's book *Negro Art: Past and Present* (1936), which continued Locke's arguments regarding the use of African art. Porter wrote, "This little pamphlet, just off

the press, is one of the greatest dangers to the Negro artist to arise in recent years. . . . Dr. Locke supports a defeatist philosophy of the 'Segregationist.'"[36] Porter's thoughts on Locke's theories of ancestral legacies tempered somewhat over time.[37] Further, Porter maintained an interest in African art—both teaching and writing on the subject (as he did for Howard's 1953 exhibition catalog).[38] But Porter's critique of Locke reflects the diverse perspectives on the utility of African art in Howard's art department and the fact that the display of African art was always read through the multifaceted interests of these diverse perspectives. For example, when Locke's African collection was first displayed in 1957 in honor of his bequest, Porter wrote the preface to the catalog of the exhibition. Although Porter praised the veracity of the collection and the importance it would hold in aiding the scholarly study of African culture both past and present, there is no mention of the works as an inspiration for Black artists and no reference to Locke's iconic concepts of ancestral legacies.[39]

Of course, Locke's collection was not subsequently hidden away. In fact, it was virtually on permanent display, and it continued to play a role in artistic debates at Howard. Some of the faculty maintained an aesthetic dialogue with the concepts that Locke introduced, such as Wells, who was photographed holding Locke's Kuba cup and taught in the department from 1929 to 1968. Yet the greatest example of an artist in Howard's art department who engaged

with Locke's concepts of ancestral legacies is that of Lois Mailou Jones. Jones taught at Howard from 1930 to 1977, and her time there was significant not only for the way in which she looked to African art as a source of inspiration but also for her broad and international interest in and study of contemporary African artists. Her interest was mirrored by the university's art gallery, which continued to show contemporary African artists, and paralleled by the rest of the university that extended and broadened the global, Pan-African interests advocated by Locke. For example, a 1962 *Ebony* article described the centrality of Howard University in training new Peace Corps volunteers for duties in countries including Niger, Senegal, Togo, and Sierra Leone and noted Howard's large population of exchange students from throughout Africa.[40]

On the domestic front, the 1960s was a decade of major cultural and political shifts for Black Americans. Progress in the struggle for civil rights in the United States saw violent resistance in the form of police brutality during the Selma marches of 1965 and the assassinations of preeminent Black leaders including Medgar Evers, Malcolm X, and Rev. Dr. Martin Luther King Jr. Riots erupted in cities throughout the country: Los Angeles in 1965, Detroit in 1967, and, significantly, Washington in 1968. From this crucible of political strife emerged the Black Arts Movement, in which artists and writers sought a more active art that addressed the political conditions of Black communities. Since it was situated within an HBCU located in Washington, Howard's art department found itself reevaluating its worldview in light of this political turmoil. During the decades under the leadership of Herring and Porter, the department favored an eclectic and multicultural arts education—one that encouraged a generation of artists who did not necessarily seek to incorporate their racial or ethnic identities into their work.[41] Yet by the end of the turbulent 1960s and with Porter's death in 1970, the department found itself at a crossroads, reconsidering its role in relation to the tenets of the Black Arts Movement and the function of Black identity in its pedagogy.[42]

The department embraced a more community-oriented art practice with the hiring of sculptor Ed Love in 1968. In 1970 it expanded this commitment by hiring artist Jeff Donaldson, who assumed the role of department chair. Donaldson was well versed in traditional African art, having studied the subject extensively while earning his PhD at Northwestern University.[43] Further, as a founding member of AfriCOBRA, he promoted a deep engagement with African art traditions.

AfriCOBRA grew out of the Black Arts Movement in Chicago, where Donaldson and a number of other artists developed a practice of collaborative work through collectives such as the Organization for Black American Culture (OBAC), which blended the arts with community activism in projects like the famous mural *Wall of Respect* in Chicago (1967).[44] By the time of its 1970 group exhibition at the Studio Museum in Harlem, *AfriCOBRA I: Ten in Search of a Nation*, AfriCOBRA included ten members: Donaldson, Jae Jarrell, Wadsworth Jarrell, Barbara J. Jones, Carolyn Lawrence, Nelson Stevens, Gerald Williams, Omar Lama, Sherman Beck, and Napoleon Jones-Henderson.[45] The group blended the community activism of the Black Arts Movement with an emphasis on an aesthetic embrace of its African roots. According to Donaldson's artist statement for a group show entitled *AFRI-COBRA III*, at the University of Massachusetts Amherst in 1973, this turn to African roots included "the *expressive awesomeness* that one experiences in African Art and life in the USA . . . the *symmetry* that is *free*, repetition with change, based on African music and African movement."[46] In this way, Donaldson and his fellow AfriCOBRA members engaged with the tradition of African art in a manner quite similar to Locke's notion of ancestral legacies.

In fact, AfriCOBRA utilized traditional African art in the exhibition materials for its early shows. The group appropriated a Yoruba Gẹ̀lẹ̀dẹ́ mask as a central emblem reproduced

AFRICOBRA
Exhibition of Chicago's African Commune
of Bad Relevant Artists

a t the MUSEUM of the
NATIONAL CENTER OF AFRO—AMERICAN ARTISTS
SEPTEMBER 13 THROUGH OCTOBER 11, 1970

We are a family — COBRA, the Coalition of Black Revolutionary
Artists, is now AFRICOBRA, African Commune of Bad Relevant
Artists. It's NATION TIME, and we are searching. Our guide-
lines are our people — the whole family of African People, the
African family tree. And in this spirit of familyhood, we have
carefully examined our roots and searched our branches for those
visual qualities that are most expressive of our people/art. Our
people are our standard for excellence. We strive for images in-
spired by African people/experience and images which African
people can relate to directly without formal art training and/or
experience. Art for people and not for critics, whose peopleness
is questionable. We try to create images that appeal to the senses
—not to the intellect. It is our hope that intelligent definition of
the past and perceptive identification in the present will project
nationful direction in the future — look for us there, because that's
where we're at.

The words are an attempt to posit where we are coming from and
to introduce how we are going where we are going. Check out
the image. Words do not define/describe relevant images. Relevant
images define/describe themselves. Dig on the image. We are a
family of image-makers, and each member of the family is free to
relate to and to express our laws in her/his individual way. Dig the
diversity in unity. We can be ourselves and be together too. Check.

We hope you can dig it — it's about you, and like Marvin Gaye
says, "You're what's happening in the world today, baby."

PUBLIC OPENING: SEPTEMBER 13 AT 3 P. M.

MUSEUM HOURS: Tuesday through Friday 12 — 9; Saturday 12 — 5;
Sunday 2 — 5

ADMISSION FREE

in announcements, posters, and other materials for the show *AfriCOBRA I* (1969-1970) and transformed the work by dressing it with sunglasses (fig. 9).[47] This altered readymade playfully embodies the AfriCOBRA desire to make art broadly accessible, based on everyday life and art in the United States, while also embracing African aesthetics. It connects the "cool" aesthetics of Black contributions to American popular culture with that of traditional African art. AfriCOBRA's inclusion of the hip Gẹlẹdẹ mask suggests sympathy with concepts that Locke advocated; yet the notion of ancestral legacies here seems less distant than Locke's—less a silent source of inspiration than an active participation in the creation of AfriCOBRA's own new aesthetic.

 In its reassessment of its position and pedagogy as an arts program, Howard's art department drew upon AfriCOBRA's aesthetic and other concepts circulating in the Black Arts Movement. The department crafted a statement outlining this new vision, which was approved by a majority vote in 1971 and renewed unanimously in 1972. In his introduction to the catalog for Howard's 1972 faculty exhibition that traveled to the Studio Museum in Harlem, Donaldson quoted the statement:

> The Department of Art of Howard University recognizes its unique advantage and responsibili-
> ty to reflect, affirm and perpetuate the visual expression of the Black Experience. It further rec-
> ognizes that the total awareness and promotion of Black values/aesthetics constitute an effective
> force in the positive development of the Nation. Therefore, the major focus of the curriculum
> and the commitment of the faculty shall be the pursuit of excellence from a Black perspective
> with supplemental instruction from other viewpoints, wherever applicable.[48]

9. Pamphlet advertising the exhibition *AfriCOBRA I*, Museum of the National Center of Afro-American Artists, 1970

Jeff Donaldson Papers, 1918–2009, bulk 1966–2003, Archives of American Art, Smithsonian Institution

The art department's newfound Black nationalism was a fairly drastic departure from the department of Herring and Porter. Yet, while somewhat more radical than the racially based modernism emphasized by Locke, the department's decision to move toward a socially and racially conscious art echoed many of his ideas. As Morrison asserted, "It is certain that the University must have recognized that its newly chosen direction was familiar to some elements of its tradition."[49]

Significantly, this philosophical shift to Black nationalist aesthetics in the department of art was reflected in a change in the organization of the gallery's permanent displays. From 1961, Howard's Gallery of Art maintained a study collection of European art on almost permanent display. Donated by the Samuel H. Kress Foundation, the collection contained a range of prints and drawings from the European Renaissance. Almost immediately after assuming the chairmanship, Donaldson oversaw the reorganization of the galleries. In correspondence with Mark Fax, dean of the College of Fine Arts, Donaldson requested permission to take down the European collection that occupied one of the three gallery spaces. The proposed arrangement would create a dedicated gallery for both African art and African American art, while preserving one space for rotating exhibitions.[50] In his statement for the 1972 faculty exhibition, Donaldson described the rehanging of the gallery as one of the department's major innovations, furthering its new Black Arts vision. Donaldson wrote, "In 1970, a third of our exhibition space was occupied by a European Study Collection. Now all three galleries are forums for top rank African and African American visual expression."[51]

Under Donaldson's leadership, the Howard art department also grew by adding new faculty who were, or would become, AfriCOBRA members, such as Wadsworth Jarrell, Frank Smith, and James Phillips (who joined the faculty in 1973 and AfriCOBRA in 1974).[52] Further, the department also broadened to international scope with the addition of Ethiopian artist Alexander "Skunder" Boghossian. Trained in Addis Ababa and France before moving permanently to the United States in 1969, Boghossian joined the faculty at Howard in 1972 and became an important figure in the department and in Washington, until his retirement in 2000.

Boghossian's presence in the department reflects just one of the ways in which Howard served as a center for contemporary African art. The Gallery of Art continued to show significant exhibitions of contemporary African artists, including solo exhibitions of the work of Bruce Onobrakpeya in 1971 and Boghossian in 1972.[53] In 1977 the gallery held a major exhibition of contemporary African artists, featuring forty-five artists from fifteen countries.[54]

Perhaps the greatest moment of the Howard art department's internationalism was the role it played in the Second World Black and African Festival of Arts and Culture (FESTAC), which took place in Lagos, Nigeria, in 1977.[55] FESTAC was an international festival of arts and culture on an unprecedented scale dedicated to assessing cultural bonds across Africa and its diaspora.[56] Donaldson served as the chair for the North American Zone, organizing the participation of 482 official delegates and establishing Howard as the de facto FESTAC headquarters in the United States.[57] For the many American artists who traveled to the event, FESTAC embodied an important moment in the debate about African American identity and notions of diaspora.

In this way, Howard kept up a constant conversation among Black American artists, contemporary African artists, and traditional African art, a dynamic that embodied what Donaldson theorized as a "transAfrican art."[58] For Donaldson, such art produced and maintained an aesthetic that transcended the geographical boundaries as well as the temporal boundaries that separate the diaspora from Africa. In its consideration of the connection between African aesthetics and African American art practices, Donaldson's theory of a "transAfrican"

10. Yoruba artist, *Ceremonial Mask* (Gẹlẹdẹ), n.d., wood

Howard University Gallery of Art, donated by Jeff Donaldson

art was in dialogue with Locke's notion of ancestral legacies but updated by the immediacy and connectivity of the increasingly globalized world of the late twentieth century. Further, traditional African art had a role to play in Donaldson's conception—think of the Gẹlẹdẹ mask used in the early AfriCOBRA exhibitions. Significantly, a very similar Gẹlẹdẹ mask is now a part of the collection, having been donated to the gallery by Donaldson (fig. 10).

Mixed today among other African works of art, Donaldson's Gẹlẹdẹ mask highlights the role of the African collection at Howard. It functions as a pedagogical tool, giving direct access to students interested in studying African art and also evincing a complex body of African diaspora ideas and attitudes layered by each collector in the gathering of African art on display at Howard. As the cornerstone to the collection, Locke's bequest of traditional African art has provided a discursive foundation for subsequent generations as students and faculty have responded to and added to the collection in different ways. Yet its continuous display, so seemingly understated yet so recalcitrantly present, highlights its enduring and continued role as a useful and adaptable legacy.

"ART MEANS INTEGRATION": DUNCAN PHILLIPS'S GALVANIZING VISION FOR THE PHILLIPS COLLECTION

Elsa Smithgall

In May 1942, as the battles of World War II were raging, The Phillips Collection founder Duncan Phillips delivered an address, "The Arts in War Time" (fig. 1), before the annual meeting of the American Association of Museums and subsequently in a radio broadcast. "I am glad to have an opportunity of affirming my faith in the *necessity* of art during this, the most crucial and decisive hour in the history of man's long fight for freedom," Phillips began. Art, he avowed, could be marshaled to "serve the cause of victory," as a powerful instrument for social change that professes "unity and universality and respect for the individual." It was the French painter Honoré Daumier, Phillips maintained, who provided an inspiring example. His masterpiece *The Uprising* (1848 or later; fig. 2), an important early acquisition by Phillips, symbolized "the volcanic explosion of all enslaved people everywhere. The Paris of its background might be the tragic Europe of today." While Phillips's fervent address revealed his strong political minded-ness and activism, its essential message about the role of arts in wartime underscored a core principle of inclusiveness that shaped the museum from its inception: "*Art means integration. Art is not art if it has not Unity*, and at its best, unity in diversity."[1]

These words from Phillips's address, which were laid out in his earlier publication *A Collection in the Making* (1926), echo his vision for the Phillips Memorial Gallery (now known as The Phillips Collection). There, in a section titled "Our Inclusiveness," Phillips expressed the museum's policy of "supporting many methods of seeing and painting."[2] Unapologetic in his desire not to conform to public taste or opinion, Phillips professed his approach as a decidedly personal one, guided by a desire to show continuities between the best representative painting from different parts of the world and from different periods of time—all in a setting in which visitors "can be made to feel at home in the midst of beautiful things, subconsciously stimulated while physically rested and mentally refreshed."[3]

This essay explores the vital role The Phillips Collection played in the cultural life of Washington's artistic community as an innovative model for "unity in diversity." In so doing, it highlights key moments in The Phillips Collection's engagement with African American artists and gallerists over the course of the twentieth century, notably through its championing of Jacob Lawrence, Horace Pippin, Lois Mailou Jones, and Sam Gilliam and its close ties to the Howard University Gallery of Art and the Barnett-Aden Gallery.

THE ARTS IN WAR TIME

An Address by

DUNCAN PHILLIPS

Director
of
The Phillips Memorial Gallery
and
A Trustee
of
The National Gallery of Art

before
The American Association
of Museums
Williamsburg, Virginia
May 19, 1942

NATIONAL GALLERY OF ART
Smithsonian Institution
Washington, D. C.

1. Cover of Duncan Phillips, *The Arts in War Time* (Washington, DC, 1942)

The Phillips Collection Archives, Washington, DC

2. Honoré Daumier, *The Uprising (L'Émeute)*, 1848 or later, oil on canvas

The Phillips Collection, Washington, DC, Acquired 1925

On December 8, 1941, the day after the Japanese attacked Pearl Harbor, the stalwart dealer Edith Halpert proceeded with her plans to open a groundbreaking exhibition, *American Negro Art*, at her Downtown Gallery in New York's Greenwich Village, featuring the work of more than fifty African American artists from the nineteenth and twentieth centuries. The previous June, Halpert had read Alain Locke's recently published book, *The Negro in Art: A Pictorial Record of the Negro Artist and of the Negro Theme in Art* (1940), which became a revelation, inspiring her to promote and champion this little-known but important aspect of American art history. Halpert recognized that she was not alone in her "woeful ignorance" of African American art at a time when it was just starting to gain national attention following several important museum exhibitions in Baltimore and Chicago in 1939 and 1940.[4] The young Lawrence had been featured in both of these exhibitions, notably at the Baltimore Museum of Art with an entire room featuring his series about Haitian revolutionary leader Toussaint Louverture. But it was Lawrence's recently completed series *The Migration of the Negro* (1940–1941; now known as *The Migration Series*) that was taking center stage in Halpert's exhibition (fig. 3). Adding further to Lawrence's rise to national attention was the savvy placement by Halpert and Locke of a spread on Lawrence's series in *Fortune* magazine the month before her show.[5]

Whether the article in *Fortune* had come to the attention of Duncan Phillips is not certain.[6] Nevertheless, it was in fact the better-known African American artist Horace Pippin, nearly thirty years Lawrence's senior, whom Phillips expressed interest in seeing during his upcoming visit to *American Negro Art* at the Downtown Gallery early the next year. Phillips was especially interested in seeing the work by two artists on Halpert's roster, Raymond Breinin and Bernard Karfiol, which he hoped to borrow for his own forthcoming exhibition on contemporary American art. In addition, he was pleased that his visit would coincide with the presentation of *American Negro Art*: "I note *American Negro Art* will still be on when we get to

3. Jacob Lawrence, *The Migration of the Negro*, installed in *American Negro Art*, The Downtown Gallery, New York, December 1941

Harmon Foundation Collection, National Archives and Records Administration, College Park, MD

New York and I am looking forward to the work of Pippin," Phillips wrote to Halpert in early January 1941.[7] But when he saw the exhibition, it was Lawrence's *Migration Series* that clearly captured Phillips's attention. He immediately arranged with Halpert to bring the complete series to Washington for an exhibition at The Phillips Collection that February. The exhibition would no doubt also provide an opportunity for Phillips to consider the possible acquisition of the series while testing out its fit within his collection, as was his practice. However, before *The Migration Series* even arrived in Washington for the exhibition, Phillips received news that the Museum of Modern Art (MoMA) had acquired half the panels through a gift from Adele Rosenwald Levy, prompting his swift purchase of the remaining thirty panels.[8]

The transformative purchase of thirty panels from *The Migration Series* marked the museum's second acquisition of work by an African American artist, joining two paintings acquired in the 1930s by DC–based artist and Howard University professor James Lesesne Wells. It was Phillips's education director, C. Law Watkins, who persuaded Wells to leave examples of his work to show to Phillips around 1930. After the museum made its first acquisition in 1931, Wells wrote to convey his gratitude in a letter to Phillips's assistant, Minnie H. Byers: "It makes me very happy to know that my efforts arouse the interest of such a distinguished person as Mr. Phillips."[9]

Whether Phillips realized it or not, his latest acquisition of Lawrence's work provided a natural link to Wells, the Columbia University Teachers College graduate who had set up the arts and crafts program at Utopia Children's House and supervised the Harlem Art Workshop, two places that had fostered the first forays into art for the young Lawrence. Although Wells drew on religious rather than contemporary subject matter, he shared with Lawrence a love of storytelling in intimate, small-scale compositions through an expressionist language of abstract forms and colors. Phillips's two previously acquired paintings by Wells, *Journey to Egypt* (1931) and *Journey to the Holy Land* (undated; fig. 4), resonated with Lawrence's series, which chronicled

4. James Lesesne Wells, *Journey to the Holy Land*, n.d., oil on canvas board

The Phillips Collection, Washington, DC, Acquired 1935

5. Allan Rohan Crite, *Parade on Hammond Street*, 1935, oil on canvas board

The Phillips Collection, Washington, DC, Acquired 1942

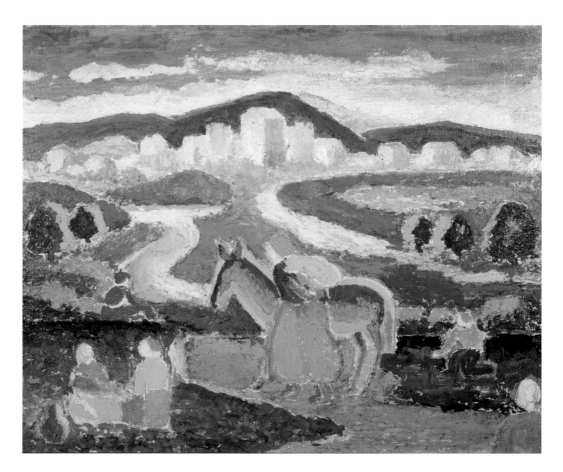

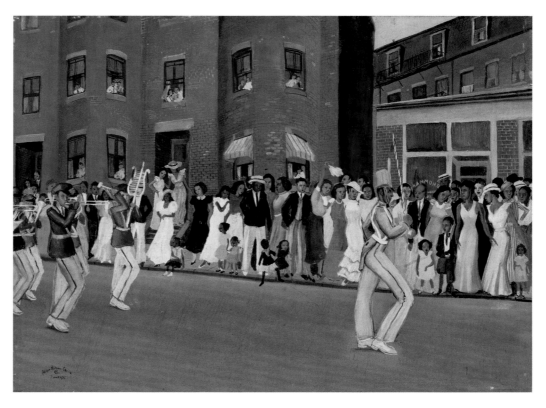

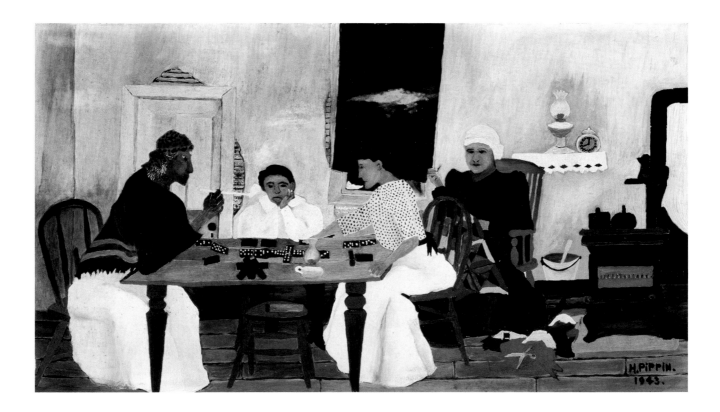

the Great Migration of African Americans out of the South into the North beginning with World War I. That movement had been equated with the flight of the Israelites out of Egypt.[10]

6. Horace Pippin, *Domino Players*, 1943, oil on composition board

The Phillips Collection, Washington, DC, Acquired 1943

Not long after The Phillips Collection acquired and exhibited *The Migration Series*, Phillips added to its holdings a painting by the African American artist Allan Rohan Crite, *Parade on Hammond Street* (1935; fig. 5).[11] As Crite later recalled, the festive street scene was inspired by his experience in Boston of the parades led by the fraternal order of the Elks: "They would be at times on a Sunday preceding a service at one of the local churches."[12] That spring, Phillips included the painting in a major survey of contemporary American paintings and watercolors, where it was shown in dialogue with works by Jack Levine, Henry Varnum Poor, and Harold Weston.

Meanwhile, what was to come of Phillips's interest in Pippin? After Phillips expressed his enthusiasm for Pippin to Halpert, she set to work behind the scenes with the artist's dealer, Robert Carlen, to mastermind a future Phillips purchase.[13] Phillips likely had been introduced to Pippin's art through the four works by the artist featured in MoMA's exhibition *Masters of Popular Painting* (1938), to which Phillips had lent several works by Vincent Canadé, John Kane, and Henri Rousseau. His first acquisition would come in 1943 with the purchase of the celebrated painting *Domino Players* (1943; fig. 6), a genre scene based on Pippin's childhood memories of evenings spent playing dominoes with his family. Phillips took no time to deliberate on this purchase, having been taken with the painting on first sight. As he told Halpert soon after its acquisition, "The Pippin '*Dominoe* [*sic*] *Players*' is certainly no mistake and in this case the wisdom of my immediate decision was confirmed on receipt of the picture."[14]

In spring 1944 the Phillips featured *Domino Players* in its major survey billed as *The American Paintings of The Phillips Collection*, a rare moment when all the galleries in the collection were filled with more than two hundred works of American art to spotlight its importance. Indeed, the American collection had far outgrown the museum's European holdings,

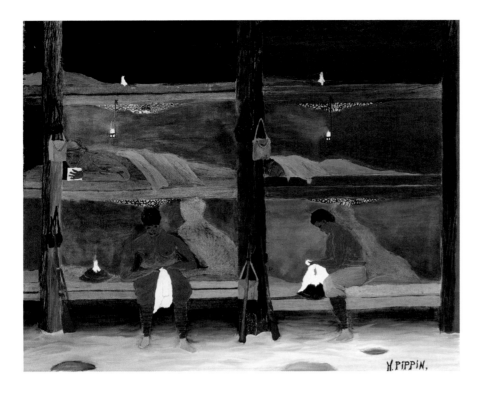

7. Horace Pippin, *The Barracks*, 1945, oil on canvas

The Phillips Collection, Washington, DC, Acquired 1946

8. Cover of *Three Negro Artists: Horace Pippin, Jacob Lawrence, Richmond Barthé* (Washington, DC, 1946)

The Phillips Collection Archives, Washington, DC

with the largest concentration of works representing living artists and, notably, many from DC. In his foreword to the exhibition brochure, Phillips reaffirmed his long-held view that "art is international, a universal means of expression extending across boundaries and overcoming the barriers of trade, race, and language."[15] Noting the increasing numbers of European artist immigrants to the United States since the start of World War II, Phillips remained hopeful about the increasing openness of American art to embracing diversity: "In our country there is bound to be a fusion of various sensitivies, a unification of differences. . . . Our art, like our national aim, can point the way to a new world of neighborly citizen states in which unity in variety and interdependence are taken for granted."[16] Phillips also made a point of explaining certain omissions from the show, including *The Migration Series*, which had been traveling the country since fall 1942 on MoMA's national tour.[17]

In 1945 Phillips acquired his second Pippin, a still life, *Victorian Interior II* (1945), but by the next year, he decided to exchange it for the purchase of a painting that would allow him to represent another important aspect of the artist's work. Purchased out of an exhibition at the Whitney Museum of American Art, Pippin's *The Barracks* (1945; fig. 7) was one of a series portraying the artist's memories of World War I as a disabled veteran. The more somber composition may have appealed to Phillips for its sensitive use of a subdued color palette to evoke the sacrifices of African American servicemen in the fight for freedom.

By this time, the two works by Pippin and the thirty panels from *The Migration Series* had secured The Phillips Collection a reputation in the DC community, resulting in a promising collaboration with the Catholic Interracial Council of Washington on an exhibition, *Three Negro Artists* (fig. 8), held at the Phillips from December 1946 to early January 1947. It featured Pippin and Lawrence alongside the work of African American sculptor Richmond Barthé. A lecture by Reverend John LaFarge titled "The Negro in Art" and one titled "Negro Sculpture" by James V. Herring, Howard University professor and art department chair, complemented the exhibition.

9. Richmond Barthé, *John the Baptist*, n.d., painted plaster

The Phillips Collection, Washington, DC, Acquired 1946

In addition to Gardiner Howland Shaw of the Catholic Interracial Council, the catalog acknowledged the scholar of American art James W. Lane, from the curatorial staff of the National Gallery of Art, for initiating the exhibition, and correspondence between Phillips and Lane indicates that he played a significant role in its assembly.[18] Pippin and Lawrence were represented by eighteen and twenty works respectively and Barthé by five sculptures on loan from the artist. The Lawrence selection included four from Phillips's half of *The Migration Series* with other loaned works, including *The Blind Florist* (1946), a watercolor on loan from the Barnett-Aden Gallery, and *Watchmaker* (1946), a painting on loan from the collection of Joseph Hirshhorn.[19] In the estimation of *Washington Post* critic Jane Watson Crane, the exhibition marked a turning point in the recognition of African American artists' vital place in the story of American art. "A little over 10 years ago, when Alfred Barr and Holger Cahill did their survey of *Art in America in Modern Times*," Crane recalled, "there was no mention of a Negro artist. Today no summary would be complete without inclusion of Horace Pippin, Jacob Lawrence, and Richmond Barthé, the trio whose work is now being shown at the Phillips Memorial Gallery."[20] Phillips acquired his first Barthé, *John the Baptist* (undated; fig. 9), out of the exhibition.

At the same time that Phillips was discovering the work of Pippin and Lawrence, he was also becoming familiar with the art of Lois Mailou Jones, the accomplished DC–based artist who had served as a professor of fine arts at Howard University since 1930. After four consecutive

10. Lois Mailou Jones, *Place du Tertre*, 1938, oil on canvas

The Phillips Collection, Washington, DC, Acquired 1944

years of selecting her work for the museum's juried annual Christmas exhibitions,[21] Phillips decided to acquire her *Place du Tertre* (1938; fig. 10) out of the fourth exhibition—which would become the first of two Parisian street scenes painted in the impressionist plein air style to enter the collection. (Nearly a decade later Phillips's fondness for the painting must have inspired his acquisition of Maurice Utrillo's variation of the same subject, painted in 1911.) After the mid-1940s, Phillips continued to feature Jones's work in special exhibitions, among them two that showcased Washington-area artists (*Some of the Paintings by Artists of Washington and Vicinity Purchased from the Annual Christmas Exhibitions 1935–45* [1946] and *Exhibition of Paintings by Artists of Washington, Baltimore and Vicinity* [1947]) and a 1948 exhibition of women painters from The Phillips Collection that was organized for the Centennial Club in Nashville. For the latter, the work of Jones was brought into dialogue with those of a diverse group of twenty-six women artists, including Sarah Baker, Isabel Bishop, Bernice Cross, Laura Douglas,[22] Georgia O'Keeffe, Elisabeth Poe, and Helen Turner, among others. Soon afterward Phillips acquired a

SMITHGALL

11. Lois Mailou Jones, *Coin de la Rue Medard, Paris*, 1947, oil on canvas

The Phillips Collection, Washington, DC, Acquired 1948

12. The Phillips Memorial Gallery in the 1950s

The Phillips Collection Archives, Washington, DC

second oil by Jones, *Coin de la Rue Medard, Paris* (1947; fig. 11), out of her solo exhibition at the Whyte Gallery, Washington, DC.

Throughout the 1950s The Phillips Collection was pleased to share its works by Jones, Lawrence, and Pippin with galleries and museums locally, nationally, and abroad (fig. 12). Widely sought-after and shown in a range of interesting contexts, Pippin's *Domino Players* was lent to the Watkins Art Gallery at American University for the exhibition *COLOR* (1953), overseen by William Calfee, chair of American University's art department and successor to C. Law Watkins, in whose memory the university's Watkins Memorial Collection had been established.[23] The exhibition, which examined the science of color in relation to modern art, was hailed by one critic as "one of the most instructive and interesting shows of the year."[24] Taking a cue from The Phillips Collection, the show brought together an unusual mix of works that positioned Pippin's work alongside that of Stuart Davis, Juan Gris, Wassily Kandinsky, Paul

13. Irene Rice Pereira, *Transversion*, 1946, ceramic fluid and porcelain cement on two planes of corrugated glass on a bottom panel of oil on hardboard

The Phillips Collection, Washington, DC, Acquired 1949

Klee, Karl Knaths, Oskar Kokoschka, John Marin, Joan Miró, Robert Motherwell, and Pablo Picasso, among others. Indeed, organizing an exhibition around color had inspired the earlier exhibition *The Functions of Color in Painting* (1941), which was the brainchild of Duncan Phillips and his associate director, C. Law Watkins.

The Phillips Collection also supported exhibitions held in nontraditional museum settings, allowing visitors to engage with art in new ways. In 1954 Jones's *Place du Tertre* was featured at the Playhouse Theatre Gallery, Washington, DC, in *Washington Artists in The Phillips Collection* and in 1959 in an exhibition at the AFA Department Store.

During the 1940s and 1950s, The Phillips Collection had also formed a warm relationship with its neighboring institutions, the Howard University Gallery of Art and the Barnett-Aden Gallery. Duncan and Marjorie Phillips enjoyed a friendship with James Herring and Alonzo J. Aden, the industrious figures who had cofounded the Barnett-Aden Gallery in 1943, thirteen years after Herring founded the gallery at Howard and hired Aden, his former student, as its curator. The Phillips Collection was a generous lender to exhibitions at both venues. In response to a loan request from Alonzo Aden, Duncan Phillips loaned one painting each by Louis Eilshemius, Marjorie Phillips, and Eugene Speicher and a bronze by Hunt Diederich to *Contemporary American Art* (1940), an exhibition at the Howard gallery in honor of its tenth anniversary.[25] In loaning the works, Phillips signaled his support for the gallery's guiding principle as stated by Herring in the foreword to the catalog: "Our policy has been to leave the discovery of racial and nationalistic artists to our chauvinistic friends. We have preferred to exhibit the works of all schools and trends regardless of ideology or any designated sphere."[26]

In 1948 The Phillips Collection lent a painting by Karl Knaths and Marjorie Phillips to another Howard exhibition assembled by Herring, *American Paintings 1943–1948*. In the catalog's foreword, Charles Seymour Jr. acknowledged the Phillips Memorial Gallery, a lender to Howard's exhibition, as one of the "forward-looking collections of modern art."[27] Seymour, then president of Yale University, further elaborated on the show's premise as centered on the question "What is American painting today?"[28] This poignant query stimulated the thinking of Duncan Phillips, who had offered his own personal response to the subject in two earlier contemporary American art exhibitions, in 1942 and 1944.

A strong focus on contemporary American painting also guided the exhibition program at Barnett-Aden Gallery, a gallery "patterned after" the Phillips in presenting art in an intimate, domestic space.[29] In 1946 Duncan Phillips received a personal request from Jones to write for the catalog of her solo show that was opening the following month at Barnett-Aden: "You are perhaps more acquainted with my work than anyone else in Washington," she told him.[30] Although Phillips declined to write, perhaps because of the short notice, he loaned her painting *Place du Tertre* to the exhibition.[31] For its fall 1952 exhibition *Privately Owned: Paintings Purchased by Patrons, 1943–1952*, the Phillips loaned Irene Rice Pereira's *Transversion* (1946; fig. 13), a colorful constructivist composition in glass on oil on hardboard panel that had been acquired from Barnett-Aden in 1949.[32]

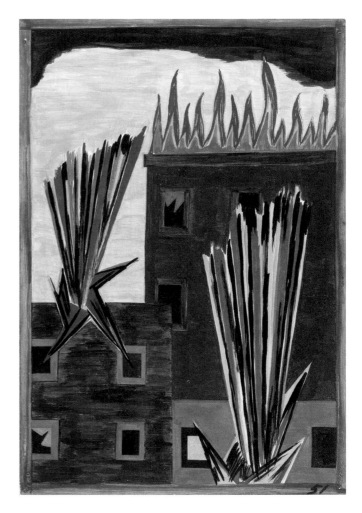

Duncan and Marjorie Phillips and their curatorial staff attended exhibitions and openings at the Howard and Barnett-Aden galleries, where they were exposed to work by familiar and unfamiliar artists and to integrated contexts for presenting art in a manner that was aligned with Duncan Phillips's view of art as a universal language.[33] Moreover, as artist and writer Keith Morrison has noted, Phillips and Herring were known to visit some of their favorite New York art galleries together on buying trips, especially Kraushaar Galleries and the Downtown Gallery.[34] The two shared enthusiasm for several of the same artists, and were, as David Driskell later recalled, "in consultation often, especially concerning the work of Theodore Stamos, I. Rice Pereira and Bernice Cross."[35]

The intense period of the civil rights movement in the 1960s brought renewed attention to its deeper roots in the transformative period of the Great Migration, as foretold by *The Migration Series* (1940–1941; figs. 14 and 15). First in 1962 and again in 1969, three years after Duncan Phillips's death, The Phillips Collection presented its *Migration Series* panels, signaling the important resonances of Lawrence's work during the country's latest struggle for racial equality and social justice. "Justice for the American negro is still a long way in the future," Frank Getlein noted tellingly in the *Sunday Star*.[36] The museum's 1969 presentation was overseen by Marjorie Phillips, who had assumed the directorship after Duncan's death. Featuring the Phillips's thirty odd-numbered panels, the exhibition ran for an unprecedented nine months, and Marjorie's

14. Jacob Lawrence, *The Migration Series, Panel No. 49: They found discrimination in the North. It was a different kind*, 1940–1941, casein tempera on hardboard

The Phillips Collection, Washington, DC, Acquired 1942

15. Jacob Lawrence, *The Migration Series, Panel No. 51: African Americans seeking to find better housing attempted to move into new areas. This resulted in the bombing of their new homes*, 1940–1941, casein tempera on hardboard

The Phillips Collection, Washington, DC, Acquired 1942

16. Sam Gilliam, *Red Petals*, 1967, acrylic on canvas

The Phillips Collection, Washington, DC, Acquired 1967. © Sam Gilliam / Artists Rights Society (ARS), New York

reluctance to part with it at that time further affirmed her awareness of its significance in the aftermath of the riots following the assassination of Rev. Dr. Martin Luther King Jr. in 1968. In her letter responding to a request from St. Paul's School, in Concord, New Hampshire, to borrow all thirty panels, Marjorie explained: "Our thirty panels have been hanging together for the last six months and the exhibition has caused great interest and appreciation in Washington, especially among the younger Negro population; therefore I feel definitely that a month to six weeks would be the longest we could spare them at this period."[37]

In between the two presentations of Lawrence's *Migration Series*, a new talent discovered by Marjorie made his debut at The Phillips Collection in 1967 in his first solo museum exhibition:

Sam Gilliam. After responding enthusiastically to his work at Jefferson Place Gallery, Marjorie decided to give him a one-man exhibition, going to his studio personally to select the thirteen works to be included.[38] Among them was Gilliam's large, ebullient painting *Red Petals* (1967; fig. 16), representing one of his earliest forays into pouring paint onto unprimed canvas. It quickly became the first of twelve works by the artist to be acquired by the museum, including *American Quilt No. 28* (1975; fig. 17). Gilliam had been a regular at the Phillips since 1962; he was inspired especially by its display of works by Mark Rothko and Augustus Vincent Tack, noting,

17. Sam Gilliam, *American Quilt No. 28*, 1975, quilt collage and acrylic washes on handmade paper

The Phillips Collection, Washington, DC, Acquired 1978. © Sam Gilliam / Artists Rights Society (ARS), New York

> At that time there was no National Museum of American Art, the National Gallery was without the East Wing, there was no Hirshhorn and there was no place at all where one could actually see contemporary painting. One reason I always used to go to the Phillips was that they didn't charge admission. I also like the atmosphere of the place.[39]

At the time, Gilliam never imagined he would later become one of those younger American painters exhibited at the Phillips. "The Phillips Collection did the most important thing for me that could have been done in 1967," he recalled. "They gave me a one-person show. . . . It was a big surprise. . . . This show came at the right time. I had just started to do things on my own."[40] The decided shift in Gilliam's work away from the hard-edge geometries of the Washington Color School toward soft-edged, poured-paint canvases did not escape the notice of *Washington Star* critic Benjamin Forgey, who expressed delight in how Gilliam "burst forth" on the walls of The Phillips Collection. Here, he discerned, were "paintings of extraordinary luminism":

> They seem to glow with an inner light. . . . Gilliam demonstrates . . . a major talent at work. He is to be congratulated; and so is the Phillips, for putting its prestige behind the right artist at just the right time. The exhibition in its way continues the honorable tradition of the late Duncan Phillips in advancing the course of American art.[41]

Just five years later, in 1972, Gilliam was selected by Walter Hopps, director of the Corcoran Gallery of Art and former director of the Washington Gallery of Modern Art, as one of six Americans representing the American Pavilion of the Venice Biennale. As a testament to his lifelong achievement, Gilliam assumed a place of honor once again in the 2017 Venice Biennale.

In many ways, the decade of the 1970s, under the leadership of Laughlin Phillips, son of Duncan and Marjorie, provided an affirmation of the growing reputation of three artists whose careers had been nurtured at the Phillips since the 1940s: Jacob Lawrence, Horace Pippin, and Lois Mailou Jones. Each artist received major solo exhibitions over the course of the decade, beginning with the reunion of *The Migration Series* in 1971, the first since 1942, followed by a retrospective of Pippin in 1977 and a solo show of Jones's paintings and watercolors in 1979.

Co-organized with the Terry Dintenfass Gallery, New York, and the Brandywine River Museum of Art, Chadds Ford, Pennsylvania, the Pippin retrospective attracted huge attendance and positive critical acclaim. It marked the largest museum exhibition of the artist's work, comprising forty-seven works, or one-third of his total output, reproduced in color in

18. Cover image from the exhibition catalog *Lois Mailou Jones* (Washington, DC, 1979)

The Phillips Collection Archives, Washington, DC

the accompanying catalog with text by artist Romare Bearden. Whereas previous exhibitions and scholarship had honored Pippin as a Black artist, a wartime combat artist, or a primitive artist, the co-organizers of this exhibition felt it was time to "honor him simply as Pippin, the artist," with a special nod to his virtuosity as a colorist. As the exhibition's curator, James McLaughlin, declared: "One can tell a true colorist by how he handles grays. By this standard Pippin shows himself a master colorist."[42]

Two years later, in fall 1979, The Phillips Collection paid tribute to Jones in an exhibition featuring twenty-five works in oil and watercolor, primarily drawn from the artist's collection (fig. 18). Earlier that June, Laughlin Phillips had been approached by the Coalition of Community Organizations for the Recognition of Dr. Lois Mailou Jones Pierre-Noël with a request to host an exhibition as part of its month-long celebration of the artist. "We can think of no better place of honor than The Phillips Collection for this special exhibit," the coalition's cochairs wrote. "The Coalition unanimously feels that The Phillips Collection would provide the most ideal and appropriate gallery for the honoree's work."[43]

In 1986, after learning of the death of Marjorie Phillips, Jones wrote to express her condolences to Laughlin Phillips. "To have two works in The Phillips Collection and to have had over the years encouragement from your gallery has meant much to me in carrying on my career over fifty years. I owe much to your dear father, Duncan Phillips, who greatly encouraged me. For some seven years I recall loaning him one of my impressionist works, 'Rue ST Michel, Paris' which he hung at his residence."[44]

The Phillips Collection rounded out the twentieth century and turned the corner into the twenty-first by coming full circle to Lawrence and a body of work that had remained a cornerstone of the collection since its acquisition in 1942. Fifty-one years later, and for the first time in twenty years, the museum's former curator Elizabeth Hutton Turner, in collaboration

with the artist and an interdisciplinary team of advisors, organized the reunion of *The Migration Series* in a major six-venue national exhibition that traveled far and wide across the United States, from Washington, DC, to Milwaukee, Portland, Birmingham, St. Louis, and New York. As writer Amy E. Schwartz reminded readers on the opinion page of the *Washington Post*, Lawrence's visual narrative brought to light a long-over-due appreciation of the Great Migration's significance in twentieth-century American history, after the history of slavery had long dominated attention in historical scholarship. "The imagery of immigration . . . is knit into the subconscious of nearly every American ethnic group," Schwartz asserted, "so it's surprising we don't encounter it more often in museums of art."[45] Several years later, in honor of his close ties with and affection for the Phillips, Lawrence asked the museum to plan a landmark retrospective coincident with the publication of his catalogue raisonné. On the occasion of the exhibition, Lawrence gave what would be his last interview. He passed away a few months later, before the exhibition's opening in May 2001.[46]

As The Phillips Collection begins a new vibrant chapter following the commemoration of its centennial in 2021, the museum has deepened its commitment to promoting more diversity and inclusion in shaping the future of the collection, exhibitions, and educational initiatives. To this end, the Phillips has made modest but significant strides over the past decade in adding to

19. Whitfield Lovell, *Kin XLI (Fauna)*, 2011, conté crayon on paper with stuffed bird

The Phillips Collection, Washington, DC, Gift of Mr. and Mrs. C. Richard Belger, Linda Lichtenberg Kaplan, and Carolyn C. Alper, 2013

© Whitfield Lovell. Courtesy DC Moore Gallery, New York

its holdings important acquisitions of works by Benny Andrews, Radcliffe Bailey, McArthur Binion, Rozeal, David Driskell, Simone Leigh, Whitfield Lovell (fig. 19), Aimé Mpane, Renée Stout, and Zoë Charlton, among others.[47] Moreover, since 2015 the Phillips has extended its reach beyond the walls of its Dupont Circle location by opening a satellite workshop and gallery at the Town Hall Education Arts Recreation Campus (THEARC), with a vibrant mix of free art educational programs and exhibitions to support the needs of the underserved community in DC's Anacostia neighborhood. In recent years, The Phillips Collection has been enriched by numerous site-specific commissions, including work by Wesley Clark, Nekisha Durrett, and Victor Ekpuk, as well as murals gracing the museum's outdoor spaces, such as those by the Australian aboriginal artist Regina Pilawuk Wilson and the Senegalese artists Muhsana Ali, Fodé Camara, Viyé Diba, and Piniang.[48]

Today, no less than a century ago, the Phillips remains committed to using modern and contemporary art to spark connection, well-being, and conversation about the pressing issues of our time, galvanized by its founder's original vision for art as a universal language nurtured by unity in diversity. More than seventy-five years since Phillips's wartime address, in the face of mounting hate crimes and racial tensions here and abroad, we continue to sound the rallying cry for the necessity of art—in all its varied manifestations—to bridge difference and affirm our faith in the common bonds of humanity.

FROM THEORY TO PRACTICE: LOIS MAILOU JONES'S AND JAMES PORTER'S AMERICAN MODERNISMS

John A. Tyson

In a letter responding to a polemic on American art by *New York Times* critic Edward Alden Jewell, artist and art historian James A. Porter writes: "We can have American art in the collective sense only. Its features must be heterogeneous."[1] Looking back on her variegated career, Lois Mailou Jones affirmed: "I am an American artist. I want to be recognized as an American artist." She did not believe that national or racial identity should bind or limit the range of styles in which she worked.[2] In various ways, Jones's and Porter's artworks (and their art-historical writing) embrace hybridity in their imaginings of American modernism. Both artists treated specifically US as well as foreign subjects. Hence, I set their work into the streams of what cultural theorist Paul Gilroy calls "the Black Atlantic," a "rhizomorphic, transcultural, international formation" of modern Black culture—which "is not specifically African, American, Caribbean," or European.[3] Gilroy draws upon W. E. B. Du Bois's idea of double consciousness, the negotiation of multiple identities (as Black and American); his insights help interpret Jones's and Porter's artworks and artistic concerns, especially those of Jones, who possessed a more constantly outward-looking gaze. Other theories—such as those of Alain Locke as well as their own—illuminate their respective artistic and pedagogical practices too.

Today, the Smithsonian American Art Museum and National Portrait Gallery display iconic examples of Jones's and Porter's work, including their self-portraits; both artists are also represented in the collection of the National Gallery of Art. While their paintings have not always been on view in national museums, Jones and Porter enjoyed certain successes in their careers, even as they faced adversity due to their race. They formed part of a common—though at times tumultuous—cultural milieu in the department of art at Howard University.[4] Both artists were hired early in the department's history. In fact, chair James Herring considered Jones as an alternate for Porter in 1927 and subsequently contracted her in 1930.[5] Works by Jones and Porter often appeared in exhibitions together.[6] And Porter contributed one of the principal essays to Jones's 1952 midcareer retrospective portfolio publication. While Porter held more "senior" positions, including chair, in the male-dominated department of art, Jones's more daring projects seem to have influenced him at various moments.

Porter's more consistently conservative work contrasts with Jones's more cosmopolitan and evolving artistic idioms, but there are definite points of confluence in their complex oeuvres. They possess similar sensibilities: both engaged in dialogue with design and other media; both

Detail, fig. 10

traveled to the Caribbean and Africa and became increasingly interested in art of Africa and the diaspora as their careers progressed. However, Jones plunged further into the Black Atlantic than Porter ever did. This essay teases out and historically contextualizes various strands of modernism in their thought and art. Assessing themes of rootedness and displacement in their work, I analyze how they weave elements of the Black Atlantic into the fabric of the American scene in Washington, DC.[7]

Washington Modernism and Its New Institutions

Modern art in Washington was not synonymous solely with planar geometric abstraction and fields of color, characteristics of the canvases of the federal city's Color School painters who achieved prominence beginning in the 1950s and 1960s. Instead, in the US capital, modernity was manifest in a dialectical parley of tradition and innovation, beginning at least as early as the 1920s.[8] Histories of modernism, for example, developed by Alfred H. Barr Jr. at the Museum of Modern Art (MoMA), tend to emphasize "purification": suggesting that artists moved away from figuration toward abstraction, or the concrete essence of their medium.[9] In contrast, modern art in Washington emerged as "polyvalent and polyvocal," developing along "discrepant" trajectories; to fully grasp the ways Jones and Porter negotiate modernism, a range of "messier" practices (not conforming to Barr's smoothly charted course) reflective of the aesthetic *and* sociopolitical milieus they were born of should also be brought into the fold.[10]

As I have argued elsewhere, the renewals and innovations that marked modernism occurred in the realms of representation *and* presentation: shifts in style, medium, and subject matter (questions of representation) appear alongside new forms of display, new collections, and new institutions (issues of presentation).[11] As will become clear, it is with Jones's more radical use of design, a field encompassing both presentation and representation, as well as transcending various brows of culture, that her aesthetic program outpaces Porter's in its modernism.

Confirming—and perhaps conforming to—Washington's negotiation of classicism and iconoclasm, Jones and Porter were backward- and forward-looking artists. They employed traditional artistic media, and many of their works, at least through the 1950s, fall into fairly standard genres (landscape, portraiture). As in the oeuvres of many of their contemporaries, a line of antimodernism courses through their navigations of the modern. It bears recalling that a certain naturalism or conservatism was central to American modernist tendencies. For instance, members of the Stieglitz circle, such as Georgia O'Keeffe and Charles Sheeler, produced precise, streamlined renderings of elements of the real world. Their paintings of cityscapes, factories, and American vernacular architecture and interiors similarly required a sensibility for design as well as an appreciation of industrial aesthetics. Arthur Dove, Marsden Hartley, and John Marin found in landscape ways of exploring abstraction and expression that are best described as modern. By the 1930s, regionalism was in vogue; being a modern American artist increasingly came to be predicated on authenticity acquired by dint of connections (real and perceived) to a particular area of the country and its people. Instances of this strategy exist in Thomas Hart Benton's links to Missouri, Grant Wood's with Iowa, and Hartley's with Maine. Jones and Porter artistically claimed multiple locations in their landscapes, implicitly connecting regions into new geographic constellations.

"Art in a democracy should above all else be democratic, which is to say representative," stated Howard philosophy professor Alain Locke.[12] Locke—a figure who, according to the poet Langston Hughes, "midwifed" the New Negro movement into being—reveals period viewpoints regarding the relationship of art and democracy.[13] As the nation's capital was viewed as a

significant "nerve center," representation—of both the artistic and political varieties—mattered.[14] By the middle of the fourth decade of the twentieth century, Washington was home to important museums and galleries presenting modern art. We must remember that it was not until the late 1930s that New York and its Museum of Modern Art began to assert their centrality in the art world, something that would continue after the conclusion of World War II.[15] Histories of modern art and culture tend (often rightly) to privilege artist networks. In most other cities, circles of artists powered new developments. Washington's modernism is discrepant to others in this regard.[16] While artists were of course a necessary facet, other producers of culture (such as curators and collectors) had a significant impact on the landscape as well. Institutions—new sites of presentation and collection—and their various internal actors were lodestars in the brokering and authorizing of modernist aesthetics (sometimes slightly belatedly) in the District of Columbia; they further served as nodes for establishing social interaction and discourse around art.[17]

Many DC institutions exhibited work by contemporary African American artists. These included The Phillips Collection (established as the Phillips Memorial Gallery in 1921), Howard University Gallery of Art, the Barnett-Aden Gallery, DuPont Theater Gallery, Franz Bader Gallery, and the G Place Gallery, as well as, though sometimes more reluctantly, the Corcoran Gallery of Art and the Smithsonian National Gallery of Art (within the Natural History Building).[18] The Washington Water Color Society exhibitions included works by Jones and Porter too.[19] Additionally, Howard's department of art and gallery were institutions that disseminated and incubated modern art in DC, which was of particular importance for Jones and Porter. The university provided the necessary financial support and stability for the artists who were employed there.

The National Gallery of Art did not actively acquire works of art by African American artists until later in its history, an unfortunate example of a lack of representation (which can perhaps in part be explained by a no-longer-extant rule that an artist had to be dead for fifteen years before their works could be acquired). Nonetheless, individual employees at the National Gallery of Art did recognize the merits of Black artists and contributed to exhibitions or collaborated in public programs at Howard University as well as other institutions: a text by James W. Lane, painting curator at the National Gallery, accompanied an exhibition of Jones's work; Erwin Christensen, curator of the Index of American Design, lectured at Howard in 1957 on African art and regularly exchanged letters with Porter.[20] The shortcomings of the collection aside, the National Gallery's cafeteria was one of very few desegregated eating places in the entire District of Columbia.[21]

Art institutions were quite exceptional for providing spaces for staging race relations that opposed the hegemonic order of the era, though their success in promoting broader integration was limited and must not be overstated. In comparison with their white counterparts, Black artists like Jones and Porter were undoubtedly constricted by the dearth of venues for exhibiting their modern art. Nevertheless, art galleries and museums' resistance to the status quo does merit acknowledgment. Woodrow Wilson's presidency saw the rise of a regime of segregation in the federal government, which began to be instated in the spring of 1913 and marred the civil service for decades.[22] Even before the racial division of the government, the federal city, too, was characterized by racial segregation. However, by 1939 there were more whites sympathetic to social and racial justice.[23] In *Art in Washington and Its Afro-American Presence: 1940–1970*, Keith Morrison affirms that art institutions posed some resistance to the dominant logic of racial separation; until the 1950s, art galleries and museums were spaces where Black and white elites could rub elbows and, thus, were important nodes of cultural

exchange.[24] For example, pioneering institutions of modern art, especially the aforementioned Phillips Memorial Gallery, Caresse Crosby's G Place Gallery, and Herring and Alonzo Aden's Barnett-Aden Gallery, proposed a tacit equivalence between artists of different races whose artworks graced their walls. Moreover, by dint of their location within the national capital, the activities of DC's institutions possessed particular gravity and newsworthiness, which further amplified and authorized the art they displayed.

Washington was home to numerous important Black intellectuals and artists in the twentieth century. The opera singer Madame Evanti (Lillian Evans Tibbs) and Georgia Douglas Johnson, a writer whose charming conversations struck a young Langston Hughes, held regular salons.[25] Later, the Barnett-Aden Gallery, which was housed in the lower floor of Aden and Herring's residence at 127 Randolph Place NW, had social openings regularly attended by Eleanor Roosevelt and other figures of DC society.[26] Locke affirmed: "Negro Washington . . . contains more of the elements of an intellectual race capital proportionately than the Washington of political fame and power." He continued, noting it had so far failed to live up to its potential: "Had this possibility been fully realized by the Washington Negro intelligentsia, a decade or so ago, and constructively striven after, Washington would have outdistanced Harlem."[27] Ultimately, New York did surpass the District of Columbia. However, his words imply Washington was hardly a desert of culture (as is sometimes imagined) and instead, very much in the running to be America's intellectual and artistic capital, as well as her political one.

Two exhibitions of paintings and sculptures "by American Negro Artists" in 1929 and 1930 organized by the Harmon Foundation and shown at the Smithsonian National Gallery of Art were, though fraught, in some sense breakthroughs.[28] The New York–based Harmon Foundation was a leading promoter of art by African Americans (and Africans) and a funder of Black artists. Each show ran for a short period in DC but attracted visitor numbers in the thousands and the attention of the Black and white press.[29] In May 1933, the Howard University Gallery of Art played host to a third Harmon show, the *Exhibition of the Work of Negro Artists*, which previously had been held annually in New York from 1927 to 1931. Works by Porter appeared in all three Harmon shows; he was awarded the portrait prize in the 1933 exhibition, which included Jones's works too. Additionally, in November 1933, the Association for the Study of Negro Life and History (now the Association for the Study of African American Life and History) organized a major exhibition of works of art by African American artists—both students and professionals—at the Smithsonian National Gallery of Art, which also included loans from the Harmon Foundation. The exhibition showcased works by many Washington-based artists, including Jones and Porter. As with the 1929 and 1930 exhibitions, this third Smithsonian National Gallery of Art exhibition was very well attended, and it attracted some eight thousand people over seven days.[30]

"Negro Art Has Merit" was the headline that appeared after the first Harmon Foundation show in 1929. Initially with an incredulous tone, exhibitions of works by Black artists in Washington were covered in the mainstream media and praised by the city's critics. An anonymous 1938 review of a show at the Howard University Gallery of Art that appeared in the *Washington Post* notes Porter's work is "by no means unknown in this city."[31] Ada Rainey, the *Post*'s principal art reporter, regularly covered and positively reviewed work by Black artists. Katrina Van Hook, a critic from the same paper, raved about Jones's important solo exhibition at the Barnett-Aden Gallery eight years later. Intriguingly though, Van Hook's laudatory review performs a formal analysis of the paintings rather than discussing the politics: *Mob Victim* (1944)—a canvas depicting a man, looking skyward, about to be lynched, which Jones saw as a translation of Locke's ideas into oil paint—is described merely as "statuesque."[32]

Albeit with less harrowing subjects than that portrayed in Jones's *Mob Victim*, Porter, too, tackled the American scene and its specific issues related to racial segregation and discrimination at almost precisely the same moment with his *Ticket-Taker at Griffith Stadium* (c. 1944; fig. 1). Griffith Stadium was home to both the all-white Washington Senators and the Black Washington Grays. A human-interest story in the *Washington Post* sentimentally profiled one of the ticket takers that same year, which possibly caused Porter to produce a more realist corrective on the same subject.[33] Black and white players were not allowed to compete together until 1947, when Jackie Robinson joined the Brooklyn Dodgers. African American fans were permitted to view Major League Baseball games, but seating in the stands was segregated. His is a variation on the genre scene, which reveals the racial schism at the heart of American society. The painting does not show the sporting heroes of the so-called national pastime. It depicts the Black and white ticket-takers and crowds, apparently also of distinct races, filing into their respective sections of the stadium.

Porter's *Modern Negro Art* (1943) is often regarded as foundational to the study of art by African Americans. This major contribution to the institution of art history has to some extent eclipsed his other scholarly and academic activities. The first publisher of Porter's book expressed ambivalence about the project; therefore, the so-called father of African American art history

1. James A. Porter, *Ticket-Taker at Griffith Stadium*, c. 1944, oil on canvas

National Gallery of Art, Corcoran Collection (Gift of Constance Porter Uzelac, Executive Director, Dorothy Porter Wesley Research Center, Wesport Foundation and Gallery, Washington, DC)

-2-

Edward Mattil	- Professor and Head, Department of Art Education, Pennsylvania State University
Mary Adeline McKibbin	- Retired Director of Art, Pittsburgh Public Schools; Art Teacher at the University of Pittsburgh
Erwin Panofsky	- Professor Emeritus, Institute of Advanced Studies, Princeton
James A. Porter	- Head of Art Department, Howard University, Washington, D. C.
Olga M. Schubkegel	- Director of Art Education, Hammond, Indiana, School System
Julia B. Schwartz	- Professor, Department of Art Education and Design, School of Education, Florida State University, Tallahassee, Florida
Grace S. Smith	- Director of Art Education, Houston Independent School District, Houston, Texas
John and Aurelia Socha (joint award)	- Art Teachers in the Minneapolis Public Schools
Wilber Moore Stilwell	- Chairman of the Art Department, University of South Dakota, Vermillion
Ruth J. Stolle	- Artist and Retired Rural Art Teacher, Tripoli, Wisconsin
Frederick S. Wight	- Chairman, Department of Art, University of California at Los Angeles
Edwin Ziegfeld	- Professor of Fine Arts and Head of Fine and Industrial Arts, Teachers College, Columbia University

End

2. List of Recipients of National Gallery of Art Medal for Distinguished Service to Education in Art, 1966

National Gallery of Art Archives (RG14A9 Records of the Office of Public Information Press Releases)

paid some of the printing costs himself.[34] Nonetheless, indicative of *Modern Negro Art*'s prescience and value, the *New York Times* issued a second edition. Porter's study underscores artists' navigations of the Black Atlantic: he repeatedly mentions that various figures received formation "at home and abroad."[35] Taking stock of his history of art in the preface, Porter affirms that he attempted "to obtain an *integrated* view of American cultural history."[36]

Aligning with the art-historical route he charted, Porter steered toward intersections with other scholars and curators. He received an invitation to the National Gallery of Art's inaugural celebrations in 1941; he exchanged letters with John Walker, the director of the National Gallery and Erwin Christensen, the curator of the National Gallery; he was named among the nation's most important art educators and, along with Erwin Panofsky, was honored by Ladybird Johnson in 1966 (fig. 2).

Porter's network extended to New York, perhaps unsurprisingly so, as he received a master's degree in art history from New York University. His contacts included James Johnson Sweeney, and he invited the Guggenheim director to visit Howard University.[37] Porter corresponded about his book with other significant art historians, including Meyer Schapiro at Columbia University. Dorothy Miller and Barr at MoMA weighed in on *Modern Negro Art* too. Indicative of the complex entanglement of modern culture in New York and Washington, Barr suggested Porter emphasize the work of Jacob Lawrence, whose series *The Migration of the Negro* (1940–1941; now known as *The Migration Series*) had been split between two hubs of modernism (MoMA and the Phillips), and the work of Richmond Barthé, whose sculpture featured in MoMA's *Twentieth Century Portraits* (December 9, 1942, to January 24, 1943).[38]

Jones, too, had a transformative role in American modernism. In her artwork she was arguably almost always a step more advanced than Porter, who perhaps took cues from Jones over the years. As well as influencing her peers, she taught numerous generations of Howard University students, influencing many budding artists.[39] However, she was also involved in important activities beyond the scope of her university appointment. Beginning in the early 1930s, when she moved to Washington, she also strove to develop pupils at an even earlier age. Her students' works were exhibited in 1933, as well as her own watercolors, in the Smithsonian National Gallery of Art's *Exhibition of Works by Negro Artists*.[40]

Jones, along with her colleague Céline Tabary, a French painter and Howard University arts instructor, founded an art academy, the Little Paris Studio. As the name implies, Jones and Tabary modeled their modest collective institution on pedagogical examples imported from Europe. The Académie Julian, where Jones trained in 1937–1938, functioned both as an alternative to the official École des Beaux-Arts and preparation for its courses. Additionally, while in France, she painted canvases in Paris's public urban spaces as well as in the countryside. We might speculate that, along with a notion of the picturesque, Jones was motivated in part

by her ability to appreciate the design of urban spaces where modern life could coexist with older forms. Notably, Jones and Tabary encouraged students to paint en plein air on the streets and docks of Washington. On one hand, this move outdoors linked them to a longer European former vanguard aesthetic tradition (of impressionism and postimpressionism). On the other, it should be seen as politically inflected pedagogical activism. Positioning themselves in public augmented their visibility (demonstrating that African Americans could excel in visual arts—as opposed to music—was a pressing issue).[41] Certainly, by staking urban space with their easels, they claimed their "right to the city."[42] Jones and Tabary also worked with younger students on Saturday mornings. They adapted the modern grassroots form of the salons and reading circles to the fine arts—all similarly facilitated academic formation when access to formal educational infrastructure was not readily available or denied because of racial discrimination.[43]

Graphic Designs and Ancestral Arts in American Modernism

"With the advent of the New Negro Movement in the 1920s, the formative arts of painting, sculpture, and of *design* finally became the acknowledged province of the American Negro," Porter affirmed.[44] In making this claim, he echoes aspects of Locke's statements in "The Legacy of the Ancestral Arts," a 1925 essay encouraging Black American artists to channel the spirit of African art, which is "at its best in abstract decorative forms. Design, and to a lesser degree, color, are its original fortes."[45] Jones's artwork best embodied the qualities Locke and Porter identified; she consistently drew from design to deconstruct and reconstruct Black identity. Furthermore, given the important role of printed matter as a platform for modernist movements to disseminate ideas and art, it should not come as a great surprise that a design impulse runs through modern African American art in much the same way as it does in works by many of the Dadaists (who relied heavily on printed matter too). Beginning in the decade of the 1920s and continuing throughout their careers, Jones and Porter would bring a modern graphic spirit to their work.[46]

3. Lois Mailou Jones, *Negro Youth*, 1929, charcoal on paper

Smithsonian American Art Museum, Bequest of the artist

Both artists produced elegant portrait drawings that re- and decontextualized their subjects on pure white pages. In Jones's *Negro Student* and *Negro Musician* (both 1934) the heads and necks of their sitters are naturalistically rendered and fully modeled in rich gray and black graphite tones, while thin, precise lines depicted their bodies and clothing as schematic outlines. Her more precisionist *Negro Youth* (1929; fig. 3) developed the body on a snowy ground free of marks. Beyond the figures, there is only the artist's signature on the sheet. There are no attributes relating to the occupations indicated by the titles. Porter created a similar drawing entitled *Negro Athlete* (1926). He also treated specific subjects in a similar manner in paintings. For instance, Porter's depiction of the architect Cyril Bow, one of the designers of Howard University's Founders Library, shown at the Smithsonian's 1929 *An Exhibition of Paintings and Sculpture by American Negro Artists*, has a similar composition.

The modernity of such images may not seem totally obvious today; however, it comes into focus when comparing them to contemporaneous artworks (some of which may have been sources of inspiration). Jones's and Porter's works on paper resuscitate the line of Jean-Auguste-Dominique Ingres, and take a trail backward toward academicism that Pablo Picasso had reinitiated in the teens and which he continued to explore in the twenties. Rosalind E. Krauss argues that, for Picasso, the technique related to an ordering of heterogeneous sources ("from

4. Lois Mailou Jones, *Textile Design for Cretonne*, 1928, watercolor on paper

Smithsonian American Art Museum, Bequest of the artist

Poussin . . . to the photograph") that "raises them onto a newer, purer plane" and moreover "works . . . to mechanize their rendering."[47]

In the North American context, the most obvious source of inspiration for Jones and Porter was the expatriate German artist Winold Reiss. In addition, an interest in the spare aesthetic that characterizes the work of precisionists like Sheeler may also have been a factor. Reiss rendered the luminaries of the New Negro movement. Locke selected him to be the movement's early de facto portraitist: Reiss's depictions of notable specific figures, as well as anonymous teachers, lawyers, and so forth appeared in the foundational 1925 "Harlem: Mecca of the New

Negro" issue of *Survey Graphic*. Locke argued that in Reiss's works younger Black artists had a "path-breaking guide and encouragement to this new foray. . . . In idiom, technical treatment and objective social angle, it is a bold iconoclastic break with the current traditions that have grown up about the Negro subject in American art."[48]

The critical difference is that this precise style does not exaggerate racial features of the sitters even as it acknowledges them. As Krauss suggests for Picasso, this "Ingres-esque" mode of rendering produces a mechanical parity between subjects. In addition to emulating Reiss stylistically, Jones and Porter possibly drew inspiration from him when selecting titles. These further serve to transform the clearly individuated subject from a single instance to a social type: educated, successful Black Americans. These images visualize "the exceptional men" who would engineer the salvation of "the Negro race" that W. E. B. Du Bois describes in his article "The Talented Tenth."[49] Porter's *Portrait of Cyril Bow* is a painted corollary to Du Boisian politics. His portraits, like that of Bow, serve as a concrete manifestation of African American achievement—which further signals the lack of broader recognition of Black architects practicing in the United States.[50] The modernism of these works comes in their relation to specific then-contemporary circumstances and the spare mode in which they represent information.

Jones had some of her earliest successes in illustration and design. She especially excelled with textiles, and a number of her designs, characterized by bold color combinations with floral and geometric patterns, were bought by Foster and Schumacher companies of New York City (fig. 4). As a painter, she never totally seceded from design; and the sensibility that produced her early textile and illustration projects informs her most exciting later canvases. Her approaches formally shifted away from the more "minor" technique, as "desire for recognition . . . triggered a shift in focus and the resolve to cultivate the fine arts," yet a certain sensibility was constant. She maintained steady contact with the graphic arts as a professor at Howard and regularly imparted courses on design. In her classes she taught students that design was the element that united all the arts (including new media such as television). She certainly presented herself as an artist-designer in the 1930s. Her archives hold a large-scale photo of the artist in 1931 surrounded by bold fabric patterns in her studio. In 1934 the *Washington Post* reviewed an exhibition of her works in various media at Shaw Gallery. Emphasizing the simultaneous importance of her work in multiple media, the paper reproduced an image of one of her textile designs even larger than a watercolor.[51]

Additionally, Jones contributed charming drawings with bold clean lines to children's books and magazines. Helen Adele Whiting's *Negro Art, Music and Rhyme* (1938) and *African Heroes and Heroines* (1939) by Carter G. Woodson, founder and director of the Association for the Study of Negro Life and History, reveal Jones's early interest in Africa and African art; in the former book she included drawings of what appear to be an antelope sculpture by the Bamana (Bambara) people of Mali, an Asante gold weight, a Benin bronze head, and a Kota reliquary guardian figure. Some years later, Porter also made clean-lined illustrations with regimented linear hatchings for Wilfrid Dyson Hambly's *Talking Animals* (1949), a more fanciful depiction of conversant African creatures.

Given Locke's assertions, it is not surprising that tastes for striking designs would accompany a growing interest in African art, which accelerated in the United States at this time. Sweeney organized an important exhibition of African art in 1935 at MoMA that Walker Evans photographed. Even earlier, African art had played a role in the history of American modernism. In 1914 Alfred Stieglitz organized *Statuary in Wood by African Savages: The Root of Modern Art*. Sheeler, part of the Stieglitz circle, photographed African art in the home of Walter and Louise Arensberg in the late teens as well. Locke and Albert Barnes, key figures for promoting

art by African Americans and modernism, were major collectors of African art, and both men penned essays on the subject.[52] Poets such as Countee Cullen addressed the legacy of Africa too. When Cullen's poem "Heritage" appeared in *Survey Graphic* (1925), Locke illustrated it with photos of works of African art from Barnes's collection.

Porter's interest in African art was born at nearly the same moment he had turned toward the "primitive" cultures of Europe. A Carnegie Foundation fellowship sent him to France in 1935 to study medieval architecture at the Institut d'art et d'archéologie at the Sorbonne in Paris. Soon after, a Rockefeller travel grant enabled him to visit collections of African art in Belgium, Holland, Germany, and Italy; he also met a number of West Africans in Europe.[53] Despite (or perhaps because of) his scholarly interest, Porter was extremely skeptical of Locke's call for Black American artists to mine African art for inspiration, as he worried this would prevent "the Negro artist from exercising the freedom that the 'modern' situation afforded to paint, draw, and sculpt about any subject he wanted."[54] In 1937, Porter composed a scathing review of Locke's *Negro Art: Past and Present* (1936); he wrote that Locke's publication, which he understood to advocate such a position, was "one of the greatest dangers to the Negro artist to arise in recent years. It contains a narrow racialist point of view."[55] Porter's emphasis was rather on "the American scene"; his scholarship generally sets modern Negro art into a longer Euro-American art-historical tradition.[56] Porter believed art was born of specific environmental and life experiences, rather than any innate connections. For instance, he describes Jones as fitting into the "tradition" of Paul Cézanne, but simultaneously "add[ing] an original note of her own."[57] He celebrates Hale Woodruff's (an artist he views as owing debts equally to Francisco Goya and his close "attention to Negro rustics") *Amistad Murals* (1939), which take up the transatlantic slave trade and African subjects with a historical materialist approach.[58]

Jones engaged with ideas of Africa in various ways from early in her career. In contrast to Porter's more ambivalent position, Jones was quite willing to embrace African art for inspiration. Despite this, her understandings of the meanings of African imagery changed during the course of her life; it seems correct to understand her nonspecific focus on Africa in the 1930s (as opposed to her later works, which are more specific in their citations or identification of particular countries) as forming part of period taste. In addition to aesthetic reasons, African American artists' turn to African motifs was motivated by politics. Like *Negro Art: Past and Present* (and regardless of Porter's critique), Locke's "Legacy of the Ancestral Arts" encouraged the use of African art not so much for direct copying, but for inspiration. His sense of its role for contemporary creation by Black artists parallels the "usable past" that cultural critic Van Wyck Brooks believed could be tapped by American writers and artists in general.[59] Locke hoped artists would be empowered and take "a cultural pride and interest" in their heritage. Jones, as well as many others, took this call to heart.

Jones's *The Ascent of Ethiopia* (1932), *Africa* (1935), and *Les Fétiches* (1938; fig. 5) take up Locke's notions about heritage. Her approach to Africa was also heavily inspired by the dual influences of artists Aaron Douglas and Meta Vaux Warrick Fuller.[60] Douglas, like Jones, was a skilled illustrator, and his paintings extend a graphic design sensibility to canvases with limited tonal ranges. He typically depicted bold racialized figures, often with Egyptian motifs juxtaposed against modern urban elements—invoking a great African civilization and proposing continuity with his present. Fuller's *Ethiopia Awakening* (1914), a bronze-over-plaster sculpture of a female figure with wrapped legs and Egyptian-inspired garb, who could be understood as an allegory for the Black population, is more naturalistic. Jones seems to synthesize both most clearly in *The Ascent of Ethiopia*, which has a blue-and-yellow color palette and a brown-skinned figure in an Egyptian crown in the foreground with other stylized figures, skyscrapers, and

5. Lois Mailou Jones, *Les Fétiches*, 1938, oil on canvas

Smithsonian American Art Museum, Museum purchase made possible by Mrs. Norvin H. Green, Dr. R. Harlan, and Francis Musgrave

pyramids in the background—similar to those found in Douglas's "Afro-deco" compositions of the same period featuring flat, racialized figures with varying African motifs, from masks to Egyptian crowns.[61] It is notable that while Jones's Africa is to a certain degree mythic, it is not necessarily imagined as "uncivilized" (as indicated by the connections to the great civilization of Egypt) or "primitive"—as African motifs blend with modern edifices and the word "jazz" in *The Ascent of Ethiopia.*

In contrast to her other paintings, imbued with the spirit of the "ancestral arts," *Les Fétiches* was produced in France. The canvas surprised her instructors at the Académie Julian, as it was a marked contrast to the more naturalistic portraits, street scenes, and landscapes that Jones had been making. Her response to them, that she had more right to the subject matter than European artists because of her race, reveals a desire to metaphorically wrest African art

6. Brassaï, *Temptation of Saint Anthony*, from *Transmutations*, 1934–1935 (printed 1967), gelatin silver print

National Gallery of Art, Gift of Madame Gilberte Brassaï Estate. © Estate Brassaï-RMN-Grand Palais

Photo © RMN-Grand Palais (Musée national Picasso-Paris) / image RMN-GP

out of the monopoly grasp of the likes of Picasso or Amedeo Modigliani: "I reminded them of the influence of African art on Picasso and the other cubists and asserted that clearly, I, with my own Afro-American background, had even more of a right than Picasso to be inspired by the mystical quality and strong geometric forms of African art."[62] Nonetheless, suggesting the place of the *malagueño* in her lineage, Jones kept a headshot of the famed Spanish modern artist mounted on her studio wall.

When set into the milieu of 1930s Paris, where she observed that masks were all the rage, we might see Jones's art practice as a kind of Afro-surrealism. Jones possessed an inherent grasp of surrealism's aesthetic program, even though direct influences from this movement on her work are elusive. Though it is not clear precisely which exhibitions she visited while in Paris, it is notable that the moment of Jones's residency saw the celebration of surrealism's scandalous "last hurrah": the Exposition Internationale du Surréalisme at the fashionable Galérie Beaux-Arts, Paris, in early 1938.[63] Indeed, it would have been difficult for Jones not to have some awareness of the avant-garde movement, as it was covered in the North American press from the mid-1920s onward.[64] Even before she embarked for France, *Newer Super-Realism* (1931), an exhibition of works by Salvador Dalí and Max Ernst at the Wadsworth Atheneum Museum of Art in Hartford, Connecticut, presented surrealism for the first time in the United States.

Jones's work fulfills many of André Breton's tenets of surrealism: "anything marvelous is beautiful, in fact only the marvelous is beautiful"; she combines strange but recognizable elements, some encountered by aleatory operations.[65] She depicted marvelous subjects (masks) that she "came across *by chance* in Paris."[66] In *Les Fétiches* and *The Ascent of Ethiopia* she radically juxtaposes elements, which appear as if in a dream; in the former, the normally hard volumes take on a succulent fleshy texture and flow into one another as they emerge from a tenebrous ground. A comparison of *Les Fétiches* to Brassaï's *Tentation de Saint Antoine* (*Temptation of Saint Anthony*) from his *Transmutations* series (1934–1935, printed 1967; fig. 6) is particularly instructive. In Brassaï's photo, inscriptions on the negative turn an image of a woman's body on an otherwise black ground into a mask form. Similarly surreal, *Africa* verges on the uncanny. The repeated dancing figures' drastically simplified masklike heads suggest they are animated mannequins or even extraterrestrials (perhaps reflecting feelings of being alien within white-dominated society).[67] With these paintings, Jones imagines an Afro-surreality—an alternative, superior transcendence of reality.

Apparently traditional canvases by Jones and Porter combine design to organize seemingly disparate elements into unified still-life compositions. Porter's *Dismounted Spirit* (1959; fig. 7) and Jones's *Two Faiths, Paris* (1944; fig. 8) and *Buddha* (1927) show carefully arranged "primitive" Western (a medieval sculpted head in the case of *Two Faiths, Paris*) or non-Western art objects set against patternistic backgrounds. Given the dates of the canvases, it is possible that Porter was influenced by Jones to explore arrangements of culturally and temporally diverse items. Their still lifes arguably can be read as documentation of acts of curation: juxtapositions of de- and recontextualized objects as well as non-Western art are central to programs of modernist

aesthetics of presentation. An illustration of such vanguard taste comes in the famous shot of Stieglitz's 291 gallery, in which a Kota reliquary, a pre-Columbian vessel from Mexico, and a wasp nest appear alongside works on paper by Picasso and Georges Braque. A similar theory of forms undergirds Sheeler's photographs of non-Western art in the interior of the Arensbergs' fashionable Manhattan home.

Contemporaneous Washington, DC, examples exist too. The exhibition *Sensibility and Simplification in Ancient Sculpture and Contemporary Painting* (1920) at The Phillips Collection put an ancient Egyptian head into a dialogue with modern paintings; at the National Gallery of Art, the installation *Art of the Americas* proposed consonant relations.[68] Interestingly, a taste for this kind of modernist display continued to Jones's home, where she arranged her works as well as objects she collected—and photographed curated compositions, hence eking out her international strand of "domestic modernism," much as the Phillips and Barnett-Aden had done.[69] The French medievalist and author of *Vie des forms* (*The Life of Forms in Art*, 1934), Henri Focillon, seems an apt corollary in art history. Indeed, in April and May 1936, Porter attended a series of lectures by Focillon at the Metropolitan Museum of Art while the latter was a visiting lecturer on fine arts at New York University.[70] It seems possible that, especially given Porter's training at the Sorbonne and NYU and Jones's affection for France, they might also have attended Focillon's lecture at the Phillips in 1940 while the Frenchman was a scholar in residence at Dumbarton Oaks.[71]

The graphic and photographic intertwine in Porter's works as well. According to a period critic, in Porter's *Soldado Senegales* (1935; fig. 9) "the color is daringly used. The figure, in

7. James A. Porter, *Dismounted Spirit*, 1959, oil on canvas

Courtesy Swann Galleries

8. Lois Mailou Jones, *Two Faiths, Paris*, 1944, oil on canvas

Museum of Fine Arts, Boston, Gift of the Lois Mailou Jones Pierre-Noel Trust

Photograph © 2023 Museum of Fine Arts, Boston

9. James A. Porter, *Soldado Senegales*, 1935, oil on canvas

Smithsonian American Art Museum, Museum purchase made possible by Anacostia Museum, Smithsonian Institution

a bright red cap, is placed against a red checkered tablecloth."[72] This "tablecloth" also pushes toward abstraction: an intersecting series of crossed colored lines, thickly applied, resolutely emphasizes the expressive material qualities of paint. Porter employed a similar compositional strategy in *Woman Holding a Jug* (c. 1930), although with far less impasto in the handling of pigment. In both canvases, the figure is located before a patterned background that flattens and abstracts the space behind the subject.

Porter's paintings of figures enveloped by abstract patterns anticipate Carl Van Vechten's celebrated black-and-white and color photography, in which sitters routinely pose in front of bold textiles.[73] Van Vechten, a writer and philanthropist, was a key supporter of African American artists and writers. Between 1932 and 1964 he photographed numerous Black luminaries (as well as other notable figures in the arts). Certainly, Van Vechten would have seen Porter's *Woman Holding a Jug* at the 1933 Harmon Foundation exhibition at New York's Art Center—aptly named as it was sited in the prime gallery district, a few minutes' walk from the then-prestigious Knoedler Gallery. Porter's painting was reproduced on the exhibition brochure's cover. Further linking the men—and suggesting a common sense of aesthetics—was Porter's wife, the Howard librarian Dr. Dorothy Porter, who was photographed by Van Vechten.[74] Indeed, in 1937 Van Vechten made portraits of the same sitter depicted in Porter's *Soldado Senegales*, the Senegalese cabaret dancer, François "Féral" Benga. Hence, in addition to his innovative style, Porter's subject—the hip, dashing figure of Benga (with his European cachet)—would have made the canvas resonate differently with contemporary audiences. Further indicative of his appeal and renown, Barthé also portrayed Benga in his *Senegalese Dancer* (1935).

It is moreover notable that while Porter disapproved of overly Afrocentric, racialized modes of depiction, as he critiqued Locke as advocating, he did not shy away from African subjects. By his decision to portray Benga as a Senegalese soldier, Porter could be carrying out a critique of the erotic primitivism inherent in more commercialized and sexualized representations of the African body as "'Féral' Benga," as James Smalls has also argued.[75] Porter's image suggests the African is not the "primitive," for with the title and costume, the uniform of Senegalese troops, Porter's painting conjures up a more complex set of ideas. According to Nell Irvin Painter's analysis of Porter's art, "conversations with Africans and West Indians broadened Black Americans' concepts of the meanings and limitations of racial identity"; the painting represented a nascent Pan-Africanism.[76] Dana S. Hale posits that following the French colonization of West Africa, the *tirailleur* (as this type of Senegalese rifleman in the French army was known) increasingly appeared in branding and advertising as a sometimes ridiculous "friendly and

harmless character": "Instead of honouring the black troops, the image of the African soldier on trademarks mocked and belittled them."[77] Like Uncle Ben or Aunt Jemima in the United States, these representations wrapped up fantasies of Black servility in consumerism. Porter's modern rendering of Benga as *tirailleur*—with its abstract background and naturalistic impression of the subject—is a counterimage to the typical mass-cultural treatment of Senegalese soldiers.

For Jones, the creation and design of murals presented a particularly compelling set of aesthetic and political questions. "Murals her new passion" was how the *Vineyard Gazette* boldly transmitted her shift to this technique from oil painting.[78] Muralism, which dates back to ancient times, had increasingly taken on new inflections in the modern era. Following the embrace of mural painting as part of the postrevolutionary Mexican state and the Works Progress Administration's commissions in this country, murals at the least connoted a sense of collectivism—if not outright left-wing politics.[79] Addressing a public in architectural space, Jones's modernism came in her subject and technique rather than style. Jones told the Vineyard paper: "I have always been more interested in design than in anything else. I think when you combine painting with design the result must be murals." In *Light* (c. 1939), a mural celebrating progressive education made for the Howard men's dormitory Cook Hall, her central female figure in a toga and a setting of white-columned Doric temple architecture evoke the classical, while the surrounding elements, men in athletic clothes and varsity sweaters, depict more contemporary North American subjects.[80] Jones explained that "the tall figure in the center is life-sized, and is my representation of the intelligent, enlightened Negro woman."[81]

Light embodies Du Bois's sense that freedom and education were fundamentally related— albeit with a feminist twist, given that it was destined for a men's dorm.[82] The author of *The Souls of Black Folk* (1903) imagines the ideal of the Black university in the following manner:

> I sit with Shakespeare and he winces not. Across the color line, I move arm in arm with Balzac and Dumas, where smiling men and women glide in gilded halls. From out of the caves of evening that swing between strong-limbed earth and the tracery of stars, I summon Aristotle and Aurelius . . . and they come all graciously with no scorn nor condescension.[83]

By her synthesis of the modern and the classical, Jones advances the same set of ideas about knowledge transcending the color line and being updated for the present. She would go on to further mural projects, including one made in support of the Democratic candidate for president in 1968, Hubert Humphrey.[84]

Porter also instructed students in muralism—the results of which the *Washington Times-Herald* reported.[85] Additionally, he made murals and designed stained-glass windows. Unfortunately, because the buildings that contained these were torn down, they are, with few exceptions, no longer extant. There is a stained-glass window Porter designed later in life at Howard University's Andrew Rankin Memorial Chapel. Like Jones's, his designs engage with a classical past and seem to graphically champion the Du Boisian Black university; they take cues from European Renaissance decorative arts and incorporate conventions from heraldic imagery.[86]

Landscapes of Liberation

Landscape is typically considered an innocuous, even pretty, sort of painting. It is in fact a fraught genre—as it intertwines with power, with claiming and constructing territory—and most certainly has the potential to be political.[87] Jones's and Porter's respective landscapes and

10. Lois Mailou Jones, *Untitled (Landscape, France)*, 1951, oil on canvas

The Studio Museum in Harlem, Gift of Dr. and Mrs. Joseph French, 1979.4

Photo: Sasha Smith-Mendez

11. Lois Mailou Jones, *Eglise Saint Joseph*, 1954, oil on canvas

Smithsonian American Art Museum, Bequest of the artist

12. Lois Mailou Jones, *Indian Shops, Gay Head, Massachusetts*, 1940, oil on canvas

National Gallery of Art, Corcoran Collection (Gift of the artist)

the locales they depict possess multiple layers of signification. Not simply picturesque renderings, paintings of France, Haiti, and Martha's Vineyard, they speak of networks and geographic routes in the Black Atlantic (figs. 10-12). They plot the artists' actual displacements—something underscored by Jones's tendency to incorporate location into her signature and/or a work's title. Like regionalist paintings, they imply their creators' belonging or identification with a specific polity—in this case, the community of Negro elites that was Black Atlantic. Their views of lands both near and far were shown regularly in DC, but their full range of meanings probably passed by most white gallery-goers.

Their canvases are more than just a registry of displacements. They communicate on multiple levels: France, Jones stated, meant, in addition to credibility and opportunity, "freedom. To be shackle free."[88] Jones was certainly not the only Black American to feel that periods of time in Europe were liberating: "the thing that released you from all of the pressure and stagnation which we suffered" constantly at home.[89] Hence, the French landscape is here double-coded; appealing not solely for the sophisticated artistic heritage it implies, it conjures up a society where superior (yet still imperfect) norms govern race relations.

Haiti, the first Black revolutionary republic and postcolonial nation, formed part of early Pan-African imaginations and held a parallel appeal. As Krista A. Thompson has explored, African Americans had a "preoccupation with Haiti" and pictures of the island nation and its heroes helped forge diasporic imaginations.[90] We should recall that Frederick Douglass served as US minister to Haiti in the late nineteenth century, making it an important point of contact between an African American representative of the government and the broader diaspora. An interest in heroic Black freedom fighters and a successful struggle for self-determination prompted Lawrence (and others) to depict the life of General Toussaint Louverture.

Jones and Porter both had profound understandings of Haiti. Jones particularly, because of her marriage to Haitian graphic designer Louis Pierre-Noel, often depicted subjects from the Caribbean nation. Porter produced a series of drawings of Haitian sitters to accompany an account of a visit. Proving his keen awareness of the power dynamics of tourism, he attempted to subvert touristic gazes and inculcate new ways of looking at Haiti and Haitians with the essay "Picturesque Haiti." Thompson astutely calls the text, which was published in *Opportunity* magazine in 1946, a "counter-travelogue."[91] Porter's focuses on humanizing Haiti and interrupting smoothly consumable "picturesque" images; he illustrates the essay with portraits of subjects with hatched ground behind them, rather than artfully composed rolling hills and flora, which typify depictions of the island.[92]

Indian Shops, Gay Head, Massachusetts (1940; see fig. 12) is a painting in a high-toned pastel palette depicting a scene of Martha's Vineyard cliffs. The well-designed canvas contains a deft rendering of a view of land and sea bathed in intense sunlight. Two wooden stands, both apparently of rough construction, appear in the middle of the composition; inside one of these, there are two somewhat loosely painted brown-skinned figures. A partially cropped teepee dominates the left third of the canvas. Jones registers the conditions of the summer environment with a kind of geometric abstraction: she represents the shadows cast by the structures as flat planes with jagged, angular contours. Impasto strokes and striations in the background depict a glimmering ocean and breathtaking sky; a wavering darker line hints at a coast made almost invisible by the brilliant atmosphere.

Jones spent her childhood summers on the Vineyard and selected the island as her final resting place. Her own artistic origins owed something to her experiences there: it was on Martha's Vineyard that she met Henry Thacker ("Harry") Burleigh and Meta Vaux Warrick Fuller, who encouraged her to continue her studies as an artist. This land off the coast of Massachusetts had a significant African American community from at least the 1800s.[93] The Vineyard's Oak Bluffs, with its concentration of Black elite property owners, provided a respite from the constraining and dangerous racial climate of much of the rest of the United States. Additionally, the town of Gay Head was home to one of the nation's first desegregated schools.[94] Images of the island could be understood variously as claims, revindications, in addition to a chart of artists' movements. Perhaps for these inflections, Porter also treated the Vineyard's landscape in a loosely handled watercolor, *Landscape, Edgartown, Massachusetts* (n.d.).

Jones often recounted the story of submitting *Indian Shops, Gay Head, Massachusetts* to an exhibition at the Corcoran in 1941. Worried it would be placed directly in the refusal pile if known to be the work of a Black artist, Jones asked a white friend (probably Tabary) to deliver it. Following this tactical maneuver, it won the Robert Woods Bliss Award for Landscape; Jones asked the prize be mailed in order to obfuscate her identity.[95] Only three years later, the famed depicter of the American scene, Reginald Marsh, responded to Jones's request for a letter of recommendation for a Guggenheim fellowship; elucidating period taste, he wrote: "I do remember very well indeed your picture. . . . It was a little difficult to gain the award for it—as

13. Lois Mailou Jones, *Photo of Lois Mailou Jones Home Interior*, n.d.

Courtesy Moorland-Spingarn Research Center, Howard University Archives

I remember, because it was honest, real and not rendered in a fashionable or showy style."[96] Clearly realized in small "c" conservative style, the painting's total value has crystalized over time. It reflects the artist's desire to render the truth of her time. In 1997 it entered the collection of the Corcoran and was accessioned by the National Gallery of Art in 2015. From our present vantage, the meanings of Martha's Vineyard's Gay Head become clearer; we can focus on how Jones's canvas tells a history of Black America. Returning to Charles Baudelaire, the artwork's "eternal and immovable" aspects—which are thrown into relief when it is seen paired with contemporary entertainment technology in the artist's home (fig. 13)—enabled the *truth* of diverse experiences to be insinuated into the center of Washington modernism at the Corcoran annual.

Globalist Aesthetics: Denationalizing American Art

By the late 1960s, Jones began to see Haiti as a node in a transnational Black community—a place that possessed actual and mythical ancestral links: "for me Haiti, Black America, and Africa

14. Cover of flyer for Lois Mailou
Jones exhibition at Barnett-Aden
Gallery, 1946

Courtesy Moorland-Spingarn Research
Center, Howard University Archives

are one," she said. Although this globalist view correlated with an acceleration of "African" subject matter in her paintings, Jones had a long-standing interest in the continent. Her embrace of Black aesthetics and concern for a postcolonial Black Atlantic in her artwork separates her from Porter. In a record of "African" paintings she created at the end of her life, she lists her 1930s Paris-made *Les Fétiches* and then jumps to her works in the early 1970s. Art historian Rebecca Keegan VanDiver's recent scholarship on Jones investigates this gap, contesting the idea that Africa was not present in the intervening decades, by analyzing a flyer Jones created for the Liberian Centennial and Victory Exposition (1947–1949) in Monrovia, Liberia, as well as other projects.[97]

In July 1946, Hilyard Robinson, the modern DC architect, was commissioned to direct the Liberian Centennial and Victory Exposition, which he described in *The Crisis* that same month.[98] Jones had collaborated with Robinson some years earlier on an interior design; she was to supply textiles for paneling elements and curtains. That same year, Jones designed a pamphlet celebrating the event with three stylized outlined figures on the left, two men and a woman, who represent the people of Liberia. As VanDiver has suggested, Jones's design "resonates" with the graphics of colonial expositions.[99] The artist-designer reprises conventions established by the 1931 Paris Colonial Exposition, using them for very different ends: to celebrate the uninterrupted agency of an African nation. Settled by former slaves from America and the Caribbean in tandem with the American Colonization Society, Liberia was never colonized during European grabs for territory in the nineteenth or twentieth centuries. According to Gilroy, Liberia held a special place in a Pan-African imagination: "it relates also to the encroachment of European political conflicts which grew up around the need to liberate Africa."[100] Although the exposition was not celebrated as Robinson planned, Liberia's centennial was recognized in Washington by a wreath-laying ceremony at Howard University in 1947.[101]

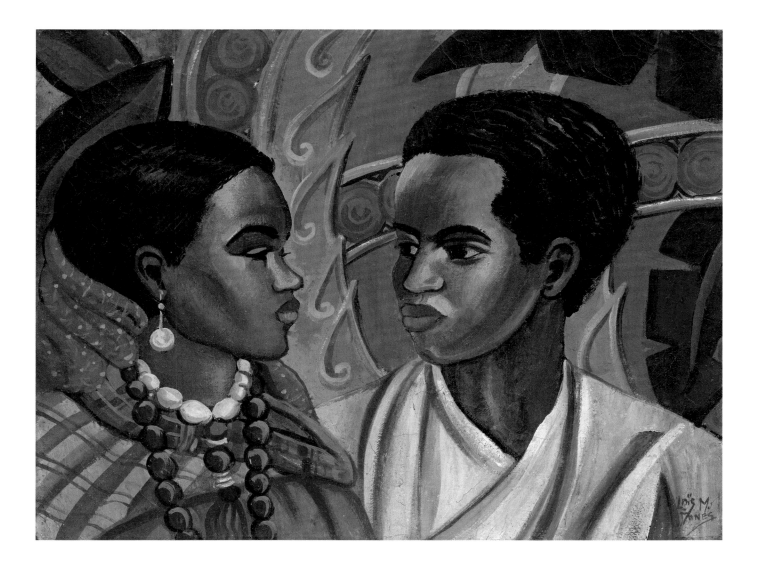

Perhaps because of the nation's symbolic weight, Jones's interest in the autonomy of Liberia extended beyond the graphic poster design into oil paint: that same year she produced *Liberian Abstraction* (c. 1946). The canvas marks a breakthrough shift. It is one of her first moves toward her mature style of embedding figures and faces within a boldly patterned ground. As is the case for many of her later works, it does not seem to be a rigid quotation of a single source but instead a synthesis of observation, photographic material, and the artist's imagination. *Liberian Abstraction* includes a female figure with an elaborate headdress and a male figure in a fez and dashiki, recalling one of the men depicted in her brochure. The patterned ground has repeated circular forms that resonate with the woman's headgear. The man, who is in profile and appears to emerge from the patterns, is at the crux of flat design and modeled dimensionality. Indicating its importance, the painting was selected as the cover image advertising her first major solo exhibition at the Barnett-Aden Gallery (fig. 14). A similar composition, *The Lovers (Somali Friends)* (1950; fig. 15), now in the collection of the National Gallery of Art, was made at the historical moment when the southern territory of Italian Somaliland became a United Nations trust territory.

15. Lois Mailou Jones, *The Lovers (Somali Friends)*, 1950, casein on canvas

National Gallery of Art, Corcoran Collection (Museum purchase from the Estate of Thurlow Evans Tibbs, Jr.)

16. Detail of Lois Mailou Jones, *Africa*, 1959, mural (acrylic on plaster)

Sasha Bruce House, Washington, DC

Photo: John A. Tyson

17. Detail of Lois Mailou Jones, *Africa*, 1959, mural (acrylic on plaster)

Sasha Bruce House, Washington, DC

Photo: John A. Tyson

Jones's celebration of the modernity of independence movements is most clearly expressed in *Africa* (figs. 16–17), a mural she completed in 1959 in the Retreat for Foreign Missionaries (now the Sasha Bruce House). With a globalist aesthetic, the multi-wall work honors the newly independent nation of Ghana. As the first African nation to break from colonial control, Ghana's trajectory—and the rise of its president Kwame Nkrumah—had been covered with interest in the mass media. Du Bois also viewed Nkrumah as a key figure, lauding his achievements and casting him as a leader for a broader Pan-African polity.[102] Gilroy notes that liberation had a particular charge beyond the continent too: "Though vitally important in its own right, the liberation of Africa also operates as an analog for the acquisition of black autonomy in general."[103] He argues that Africa—understood as more than "a mythic counterpart to modernity in the Americas" held the possibility of filling the "empty, aching space between . . . local and global manifestations of racial injustice."[104]

A portrait of Nkrumah, informed by iconic photos and accompanied by the crest of Ghana, prominently fills one wall of *Africa*'s cycle. In particular, although it is not an exact copy, Jones's image of the president resembles the one that graced the cover of *Time* magazine. Below the visage of Nkrumah is a group of Ghanaian people—the agents of the revolutionary new democracy. Beyond the connection to print journalism implied by her source material and style, her mural program contains a further journalistic and pedagogic thrust. To the right of the assembly representing the population is a map with arrows emanating from Ghana. These vectors chart currents of the Black Atlantic (of people, culture, or ideas perhaps) out from West Africa to the rest of the world. On the wall across from Nkrumah, Jones produced a profound instance of art as infographic: she rendered a map of Africa next to a family group in which the man stares out at the viewer while the woman gestures toward the visual data. A series of arrows and concentric circles, which are accompanied by texts describing developments in then-recent history, are superimposed on the continent. The result is a diagram signaling struggles still underway and revealing that the political climate is moving toward postcolonial independence.

Works by Jones in her mature idiom, such as *Homage to Oshogbo* (1971), *Moon Masque* (1971; fig. 18), *Ode to Kinshasa* (1972), *Deux Coiffures d'Afrique* (1982), and *Petite Ballerina* (1982), consist of boldly patterned grounds, with hard-edged blocks of color in shades of orange, teal, crimson, and yellow. Above these dynamic fields, modeled faces or masks appear to float. In the case of *Moon Masque*, the central visage is a bas-relief element. She remixed photographic elements (for instance, the same crisply rendered face recurs in *Deux Coiffures d'Afrique* and *Petite Ballerina*) into allover compositions. Her canvases are zones of exchange; their titles and content cite locations in the Democratic Republic of the Congo and Nigeria (thus siting them in the geography of Africa, too). In 1970–1971 and again in 1972, Jones visited multiple African nations with the express goal of photographing hundreds of artworks to augment Howard's slide collection.[105] Photography was a fascination Jones cultivated all of her adult life—which began in earnest with documentation of her sojourns in France.[106] Her increased exposure to the medium with her African art slide project clearly drove her image making. In addition to adopting a photographic vision, Jones seems to possess an art-historical or museological sensibility; her compositions evoke conventions of display of non-Western art objects, which, in museums, are often placed in front of a dark ground and directed to face the viewer straight on.

Similarly, Porter traveled to Africa, which impacted his theory and practice. He produced a series of paintings, which range from naturalistic sketches to more lyrical abstractions, including *African Venus* (1963), *The Birth of Africa (Rebirth of Africa)* (1963–1964), *Fish Vendors at Bar Beach, Lagos* (1964), *Storm over Jos (Nigeria)* (1964), and *Tempest of the Niger* (1964). The works clearly reveal a growing concern for African subjects. However, unlike Jones, whose style continued to evolve with the times, Porter addresses Africa in more academic paintings that are not his most visually compelling projects. As he implicitly acknowledges with his title, "Africa" really entered into his oeuvre as a central subject only at the moment it was returning as a topic for younger practitioners and blossoming in Jones's output. In a 1966 speech given in Dakar for the First World Festival of Negro Arts, his prime focus remained on the position of the modern African American artist; he stated, "The contributions of scientific research in this century to knowledge of the Negro have made invaluable evidence for the prolongation of African culture into the complex civilizations of the Western hemisphere."[107] Porter continues, "It is unlikely that we shall ever have a truly great American artist among us until American society completely accepts the Negro and his valid interpreters."[108]

Jones in some sense successfully heeded Porter's call and developed ways of registering the outward spread of African culture even as she produced American art. The influence of two African modernists, both involved in the imagining of new art for their newly independent nations, should be noted. The Nigerian painter Ben Enwonwu, famous for his expressionistic masked dancers, had an exhibition at Howard in 1950 and was a visiting artist in 1971. He translated masks into the "European" medium of oil paint. Jones also draws upon lessons from her early work in the supposedly "minor" arts of textiles and seems to reprise the illustrations she made in the 1930s in her works of the 1970s and 1980s. While textiles were not always highly regarded in the West in the modern era, tapestries were central to the artistic program of independent Senegal under its first president, Léopold Sédar Senghor (in office 1960–1980). As state-sponsored art, they came to have a strong association with the liberated nation.[109] On her travels, Jones witnessed firsthand the tapestry workshop of the star Senegalese artist Papa Ibra Tall; moreover, she depicted the Senegalese leader, drawing upon a photographic image, in *Hommage au Président Léopold Sédar Senghor* (1976).[110] The motifs she explores for the vivid backgrounds bear a definite formal resemblance to the dynamic and multicolored weavings

18. Lois Mailou Jones, *Moon Masque*,
1971, mixed media

Smithsonian American Art Museum,
Bequest of the artist

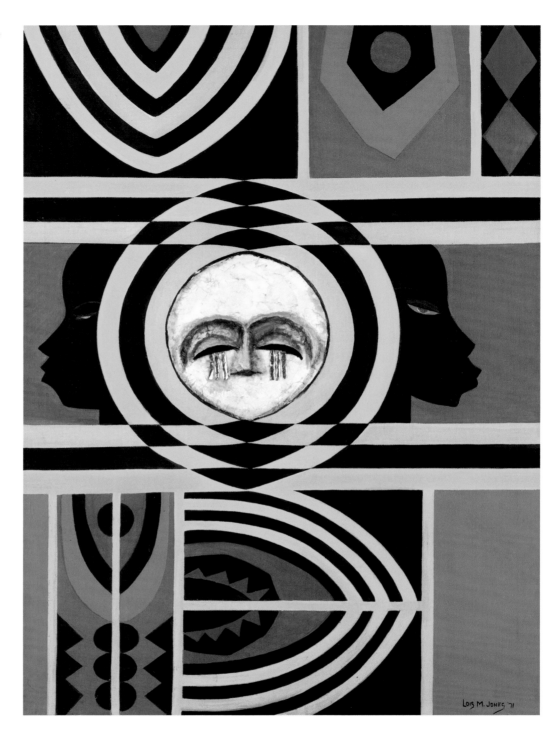

of Ibra Tall. Hence, in yet one more act of translation and transposition of motifs recalling
Ibra Tall's, Jones weaves an ur-form of modern Senegal into her rendering of Pan-Africanism.

By remixing the modern, Jones transcends that cultural logic. Indeed, when compared
with contemporaneous works, a postmodernist aesthetic is tangible here. Her artworks very
much seem to anticipate and engage dominant trends of the 1980s. For example, the "circuit
boards" of Peter Halley or the constructions of Ashley Bickerton, plastered with commercial

logos, rely upon similar geometric formal arrangements and color palettes. But Jones presents a rerouted postmodernism; her works' decorative ornamentality contrasts with these slick neo-geo works, which employ similar strategies to embrace international brands and quite literally render circuits as hard-edged abstraction. Jones suggests a different kind of programming with her paintings; they give a concrete form to the cultural exchanges and flows that constitute the African diaspora.

Ultimately, it is Jones's and Porter's uprooting of American art with the flows of the Black Atlantic—yielding many iterations of *creolité*—that is their key contribution: the title of a 1961 exhibition of works by artists of all races that Porter organized, *New Vistas in American Art*, pithily encapsulates the purview his and Jones's oeuvres opened up. Porter, and to a greater extent Jones, added new inflections to American modernism, expanding its definitions and allowing the Black Atlantic to rush in. Their art performs a function paralleling the texts Gilroy assesses: it has "overflowed from the containers that the modern nation state provides."[111] Their transnational vistas present new points of view about the constitution of American art.

Coda: Legacy and Institutionalization

"Talent accompanied by vigorous expression may arise from almost any quarter in American life," Porter writes in the foreword to *New Vistas in American Art*; he continues, "it should be noted that in nearly every instance the artists in this exhibition hold positions as instructors in workshops or educational institutions . . . American artists are not always stultified by the work they must perform as teachers in order to survive."[112] As with the broader field of modern art, institutions dedicated to showing art and providing education (though at times imperfect) are of paramount importance. Both Jones and Porter have been variously "institutionalized." A gallery at Howard University is named in Porter's honor. Jones and printmaker James Lesesne Wells share the same recognition in another. In addition, every year Howard presents the James A. Porter Colloquium, which showcases new scholarship in the field of African American art. At the time of Jones's retirement, Howard art department chair Jeff Donaldson (an artist of the subsequent generation and major figure in the Black Arts Movement in the late 1960s and 1970s) summed up her forty-year career: "Lois is an institution which has endured. Institutions that endure perform superior services and/or provide excellent goods. She has."[113]

THE MUSEUM OF AFRICAN ART AND AFRICAN AMERICAN ART IN 1960S WASHINGTON

Steven Nelson

On June 3, 1964, the Museum of African Art opened its doors to the public (fig. 1). The museum's founding director, Warren M. Robbins, was very proud that this new museum was, in his words, "the only institute in the United States devoted *exclusively* to fostering understanding and respect for the African peoples by portraying their cultural heritage" (emphasis in original).[1] The new museum was an integral tool for realizing the goals of the nonprofit Center for Cross-Cultural Communication (CCCC), founded by Robbins in 1962. A former US foreign service officer, he had first encountered African art in Germany when he was posted in Europe in the 1950s. His interest in African art blossomed through his interest in European modernism, and he quickly became persuaded that African art was a fundamental catalyst of European modernist innovation. Understanding its transformative potential, he believed a museum of African art could provide an opening for interracial and international dialogue.[2] In the shadow of the ongoing civil rights movement and on the eve of the enactment of the landmark Civil Rights Act of 1964, Robbins thought that such communication would improve deteriorating race relations in the United States. As a visual manifestation of African cultures and their extraordinary contributions to world civilization, African art, he felt, could put to rest stereotypes of African inferiority and lack of historical consciousness. These last two objectives were no small detail, for Robbins knew that if such stereotypes could be neutralized in concert with African decolonization and a renewal of diasporic consciousness in Black communities, African art could also be viewed as a visual manifestation of African American pride.

The Museum of African Art entered the Smithsonian Institution in 1979. This essay explores the relationship of the Museum of African Art with Howard University and African American art in Washington. Focusing on the years before the Museum of African Art became part of the Smithsonian allows us to chart the complicated nature of the museum's founding and to see how Robbins invoked and learned from Howard in the making of the institution and in understanding African American art. This discussion seeks to recover a sense of the early eclecticism in collecting, programming, and forging of relationships that has largely been suppressed in histories of what is now the National Museum of African Art (NMAfA). Such an examination will allow us to understand better the intersecting, multilayered spaces of African and African American art that made up Washington's Black art world at the time.

Detail, fig. 14

1. Frederick Douglass Institute,
Museum of African Art, 316 A Street
NE, Washington, DC, c. 1968

Eliot Elisofon Photographic Archives,
National Museum of African Art,
Smithsonian Institution

Photo: Gerry Peck. © Gerry Peck

Robbins noted that more than three thousand people visited the museum during its first few months of operation and that more than half of this number consisted of African Americans. He boasted that the institution had garnered support from Black scholars and public figures, including historian William Leo Hansberry; US ambassador Will Mercer Cook; James Robinson, clergyman and founder of Operations Crossroads Africa; as well as comedian and activist Dick Gregory, among others.[3] In addition, the museum hosted myriad public programs on African art and cultures, supported school groups, and held events aimed at fostering interracial and international communication.[4]

The Museum of African Art quickly became the most important place in the capital to see African art. It featured an extraordinarily eclectic scene, beautifully encapsulated in a 1969 *New York Times* article about the success of the museum and its twin, the Frederick Douglass Institute

for Inter-Cultural Understanding, founded in 1966.[5] Building upon CCCC and the museum's aim to foster interracial communication, the institute focused on African American and culture. (By 1969 the organization was renamed the Frederick Douglass Institute of Negro Arts and History.) With their overlapping agendas, staff, and even stationery, the museum and the institute were, for all intents and purposes, the same entity. The museum and institute were located in the Capitol Hill townhouse formerly owned by Frederick Douglass, who had escaped slavery to become a famed abolitionist, publisher, and statesman. The museum house featured a re-creation of Douglass's office, replete with a rolltop desk, bowler hat, typewriter, and other personal effects that may or may not have actually belonged to the former resident.[6]

2. *African Sources in Modern Art* (permanent gallery display), Frederick Douglass Institute, Museum of African Art, 316 A Street NE, Washington, DC, *Washington Post*, January 7, 1967

Eliot Elisofon Photographic Archives, National Museum of African Art, Smithsonian Institution

Photo: Ellsworth Davis.
© Ellsworth Davis

Upon entering the museum, the *New York Times* reporters, Penelope Lemov and Gail Werner, first encountered a large Senufo headdress set off by wall hangings in terracotta and tropical plants. They then heard polyphonic drums as they viewed instruments from Nigeria, Ethiopia, and Malawi; architectural ornaments from Mali; and brass gold weights from Ghana. The duo then came upon a gallery that featured African art in concert with reproductions of modern European work that, in Robbins's mind, owed a debt to the continent (fig. 2). In their article, the reporters noted in particular an Akan *akua'ba* (fertility figure) juxtaposed with a reproduction of Paul Klee's painting *Senecio* (1922), which, they observed, "seems as if Klee traced the moon-shaped face of the goddess on his canvas and then softened it with pastels." Other objects appeared next to reproductions of works by Alexander Calder, Amedeo Modigliani, and, in the reporters' words, "a group of German Expressionist painters."

Just outside this gallery, a wall of works by nineteenth-century African American artists Edward Mitchell Bannister, Joshua Johnson, and Henry Ossawa Tanner were on view. In their article, Lemov and Werner mentioned that these artists' works would be among the first beneficiaries of the institutions' expansion, which was to include a gallery devoted to African American art. Upstairs, Lemov and Werner saw a display of the contributions of Black Americans to the culture and life of the nation. This history, which extended from the Revolutionary War to the present day, included paintings by Henry Dabs and images and texts by famous African Americans, some whom history had forgotten. Taken together, Lemov and Werner concluded, the museum and institute outlined "a continuum in the documentation of the black heritage."

In the Beginning

When Robbins established the Museum of African Art in the early 1960s, he had never been to Africa. He had no museum experience. He had never been professionally involved in the arts. He had never engaged in fundraising. He had no training in African art or museum administration. His interest in African art was fueled by his interest in European primitivism. The appropriation of African art by the French cubists and German expressionists validated its importance for Robbins. From this point on, he often stressed the critical role of African art in the advancement of European modernist practice.

He became a career officer for the US Information Agency in 1951 and during the 1950s was stationed in Bonn and Vienna. As a public affairs officer and cultural attaché, Robbins

spearheaded exchange initiatives that brought American writers and entertainers to West Germany. He also ran book publication and translation programs. In the late 1950s, he purchased a carved wooden figure of a Yoruba man and woman for the equivalent of fifteen dollars. Shortly thereafter, accompanied by linguist, semanticist, and later US senator Samuel I. Hayakawa, he visited an antiques shop in Hamburg that sold African art objects. He paid $1,000 for thirty-two more objects, including masks, textiles, and figures.

Robbins was reassigned to a post in Washington in 1960. He settled on Capitol Hill and continued to work in educational and cultural relations, leaving the State Department in 1962. That same year he founded the CCCC, a nonprofit institute to "promote better understanding between the peoples of different cultures."[7] Not simply a consciousness-raising venture, CCCC sought new ways to bring people of disparate backgrounds together.[8] Its mission articulated three primary aims. The first, which the CCCC prospectus titled "Inter-Disciplinary," focused on bringing together the insights of the social sciences and artists and making their work accessible to politicians and the general public. The second, "Inter-National," concentrated on international conversations and publishing aimed at improving relations between the United States and other nations. The third, called "Inter-Racial," centered on opening channels of contact between Black and white Americans as well as Africans to capitalize on the groups' common personal and professional concerns.[9]

This third aim was Robbins's chief interest, for he was convinced that the racial animus between Black and white Americans was a problem of a "cross-cultural communication barrier," one that, for him, was the equivalent of international divides.[10] Moreover, as Robbins would repeatedly write, another critical aspect of American racial problems was a lack of knowledge of African and African American history.[11] This lacuna, the basis for a misperception that American Blacks were without a past, had two primary effects. It anchored persisting white arguments of Black inferiority. As important, it negatively affected Black self-esteem.

To learn more about African art, as Robbins explained in a 1979 interview with *Washington Post* reporter Sarah Booth Conroy, he had read *Life* photographer and journalist Eliot Elisofon's *The Sculpture of Africa* (1958) during his trip back to the United States by sea from West Germany.[12] Complete with 405 photographs and essays by noted anthropologists William Fagg and Ralph Linton, the book casts African sculpture as both primitive and contemporary, a product of both pure form and long-standing cultural forces. Linton's essay questions the very definition of the term "primitive" when applied to non-Western peoples and their cultural manifestations. Stressing that the use of the word to describe the majority of world cultures "is an unfortunate aftermath of the ethnocentrism of the nineteenth century European scientists who laid the foundations of modern anthropology," Linton insisted that such a term deceptively renders non-Western cultures as "living fossils, surviving stages in a unilinear development of which European culture of the nineteenth century was the climax."[13] He compared forms and practices in Africa and beyond to those in Western art and thought, suggesting that each, depending on the context, could fall under the rubric of the primitive. In a way not unrelated to the driving force of Edward Steichen's exhibition *The Family of Man* (Museum of Modern Art, New York, 1955), Linton's work is steeped in a cultural relativism that attempts to make fundamental connections among peoples from different parts of the world. Fagg's introductory essay applies Linton's ideas to African sculpture.

The Sculpture of Africa is both a scholarly work and a large, sumptuous coffee-table book replete with Elisofon's extraordinary images of African art as well as photographs of Africa's peoples and places. Its descriptions of objects cast them as serving social and cultural needs. Robbins took from Elisofon's book a view of African art that is both local and multicultural,

primitive and modern, and socially grounded while being wholly abstract. This book, combined with Robbins's modernist entry into the worlds of African art, would dictate the cultural attaché's ideas about not only the meaning and importance of African art but also its display and interpretation. The book's arguments about African art and Black people dovetailed with Robbins's desire to foster constructive dialogue across racial, cultural, and national divides, as well as to create a space capable of bolstering African American self-esteem. In this way, African art became both a cultural ambassador and, as Black Americans embraced their connections to the African continent, a sign of a remarkable Black past.

Robbins connected African art, African American identity, and the possibilities of interracial dialogue through the work of anthropologist Melville J. Herskovits, whose book *The Myth of the Negro Past* (1941) set out to dispel the notion that Black Americans were without history.[14] By studying African Americans through the elements of African cultures that survived the Middle Passage, Herskovits aimed to invalidate arguments about the lack of history that also functioned as a means to legitimate ideas of Black inferiority. Robbins freely quoted from Herskovits in presenting the rationale for his fledgling institution. For example, Herskovits wrote, "To give the Negro an appreciation of his past is to endow him with the confidence in his own position in this country and in the world."[15] Taking from these ideas, Robbins insisted, "African art, indeed, is African History in plastic form. In the absence of written language, tribal sculpture was history, literature, philosophy, and law. And its proper study—not *as art* but as all of these things—adds up to a perspective of Africa which is different from the Christian rationalization of slavery which has been our diet for the past 400 years" (emphasis in original).[16] It was not a leap for Robbins to see African art serving as material proof of Black Americans' ties to Africa, which provided a way to visually demonstrate Herskovits's contention that knowledge of ancestral African cultures and African retentions in African American life would positively influence opinions of Black Americans, expand Black potentiality, and defuse interracial tensions.[17]

Howard University

Cultural relativism, African retentions in the Americas, and his vision of CCCC were certainly in Robbins's mind when he became acquainted with Howard University. By the time he founded the center, he was familiar with the university's eminent department of art and its storied faculty, including James A. Porter, chair of the department and director of the Howard University Gallery of Art, established in 1928. Robbins was fully aware of its status as the epicenter of Black art making and the study of African American art history in Washington and beyond. On the evening of November 20, 1962, the Gallery of Art hosted an opening for its exhibition of works owned by Robbins, titled *Paintings, Prints, and Drawings by 20 Modern European Artists*, which included work by Marc Chagall, Lyonel Feininger, Käthe Kollwitz, Pablo Picasso, and Odilon Redon, among others. *Washington Star* art critic Frank Getlein referred to the collection as "small but choice."[18] As if unwilling—or simply unable—to give the gallery unqualified praise, even though the gallery's exhibition program was, in Getlein's words, "running rings" around those at other Washington university facilities and had shown an international, interracial array of art since its first exhibition in 1930, the critic saw this small show as expanding the institution's scope.

Aside from the public attention and the acknowledgment that his collection was of some importance with respect to Howard, Getlein's review also legitimated Robbins's art world bona fides, at least in Robbins's own mind. Not shy when it came to self-promotion, Robbins tirelessly publicized the exhibition of his collection of modern European artists. He also arranged his

own events at the Gallery of Art. After the show closed, Robbins gave Austrian artist Georg Rauch's lithograph *Young Negro Boy* to the gallery.

In addition to the legitimation the exhibition and press provided for Robbins, it also created an opening for presenting his worldview to the university and set the stage for a possible collaboration between Howard and CCCC. Just after the exhibition's opening, Robbins offered to help Porter drum up interest in the gallery, "to strengthen its capacity to carry out ever more ambitious projects."[19] Seemingly unaware of Washington's enduring racial segregation and its consequences, Robbins all but blamed the gallery for suffering from what he described as "the cultural isolation that has only begun to break down between the negro and white groups in this city."[20] Echoing his ambition for the CCCC, Robbins envisioned the Howard University Gallery of Art as a space where Blacks and whites could come together toward better understanding, and he offered specific steps to achieve such a goal. First, he suggested moving all openings to Saturday afternoons to attract those who were interested "but afraid to come to a strange and unknown (to them) section of the city unescorted after dark."[21] He suggested sending an overview of the university and mimeographed maps of the campus to invitees. Getting granular, he advised Porter to guide people to the gallery through the main campus entrance. Additionally, Robbins suggested a program to train students in curatorial and administrative duties, offer courses for internship credit, and produce publications, such as a journal for student work as well as a series from Howard University Press for aspiring African American artists and writers. Finally, Robbins advised Porter to create a "Friends of the Gallery Group" that could raise the gallery's public profile and possibly provide financial support.[22] Robbins hoped that some of these suggestions could be implemented in time for a private showing of the exhibition he had planned. Indeed, Robbins's event took place on Saturday, December 8, 1962, from 3:30 to 5:30 in the afternoon. Creating a publicity program for what was arguably the best-known Black university in the United States and moving gatherings from evenings to afternoons suggest that Robbins felt the need to make Howard, which he arrogantly called a "bi-racial" institution, safe for white people.[23] So if intercultural exchange was the goal, as has been the case throughout American history, Robbins placed the burden on Black people to make it happen.

Perhaps just before or just after writing to Porter, Robbins informed Edith Halpert, director of New York's Downtown Gallery, of his intentions for the gallery. Aside from boasting about his own Howard exhibition, he wrote, "I have decided to start a 'Friends of the Gallery' group to support it and help, among other things to break down the cultural isolation between negro and white groups in the city." He suggested that he could convince his friend Harry Holtzman to lend his Piet Mondrian collection for display. Robbins also asked if Halpert thought a show of Jacob Lawrence's work at Howard would be a good thing, and whether she would consider showing one of her gallery's artists there.[24]

Like the *Washington Star* critic, Robbins honestly believed that this exhibition represented a leap forward in scope and ambition for the gallery. With no small measure of paternalism, he also felt that he could lead this change. Most important, he believed that the institution would be an advantageous partner for CCCC and the development of a museum of African art. Robbins's desire to make Howard safe for white people as well as his insistent behavior toward the institution was less about real or perceived issues in the Howard University Gallery of Art than it was about his desire to expand the reach of the CCCC and to bring the university on as a supporter for his planned Museum of African Art. As part of this plan, Robbins, even if unconsciously, strove to convince Howard to embrace the CCCC's mission.

The irony, at least with respect to Howard's program, is that under Porter's leadership, the gallery had been doing for decades the kind of integrationist and internationalist work in

visual art and art history that Robbins mistook as groundbreaking when he mounted his own collection there in 1962. Moreover, Alain Locke's impressive collection of African art became part of Howard's holdings in 1955, a year after the longtime faculty member's death. In part because Jim Crow segregation prevented African Americans from visiting many of Washington's cultural institutions, Porter and his colleagues brought an international array of art to Howard. The gallery already considered African (and African American) art within the larger contexts of American art and European art. An example Robbins saw was Howard's 1961 exhibition *New Vistas in American Art*, which included a provocative array of Black and non-Black artists.

Despite not knowing how Porter and his Howard colleagues felt about his overbearing behavior and, on a certain level, often inappropriate suggestions, by early 1963 Robbins had set his sights on forging some kind of affiliation between the university and the CCCC, and the planned Museum of African Art. Robbins knew that getting Howard on board would lend a great deal of gravitas to his endeavors. To begin execution, he contacted Howard president James Nabrit, introducing himself, elaborating his ideas about Howard's value, and articulating the mission of the CCCC. "I believe," Robbins wrote, "it would be fitting for the University to have affiliated with it an educational-information institute active in the cross-cultural field." Robbins then asked for a meeting to talk about the possibilities.[25] Nabrit indicated his interest in Robbins's plan, suggesting that Porter could coordinate and set a meeting with Robbins, the president's assistant Vincent Browne, and other parties to explore the idea in depth.[26] The meeting took place on April 23, 1963. It is unclear what, if anything, emerged from the conversation.

Even before the meeting, Robbins took the liberty of sharing the schemes for his new museum, implicating Howard as a fundamental part of them. On April 20, he informed G. Mennen Williams, assistant secretary of state for African affairs, that the Museum of African Art would be "affiliated with Howard University so that, like MIT, Harvard, and countless other American universities today, Howard, too, will have a fitting international affairs institute." Robbins insisted that in addition to his own museum he would aid the Howard gallery in arranging for major shows of the quality one would expect at the Corcoran Gallery of Art or another major venue.[27] The same day, Robbins claimed that Porter had signed on as one of the museum's trustees and that the new museum would eventually be turned over to Howard, "which I feel is the most logical place in the Western Hemisphere for such a Museum, uniquely bridging African and Western cultures, to be located."[28] He framed the 1962 exhibition of his collection as the first step in bringing Howard into the process.

Robbins pushed ahead with Howard administration. On November 15, 1963, he sent a detailed plan of engagement to Browne that covered everything from promotional materials to the intent of the museum vis-à-vis the university. Robbins insisted in this correspondence that the Museum of African Art had no desire to create and maintain an art collection but that it sought the rights to make use of one. The objects would be the property of the university, which would make them available to the museum on indefinite loan. He also put forward a plan to include Howard faculty on the boards of both the CCCC and the Museum of African Art. The member of the latter would come from the department of art. Robbins added, "the University would have still an added voice if the President is willing to serve as an honorary trustee of the Museum."[29] Although Robbins was in the process of setting the museum up in the Capitol Hill townhouses that once belonged to Frederick Douglass, he stated that the center's ultimate goal was the construction of a new building on or near the Howard campus.[30] At the same time, he suggested that given the desire for the museum to be the center of intercultural communication, it should be in the "Douglass house or any case such an integrated area on Capitol Hill."[31]

In his letter Robbins stipulated the kinds of support he expected from the university. While he did not request financial or logistical aid, he suggested that Howard could figure out some means of unspecified material support. He also wanted the right to call on the department of art and the Gallery of Art for advice and assistance in the formulation and implementation of exhibitions. He even expected the university to supply staff and student help in the form of internships for university credit and research assistance. In addition, Robbins also wanted office space, furniture, and equipment.

Congruent with CCCC's desire to bring together the social sciences and the arts to improve interracial and intercultural communication, Robbins insisted in this letter to Browne that the real purpose of the Museum of African Art was social education. As such, he envisioned relationships stretching beyond stakeholders in the department of art and the gallery to faculty from myriad units, including sociology, anthropology, and African studies, among others.[32]

It appears that Howard University officials did not respond to Robbins's proposal. By the end of 1963, while Robbins continued to claim that the museum was being created on behalf of Howard in requests for foundation funding, he no longer included university affiliates on his long list of trustees and advisors.[33] However, similar requests sent the same day for support claimed that Howard faculty were cooperating with the effort.[34]

Howard's silence irritated Robbins professionally and personally, and he complained on several occasions that the university had taken no position on his ideas. As if to force Howard's hand, he shot off a letter to Nabrit. "But to be perfectly candid," Robbins barked, "we do not come to the University because we want or need something from it, President Nabrit, or because the project cannot be carried forth without its support. On the contrary, it is our intent to have the University benefit from the fruits of our undertaking." He further insinuated that the university should be grateful for the proposal. Robbins warned that if the university showed no sign of interest, he would drop the plans to include it. But then he stepped back, asking Nabrit to meet with him in person to discuss an appropriate course of action.[35]

Nabrit did not respond.

A couple of months after airing his grievances to Nabrit, Robbins told Porter that he could no longer wait for Howard's participation in the museum. Putting a fine point on it, Robbins suggested that instead of Howard, the Smithsonian could become the beneficiary of the grand collection he planned to amass. As if the deed were already done, he added, "I would like to have seen it go to Howard."[36]

Despite this warning to Porter, Robbins couldn't let the issue go. A couple days later, Joseph Douglass, a grandson of Frederick, reopened the issue in a letter to Nabrit:

> Mr. Warren M. Robbins . . . has indicated to me that he has earnestly sought to reach you on several occasions . . . but has been unsuccessful. His interest is in working out some type of co-operative arrangement between the Center and Howard University, whereby in effect, this very valuable collection of African Art would be donated to the University or developed in behalf of and in cooperation with the University's Gallery of Fine Arts.[37]

Perhaps as an indirect response, Nabrit, in a separate letter, reaffirmed Howard's interest in Robbins's mission and in a possible collaboration. The university president also wished the director well on the launch of the museum.[38]

With Nabrit's polite brush-off, it would seem that Robbins's dream of political and social support from Howard would end. Not so. Over the next several years, events rekindled Robbins's interest in Howard and his pique at its lack of engagement with him and the Museum of African

Art. On March 6, 1967, about a month after the opening of Porter's well-received exhibition *Ten Afro-American Artists of the Nineteenth Century*, Robbins congratulated the art historian for the show's rave reviews and requested fifty copies of the catalog. He reiterated his wish to collaborate with Howard. However, unable to constrain his years-long frustration and anger, he wrote, "It becomes increasingly dismaying to me to have my own efforts looked upon as those of an interloper or as the good Dr. Wesley recently put it to my face, 'an opportunist.'"[39]

Robbins's rekindled desire and rancor lasted for weeks. On March 23, 1967, he sent Nabrit a souvenir album commemorating the ceremony of the release of the Frederick Douglass postage stamp, and in the accompanying letter, he could not resist relitigating his failed attempts. "It is regrettable," Robbins wrote, "that there was no response on the part of the University to our proposal *three years ago* that the museum of African Art—which subsequently has developed into the broader Frederick Douglass Institute of Negro Arts and History—become affiliated with Howard, much as Dumbarton Oaks is a part of Harvard University" (emphasis in original).[40]

Nabrit responded about a month later. Thanking the director for the souvenir album and deflecting Robbins's hostility, the university president claimed not to know of any lack of interest in Robbins or the museum. Nabrit asked for information on this score, "because certainly Howard University has nothing but the best of good-will toward your undertaking."[41] Robbins may have viewed the response as another brush-off.

Given the gallery's record of exhibitions, its already existing pretentions for attracting an interracial audience, and its possession of some 365 works of African art, it is reasonable to wonder what the university might have gained in a partnership with Robbins, whose ideas on expanding Howard's appeal were already part of the institution's agenda, whose views on African art's relationship to European modernism and African American identity had been espoused by Locke in 1925, and whose collection was not yet established.[42]

However interracial the Howard University Gallery of Art audience may have been, it is perhaps more important that it was one of the few venues in this racially segregated city where Black audiences could see art from around the world. Excepting the Barnett-Aden Gallery, it was also the only well-established institution showing African American art in the city. Given its position in the city's art world, was it wise for Robbins, no matter how well intentioned, to insist upon what might have been understood as making the Gallery of Art less Black identified?[43]

Nabrit retired from Howard in 1969. Shortly afterward, Beth Rogers, a doctoral student in political science at Howard who also served as a consultant and advisor to the Museum of African Art, wrote a letter of welcome to the new university president, James E. Cheek. In it she introduced the museum, claiming that it had held a "direct, but informal relationship with Howard University" since 1963. She expressed her hope that the relationship could be expanded and that a formal arrangement could be established so that the museum's resources could be made more easily available to Howard students.[44] No formal arrangements followed, but Robbins and Cheek did correspond from time to time.

Nabrit's mixed signals and Porter's silence on the matter were tacit rejections that Robbins didn't understand. But in other quarters, word of Howard's disinclination to work with the Museum of African Art made the rounds. In early 1966, Robert Luck, head of special programs at the American Federation of Arts, confided to philanthropist Albert List that dealing with the organization had been very difficult. He added, "My friends at Howard University in Washington are not favorably impressed by the administration of the Museum and apparently speak for an important segment of the Negro population in the Washington area."[45]

Robbins was incapable of seeing his own culpability in the failure to forge a formal relationship with Howard. He could understand the unsuccessful situation only as the responsibility of

others who were not acting as he wished and as the product of Howard's institutional difficulties. To be fair, Howard contributed to the problem through its silence, which Robbins interpreted as resentment of and resistance to the Museum of African Art, especially its entrance into the realm of the education of African American students about their own history and contributions to the United States.[46]

In the larger scheme of things, while Robbins routinely touted the sizable percentages of African American visitors to the museum, he deeply resented the lack of cooperation of the majority of African American community leaders in his endeavor. More seriously, as comes through in his letters to Howard, he was personally aggrieved by the lack of unqualified gratitude on the part of Black constituencies for his efforts. As he indicated to Porter and to Cheek, Robbins felt that this lack of support and praise came from Black resentment centered on the director's position as a white man. From the earliest plans for the museum, Robbins knew that as a white man he needed Black support to forward his agenda. But it seems that he did not realize that African Americans would not always greet him with open arms.

These slights hurt Robbins's feelings. In 1971, a year after James Porter passed away, Robbins wrote to Cheek:

> I regret to say that since Jimmy Porter died and some of my other old friends have left Howard I have had very little contact with the campus, which used to be one of my favorite places in Washington. It dismays me no end to feel so unwelcome there since I believe that I have gone about the business of building a vital institution in a way which, though regarded by some as exploitative and patronizing, is not different from what it was in earlier years when my efforts were not unwelcome. I feel that our institution is important to Washington—both its black and its white communities. I do not feel that what or who I am (or the color of my skin) is important to the undertaking, so long as we succeed with our stated goal of excellence.[47]

Robbins envisioned an integrationist world exemplified by the promises of a Hubert Humphrey–esque platform for civil rights, to which Robbins fully subscribed. But the encouragement proffered by this ideological paradigm and ignited by the 1963 March on Washington had resulted in unfulfilled promises and broken dreams marked by the assassination of Rev. Dr. Martin Luther King Jr. in 1968 and the deadly Washington, DC, riots that followed. Howard's department of art, with the appointment of AfriCOBRA artist Jeff Donaldson as chair, had embraced Afrocentrism and had aligned itself more closely with the tenets of postwar Black nationalism. The world was radically different in 1971 than it had been in the mid-1960s, and much of it no longer subscribed to the integrationist ideals of the Museum of African Art and its director. This failure was, in retrospect, the failure of both Robbins and Donaldson to meet each other halfway.

Yet Robbins was not off the mark when it came to his whiteness and how it registered—at times quite negatively—vis-à-vis his mission for the CCCC and his leadership of the Museum of African Art. Teixeira, a reporter for Howard's student newspaper, *The Hilltop*, reported in 1968 that there was controversy about whether the museum could fulfill its educational mission as effectively as African American–led organizations. Robbins registered his resentment at such an idea, adding, "I do not wish to have my efforts and motivations evaluated in terms of color."[48] In a profile of Robbins and the success of the museum, *Washington Post* reporter Philip Stanford shared Black opinions about the director. They varied. Some credited him for being ahead of the Smithsonian and the Corcoran. Some thought that the art in the museum's collection should have a closer relationship to the Black community. Stanford interviewed

"separatist" Gaston Neal, who, with some of his friends on a visit to the museum, exclaimed that they would not pay fifty cents to see their own heritage. They felt that Robbins was a colonialist who was profiting off of Black culture. "He makes money off of his shop just like the promoters of black music."[49] Neal also took issue with the exclusion of radical figures from the *Afro-American Panorama* (formerly the *Panorama of Negro History*, which opened in 1966). In a display of naked anti-Semitism, Neal charged that Robbins's intent for the museum resulted from his Jewish background.[50]

Robbins responded to Neal's criticism by noting that he had spent his entire savings to start the museum and that his entire salary went to a trust for the institution.[51] "I'm not doing this as a white person, but as a sponsor of an institution the city needs." He also insisted that the museum was not just for Black people but for everyone. "White people should know about African Culture too."[52] Robbins and Neal had crossed paths before the publication of the article, and Neal's radical, anti-Semitic stance rankled the museum director. On the one hand, Robbins depersonalized Neal's remarks, insisting that the museum would outlive them both. On the other, he craved Neal's approval. Stanford reported that after Neal opened the New School of Afro-American Thought in Washington in 1968, Robbins sent him a copy of his book *African Art in American Collections* (1966). "Robbins," Stanford noted, "still betrays injured feelings that Neal never acknowledged his gift."[53] Robbins also took umbrage at the notion that the museum should modify its programs to suit an increasingly radical Black community.[54]

Some thirty years later, Robbins accused Neal of being a thief and a drug addict in handwritten notes scrawled on a page of Robbins's manuscript of a book titled "Before and After the Smithsonian, The Legacy of Warren Robbins, Founder, National Museum of African Art: A Biography of Letters and Essays."[55] These unsubstantiated accusations arose from Robbins's feelings of hurt and resentment, emotions similar to those he experienced when feeling slighted by Howard. Indeed, in a prospectus for the proposed book Robbins himself described the relationship with Howard as "degenerative."[56] Roulhac Toledano, compiler of Robbins's *A Man for All Reasons: Letters of a Visionary* (2014), telegraphs Robbins's deep-seated bitterness at what he saw as a lack of acknowledgment and, more seriously, reverse discrimination meted out by African American Washington. "So it was," she writes, "that each wave of success for the Museum of African Art and the Frederick Douglass complex brought resentment from the very Blacks who were the beneficiaries of Warren's ideas and hard, effective work."[57] Despite Robbins's success in making an interracial space that featured African art, it is clear that he held on for decades to resentments stemming in part from feeling negatively judged not by the content of his character but by the color of his skin.

Collecting African American Art

Porter and the Howard University department of art left an indelible mark on Robbins and the Museum of African Art. Despite his failure to collaborate with the university, Robbins kept close track of its integrationist exhibition program, especially after the Howard University Gallery of Art 1961 exhibition *New Vistas in American Art*, which insisted that, regardless of an artist's color or creed, there was "a growing cultural unity in American art."[58] Robbins read Porter's work, notably the art historian's groundbreaking survey *Modern Negro Art* (1943), which charted a history of African American art from the eighteenth century through Jacob Lawrence's *Migration Series*, completed in 1941. Whether by exhibition or in prose, Porter hammered home that African American art was part and parcel of American art writ large. He also insisted on the recognition of the immense contributions African Americans made in the

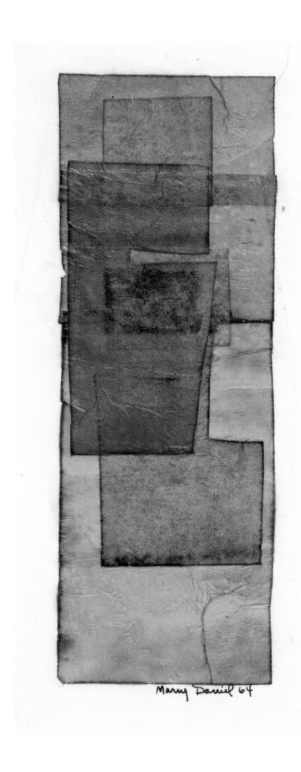

3. Mary Reed Daniel, *Integral Form*, 1964, collaged watercolor paper mounted to paper

Anacostia Community Museum, Smithsonian Institution, Anonymous gift through the American Federation of Arts

visual arts. In this way, African American art provided irrefutable proof of Black ingenuity and accomplishment. These lines of inquiry beautifully reinforced Robbins's own ideas of African art as a visual manifestation of a grand, impressive history of Black achievement in Africa and the United States.

By the late 1960s Robbins had shaped the Museum of African Art into a major player in the larger Washington Black art scene that contributed to what artist and art historian Keith Morrison described as "the transmittal of ideas of people of African descent."[59] With Howard taking the lead in the exhibition and analysis of African American art, Morrison viewed the Museum of African Art as the African piece in this varied world of art and artists, academics and curators, viewers and patrons. But the signature innovation of these years was Robbins's decision, most likely arrived at through his exposure to Porter and Howard, to start collecting African American art shortly after the 1964 opening of the museum. In effect, Robbins added the missing piece to a fully diasporic view of African art and its relation to African Americans by collecting the art that Porter favored, thereby expanding the contemporary appeal of his museum and fulfilling his conviction about the role of art in social change.

Six months after its grand opening, in December 1964, the Museum of African Art received a $5,000 grant from the American Federation of Arts (AFA) to collect works by contemporary African American artists. Robbins's stated interest was to "educate the public to the implications of traditional African sculpture in regard to its influence upon modern art and the role it can play in counteracting race prejudice." Concerning African American art specifically, he was interested in acquiring work influenced by African art as well as work by young African American artists, whatever their aesthetic leanings.[60] AFA officials approved the purchase of work by these younger artists. Given that some of the artists whose work was acquired were in their fifties and sixties at the time and that none of the objects took cues from Africa or its art, it is clear that Robbins and his assistant director, Henry Hecht Jr., interpreted "younger" broadly. Robbins told Museum of Modern Art director René d'Harnoncourt of the award of funding, adding that the works would be exhibited when the Museum of African Art facilities could include a gallery of African American art "under the umbrella 'The African Heritage.'"[61]

The AFA funds were to be spent by the following March, so Robbins and Hecht had only a couple of months to compile a list of works to be purchased. Robbins quickly put Hecht on the case. Hecht, a white man whom Robbins had hired in 1964, had previously been a lecturer and arts advisor to galleries in Washington, New York, and Provincetown, Massachusetts, and had been employed as an administrative assistant at the Corcoran Gallery of Art.[62] He was also a member of the Hecht department store family, whose company donated $1,000 to the Museum of African Art in 1964.[63] The assistant director collected information on myriad African American artists and visited

galleries, studios, and even artists' living rooms in Washington and beyond.[64] On February 23, 1965, Hecht reported to Robert Luck at the AFA that he had seen the work of twenty artists in Washington and New York and that he had plans to call in on several other artists. He was concerned, however, with the singular concentration on East Coast artists, and he asked Luck for an extension on spending the funds so that he could see artists from other parts of the country.[65] The museum was permitted to hold back $1,500.

Robbins and Hecht had a difficult time deciding on what to acquire. It is also clear that the AFA deadline was not met. Despite the rapidly approaching deadline to spend the funds, Robbins insisted that they create the best possible collection, dictated by both the quality of the artwork and the desire to include work by a broad swath of African American artists. He saw the requirement to make selections quickly as a deterrent to this goal, and he accused Hecht of making hasty decisions.[66] Robbins also took issue with the high prices Hecht was willing to pay for some works. "I believe," Robbins wrote, "that we should have more than ten or twelve artists represented for a $5,000 grant." With these funds, Robbins wanted to purchase the best examples they could get of work by the twenty-five best African American artists.[67]

More specifically, Robbins felt that it was vital to include works by Jacob Lawrence, at the time one of the best-known African American artists, and James Porter. Robbins knew that having one of the latter's paintings could prove beneficial to the museum's relationship with Howard, which he described as "important if not ultimately crucial."[68] Robbins also thought that including Porter in the collection might spur him to become actively engaged in the museum, something, Robbins noted, that had not yet happened. Beyond the inclusion of a painting, Robbins sought Porter's approval of his choices, as "he is an Old Pro who has earned much respect as a teacher, and we suffer in comparison for being too new in the field (your age and my inexperience)."[69]

Despite his newness and position as a twenty-something assistant director of a museum, Hecht provided insight into the museum's plans for contemporary African American art. On notifying Mary Reed Daniel on the recommendation that her watercolor/collage *Integral Form* (1964; fig. 3) would join the museum's burgeoning collection, Hecht explained:

> The American collection was started when we received a grant from the American Federation of Arts Association [*sic*] to select and purchase works by Negro American contemporary artists. We accepted on the grounds that it would be interesting, educational, and beneficial to have, in addition to the African collection, examples of contemporary African, historical American Negro, and contemporary American Negro artists represented in order to show the flow of the Negro in the visual arts.[70]

The museum purchased Daniel's work for forty dollars.

Hecht continued to seek out art that formally satisfied the demands for quality and accorded with financial requirements. The Daniel purchase was the least expensive. In cases of better-known, male artists, Hecht paid far more. Charles Alston's *Arrangement in Blue and Gray* (before 1965; fig. 4) went for $1,000. Richard Mayhew's oil *Ephemeral* (1965; now lost) cost $800.

Hecht bargained aggressively to get better prices for the works. In the case of Alston, Hecht claimed that if the artist could lower the price of *Arrangement in Blue and Gray* by one-third, he could include "four additional younger artists who are struggling for recognition." He added that this was not in the interest of cost savings but in building as broad a collection as possible. Hecht made similar cases to other better-known artists.[71] Alston agreed to lower his price from $1,500 to $1,000. The $500 discount would be considered a personal contribution from

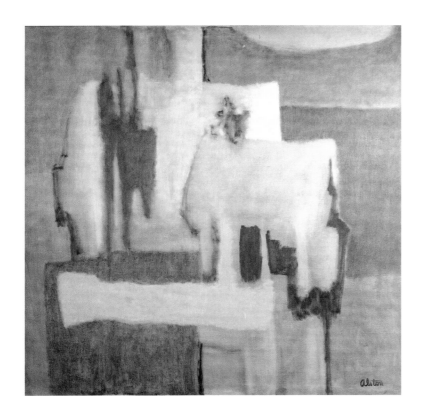

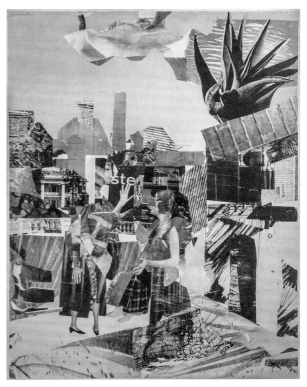

4. Charles Alston, *Arrangement in Blue and Gray*, before 1965, oil on canvas

Anacostia Community Museum, Smithsonian Institution, Anonymous gift through the American Federation of Arts

5. Romare Bearden, *Blue Projection*, 1965, photographic print and collage on paper mounted to hardboard

Anacostia Community Museum, Smithsonian Institution, Anonymous gift through the American Federation of Arts. © 2022 Romare Bearden Foundation / Licensed by VAGA at Artists Rights Society (ARS), New York

the artist to the museum.[72] Other artists also agreed to discount their work. Romare Bearden's *Blue Projection*, priced at $350, went to the museum for $300 (1965; fig. 5).[73] Perhaps one of the lesser-known artists who benefited from Hecht's negotiations was Sam Gilliam, called "an artist to watch" in 1964. The museum purchased his painting *Muse I* (1965; fig. 6) for $250.[74]

Despite his anxiety about the speed of making selections, on March 9, 1965, Robbins sent two lists compiled by Hecht to Luck. Robbins considered the first to be definitive and asked that AFA approve it so the Museum of African Art could move ahead with its purchases. The second was a tentative list with options for spending the $1,500 that was held back. Hecht noted when transmitting the lists to Robbins that they had chosen a painting by Porter, but it had been sold before they could come to an agreement on it. He was also receiving references for artists in Philadelphia.[75] With AFA funds the museum purchased twenty-six objects by seventeen artists. In addition to those already mentioned, they included Benny Andrews, Ralph Arnold, Calvin Douglass, Alvin C. Hollingsworth, Theodore J. Jones, Jacob Lawrence, Norma Morgan, Robert Dennis Reid, and Hale Woodruff (figs. 7–15), as well as Emma Amos and Norman Lewis.[76] At the end of the day, Luck, no doubt irritated by Robbins and Hecht's lack of organization and influenced by conversations with people at Howard, felt "that trivial and unimportant minor works unworthy of a museum's walls have, in general, been selected by the Museum."[77] As much as Luck hated Hecht's choices, several of the artists whose work Hecht purchased are among the best-known and most highly acclaimed African American artists of the twentieth and twenty-first centuries: Alston, Amos, Andrews, Bearden, Gilliam, Lawrence, Lewis, Mayhew, and Woodruff.

Robbins employed other strategies to build the museum's collection of African American art. He contacted longtime Harmon Foundation director Mary Beattie Brady. The Harmon Foundation had begun sponsoring programs for African American artists in 1926 and over the

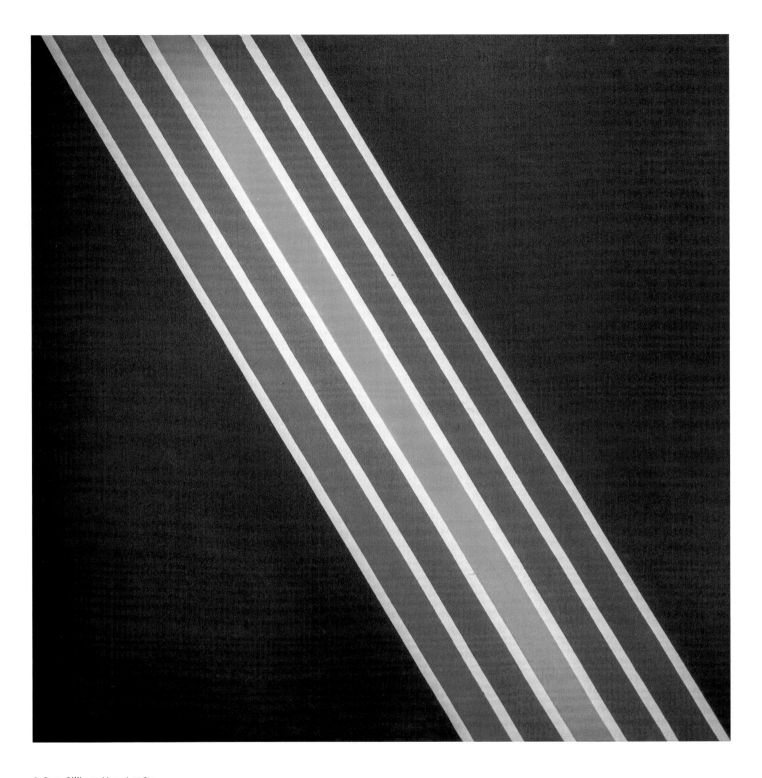

6. Sam Gilliam, *Muse I*, 1965,
acrylic on canvas

Anacostia Community Museum,
Smithsonian Institution, Anonymous
gift through the American Federation
of Arts. © Sam Gilliam / Artists Rights
Society (ARS), New York

7. Benny Andrews, *Bliss*, 1964, oil and painted fabric on canvas

Anacostia Community Museum, Smithsonian Institution, Anonymous gift through the American Federation of Arts

8. Ralph Arnold, *Odalisque*, 1964, oil, acrylic, and printed paper on canvas

Anacostia Community Museum, Smithsonian Institution, Anonymous gift through the American Federation of Arts

9. Calvin Douglass, *Composition in Red ("And")*, 1965, acrylic, resin, and plaster on board

Anacostia Community Museum, Smithsonian Institution, Anonymous gift through the American Federation of Arts

10. Alvin C. Hollingsworth, *Untitled*, before 1965, ink on collaged paper

Anacostia Community Museum, Smithsonian Institution, Anonymous gift through the American Federation of Arts

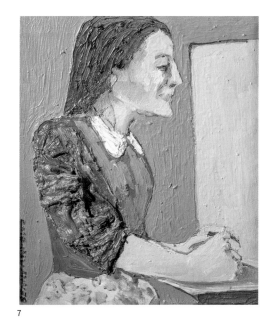

7

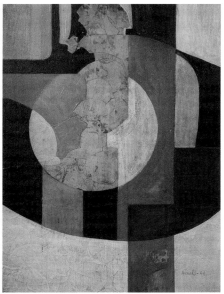

8

9

10

11

12

13

14

15

11. Theodore J. Jones, *Untitled #14*, 1965, ink and watercolor on paper

Anacostia Community Museum, Smithsonian Institution, Anonymous gift through the American Federation of Arts

12. Jacob Lawrence, *Untitled*, before 1965, tempera on board

Anacostia Community Museum, Smithsonian Institution, Anonymous gift through the American Federation of Arts

13. Norma Morgan, *A Moor Fire*, 1960, watercolor on paper

Anacostia Community Museum, Smithsonian Institution, Anonymous gift through the American Federation of Arts

14. Robert Dennis Reid, *North Win X, O Games*, before 1965, mixed media on canvas

Anacostia Community Museum, Smithsonian Institution, Anonymous gift through the American Federation of Arts

15. Hale Woodruff, *Study for "Africa and the Bull #4,"* before 1965, gouache and charcoal on paper

Anacostia Community Museum, Smithsonian Institution, Anonymous gift through the American Federation of Arts

years had amassed a considerable collection of work. It ceased operations in 1967, and as part of its dissolution, its art was to be distributed among various institutions around the United States.

Robbins explained the museum's mission to Brady and outlined what he felt were their shared values with respect to American education and interracial understanding. The two had talked about Black identity and its place in the psyches and work of Black artists; for example, they both believed that racial identity should be incidental in the larger scheme of things. Robbins insisted on the need for Black Americans to see the work of accomplished African American artists as examples of extraordinary Black achievement. "There has been precious little," he added, "that our society has done to show the Negro people how much they have participated in—and how much they have a stake in—everything that is American."[78]

As Robbins had done with others on numerous occasions, he described to Brady plans to create a gallery of African American art that would consist of, in his words, "a historical collection of as many of the important Negro artists as possible."[79] Robbins noted that work had already begun with the AFA grant. He detailed plans for individual shows of artists such as Lawrence, whose famous and often lauded work would legitimate the museum's mission. As Robbins had explained to d'Harnoncourt some eighteen months earlier, the gallery of African American art was part of a larger move to show the African heritage of Black and white America. Placing African American art under this rubric was intended to convey a transatlantic continuum of Black contributions to world culture.

Robbins noted the Harmon Foundation's plan to distribute its collection to organizations such as the National Portrait Gallery, the National Collection of Fine Arts, and the Hampton Institute, among others. Offering his opinion that the foundation's strategy was "wise" but attempting to make the case that the Museum of African Art was best poised to continue the Harmon Foundation's objectives after its dissolution, he asked that Brady consider the Museum of African Art as one of the repositories for the foundation's collection.[80] About two months later, on September 22, 1966, Robbins followed up with an urgent plea for help in creating a solid collection of "paintings of great Negro figures in American life and history" consisting of works that were both informative and aesthetically superior.[81]

By mid-October, it seemed that the Harmon Foundation was inclined to give art to the Museum of African Art. Robbins issued an exigent request for action, reiterating that the institution was in greatest need of depictions of important African American historical figures.[82] "It is in this area," Robbins wrote, "that as a Museum we are almost totally lacking in suitable materials, and it is in this area that we can develop the strongest exhibit context in which to interest and inspire the thousands of Negro children who will be coming to the Institute and Museum for lectures and orientation."[83] These works were to be included in the *Panorama of Negro History*, replacing the paintings by Henry Dabs that Robbins had commissioned for it.[84] In an attempt to further convince Brady of the value of the Museum of African Art as a repository, Robbins assured her that whatever the Harmon Foundation sent would have "maximum pedagogical impact."[85]

However hard Robbins tried to persuade Brady of their shared pedagogical interests and of the benefit of continuing them under the auspices of the Museum of African Art, the Harmon Foundation did not choose the institution as a beneficiary of its collection. Perhaps the foundation was unmoved by Robbins's educational claims. Perhaps it took umbrage with his aggressive manner. In a last-ditch letter of March 4, 1967, Robbins pleaded that Brady reconsider. Maintaining his forceful stance, he insisted that donating works to the Museum of African Art would have greater value than giving them to the National Portrait Gallery, writing, "Many of the things you would give them would be a drop in the bucket for them but would be

16. Edward Mitchell Bannister, *Swale Land*, 1898, oil on canvas

Smithsonian American Art Museum, Gift of G. William Miller

fully exploited by us."[86] He also claimed that in his institution, the works would enjoy a much greater audience than they would at Black colleges whose following would be confined to the local educational community.[87] Driving home his desire for Harmon works, he warned, "I think that hindsight will some day convince you that you are making a mistake in not enabling us to receive some modest but representative group of the works of Negro artists, and of paintings dealing with historical figures or events. You see I am persistent."[88]

While Robbins was working on acquiring art from the Harmon Foundation, in the aftermath of purchasing works with the AFA funds he had begun amassing works by nineteenth- and early twentieth-century African American artists. The collection began in 1967 with a gift from G. William Miller of fourteen works by Edward Mitchell Bannister, which he exhibited that year (1898; fig. 16).[89] In order to learn more about the field and to find works of art, Robbins enlisted the help of Carroll Greene Jr. Although not trained as an art historian, Greene had become an increasingly active figure in African American art in and around New York by the mid-1960s. He and Romare Bearden curated the important 1967 exhibition *The Evolution of Afro-American Artists: 1800–1959*, at the City College of the City University of New York. Greene and Robbins had made each other's acquaintance by 1966, and, according to Keith Morrison, Greene was instrumental in the founding of the Frederick Douglass Institute of Negro Arts and History.[90]

Greene was also an important force in the formation of the museum's African American collection, connecting Robbins with dealers who specialized in nineteenth-century African American art and conducting research on artists while locating their work. In 1966 Greene sent Robbins a photograph of Edmonia Lewis's sculpture *Hagar* (1875; fig. 17) and informed the director that the Andrew Kashey Gallery in New York owned it. Greene also included a fact sheet that, in addition to Lewis, listed four "notable" nineteenth-century African American painters, six twentieth-century Black artists, and two white artists who produced images of African Americans. Robbins quickly followed up, informing the gallery of his interest in purchasing Lewis's work. Through Greene's connections, Robbins made the acquaintance of the

17. Edmonia Lewis, *Hagar*, 1875,
carved marble

Smithsonian American Art Museum, Gift
of Delta Sigma Theta Sorority, Inc.

18. Henry Ossawa Tanner, *Gateway, Tangier*, c. 1910, oil on plywood

Smithsonian American Art Museum, Gift of Mr. and Mrs. Norman Robbins

African American sorority Delta Sigma Theta, which purchased *Hagar* in 1967 and donated it to the museum.[91] By the end of the 1960s, the museum had also acquired fifty works by Henry Ossawa Tanner, donated by Robbins's brother, Norman, and his wife, Anita (c. 1910; fig. 18).

As the Frederick Douglass Institute raised funds to purchase *Hagar*, Greene published an essay titled "The Negro Artist in America, Part I." The essay views nineteenth- and early twentieth-century African American artists in the context of the civil rights movement, which he viewed as a catalyst for reconsidering all aspects of African American experience. Political and personal, the essay creates a series of snapshots of pre-twentieth-century Black artists and details their contributions to the larger world of art against the backdrop of American racism. "The 19th-century Negro artist," Greene writes, "was confronted not only by the usual, precarious, economic plight of artists, but also by the 'cultural provincialism' of the period, the

almost universally held belief in Negro inferiority, and toward the latter part of the century, the widespread influence of the 'Gospel of Social Darwinism' which placed the Negro very low on the scale of humanity."[92] To drive his point home, he detailed how Edward Mitchell Bannister combated a racist crowd at the Philadelphia Centennial Exposition of 1876 to claim his prize for his now lost painting *Under the Oaks*.[93] Greene also attends briefly to the artist's career: "A contemporary of Church, Durand, Bierstadt, and Cropsey, with whom he shows the greatest affinities, Bannister has been considered by at least one critic as part of the American Barbizon–influenced group."[94] With such details and exegeses on the positive reception and patronage of the artists under scrutiny, in claiming that these artists were as good as—if not better than—their white counterparts, Greene wrote a revisionist history, one aligned with Robbins's conviction that showing great achievements by Africans and African Americans would undo negative stereotypes assigned by whites while raising Black self-esteem. Such lines of thought were no doubt descended from Porter's writings and exhibitions representing pre-twentieth-century artists as well as Cedric Dover's survey *American Negro Art* (1960), which interpreted African American art through the lens of Black history.[95] Greene's framing of African American art closely aligned with the Frederick Douglass Institute's mission to redress the suppression of African American history and achievement, presented in its *Panorama of Negro History*, along with what Robbins often characterized as "educational grievance" situated in "a several hundred-year 'historical blackout' concerning the role of the Negro in the development of the United States."[96]

Robbins's amassing of a collection of nineteenth-century art shows, in addition to the influence of Greene's counsel, his understanding of and fidelity to Porter's project. It also shows that Robbins's attempt to reconstruct Black history is twofold. On the one hand, African art stands as visual evidence of the longue durée of diasporic history and agency. On the other, the work of nineteenth-century African American artists shows a similar history at home. On this level, nineteenth-century African American art, as visual proof of Black history and Black achievement, serves the same social purposes as African art.

Robbins's collecting of nineteenth-century African American art did not go unnoticed. The consummate publicist, Robbins sent notices of his acquisitions to the Black and the white press. On April 27, 1967, the *Los Angeles Sentinel* published a stand-alone photograph of Delta Sigma Theta Sorority's presentation of Edmonia Lewis's *Hagar* to the Frederick Douglass Institute.[97] The museum also liberally lent works to institutions mounting exhibitions of African American art. Barely three months after the Delta Sigma Theta gift, Robbins agreed to lend *Hagar* and six Bannister works to the City University of New York for Greene's exhibition. Greene selected the paintings to be on loan. To avoid hassles and expense, Robbins told Dean Marilyn Mikulsky that he could drive the works up to New York in a station wagon.[98]

While Robbins lent out works from the museum's rapidly growing holdings in nineteenth-century African American art, the museum and institute also exhibited some of the work widely under their own auspices. In 1969 the Frederick Douglass Institute, in collaboration with the Smithsonian Institution's National Collection of Fine Arts (now the Smithsonian American Art Museum), organized the exhibition *The Art of Henry O. Tanner*, which followed the example of Greene's earlier exhibition and Porter's *Ten Afro-American Artists of the Nineteenth Century*, shown at the Howard University Gallery of Art in 1967. Robbins noted that this exhibition was a product of the increased interest in understanding the contributions of African Americans to the life and culture of the United States.[99] He also boasted that it "provides the first real opportunity for the American Public to become acquainted with the work of an important American expatriate artist of the late 19th and early 20th centuries."[100] Through the

Smithsonian Institution Traveling Exhibition Service, during 1969 and 1970 *The Art of Henry O. Tanner* traveled to six venues across the United States: Cleveland Museum of Art; McNay Art Institute, San Antonio; Isaac Delgado Museum of Art, New Orleans; Museum of Art, Carnegie Institute, Pittsburgh; and Brandeis University in Massachusetts. With this kind of exposure, it is fair to say that in the late 1960s, Tanner and his fellow nineteenth-century African American artists were the jewels in the crown of the Museum of African Art.

Although the nineteenth-century works of art, particularly those by Tanner, traveled widely and African art was showcased in the museum, the same was not true for contemporary African American art. It is not even clear, outside their exhibition between March 1965 and January 1966, that these works were ever on display. During the museum's 1970 renovation and expansion, in a welcome to attendees of that year's College Art Association conference in Washington, Robbins noted that most of its work by African American artists was out on loan. Beyond the forty Tanner works in the traveling exhibition, Robbins explained that in addition to nineteenth-century works, those by Alston, Arnold, Gilliam, Lawrence, and Woodruff had been lent to various museums for exhibitions. He also reported that twenty-four African American artists were presently represented in the collection.[101] During the renovation, the Smithsonian's National Portrait Gallery hosted the critically acclaimed Museum of African Art exhibition *The Language of African Art*, which included 425 objects. Three hundred of these were from the museum's 2,500-item collection. The others were borrowed from public and private sources.[102]

The Museum of African Art had nine-inch busts of Frederick Douglass by African American sculptor Inge Hardison and publications on African American art for sale to visitors. The texts included not only catalogs of the nineteenth-century exhibitions spearheaded by Greene and Robbins as well as by Porter but also Dover's survey, a reprint of Greene's essay on African American artists, and the catalog *Ten Negro Artists from the United States,* produced for the First World Festival of Negro Arts, which took place in Dakar, Senegal, in 1966.

The Museum of African Art and the Frederick Douglass Institute, twin children of the 1960s, entered a conversation about art, Black history, and African American agency that had already been taking place. Yet, because of the nature of the institutions or perhaps because of Robbins's personality, while the museum enjoyed considerable Black attendance and offered myriad educational initiatives, it never succeeded in becoming a central institution in Washington's Black art world or in the city's Black communities writ large. However, Black artists did visit the institution. Sam Gilliam noted that Robbins's juxtaposition of African and modern art at the museum "brings out a sense of identity very strongly."[103] If Gilliam's observation is any indication, Robbins's intentions for art and the possibilities for raising African American self-esteem were not lost on the museum's visitors. The Frederick Douglass Institute and the Museum of African Art did create an interracial audience that otherwise would never have seen African and African American art in Washington. On this score, the museum succeeded where other institutions failed. For Robbins and his white supporters this development was the fulfillment of the civil rights dream.

Coda

By the mid-1970s Robbins had decided that the Museum of African Art's best chance for survival would be to become part of the Smithsonian Institution, and he proposed the plan to then Smithsonian secretary S. Dillon Ripley at the opening of the Hirshhorn Museum in 1974. Ripley supported the idea. The proposal, which moved smoothly through Congress, became a reality in 1979.[104] At the time of the transfer, the museum's collection and its real estate were valued at

19. Edward Mitchell Bannister, *Driving Home the Cows*, 1881, oil on canvas

Smithsonian American Art Museum, Gift of G. William Miller

$10 million.[105] However, Robbins did not realize that the move to the Smithsonian would mark the beginning of the end of his control over and vision for the museum.[106]

The museum and the Frederick Douglass Institute had continued collecting nineteenth-century African American art throughout the 1970s. With the help of Providence-based dealer Edward Shein, this area of the museum's collection grew by leaps and bounds. Indeed, in a draft version of a 1979 press release for the Black History Month exhibition *Five Nineteenth-Century Afro-American Artists*, the organization claimed that its holdings in this area constituted "the most comprehensive of its kind in existence."[107] Robbins and his colleagues may well have been right. Be that as it may, despite collecting activity, African American art would never make up more than a small portion of the museum's holdings.

As the museum continued to amass works by nineteenth-century African American artists, it began storing more and more of them at the Smithsonian's National Collection of Fine Arts. It seems that, with the entry of the Museum of African Art into the Smithsonian, plans were afoot to transfer the works in storage to the National Collection of Fine Arts. Some works, such as Bannister's 1881 *Driving Home the Cows*, were already on display in this venue (fig. 19).[108] In 1983 the National Collection of Fine Arts, by then renamed the National Museum of American Art, officially accessioned the Museum of African Art collection of more than two hundred paintings, drawings, and sculptures by nineteenth-century African American artists, more than quadrupling the number of works by African American artists in its collection. With its holdings from the Harmon Foundation, acquired in 1967, the National Museum of American Art could credibly claim to have the country's largest, most comprehensive collection of African American art.

The contemporary works by African American artists purchased in 1965 remained in the Museum of African Art collection until their move to the Smithsonian Anacostia Community Museum in 2002. In making the offer of the work, assistant curator Bryna Freyer noted that this body of work was part of a plan of "deaccessioning objects outside of the scope of the National Museum of African Art . . . collection."[109] The cleaving of African American art from the museum's collections and the erasure of its presence from written accounts of the National Museum of African Art have resulted in the forgetting of Robbins's diasporic vision and the institution's roots in the civil rights movement.[110]

The transfer of nineteenth-century African American art to the National Museum of American Art was a concrete sign that under the aegis of the Smithsonian, the mission of the Museum of African Art was changing. In 1982, as these works migrated, Robbins's tenure as director came to an end. The following year he was succeeded by Sylvia Williams, an art historian with a master's degree in African art history from New York University and former curator in the department of African, Oceanic, and New World cultures at the Brooklyn Museum. Gone would be Robbins's interdisciplinary vision of the CCCC, with its allowance of an intersection between African and African American art that offered a broad view of peoples dispersed by the transatlantic slave trade and relayed a visual history of Black achievement in the United States. In its place, Williams developed a professional museum driven by scholarly research and the exhibition of the finest examples of African art available. This shift coincided with a rapid professionalization of the study and presentation of African art that took place in US and European academic institutions and museums during the 1980s.

We will never know how the Museum of African Art and Robbins's control over it would have evolved had a Howard collaboration worked. Be that as it may, both institutions advanced diasporic notions of Black art that were in conversation with one another. The failure of the two institutions to forge a sustained relationship was a lost opportunity to create an art museum in Washington that reflected the city's unique approach to linking the art of Africa to the art of African Americans in the nineteenth and twentieth centuries. This was the vision that Porter supported in his later years, Donaldson stressed during the 1970s, and Robbins realized in the Frederick Douglass Institute. But the Smithsonian's National Museum of African Art left it behind. Moreover, under Williams's tenure, NMAfA renounced the spatial politics of the earlier iteration, morphing from what Paul Richard remembered as a "warren of townhouses" resembling a "multimedia, multicultural, multi-audience community center" more than a museum to an institution that "strove . . . to serve the art of Africa much the way the grand museums of the West treat the art of Europe."[111]

Without knowing the full scope of NMAfA's multilayered history and without considering Robbins's drive in its creation, it is impossible to grasp fully the myriad forces that shaped the museum. More important, it is impossible to understand the museum's complicated and often contentious relationship to its African American surroundings. The museum's history as a private institution that strove to link itself locally contributed paradigms for African art, African American art, and African American history that, however challenging, created a unique exhibition space for Black art. While we might argue that the Museum of African Art had a bigger effect on white politicians, the field of African art history, and schoolchildren than it did on Washington's African American art circles, the opportunity it created for an interracial community of people to routinely attend openings and other events centered on African art was groundbreaking. This interracial, and international, community continues to come together at NMAfA today.

DC'S BLACK-OWNED ART GALLERIES, 1960S TO 1980S: PREQUEL TO A RENAISSANCE

Jacquelyn Serwer

"What [is it] about Washington that allows even an important part of its cultural heritage to lie fallow, to go unrecorded and/or uninterpreted?"

—Benjamin Forgey

One sphere of culture in Washington, DC, to go unrecognized for most of the twentieth century, except by its own community, is art created by African American artists. Until the 1970s, there were only a few venues where the public could see such work. Although sculptor May Howard Jackson exhibited at the Veerhoff Galleries as early as 1916,[1] during the early twentieth century, the primary DC home for African American artists was the Howard University Gallery of Art, founded in 1928. James Vernon Herring, founder of the university's art department, and James A. Porter served as the gallery's first two directors (fig. 1). Gwendolyn H. Everett's essay in this volume provides a detailed history of that institution. This essay surveys some of the other venues, many of which have not endured but played a vital role in supporting the African American art community in Washington, DC.

The Tanner Art League, whose home was the distinguished Dunbar High School (fig. 2), hosted exhibitions from 1919 to 1923, under the auspices of an organization originally known as the Tanner Art Students' Society. Several artists featured in those exhibitions went on to enjoy successful careers. Those artists include Laura Wheeler Waring, a painter and printmaker who studied in France (fig. 3); painter Lois Mailou Jones, also a professor of art at Howard University (fig. 4); Allan Randall Freelon Sr., the grandfather of Philip Freelon, who was one of the key architects of the building for the Smithsonian's National Museum of African American History and Culture (fig. 5); May Howard Jackson, a successful sculptor who had exhibited her work at New York's National Academy of Design; and Frederick Jones Jr., a Chicago artist and alumnus of Clark College, Atlanta University, Georgia (fig. 6).

The *American Magazine of Art* praised the Tanner Art League's first show in 1919, calling it "an exceedingly creditable exhibition of paintings, drawings and works in sculpture by young colored men and women who are making a profession of art."[2] By 1922, the league's annual show featured more than one hundred works of art, including examples by young artists such

1. Scurlock Studio, *James A. Porter*, n.d., cellulose acetate photonegative

Scurlock Studio Records, c. 1905–1994, Archives Center, National Museum of American History

2. Third annual exhibition catalog of the Tanner Art League, 1922, Dunbar High School, Washington, DC

Courtesy Smithsonian Libraries

Catalogue
of the
Third Annual Exhibition
of the

TANNER ART LEAGUE (COLORED)

Art Rooms, Dunbar High School
Washington, D. C.
1922

3. Laura Wheeler Waring, *Girl in Red Dress*, c. 1935, oil on museum board

Collection of the Smithsonian National Museum of African American History and Culture. © Laura Wheeler Waring

4. Lois Mailou Jones, *Château d'Olhain*, 1947, oil on canvas

Collection of the Smithsonian National Museum of African American History and Culture, Gift of the Dr. Gregory L. Shannon Family. © Lois Mailou Jones Pierre-Noel Trust

5. Allan Randall Freelon Sr., *Number One, Broad Street*, 1935, aquatint and etching

Collection of the Smithsonian National Museum of African American History and Culture. © Allan Randall Freelon Sr.

6. Frederick Jones Jr., *The Strikers*, 1937–1940, black carbon ink on paper

Collection of the Smithsonian National Museum of African American History and Culture. © Estate of Frederick D. Jones

7. Meta Vaux Warrick Fuller,
Ethiopia, c. 1921, paint on plaster

Collection of the Smithsonian
National Museum of African American
History and Culture, Gift of the Fuller
Family. © Meta Vaux Warrick Fuller

as Meta Vaux Warrick Fuller (fig. 7) and Charles Alston (fig. 8). Both would later enjoy wide recognition and acclaim.

In addition to the Howard University Gallery of Art, there were a few places of pilgrimage where the work of African American artists permanently installed could be admired. A notable example is the DC Recorder of Deeds office (figs. 9–10). When the office was relocated in 1943, an art competition was held for murals to ornament the new space. African American painter William Edouard Scott, a Chicago artist who had studied in France with Black American expatriate Henry Ossawa Tanner, was one of the painters selected. The subjects were intended to honor the contributions of African Americans. Scott's mural was entitled *Frederick Douglass Appeals to President Lincoln* (1943)—a fitting subject given that Douglass had been the first to hold the position of recorder of deeds, from 1881 to 1886. The space also featured a bronze relief of Franklin D. Roosevelt by African American artist Selma Burke, whose image is thought by many to have inspired the engraving of FDR on the dime (fig. 11).

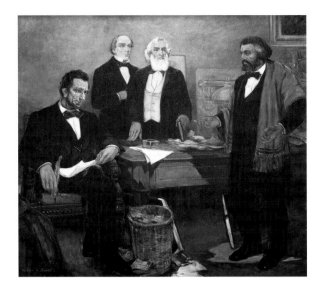

8. Andrew Herman, *Charles Alston*, 1939

Federal Art Project, Photographic Division collection, c. 1920–1965, bulk 1935–1942, Smithsonian Archives of American Art

9. William Edouard Scott, *Frederick Douglass Appeals to President Lincoln*, 1943

Recorder of Deeds Building, Washington, DC

Library of Congress, Prints and Photographs Division

10. Recorder of Deeds building, 515 D Street NW, Washington, DC

Courtesy DC Preservation League. Photo: Carol Highsmith

11. Selma Burke, plaque of Franklin D. Roosevelt, bronze

Recorder of Deeds Building, Washington, DC

Creative Commons 2.0, http://flic.kr/p /adkQZ

12. Alonzo Aden helps Eleanor Roosevelt sign the guest book during her visit to the Barnett-Aden Gallery, 1943

Photo: Afro-American Newspapers/Gado/ Getty Images

13. Elizabeth Catlett, *Reclining Female Nude*, 1955, bronze

National Gallery of Art, Corcoran Collection (The Evans-Tibbs Collection, Gift of Thurlow Evans Tibbs, Jr.)

14. James A. Porter, *Self-Portrait*, c. 1935, oil on linen

Collection of the Smithsonian National Museum of African American History and Culture. © James Amos Porter

15. James Lesesne Wells, *Sisters*, 1929, linocut

David C. Driskell Collection, Permanent Loan to the David C. Driskell Center at the University of Maryland, College Park

Image courtesy David C. Driskell Center at the University of Maryland, College Park. Photo: Greg Staley

16. Hale Woodruff, *Georgia Landscape*, c. 1934–1935, oil on canvas

Smithsonian American Art Museum, Gift of Mr. and Mrs. Alfred T. Morris Jr.

17. Map of Black-owned galleries in and around Washington, DC, as listed in Bill Alexander, "Black Art Galleries Turning Financial Corner," *Washington Post*, October 15, 1981

Courtesy Mapbox, Inc.

❶ 10th Street Gallery
❷ Capitol East Graphics Gallery
❸ CLL Gallery
❹ Collector's Show
❺ Evans-Tibbs Collection
❻ Galerie Triangle
❼ Gallery House
❽ Genier Art Gallery
❾ Haitian Art Forum
❿ Market Five Gallery
⓫ Miya Gallery
⓬ Museum of African Art (Frederick Douglass Institute)
⓭ National Gallery of African Art
⓮ Newton Street Gallery
⓯ NOA Gallery and Design Studio (New, Old, and Abstract)
⓰ NP Gallery
⓱ Nyangoma's Gallery
⓲ Raku Gallery and Sculpture Park
⓳ Smith-Mason Gallery
⓴ Sun Gallery

After World War II, African Americans in DC began to show a marked interest in the art created in their community. This trend was due in part to the relative prosperity of well-educated African Americans, many of whom were graduates of Howard University and were successful professionals or had access to decent government jobs. The Barnett-Aden Gallery was one venue where art by African Americans could be viewed and purchased. Herring and Alonzo Aden, a former student of Herring, opened the Barnett-Aden Gallery at their home in 1943 (fig. 12). They became life partners, sharing their work at Howard and their home with the many visitors who frequented the gallery. Barnett-Aden opened with the exhibition *American Paintings for the Home*. This show featured an interracial roster including Elizabeth Catlett (fig. 13); Nicolai Cikovsky, a Russian émigré; Aaron Douglas; Porter (fig. 14); James Lesesne Wells (fig. 15); and Hale Woodruff (fig. 16) and inaugurated a remarkable series of exhibitions that spanned more than two decades.[3] The Barnett-Aden Gallery's exhibitions attracted art lovers of diverse racial backgrounds and ages.[4]

In the last quarter of the twentieth century, a remarkable change took place in the Washington art world with the emergence of twenty Black-owned art galleries (fig. 17). Reporter Bill Alexander, in a *Washington Post* article of October 15, 1981, described the phenomenon in these words:

18. Thurlow Tibbs House

Courtesy DC Preservation League

19. District Weekly cover article featuring photograph of Thurlow Evans Tibbs Jr. by Vanessa Barnes Hillian, *Washington Post*, March 14, 1985

National Gallery of Art Library, The Evans-Tibbs Collection, Subject Box: Oversize Periodicals T–Z

> A Black Visual Art Explosion is reverberating through Washington, challenging the authority of the white-owned art institutions and paving the way for black art galleries to become money-makers.[5]

Within the Black community, Adolphus Ealey, second director of the Barnett-Aden Gallery, recipient of a portion of the estate, commented:

> The white art establishment has been trying to crush us for years by determining who our artists are, but now we're around in such numbers that we can provide the space, set our own styles and values, and market our own project.[6]

A significant collection of African American art in private hands belonged to Thurlow Evans Tibbs Jr., a government employee who had inherited the works from his grandmother, the celebrated opera singer known as Madame Evanti. (See Jacqueline Francis's essay on Thurlow Evans Tibbs Jr. in this volume.) Tibbs opened a private gallery showcasing his grandmother's collection and other collected works (figs. 18 and 19). The *Washington Post* describes the collection in these words:

> The entire collection of hundreds of works included early landscapes and allegorical paintings by Henry O. Tanner, William Harper and the Harlem Renaissance artist Aaron Douglas, as well as more recent works by Lois Mailou Jones, Betye Saar, Raymond Saunders and . . . the work of Harlem photographer James Van Der Zee and Washington photographer Addison Scurlock.[7]

In 1996, a year before his death, Tibbs bequeathed the collection to the Corcoran Gallery of Art, which transferred it to the National Gallery of Art upon the Corcoran's dissolution in 2014.[8] The rich Evans-Tibbs Archive of African American Art is now cataloged and available for research at the National Gallery.[9]

One of the earliest Black-owned galleries, Smith-Mason Gallery opened in 1967 (fig. 20).[10] The Sun Gallery, founded in 1978, was another pioneer among the Black galleries (fig. 21).[11] It handled the work of painter and printmaker James Lesesne Wells, and another of its artists, Delilah Pierce, was a DC schoolteacher whose work was featured at both the Anacostia Museum

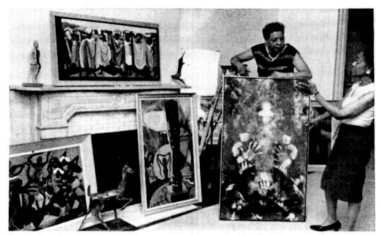

Preparing for one-woman show at Washington's Smith-Mason Gallery of Art, artist confers with gallery director, Mrs. Helen S. Smith. Haitian government later purchased three of her paintings for permanent palace collection.

SUN GALLERY

Presents
recent work
by

3 friends

Justine McClarrin
Corinne Mitchell
Delilah Pierce

October 1 thru 30, 1982
at
Sun Gallery
2324 18th Street, NW
Washington, DC

Reception
Saturday, October 16, 1982
12-5 p.m.

20. Helen Smith, director of the Smith-Mason Gallery, in *Ebony*, 1968

21. Exhibition announcement for *3 Friends: Justine McClarrin, Corinne Mitchell, Delilah Pierce*, Sun Gallery, Washington, DC, October 1–30, 1982

National Gallery of Art Library, The Evans-Tibbs Collection, Vertical Files

22. Delilah Pierce, *DC Waterfront, Maine Avenue*, 1957, oil on board

Smithsonian American Art Museum, Museum purchase made possible through Deaccession Funds

and the Smithsonian American Art Museum (fig. 22).[12] In his *Washington Post* article, Alexander noted: "Barely four years old, it [the Sun Gallery] has met with success from the beginning by seeking out the Black clientele, capturing it and keeping it."[13] In the same article, Washington artist Sam Gilliam described the new art scene for Black art in these words: "The District is going through a phase of aggressive growth without comparison anywhere."[14] The formula for success included cultivating economically secure Black professionals, encouraging them to visit the galleries not only to see new contemporary art but to enjoy ethnic crafts. In addition to the fine art, the Sun and Miya featured African-inspired handmade items and fabrics; and the

23. Location of Raku Gallery and Sculpture Park Building, 310 Seventh Street NW, Washington, DC

Square 432 (Commercial Buildings), Seventh, D, and Eighth Streets and Pennsylvania Avenue NW, Washington, DC

Historic American Buildings Survey, Library of Congress Prints and Photographs Division

24. Richard Dempsey, *Untitled*, 1940, pastel on paper

Smithsonian American Art Museum, Gift of Vonja Kirkland-Dempsey

Miya Gallery offered a display window where clients could be seen having their hair braided into corn rows.[15]

That Black-owned galleries were in existence as early as 1943, with the Barnett-Aden Gallery, speaks to the existence of an audience and a continuing production of art over many decades. Other Black-owned galleries and spaces where Black artists could present their work include the Market Five Gallery (founded in 1974); Capitol East Graphics Gallery (1979); Galerie Triangle (1978); Gallery 1221 (1982); and the Parish Gallery (1991). Art by Black artists in DC was not only fostered and cherished at Howard University but also blossomed in venues throughout the city, contributing to the culture and sophistication of the nation's capital. The Raku Gallery and Sculpture Park was perhaps the most innovative among its peers (fig. 23). A family affair, the owners claimed they were ignored by the cultural media, in contrast to their white counterparts.[16] Among the established white commercial galleries in DC that exhibited the work of African American artists, Franz Bader Gallery and Bookshop was exemplary. It featured Black artists from its beginning, including Richard Dempsey (fig. 24) and Alma Thomas (fig. 25).

Another nontraditional gallery, Nyangoma's Gallery, was established by Lusetha Rolle, JoAnn Rolle-Katabaruki, and Constance Hamilton—all Black women—and considered its mission to be "a building program for unknown or unrecognized Third World Artists."[17] However, the gallery also exhibited work by the world-renowned Gilliam in 1983, when it featured prints made at the Brandywine Workshop (fig. 26).

Despite this blossoming of art and craft in commercial venues around the city, Black artists remained under-represented in the city's museums. The exceptions were The Phillips Collection and the Smithsonian American Art Museum, then known as the National Museum of American Art. (See Elsa Smithgall on The Phillips Collection in this volume.) At the Phillips,

160

25. Alma Thomas, *Suddenly It's Spring*, 1970, acrylic on canvas

Collection of the Smithsonian National Museum of African American History and Culture, Gift of Joan Willis Holton. © Charles Thomas Lewis

26. Sam Gilliam, *Pretty Boxes*, 1993, offset and screen printed colors, edition of 86, printed by Robert W. Franklin and Allan L. Edmunds at Brandywine Workshop and Archives, Philadelphia

© Sam Gilliam / Artists Rights Society (ARS), New York

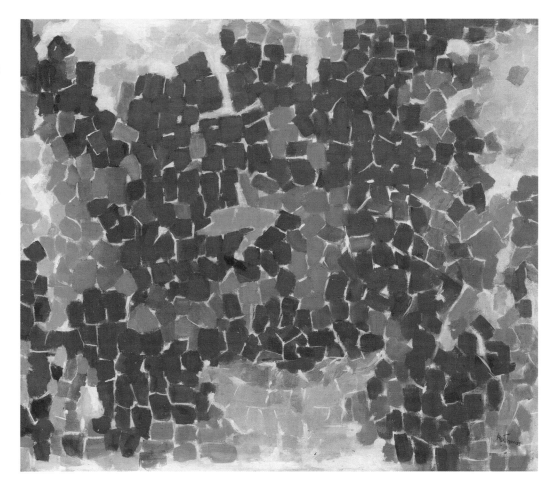

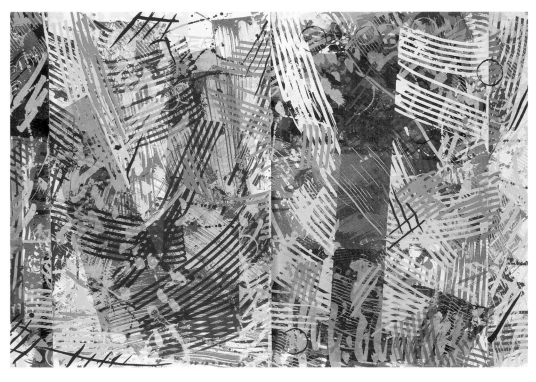

Jacob Lawrence's *The Migration of the Negro* (1940–1941; now known as *The Migration Series*) was featured from time to time. In 1946, The Phillips Collection had hosted a loan exhibition entitled *Three Negro Artists: Horace Pippin, Jacob Lawrence, Richmond Barthé*.

In 1967 the Smithsonian American Art Museum (SAAM) had become the beneficiary of a major Harmon Foundation gift of art by African American artists. Later, donations from the Museum of African Art in 1983, the Hemphill Collection of art by self-taught artists in 1986, and the body of work by painter William H. Johnson greatly enriched its collection.[18] The subsequent stewardship by SAAM director Elizabeth Broun, chief curator Virginia Mecklenburg, and former SAAM curator Lynda Roscoe Hartigan reinforced the importance and legitimacy of this work and ably brought to bear the needed scholarship. Major exhibitions, including *African American Art: Harlem Renaissance, Civil Rights Era, and Beyond* in 2012, with its substantial catalog, have established this art as an essential component of the American art history. Curators at the Smithsonian's National Museum of African American History and Culture (NMAAHC) have benefited greatly from SAAM's collections and publications showcasing art by African Americans.

In large part, the spring 2017 symposium where this material was originally presented was inspired by the great gift of the Corcoran's Evans-Tibbs Collection, now safely housed at the National Gallery of Art. Given the National Gallery's expertise and stewardship, I trust there will be new opportunities to share this treasure trove, not only with the audience of locals and tourists here in DC but also with art galleries at historically Black colleges and universities around the country. The National Gallery deserves enormous credit for ensuring the survival and preservation of the legacy we celebrate with this publication.

VENUES FEATURING AFRICAN AMERICAN ART IN WASHINGTON, DC, c. 1940–2005

10th Street Gallery
1337 10th Street NW

Alma Thomas Memorial Gallery (1980s)
Shaw Junior High School, Rhode Island Avenue at 10th Street NW[1]

Barnett-Aden Gallery (1943–1969)
127 Randolph Place NW[2]

Bethune Museum-Archives (1980s)
1318 Vermont Avenue NW[3]

Capitol East Graphics Gallery (1979–1999)
600 E Street SE[4]

CLL Gallery
2219 First Street NW

Duke Ellington School of the Arts (1980s)
3500 R Street NW

Evans-Tibbs Collection (1979–1997)
1910 Vermont Avenue NW

Galerie Triangle
1206 Carrollsburg Place SW (until 1987)
3701 14th Street NW (1987)[5]

Gallery 1221 Inc. (1982)
1221 11th Street NW[6]

Gallery House
1219 O Street NW[7]

Haitian Art Forum
1823 Kalorama Road NW

Howard University Gallery of Art (1928–present)
2455 Sixth Street NW

Market Five Gallery (1974–2005)
Seventh Street and North Carolina Avenue SE[8]

Miya Gallery
720 11th Street NW (1978)
420 Seventh Street NW (1981)[9]

Museum of African Art (Frederick Douglass Institute) (1964–1979)
316–322 A Street NE[10]

National Gallery of African Art
317 Massachusetts Avenue NW[11]

Newton Street Gallery
1646 Newton Street NW

NOA Gallery & Design Studio (New, Old & Abstract) (1978–2013)
132 Rhode Island Avenue NW[12]

Nyangoma's Gallery (1980–1990s)
2335 18th Street NW[13]

Parish Gallery (1991–2013)
1054 31st Street NW[14]

Raku Gallery and Sculpture Park (1981)
310 Seventh Street NW

Smith-Mason Gallery (1967–1985)
1207 Rhode Island Avenue NW[15]

Sun Gallery (1978–1984)
2324 18th Street NW[16]

Vision Inc. (1982–unknown)
413 H Street NE[17]

This list documents venues in Washington, DC, that showed work by Black artists. Many of them were also Black-owned galleries. Dates given in parentheses indicate documented periods of operation.

THE EVANS-TIBBS COLLECTION:
A LEGACY PROJECT

Jacqueline Francis

Over the last twenty-five years, private collections of African American art owned by African Americans have been the subjects of exhibitions at American museums and libraries. The holdings of Camille and Bill Cosby, David C. Driskell, Grant Hill, Robert Johnson, Pamela Joyner, Harmon and Harriet Kelley, Elliot and Kimberly Perry, and Darrell Walker have been featured in eponymously titled traveling shows, and they are the main subjects of scholarly publications that accompany them. These projects in no small part were born of *African-American Artists, 1880–1987: Selections from the Evans-Tibbs Collection*, an exhibition mounted at twenty venues from 1989 to 1992. A partnership between Washington collector and art dealer Thurlow Evans Tibbs Jr., the Smithsonian Institution Traveling Exhibition Service (SITES), and the University of Washington Press, the exhibition and its accompanying catalog had a clear objective: they came together "so that the story of Black American artists can be told."[1] The through line between Evans-Tibbs and successive generations of African American collections is most evident.

Tibbs was a passionate, self-made collector (fig. 1). Born in Washington, DC, he earned undergraduate and graduate degrees from Dartmouth and Harvard colleges, where he had studied design and city planning, as well as taken a few art history courses. Afterward, he returned to Washington. He was a facilities planner for the federal General Services Administration—a position he held until 1989—and he began to acquire art, rare books, exhibition catalogs, and ephemera by or about Black Americans.[2] Tibbs established his collection and exhibition space at a time when there were several galleries in Washington dedicated to featuring the work of artists of African descent, among them the Smith-Mason Gallery, Capitol East Graphics Gallery, and Parish Gallery.[3] Before the 1980s, the number of Washington museums that invited Black artists' participation was few.[4] In 1933, the Smithsonian National Gallery of Art (now the Smithsonian American Art Museum) presented *Exhibition of Works by Negro Artists*, a survey of work by Howard University and Atlanta University students, and by mature contemporary artists, including Archibald J. Motley Jr., William Edouard Scott, and Albert Alexander Smith. In 1942 The Phillips Collection displayed Jacob Lawrence's *The Migration of the Negro* (1940–1941; now known as *The Migration Series*) and purchased half of the series's sixty paintings for its permanent collection. In the mid-1940s the Phillips also showed the work of Horace Pippin, Allan Rohan Crite, and Lois Mailou Jones, who was honored with a solo show in 1972 as well.

1. Thurlow Evans Tibbs Jr. in his gallery, July 25, 1984

Photo: Bill Snead/*Washington Post* via Getty Images

In 1944 Caresse Crosby organized a solo exhibition for Romare Bearden at her G Place Gallery. Painters Jones and Lila Asher, both longtime Howard University art history department faculty members, organized African American art exhibitions not only in their studios but also in public institutions, such as at the Martin Luther King Memorial Library Gallery, where they curated the group show *The Blue Horse* in 1978, along with Delilah Pierce (fig. 2). The previous year this library had been the site of another group exhibition, *Paintings and Graphics by Women on African and Afro-American Themes*, curated by Edith T. Martin, an active artist and curator who organized exhibitions for the Anacostia Neighborhood Museum.[5]

The Evans-Tibbs Collection and the Barnett-Aden Gallery

The Barnett-Aden Collection was a model for the Evans-Tibbs Collection in a number of ways. The Barnett-Aden Gallery opened in 1943 under the leadership of codirectors James V. Herring and Alonzo J. Aden, and it was named for Aden's mother, Naomi Barnett Aden, a teacher and arts patron.[6] Aden, the curator at the Howard University Gallery of Art, lived with Herring, an art professor and painter at Howard University, at 127 Randolph Place in Northwest Washington. They were life partners who made their private home a public exhibition space. The Barnett-Aden Gallery presented School of Paris prints by such artists as Henri Matisse, Amedeo Modigliani, Pablo Picasso, and Georges Rouault, and historical and contemporary art by Americans of African and European descent, including Bearden, Henry Ossawa Tanner, Isaac Soyer, and Irene Rice Pereira. Some of the exhibited works were from Aden and Herring's collection; others were borrowed from other Washington collections, including The Phillips Collection.[7] Barnett-Aden was an interracial social space, regularly visited by artists who showed there and interested Washingtonians, such as Sam Gilliam, Duncan Phillips, Eleanor Roosevelt, Kenneth Noland, and Morris Louis (fig. 3).[8] The gallery closed in 1969, and Tibbs had never visited it. Yet its history surely resonated for Tibbs, an Ivy League–educated, gay African American man

LIBRARY FOR THE ARTS
D.C. PUBLIC LIBRARY
PRESENTS

THE BLUE HORSE

An EXHIBIT organized by: Lois Jones Pierre-Noel
Delilah Pierce
Lila Asher
assisted by: Bernard Brooks
Clemon Smith

MARTIN LUTHER KING
MEMORIAL LIBRARY
Gallery A-6

APRIL 6-29, 1978

RECEPTION:
Thursday, 13 April, 5-7 PM

WHY THE BLUE HORSE?
Often colors, other than the expected natural ones, express the essence of an object in a special and personal way for the artist, which may communicate in that special and personal way to the viewer.

Franz Marc's "Blue Horse" was the inspiration for the name and theme of this exhibit. Marc was a German artist, influenced by earlier French impressionist painting. He was one among many who painted animals, objects, and landscapes in unexpected colors.

It is our hope that the brilliant, exciting, and unusual colors used in the paintings and works in other media in this exhibit will help to enhance the happy spirit of spring.

Lois Jones Pierre-Noel
Delilah Pierce
Lila Asher

EXHIBITING ARTISTS
and their WORKS

Asher, Lila
The Jazz Piano (linocut)
Quartet in D Major (linocut)
Brooks, Bernard
Cityscape (acrylic)
Untitled (acrylic)
Brown, Bruce
Les Fleurs (acrylic)
Still Life (acrylic)
Cambridge, Roslyn
Dizzy Spell (oil)
Random Strokes (oil)
Roots (linocut)
Cherry, Shroeder
Boogie (acrylic)
Guidance (acrylic)
Young angels...FLY (acrylic)
Day, Juette
Fertility (oil)
Lake (watercolor)
Day, Marie-Denyse
Spectateurs (oil)
Gourgue, Enguerrand
Dans les Bois (acrylic)
Lois Mailou Jones
The Blue Mask (mixed media)
Letitia and Patrick (oil)
Portrait in Blue (watercolor)

Mathews, Grace
The Blue Horse (oil)
(inspired by Franz Marc)
Deer in the Forest (oil)
The German Festival (oil)
The Girl with Green Hair (oil)
Variation - The Red Horses (oil)
(inspired by Franz Marc)
Person, Peggy
Blacks and Blue (mixed media)
Pierce, Delilah
Sea & Seashells (acrylic)
Smith, Clemon
Mood of Love (acrylic)
The Fate of Pegasus (serigraph)
Tabary, Celine
Les Compagnons - Fantasy (oil)
(lent by Dr. Myrtle Henry)
Tessema, Tesfaye
One Day (acrylic)
(lent by L.J. Pierre-Noel)
Thompson, Mildred
The Blue Cat (etching)
(lent by L.J. Pierre-Noel)
Yellow Bird (etching)
Wells, James L.
Fisherman's Daughter (oil)
Tshiku-Phezo, N'damru
Fisherman (oil)

At the opening of Mr. Aden's 10th anniversary show, his gallery is crowded with artists and visitors. He is talking with Mrs. Thurlow Tibbs.
Keith Photos

PAGE 22—THE WASHINGTON STAR PICTORIAL MAGAZINE, MAY 2, 1954

2. Flyer for *The Blue Horse* exhibition at the Martin Luther King Memorial Library Gallery, April 6–29, 1978

National Gallery of Art Library, The Evans-Tibbs Collection

3. Photograph of Barnett-Aden Gallery by Keith Photos, *The Washington Star Pictorial Magazine*, May 2, 1954

National Gallery of Art Library, The Evans-Tibbs Collection

4. Addison Scurlock, *Portrait of Madame Evanti (Lillian Tibbs)*, c. 1934, gelatin silver print

National Gallery of Art, Corcoran Collection (The Evans-Tibbs Collection, Gift of Thurlow Evans Tibbs, Jr.)

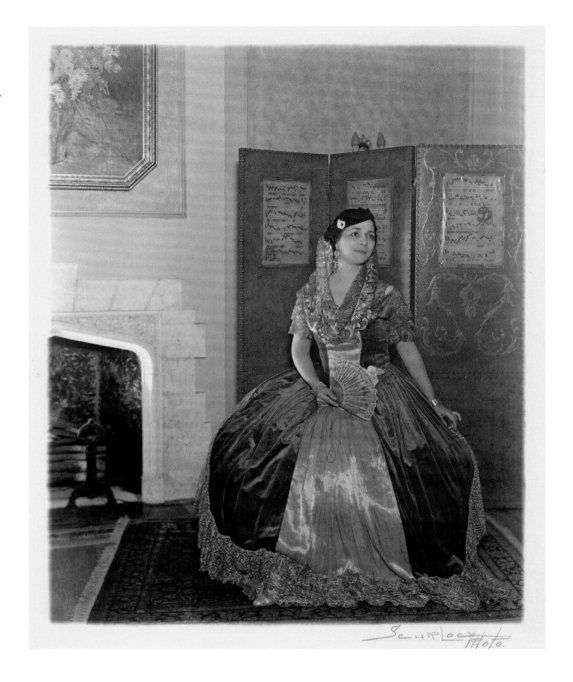

from a cosmopolitan Washington family. Indeed, he had heard about Barnett-Aden Gallery from his beloved paternal grandmother, Lillian Evans Tibbs, who had attended its openings with the writers May Miller Sullivan and Georgia Douglas Johnson.[9] An acclaimed opera singer who had performed in Europe and the United States as "Madame Evanti," Evans Tibbs was a supporter of the visual arts as well. She owned a still-life painting by Laura Wheeler Waring and portraits of herself by photographers Addison Scurlock (c. 1934; fig. 4) and P. H. Polk. Among her friends were the Washington abstract painters Alma Thomas and Delilah Pierce. Tibbs recalled meeting Thomas and Jones in his grandmother's house and noted that Waring was his father's godmother.[10] Evans Tibbs—a grandniece of Hiram Revels, the first African American to serve in the US Senate—was a formative influence on her grandson Tibbs, who kept her papers

and sought ways to honor her legacy and the family's contributions to public life and culture.[11] After her death, her friends, including Pierce, advised Tibbs, encouraging him to collect art and to nurture creative communities, as she had during her lifetime.[12] In 1979 Tibbs began to host salons, mount exhibitions, and form an African American art history archive in the Shaw Victorian row house he inherited from his grandmother. These programs were open to all. But it is worth noting that most of the artists, collectors, and others who attended the events were Black.

Tibbs, like Aden and Herring, understood that his collection was, for many, an introduction to the work of African American artists. While some Black nationalist and Afrocentric artists in Washington drew sharply constricting lines around the roles of Black artists in their communities and argued for a functional "Black art" with latent ties to the traditions of ritual African art, Tibbs encouraged formalist consideration of Black artists' production and consideration of their works within broader art-historical narratives.[13] At Evans-Tibbs salons, research presentations about African American artists' different styles, creative influences, and collective art movements were the norm. Evans-Tibbs's exhibitions, such as *Surrealism and the Afro-American Artist* (1983), *Six Washington Masters: Richard Dempsey, Lois Jones, Delilah Pierce, James Porter, Alma Thomas, James Wells* (1986), and *Afro-American Abstract Artists, 1945–1985* (1986), advanced consideration of cross-cultural, international, and interracial artistic exchanges and produced spirited debate, which was exactly what Tibbs desired. "There's so much in this area that hasn't been done," Tibbs told the *Washington Post* in 1984 for a feature story entitled "The Collector and His Gold Mine." The article's author, Jo-Ann Lewis, deemed Tibbs "a true believer."[14]

The Evans-Tibbs Collection and SITES

In 1989 Tibbs entered an agreement with the Smithsonian Institution Traveling Exhibition Service (SITES) to send more than seventy works from his collection to museums across the United States for a three-year tour. SITES, established in 1952, exposed American audiences to art, science, and technology from around the world. Early SITES projects were solo shows presenting the art of George Catlin, famed for his portraits of Native Americans; Swiss Romantic painter Henry Fuseli; Colorado-born realist printmaker Rudy Pozzatti, and group exhibitions of "Eskimo carvings" and "German drawings" executed between the fifteenth and nineteenth centuries.[15] Fifteen years prior, the Smithsonian had supported the exhibition of the Barnett-Aden holdings at the Smithsonian's Anacostia Neighborhood Museum, which was located in a predominantly Black community in Southeast Washington.[16] Once again, Tibbs was following a path established by Aden and Herring; yet he was aware of his position as a newcomer to that enterprise. Tellingly, the Evans-Tibbs exhibition was initially titled *Emerging Legacy: A Collector's Perspective*.[17]

From the outset, both SITES and Tibbs anticipated the impact of sending works by African American artists owned by an African American collector around the country. The exhibition objective, articulated in the letter of agreement that SITES sent to Tibbs, is striking for its intention to redress historical and contemporaneous injustice:

> The purpose of the exhibition is to illuminate the work of a group of Black American artists who have not received the scholarly attention and museum exhibition opportunities that artists from other backgrounds have received. The artists' work and the impact of that work will be placed in an American art historical as well as historical context. African-American artists have created their remarkable legacy influenced by the special circumstances that have shaped

the African-American heritage as well as by mainstream influences in American art. They have demonstrated a commitment to excellence in the face of adversity, and those who have become known have done so against significant odds. It is SITES' objective to tour this exhibition to a geographically widespread audience through qualifying museums and galleries so that the story of Black American artists can be told.[18]

The year 1989 marked the end of Ronald Reagan's two-term presidency. For this standard-bearer of Republican Party politics and his followers, the decade had been "morning in America" for many reasons. The 1980s witnessed resurgent white American nationalism and racist denigration of Black people. Reagan sought to undermine previously enforced civil rights legislation, opposed affirmative action, and rejected public health initiatives during the AIDS epidemic.[19] In 1988 George H. W. Bush's presidential campaign commissioned a divisive television advertisement that featured Willie Horton, an incarcerated African American who committed a crime while on weekend furlough. The message was that Michael Dukakis, the Democratic Party's nominee for the presidency and the state governor who signed off on the inmate rehabilitation program, was to blame for Horton's recidivism. In 1989, the Corcoran Gallery of Art canceled Robert Mapplethorpe's *The Perfect Moment* exhibition, which ultimately was shown at the Washington Project for the Arts. (Mapplethorpe died of AIDS-related illnesses in 1989.) In 1990, National Endowment for the Arts grants—promised to performance artists John Fleck, Karen Finley, Holly Hughes, and Tim Miller—were rescinded. Individual artists' grants were subsequently abolished, and new regulations on subject matter were established. In 1991, attorney Anita Hill participated in Senate hearings regarding Bush's nomination of Clarence Thomas to the Supreme Court. Hill testified that Thomas, who had been her supervisor at the Department of Education and the Equal Employment Opportunity Commission (EEOC), had sexually harassed her. Thomas was confirmed, his suitability and fitness for the Supreme Court supported by then-Democratic Senator Joseph Biden of Delaware and others. In 1992, sexual harassment claims filed with the EEOC increased by 50 percent.

In these moments, staged in the capital city and central to the national discourse, the SITES statement heroicized African American artists, pointing out that many had distinguished themselves even as they were neglected by the Eurocentric academy and institutional museums. The claims that African American artists' production should be incorporated into American art history and at the same time required its own culturally informed historical frame demanded agile thinking, which eschewed strict assimilationist and separatist stances. Organizing an exhibition of Black artists' works and sending it out on tour were bold, affirming tactics that addressed historical ills and brought a necessary, multiculturalist way of thinking and programming to American exhibition spaces.[20] That the federal government, with an anti–affirmative action and anti–gay rights president then at its helm, funded this SITES effort instructively demonstrates how reactionary ideology and liberal administrative policy can not only coexist but be strangely compatible as each responds to the other in a public, democratic arena.[21]

Smithsonian Institution records list twenty venues for the exhibition tour, which started in January 1989 at the Hood Museum of Art at Dartmouth College (Tibbs's alma mater) and ended at Western Washington University in Bellingham in November 1992.[22] Significantly, the show traveled to every region of the lower 48 states and to modest and grand art spaces. Works were displayed at municipal museums such as San Antonio's Marion Koogler McNay Art Museum, the Fort Wayne Museum of Art in Indiana, and the Telfair Academy of Arts and Sciences in Savannah, Georgia; it was also sent to a variety of higher education venues, including highly selective liberal arts schools, such as Vassar and Grinnell (fig. 5); community

5. Poster advertising *African-American Artists, 1880–1987* at Grinnell College, Burling Library, Print and Drawing Study Room, April 7–May 21, 1990

Courtesy Grinnell College

6. Front and back of a postcard advertising *African-American Artists, 1880–1987* at Telfair Academy of Arts and Sciences, July 3–August 11, 1991

Telfair Museum of Art, Savannah, GA

Photo: Daniel L. Grantham Jr., Graphic Communication

AFRICAN-AMERICAN ARTISTS 1880-1987:
SELECTIONS FROM THE EVANS-TIBBS COLLECTION

July 3 - August 11, 1991

Telfair Academy of Arts and Sciences
121 Barnard Street
Savannah, Georgia

Tuesdays-Saturdays: 10:00 a.m.-5:00 p.m.
Sundays: 2:00 p.m.-5:00 p.m.

FREE admission due to the sponsorship of
the City of Savannah through its Arts Commission.
Ben Sheftall Distributing Company,
Today's Beauty Supply, and
Carson Products, the maker of Dark & Lovely,
have provided generous promotional
support for the Savannah venue.

The exhibition was organized by the
Smithsonian Institution Travelin Exhibition Service.

RELATED EVENTS

June 12
2nd Wednesday Gallery Talk, 12:30 p.m.
By Lev T. Mills, Printmaker in the Exhibition

July 2
Opening lecture, 8:00 p.m.
By Thurlow Tibbs, Collector

July 10
2nd Wednesday Film, 12:30 p.m.
Two Centuries of Black American Art

July 14
Sunday Gallery Talk, 2:30 p.m.
By Diane Edison, Artist and Instructor

July 19
Third Friday of Savannah Reception and Tour
(for further information, please call Elliot Ferguson
at 897-5950 evenings)

July 28
Family Sunday, 2:00-4:00 p.m.
An African-American Celebration

Cover illustration: Lois Mailou Jones, *The Lovers (Somali Friends),* casein on canvas, 1950, The Evans-Tibbs Collection

colleges in Fort Myers and Gainesville, Florida; and the campus art museums of large public institutions such as Rutgers, The State University of New Jersey; the University of Kentucky; the University of Missouri; and Western Washington University. SITES provided curators at the host institutions with a script for didactic text that could be printed on panels and displayed in the exhibition space. An epigraph from Alain Locke's *The Negro in Art* (1940) welcomed visitors to the exhibition, likening that formidable arts advocate's ambitions to those of SITES: "The Negro's creative career in the fine arts is longer and more significant than is generally known, and the main objective of this portfolio is to document this pictoriality for the wider knowledge

of the general public."[23] Below Locke's words was an overview statement that characterized four African American artists' success in market and historical terms: "prices in the hundreds of thousands" for works by Joshua Johnson and Tanner and the recognition of Bearden and Lawrence as "American masters." A warrant followed, noting the relative lack of appreciation for "the wealth of African-American talent in the fine arts." Thurlow Evans Tibbs Jr. and Lillian Evanti Tibbs were named in the final section of this introductory text, where he is presented as a legatee who continued and expanded the arts patronage that she began with his own collection and library. Panel text for the exhibition's presentation of the work by period followed the organization of the accompanying catalog: 1880–1920, 1920–1950, and 1950–1987.

Tibbs identified himself with the collection. While he was not named as the author of any exhibition text (or that published in the accompanying catalog), he traveled to several of the hosting venues to speak to general audiences about his family and his collection. Among these sites were Dartmouth College, the Telfair Academy of Arts and Sciences, Rutgers University's Camden campus, and the McNay Art Museum. A video recording of Chicago art dealer Richard H. Love's interview of Tibbs was prepared and sent to venues for screening in public programs. On one occasion, Tibbs's hand in the installation was literal. In January 1990, he removed *Music Lesson* (1966), a large painting in oil on canvas by Bob Thompson, from the McNay Art Museum. In a handwritten, signed, and dated record of the act, he stated that the painting was "being withdrawn for conservation work" and instructed McNay staff to ship it to him in Washington, DC, where he would arrange for repair.[24] While SITES provided the infrastructure for the exhibition, Tibbs still viewed himself as the singular caretaker of the collection whose value, he declared, was $850,000.

Museum administrators and curators—having received the exhibition script, programming ideas, and educators' packets that framed African American culture and history for school groups that traveled to see the exhibition—were pleased to host *African-American Artists, 1880–1987*, for it was both groundbreaking and popular.[25] Six thousand people saw the exhibition at the Stedman Art Gallery on Rutgers's Camden, New Jersey, campus. At the Telfair Academy of Arts and Sciences, curator Carol D. King reported 7,451 exhibition visitors, and she credited the dissemination of billboards across the city and postcards "distributed to libraries, businesses, and churches" as especially "effective in reaching our audience" (fig. 6). At many venues, the uptick in the number of African American visitors was noticed and celebrated (fig. 7). In some cases, these visitors had either rarely visited the museum or had never visited at all. For the Fort Wayne Museum of Art (fig. 8) and the Columbus Museum, Georgia, the Evans-Tibbs exhibition was the first group presentation of African American artists' work in their galleries.[26] Another participating institution, in so many words, marketed the value of multicultural exhibition programming as pedagogically necessary and timely: ad copy for the University of Kentucky Art Museum's teachers' workshop stated that "presenting cultural diversity is important to many teachers today." Such language and program plans were emerging signs of the times: institutional administrators indirectly acknowledged that museums were not always inclusive and inviting spaces. Both institutional records and public relations documents indicate that the community groups and museum staff recognized the opportunity *African-American Artists, 1880–1987* presented, not only to ameliorate the situation but also to work collaboratively to do so. In Savannah, for instance, Westley W. Law, president of the city's chapter of the National Association for the Advancement of Colored People (NAACP) and of the King-Tisdell Cottage Foundation, an African American heritage site, suggested to Telfair Academy director Gregory Allgire Smith that some of the related programming take place in Black organizations such as the King-Tisdell Beach Institute, a cultural center. Smith responded to Law by writing:

7. From left to right: Victor Hagans, Arturo Sandoval, Anthony Gay, and Teresa Unseld at the opening reception for *African-American Artists, 1880–1987* at the University of Kentucky Art Museum, 1991

Image courtesy University of Kentucky Art Museum

I also appreciate your advice at our last meeting on the image of the Telfair in the community in light of our Board's thrust to broaden our museum's impact and my desire to build a culturally diverse audience. Your help and that of others I have begun to reach out to will make a great difference to this process and our progress.[27]

Letters indicate that Law and Smith met to coordinate media promotion of these events.[28] The exhibition's run at the Telfair Academy also overlapped with a relatively new initiative in Savannah, namely, a city government–funded Black Heritage Festival organized by the NAACP and the Association for the Study of African American Life and History.

The meaningfulness of a presentation of Black artists' work was recognized by commentators who noted that the exhibition was the first of its kind in the Midwest or the South. And for sites such as Rutgers's campus in Camden, a predominantly Black city that had experienced deindustrialization, depopulation, and a dramatic economic downturn in the postwar decades, *African-American Artists, 1880–1997* was meant to boost the mood of a depressed community and the greater South Jersey region.[29] Exhibition reviews and public interest stories generally followed the upbeat tone of the museums' marketing. Newspaper headlines celebrated the exhibition: "Black Art Receives Its Due Respect" (*San Antonio Reformer*); "Camden Show Celebrates a Century of Black Art" (*Courier-Post* [New Jersey]); "McNay Exhibits Best of Afro-American Art" (*San Antonio News*); and "A Century of African American Art Is Powerful Viewing" (*Seattle Post-Intelligencer*).[30] Journalists took note of the host museums' efforts to engage infrequent museumgoers or first-time visitors who presumably were not aware of African American artists' existence and output. Eric Ries in the *Savannah Morning News* opened his feature article with a prediction: "People unfamiliar with the diversity and quality of African-American Art are in for some big surprises and real treats."[31] His lede was no doubt informed by his separate telephone interviews with exhibition catalog contributors Sharon F. Patton and Richard J. Powell, because they were quoted for their surmises concerning the standing and accessibility of the work. According to Powell, "Regardless of ethnicity, people can enjoy these works for their

8. Installation views of *African-American Artists, 1880–1987* at the Fort Wayne Museum of Art, 1991

Courtesy Fort Wayne Museum of Art

intrinsic value. These are artists who are top notch."[32] Still, in Patton's opinion, that attention had not previously been paid to these artists was a symptom of Americanist art historians' long-standing blind spot regarding achievement outside of the Eurocentric framework, and her critique published in another press outlet was stark: "Art historians in major institutions are, in general, not familiar with artists of color."[33]

This claim notwithstanding, it is telling that a few commentators overtly displayed their African American art-historical knowledge by discussing and situating these artists' oeuvres and naming exhibitions that were mounted in their cities. For example, Marcia Goren Weser cited *Hidden Heritage: Afro-American Art, 1800–1950* at the San Antonio Museum of Art; Vivian Raynor of the *New York Times* mentioned the Newark Museum's *Against the Odds: African-American Artists and the Harmon Foundation* and advised readers to see New York's Kenkeleba Gallery survey of Edward Mitchell Bannister's paintings.[34] Regina Hackett offered readers a "caution" about the Evans-Tibbs holdings of modest-size art objects suitable for display in the family's house museum: "Painters who are at their best when working large, from Henry O. Tanner to Sam Gilliam, aren't particularly well-served by displays of smaller work only." She also registered her preferences: the realist painter Charles White, she wrote, "is the African American Andrew Wyeth, better than Wyeth because he avoids Wyeth's stultifying detail. Alma Thomas's watercolor from 1966 tops anything Sam Francis was doing during the period."[35] An insider's tone also suffused *Philadelphia Inquirer* art critic Edward J. Sozanski's ambivalent appraisal:

> The story of black art in America has been told many times and this show doesn't add much to the historical record. But it does summarize that history logically and concisely, hitting most of the highlights in terms of significant artists. . . . It manages to convey the essential flavor of the black experience in American art.[36]

"Black art," "the black aesthetic," and "the Black experience" were, unsurprisingly, key phrases summoned by the critical body: they were used loosely in the press, the first and second as synonyms for "African American art" and the third as a proprietary cluster of historical group conditions such as enslavement and disenfranchisement and as phenomenal survival in the face of these conditions. Cynthia Parks, in the *Florida Times-Union*, sought a working definition of Black art via Socratic method–like questions, raised in the spirit of good-natured debate:

> So, why an exhibition of black artists? Why not simply a landscape show or portrait show with black artists? After all, African-American artists, like any other American artists, painted to express themselves and their surroundings. Well, that question [*sic*] is still an academic shuttle-cock. Black aesthetic proponent Frank E. Smith, a member of AfriCobra (African Commune of Bad Relevant Artists), is on one side of the net saying today's artists ought to draw from African culture, whether it's over there or over here. He supports jam-packed, jelly-tight images in Kool Aid colors—visual jazz. His richly patterned 1986 acrylic and ink, *River and Darkness*, clearly comes from continental African designs. On the other side of the net is David Driskell . . . who wants to paint abstract art based on color—not "color" as in social commentary but color as in red, blue and yellow. Driskell went his egg-tempera way with circles and squares building up form on a red background in *Movement, the Mountain* and never thought about his race. This show reveals the evolution of African-American art.[37]

Teleological mapping is not uncommon in art history, for scholars often write about contemporary art as a demonstrated improvement in artists' conceptual thinking and as production that

was superior to the work that preceded it. Hence, while it was not unusual that twentieth-century Black American artists were deemed better than those of the colonial period and the nineteenth century, the terms of judgment were built on top of troubling binaries that commentators attempted to resolve: assimilation and authenticity, naturalism and abstraction, and acknowledgments of difference and subscriptions to color blindness. These discussions revealed that late twentieth-century African American artists, actors with great agency, still labored under expectations about what a Black artist in America could and should do.

The Evans-Tibbs Exhibition Catalog

The Evans-Tibbs exhibition catalog eschewed such predictions and prognostications. Instead, it communicated the character of the collection holdings, which exceeded 400 works, and made a case for their quality. The book consisted of 126 printed pages, including 68 full-page color reproductions of selected works from the collection. Four art historians contributed essays: Driskell provided readers with an introduction to the collection; Guy C. McElroy handled the turn-of-the-century naturalism and the realism in emergent "New Negro" years of the early twentieth century in "The Foundations for Change, 1880–1920"; Powell's section carried the reader from Harlem Renaissance portraiture to the mid-twentieth-century figural abstraction; and Patton addressed late modernism and burgeoning postmodernism. Both Powell and Patton considered the work of self-taught artists.

As Patton explained in an interview in 2016, the charge for each scholar was broad. Tibbs decided what part each researcher would play. "He knew our respective strengths and our interests," Patton said, and he "didn't want us to leave people out. He'd ask what about so-and-so? You have to talk about so-and-so." She added: "He was a low-key person, but he knew what he wanted. If he had a statement about the artist, he would share it with me." Nonetheless, Tibbs deferred to the art historians and respected their expertise. "He knew the importance of having the documentation. He had files on artists, but he wasn't pretending to be an art historian. His ultimate goal was to have a legacy for these artists."[38]

At the time of the exhibition, the Evans-Tibbs Collection's historical strength was nineteenth-century art, which was McElroy's passion. As art historian Renée Ater stated in a 2017 interview, McElroy was probably thinking about his project *Facing History: The Black Image in American Art, 1710–1940*, as he was writing his essay for the Evans-Tibbs publication.[39] The exhibition of the same name opened at the Corcoran Gallery of Art in January 1990 and subsequently traveled to the Brooklyn Museum in March of the same year. And as was the case with the Evans-Tibbs book, *Facing History* was a critical intervention, with an incisive and widely admired essay by Henry Louis Gates Jr., informative catalog entries penned by McElroy and his research team, and high-quality color reproductions of art made by and/or depicting people of African descent.

Thinking about McElroy's essay for the Evans-Tibbs publication, one could make an argument that he was the successor to James A. Porter, an artist, curator, and scholar invested in the practices of artists of color born in the nineteenth century; Porter had been dedicated to writing about them since the 1940s. Fifty years later, McElroy focused on those nineteenth-century artists who captured the scenes of the city, rural land, and sea: William Harper, Edwin Mitchell Bannister, Grafton Tyler Brown, Tanner, and William Edouard Scott. He also considered the genre portraits of Tanner, Scott, Scurlock, and Nelson Primus.

With authority, McElroy wrote about the state of affairs for these artists: Bannister's Barbizon-influenced landscapes, Tanner's ambitious etchings, and his student Scott's emotionally

9. Palmer Hayden, *Cafe L'Avenue*, 1932, watercolor over graphite on wove paper

National Gallery of Art, Corcoran Collection (The Evans-Tibbs Collection, Gift of Thurlow Evans Tibbs, Jr.)

provocative lithography. McElroy turned a discerning eye to artistic interpretation of the figure as well, noting Scurlock's purposeful reworking of the photograph and Primus's "skills and limitations" in this canvas. Along with the biographical information that McElroy provided in "The Foundations for Change," the formal analysis and critical assessment he brought to the assignment offered a model for students and emerging scholars. In these writings, he presented art making as a challenge to compose something to be seen, consumed, and judged. He demonstrated how each work sat in dialogue with others and with expressive practices across time.

Powell's "From Renaissance to Realization, 1920–1950" was a discussion of painting genres, from Hale Woodruff's expressionist *Landscape* (1936) to the figurally abstract still life as interpreted by Laura Wheeler Waring, Margaret Burroughs, and Beauford Delaney. Powell's primary interest was the figure represented as the hero, the humorous caricature, and the enigma, each imbued with the creative spirit and "race man" ethic in the work of two New York City artists, Richmond Barthé and James Van Der Zee. An artist (as well as art historian, curator, and administrator), Powell flagged the cardinal point of realism as the modus operandi of most interwar US artists and related the rigor of Barthé's drawing to the conventional pyramidal structure of Van Der Zee's photo *Alpha Phi Alpha Basketball Team* (1926). Powell situates both works as symbolic images, forged in the crucible of the "Negro Renaissance," advancing its ideals and the respectability politics fashioned to oppose racist stereotype and broad, racialized representations. With economy, Powell gives the reader a sense of how such things operated in visual culture by setting Palmer Hayden's oeuvre just to the side of them. Hayden, Powell says euphemistically, was "an artist who did not always fulfill the movement's mandate for uplifting and forward looking images."[40] Powell subsequently connects Hayden's absurdist humor with the artist's *Cafe L'Avenue* (1932; fig. 9), a genre portrait that he reads as a satirical caricature of the artiste, self-medicated by alcohol and the balm of music.

Similar to *Cafe L'Avenue,* Charles Sebree's *Boy in a Blue Jacket* (1938) is a product of a "middle period" for African American artists—the Depression years, which many navigated with the patronage of the Harmon Foundation and the support of the US Works Progress Administration. Powell argues that the modernist tack of Aaron Douglas, James Lesesne Wells, and Charles Alston in the 1930s was at least partly grounded in their respective appraisals of Black subjects and subjectivity: Douglas's developed icons of Black enslavement, erudition, and advancement; Wells's study of West African ritual sculpture (and German expressionism that was influenced by it); and Alston's "salute [to] African physiognomy," which reverberates with Douglas's murals and Langston Hughes's 1923 poem "When Sue Wears Red."[41] Deftly, Powell makes a distinction between modernisms and modernity, with the work of Douglas, Wells, and Alston slotted in the former category and with Polk's circa 1937 photo of Lillian Evans Tibbs assigned to the latter (fig. 10). Powell rightly points out how all these visual idioms of Black pride and powerful Blackness were coeval with emergent consumption of "folk art," framed during the 1930s and 1940s as raw and intuitive and, resultantly, more authentic. Powell addresses the work of self-taught artists Bill Traylor and Clementine Hunter in the Evans-Tibbs Collection. As the catalog does not provide accession numbers and provenance information

10. P. H. Polk, *Lillian Evans Tibbs*, c. 1937, gelatin silver print

National Gallery of Art, Corcoran Collection (The Evans-Tibbs Collection, Gift of Thurlow Evans Tibbs, Jr.)

for any of the art it presents, we wonder when Traylor's and Hunter's works entered the Evans-Tibbs Collection and what their work meant for Tibbs or for his grandmother. Did Traylor's and Hunter's graphic paintings arrive with the expressionist rural landscapes and "folk" types, both realized by trained artists who self-consciously turned to primitivism? Even without an answer to this question, Powell's essay helps readers see the intersection of market forces, popular culture, and art history's modalities.

And Powell's management of vastly different approaches to figural abstraction, distortion, fragmentation, and exaggeration during the 1940s was equally instructive. In Powell's account,

11. Hughie Lee-Smith, *Reflection*,
1957, oil on particle board

National Gallery of Art, Corcoran
Collection (The Evans-Tibbs Collection,
Gift of Thurlow Evans Tibbs, Jr.)

mimesis is on the run in avant-garde circles in the decade of the 1940s. Black American artists formed this heroic discourse around the figure and operated within realms that still respected it. As was the case for their non-Black counterparts, the body was a critical form on which to act for African American artists. Bearden's decisions, Powell asserts, were "multi-cultural" and "ethnically neutral"; Lawrence's and Sargent Claude Johnson's decisions culturally Black; and Eldzier Cortor's a nominative conjunction of Black America and historical forces Powell codes as "not Black," namely, labor and Marxist politics. By the end of his essay, Powell, having worked through the heterogeneity of interwar, wartime, and post–World War II art in the Evans-Tibbs Collection, has shown that African American art was a plural and capacious notion. This conclusion seems like the best one possible, for Powell's account might actually apply to any artist-agents who create necessary room to maneuver, who work "-isms" and modes that they want to advance, and who bring the content that matters to them to each project.

With more objects to engage than the publication's other essayists, Patton finds broad themes to underpin her overarching subject: Black American artists' active "search for identity." Appropriately, Patton considers states of mind and heart, such as alienation and isolation; populist, liberal, and leftist political convictions; the inspiration of nature; art making's ritual aspects; and coalition building and group action. In general, US figurative art of the 1950s, according to Patton, manifested pessimism. In Walter H. Williams's gouache painting, she identifies a strain of Afro-pessimism, avant la lettre. She relates the dire mood of *Third Avenue El* (1955) not only to Williams's difficult upbringing in New York City and resignation about the prejudice he faces, but also to mid-twentieth-century African Americans' bitter recognition about the limits of the American dream. The austerity of Richard Dempsey's *Cityscape* (1955) and the barrenness of Hughie Lee-Smith's *Reflection* (1957; fig. 11) are, Patton writes, American signs of a downer decade. And when figures are rendered, they seem racked by indifference, ennui, hopelessness, passed from one generation to the next. Still, Patton notes, it was important that some Black American artists tried to address the problems facing Black American communities in their work of the 1960s and 1970s: Lev T. Mills's and White's poignant interpretations of Black youth trying to make their way in the world were exemplary. And, by fitting Elizabeth Catlett's oft-reproduced image *Sharecropper* (1952) into this context, Patton mirrors the artist's lifelong commitment to citing the presence and import of the female laborer who struggles for equity just as much as her father, brother, partner, and son do.

Patton makes it her business to respond to the Evans-Tibbs holdings of work by modernist and postmodernist female artists. Best known is Alma Thomas, who was the subject of major traveling exhibitions in 2016 and 2021–2022 (fig. 12). In the Evans-Tibbs exhibition catalog, Patton discusses watercolors by Thomas and her good friend Pierce one after the other (fig. 13). These two atmospheric works are reproduced side by side in the book, an apt layout decision considering the artists' friendship. Both Thomas and Pierce regularly attended exhibitions and salon-style gatherings organized by Tibbs at the house on Vermont Avenue NW. Tibbs, in turn, was an important patron of theirs.

For Patton, it was important to document the abstract and mixed-media art in the Evans-Tibbs Collection. For certain, the collection is heavy with realist and naturalistic paintings and prints. During the years in which Tibbs was collecting—from the 1970s until his passing in 1997—he acquired pieces from artists who worked in these social realist and conservative modes. Patton writes that these artists were "taken less seriously by critics because they were out of step with current avant-garde styles—in this case, abstract expressionism, minimalism, and conceptualism."[42] She offers a history of the New York School, and of Washington artists' advancement of their own projects in which color, line, and shape are the subjects of painting. She makes sure that we know when we are looking at the Washington Color School and when we are not, as is the case with Sylvia Snowden's impastoed canvas with its fabulously liquid figural form (*Mamie Harrington*, 1985; fig. 14). Patton's essay stretches as much as the Evans-Tibbs Collection did. She accounts for the contemporaneous DC-area artists whose work is represented, such as Snowden, Irene Clark, Frank Smith, and Barbara Tyson-Mosley. Patton doubles back for the historical figure with a brief but blazing career: Bob Thompson, a comet with a tail trailing from his birthplace of Louisville to the New York bohemian world to Rome, where he died in 1966. The journey on which the collection and publication take their audiences extends to the US West Coast, to artists who were already visible, vocal, and innovative figures in the 1980s when the Evans-Tibbs exhibition catalog was published. That Ulysses Marshall, Betye Saar, and Raymond Saunders are now canonical African American artists makes the collector (Tibbs) and the scholar writing about the collection (Patton) prescient; they knew about the power of these artists' works "way back when." Although the chronological structure of the Evans-Tibbs book required Patton to handle the collection holdings of self-taught artists active in the 1970s, it is worth noting the way she slips their production into the essay's penultimate section. There, their resourceful, abstract, conceptual, and unique art-making ways sit comfortably next to the like-minded strategies of formally trained artists, who integrated their academic skills and also looked back to craft in order to learn from and revive it.

One might conclude that Patton's research and writing assignment for the Evans-Tibbs book should have been split into two chapters. But maybe the weight of the collection and the

12. Alma Thomas, *Leaves Outside a Window in Rain*, 1966, watercolor

Collection of Mr. and Mrs. Lester H. McKeever

13. Delilah Pierce, *Nebulae*, 1982, watercolor

Private collection

14. Sylvia Snowden, *Mamie Harrington*, 1985, acrylic and oil pastel on Masonite

National Gallery of Art, Corcoran Collection (The Evans-Tibbs Collection, Gift of Thurlow Evans Tibbs, Jr.)

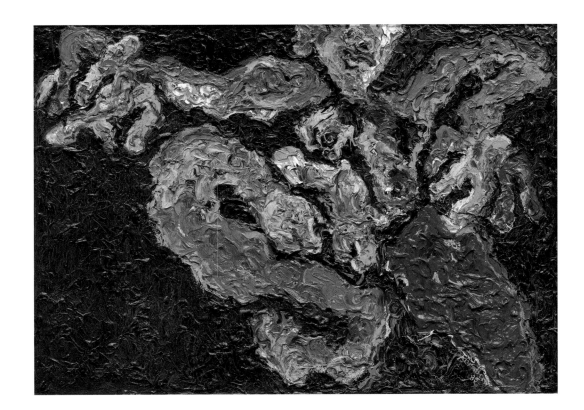

number of works made between the years 1950 and 1987 are "facts" that we are supposed to feel, sense, and register. Maybe we are supposed to be overwhelmed by the collection and how much could be written about it. There is a weight to legacy and its quantification. Legacy is a word and a concept that threads throughout this essay, which asserts that Thurlow Evans Tibbs Jr.—who modeled the Evans-Tibbs Collection after the Barnett-Aden Collection, itself modeled after The Phillips Collection—created legacy as something with which we must contend, because it is too much to ignore.[43]

Epilogue

In 1996, Tibbs, aware that his HIV status was seropositive, donated thirty-two paintings, sculptures, and works on paper to the Corcoran Gallery of Art. When the Corcoran closed in 2014, the National Gallery of Art accessioned forty-four paintings, sculptures, and works on paper with a connection to Tibbs, including his bequest, a painting that the Corcoran purchased from him, and eleven works donated in his memory. In April 2019, Harry Cooper, senior curator and head of modern art at the National Gallery, organized an installation of Evans-Tibbs works in the East Building (fig. 15). There, eight works of painting and sculpture by Richmond Barthé, Margaret Burroughs, Elizabeth Catlett, Aaron Douglas, Lois Mailou Jones, Hughie Lee-Smith, and Edward L. Loper Sr. shared the space with work produced by the Stieglitz circle: Arthur Dove, Marsden Hartley, Georgia O'Keeffe, and Charles Sheeler. Cooper's intervention was significant in several ways. It demonstrated the diversity in the holdings of the nation's public fine arts museum. The introductory wall panel asserted, "With this display, the National Gallery continues the work of the Corcoran in advancing Tibbs's legacy." Indeed, the juxtaposition of

15. Installation view, *The Evans-Tibbs Collection* at the National Gallery of Art, 2020

Photo: Rob Shelley

Black artists' work with that by their non-Black contemporaries constitutes a follow-through of *African-American Artists, 1880–1987*—that is, the integration of mainstream museum spaces and recognition of African American artists.

At present, when African American population numbers in Washington, DC, are falling precipitously, the display of the Evans-Tibbs Collection serves as a marker in several meanings of that word. It indicates the place of a Black American patron of the arts who sought to position himself and his family in discussions of the city's art world. The installation also might be read as a payment of promises made in the nation's credos of equality. Yet because markers are standards against which success and failure are registered, they prompt comparative thinking and differentiation. How has the notion of difference for the National Gallery of Art and for its audiences been constructed, reifying related terms of identity and identification? As we tally up the legacies of multiculturalism—a term summoned with true risk in 2022—what do we erect, in the name of equity and empowerment, in its place? What planks of multiculturalism are redeemable?

While the exhibition of work from the Evans-Tibbs Collection by the National Gallery met some of Tibbs's objectives—for example, the placement of Black American artists' production in a major museum, mainstreaming it by installing it in proximity to non-Black artists' works—goals such as the full realization of cultural equity, social justice, and critical multicultural histories of colonial and US art have not been reached. As yet unresolved is a consensus on what is best for institutions and for audiences: What if wall labels listed the identity positions of every artist (and not just those who are members of minority groups)? How might the presentation of such information facilitate conversations about canons, institutional histories, and intersectionality? These questions do not stand in judgment on the National Gallery's acquisition and installation of the Evans-Tibbs Collection. Instead, they situate projects and actions that generally differentiate artists from one another as legacies handed down to us—ones with which we can productively engage rather than reconcile.

To the memory of Thurlow Evans Tibbs Jr. (1952–1997)

THE ART OF
BLACK BEAUTY

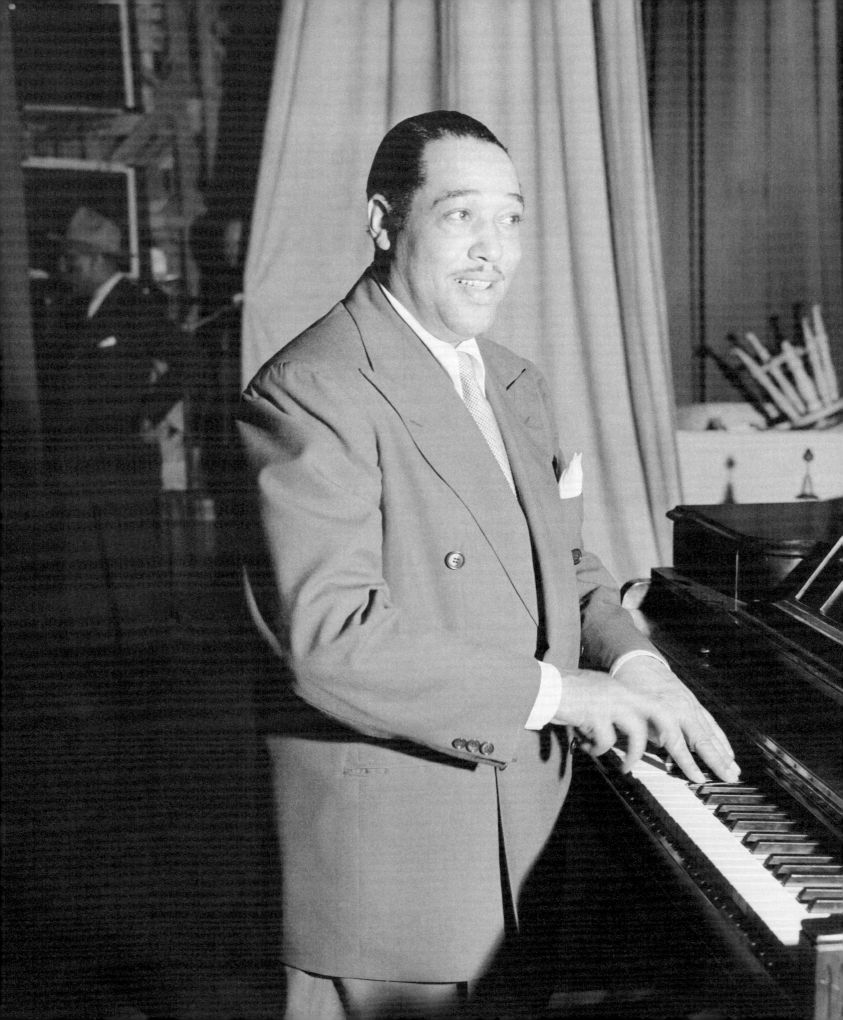

TRANSBLUCENCY: DUKE ELLINGTON'S *BLACK AND TAN* AS CELEBRATION AND REFUSAL

Robert G. O'Meally

I write about Washington, DC, at a time of emergency in our city, our nation, and in the world. At such a time it's important for us all to remember that art is a powerful institution with indispensable civic uses[1]—and that *now*, as an old church song says, *is the needed time*. For when our officially trumpeted political institutions fail us, as they're doing day by day, here and now, we in the arts are required to support one another and the vision that the arts offer of what it means to be human, what it means to create a coordinated community—to remember that Democracy is our nation's word for Love.[2] At its finest, art offers visions not of mere subsistence survival—something itself imperiled nowadays—but of living with high-energy purpose and capital-letter Love for all our sisters and brothers everywhere and for our planet. As a senior university scholar, I write in angry defiance of those in positions of leadership who do not believe in education, whether in the sciences or in the humanities, any more than they believe in education in the arts. These are trying times; singer Roberta Flack (Howard University graduate that she was) had it right. In such times the university must step forward to declare that these knowledge systems—including art's rare capacity to fathom mysteries and reveal yet unseen signs of light all around us—are superlative guides, as we feel our way forward in the dark. All these systems of knowing offer indispensable equipment for contemporary living. And among these technologies for living, art is the very brightest lighthouse that we have.

In the spirit of such lofty claims, I offer here an investigation that is prompted by the pictures and references to music (and sometimes to the other arts) included in this essay. My aim is to demonstrate how paying close attention to the arts—including ones that can't be experienced on the printed page but that, in most cases, can be found online—enables new perspectives on who we are as a nation and what it could mean for Washington to be, when it comes to leadership in values, a true *capital city*.[3]

The path I chart here is partly autobiographical. Here, I draw a line from 1960s DC house-party dances, which I grew up trying to emulate, to the "hops" and "socials" for which Duke Ellington played throughout his career (fig. 1). I want to draw a line, in other words, from the blue-light basement sets of African American residents of Washington in those years to the kind of parties that Ellington played for at Odd Fellows Hall and the Howard Theatre of the 1920s, and then at public dances like the Alabama breakdowns, AKA balls, and other dance bashes he rocked through the rest of his working life.

Detail, fig. 1

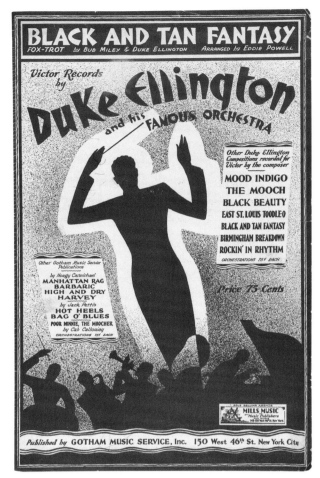

1. William P. Gottlieb, *Duke Ellington*, c. June 1946, Washington, DC, possibly Howard Theatre

Library of Congress, Music Division, William P. Gottleib Collection, LC-GLB13-0232

2. Sheet music, "Black and Tan Fantasy," 1927

Courtesy the Smithsonian Libraries, Washington, DC

Here I'm defining Ellington's music as a kind of site or place maker: one of Toni Morrison's black-historical "benches by the road," this time figured in sound. In the music-saturated places I'm talking about, music served not primarily as commercial fluff or as wallpaper entertainment but as part of something much larger. I'm thinking about the power of art to activate, to reveal, to change. I'm thinking about this music as part of an institution designed to draw people together: sometimes *very* tightly together. These blue-light functions worked on the romantic level of one person holding onto another person in the dark, *O yes they did!* I knew a kid from Northeast DC whose nickname, not for nothing, was "Slow Drag." "If you be the party of the first part," Slow Drag used to smile-whisper to girls he wanted to "dance-on-a-dime with," *"I'll be the party of the second part."*

My thesis is that those close dances had a spiritual dimension that I'm calling "transblucency." They were soulful sets as well as bodily ones—the metaphysical depending so much, it seems to me, on the physical anyhow.

For at these down-the-steps parties we celebrated ourselves and the fantastically welcoming neighborhoods we lived in, whether the violent regime of Jim Crow segregation was coiled just around the corner or not. For these social gatherings also were our institutions, our guides through the world, balancing those of the church and the school. For these blue-basement lighthouses took us just as we were, robustly celebrating our beautiful black selves and affirming our own styles and values, our own dances and music, slow dances and fast dances

(in the unfancy lingo of those days) and our own capacities to sustain ourselves on our own sometimes James Brown–energized terms.

So many of us in black DC had so recently gotten off buses and trains from the Deep South that we created something called "'Bama Day," an All-Fools Day dress-up/dress-down day at school where (just under the teachers' radar, or so we liked to think) we made good fun of one another and our own "country" selves. In our house-party music there was more of the country blues—that music of ever-springing hope where nonetheless it is never forgotten that life is full of terse ironies and unavoidable "low-down dirty" sorrows—than is generally remembered. Songs like the Marvelettes' "Forever" lifted our hopes while another Marvelettes hit taught us that love could end in a heartbeat. "When you get home," Marvelette Gladys Horton proclaimed in sexy husky tones, "I'll be gone!" "It's strange I know," she continued, "but that's the way it go." As we moved to Smokey Robinson and the Miracles' "The Tears of a Clown"—lyrics: "Just like Pagliacci did, I try to keep my sadness hid"—we prepped for the world of blues we knew we'd have to face. For who among us could not know that "the world waited outside, as hungry as a tiger," as James Baldwin put it (during the years of which I speak), "and that trouble stretched above us, longer than the sky?"[4]

This black community affirmative face-to-face with the blues is what I hear sounding strong and steady through Ellington's music and group-centric ways of composing music: both offer shining examples of living robustly with music and blues-tempered living as democracy in action. To elaborate these insights into a tentative theory of democratic living, I want to look at and listen to Dudley Murphy's 1929 film *Black and Tan*, starring Ellington and his soundtrack (fig. 2). In this movie, the soundtrack is cast as a kind of character. Here, moving images and dialogue second the music's affirmation of community togetherness. The film stars community-love music, which stands for perseverance through the fractures and breaks of calamity—soul qualities that are part and parcel of an African American democratic politics.

Such airy talk leads me back to my title, "Transblucency," borrowed from a beautifully airy Ellington piece of 1946, scored for trombone and wailing wordless soprano voice. Here "Transblucency" refers not only to the blues structures underlying virtually all of Ellington's music, including "Black and Tan Fantasy" and "Transblucency," but also to the dim blue-light house-party settings I've been speaking about as sites of body and soul communion. I do like that title's suggestion of transcendent qualities too—qualities we need as we face our current difficult days, and those that are coming.

This essay anchors a series of meditations long playing in my head on art as multisensory expression. I'm thinking of Henry John Drewal's virtuoso riffing on Robert Farris Thompson's *African Art in Motion: Icon and Act in the Collection of Katherine Coryton White* (1974), and in particular Drewal's idea, elaborated from Thompson's work, that we need to see, hear, touch, smell, and dance Afro-art in order to activate and tap its full meaning.[5] You cannot understand much African art, ancient to modern, these art historians argue, unless you understand that typically its forms were not meant to adorn a wall but to be worn, held, played, danced—used as part of ritual and everyday living.

Consider, for example, Romare Bearden's 1987 watercolor on collage *Fancy Sticks* (fig. 3), which brings to light Drewal and Thompson's multisensorial argument as it presents the figure (Bearden himself?) as a drummer who might also be a writer who, oh yes, might also be a painter. With rhythmic strokes and colors, Bearden dissolves the borders between figuration and abstraction, as he liquefies the spaces supposedly separating the art forms themselves: music, literature, and painting. Here, in the spirit of the jazz aesthetic, Bearden replaces the idea of the human being as fixed in one persona and place with this image of multiple identities in

3. Romare Bearden, *Fancy Sticks*, 1987, watercolor on collage

© 2020 Romare Bearden Foundation / Licensed by VAGA at Artists Rights Society (ARS), New York

one—*e pluribus unum*—asserting a democratic politics in which citizens and communities can play multiple roles, even contesting and clashing roles, as they move through space, refusing to settle.

One of several portraits of Duke by his friend Bearden is the collage called *Ellington, Rainbow* (1981; fig. 4), in which Duke, conducting, conjures a brilliant watercolor world of yellows, oranges, and greens. This work reminds us that as a composer, Ellington, who turned down a scholarship to study visual art at Pratt Institute in Brooklyn to stick with the music thing for a while, was extraordinarily mindful of color and other aspects of visual art. "Mood Indigo," "Azure," "Multicolored Blue," "Magenta Haze," and "Purple Gazelle" are a handful of Ellington composition titles referring to color. Much more important than titles are the mixes of sound-color throughout Ellington's music, created by sometimes very surprising combinations of instruments (and of his instrumentalists' personal styles) and the rainbow of harmonic patterns at his/their command. In Ellington's "David Danced Before the Lord with All His Might" (1968), a solo singer's voice (Jon Hendricks), call-response choral sections, and the quick beats of a tap dancer's feet (Bunny Briggs) interweave with solo and then shouting ensemble horns—all with a rhythmic play of colors, textures, and layers that recalls Duke's portrait by Bearden.

As Klaus Stratemann makes evident in *Duke Ellington, Day by Day and Film by Film* (1992), Ellington played for dancers night after night, for many years—sometimes departing an early-evening stage show featuring dance to play a prom or another social dance function.

4. Romare Bearden, *Ellington, Rainbow*, 1981, collage

© 2020 Romare Bearden Foundation / Licensed by VAGA at Artists Rights Society (ARS), New York

5. Duke Ellington, n.d.

Library of Congress, Prints and Photographs Division, LC-USZ62-42991

"I think it's very important that a musician should dance," Ellington told an interviewer in 1962." I think that people who don't dance, or who never did dance, don't really understand the beat."[6] As certain clips of Ellington directing the band show, Duke himself knew how to move to the music, and might be classified as one of dance historian Jacqui Malone's dancing jazz conductors (fig. 5).[7] And so that's part of what I want to get at: while I'm thinking about

6. Cover of Toni Morrison, *Jazz* (1993), cover design by Melissa Jacoby

Ellington and the art of film—calling on Bearden as a painter for perspective—I want to consider dance as African American art in motion. Crucial to digging the movie *Black and Tan* is reading not only the film's music but also the dances and dancers offering visualizations of that music.

Toni Morrison is another key guide for me through this terrain where the arts flow together. In the preface to her novel *Jazz* (1993) she describes trying to write a story in which structure would not only enhance meaning but would equal meaning (fig. 6). In the case of this novel, she wasn't just trying to write *about* jazz or to use it as a touchstone or historical marker, she was trying *to write jazz.* Likewise, I think Murphy's *Black and Tan* was part of the director's ongoing project to make a film that depicted jazz and also somehow *was* jazz. "There has to be a mode of writing," Morrison told an interviewer, "to do what the music did for blacks, what we used to be able to do with each other in private, and in that civilization that existed underneath the white civilization. I think this accounts for the address of my books. I'm not explaining anything to anybody. My work bears witness. All that is in the fabric of the story in order to do what the music used to do."[8] Recall with me the moment in *Beloved* (1987) when it's music that "breaks the backs of words." So, while I'm thinking about the power of music to include words—or to imply, in its sounds, a will to speak or write, I'm also thinking about the capacity to move beyond words altogether *into the transblucensphere.* With this, I'm thinking about art's capacity—in its fluid or molten states at art's lively edges—to invoke and embody powers beyond what we think of as single-genre art forms, or even as one art form yearning to be the other. I speak of the capacities and urges of modern and contemporary Afro-art to break the back of single-genre expression.

Along these lines, consider these next pictures by Gerald Cyrus, from his mid-1990s *Stormy Monday* series. *Three Couples, La Place, New York* (1995; fig. 7) and *Kathy's Arms around Buster, Harlem* (1995; fig. 8) reflect the sense of a blue-light house-party joy and closeness that I've been trying to define: the sound and rocking dance-floor spirit radiating throughout the neighborhood—in this case from two musicians' hang and party-time places (now gone), La Place and St. Nick's Pub. You can hear a democratic sense of community sounding through Cyrus's photographs as well as in Bearden's paintings. It's in the sounds, rhythms, and colors of Morrison's novels, too—and in the transblucent downstairs house parties of Washington, DC, where a democratic sense of community shone and sounded "underneath" (and in defiance of) the white community's me-first violence. As we shall see, it also shines and sounds through *Black and Tan*, movie and music.

Ralph Ellison recalled that some musicians he knew on the Oklahoma jazz circuits of the 1930s "wore their instruments as a priest wears the cross."[9] This is one context in which to regard the transcendent part of what I'm calling transblucency. For I speak not only of identity as multiple/relational and of a jazz aesthetic regarding all the arts as cousins—all arts seeking structure, color, and rhythm—but also of the shared project of doing the best work that can be imagined, of striving not for the sterile finishes of perfection but for a quest that Kenneth Burke calls "a gesture toward perfection," a gesture, we might say, toward transcendence. A

7. Gerald Cyrus, *Three Couples, La Place, New York*, 1995, from *Stormy Monday* series

Courtesy the artist

8. Gerald Cyrus, *Kathy's Arms around Buster, Harlem*, 1995, from *Stormy Monday* series

Courtesy the artist

character in Ellison's posthumous fiction corrects Burke's ideal of reaching toward individualized perfectionism, declaring his preference instead for a dynamic group project: "We seek not perfection," he says, "but coordination."[10] Here is transcendence as a community-wide ideal of working (and playing) together.

And how, we must ask, might the rowdy streams of jazz connect with the fresh clear waters of spirituality? To begin with, one of the jazz artist's mandatory quests is for a personal voice—a

spiritual quest in itself: for voice, self, soul. My correction to this received wisdom comes in light of Ellison's ideal of "coordination." I see this famously definitive striving for voice in jazz as a matter of coordinating one's voices within one's selves "in relation," to borrow a phrase from the philosopher Édouard Glissant. This makes jazz's famous woodshedding in search of voice not only a single-person project but also a *group* project. As the true jazz artist seeks a variety of distinctive personal ways to play, she and he also seek ways to make music with others. "The Ellington sound" or "the Ellington effect" depended not on mystery but on the projection of hard-won personal styles from the palette of each band member: Johnny Hodges could play with an insinuating softness, smoother than silk; or he could "call the dogs" in a voice that was burly and louder than most of the trombones or trumpets—never sounding like anyone but himself. Just as crucial to the Ellington sound was the coordination of strongly diverse individual voices. Ellington's music projected this perennial search for beautifully coordinated individual selves orchestrated to maximize total effect. Here, again, was music exemplifying beautifully coordinated community: a blues-based labor of love that is, by definition, capital-P Political and thus always deeply spiritual work.

This discussion leads back to Ellington the Washingtonian. Duke was Duke even as a little boy—as the pictures show. That's when he got the nickname. He was a very good athlete, careful dresser, and very well spoken. Of course, it is significant that his father not only "worked at the White House," as biographers report. He was a *butler* at the White House, which meant that he was the one who had a sense of manners in that place (once upon a time when sometimes manners there were good). The elder Ellington was also one of those who would have to tell city and country yokels from Congress, when they visited the White House, which silver fork to use when, and what to do with the crystal glass they had never seen before. Duke and family lived on Ward Street in Northwest DC, a short street you can hardly find nowadays. He attended Armstrong Vocational High School, where he studied mechanical drawing and other applied arts. Sometimes it's mistakenly claimed that because Ellington did not go to M Street High School, which became Dunbar High School, he wasn't part of the Washington elite. But since, as we have seen, Duke's first professional ambition was to work as a visual artist, Armstrong was the place to go, not M Street High, despite class associations with academic rather than vocational training. Ellington's music soon reached beyond DC's high school proms, private parties, and public dance halls, across class and color lines, and into social functions and theaters far beyond what we now call the Washington Beltway. Early on, too, he was involved in a wide variety of collaborations and crossover projects. Eventually he would compose the superb film scores for *Anatomy of a Murder* (1959) and *Paris Blues* (1961); altogether he was involved in more than one hundred films—feature-length works and cameos, as well as the shorts called "soundies."

It's quite important in any discussion of Ellington on film, or for that matter of Ellington in performance, that he would appear only as Duke Ellington the musician/bandleader/composer. In no film was he ever the janitor who happened to play piano, or any other such role typically assigned black celebrities working in Hollywood. Tempered by the social confidence imparted by his dad and by his discipline as a working jazz musician, he'd created the persona of the Duke and refused to relinquish it, from his earliest films in the 1920s, including of course *Black and Tan*.

As for director Dudley Murphy, *Black and Tan* was a crucial step in his ongoing creative effort to invent ways to translate the young twentieth century's exciting new forms of music, both European modernist music and jazz, into the era's just as thrilling new language of moving pictures. Completed the same year as *Black and Tan* in 1929, his *St. Louis Blues*, with its superb footage of Bessie Smith, is a miniature gem; and his 1933 feature *Emperor Jones* was an even

more significant film showcasing Paul Robeson. Music is the common thread. Murphy's first movie, *The Soul of the Cypress* (1921), features a modernist flute player serenading and a woman in diaphanous clothing who represents the spirit and tantalizing physicality of the music—themes he and Duke also explore in *Black and Tan*. As art historian Richard J. Powell says,

> The son of a turn-of-the-century New England academic painter, Dudley Murphy grew up in Southern California, and was a pioneering participant in Los Angeles's burgeoning motion picture industry. But it was probably Murphy's involvement in experimental filmmaking (following his 1922 move to Paris and his collaboration with artist Fernand Léger on the 1924 film *Ballet Mécanique*) that launched his cinematic penchant for [un]usual camerawork and visual dazzle.[11]

9. Duke playing for Joan Miró, still from *Duke Ellington at the Côte d'Azur*, 1966, directed by Alexander Arnz

Library of Congress, Music Division

Enlisting stop-animation to dance a cubistic Charlie Chaplin figure in and out of fractured configurations and mobilizing percussive repetition of geometric shapes, machine parts, and body fragments in an ode to modern beauty, *Ballet Mécanique* (with experimental score by George Antheil) is a milestone in transatlantic modernism.[12] In fact, *Black and Tan* exemplifies the traffic of influences between the modernisms of Ellington's world and the modernisms of Murphy. For example, certain scenes in *Black and Tan* refer to *Ballet Mécanique*'s then-virtuosic camerawork as they slyly quote *Ballet Mécanique*'s own references to landmark French modernist works such as Abel Gance's *La roue* (1923), as well as Erik Satie and René Clair's *Entr'acte* (1924). Like Murphy, the European moderns in film and music were listening avidly to jazz (and to Igor Stravinsky in particular, who was so manifestly influenced by jazz) and watching jazz dancers as they tried to find ways to translate their new lines and colors into their own work.

Ellington was also thinking of how he could confront and distill into his artistic language the European modernisms, as well as new forms he encountered in other parts of the world. Consider the section of the documentary film *Duke Ellington at the Côte d'Azur* (1966) that features Ellington playing for and chatting with the Spanish painter and sculptor (and jazz lover) Joan Miró (fig. 9). Producer Norman Granz has set the encounter in a sunny sculpture garden of the Fondation Maeght in Saint-Paul-de-Vence, France. Here Ellington, accompanied by Sam Woodyard on drums and Ernie Shepard on bass, improvises on a new composition called "The Shepherd," while the film cuts to sculptures by Miró, suggesting comparisons in form that include the documentary film itself. A studio recording of 1968, released decades later, includes Ellington's little-known composition "The Degas Suite," a meditation on the French artist's vibrant images of horses and racing jockeys. In an interview with Stanley Dance, Ellington speaks of his encounters with Asian musicians in a way that sheds light on the composer's attitude toward new influences in general. "I think I have to be careful not to be influenced too strongly by the music we heard," says Duke.

> The moment you become academic about it you are going to fall into the trap of copying many other people who have tried to give a reflection of the music. I don't think that is the smart

Library of Congress, Music Division

10. Duke rehearsing from home with trumpet soloist, still from *Black and Tan*, 1929, directed by Dudley Murphy

thing to do. I would rather give a reflection of the adventure itself. . . . I didn't want to . . . copy down that rhythm or that scale. It's more valuable to have absorbed it while there. You let it roll around, undergo a chemical change, and then seep out on paper in a form that will suit the musicians who are going to play it. The most work I have to do is to *think*. . . . It really takes quite a bit of doing to decide what to do and what not to do.[13]

True to his practice, Duke Ellington plays *himself* in *Black and Tan*—the responsible composer/pianist/bandleader and complex man of parts—Ellington, the Harlem Renaissance Man. While the film's opening scenes foreground a duo of stereotypical Negro characters, Alec Lovejoy and Edgar Connor—cast in roles that are holdovers from nineteenth-century minstrelsy—Ellington quietly enacts a politics of refusal, the hard work of deciding "what to do and what not to do." He stands apart from the minstrel comics, regarding them from an oblique angle, hinting that these others must have walked into the wrong movie! Indeed, the Dukish oblique regard and refusal is the modality of Ellington's transblucency that I'm aiming to define here. Typically, these cardboard types can read neither words nor numbers. So, scratching and mumbling, they locate the apartment they are looking for. (Only when they hear Duke's piano do they know where to go.) By contrast Ellington is the film's super-literate reader and writer of music who is a quick reader of one racialized situation after another, this one and ones yet to come in *Black and Tan*. From his sideline skeptical view, he misses nothing.

Such politics of refusal operated in Ellington's approach to music as well. Beginning in the first years of his musical career, he was creating concert-length pieces in defiance of the marketplace's racialized demand for shellac commercial platters. One of Ellington's strategies around the recording industry was to compose a steady flow of new compositions for the movies (and concert halls), multiform pieces where he was freer to write what he wanted without forgetting the business of meeting the payroll of a big band on the road. And so, like *Symphony in Black* (1935), *Black and Tan* demonstrates the collaborative way Ellington worked, as it also assembles a variety of his compositions, new and old.

11. Hot Shots performing "the one-man dance," still from *Black and Tan*, 1929, directed by Dudley Murphy

Library of Congress, Music Division

More than *Symphony in Black*, *Black and Tan* offers a view of the commercial world he and Murphy were navigating—a view from behind the curtain, off-stage. In the opening scenes, Duke is rehearsing at home with his trumpet soloist (fig. 10). This is by no means a scene of the composer giving a horn player the music and saying, "Play the notes precisely as written." Instead, we see what Ellington scholars have long described as his dynamic give-and-take process, the composer and the improvising instrumentalist as co-composers. In this scene, Ellington has written the trumpet player's *Black and Tan* solo to include a mute creating the human voice-like effect for which Ellington's brass was (and has remained) known. But it is highly significant that Ellington has written this muted trumpet part for a particular player, Arthur Whetsol. At the top of this man's music score are no generic "First Trumpet" or "Second Trumpet," but "Whetsol." This is collaborative art making that depends on the particular sound of each player, including their capacities for improvisation, and, just as importantly, their ability to hear one another and to bring something unique to the composition.

It certainly is important that this movie, *Black and Tan*, is explicitly about dance music, music played for dancers. In one passage, the dance team called the Hot Shots performs "the one-man dance" (for which they were best known) in a way that recalls again this movie's debt to *Ballet Mécanique* (fig. 11). Here, the Hot Shots perform a dance that combines uncannily virtuosic coordination and elements of ironic contradiction: the team of Hot Shots as a tightly knit unit in a country that denies black men their humanity—or, more cynically, that treats black men as if they were all the same (according to Lynch Law, any sacrificial black man will do). These are men who can't eat in DC's downtown restaurants; and yet along with Ellington, they have created outside of official Washington culture another culture that dances its cool, complex response to the racial madness around them. Dancing to Ellington's blue note of celebration and refusal, they coolly perform their dances of democracy: the swinging many as one! Their transblucent American modernism is underscored by the music and by the film's Afro-deco sets. Seen through rotating lenses and special mirrors, the Hot Shots perform African American art in motion: modernity jazz-danced, *black*.

12. Duke playing "Black and Tan Fantasy" to Fredi Washington, still from *Black and Tan*, 1929, directed by Dudley Murphy

Library of Congress, Music Division

I think it's important that Harlem's whites-only Cotton Club, which inspired *Black and Tan*'s theater setting, opens a window onto segregated Washington. Coming to this club, white patrons could sip martinis while bathing in nostalgia for the Land of Cotton: for white dominance and black subservience. They could revel in images of "The South," "Africa," and slavery, and even of black performative skills for entertainment, as long as they were served from the standpoint of white superiority. (This perspective on the film makes perverse sense of the black stereotyped characters.) The wonder is that given all this, Ellington, in partnership with Murphy, is nonetheless appropriating the Cotton Club space, and the space of the movie, as absolutely his own. Now these haunted spaces become platforms of transcendent black creativity, of *transblucency*. In the interstices or "undercommons" of these spaces, Ellington asserts what I've called elsewhere "a black unruly cosmopolitanism." *Duke does his thing!* Shedding light on this Cotton Club scene, one long-term member of the band, Harry Carney, told an interviewer that to please white-only audiences and get paid, every night the band played what such audiences took for the widely advertised Ellingtonian "jungle music." But at the same time—playing exactly the same music!—keeping their eyes on the radio microphone, the musicians never forgot that they were playing for their girlfriends who, just around the corner, were listening to the radio broadcast. So, with that wondrously recentered sense of audience, we witness once again the "multilingualism" of Ellington and his band members. Reading the complex scene, they serve an unseen black audience's sense of taste—giving people in the blue-light basements of our community what they came for, and more—while maintaining their hold on the white patrons seated in front of them.

It is very important to realize that in this movie, these complexly nuanced performances take place under the gaze of the owner of the Cotton Club, under the deadly aegis of his idea of the black artist as mere entertainment, and of the artist as representative of a people made up of mechanical stick figures who are easily disposable. *Black and Tan*'s lead dancer Fredi Washington falls sick; but so what? If one cog in the machine cannot function properly, get another! What difference does it make?

The final scenes of *Black and Tan* are the most revealingly transblucent of the entire film. In the final two minutes of the film, we see the musicians, led by Duke, turn away from the commercial space of the theater and go back to Duke and Fredi's apartment, where suddenly the movie's contest over the meaning of the music in compromised spaces is over. With a quick closing of the theater curtain, now the music is by no means about white power but shifts to the black-and-blue musical rituals that create and sustain the black community. For in this last scene, as the dying dancer Fredi requests that Duke play "Black and Tan Fantasy," the transblucent power of the music takes over (fig. 12). Now instead of dancing for the distraction of the theater's white audience, Fredi and this film's audience overhear "Black and Tan Fantasy," the Negro spiritual-like ritual song of loss and consolation, of safe travels to other worlds. Ethereal as it is, this music of redemption embodies a community drawn together, mutually supportive in its sense of continuum. Now a full chorus, the Hall Johnson Choir (best known for their concert arrangements of Negro spirituals) adds urgency to the orchestra's *Black and Tan*. Horns and singing voices call and counter-call each other, making ready, mourning, testifying. In moments of crisis and loss, the community has its say in words from the spirituals—"the same train that carried my mother"—and in sounds resounding beyond words.

In that final scene, Ellington is quoting Frédéric Chopin (and the black DC joke that Chopin's famous notes may be sung as "Where shall we all be a hundred years from now?") at the same time that he's quoting a church song called "The Holy City." This last performance in *Black and Tan* exchanges the extractive space of commercial entertainment for the domestic black counterpoint spaces of creative refusal, assertion, and celebration. "Wait, a minute!" Duke and his music say to the story line of this movie. "Stop this, the show will not go on. We're done, we're gonna go back to basics now. This music is not about entertainment or about a scene where the people are interchangeable; it's about Fredi Washington—a human being, somebody we know and care about. She needs the real music now."

This music celebrates the basic unit of any healthy community, any democracy worth stopping the show to preserve: one person unselfishly caring about another. This is what I'm aiming to express: That through *Black and Tan*, complexly read across its mediums of music and dance, as well as stage show and film, a deep sense of love is celebrated. Viewed from the sidelines and heard on its lower frequencies, *Black and Tan* makes a bold statement about the blue-light party where we hold onto one another. Taken together, movie and music exult in a black DC, heralding a new kind of black-brown-and-beige democracy shaded in a translucent blue that revealed perspectives of hope.

SAM GILLIAM: THEATER OF LIFE

Adrienne Edwards

W hat would it mean to take *Composed (Dark as I Am)* (1968–1974; fig. 1) as artist Sam Gilliam's first "black" work? Curator Jonathan P. Binstock described it as an "overtly biographical statement" that "does show evidence of history, memory, and details of the artist's lived experience" and is "a direct response to the tempestuous debates surrounding African American cultural identity in the late 1960s and early 1970s."[1] Born in Tupelo, Mississippi, halfway between Memphis, Tennessee, and Birmingham, Alabama, in 1933, Gilliam moved with his family to Louisville, Kentucky, in 1942 and eventually to Washington, DC, in 1962.[2] *Composed (Dark as I Am)* similarly had a circuitous evolution realized through many variations. Initially more simply and evocatively titled *Dark as I Am*, it was first shown at Jefferson Place Gallery in Washington in 1973 (fig. 2).[3] A peculiar and uncharacteristic turn in Gilliam's art, the original iteration, where it was installed in a corner, fused the artist's personal items, including a denim jacket suspended on a wall, a pole, a small bag, and other miscellaneous items; on another wall was an assemblage, including canvas sloshed with paint and more coveralls and painting materials such as brushes, rollers, a tray, and a trowel, which were attached to a door, hanging on the wall.[4] Across the room, facing the two walls in yet another corner, was a pair of Gilliam's impastoed work boots installed on a low, rectangular support.[5] It also featured a range of found objects Gilliam sourced from "the street, and resale shops near his home at the time in the Mount Pleasant neighborhood of Washington, DC."[6] In 1974, on the occasion of his exhibition with contemporaries Melvin Edwards and William T. Williams at the Wadsworth Atheneum Museum of Art in Hartford, Connecticut, Gilliam altered the work, eschewing the boots and presenting *Composed (Dark as I Am)* as a wall work, all other materials congealed and compressed to the door, which was placed inside a wood frame that enabled it to be shown like any other two-dimensional painting.[7] Between these two exhibitions and in the ensuing years, the work was in the artist's studio, where he revisited it, working on it countless times.[8]

In its varying manifestations, *Composed (Dark as I Am)* seems to have ultimately delivered, even if belatedly, what everyone wanted from Gilliam: to provide some concrete visual anchor or representational sign with which to mark race in his art. At the time of its making, the Black Arts Movement in the United States, which was founded by Amiri Baraka in the 1960s and 1970s in Harlem, fueled by the civil rights and Black Power movements, advocated for the

Detail, fig. 5

1. Sam Gilliam, *Composed (Dark as I Am)*, 1968–1974, acrylic, clothing, backpack, painter's tools, and wooden closet pole on wooden door

© Sam Gilliam / Artists Rights Society (ARS), New York

creation of black art for black audiences, necessarily turning to Africa for aesthetic inspiration, dramatizing black life, portraying so-called black features and characteristics, and leveraging suffering for expressive purposes. Black representation involved the confluence of an artist's individual perspective or desire for personal agency with the discourse of the movement circumscribing the parameters of blackness in art. There has been a tendency toward figuration and realism in the movement, which operated on principles of transparency, immediacy, authority, and authenticity. These well-meaning efforts ultimately reinforced a reductive notion of "black art" or the idea of an essence locatable in works of art by black artists. Gilliam's art, along with that of Barbara Chase-Riboud, Ed Clark, Edwards, James Little, Al Loving, Mary Lovelace-O'Neal, Howardena Pindell, and Williams, among others, elides such essentializing inclinations, evident in the social realism of the Black Arts Movement, which necessitated a giving of one's account of lived blackness. The work of Gilliam and others with a shared sensibility was emblematic of the possibilities for abstraction, not only to serve as a platform to consider the context in which it is shown but also to vitally, yet subtly and opaquely, convey the social, historical, and political environment through which it arises.

2. Installation view of *Composed (Dark as I Am)* at Jefferson Place Gallery, 1973, from Jonathan P. Binstock, *Sam Gilliam: A Retrospective* (Berkeley, CA, 2005)

© Sam Gilliam / Artists Rights Society (ARS), New York

Courtesy National Gallery of Art Library

This is the context in which *Composed (Dark as I Am)* arises. However, beyond the personal objects—dispersed and occluded nonetheless by the sediments of paint and the inclusion of found material—and the undeniable, unmistakable self-referential "I" in the title, there is not much more to hold onto that suggests a body or its representation besides the way in which Gilliam marks the "I"—decidedly, unabashedly dark. In Gilliam's installation there is a profound sense of alienation and distension, a material elucidation by way of contradictions, paradoxes, and presuppositions. This dark instance, with its outlier reputation, confounds critics and historians precisely because Gilliam withholds the lush color, seductive composition, and sublime beauty of the work for which he is best known to indirectly redress long-standing questions about where his blackness is in his abstractions. What he delivers in his response is an impenetrable, coagulated, strewn density, thick with the sediments of the aftermath of things and events without index that does not attempt to represent blackness but as a self-presence might rather suggest how it feels and thus can be felt, performed in the minute intricacies and duration of the work itself.

For if we are to think of *Composed (Dark as I Am)* as a kind of black work, as enveloped in and expressing blackness, we feel not only what is in front of us but always coincidently both with and beyond it. The quality of sensing outside the real and metaphorical frame of that which is before us is what theorist Brian Massumi has described as a "perceptual feeling," as that which resonates even in the absence of proof of presence.[9] When we encounter *Composed (Dark as I Am)*, a black work by a black, this differential between what is seen and what is felt registers as an excess over, beyond, and deeper than that which is actually physically in the work itself (at least in any literal sense). Such animating qualities of *Composed (Dark as I Am)* enact a "continuing across" that is never solely situated in the one artwork. In this instance,

the black work extends within itself and in a relational fashion that is absolutely indivisible although perhaps without clear correspondence: a continuity with Gilliam's body of work, a continuity with other black abstract works, a continuity with the context in which they arise.[10] These shared perceptible affinities register through the function of repetition, which is often indirect, meaning we perceive their affiliation, despite absolute difference, through the distinct ways their qualities foment across, through, and beyond this particular work.[11]

After his graduate school training in a more academic style of painting, it was Gilliam's simultaneous introduction to Bay Area artists in California, particularly Nathan Oliveira, that would instigate his affinity for being in and as abstraction. Though typically historicized in the genealogical lineage of the Washington Color School, Gilliam's aesthetic innovations went well beyond it. The Washington Color School was a loose network of Color Field painters, including Thomas Downing, Morris Louis, and Kenneth Noland, among others, who showed in the US capital from the late 1950s to 1970s and gave the city its singular modern visual art movement, reaching its height in the mid-1960s. Arising in the aftermath of New York's abstract expressionism, Washington Color School artists were known for canvases featuring hard-edged lines of color, chromatic washes, or single areas of color.

The early years of abstract art are often historicized as artists being predominately concerned with a work's formal appearance as opposed to its content. This is despite modernism's long-established qualitative correspondence of art with the quotidian. Nevertheless, that Gilliam initiated what would become *Composed (Dark as I Am)* essentially at the same time he would create two bodies of work for which he is best known—the Slice and Drape paintings—undermines the former position, one that aligns with art critic Clement Greenberg's thought. First, a consideration of the metacharacteristics of Gilliam's art and his seminal works is necessary. Gilliam's paintings demonstrate a kind of fearless versatility in his idiom that makes known abstraction's boundless possibilities. Most notable are his works' qualities of monumentality, even when intimate in proportions. For the monumental effect of Gilliam's paintings exceeds a mere reference to their imposing, all-encompassing, enveloping size and scale (fig. 3). While these qualities are signatures of his experimentations, the paintings' monumental assets equally illumine their historical and enduring significance and exceptional resonance within and away from the arc of modernism. Second, theatricality powerfully shapes Gilliam's art. As he has said, "I wanted to deal with the possibility of 'there's a painting,' 'there is not a painting' or sort of being a little bit more into the theater of what was actually going on."[12] For him painting is "all theater or performance."[13] Gilliam's consistent references to the theatrical, more specifically the performance that is life itself, allows for a rethinking of his visual language and material choices to illuminate what artist and scholar David Driskell pinpointed as their capacity to "metaphorically and symbolically carry the weight of a colorful idea."[14] The theatrical saturation, thickness, and color avoid the discursive and figurative language of representation while nevertheless posing a new sensual (visual, haptic, visceral) ideogram in abstraction that performs duality, a shape-shifting between the desire for representation and his terms for resisting it.

Gilliam's first pivotal advance occurred in 1967, occasioned by the emergence of his Slice paintings (alternatively described as Beveled-Edge paintings). Gilliam got the idea for the Slice works from fellow artist Ronald Davis, who was using Plexiglas on his canvases, placing them on beveled edges.[15] Gilliam achieved these allover compositions by applying diluted acrylic (composed with the application of a water-tension breaker)[16] to raw canvas, then quickly imparting intense, improvisational manipulations of the still wet material, resulting in a distinct polychromatic luminosity. Chromatic tones were first lightly applied then overlaid with darker hues. After

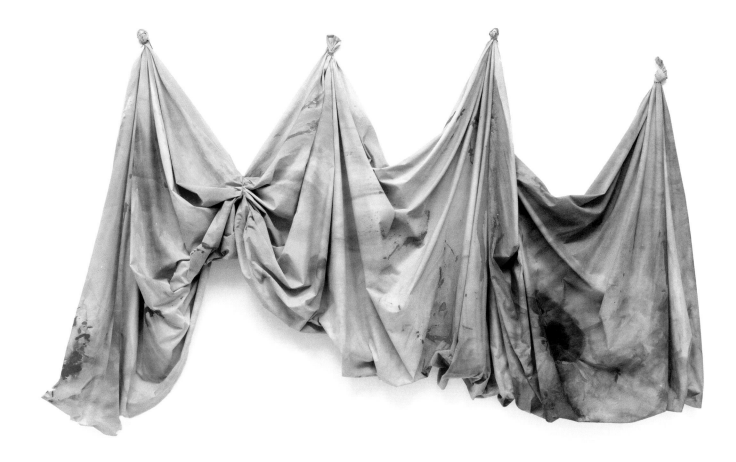

Gilliam acted upon the canvases, allowing the pigments to leak among one another, he would then fold and crease them, resting them in piles upon themselves, either hanging from a wall or mounded over furniture or studio tools. Gilliam's interactivity with his materials, pressing color and canvas, imbued the works with lines that deliver a kind of geometry of attention to the viewer. With such a visual guideline, the eye wavers between the structure created by anxious, agitated, and precarious lines that are the result of folds and creases, and the painting's sensual dimensions—tactile, lush, volumetric. The works' sensuality is enabled by Gilliam's reliance on chance and improvisation, on the easy and alluring amalgamation of colors, one upon the other. The works were then stretched on a beveled frame, the slanting edge angled into the wall such that they seem to levitate in absolute suspension above it.

A year later, in 1968, his indelible Drape compositions appeared, for which he discarded the typical framing apparatus of wooden stretcher supports that give paintings their geometric shapes in favor of scenes of billowing, swooning, and swinging color. For these works, Gilliam poured paint with the help of a tool or directly from a can, allowing it to saturate the canvas or polypropylene. The artist extended this contingent operation by rolling or folding the material like a fan, bounding it in varying parts, dangling it from the wall or studio props like a sawhorse or ladder, and allowing it to dry.[17] Such a protean shift rendered arcane aesthetic distinctions between painting and sculpture, painting and architecture, theatricality and repose, and between one who observes and one who activates a work of art.

3. Sam Gilliam, *Relative*, 1968, acrylic on canvas

National Gallery of Art, Anonymous Gift. © Sam Gilliam / Artists Rights Society (ARS), New York

By removing the conventional structure with which painting is identified and eliminating its reliance upon the wall, Gilliam actually disavows convention as it relates to the qualities we historically assign to two-dimensional works and our experience of them. We behold Gilliam's draped works not solely through our optical absorption of them but also through being enveloped by and entangled in them. At the moment of encounter, the drape atmosphere binds us up and embraces us, while also intervening in its surroundings, whether by sloping against the side of a building, looming overhead in a museum gallery, or siphoning the corner of a church or home. The fact that Gilliam's Drape paintings are reimagined with every reinstallation not only shifts the location of the work but substantially alters the perception of it. He creates sensescapes, fields of projection, and self-reflexive harnessing that trigger the viewer's active engagement, necessitated by a demand for total immersion.

Gilliam's treatment of canvas and color is a proposition for considering the timing of the event that ultimately results in a painting. Each work is a durational singularity, making temporal experience not merely an element of contingency but rather a distinct, specific medium in and of itself, mobilized through its interrelationship with the specifics of matter that we recognize as color and canvas yet going far beyond them. In the inseparable intermingling of pigment and cloth that which is unrepresentable comes to the fore, and that which is unique to the occasion of their commingling enters a force field that we come to recognize as a painting. The painting is always already an inflection point, a place of fusion and cohesion where Gilliam makes allegiances in deference to material capacities. From the time required to apply layers of color, to the unwieldy mutability of the method of folding, to the submission to chance in having to wait for the painting to dry, to the unknown result not revealed until it is unraveled from its bound form, Gilliam evolves a process reliant on extreme mutability and bold immediacy. The extreme expression of these tendencies is reached in the variations of *Composed (Dark as I Am)*, as it foregrounds color as darkness and its broad-ranging implications. The materials are indistinguishable between what is personal and what is found (essentially trash), and their assemblage is a tricky guise of relation. The "body of the work" is splayed around the space—initially having no frame, no container, utterly unbound.

In all of these instances, it is as if Gilliam's very process is far beyond abstraction as form and aesthetic. Rather, his work is a mechanism for feeling abstractly, thinking abstractly, exploring the capacities of abstraction, an invitation to lean into the abstract—which is to say, the works are beings toward and for an abstract state. Through such a pivot in our understanding of these works, the significance of volume, dispersion, and improvisation and the ways they are inseparably intertwined attain a heightened significance in the stakes of Gilliam's art that are later crystalized in his series of black monochromes.

Gilliam remarked about his shift from white paintings in 1976 to black paintings in 1977 as aiming "to create a fork in the road"—the evolution of which actualizes a process of exploring a new way of working by experimenting with the psychic landscape, force of color as a symbol, and corporeality of paint media. Already we see this redirection in the work as a repetition of aspects of *Composed (Dark as I Am)* in its myriad presentations with their density of material, dispersal, accumulation, and the profound sense of disharmony as acts of opacity. Whereas the draped works have nearly operatic qualities—in the sense of their extravagance in complexity, scale, and ambition—Gilliam's black monochromes are, like *Composed (Dark as I Am)*, similar experiments in interiority felt through tactility and texture (fig. 4). In particular, in its penultimate version, form coagulates and compresses some of the materials from the installation into a structure, literally into a frame. In so doing, the painting confines and delimits its referent (a black life), as that which began as unwieldly, materialized individual agency now is refashioned,

4. Sam Gilliam, *Untitled (Black)*, 1978, acrylic, yarn, and cut canvas on stained canvas

Whitney Museum of American Art, Gift of Suzanne and Bob Cochran. © Sam Gilliam / Artists Rights Society (ARS), New York

constrained, and bound. Such a shift suggests a mimesis with the construct of racial categorization and the impossibility of representing a life submitted to it. Our encounter with the black paintings also enacts a similar agitation, activated by their vibrational sensibilities, the ways in which their varying frequencies are perceived as a result of the volumes of matter applied to their surfaces, as they oscillate in different directions, in different ways, to different degrees depending upon what is observed, by whom, and under what conditions. While Gilliam has always been concerned with the spatial synergy of his paintings, the black works, like his dark "portrait," animate differently. They are sensory experiments in chroma dynamics of distance, in the same way that line, color, and density of material push one away from the surface and boundary of the painting and into the enveloping space on a trajectory well beyond the object itself. Such a move has less to do with the sense of literally enrapturing the viewer within the work, as is the case with the Drape paintings, but rather demonstrates a deliberate denouement with dissonance and density—precisely because of the performance of a color and the feelings it conjures.

As early as the Beveled-Edge paintings, their "forward edges chamfered," Gilliam reveals what would be a long-standing interest in magnifying and testing the dimensions of his wall-based works, in which the black monochromes are an important turning point.[18] Where the Beveled-Edge paintings gave the *appearance* of what Gilliam describes as a "slablike concreteness," the black and his subsequent Red and Black paintings materialize this perception—as did *Composed (Dark as I Am)*, for that matter. Indeed, the artist called the works made beginning in 1982 "constructed painting," a reference to their built-up, thick, and heavy materiality that is both sculptural[19] and architectural as well as affecting:

> My work consists of solids and veils . . . (solids or metal forms) seen as volumes against a raked and grooved paint surface. It is constructed painting, in that it crosses the void between object

5. Sam Gilliam, *April 4*, 1969, acrylic
on canvas

Smithsonian American Art Museum,
Museum Purchase. © Sam Gilliam /
Artists Rights Society (ARS), New York

and viewer, to be part of the space in front of the picture plane. It represents an act of pure
passage. The surface is no longer the final plane of the work. It is instead the beginning of an
advance into the theater of life.[20]

One of the resonant ways in which Gilliam explores and intersects ideas of the veil, the
void, and life, which is to say the triangulation of the concept and aesthetics of blackness in
his art, is through the dark, dense, thick, encrusted, and coagulated surfaces that emerge with
Composed (Dark as I Am) and continue in the black monochromes. He figured the surface
with a mark-making technique in which he inscribed the work using a shag-rug rake. As early
as 1973, Gilliam began to collage into various series of paintings.[21] It is as though his choice
to thicken the canvas with other bits of fabric served as a visual structure akin to the ways in
which line and shading function in perspectival and figural work. In this way, collage and paint
entangle to give the painting a form or "technique of existence" in which formal abstraction
commingles with lived abstraction (understood as experience formed by the concept of race)
in the materialization of the work. Rather than thinking of black abstract work by a black as a
disavowal of the figural, of being beyond a threshold, perhaps we could think of it as an extreme
minimal gesture of it, unfolding in the important context that is social, cultural, political, and
historical. Previously, the indication of a figure could be located in the titles of the Drape and
Beveled-Edge paintings, which periodically referenced blackness; for instance, *April 4* (1969;
fig. 5) alludes to the assassination of civil rights icon Rev. Dr. Martin Luther King Jr., and *Three
Panels for Mr. Robeson* (1975; fig. 6) was in recognition of the artist and activist Paul Robeson.

Less literally, blackness also appears as the affective resonance of jazz. As art historian
and curator Mary Schmidt Campbell remarked, "Gilliam's cascades of color are not unlike
Coltrane's sheets of sound."[22] We can understand this impulse as concerning less a desire for a
visual representation of jazz than a committed effort to materialize, give a physical manifestation
to the sensual dimensions of musical abstraction, transposing its sonic qualities to canvas and
paint for a fleshy embodiment. Gilliam has said, "Coltrane worked the whole sheet: he didn't
bother to stop at bars and notes and clefs and various things, he just played the whole sheet at

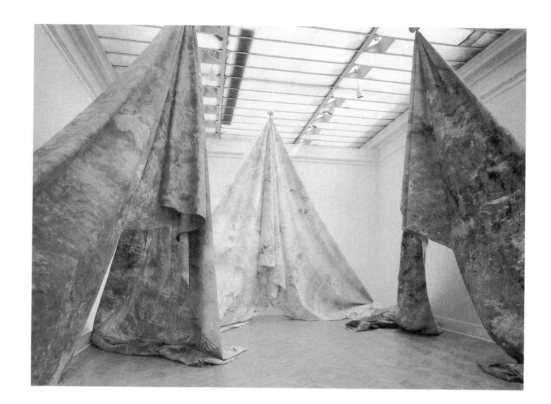

6. Installation view of Sam Gilliam, *Three Panels for Mr. Robeson* at the Corcoran Gallery of Art, 1975, from *The Corcoran and Washington Art* (Washington, DC, 1976)

Corcoran Gallery of Art curatorial office records, COR-0005-0-RG, Series 6 Subseries 1, Box: RG5.0-2008.012, Folder: 20. © Sam Gilliam / Artists Rights Society (ARS), New York

once."[23] As art historian Kellie Jones notes, artists like Gilliam, Williams, Jack Whitten, and David Hammons were in search of an abstract voice akin to jazz, "something that could be nonobjective in form and coded with (self-) reference, without relying on representation."[24]

While these cursory references suggest and name blackness in Gilliam's art, they do not reflect the dynamism, fluidity, and slipperiness of its presence. While Campbell further proposes that Gilliam's works of this period do not reference personal events and are, rather, "elusively abstract references of music, nature and architectural detail," there is a subtle yet direct proposition within the material and facture of the work to produce and correlate a relation between the black work as an object with a resemblance to black life.[25] Massumi offers the example of a dance meant to interpret a storm: "The sensuous experience of the word 'storm' does not resemble a downpour, or an undulation of hands a billowing of clouds. The dance and the storm are nonsensuously similar in that *between them* they co-compose a joint activation contour of differential attunement to the same event."[26] His example suggests that an analogy occurs between them in which these two events—the storm and the dance—relate abstractly. They align because they share a "technique of existence" that "takes as its 'object' process itself," which in the instance of the dance and the storm is ritual, while for the black work, it is the mutuality of blackness in the object as much as in life.[27] How might the process that occurs between a life and the object reveal itself as a technique of existence that is blackness? The qualitative and relational peculiarities of blackness as an object and a life clarify its veracity, namely the ways in which it is "inventive of *subjective* forms,"[28] which is to say self-abstracting the black object and black life mutually in a coterminous event through a shared affective tone—the whole array of modes, means, vibrations, pitches, styles, manners, states, and values assembled—sieved into the black work thick, dense, and precarious, dispersing blackness as lived abstraction. This

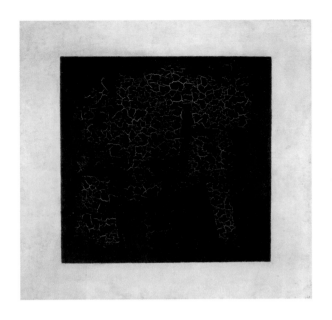

7. Kazimir Malevich, *Black Square*, 1913 or 1915, oil on linen

© State Tretyakov Gallery, Moscow

8. Alphonse Allais, *Combat de nègres dans une cave, pendant la nuit* (Negroes fighting in a cellar at night), page 7 of *L'Album Primo-Avrilesque* (1897)

Bibliothèque nationale de France

object as process, and its counterpoint, process as object, is profoundly conceptual inasmuch as it is performing the idea of blackness, in which the concept of race virtually enacts capitalism, the very system through which it was formed, which always already exemplifies the limits and possibilities of black life.[29] The mode, means, and methods are the dynamics and choreography of capitalism's subjection upon black life itself—accumulation, repetition, precarity, exhaustion, extraction, and so on. It is never as simple as the black work representing the system or black life, but rather that its very objectness has an attunement to and a tone in its qualities, in its affective tonality, that enable the artist to convey and the viewer affectively to feel them both.

It is thus necessary to be quite specific in describing the role of experience, how bodily knowledge is presented—as an acquisition in *Composed (Dark as I Am)*—and revisited in its later formation, as well as how the black monochromes use this in order to explain its emergence in the abstract, its manifestation as abstraction for Gilliam. The work of art qua body's vigor is the figure of repetition and the social field its stage, and its mode is a kind of tuning into how its elements co-constitute the event and experience. While it would seem that the "tuning into" would involve a coming together in mutual recognition, this is not the case. Rather what transpires is a pulling apart, a kind of polarizing into distinct forms: black life and black object as "the cross-embodied vitality affect."[30] In the necessary separation, the black work's objective is toward density, having absorbed remainders of its eventfulness, which is to say its foundational relationality to black life. Withdrawal is the choreography of consent, the necessary enacting of a relational independence that merely veils a shift in the qualitative presence of black life to that of a trace. For black life continues in the black work quite literally in the dark. The black work as a form abstracts, seeming to separate the form of itself as object and its relation to a life, since "*it is the separation of forms that is learned*—not their dynamic relations."[31] The initial locus of separation for the black work—the primordial life from which it is asunder—is that of its maker. The black work is made to feel as an object among other objects made by the artist, as well as other forms. Yet it always carries the trace, though obscured, veiled, foreclosed because of how it has come to be in the world as a form.

An important part of the trajectory of such a trace, as it concerns the black monochrome, is the recent discovery of a racist joke—"Negroes battling in a cave"—handwritten under Kazimir

9. Sam Gilliam with his installation *Custom Road Slide* at Artpark, Lewiston, New York, 1977

© Sam Gilliam / Artists Rights Society (ARS), New York

Image from the Archives of the Burchfield Penney Art Center. Photo: Andrew L. Strout

Malevich's *Black Square* (1913 or 1915; fig. 7).[32] In this long-lost inscription, Malevich references writer and humorist Alphonse Allais's earlier version of the black painting *Combat de nègres dans une cave, pendant la nuit* (Negroes fighting in a cellar at night, 1897; fig. 8).[33] Scientific analysis has revealed two paintings—a proto-suprematist work and a hybrid cubist-futurist composition—hidden alongside the handwritten racist joke.[34] These inscriptions figured in the work trouble our common understanding of Malevich's abstraction as the "zero degree" of painting and implicate race at one of the earliest inceptions of Western abstraction. Gilliam's formal technique of layering bits of cut canvas upon canvas and inscribing by raking into its veneers allows the troubled anachronistic relationship among material, history, race, society, and culture to be buried and resurfaced, similar to the Allais reference in Malevich's work. These fugitive surfaces—Allais's and Malevich's—are paradigms of resistance, as all that may have remained invisible, just out of sight, rises through the cracks, animating from within, and up into the raking black light.

For a distinct point of departure is achieved with the development of a tool and the choice of chroma, but less considered is the literal "fork in the road" Gilliam enacts through his mode of inscription—his intention in marking, in going into the surface of the work with a facture that is physically and materially unruly, irrationally abstract. The density of Gilliam's surfaces, the ways in which he burdens the paintings, is a study in the elasticity of hypostasis—the capacity of a strained body to recover its form after a process of deformation. This is to say, the building up of their surfaces instigates the effects of sediment in that as much as the works are constructed, to use Gilliam's word, they are also broken down, weathered, eroded, transported, directed toward some unascertainable center of gravity that seems to act upon not only the work but us as viewers, continuously drawn in and down, indeterminably dispersed from underneath. The result of extracting strips and sections of other paintings and collaging them within the black works is a denser, tactile facture, a distinct physicality. The inception of Gilliam's interests in the carnality of matter is inextricably connected to his outdoor installation *Custom Road Slide* (1977) at Artpark in Lewiston, New York (fig. 9). Here the artist extended the dimension of

performance in his art by installing paintings over four hundred yards of highway along the Niagara River Gorge.[35] Evolved over the course of eleven acts in one month, "Gilliam and his assistants used sawhorses . . . screens, timbers, poles, wire, rope, and shale to elevate or cover large pieces of white and scarlet polypropylene and white polyester fabric, each measuring about 12 by 100 yards."[36] The rich chromatic range of the fabrics, reminiscent of the Slice and Drape works, evolved from natural dyes present in the soils' minerals commingled with synthetic paints; they undulated along the roadside in compelling variations of objects, material, and sediment, carving fissures of stone and interweaving bold, solid colors of paint and food dye to complete the composition.[37] When describing the piece Gilliam said, "The initial phase was performed rather than constructed"—in reference to the process of its realization.[38] Such is the effect/affect of thickness and its inextricable relation to the body; Gilliam's veneers make known the indivisible sentient entanglements between matter and subjectivity, between formalism and conceptualism, between blackness as abstraction and the abstraction of blackness.

The Red and Black series, first shown in 1981 at the Nexus Gallery in Atlanta, Georgia,[39] is the fulcrum of the interrelation between body and process among the black paintings, in which Gilliam makes color sculptural with a thick tactility amplified by a return to the architectural, experimenting with shape, line, and a new system of display. In this body of work, Gilliam continued his mark-making by inscribing lines using a rake or broom.[40] Here the capricious process of staining canvas, as in the Slice and Drape series, gave way to a methodical mode of accumulation in which layers of various kaleidoscopic hues of acrylic paint, Rhoplex, and pieces of paper and canvas were applied one on top of another, densely deposited in some places, while almost evanescent in others. The apparatus etched fissures and blurs within the surface, as the colors held their own even though they seemed to reluctantly coalesce. Such an approach to color was concatenated and thereby compounded with the assemblage of canvas forms extracted from stained paintings and applied to these works, as well as others from the late 1970s onward. The cuts were initially straightforward geometric forms. As the work evolved, they took on the sense of fluidity and chance reminiscent of the Drape works inasmuch as they are more variable, even feeling random.[41] Becoming more elaborate, some of the mural-scale diptychs or triptychs could also be presented in a variation of configurations, as parts within a work that could be mixed in response to the environment of the exhibition space.[42] Now the geometric style is not simply inserted into the painting but rather the very configuration of the supports, as "Euclidean shapes out of sync with each other."[43] Further, the cut forms are also arranged as if to contour the lines and arcs expanding and connecting patterns across the panels that compose the work. Take for instance *The Arc Maker I & II* (1981; fig. 10), a four-part whole made up of red and green underpainting on an unprimed canvas support blanketed in black in which

the pentagons were first cut into quarters; three of the quarters were then bisected by arcs and the opposing elements exchanged between the pentagons. Similar cuts and exchanges were made between the rectangular panels. The lines and arcs were highlighted by repainting them a different color, and the panels hung in such a way that the circles continue across the gaps between the panels.[44]

Both unlimited and necessarily delimited black paintings such as *The Arc Maker I and II* continually trace blackness and its embodiment (through process and material), attuned to and enacting the notion of "continuing across" that makes the work foundationally relational. The black works figure a double abstraction of the technique of existence, the formalism of artistic

medium on the one hand, and the lived abstraction that is black life on the other. In this way, black works by blacks are already always compounded, polarized; the materialized, mattered manifestation of blackness:

10. Sam Gilliam, *The Arc Maker I & II*, 1981, acrylic on canvas with collage

Detroit Institute of Arts, Gift of the Friends of African Art. © Sam Gilliam / Artists Rights Society (ARS), New York

> The consequence of this is that the "purity" of a technique of existence's expression is a fragile achievement. In fact, the emptying of the event of expression of all content other than its own occurrence is a *limit* of process toward which the world's creative advance ever tends, never reaching. The doubling of every lived abstraction by a sensuous encounter means that there are always remainders of embodied animateness and objective order that are nonsensuously doubled—but not erased. Emptying is not erasing. It is taking off from. Breaking up is not sweeping away. It is breaking-away-from.[45]

In the enactment of a seeming separation, something else becomes possible in Gilliam's black abstract work: indirectness, allusion, innuendo inscribe them, too, thereby fostering conditions for an elemental reassessment of the presence of blackness, meaning a different consideration of the work of art at its most primary, which is also to say primal, level. Some might describe this as a fundamentally ontological question. However, what is most useful is knowing not only its basic nature but also and equally how convoluted, constellatory, and extensive the embeddedness of an embodied blackness as that which is always already "continuing across"—this is how I understand the full implications of Gilliam's "theater of life." The modicum of a black work's materiality is profoundly dense, dark, and elaborate, a "color in the absence of man, man who has passed into color."[46] For "when painting wants to start again at zero . . . by bringing it closer to the maximum of the concept, it works with monochrome freed from any house or flesh."[47]

Gilliam's black works attend to the ways in which the black work forecloses the limited articulation of the capacities of formal abstraction, which always asperses in the abyss of endless illusions and mythologies about art for art's sake, ever resistant to the worldly conditions through which it takes form and exists. Content—never a question therein—is indeed required to assess what his black works do, how they pressurize the limits of abstract art and lived

abstraction, how they relate compositionally—a "relational co-habitation."[48] The black work pushes the limits of material in order to matter the abstractive intensity of lived abstraction, making it not just seen but importantly felt. The viewer is beguiled by its animatedness, which is a figural extraction of the actual body, which lies in wait, acting through and as process itself. For in animation, what is perceived as a historical condition or fact is always in a state of presentness, that promise functioning repressively and retrogressively.[49] The performativity of blackness has always been attended by what theorist Sianne Ngai has described as "exaggerated emotional expressiveness."[50] Indeed, as she has it, "'animated' in American culture is to be racialized in *some* way."[51] Animatedness in relation to the black subject signifies the body, operates within the bodily, such that perception registers this signification as an authentic mark, an inarguable truth, precisely because it is embodied.[52] Nevertheless, as the scholar Frank B. Wilderson III reminds us, "Black authenticity is an oxymoron."[53]

In demonstrating, expressing, the capacity to withhold, Gilliam's black works, absolutely irreducible, establish a set of constraints he and the viewer cannot escape but must negotiate, must establish their own set of procedures for the experience and grapple with its emotional resonance. Massumi, via Roland Barthes, explains, "The event passes from pure 'uncoded' liveness (mechanically produced or not) to coded 'message.' It becomes communicable."[54] For the black work to acknowledge the concept of race as a co-constituting element, it must nevertheless separate itself from it, it must render blackness as being "detached-from-out" or "outed-in"; the blackness of the black work must be "actively ex-included."[55] Such capacities reveal the truth of their indivisible bond.

In commenting on his work and the imperative of representations of blackness, Gilliam remarked, "One looks at my art in terms of a different esthetic. Underneath, what's important to me is to do what I want to do. . . . You feel less afraid when someone says, 'I can't believe these paintings express your blackness.'"[56] In determining to "do what I want to do," Gilliam points to the expectation of having to negotiate and exhaust the paradigm of black representation in visual art. As if in response, his work resists a precise legibility, leveraging abstraction through seemingly infinite manifestations of it for its profound capaciousness. The installation and paintings are specific instances in which this desire is expressed, and their influence and trace on varying approaches to abstraction (those given not only to blackness but to a range of concepts and systems that delimit individual agency) cannot be underestimated. Tactile, they lend something a physical quality that constitutes its own corporeality—a tangible, visceral, somatic presence—while also imaging without representing a specific figure. The black work does not seek to reference the body, that which has been embodied through concept and form; rather it is an imaging of the feeling toward such a figure, toward the experience of its embodiment, a semblance of the real thing as the virtuality of blackness. Herein lies the performative expression of blackness—not type but force of color, facture, scale, texture, thickness noted as such because it operates at the extremes of how we think about art and representation through the absolute delimitation of any form of depiction. Resemblance is forsaken for semblance. As Wilderson suggests, "We need a new language of abstraction to explain this horror . . . [a] quest to forge a language of abstraction with explanatory powers *emphatic enough* to embrace the Black, an accumulated and fungible object, in a Human world of exploited and alienated subjects."[57]

We search for intensities now instead of lines, icons, narration. The black work is the "highest degree of abstractive intensity," an absolute manifestation of "composing away" its referent, "rendering it excessively non-specific" precisely because it is "not an extra-element but rather an element of an excess of immanence."[58] Malevich's *Black Square* nakedly reveals the fact and the contours of such a surplus in its attempt to "compos(e) away" that which

makes abstract painting "objective," as opposed to nonrepresentational, while simultaneously enabling the black monochrome to objectify blackness as color and as life. In Gilliam's black works, we now attain a different understanding of the implications of *Composed*; it is a body that returns strewn, fragmented, patinaed, haunted over the course of twentieth-century modern art. Indeed contrary to how the work has long been read, Gilliam in fact returns the black body to us precisely through abstraction—an aesthetic, to which it is uniquely bound, and no one ever saw it coming; it was always there in plain sight. Because "when attempts are made to compose-away all trace of content-readiness from the get go, the growth returns at some point later in the process, often with a vengeance."[59] Gilliam is that point in the evolution of modernist abstraction. His embodied blackness, its black objectness "composed," as it were, returns at the point at which the artistic process crescendoes, where it maximizes its intensity as paint begins to take on other qualities and capacities beyond what it is thought to be and what it is thought to do; the black work feeds on its insatiable desire to make itself known to us, an insistence that is always a return of that which had been thought erased. One that is also always already contending with the expectation of representation—show me what I want, show me what I know, or at least think I know. Gilliam's abstract black works resist absolutely our chimeric delusions of felicitous representations of blackness while countering any lingering fantasies of the so-called purity of abstraction.

ALMA THOMAS'S WASHINGTON, DC

Lauren Haynes

When I was working on the exhibition *Alma Thomas* at the Studio Museum in Harlem, New York, in 2016, I became deeply interested in the story of the artist's life. I was captivated not only by the biographical aspects such as her family's background, her experiences in Columbus, Georgia, and her family's move to Washington, DC, but also by the substance of her career before she became well known as an artist: her thirty-five years in the profession of junior high school art teacher and how she lived fully immersed in the Washington art scene before she retired. I was not really sure how this interest would factor into my research about the exhibition and her career because, as we all know, biographical information can be called on when discussing artists, particularly women and artists of color, when it's not relevant, giving us this sort of "oh, well, she did this" or "here's this bit" when it has nothing to do with the work or the art that they are making. But I realized that certain details about her background, particularly her involvement and friendships in Washington, had a direct impact on her work and were indeed relevant.

Art is not created in a vacuum. Artists, like all of us, are inspired and influenced by a variety of sources. Whom you know, where you go, and what you do can all have an effect on how art is made. And this seemed especially the case with an artist like Alma Thomas, who had a whole life and career as an arts educator before she retired at the age of sixty-eight and became an artist full-time. Whom did she know? How did her life as an educator prepare her to commit herself fully to making art? What kind of community nurtured or restrained her ambition to be an artist? These questions became important to me in my thinking about Thomas and her art and the ways in which the exhibition might show her deep investment and interest in the arts, particularly in relation to the art scene in Washington.

It is not as if Thomas just woke up at sixty-eight and developed all the skills that she would need to become a successful artist. Indeed, she had been working on these skills for quite some time. But to jump back a bit: Alma Woodsey Thomas was born on September 22, 1891, in Columbus, Georgia. She had three younger sisters, and when Thomas was a teenager, her parents moved the family to Washington. They did this to give their daughters a chance at a better education.

Thomas attended Armstrong Technical High School, where she took math and science classes and did really well in her architecture courses. She actually wanted to be an architect

Detail, fig. 5

1. Alma Thomas, costumes designed
for the Howard University Players,
 c. 1923/1924

Alma Thomas papers, c. 1894–2001,
Archives of American Art, Smithsonian
Institution

and, as she said, "build beautiful bridges."[1] If you look closely at Thomas's work, you can see that she never strayed far from her interest in architecture. Her paintings show how she was able to organize and handle space architecturally.[2]

However, not surprisingly for the period, Thomas was not able to achieve her dream of being an architect. She became a teacher after attending the Miner Normal School in Washington from 1911 to 1913. In 1921 she enrolled at Howard University. She was a home economics major who had an interest in costume design. A photograph shows costumes that she designed for the Howard University Players in 1923 or 1924 (fig. 1). It was during her time at Howard that she met James Herring. At his urging she joined the newly founded art department, and in 1924 she became Howard's first graduate in art.[3]

Thomas has spoken about what an informative and important period these early years were in her life. In a recorded broadcast, in her papers at the Archives of American Art, she relates, "After graduating from Armstrong High School, I attended the Miner Normal School. That was a two-year course. I took kindergarten, so during the kindergarten course, I found out that I could express myself quite a bit by making things."[4] So, even in this moment when she was still learning how to teach and especially to teach kindergarten, Thomas realized that her skills as a maker were developing and growing. She continues:

> When I lived in Howard, it happened that Professor Herring had one of the classes in home economics, called costume design. And when he saw my drawings, he decided that I should go into art. I was the only one that enrolled as a fine arts student. But after I had finished Howard University, I was employed in the school system here, and I was appointed at Shaw Junior High School, where I was [during] the whole career of my teaching. That was thirty-five years that I taught in one room.[5]

Not only did Thomas teach generations of students during those thirty-five years, but she was also a major presence in the Washington art world. She affected the lives of many young people during her tenure as a teacher, which was a kind of pedagogical art practice. While I was working on the Studio Museum exhibition, people would say to me that an aunt or a cousin was her student, or simply, "She taught me." Her teaching for thirty-five years at one place had an impact.

While Thomas was an inspiration to her students, whom she told to "get as much education as they could because that would be their only weapon,"[6] she continued her own education. She studied painting and art appreciation at American University for ten years in the 1950s and 1960s. It was there that her style began to develop. Thomas realized that her fellow students were not painting realistically. That inspired her to strive, as she put it, "to paint creatively, too."[7] Her desire to master her craft led Thomas to gallery shows and museum exhibitions and into relationships with other artists working in DC and New York, where she spent summers taking classes at Columbia University.

This study and self-education culminated in Thomas's inspiring artistic achievement—a body of exuberant mature paintings that are not only stunning but also influential, the canvases marked by clear and rigorous structures overflowing with vibrant colors. Great examples of her mastery now hang in the National Gallery of Art: important works that gained traction in the commercial art world after her retirement from teaching. Many scholars have written about this moment, this spurt of creativity, but something of the uniqueness of her paintings comes from her whole adult life and career in Washington, a long period of gestation, reflection, and practice that preceded the outpouring of brilliant works of art. Those paintings owe something

to the vibrant scene and the various groups and spaces she was involved in, a Washington milieu that created a distinctive segregated and integrated world of art education that shaped her own work as well. As a black artist in Washington during a time of unrest and change from the 1950s to the 1970s, Thomas was unusual in her decision to embrace abstraction when many African American artists employed figuration and directly symbolic forms to express social issues and political ideas. She developed her own unique style and continued to create an ambitious body of work until her death in 1978.

Thomas's art was also shaped by the kinds of arts institutions that emerged in Washington and that nurtured her aesthetic independence. In 1943, while she taught at Shaw Junior High School, Herring and Alonzo Aden, curator of the Howard University Gallery of Art, founded the Barnett-Aden Gallery. Their interests reflected her aesthetic program to forge a body of work out of abstract forms and not submit to trends in figurative blackness and social realism that dominated African American art in the 1930s. Thomas was one of the first vice presidents of this gallery during the 1940s, contributing to both its success and its social scene as an important gathering place for artists.

The Barnett-Aden Gallery believed in welcoming artists from all backgrounds. The only criterion was talent, judged solely by the quality of an artist's work. Throughout Thomas's career, she wanted recognition based on the strength of her work, not just her background. The list of exhibited artists at the Barnett-Aden Gallery includes, along with Thomas, many with whom she would form lifelong friendships and connections. Her connections with the gallery, not just in an administrative role but also as an exhibited artist, had a lasting impact on her work. She was able to interact and share ideas with the best artists living and working in DC at the time. These relationships encouraged her to create work that was different from her peers, even though she remained constantly influenced and inspired by others.

She was able to do this creative balancing act and emerge from it with such a distinctive body of work because her voice is so powerful and distinctive. We can see it in her paintings, but we can also read it in the many materials that make up her papers at the Archives of American Art. Her voice drew strength from her connection to DC. Something in the family of artists, universities, and semiprivate art fraternities in Washington provided her with the support to explore what others might shrink from and avoid. Upon her death, her sister, as the executor of her will, strove to think about how to divide papers, drawings, and photos between the Archives of American Art and the Columbus Museum in Georgia, so that this important connection to DC would be sustained.

In the 1940s Thomas attended a twice-weekly meeting of artists known as the Little Paris Salon, run by Lois Mailou Jones and Céline Tabary, which met at Jones's house at 1220 Quincy Street NE (fig. 2). Some members would go on to exhibit together, and each was expected to complete six works within a season and participate in a group exhibition. These meetings were important for Thomas to discuss ideas, experiment with new techniques, and continue to develop her style methodically in her later career. Like Thomas, many of the group's members had full-time jobs in addition to their careers in art. The salon gave them time to focus on their art and to grow as artists.

An offshoot of these meetings, called the Studio Group, was organized in 1951 for the purpose of discovering and developing local talent and encouraging participation in local and other art exhibitions. Members worked in creative painting, still life, and drawing from the nude in the studio of Jones and Tabary. The gatherings were open; anyone could attend by going to the address on a Thursday evening and joining in to make and discuss art. In that sense, it was a real salon. A booklet for the first exhibition of the Studio Group also mentions that two

"LITTLE PARIS GROUP" - LOIS JONES STUDIOS, 1948

Lft.to rt.
Barbara Buckner,Celine Tabary,Delilah Pierce,Elizabeth Williamson,Bruce Brown,Barbara Linger,
Frank West,Don Roberts,Richard Dempsey(Guest artist)Russel Nesbit(Model)Lois M.Jones, Alma
Thomas,Desdemona Wade .

1ˢᵗ ANNUAL EXHIBITION of the LOIS JONES & CÉLINE TABARY STUDIO GROUP

MAY 6 - 26 - 1951

INSPIRATION HOUSE
1867 KALORAMA ROAD, N.W.
WASHINGTON, D.C.

members won prestigious prizes that year and that Richard Dempsey was the artist in residence throughout the year (fig. 3). Here was a supportive group, organized by black women artists, that acknowledged two group members' successes, sharing in the excitement of two people winning prestigious prizes. Rather than simple individual accomplishment, the occasion registered a sense of collaboration in striving for excellence in art.

Complementing this black community support for artists was support from mainstream institutions like American University, where Thomas was inspired by the variety of artistic practices she could study. She began to experiment with new abstract styles. Her works during this period were transitional, a mix of figuration and abstraction. In her first solo exhibition at Howard University in 1966, you could begin to see her unique style develop. In an interview about this period, Thomas explained:

> I thought about the Washington Color School of painting. I didn't know how I would express myself to be different from them. I did arrive at the type of expression I have today. So I made about ten of those new types of paintings. . . . I had those framed, and I displayed them in my retrospective show at Howard University in 1966. After that time, the next show that I was in was called *Black Artists* at George Washington University Art Gallery. I was the only woman, and that did arouse a lot of interest in Washington, that I was accepted as one of the Washington Color School Painters.[8]

But she did not have time to celebrate the attention, even though she knew that people were talking about the paintings and excited about them. "I was so busy painting, I didn't look around to see whether they were singing or not to me," meaning that she was just in the flow of painting her new style and really happy to be there.[9]

2. The Little Paris Salon in Lois Mailou Jones's studio, 1948. Left to right: Barbara Buckner, Céline Tabary, Delilah Pierce, Elizabeth Williamson, Bruce Brown, Barbara Linger, Frank West, Don Roberts, Richard Dempsey, Russell Nesbit (modeling for a live drawing class), Lois Mailou Jones, Alma Thomas, and Desdemona Wade

Alma Thomas papers, c. 1894–2001, Archives of American Art, Smithsonian Institution

3. First Annual Exhibition of the Lois Jones and Céline Tabary Studio Group, May 6–26, 1951

Alma Thomas papers, c. 1894–2001, Archives of American Art, Smithsonian Institution

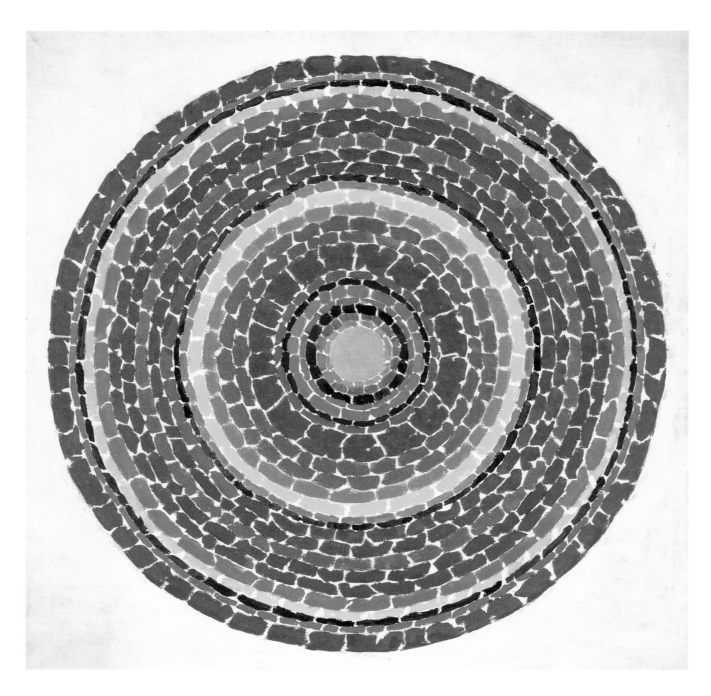

4. Alma Thomas, *Springtime in Washington*, 1971, acrylic on canvas

Private collection

Image © 2008 Christie's Images Limited

5. Alma Thomas, *Apollo 12 "Splash Down,"* 1970, acrylic and graphite on canvas

Private collection

Courtesy Michael Rosenfeld Gallery LLC, New York, NY

6. Cover of *The Crisis*, May 1970

7. Jack Whitten, Alma Thomas at Whitney Museum of American Art exhibition opening, 1972

Alma Thomas papers, c. 1894–2001, Archives of American Art, Smithsonian Institution

Many paintings express this mature style, but for me *Springtime in Washington* (1971; fig. 4) is a key work, as it exemplifies the achievement of that stage of mastery in which Thomas's technical skills allowed her to express in her work everything that influenced her. The "everything" included the local and immediate, as in her garden, which she talked a lot about—how she painted from her garden—but also the transcendent and celestial, which she spoke of when saying she tried to imagine in the painting how her garden would look from planes in the air.[10] Thomas said that she was born in the horse-and-buggy days but lived long enough into the modern era to see a man walk on the moon and that all the space exploration leading up to and after that had a huge impact on her work and her life.[11] *Apollo 12 "Splash Down"* (1970; fig. 5) is part of a series of space paintings in which Thomas was envisioning what Earth looks like from space and what actual moments such as a splashdown look like. How does one capture on a canvas the meaning of a satellite splashing down into the water in order to land? This irony is visualized spectacularly in this work, albeit still in her very gestural abstract style.

Once Thomas found her mature style, she gave herself as much time as possible to realize her ambitions on the canvas. And that larger ambition, I believe, was to create an art that spoke to the African American community in Washington in a universal visual language. Works like *Springtime in Washington* and *Apollo 12 "Splash Down"* are a dialogue with place, in Washington, on Earth, but also with the universe, giving us and Thomas a sense of relief, perhaps, that something larger than our familiar group conflicts operates in the universe. Rather than looking away from Earth and those close to her, she created transcendent abstract

compositions that embodied her relationships, studies, and friendships. In effect, *"Splash Down"* is a kind of artistic autobiographical statement, for the painting registers the success of an endeavor—the Apollo space program, which attempted something thought to be impossible— and being able to "bring it home" with a successful "splashdown" that shows the rewards of striving to get better and learning from the artists and creatives around her. For Thomas, this circle included rivals and sometime enemies, sometimes friends, but always seekers of the truth in expression—her peers—who made her better.

Finally, while working on the Alma Thomas exhibition at the Studio Museum, I learned about another dimension to her artistry: how she influenced a younger generation of artists. The influence that she had on artists who never met her but who were inspired by her style and heard her voice throughout her work is something she thought about and activated throughout her career and her life in Washington. I end with a cover she created for *The Crisis* (fig. 6) and a photograph from her opening in 1972 at the Whitney Museum of American Art, New York, where she was the first African American woman to have a solo exhibition (fig. 7). These are bookends to a career that included contributions to "the race," as teaching young black children in underfunded schools was sometimes called, and a transcendent experience that signified the "so much more" that is also African Americans in Washington, DC.

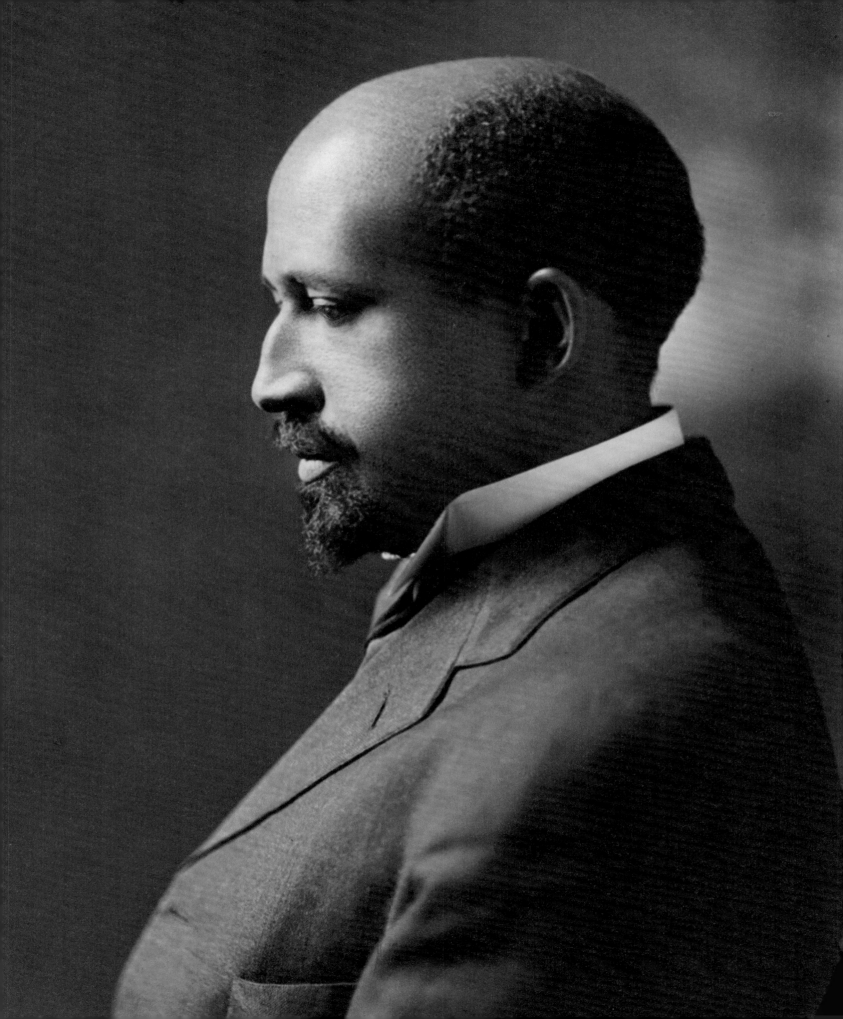

SCURLOCK'S WASHINGTON

Rhea L. Combs and Paul Gardullo

The year is 1944. A woman poses with her husband for a portrait after his return from a war fighting fascism overseas to find racism alive and well at home. She is dressed in a two-piece outfit with scalloped trim and three large buttons—her fashionable Sunday best. Her hair is neatly coiffed into a finely manicured crown. The gentleman wears his dress uniform, proudly displaying his lieutenant's bars. They both have thinly pierced smiles, and their eyes softly gaze toward the camera, hers slightly dreamier and more distant than his straightforward gaze. With her hands resting softly in her lap, either at the suggestion of the photographer or on her own volition, the woman slightly leans back into her husband in a posture that betrays a hint of relief, while one of his arms protectively embraces her shoulder. The carefully crafted studio lighting provides a soft glow on their faces, offering promise of brighter tomorrows made more resonant by the subtle glimmer of their wedding bands. The photographers, Addison Scurlock and George Scurlock, a father and son team whose names are synonymous with respectability in Washington, have been recommended to the woman by many friends in the community (fig. 1).[1]

In another photograph, two young boys stroll down a suburban-looking sidewalk. The surroundings and their attire suggest that it is spring in the early 1950s. Unlike the previous image, taken in a studio with meticulous attention to detail, this one is taken outdoors and appears more candid. The reliability of studio light is abandoned for natural light. Instead of a plain backdrop behind the young boys, telephone wires crisscross the street, running to houses adorned with television antennas and wide front lawns. The boys wear well-worn high-waisted dungarees and Keds, with a baseball, bat, and glove in hand. The pair appear absorbed in conversation—perhaps about the previous night's boxing score or what local ballfield they could use for the day's game. The image by photographer Robert Scurlock offers a different aspect of hope and promise: two seemingly carefree Black boys enjoying a walk in their new Washington housing development in Eastland Gardens, across the Anacostia River, close to an area where Robert's father, Addison, had photographed a Black-owned amusement park, Suburban Gardens, decades earlier (fig. 2).

One family and three photographers—Addison and his sons, Robert and George—shared nine decades of documenting Black life. These two mid-twentieth-century images, although distinctly different, are still remarkable, but not because of their iconic status as depictions of the Black elite or aesthetic and compositional qualities of dramatic light and shadow perfected by

Detail, fig. 14

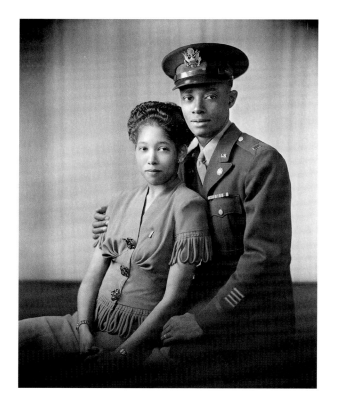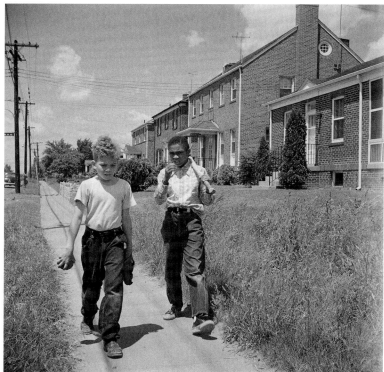

1. George H. Scurlock, Lieutenant Ulysses S. Ricks and Gloria Ricks, 1944, negative

Scurlock Studio Records, Archives Center, National Museum of American History, Smithsonian Institution

2. Robert S. Scurlock, Larry Arnold and Jerry Porter in Eastland Gardens, 1951, negative

Scurlock Studio Records, Archives Center, National Museum of American History, Smithsonian Institution

Addison Scurlock that became known as the "Scurlock look." Finely crafted, they are important mainly because they epitomize qualities for which the Scurlocks came to be beloved by their community for the better part of a century: their reliability, insight, and loving care in depicting Black people, spaces, and places through the lenses of their cameras for those who mattered most—the African American citizens of their home city. These images also are representative of the Scurlocks' oeuvre and reveal the crucial dialogic relationship between the Washington Black community and the long-standing success of the Scurlock Studio: a success that experienced different iterations as the cultural and political landscape shifted over the years.

From 1904 to 1994, the photography of the Scurlocks captured and captivated their city. Because of segregation and a fear of not being able to establish a large customer base on the famed "Photographer's Row" on Pennsylvania Avenue, they operated their family business in the midst of the historic Black neighborhoods surrounding U Street and Howard University in Northwest Washington. Often called "Black Broadway," U Street was considered the nexus of Black culture, art, business, and intellect, second only to Harlem on the East Coast. People shopped on this thoroughfare, found refuge in the local pubs and theaters along it, and enjoyed a vibrant community whose identity was made even more pronounced by the many hundreds of thousands of photographs created in the famous Scurlock Studio. Though this area existed a short distance from the White House and the Capitol, segregation imposed a racial divide in the city throughout most of the twentieth century. The photographic art of the Scurlocks highlights both a rich and tight-knit population that had been overlooked—or dismissed—as a result of racial discrimination and white supremacy, and a family adept at recognizing, creating, and capitalizing on the art that grew out of this milieu.

For decades the Scurlocks photographed individuals, families, groups, and businesses at weddings, graduations, and meetings. Despite the racial injustice that confined their world,

230 COMBS AND GARDULLO

African American families and business owners like the Scurlocks were resilient and successful in the spheres of business, education, science, arts, and entertainment. They were residents of a city whose Black middle class refused to be defined or held captive by racial segregation and discrimination, even as it sometimes instilled divisions of its own. Widely known for dignified, mature, and sophisticated likenesses of Black sitters, the Scurlock Studio expanded upon and pursued multiple avenues of photography, creating portraits of an entire city. This powerful alchemy, which fused artistry with business and community with politics, begs our attention because it provides us with a compelling look into the dynamic and changing nature of Black art and aesthetics through the decades-long work and legacy of a single extraordinary family. An examination of their work and its impact on Black Washingtonians, shows how often photography by Black artists serves as a mode of representation and intervention.

The presentation of Black images is rooted in the history of photography as a "troubling vision," to borrow a phrase from visual theorist Nicole R. Fleetwood.[2] Nineteenth- and many early twentieth-century images located Black subjects in relation to physical labor or some other subservient or stereotypical, racialized imagining. The work of Addison Scurlock and his sons offered a counternarrative that transformed historical images of Blackness and Jim Crow–era depictions of African American life. Examining the cultural and aesthetic significance of the Scurlocks' output allows for a greater understanding of their work. It also situates their artistic practice within a pantheon of other Black photographers who, during the late nineteenth and early to mid-twentieth century, showcased aspects of Black life that resonate beyond the boundaries of the nation's capital. The sustained rise, transformation, and demise of the Scurlock business, along with the way in which its body of work has been accepted and incorporated into the narrative of the city as well as national institutions, also suggests an important chronicle of race and representation within Washington that illuminates complex issues of gentrification and disenfranchisement, belonging, value, and changing notions of community, especially for African Americans.

Addison Scurlock: Positioning the Race

The second of three children of George Clay Scurlock and Nannie Saunders Scurlock, Addison Norton Scurlock was born in Fayetteville, North Carolina, in 1883, six years after Reconstruction had ended and during a moment when in North Carolina, as in most of the South, African Americans were experiencing extreme social, political, and economic disenfranchisement. The family moved to Washington around 1900, shortly after George lost a political contest on the Republican ticket for state senator and the horrific Wilmington, North Carolina, race riots of 1898 further strained race relations and disempowered African Americans in the Tar Heel State. Once in DC, the family settled near the elite LeDroit Park neighborhood, which housed many professors from Howard University. Here the members of the migrant family began to pursue their dreams: the patriarch, George Scurlock, trained to become a lawyer while sustaining the family with his job as a messenger for the US Treasury. He eventually set up his law practice on the famed U Street in Northwest Washington. Addison's older brother, Herbert, became a physician, and his younger sister, Mattie, entered school to become a teacher in Washington's formative and formidable Black school system. Addison knew he wanted to be a photographer by the time the family arrived in Washington, and he declared himself as such on the 1900 census at the age of seventeen (fig. 3).

To hone his skills, in 1901 Addison began a three-year apprenticeship with white photographer Moses P. Rice. Even in a segregated city, this connection was not unique. The first

3. Unidentified photographer, Addison N. Scurlock in Fayetteville, North Carolina, 1900, gelatin silver print

Scurlock Studio Records, Archives Center, National Museum of American History, Smithsonian Institution

4. Moses P. Rice, cabinet card of Addison N. Scurlock, c. 1901, collodion silver print

Collection of the Smithsonian National Museum of African American History and Culture, Gift of the Scurlock Family

Black photographer to open his own studio in DC in 1885 had also apprenticed with a white photographer.[3] Rice was originally from Nova Scotia, Canada, which may explain why he did not share the sentiments of most whites during this time and influenced his decision to work with Scurlock. While apprenticing with Rice, Addison learned portraiture as well as the techniques of lighting and negative retouching, skills that became signature components of his photographic practice.

A portrait from Rice Studio of a young Addison Scurlock, made in 1901, looks as if it could have been included in W. E. B. Du Bois's presentation at the 1900 Paris Exposition, the landmark exhibit that showed the "small nation within a nation" striving and achieving, despite years of discrimination and white supremacy. The cabinet card of a dapper and clear-eyed Addison has a floral display in the background, matching the aesthetic approach taken by other Black photographers during this period (fig. 4). Photographers like Thomas Askew, J. P. Ball, C. M. Battey, the Goodridge brothers, P. H. Polk, and Augustus Washington, as well as the aspiring photographer Addison Scurlock, understood their role as critical in combating negative perceptions of Black people. Studio portraits of the time were often taken with floral backgrounds, draperies, pillars, or showing the sitter holding a book. The props were devices to counterbalance negative perceptions and "shape people's ideas about identity and sense of self."[4] This approach can also be seen in the work of New York–based photographer James Van Der Zee. Like Scurlock in DC, Van Der Zee became famous for his extensive documentation of the Black community in and around Harlem in the mid- to late 1910s. As the designated photographer for Marcus Garvey's Universal Negro Improvement Association (UNIA), Van Der Zee was busy presenting Black life in New York as urbane, dignified, and cultured, while Scurlock was busy doing the same in Washington. Like other Black photographers throughout the country, they understood their work not merely as a commercial enterprise but as a rebuttal to negative perceptions of self and the Black community writ large. The image of a dignified

5. Addison N. Scurlock, cabinet card of Herbert Scurlock, c. 1908–1911, platinum print

Collection of the Smithsonian National Museum of African American History and Culture, Gift of the Scurlock Family

6. Verso of Herbert Scurlock cabinet card, c. 1908–1911

Collection of the Smithsonian National Museum of African American History and Culture, Gift of the Scurlock Family

and determined Addison serves as a harbinger of the careful approach that he and the Scurlock Studio would take with clients for years to come.

Employing skills learned during his training days, Addison established his own photography business in 1904. At the time, the only known African American photographer with his own studio in Washington was Daniel Freeman. Freeman's studio was on Fourteenth Street NW, near T Street.[5] In addition to working in proximity, Freeman and Scurlock often shared (or competed for) their clientele, middle-class Black Washingtonians. Fifteen years older than Scurlock, Freeman had also apprenticed with a white photographer, E. J. Pullman, and both were known for excellent fine art photographs. Freeman and Addison saw a model and an opportunity for establishing their businesses on documenting African American life through photographs. Freeman died suddenly in an automobile accident in 1919. Considering they obtained work from the same client base, it is difficult to ascertain what impact Freeman's untimely passing had on Scurlock's business, but one can speculate that reduced competition allowed the Scurlock Studio a stronger foothold in the African American community.

The slim and soft-spoken Addison Scurlock initially opened studios in his parents' homes, starting his practice on S Street NW and then moving with them to Florida Avenue NW. In 1907 he moved to 1202 T Street NW, where he would later make a home with his wife, Mamie Estelle Fearing, and he began taking portraits in his home photography studio. An early image by Addison Scurlock of his brother taken between 1908 and 1911 in his home studio shows Addison's incipient photography skills (fig. 5). This early portrait of Herbert Scurlock, wearing a high stiff collar, ascot, and blazer nicely frames his distinguished-looking face and epitomizes the Victorian-era dignity and respectability for which Scurlock's photographs would become known. Herbert's distant gaze, away from the camera, offers a slight profile that is accentuated by his straight posture and the exquisite studio lighting that offered little to no shadows—all conventions that would serve as Scurlock's signature aesthetic techniques in the future.

A critical element of Addison Scurlock's photography was the "Scurlock face," which he wanted to look as close to nature as retouching would allow.[6] This photograph of a young Herbert presents a young man, focused and determined and showing his "best face forward,"[7] which Scurlock understood as one of photography's powers and was a trait particularly important for his African American clients. The image's verso also offers further insight into Scurlock's business approach: "Addison N. Scurlock, photographer: portraits, views, copying, and flash-light work" (fig. 6). From the start of his professional career, it appears the training received from the Rice brothers afforded Addison a technical acumen that helped to define the "Scurlock look."

Before stepping behind the portrait camera and slipping under the hood, it was Addison's style to sit and talk briefly with the sitter. Addison was a dandy and always smartly dressed, perhaps to help instill a confidence in his sitters that he would render their likenesses in a way that dispelled the racist caricatures that adorned movie posters and minstrel stages of the city's white neighborhoods or repelled the insults hurled at them while strolling the city's streets. The knowing look between artist and subject helped make the sitter feel at ease, while tools of the trade were positioned systematically, like scientific instruments, around the studio. Addison, a master of light and shadow, would adjust the lighting once more to make absolutely sure he was capturing the subject as best he could. The rest of the work would take place afterward, retouching the negative or perhaps hand coloring the print itself (fig. 7).

Understanding that portraits of middle- and upper-class Black life provided what Deborah Willis considered a "New Negro visual aesthetic," Scurlock saw photography as both an aesthetic enterprise and social endeavor.[8] While there are few documented records of Addison Scurlock's words, a presentation he made in 1909 to the National Negro Business League on the topic "Creating Business" offers some useful insights. Like African American educator, orator, and community leader Booker T. Washington, Scurlock believed entrepreneurial endeavors would create equality for Black people. Scurlock's address to the business league called for understanding racial segregation as a "point in our favor" and emphasized the importance of establishing a confidence on the part of the consumer that "possess[ed] a spirit higher than mere commercialism."[9] In other words, focusing on serving the Black community could be something positive, as long as aesthetics remained impeccable and relationships with clients unflappable. This notion is supported by scholars who explain that

> People trusted him. He was allowed in all their homes, and he entertained people in his home. He didn't need a calling card. He had to establish that he knew what he was doing and be accepted in Washington society, and because of his skill, his talent and his personality, he was taken seriously.[10]

He was taken so seriously by early clients like Howard University and "colored" high schools—M Street (later known as Dunbar) and Armstrong—that by 1911, at age twenty-nine, Addison opened his first photography studio outside the family home. The green brick two-story building sat at the corner of Ninth and U Streets NW, in the heart of Black Washington. Here, he realized his goal of a shop window to display his work to the public and attract an aspiring clientele. His son George would later remember:

> Our father would put photographs of famous people and not-so-famous people out there, and people saw this nice display and just walked in and asked if you could make *them* look as beautiful as the people in the case. . . . There'd be a picture of somebody's cousin there, and they would say "Hey, if you can make *him* look that good, you can make me look *better.*"[11] [Emphasis in original].

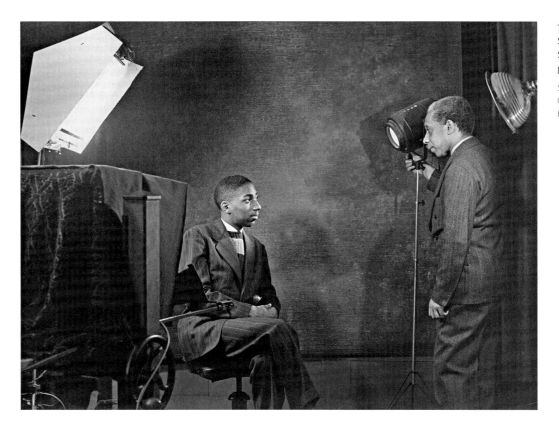

7. Scurlock Studio, Addison N. Scurlock posing a client in Scurlock Studio at 900 U Street NW, c. 1951, gelatin silver print

Scurlock Studio Records, Archives Center, National Museum of American History, Smithsonian Institution

From statesman Frederick Douglass to historian Carter G. Woodson to educator Anna Julia Cooper and countless others, Scurlock recorded and pictured African American progress. At a time when the predominant images of African Americans were demeaning and stereotypical, Addison's shop window served as a site of aspiration, inspiration, congregation, and resistance, and his business would do so for the next half century as Addison and the Scurlock Studio promoted and supported Black political movements, education, businesses, families, and the local community through photography (fig. 8). Throughout the decades, the Scurlocks did not just portray the social, political, and community life of Black Washington; they actively participated in it, like hundreds of other Black Washingtonians. Addison joined the exclusive all-male Mu-So-Lit (music, social, literary) club, whose membership included Black intellectuals from across America. He was an active participant in and documenter of activities of the National Association for the Advancement of Colored People (NAACP) and established a professional relationship with scholar, activist, and author W. E. B. Du Bois that extended to the pages of *The Crisis* magazine and a variety of Black-owned publications.

Centering the Family

To know better how the Scurlocks conducted a successful business in Black Washington for nearly a century, it is important to understand the role family played in making this possible. Segregation and white supremacy had deeply divided the country; Washington was not immune to this racial and social sickness. Home and family became critical sites for race-building and refuge. The Scurlock family was very close-knit and often the subject of Addison's photographs. However, they were not merely subjects for him to hone his skills for future clients; they were

8. Addison N. Scurlock, interior of the first Scurlock Studio at 900 U Street NW, 1911, gelatin silver print

Scurlock Studio Records, Archives Center, National Museum of American History, Smithsonian Institution

also crucial members of the business. Mamie Fearing, Addison's wife, a "strikingly beautiful woman, petite with long brown hair and soft, patient eyes,"[12] played a critical role in ensuring the viability of the photography studio (fig. 9). During fifty years of marriage, they shared a home and a livelihood. While Addison stayed behind the camera artfully composing photographs, Mamie managed the business and its finances.[13] She meticulously kept the invoice logbooks—numbering customer orders, entering negative sizes, listing print sizes ordered—and maintained the petty cash account (usually about $40). Addison Scurlock trained assistants (often relatives and community members) and later his sons to meticulously retouch negatives and hand color prints to minimize any imperfections. Their eight-room place on T Street was the site where friends and family members met for social gatherings and special occasions. The commitment to be everywhere taking pictures while opening their house to friends and family within their social circle undoubtedly helped their business, as it solidified their standing within Washington's "Secret City,"[14] a moniker given to the segregated city whose vibrant African American society was virtually unknown to most white Washingtonians (fig. 10).

The intimate views of Addison Scurlock and his young son Robert; the portrait of his three sons, Addison Jr., Robert, and George: these images demonstrate the care with which the Scurlocks composed their photographs to emanate cultured respectability, family stability, pride, joy, and love (figs. 11 and 12). They instilled these same exacting qualities in many of their portraits of clients, such as a portrait of Esther Popel Shaw and her daughter, Patricia, taken in the 1930s. Shaw was an accomplished teacher, author, activist, poet, and a sometime member of Georgia Douglas Johnson's "Saturday Nighters," the Washington Renaissance literary salon whose members included Langston Hughes, Alain Locke, and poet Jean Toomer. When Addison crafted this portrait, he was well aware that his sitter wrote searing poems that highlighted the American system and its injustice toward African Americans, like the one

9. Addison N. Scurlock, Mamie Fearing Scurlock in Great Falls, Virginia, c. 1912, gelatin silver print

Scurlock Studio Records, Archives Center, National Museum of American History, Smithsonian Institution

10. Scurlock Studio, wedding of Addison N. Scurlock and Mamie Fearing, 1912, gelatin silver print

Collection of the Smithsonian National Museum of African American History and Culture, Gift of the Scurlock Family

11. Scurlock Studio, Addison N. and Robert Scurlock, c. 1920, gelatin silver print

Scurlock Studio Records, Archives Center, National Museum of American History, Smithsonian Institution

12. Addison N. Scurlock, Robert, Addison Jr., and George Scurlock, 1924, gelatin silver print

Collection of the Smithsonian National Museum of African American History and Culture, Gift of the Scurlock Family

published in *The Crisis* with the title "Flag Salute." *The Crisis*, a publication established in 1910 and edited by leading African American thinker W. E. B. Du Bois, was dedicated to exposing the dangers of racial prejudice and its impact on the African American community. Shaw's poem starkly juxtaposed the voices of schoolchildren reciting the pledge of allegiance with a blistering news account of a lynching and riot that occurred in the town of Princess Anne on Maryland's Eastern Shore.[15] Despite her searing prose, in Scurlock's portrait we see "his knack for capturing the softness of every woman."[16] Shaw wears a lace dress, drop pearl earrings and necklace that accentuate her profile, cropped hair, and keenly shaped nose. Patricia looks angelic while posing "face forward" wearing a light-colored cotton dress. Her head gently lies on her mother's shoulder, and her hand delicately rests inside her mother's hand. The image is both softened and deepened by the poignancy of Shaw's words in "Flag Salute" and the desire to protect young people who look like her child (fig. 13).

Perfecting the Look and Capturing the City

Addison founded his business and developed his art in an environment of enormous flux on the one hand but increasing rigidity on the other. With the Black population nearly doubling each decade since 1880, resulting in a population of well over one hundred thousand Black residents by 1920 and more migrants pouring in from the rural South each year, Washington held the third largest African American population in the country, after only New York and Chicago.[17] Higher education combined with economic and culture activities reinforced the status of the Black middle class in the nation's capital. As Black lawyer Archibald Grimké claimed, the District of Columbia contained "more wealth, more intelligence, and a much larger number of educated and refined colored people than any city in the country."[18] In this environment, Scurlock portraits constructed a vision of Black Washingtonians that was urban, urbane, and modern for a wide range of the Black middle class. They turned the derogatory label of race into a source of dignity and self-affirmation for African Americans.

13. Addison N. Scurlock, Esther Popel
Shaw and her daughter Patricia,
c. 1930, negative

Scurlock Studio Records, Archives
Center, National Museum of American
History, Smithsonian Institution

Scholars and family members described Addison Scurlock as meticulous and a perfectionist who saw each subject as extraordinary, and he attempted to document that in his work. Historian Jeffrey John Fearing writes that "technically speaking, Addison's son George attributed the Scurlock style to three qualities—posing, lighting, and retouching, where the final image was fine-tuned on the negative itself." Fearing concludes that these techniques, along with the

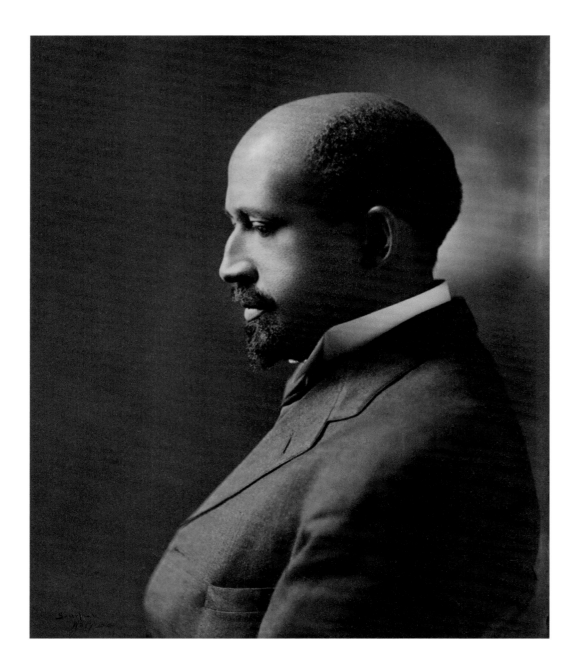

14. Addison N. Scurlock, W. E. B.
Du Bois, c. 1911, gelatin silver print

National Portrait Gallery, Smithsonian
Institution

rapport built by the family with the studio's largely Black clientele, meant that they "could sit before cameras in complete confidence that the resultant images would capture them accurately and in the best light possible."[19] George Scurlock also explained his father's aesthetic and photographic style this way: "His brush was his camera and his techniques firmly establish his work as a part of art."[20]

In one of Addison Scurlock's most famous early portraits, that of Du Bois, we see the results of this signature technique, which mirrored the political ideology of racial uplift through education and community cohesiveness espoused by African American leaders like Du Bois. Both men recognized the power that visual culture could play in crafting a modern Black self. In an academic paper of 1897 entitled "The Conservation of Races," Du Bois rhetorically wondered, "What, after all, am I? Am I an American or am I a Negro? Can I be both? Or is it my

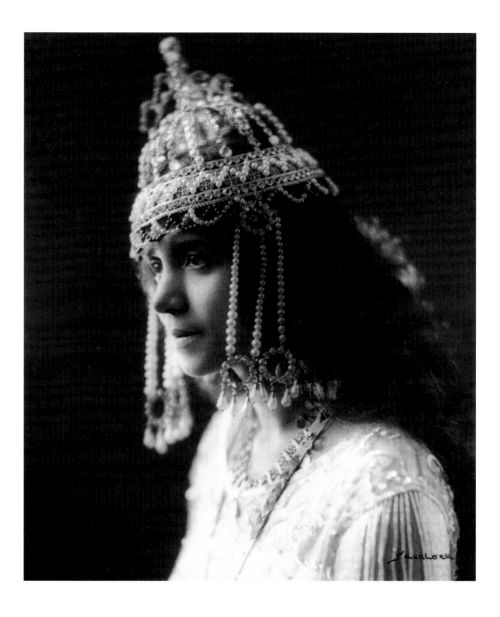

15. Addison N. Scurlock, Lillian Evans
Tibbs (Madame Evanti) as Lakmé,
c. 1925, gelatin silver print

Scurlock Studio Records, Archives
Center, National Museum of American
History, Smithsonian Institution

duty to cease to be a Negro . . . and (just) be an American?"[21] The effect that Addison Scurlock
attained through the combination of light, shadow, posing, retouching, and chemical reaction
contended that African Americans could be both "American" and "Negro." It is no surprise, in
fact, that some of the first issues of *The Crisis* edited by Du Bois prominently featured Scurlock
photos on the interior and its covers—and that the magazine would continue to do so for more
than a decade (fig. 14).

As Scurlock's reputation for portraiture grew, his studio at Ninth and U Streets became a
ritual stop for celebrities and local residents alike. The distinctive use of a dignified soft focus,
artful bust-length compositions, and color-conscious lighting soon attracted this important
clientele. A portrait of Washington native Lillian Evans Tibbs (who adopted the stage name
Madame Evanti in Europe, where she was widely celebrated) posing in character in the opulent
bejeweled costume she wore in the opera *Lakmé* is an iconic representation of Scurlock's craft
that captures the tenderness he often conveyed in his photography, and Evanti's grandeur as a
grande dame of the stage (fig. 15).

16. Addison N. Scurlock, Lillian Evans Tibbs with her son Thurlow at McMillan Reservoir, c. 1930, gelatin silver print

Scurlock Studio Records, Archives Center, National Museum of American History, Smithsonian Institution

While Addison perfected his signature look for portraiture in the studio, he brought many of the same qualities to his work outdoors. In a second photograph of Evans Tibbs, he presents her with the same dignified air as in her Lakmé portrait, but in full length, promenading at McMillan Reservoir adjacent to the campus of Howard University in Washington with her son, Thurlow Evans Tibbs Sr. (fig. 16). Scurlock photographs them in a seemingly carefree moment, both looking away from the camera. She wears a flapper-style dress and hat, with white gloves, walking stick, necklace, clutch purse, and fur stole. She is the epitome of style and sophistication. Thurlow, cupping his mother's hand, wears saddle shoes, argyle socks, jodhpur shorts, button-down shirt, and a dark blazer. Thurlow points at something in the distance, and both he and his mother are caught in mid-conversation about the discovery. Natural as it appears, it was undoubtedly carefully crafted by the man described as knowing exactly what he wanted.[22] The subjects' demeanor and posture also demonstrate how the visual image as constructed by Scurlock was both a private and a public performance in which various identities of race, class, and gender were negotiated. We as viewers are invited to ask, perhaps: Is this mother and wife Lillian Evans Tibbs, or the international diva Madame Evanti?

Portraiture often promoted and historicized people from an elite class. And Scurlock images such as these reveal a great deal about the fears and needs of the Black middle class in twentieth-century Washington. Longtime residents, so often photographed by the Scurlocks, developed a social hierarchy that left little room for less affluent members of the community. Black Washingtonians who enjoyed access to education at elite schools, including Dunbar High and Howard University, often saw themselves in a category distinct from those of a more modest background. One of the most complex qualities was the role of skin color in determining status within the African American community. The lightness of one's skin or the straightness of one's hair was often a multifaceted and highly prized marker that could constitute "beauty," signify class, and reaffirm status in an intraracial hierarchy. This skin color stratification, or colorism, is a by-product of internalized white supremacist notions of what constitutes beauty. Over the years, these standards have normalized whiteness and deemed everything that strayed from that standard as "other."

Although Scurlock portraiture did not invent class divisions based on colorism, one wonders if his penchant for retouching reinforced some of these ideas—if not for himself, perhaps for his clients. Emphasizing Scurlock's mastery of lighting and shadow, nothing in the scholarship indicates that his retouching or hand painting work included lightening a person's skin tone. He would remove a blemish, or smooth out crow's feet—maybe even slightly straighten a nose or a lip a little bit.[23] It is difficult to project if these "creative flourishes" by Addison suggest a penchant for adhering to a white beauty standard; yet, it is likely he was quite aware of the intraracial complexities apparent within the Black community. Scurlock attempted with his work, like many of his photography peers from that era, to challenge racist beliefs about Black people

by reinforcing and capturing a middle-class ethos that too often smoothed over the rough edges of Black life in the District.

Acknowledging the power of visualization, Scurlock—like many African American photographers of the early twentieth century—also understood how people from all socioeconomic backgrounds found respite in fashioning and displaying images of themselves. And even though many published images that showcase his significance as a photographer tend to focus on "the best and the brightest" from the African American community, it is important to recognize that Scurlock and the 900 U Street NW photography studio were institutions in the community. The archive of Scurlock images numbers in the hundreds of thousands and includes people from all walks of life, from the most notable to the anonymous—beauticians and busboys, cooks and clergy

17. Addison N. Scurlock, Alexander and Margaret Underdown with employees at Underdown Family Delicatessen, c. 1904, gelatin silver print

Scurlock Studio Records, Archives Center, National Museum of American History, Smithsonian Institution

members, waiters, porters, conductors, and teachers—all featuring a diverse range of looks, classes, and complexions. The Scurlock reputation as the city's premier photographer reached well beyond the so-called Black elite and extended across a wide-ranging population. It is in this relatively wider-angle (though problematic) view that we can see how Scurlock images also created a visual archive of African Americans that not just shaped but, importantly, corresponded with and responded to the realities, hopes, and aspirations of their own lives.

As Washington was developing into a twentieth-century metropolis of massive contradictions, Addison began to document its vibrant Black life. Primarily focusing on the burgeoning Black neighborhoods that surrounded the studio at 900 U Street NW, Addison realized the need to position the African American community itself, creating portraits of a city. He recognized the power that these images wielded in constructing a visual record of accomplishment. With his Cirkut Panorama camera in tow, deftness with flash photography and lighting, and the keen sensibility of a film director, he carefully crafted depictions of successful businesses, such as the Underdown Family Delicatessen or Murray Brothers Printing; churches, like the construction of the Lincoln Temple Congregational or Shiloh Baptist Church; high schools, including Armstrong, Cardozo, and Dunbar; leisure events, at the Suburban Gardens Amusement Park, Club Prudhom, Bohemian Caverns, and the Howard and Lincoln theaters; and a myriad of street scenes and of protests outside and inside venues. All demonstrate Addison Scurlock's equal interest and expertise in creating a powerful image of the city as a site of working middle-class culture. By doing this, he made the city of Black Washington as respectable as the middle-class people he photographed in his studio (figs. 17–22).

Rooted in his community, yet reaching beyond its geographic borders, Scurlock had a booster mentality that served his own and his city's interest. He took advantage of print media to advance his business and publicize his vision of Black success and aspiration on the pages of various African American periodicals, including the DC-based *Afro-American* and *Washington Bee*, *Norfolk [Virginia] Journal and Guide*, *Chicago Defender*, *Pittsburgh Courier*, *Cleveland Call and Post*, and *Amsterdam News*. Of his many professional relationships with Washington businesses, organizations, and institutions, the largest and most beneficial link Scurlock forged was

18. Addison N. Scurlock, Elder Solomon Lightfoot Michaux holding a mass baptism in the Potomac River, 1933, gelatin silver print

Scurlock Studio Records, Archives Center, National Museum of American History, Smithsonian Institution

19. Addison N. Scurlock, Suburban Gardens Amusement Park, c. 1925, negative

Scurlock Studio Records, Archives Center, National Museum of American History, Smithsonian Institution

20. Addison N. Scurlock, Club Prudhom dancers, c. 1930, negative

Scurlock Studio Records, Archives Center, National Museum of American History, Smithsonian Institution

21. Addison N. Scurlock, Midwinter Ball of the National Association for the Advancement of Colored People, Baltimore, 1912, negative

Scurlock Studio Records, Archives Center, National Museum of American History, Smithsonian Institution

22. Addison N. Scurlock, Howard University Law Library, 1933, negative

Scurlock Studio Records, Archives Center, National Museum of American History, Smithsonian Institution

23. Robert S. Scurlock, Marian Anderson's Easter concert at the Lincoln Memorial, 1939, negative

Scurlock Studio Records, Archives Center, National Museum of American History, Smithsonian Institution

with nearby Howard University. Decade after decade, Howard retained the Scurlock Studio as its official photographer. The Scurlocks depicted all aspects of life at the university—intellectual, athletic, social, and political. The photographs range from portraits of presidents, deans, and faculty members to group shots of academic departments and social clubs to candid views of classrooms, graduations, and campus landscapes. Addison applied the Scurlock look wholesale at Howard, positioning and portraying the university as one of the nation's finest institutions of higher learning. Much like his visual constructions of Black middle-class men and women, his careful presentation of Howard's activist intellectual and artistic community showcased the university's promise to the Black community, the nation, and the world. The resulting body of work verifies the unique role that Howard played in shaping Washington and the struggle for racial and social change in America. It also provided a carefully constructed vision of Howard vetted by the administration, one that forms the capstone in a uniformly positive, noncontentious vantage that was often strictly divided along gender lines.

The "look" crafted by Addison Scurlock is an important portrait of African American life in the nation's capital, and although it is not the only look of a deeply racially and socially stratified city, it is a crucial one. At a moment when dominant forms of racism reduced the African American community to caricature, Addison Scurlock's camera became an instrument to advance racial pride and justice. His portraits emphasized the dignity and integrity of individuals, families, and communities, giving richness, depth, complexity, and deep meaning to

COMBS AND GARDULLO

Black Washington. As the 1930s and 1940s unfolded, Scurlock passed these values, talents, and skills on to his sons, who struggled with, challenged, made sense of, and sometimes rejected and refashioned them for a later generation that was quickly changing with the advent of war, the evolution of the civil rights movement, and the explosion of Black publishing and attendant opportunities afforded to and seized by Black photographers in Washington's changing world.

Robert and George Scurlock: A Changing Studio and World

Easter Sunday, 1939. The photographer feels as if he is bearing witness to history in the making. A crowd of what looks to be nearly one hundred thousand has gathered at the base of the Lincoln Memorial to listen to her sing. His city. His people. His father, Addison, has provided him with this assignment, just a mile from the studio but a world away. He knows the location, having lived his life here, and he has assessed the many different angles. But still, the crowd and her voice perhaps take his breath away. He likely works with a large-format camera, perhaps a Speed Graphic 4 × 5, which requires changing both plate and bulb with every shot. It is not easy to lug around, but capturing this moment is what he has come here to do. She wears a full-length fur coat covering an orange brocade blouse that his black-and-white film will never pick up. She steps to the array of microphones assembled before her. Her eyes close and she begins to sing from her soul to the nation. The aperture is set to allow the correct amount of light. The shutter opens and closes. When Robert Scurlock returns to the Scurlock Studio and develops the film, it looks as if you can see her soul and hear the song all over again. He has begun a new journey on a path he feels well prepared for. He's twenty-three years old. Robert's 1939 image of the internationally renowned singer Marian Anderson on the steps of the Lincoln Memorial illustrates his deftness at blending his father's training in portraiture with his photojournalistic ambitions. Taken as a whole, the series of images serves almost as a kaleidoscope or a flip picture book of the historic occasion and tells the remarkable story of a photographer's unencumbered access (fig. 23).

Robert and George Scurlock apprenticed with their father during high school; and as college students at Howard University, they both maintained interest in the family business. At a young age, Robert had demonstrated a keen photographic sensibility and by fifteen was already an expert in negative retouching.[24] Addison had spent decades establishing the Scurlock reputation as reliable for the quality of its product and for creating beautiful images of Black Washington. His craft was unmatched and his perfectionism well known, but he was never considered cutting-edge or avant-garde, nor was his work aligned with the growing social realism and documentary ethos of the Farm Security Administration photography program born from the New Deal.[25] The next generation of Scurlocks, however, would be influenced by these movements, along with the burgeoning opportunities brought by the rise of Black business in the publishing industry. World War II was a turning point for the Scurlock Studio.

Robert, the elder of the Scurlock brothers, was a highly creative personality.[26] Although he majored in economics, in 1937, while he was in college, some of his photographs of the Fort Howard ROTC appeared in *FLASH!* magazine. And on his graduation from Howard, Robert received a Voigtländer plate camera, which he took with him while he served in the military during World War II.[27] George failed the military health examination and was denied entry into the armed forces but served his community and country in a different way. He stayed in Washington and helped Addison in the studio. He honed his portraiture skills and covered much of the commercial side of the business, photographing weddings, commencements, and special programs throughout the city; he also began to develop a specialty in retouching,

24. Robert S. Scurlock, General Benjamin O. Davis Jr., c. 1944, gelatin silver print

Collection of the Smithsonian National Museum of African American History and Culture, Gift of the Scurlock family. © Robert Scurlock

hand coloring, and creating portraits. It was here that he had the opportunity to photograph a young Lieutenant Ulysses S. Ricks and his wife, Gloria, amid photographing hundreds of individual soldiers and sailors, couples, and families on the home front (see fig. 1).

Robert, on the other hand, honed his photographic skills in Europe as a member of the Tuskegee Airmen. While stationed in Ramitelli, Italy, he photographed his fellow airmen, including commanding officer General Benjamin O. Davis Jr. His images of them at work on their planes and resting and relaxing on base reveal how this segregated unit lived on a daily basis. In Robert's evocative depictions of the valor of the Tuskegee Airmen, one can see all of the techniques of his father's portraiture on display in crafting a new likeness of a modern American hero. Like his father, Robert captured images of subjects typically not represented in mainstream imagery at the time. As a result, he helped create a collection of moving American patriotic imagery that reflected a segment of the population often overlooked and discounted simply because of their racial identity. Some images shared the traditional Scurlock aesthetic established by Addison, but there were also some distinctions.

One familiar element of Robert's portrait of Davis is the family tradition of the "Scurlock face." As in thousands of Scurlock images, the subject's gaze looks away from the camera beyond the horizon. However, Robert's use of natural light and a fairly close-cropped photograph of the soldier in his work uniform with a fighter jet in the background creates more shadows than typically seen in a photograph from Addison. The mise-en-scène of bomber jacket, goggles, and airplane in the background demonstrates an assertive self-determination typically absent from Addison's portraits. Robert Scurlock strives for a fine balance, however. While the soldier reveals self-possession and a sense of confidence, there is also a pride that was a constant feature of Addison's work. Looking at the future of the Scurlock Studio business, one imagines this photograph could easily have been licensed to an advertising firm or as a promotional tool, as the "new face of patriotism": the competent, capable, and charming Black aviator as American war hero. Robert's photographic aesthetic was perhaps mimicked in several war bond poster illustrations that focused their attention on Tuskegee Airmen and other Black military heroes (fig. 24).

Back in Washington after returning from war, Robert organized his first solo exhibition at his alma mater in 1947. In Howard's art gallery, he exhibited approximately thirty photographs that he took of airmen while he was in the military.[28] In addition, he became increasingly interested in the burgeoning field of photojournalism and stock photography. The desire for commercial success was apparent not only in his exhibition but also in a renewed sense of loyalty to the family business. Competition was growing; the Scurlocks were no longer the only photographers dedicated to serving the African American community. Photographers like Robert

H. McNeill, with his studio at 13th and U Streets NW, were also actively photographing DC's Black community. Others attempted to poach the Scurlocks' long-standing clients like Howard University. And loyal customers were growing impatient with the studio's labor-intensive photographic process, finding the immediate gratification and lower expense of quick photo processing desirable. To adjust to the changing demands of the business, Robert expanded the Scurlock reach by licensing images to various press and media outlets, engaging more widely with the publishing world, Black news outlets, and newspapers. This was a practice that started before Robert served in the war, but it expanded after his return.

Before the war, as a generation of African Americans insisted on pursuing the constitutional rights guaranteed to all Americans, the Scurlocks depicted faces of the long prewar movement for civil rights. Directed by their father, Robert and George began documenting activities close to home in the nation's capital, such as the March on Washington Movement of the late 1930s and early 1940s, local Don't Buy Where You Can't Work campaigns at Peoples Drug Store (fig. 25), *Gone with the Wind* protests on U Street, gatherings of A. Philip Randolph's Brotherhood of Sleeping Car Porters at the Twelfth Street YMCA, rallies of the Scottsboro Mothers, and the changing face and makeup of the National Council of Negro Women following the death of civil rights icon Mary McLeod Bethune.

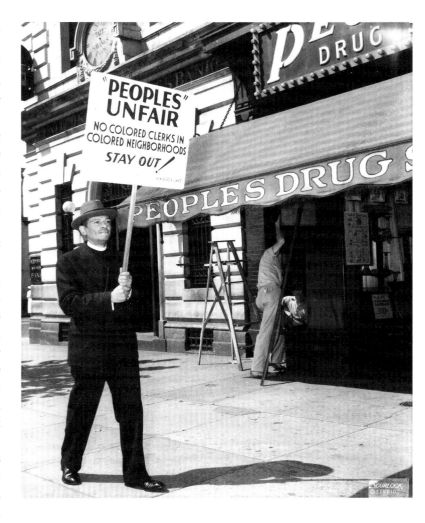

25. Scurlock Studio, Picketing for equal employment at Peoples Drug Store, c. 1940, gelatin silver print

Scurlock Studio Records, Archives Center, National Museum of American History, Smithsonian Institution

In 1948, taking advantage of the GI Bill, which enabled large numbers of veterans to pursue educational opportunities, Robert left the Scurlock Studio on U Street to open a new business, the Capitol School of Photography. Addison disapproved of the new venture. He felt the school would end up training their competition and thought that Robert should focus purely on portraiture in the African American community. Robert, however, was influenced deeply by his personal experience during wartime and by the changing face of publishing and photography at midcentury, which seemed to offer new and growing opportunities for Black photographers and cultural workers. He opened the school in Northwest Washington, decidedly on the edge of the historically Black community at 18th and Swann Streets NW (fig. 26). The location of the school, with its expansive mindset and its mission to train a new generation of Black photographers, all demonstrated an optimism perhaps partially born from the "Double V" idea that many African Americans shared during World War II—a victory against fascism abroad and a victory against racism at home. It signaled an aspiration to a business model that could reach beyond a portrait-based or even African American clientele, while still serving a broader notion of Black community and representation.

Both sons were deeply involved in the school, developing its curriculum, instructing, and even documenting its operations photographically. While Robert strived to reach out on his own,

26. Unidentified photographer,
Capitol School of Photography,
c. 1947–1952, gelatin silver print

Scurlock Studio Records, Archives
Center, National Museum of American
History, Smithsonian Institution

the younger George bridged the gap between his elder brother and their father, attempting to keep a foot in each world. Robert taught classes during the day, and George taught at night while also continuing to work with their father at 900 U Street NW during the day. Classes embraced topics such as color photography, lighting and makeup for African American subjects, and training in more commercially based forms of photographic portraiture including modeling. Since Addison had received training and apprenticed early in his career, as well as trained his family, it is difficult to believe he was simply opposed to the kind of mentoring and training in which his sons were engaged. It is more likely that his reluctance was a by-product of the shifting times in the marketplace. Addison's career started with a call to picture the increasingly segregated Black world and to prove its rightful place within American citizenry. With greater social integration and the advent of smaller, cheaper cameras in Kodak's Instamatic line making photography more accessible, the need and demand for formal portraiture decreased. Addison's Scurlock Studio, geographically less than ten blocks from the new Capitol School, might have seemed a world away from the new business in terms of its outlook. Despite its long-standing reputation in the community, the studio would naturally be affected by these social changes, which would explain the father's reluctance to train the real or perceived competition.

Gains and Losses

The Capitol School was short-lived, unfortunately, and closed in 1952. However, it made a lasting impact and maintains a storied legacy in the world of African American photographers in Washington. Many of the students were veterans who wanted to start new careers and used their GI Bill benefits to pay for their studies. The school accepted Black and white students, male and female. Some of the most notable included Ellsworth Davis, the first Black staff photographer

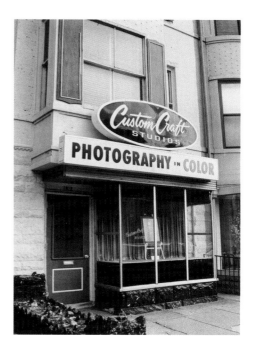

27. Scurlock Studio, George and Robert Scurlock in front of Scurlock Studio, c. 1965, gelatin silver print

Scurlock Studio Records, Archives Center, National Museum of American History, Smithsonian Institution

28. Unidentified photographer, Custom Craft Studios, c. 1970, chromogenic print

Collection of the Smithsonian National Museum of African American History and Culture, Gift of the Scurlock Family

for the *Washington Post*; the photojournalist George Clifton Cabell; Bernie Boston of the *Los Angeles Times* Washington bureau; Maurice Sorrell, the first Black member of the White House Photographers Association; and Jacqueline Bouvier, who was the "Inquiring Camera Girl" for the *Washington Times-Herald* before marrying John F. Kennedy.

The closing of the school, however, merely rerouted Robert's aspirations for charting a new path for himself and for Black photography. Both Scurlock brothers recognized the incipient but inevitable shift in social, cultural, and market forces and understood that the Scurlock Studio's power and greatest economic strength—maintaining a diverse and growing client base for portraits—was increasingly at odds with expanding opportunities for Black photographers engaged in freelance work (albeit in a racist economy that structurally favored white picture makers). Over the course of the 1950s and 1960s, somewhat chastened by their failed business endeavor, they tried to maintain the business on both fronts, staying true to their client base while reaching new corporate and institutional clients and beginning to explore the worlds of fashion and commercial photography, especially color photography (fig. 27).

In 1952, the year he closed the school, Robert kept the physical location and expanded into commercial photography, realizing the field was offering increasing (but still limited) opportunities for African American photographers. At the time, a New York–based photographer named Gordon Parks was becoming known for his spreads in *Life* magazine. Other African American photographers, such as Roy DeCarava and even Pittsburgh-based Teenie "One Shot" Harris, among others, were also gaining recognition for their images. In a postwar era on the cusp of the modern civil rights movement that was focused politically on "shocking the conscience"[29] through photography, on the one hand, and culturally on showcasing Black creativity, professionalism, and entrepreneurship on the other, Robert understood it was important to find a way to capitalize on the long-standing reputation of the family's name while also expanding his reach.

The new business, Custom Craft, was Washington's first custom color lab (fig. 28). Robert had learned custom color and dye-transfer printing while serving in the military. As

29. Scurlock Studio, Poor People's Campaign Headquarters, 1968, gelatin silver print

Scurlock Studio Records, Archives Center, National Museum of American History, Smithsonian Institution

a photographer he excelled at color photography and night lighting. Adapting to the shifts in technology and the realities of running a photography business in an increasingly competitive marketplace, Custom Craft began specializing in color and night views of Washington landmarks, monuments, and political institutions (fig. 29). Eventually the studio's commercial clientele included government agencies, IBM, and Westinghouse; they also began providing other photographers and studios in the area with color processing and printing.

Meanwhile, Addison remained committed to presenting a vibrant Black middle-class Washington experience and instilling that ethos in his son George. Robert and George worked diligently at maintaining the empire Addison had built; they continued their long-standing sole-provider contract with Howard University. At the same time, they wanted to build on their father's early experience of placing Scurlock images in *The Crisis* magazine and in the social pages of Black newspapers by creating images of everyday Black American life and selling them to the national Black press and other publications, such as *Ebony, Jet*, and *Tan*.[30] Over the course of the ensuing decades, Robert pitched successful photo-essay projects to various glossies, profiling African American Gold Star Wives, young Black professionals, and the expanding new Black suburbs east of the Anacostia River—where he captured two young boys in Eastland Gardens in 1951 for the pages of *Ebony*—just to name a few images (see fig. 2).

By the early 1960s, Addison was in his late seventies. He still worked with longtime clients, such as Howard University, but his son Robert was becoming known as a photographer

COMBS AND GARDULLO

superior to his father and considered "one of the best in the business."[31] Just before his death in 1964 at eighty-one, Addison sold the business to his sons. Robert's interest in photojournalism continued, and he published images in *Look, Time, Fortune, Ebony, Our World*, the *Afro-American*, the *Pittsburgh Courier*, the *Amsterdam News*, the *Norfolk [Virginia] Journal and Guide*, and the *Chicago Defender*. And his photograph of the 1968 DC uprisings received a two-page spread in *Life* magazine.

While Robert continued exploring the worlds of documentary and commercial photography as well as color printing, George steadfastly took over the task of carrying forward their father's business to a new generation of clients. He maintained relationships with many major schools in Northwest Washington, taking their class and individual student photos for decades. He nurtured the relationship with Howard University and continued to maintain and build the client base. The Scurlocks later incorporated Scurlock Studio and Custom Craft, and each brother ran a division, George continuing with portraits and photography assignments and Robert doing more corporate and color work, as well as printing and processing.

The late 1960s and early 1970s were a time of transition in Washington—as they were throughout the United States—which led to changes in African American businesses like the Scurlocks'. The 1968 uprisings in Washington damaged or destroyed thousands of businesses, but more often than not the Black-owned ones were salvaged. After the riots, there was even an uptick of Black-owned shops because more white business owners left downtown for the outskirts.[32] Images from the Scurlock Studio throughout this time illustrate how race was deeply intertwined with issues of class in Washington. For all its ills, racial segregation created an environment in which Black elites, as well as members of the middle and working classes, lived, worked, went to school together, and played alongside one another. Professors and police officers, poets and plumbers forged a way for themselves and for the greater community—not without tensions, rivalries, and social stratification; but still, together. As legal segregation ended and white flight followed, the economically and socially diverse Black community that was Scurlock's Washington—and that, ironically, had been held together in part by the limitations imposed by a racist society—started to unravel.

Business for the Scurlocks fluctuated in the 1970s. George left to pursue another career as an automobile salesman. Robert eventually closed the Connecticut Avenue location and consolidated all the businesses at the 18th Street address. U Street was forced to shutter its windows by the development of a Metrorail station. Robert worked hard to cement the family's legacy. He created and proposed traveling exhibitions featuring his father's work. His efforts resulted in an exhibition at the Corcoran Gallery of Art in 1976, the first show dedicated to his father in all of his time working as a photographer, as well as a 1981 show in Chicago.[33] And although he tried to avoid portraits, Robert kept taking them because of demand and business needs.

The Scurlocks: A Changing Same

It is early April 1968, days after the assassination of Rev. Dr. Martin Luther King Jr. The shop window at 900 U Street NW reads "Photography by Scurlock." Inside the encasement are artificial cherry blossoms accentuating nearly a half dozen photographs of beautiful brides dressed in fashions of the era. From the paint that has chipped away from the siding and the style of typography advertising the business, it is apparent the studio has been a site of aspiration for decades. According to photographer Robert McNeill, "It was said that if Scurlock didn't take your picture . . . at a wedding, you weren't married."[34] But two of the wedding photos are obscured, covered by a hastily written sign affixed to the window with tape that reads "Soul

30. George H. Scurlock, "Soul Brother All the Way" sign at Scurlock Studio, 1968, negative

Scurlock Studio Records, Archives Center, National Museum of American History, Smithsonian Institution

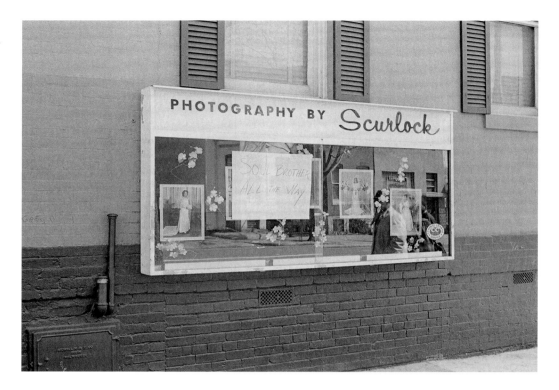

Brother All the Way." The juxtaposition of the well-composed bridal images carefully placed in the storefront window, as others had been for the past half century, with the handwritten sign is a poignant, if not jarring, visual. The sign's placement on a glass window feels as precarious as the moment it reflects. Its message is repeated up and down the Black-owned businesses on the U Street corridor, as a hopeful inoculation against the rage and destruction of rioters being visited upon the neighborhood in the wake of the assassination (fig. 30).

George Scurlock, the photographer whose reflection appears in the window, left his home and family in Southwest Washington to travel to the studio to ensure its safety. "Soul Brother All the Way" may be a mantra he repeats to himself as he shoots a roll of film, the shutter clicking with the exhalation of each word. The streets around the studio appear quiet, almost ordinary, as is reflected in the image captured in the shop window. The reflection of light bouncing off the glass serves as a powerful metaphor for not only the long-standing studio, which is experiencing a fractured but prismatic sense of community—racially, locally, nationally, and politically. It is drastically different from the image taken by the photographer's brother that *Life* would choose to publish, of looters swarming over a business less than half a mile away. This would be the image that would be fixed in people's minds: a picture of a community destroying itself. Not the quiet, strangely ordinary scenes captured in this single example from a roll of George's film. George does not stop to consider the totality of what his and his brother's cameras are each capturing, and what it might teach later generations about the complexity of his city's history. Maybe he's thinking about his father, now four years passed, and what his reaction to the situation would have been. Maybe he's thinking about getting home to his young children and what the future holds for them. Within the next ten years, he will leave his family business behind.

Scurlock Studio: Lasting Impressions

It is tempting to write the history of the Scurlock Studio in the post–World War II era as one of decline and fall. We must be careful of mining the historical era of segregation, however, with an eye toward pure nostalgia. It is important to examine the work of the three Scurlock men individually, as well as part of a longer continuum of photographic history. Addison Scurlock was uniquely influenced by the era in which he came of age, as were his sons by theirs. These varied effects swayed their aesthetics, business decisions, and goals. Addison clearly strove to make his statements about Black life and culture in subtle and refined ways through portraits focused on the individual and the beauty of the Black image. During Robert and George's period as proprietors, the "Black is beautiful" ethos was popular, and during the 1960s and 1970s it was being fully realized, chanted, and embraced. If the world of Addison was an Ellingtonian Black-and-tan fantasy, it was riven with a vibrant and seemingly immutable racism. The Chocolate City that Robert, George, and later generations inherited was in part structured by the struggles that their parents and grandparents' generations enacted and by the afterlives of segregation and the failed promises of integration.

One constantly changing theme through the various permutations, tragedies, and successes on scales small and large was the commitment that the Scurlocks maintained to depict their beloved community in its best possible light, to create a record that would speak forever to the hopes and dreams of those pictured, and how they wished to be remembered. In the first half of the century, Addison Scurlock's work epitomized the development of a Black photographic aesthetic that fused artistry with a strong sense of business acumen, respectability, and deep community engagement that began literally at home. It was the powerful awareness and blending of business, art, and community that made the Scurlocks' work and the work of many Black photography studios so powerful and important in crafting and sustaining Black communities from the early to well past the mid-twentieth century.

The Scurlocks' lasting commitment to these elements is evidenced by a document from 1942 titled "Our Obligation—as Portrait Photographers," which they kept and used in various formats throughout the years.

> It is by no means an idle assumption when, in these days of anguish for many and uncertainty for all, we speak of "our obligation" as portrait photographers. Millions of American men—and even women—are leaving their homes to join the armed and auxiliary forces of War.
>
> We, as professional photographers, are being called upon to portray these men and women with our camera. With patriotic fervor we are happy to dedicate every detail of our service to a full sense of the responsibility thus imposed.
>
> Therefore, we pledge to give wholeheartedly of our best to every subject; to do our utmost to make every negative a true characterization of the subject; to never fail to remember that for the period of these dark hours our portraits will be the cheer for many hearts.
>
> All of this we consider our obligation. By fulfilling it truly, when the light dawns of the better day that is to come, we shall be able to hold our heads high—our duty well done.[35]

A cynical reading of this statement might view it as a typical marketing ploy, a way to remind customers they are still open during a difficult period when many families were facing

31. Addison N. Scurlock, Young
George Scurlock and friends enjoy-
ing cake, c. 1925, gelatin silver print

Collection of the Smithsonian National
Museum of African American History and
Culture, Gift of the Scurlock Family

32. Robert S. Scurlock, Children
enjoying Popsicles, c. 1970,
chromogenic print

Scurlock Studio Records, Archives
Center, National Museum of American
History, Smithsonian Institution

COMBS AND GARDULLO

uncertainty during a time of war and increased competition for the same clients. This interpretation contains some truth. The Scurlock Studio, like all portrait photography studios, was a business in the midst of a segregated city with a striving Black middle class and necessarily developed a dialogic relationship with its clientele because of it. The Scurlock aesthetic was necessarily and directly tied to its entrepreneurial values and ethos. But when we look across the long arc of the studio's life, through the many years of portrait sittings, operating a family-run business six days a week, year after year, and recording thousands of graduations, weddings, and birthdays, as well as taking grade school, high school, and university photos, we can discern a deep and abiding demonstration that the Scurlock aesthetic was wedded to something more than peerless photographic technique and business acumen. The Scurlock signature "look" was also developed from and sustained by a deep commitment to service to the community through ongoing and direct representation and participation. This is apparent and initially expressed by Addison as early as 1909, when he addressed the National Negro Business League about being a business that took pride in offering more than "commercialism" to the Black community. It is also evidenced by the wartime manifesto, later refashioned by his son and reflected on the handwritten storefront sign for a new generation: "Soul Brother All the Way." A simple juxtaposition of images from the first and second half of the century provides powerful evidence that this continuum of professionalism and commitment to community was perhaps the fundamental characteristic of constructing the visual aesthetic for which the Scurlocks became famous and in turn provided a powerful portrait of their city throughout its changes.

The gelatin silver print of children, including a young George, in their Sunday best on the front lawn of a large home in a well-manicured neighborhood as they enjoyed homemade cake and ice cream is replaced by its 1970 equivalent: a color photograph of three unknown, shirtless young boys surrounded by high-rise buildings as they try to combat the sweltering DC summertime heat with Popsicles likely purchased from the neighborhood ice-cream truck (figs. 31 and 32).

Aspiring educators finely dressed in stylish overcoats, stockings, and sensible shoes that match their carefully pressed hair carefully descend the steps of Miner Teachers College, an institution of higher learning on Georgia Avenue whose mission was to educate Black teachers. Up the street and fast forward fifteen years is the campus of Howard University, where Robert photographed a group of young women who have replaced mid-calf-length skirts with thigh-high peacoats, stockings with jeans, and straightened hair with Afros (figs. 33 and 34).

The panoramic majesty showcasing a crew of Black newsboys in front of the Howard Theatre with owner Shep Allen in the 1930s is reseen in 1965 as a cast of young boys and girls running toward the camera at child's-eye level in an updated advertisement for a different Black-owned business, Bison Bus Lines (figs. 35 and 36).

The carefully composed 1915 family photograph celebrating Addison Jr.'s first birthday becomes a celebration of the family and their commitment to each other, the craft of photography, and all the dignity and sacrifice that come with fifty years of matrimony in this 1962 gelatin silver image of Addison and Mamie's anniversary gathering at their home on the 1200 block of T Street NW (figs. 37 and 38).

33. Scurlock Studio, Students at Miner Teachers College, c. 1950, negative

Scurlock Studio Records, Archives Center, National Museum of American History, Smithsonian Institution

34. Robert S. Scurlock, Students outside Founders Library, Howard University, c. 1965, gelatin silver print

Scurlock Studio Records, Archives Center, National Museum of American History, Smithsonian Institution

35. Addison N. Scurlock, Shep Allen (center) with newsboys at Howard Theatre, 1936, negative

Scurlock Studio Records, Archives Center, National Museum of American History, Smithsonian Institution

36. Robert S. Scurlock, Children in Bison Bus Lines advertisement, c. 1965, negative

Scurlock Studio Records, Archives Center, National Museum of American History, Smithsonian Institution

37. Unidentified photographer, Scurlock family celebrating Addison Jr.'s first birthday, 1915, gelatin silver print

Collection of the Smithsonian National Museum of African American History and Culture, Gift of the Scurlock Family

38. Unidentified photographer, Scurlock family celebrating Addison and Mamie's fiftieth wedding anniversary, 1962, negative

Scurlock Studio Records, Archives Center, National Museum of American History, Smithsonian Institution

COMBS AND GARDULLO

Coda: Gains and Losses Revisited

The year is 2009, months after the inauguration of the country's first Black president. A woman steps into a special exhibition gallery in a museum on the National Mall, sixty-five years after she and her husband left the Scurlock Studio following their portrait session. The exhibition is an inaugural foray for the National Museum of African American History and Culture (NMAAHC) as it begins its process of conceptualizing, collecting for, and constructing a new museum on the National Mall. The woman has never been to this museum, the National Museum of American History (NMAH), but she has heard about an exhibition of the work of a famous Black photographer from Washington who took a portrait of her and her husband when he returned from war in the 1940s. Though in her words it was a "lovely photograph," she destroyed her print and threw it away soon after it was taken.[36] Being newly pregnant, she was self-conscious about how she looked. Contemplating images of a city she partly remembers but largely has not known, she is fascinated by a history and culture she did not expect to see on the walls of a national museum. She is then more than surprised to see a younger version of herself and her husband staring back at her. Gloria and her husband, Ulysses S. Ricks, return another day and meet two gentlemen, Larry Arnold and Jerry Porter, who are also there to have their picture taken next to ones taken of them decades before. After admitting that she discarded the original portrait in a pique of self-doubt, she admits that she now loves the photo. When she receives a new print she claims, "I'm never throwing this one away."[37] She's proud to be celebrated in the nation's museum and to be part of a story that celebrates her community and her life (figs. 39 and 40).

The journey of the Scurlock portrait of Gloria and Ulysses S. Ricks is a circuitous one that upon reflection reveals layers of depth and complication. Created during a time of war and segregation, in part to illuminate the complex patriotism of many Black Americans in the face of injustice, it reflects an ethos of self-fashioning on the part of subject and photographer that portrays the resolve and attitude of Washington's and America's Black community to embody and display pride simultaneously in their Blackness and their Americanness. Unseen for decades until showcased in the exhibition *The Scurlock Studio and Black Washington: Picturing the Promise*, the photo—much like the construction of the new museum—is on one level a metaphor of arrival and reappraisal and on another level an embrace of a story seemingly lost, repressed, or unacknowledged, now reintroduced to a national and international audience.

The embrace of the Scurlock Studio by the Smithsonian is not just reflected in the arrival of NMAAHC, a museum dedicated to telling the American story through the African American lens, but is also evidenced by the acquisition of the studio's multigenerational archive by the NMAH, as a result of negotiations with Robert Scurlock that concluded in 1997 after he passed away. The archive consists of hundreds of thousands of photographic prints and negatives along with equipment and business records, saved by a national institution at a time when they might have been lost. Of course, the life and memory of Scurlock's Washington was never lost on the Black community of Washington. Even though the exhibition highlighted only a tiny fraction of the trove that the NMAH acquired from the family a decade prior, visitors flocked to the exhibition, demanding to have their voices heard by participating in leaving memory cards in a small comment box and an accompanying display case entitled "Remembering Black Washington." Hundreds of notes flooded the gallery box. Some messages focused on identifying people in the photographs on display, some corrected errors of fact or offered words of praise and thanks, and some deposits were whole packages containing photocopies of old Scurlock photographs with stories connected to them. Others were meditations that reflected a wide

39. Hugh Talman, Ulysses S. and
Gloria Ricks at the exhibition
*The Scurlock Studio and Black
Washington: Picturing the Promise*,
2009, digital file

Courtesy the National Museum of
American History, Smithsonian
Institution

40. Hugh Talman, Larry Arnold
and Jerry Porter at the exhibition
*The Scurlock Studio and Black
Washington: Picturing the Promise*,
2009, digital file

Courtesy the National Museum
of American History, Smithsonian
Institution

range of memories of Black Washington, or events related to life in historic Black communities
in cities and towns across the United States. It is this process of a community laying claim to
its own history that led Gloria and Ulysses S. Ricks, Larry Arnold, and Jerry Porter, along with
hundreds of others, to reclaim and give voice to their histories, just as the Scurlocks had done
for decades and before the Smithsonian preserved the collection or NMAAHC was established.

The hunger on the part of Black Washingtonians to remember, give voice to, and attempt
to reclaim this history came at a time when Washington was drastically gentrifying. In the
late 1990s and early 2000s, the U Street corridor and surrounding neighborhoods of Shaw and

LeDroit Park were quickly being economically revitalized. With that came a continued and hastened removal of Black-owned businesses, institutions, and families from that neighborhood, as well as from the city as a whole. The Black culture and community that had given shape to the neighborhoods where the Scurlock Studio stood and that it lovingly documented was systematically being disappeared by the engines and practices of redevelopment and divestment. Scurlock's Washington began to be seen through a prism of nostalgia: a rich Black world that could be remembered and capitalized upon, and one that, except in increasingly rare exceptions, would be relegated to the past and placed on new construction fences or as civic education through public heritage trails.

Placing the archives, objects, and photographs of one of Washington's longest-standing Black businesses in the corridors of what some lovingly and others suspiciously label "America's attic" marks a complex transition in the life of the nation's capital, one that traces both gains and losses. The power of Black cultural production and the simultaneous arrival of grand-scale Black representation in the halls and on the walls of national institutions comes at a time of devastating loss of Black representation on the streets and neighborhoods of what, for much of the twentieth and part of the twenty-first century, was the nation's "Chocolate City." This transition demands that we embrace and explore complex themes of loss and irony when charting trajectories of progress and change. As with the long-anticipated and much-celebrated arrival of a new national museum dedicated to telling American history through an African American lens, it is important to stay cognizant of simply celebrating "arrivals" or gains without acknowledging losses.

It perhaps also demands a concerted response from the large cultural institutions that become the ultimate repositories of these archives and histories. Beyond the preservation of collections or display of exhibitions and their accompanying catalogs, what is the role of institutions as they collect and represent businesses like that of the Scurlocks or of other Black archives? What are their responsibilities to the communities that are represented therein? Charting the changing cultural, political, and racial landscape of Washington also means grappling with the responsibilities that cultural institutions now hold when preserving and representing Black history and culture. In other words, institutions must move beyond simply exhibiting Blackness and toward an ongoing and vigilant advocacy for and relationship with the local communities whose histories are a shared stewardship. In this regard, there may be important lessons for us to learn still, not just in analyzing the Scurlock look and oeuvre, but from also heeding the family and studio's long-lasting commitment to their community.

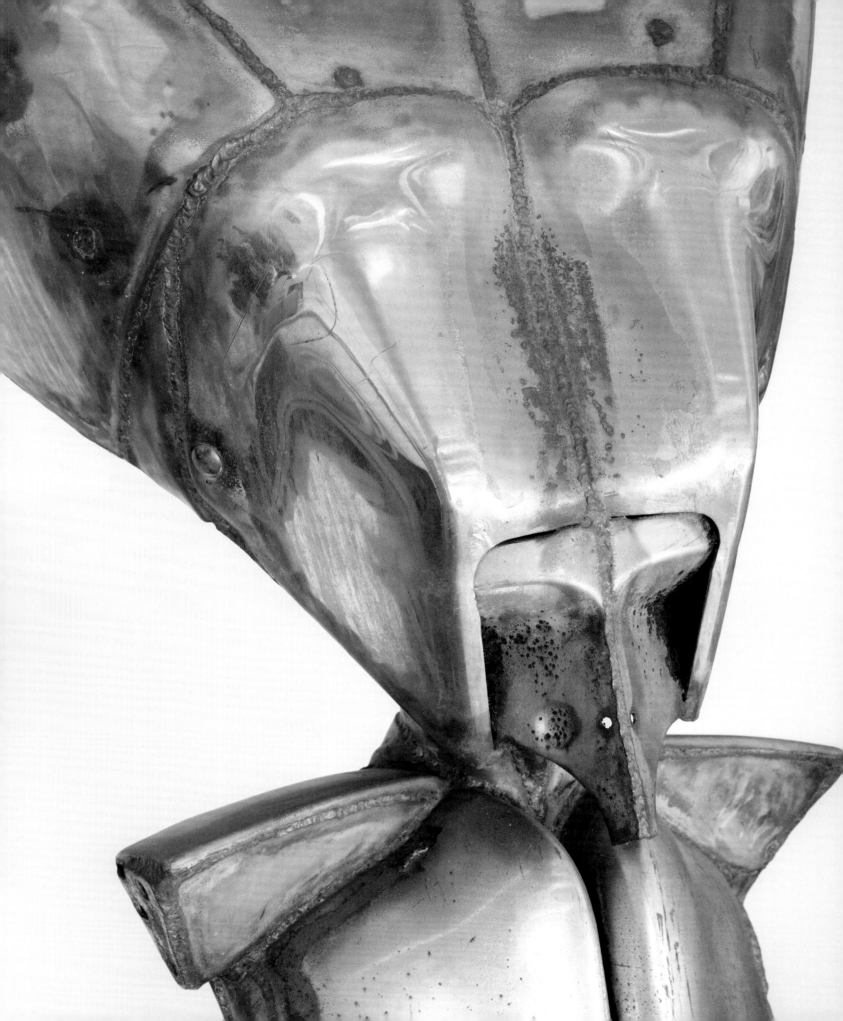

EMANCIPATION THROUGH ART:
THE NEW NEGRO, THE HUEMAN, AND
THE SOCIAL SCULPTURE OF ED LOVE

Jeffrey C. Stewart

"A great race-welding" is how Alain Locke described the metamorphosis he saw in Harlem in 1925, the result of the kaleidoscopic colliding of diverse elements of the African American diaspora flowing into New York's Black enclave after World War I.[1] In a special issue of *Survey Graphic* entitled "Harlem: Mecca of the New Negro," Locke argued that a new subjectivity emerged from the fusing of peoples streaming from the South, the Midwest, the West Indies, and Africa into the crucible of Harlem.[2] But Locke admitted that this new identity was fragile, untested, and tentative. It needed spiritual deepening if it was to survive the twin evils of American society—racism and materialism—and become something fresh. The Negro artist, Locke later argued, was the one figure in American life who could supply that spiritual tempering by making art that served the needs of the Negro community as it struggled to embody agency and beauty.[3] For most of the twentieth century, the leadership of the art department at Howard University—the university where Locke taught—rejected his raison d'être for Negro artists, believing that their highest calling was their freedom of expression. But fifteen years after Locke's death in 1954, something magical happened. A Los Angeles–born, African American sculptor migrated east to Washington, DC, to take a job teaching in that Howard art department and would become the primary missionary of Locke's idea that a race could be welded together through art.[4]

Born in Los Angeles in 1936, at the end of the Harlem Renaissance, Edward Arnold Love came to Howard University in 1969 from Los Angeles, itself a kind of crucible. When we think about Los Angeles in the early 1960s, we are reminded that this was the mecca of a late wartime migration during World War II, when hundreds of thousands of African Americans left the South for the West Coast to take jobs in the aircraft industry. But Los Angeles was also the first postindustrial city, a metropolis of freeways, not skyscrapers, where consumption, Hollywood, and the automobile displaced the inner-city downtowns of the East Coast. Los Angeles was also the place where Sam Rodia, an Italian immigrant and self-trained artist, constructed Watts Towers, a mini-skyscraper of his own, out of scrap metal. It was in this milieu that Ed enrolled in an architecture program. But when he was told by his teachers that he had no chance of being hired as an architect, given that he was an African American, he entered the art program at California State University, Los Angeles, and earned a BFA in 1966 and an MFA in 1967.[5] And there is just the chance that at the Cal State LA art department, Ed Love discovered the

Detail, fig. 4

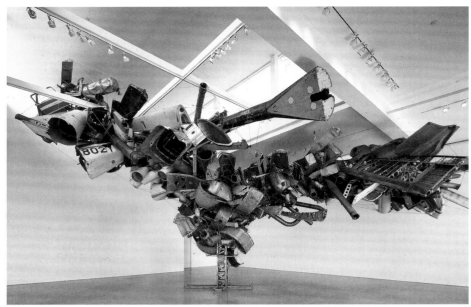

1. David Smith, *Cubi XVIII*, 1964, polished stainless steel

Museum of Fine Arts, Boston, Gift of Susan W. and Stephen D. Paine. © Estate of David Smith/Licensed by VAGA, New York, NY

Photograph © 2023 Museum of Fine Arts, Boston

2. Nancy Rubins, *Airplane Parts Chas' Stainless Steel, Mark Thompson's Airplane Parts, About 1000 Pounds of Stainless Steel Wire, and Gagosian's Beverly Hills Space*, 2001, stainless steel and airplane parts

© Nancy Rubins. Courtesy the artist and Gagosian

three-dimensional welded steel sculptures of David Smith (fig. 1), since it was at Cal State that Ed took up welding scrap metal into abstract and anthropomorphic forms. And I want to push this even further and suggest an affinity between Ed Love and Nancy Rubins, who epitomizes in my mind the taking of the scraps of industrial decay, especially airplane parts, to utilize them in huge metal constructions that serve as a kind of critique of the entire throwaway environment produced by late industrial capitalism (fig. 2).[6]

But Ed left the Left Coast, and after a brief stopover at Uppsala University in Sweden as a postgraduate fellow, migrated to an East Coast city that was never a site of urban industry, but is a site of political conflict: Washington, DC. Ed joined the art department faculty at Howard University in 1969 because he had a political notion of the work art can do. Unlike Smith, Ed was not motivated by an art-for-art's-sake abstract expressionism or given to eschewing the political interpretations of his work, as Rubins has. Rather, Love became an inspirational figure at Howard for the next eighteen years precisely because he was about the business of creating "social sculpture," the term coined by Joseph Beuys, who in late 1960s Germany also advanced the notion that art could offer a new emancipatory framework for society. While the distance between Beuys's agitprop student political parties and Love's Howard University classroom may seem great, Howard in fact had been incubating a radical aesthetic politics since the 1930s and 1940s, when Locke's theories of Black aesthetics led to the radical notion that the purpose of art was to bring about new forms of social relations in the American polity. Ed came to Howard, in part, according to his wife, Monifa Love Asante, because of Alain Locke, and because of his New Negro notion that art is catharsis and exists to free people from the "invisible structures" that "govern our lives and relationships," as one recent exhibition project puts it.[7] Art was social sculpture because it chiseled away old ways of thinking and molded new possibilities of a revolutionary future.

What separated Love from Locke and Beuys was that for Love, emancipation was an object-making *practice*. Love's artistic vision was fundamentally embodied and anthropomorphic even as it focused laser-like on one particular visible and invisible structure—the scourge of White supremacy and racism in contemporary life. His Los Angeles artistic heritage was

important here as well: Ed's approach to the problem of envisioning utopia was architectonic. Through the creation and exhibiting of humanoid structures built up out of metal, his art would create an invisible architecture in people's souls to resist the imprint of White supremacy and racism in daily life. Ed's sculptures were designed to armor viewers psychically against the destruction of the soul that is the intent and agenda of racism in all people's lives. What, then, did Ed Love find when he reached Howard in 1969? He tells us:

> When I came to Howard, there really was not a sculpture major. I was hired to teach painting and to begin to teach sculpture. I started to use materials and tools that were basic and inexpensive. One of these tools was a gas-welding torch. The process of welding is relatively simple. The materials are not restrictive and you can do a great deal with scrap materials. There was a junkyard and a bumper-replating factory near the university. They became our primary source of materials.[8]

3. *Ed Love Welding*, c. 1992–1993, gelatin silver print

The Love Family Private Collection.
© The Love Family Private Collection

For Love as for Beuys, teaching was a form of research, for by collecting and repurposing scrap metal, students no less than teachers transformed the waste of a dying industrial civilization into art (fig. 3). And through this practice they modeled the social and psychological process of transforming the outworn elements of their thinking into new possibilities for humanity's future.

But he found something else. When Jeff Donaldson, originally hired by James Porter, took over the chairmanship of the department of art, Donaldson institutionalized an Afro-diasporic art agenda that reversed the decades-long pursuit of art for art's sake under Porter and the department's founding chair, James V. Herring. With Love and Donaldson sharing many ideas of what became known as the Black Aesthetic in the visual arts, Locke's philosophy that the Negro artist should produce an art of beauty for Black people was resuscitated. Actually, this development would not have surprised Locke. Embodied in his New Negro concept but realized more successfully by the Black Arts generation—and especially by Ed—was the concept of rebirth through art that produces a new subjectivity, one that retains the lessons of slavery but has the capacity to create new possibilities through art. Here, in effect, is the second try at renaissance: to actualize in Washington what Harlem imagined but could not weld into compelling aesthetic form. In the 1970s, the art department at Howard was arguably foremost in the African diasporic world, with such faculty members as Love, Donaldson, Malkia Roberts, Frank Smith, and Martha Jackson Jarvis producing an art of Black spiritual liberation, the term Black having replaced that of the New Negro.[9]

But Love understood what Locke perhaps never faced—that beauty alone would not do it. In meetings and late-night rap sessions among members of the department, but also with such Gramscian intellectuals as Neely Fuller Jr., who recorded some of the dialogues in his book *The United-Independent Compensatory Code/System/Concept*, Ed and the art faculty debated what was to be done to defeat the major challenge to Black existence throughout the world: the practice of White supremacy.[10] Love, Roberts, Donaldson, Smith, Jackson Jarvis, Winston

4. Ed Love, *Osiris, Monster 3*, 1972, from *Big O* series, chromed steel

The Love Family Private Collection.
© The Love Family Private Collection

Photo: Lluvia Higuera

5. Ed Love, *Isis, Monster 6*, 1973, from *Big O* series, chromed steel

The Love Family Private Collection.
© The Love Family Private Collection

Photo: Lluvia Higuera

Kennedy, and others regularly met and concluded that racism would not be defeated by the Black Victorian formula of creating counterpositive images or by Locke's formula—that is, by beauty alone. There needed to be something else, a cleansing, a reorientation of the Black mind to free itself from the brainwashing of White supremacy. Love stated that as a young man he had participated in such discussions of W. E. B. Du Bois, Marcus Garvey, and Paul Robeson; but in this hothouse situation, Black artists workshopped the Black experience as "technicians of the sacred," whose special trust was to foster in their work the liberation of Black people.[11]

At Howard, Ed entered a dialogic environment where his investigations into how to be a powerful, transformative artist developed a level of criticality through peer discussions that made him realize that White supremacy would have to be defeated, not simply persuaded of the humanity of Black people. As he noted in 1986 on the occasion of his exhibition *Soundings*, "Being at Howard is very important to me. I think my teaching has lots to do with my believing that the environment can be affected and changed by people who care. And caring requires that you not be afraid of being critical, that you not be afraid to work, and that you believe everything adds up . . . that the 'second why' is most important in seeing."[12]

I suggest that "technicians of the sacred" had a particular meaning in regard to Ed. First, he was a technician—a mechanic, really, like his father had been. Making things, and the making of things, the welding of metal, was tremendously important to him—the making of

the work was itself a form of catharsis. Wrestling with the material was tremendously liberating for him. But the sacred was also important: his work was a meditation of the spirit, often with the sense that in creating his sculptures, he was creating containers for the spirit that lived inside and spoke from those enclosures, such that he was about a sacred business, of creating work that mediated between the material and the metaphysical.

But here is the catch. Ed realized that if art was going to stop the damaging practice of White supremacy, it would have to advance a new subjectivity that would transform White people as well as Black. Part of being truly metaphysical was to realize the metaphysical was superior to the material. This was reinforced in his thinking by his reading of Buckminster Fuller's *Operating Manual for Spaceship Earth* (1968), which states, "Abraham Lincoln's concept of 'right triumphing over might' was realized when Einstein as metaphysical intellect wrote the equation of physical universe $E=mc^2$ and thus comprehended it. Thus, the metaphysical took the measure of, and mastered, the physical."[13] The new subjectivity would have to be metaphysical, based on a consciousness, not a skin tone. It would have to be more than an updated New Negro. It would emerge out of the knowledge of the Black experience but advance a new subjectivity that transcended the purely racial—a true singularity, what Neely called Universal Man and Universal Woman.[14] Here, it would be not the fake universalism of the Enlightenment and other European philosophical formulations, but rather one that was truly a new universal melding. His metaphors for this new subjectivity would the *hueman* and *huewoman*.

Here, therefore, we see realizations of this new consciousness in metal sculptures that resemble a pair of Star Wars creatures made of shiny steel, extremely tall figures whose size communicates their spiritual superiority over everyday man and woman. Osiris, as we know from our study of Egyptian mythology, is the Egyptian god of the afterlife, but also a god of transition, reformation, and regeneration—the kind of reinvention that Locke tried to capture in the New Negro—but here fully realized in a new subjectivity. For Ed, of course, it is not a god, but a hueman: a hue-man, whose spelling makes us aware of man of color, but also an "e" that forces us to think about what it means to be human—in this case, a new form of human existence and representation. Here, universality emerges from an African particularity to announce a new, transcendent subjectivity that is in essence a universal particularity. One notices Ed's distinctive rendering of the crown that often adorns and identifies the head of Osiris here as a silver pyramidlike headdress. We recall, too, that Osiris is also considered the generator of all life, including vegetation, bringing in a sustainability concept, even as it is made of metal that is the product of the industrial world that is strangling our planet. Isis is the goddess of health, wisdom, and marriage, but also the friend of slaves and the oppressed, who brought about the resurrection of Osiris. In that sense, she had more power than her brother as the giver of life. Finally comes Horus, here Horus the Younger, the son of Osiris and Isis. The last of the five Egyptian gods Love sculpted, he takes on many forms, often of birds but tellingly representing the capacity for transformation.[15]

Ed created this "divine family" in huge, eleven-foot-tall sculptures, using his knowledge of architecture as well as art (figs. 4–7). He also displayed them in Washington as totems to activate reflection, consternation, and possibly questioning as to why they were there, what they meant, and to promote the "second why"—a deeper questioning of the taken-for-granted

6. Detail of Ed Love, *Horus 3, Monster 9*, 1973, from *Big O* series, chromed steel

The Love Family Private Collection.
© The Love Family Private Collection

Photo: Lluvia Higuera

value systems of thinking in the West. Today this might be called a process of decolonizing thinking or pursuing "strategies of epistemic disobedience," as Charlene Villaseñor Black and Tim Barringer put it, in that it clears a space for new, transgressive, "productive models in contemporary art" once Eurocentric epistemologies are exorcised from our thinking.[16] Only through such epistemic exorcism can the contemporary citizen, no less than the artist, become universal man and universal woman.[17] Ed's inspiration for many of these sculptures is a process of emancipation that relies not only on ancient mythology but also contemporary jazz. He worked on the sculptures while listening to jazz and made them appear to dance (recalling Robert G. O'Meally's idea that dance is a fundamental characteristic of the Washington Black experience). They were designed to uplift the consciousness of the largely Black population in that section of Northwest Washington with images of themselves as gods. Ed hoped that viewers would confront themselves in the sculpture, and through a process of knowing and unknowing (from his listening to jazz composer Thelonious Monk) or in the "flash of the spirit" (from art historian Robert Farris Thompson) in a reflective third space, the confrontation with the self/nonself would produce a shedding.[18] Someone would catch their breath, and in that exclamation something would be relinquished that was a layer of not knowing oneself. Exhibiting these sculptures on Georgia Avenue was part of his hope that by providing opportunities that were not necessarily gallery experiences the viewer would have the chance to divest. "In the book *Black Magic*, Amiri Baraka described a patron of Ornette Coleman who got so discombobulated by what he was listening to that he had a nervous breakdown and on the other side he became more human."[19] As Neely Fuller Jr. put it, "if you do not understand White Supremacy

(Racism.)—what it is, and how it works—everything else that you understand will only confuse you."[20] Rather than argument or intellectual contestation, Ed Love proposed sculpture to provide opportunities for us to awaken to ourselves. As the historian Ivan Van Sertima put it:

> The object of this highly imaginative exercise is to demonstrate the capacity of the human spirit and substance to recreate itself, to feel its way toward a Consciousness that breaks down and breaks through apparently fixed and frozen, partial and polarized, states of being and belief. The revolution implied here is a revolution of the imagination, a revolution in consciousness, a fundamental revision and reassessment of static and ritualised modes of seeing, thinking, feeling, which may afflict a whole civilization, regardless of whether one is in the black or white race, the capitalist or communist camp, the group of the ruler or the ruled. This is, in effect, the ultimate conflict between man's freedom to remake himself and the world he has already made, which imprisons him in the tightly woven fabric of its ritualised reflexes, ideologies and institutions.[21]

One way of thinking about the hueman is to see it as a work in progress that captures what has existed and projects it into the future, with a dash of Afro-futurism from Buckminster Fuller and Neely Fuller Jr. added to the mix. As part of the monster series, these huge sculptures were meant not to frighten but to reclaim the old meaning of inspiring awe, to command another kind of dimensionality, one rooted in the largeness of spirit one could claim by moving back and forth between antiquity and what was yet to come. The monster for Ed was another term for the "monumental" in humans, a term Beuys used for similar purposes, although with a different aesthetic practice in mind. Beuys became professor of "monumental sculpture" at Düsseldorf in 1961, a testament to his aspiration to construct a public politics on the basis of "a theory of sculpture," as Stuart Morgan puts it, "as activity, demonstration and social comment . . . the testing of his world view and the fictionalization of incidents in his life . . . rooted in the folkloristic and scientific strains of German Romantic thought [to] redress failure of intuition and spiritual awareness in an era of disintegrating capitalist values."[22] Through performance of public ritual, Beuys sought to create a new politics based in aesthetics. But Love was creating physically monumental sculptures for viewers to interact with, to launch not a particular legislative politics but a spiritually enhancing politics rooted in self-knowledge. Ed utilized Egyptian myths, but he also wanted the resulting sculpture to be *tactile*. The encounter with metal, metallic sculptures that possessed even an abstract minimalism, with identifying racial, national, or human markers, were reduced in favor of a Brancusian verticality designed to lift our consciousness upward through its reflection in sculpture. Through "monumental" metallic structure, he wanted us to find inspiration for an elevated and liberating view of life's unrealized possibility. [23]

But Ed began to move away from the monumental, in part because of his increasing sense that he needed a sculpture that was more on a human scale to bring about the enlightenment he sought. If he continued to make huge sculptures, they would tend toward spectacle, like Nancy Rubins's gigantic bursts of metal and wood: they would command awe, not human engagement. Instead, while still at Howard University, Ed turned to making metal sculptures closer to human scale based on historical and living heroes, rather than mythic characters. His *Monument to Robeson* (1974) is a case in point (figs. 8–10). It is scaled down from eleven feet to eight feet and, while still monumental in impact and presence, presents Robeson as an example we can aspire to follow. Here, Paul Robeson is a svelte-looking hero, part New Negro beauty, in a way that Locke would have appreciated, but also something lofty, imposing, and powerful. While an homage to the dead Robeson, it is also the embodiment of Robeson the artist,

8. Ed Love, *Monument to Robeson*, 1974, chromed steel

Private collection. © The Love Family Private Collection

Photo: Lluvia Higuera

9–10. Details of fig. 8

Photo: Lluvia Higuera

beautiful and enlightened, the tube extending from his head on one side a column capturing his modernism as an artist and thinker. The sculpture also seems to be dancing, bending to the music, the artist in his element. But there is also a cautionary awareness here as well, as if Love, in turning to representing a Black artist, wants to ensure that we see the whole story. Notice, for example, the heart covering the knees, as if a pillow. The artist, Ed is saying, always has to bow down to power—whether the state, the patron, or the institution. Ed has placed his heart on his knees to soften the blow to the artist when he has to genuflect to power. Of course, the figure is powerfully male and sexual, but also birdlike, undeterred from flying by the reality of power.

Contrast that with another Robeson sculpture by Ed Love, *Robeson Totem (2nd Variation)* (1975; fig. 11), no longer a monument to the dead but a living, moving agent of change. Here, the metaphysical is not represented by a particular appendage, such as the column in *Monument to Robeson*, but suffuses a statue of steel, where the steel is a plastic container of tightly held power and memories. Here is Robeson the world citizen, the human rights leader, the transcendent and fearless defender of the rights of Black sharecroppers in Mississippi and Aboriginal peoples in Australia. Here is Robeson walking the earth and defending the weak, enabled, yes, by his great talent as a singer and actor, but using that agency—really giving up his life—to achieve what Neely called "correctness"—"balance between people (guaranteeing that no person is mistreated and guaranteeing that a person who needs help the most, gets the most constructive help)."[24]

Installed in the lobby outside the admissions office at the University of the District of Columbia, an eight-foot-tall sculpture of Robeson dominates—really, reconfigures—space. It stands like a sentry over those who would enter the university to gain knowledge, especially those less able financially to pay for a high-priced education in the numerous other colleges and universities in Washington. Here, too, in its placement, it is a cypher of correctness—the idea that those who need an education but come from the under and working classes can have the hope, really, the justice, of access to higher education. People walk by this sculpture outside these administrative offices, mill around, comment that it is striking and moving, but do not really understand what it was. This is also part of Ed's message: the sculpture does not have

272

11. Ed Love, *Robeson Totem
(2nd Variation)*, 1975, chromed steel

President's Office, University of the
District of Columbia. © The Love Family
Private Collection

Photo: Jeffrey C. Stewart

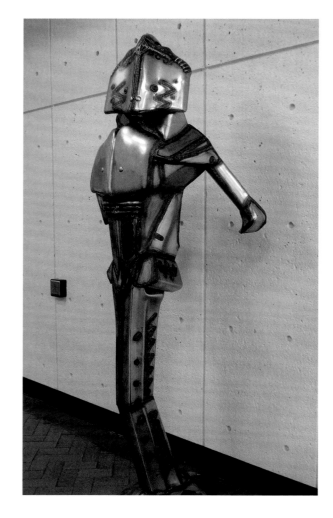

12. Michelangelo Buonarroti,
David, 1501–1504, marble

Galleria dell'Accademia, Florence

Saskia Ltd., Cultural Documentation.
Courtesy National Gallery of Art Library,
Image Collections

13. Ed Love, *Robeson Totem
(2nd Variation)*, 1975, chromed steel

President's Office, University of the
District of Columbia. © The Love Family
Private Collection

Photo: Jeffrey C. Stewart

to demand attention to go about doing its work, which is to continue to prompt the "second why"—"why is it here, why are we here?"

Part of the answer is that it is a political representation of republicanism and a worthy accomplice to that other, more famous representation of Florentine republicanism—*David* (1501–1504) by Michelangelo Buonarroti. Both stand aloft, head turned slightly to the left, engaged, resolute, but also calm and mindful (figs. 12–13). Despite their many differences, these two sculptures are posed as exemplars of the citizen, Robeson the American democratic citizen, just as David embodies the republican for the Florentines. At seventeen feet tall, David is perhaps the first monument to the rights of the citizen, a cause that I would argue *Robeson Totem* takes up at eight feet and continues in America. Their towering organization of masses is similarly muscular and powerful—yet realized with a lightness and vulnerability that shows extreme tenderness. Where a super aggressive form would be expected, this one is actually open and vulnerable in unexpected ways. It has a powerful breastplate, but also a soft and still, psychologically available face. Note the rock in both hands—at least in David's, for sure, but I catch a glimpse of one in Robeson's as well—to hurl against illegitimate authority oppressing humanity and retarding the development of a true hueman, metaphysical consciousness in us.

That rock unexpectedly is in conversation with another sculpture with which it shares space, even seeming to be looking mournfully toward—*Faena (The Killing of M. L. King,*

Maximum Security Series) (1976; fig. 14). Done a year after *Robeson Totem, Faena* marks Ed's movement into more abstraction to find a more powerful way to represent the violence essential to maintaining White supremacy. Ed Love gave the name *Faena* to this piece, according to Monifa Love Asante, to evoke a bullfighting tradition:

> After the bull has been beleaguered by a variety of attacks and thus exhausted, the matador taps the bull on the nose with the sword to get him to lower his head, and then plunges the sword with the idea of severing the bull's spinal cord. Ed believed that bullfighting was the ritual reenactment of the expulsion of the Moors from Spain. He saw in the bullfight a metaphor of the routine of exhausting the Black man through a series of microaggressions, then finishing him and heralding the matador as the hero.[25]

From this perspective, the Killers of King, meaning the killers of the metaphysical idea that was King, had already been working on King for years; Memphis was simply the Tercio de Muerte. The sword is the long pillar angled into King's heart, which, when you see it, feels like it is angled into your heart.

The unabashedly masculine nature of these sculptures can give pause. Although Ed did numerous sculptures of women artists and intellectuals he valued tremendously, such as Bessie Smith, Abbey Lincoln, Sojourner Truth, and Angela Davis, he frankly admitted that his artistic practice was designed to yield him self-knowledge, and he wanted to understand himself first and foremost. Indeed, the sculpture was a gendered excavation, a struggle waged for decades to find an authentic basis for a Black male identity in a world Ed and countless others of his generation experienced as determined to destroy Black men especially. The struggle he faced, then, was how to create the basis for authenticity as a man in a world in which Black and man constituted a contradiction when brought together.

14. Ed Love, *Faena (The Killing of M. L. King, Maximum Security Series)*, 1976, chromed steel

President's Office, University of the District of Columbia. © The Love Family Private Collection

Photo: Jeffrey C. Stewart

Key to Ed's struggle to become an authentic artist was a strong sense of integrity, and that began to become bruised at Howard by the mid-1980s. Always something of a loner, Ed increasingly found the circle of dialogism, so sustaining at an earlier time at Howard, no longer worked for him. He came to believe that even progressive Black educational spaces needed to undergo a profound *shedding* of attitudes and behaviors developed under racism and internal colonialism to deliver the kind of education students needed to be free. Later in his life Ed would represent this concept by producing art with brooms that could be used to do the sweeping away of the false thinking that kept people enslaved, mentally if not physically.

An invitation came in 1987 to Ed that offered an interesting opportunity and welcomed recognition of him as an innovative art teacher: he was invited to be the founding dean of visual arts at the New World School of the Arts (NWSA) in Miami.[26] Funded by the Florida state legislative, NWSA planned to offer education from tenth grade through graduate school, and Ed was tasked to design a program of visual arts education from the ground up.[27] Having worked with the School Without Walls and the Duke Ellington School of the Arts in Washington, Ed seized on this as an opportunity to teach a new kind of arts education in a dual enrollment situation.

When Love arrived in Miami, the high school was being put in place. His aim as an educator was to treat the environment as a fiery furnace and see what students could do through visual art. Initially, he experienced tremendous success and was astounded by what high school students accomplished. Evidently, they were receptive to his style of instruction and ready to produce the kind of work he wanted. But unfortunately, Ed met with deep opposition from the administration. When he started implementing a radical pedagogy, it was frightening to administrators. The level of critique with which he analyzed education, art, and popular culture was surprising to those who had hired him. At one meeting at a high school, Ed castigated using *Miami Vice*, a popular hip cop television show based in Miami, as a model of success, especially since literally across the street from his house in Miami was a crack house that people in the neighborhood could not get removed. The conflict brought home to Ed how people had been domesticated to accept even a caricature of integration as something to be proud of. But the incident also brought home to the administration that he would not leave his criticality, honed from years of debating the internal structures of domination while a professor at Howard University, out of art education. Suddenly he lost the ability to hire and fire, even though he was a dean. After he received threats against his life, he realized he had to leave.[28] In 1990 he accepted a position as professor of art and director of undergraduate studies at Florida State University, returning to his personal love, being a professor and teaching, but also with a sense that his larger revolutionary approach to art had been constricted because he refused to submit, to bend, to bow down to power.

Ed's work after 1990 seems more personal, less public, less monumental than the Osiris and Isis sculptures, and less confident of world-striding success, as in the Robeson sculptures, all done in the 1970s at Howard. Perhaps most deeply revealing was his new series produced in the 1990s, *Passages from the Middle*, a play on the Middle Passage, obviously, but also a meditation on what all of us have to pass through, the middle of strife and struggle, to be free. Many of us never actually get through the middle, as his meditation *Basquiat's Door (for Terrance Johnson)* suggests (1996; figs. 15–17). Basquiat was important symbolically, because he seemed to be the epitome of the successful Black artist entering the mainstream art world, something that Porter and Herring had preached as possible if the artist eschewed a racialized art practice and, of course, was relentlessly brilliant. Basquiat's famous tag, "Plush Safe He Thinks," however, is a reminder to us that this was a mirage, given Basquiat's torturous life, even after he became a famous and wealthy artist.

Basquiat's Door was also a breakthrough formally for Love and showed how he had adapted to change. By the mid-1980s, automobile manufacturers stopped using chrome bumpers, and it was too dangerous for Ed to try welding the plastic composite bumpers that replaced them.[29] So he moved to working in large blocks of discarded steel, and *Basquiat's Door* exemplified this new form—a door, or wall, of steel, on which he hung implements of power and suffering. In the shift a new complexity and abstraction emerged, as he did a series of doors dedicated to Black artists, Bessie's Door, and of course, Basquiat, that allowed him to create a whole world in the sculpture rather than a sleek and shiny anthropomorphic subject. Perhaps inspired by the infamous "door of no return" of the Cape Coast Castle in Ghana, Ed found in the door a way back to an African notion of sculpture as fundamentally three-dimensional. Now, the sculpture is a narrative of memories, hung as instruments of suffering—ball and chain, hand and foot cuffs, shovels and agricultural tools—that directly reference neo-slavery.

Basquiat's Door is a guide to aesthetic survival. It includes memories and tools for your successful passage from the middle (and muddle) of controversy about who and what the artist is and should be to a state of grace. While earlier pieces like *Isis* and *Robeson Totem* were mythic

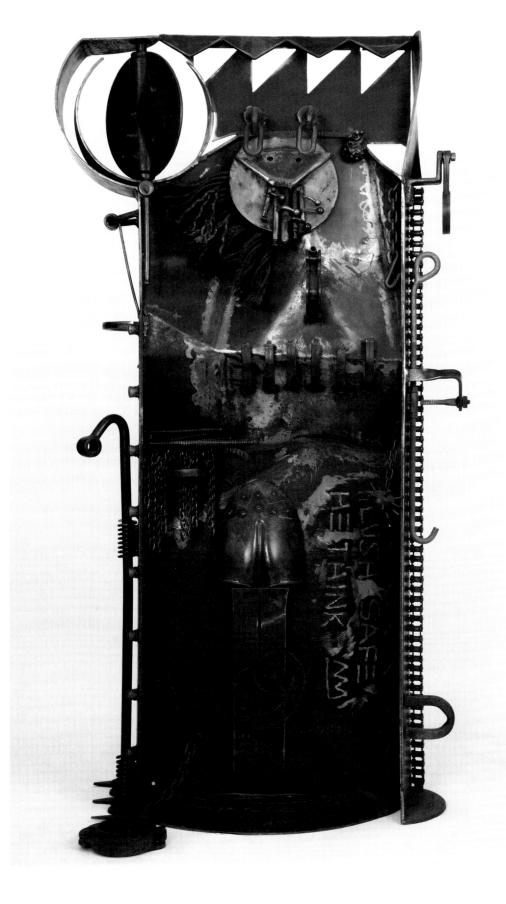

15. Ed Love, *Basquiat's Door (for Terrance Johnson)*, 1996, from *Passages from the Middle* series, chromed steel with chain, shovel, and other elements.

The Love Family Private Collection.
© The Love Family Private Collection

Photo: Lluvia Higuera

STEWART

heroic figures passing through the world, *Basquiat's Door* shows us the world passing through him. There is the face with nose and mouth made of rifle bolts; dreads made of industrial wire; a turning windowlike door at the top of the composition, near the crown, that opens and closes, showing us we can never be too confident that the way is open for us to proceed. The artist is still the warrior but more fully aware and equipped to deal with the world that is, a world of pain, yes, but also a world of hard-won beauty. *Basquiat's Door* also suggests that beauty has emerged from a new aesthetic flexibility in Ed; a multilayered visual experience suggests he wants us to walk around this sculpture and look deeply, with patience and care, at what stands between us and success.

By turning the hueman into a door, Ed reached a new level of abstraction that symbolized other transitions—the doorway to death, the door that keeps men and women from speaking truth to one another, the way that barriers do not bend because we are just and justice seeking. There is also exuberance to this piece, escaping sadness by equipping its now educated subject— Basquiat and us—with the tools we need to succeed. Although there is no broom to sweep away false ideas, there is a shovel to dig yourself out of the muck your incorrect ideas have led you into. Ultimately, studying this door, he hopes, gives us the tools to walk through it.

One of those tools for Ed was to forge aesthetic bonds through his sculpture with other artists he respected. Perhaps the greatest homage to collaboration is his sculpture *The Piano Lesson: Homage to Romare Bearden* (1994; figs. 18–19). What lessons does it have for us? It continues the lesson Ed imbibed from African sculpture: how to create sculpture three-dimensionally, perhaps taken to a higher level than in *Basquiat's Door*. Without a two-dimensional wall, *Piano Lesson* is a three-dimensional environment, floating in space rather than grounded heavily in place, offering visual surprises from every angle it is viewed. As the National Gallery of Art website tells us, "the central subject" in Romare Bearden's 1983 collage *Piano Lesson* "is thought to be jazz pianist Mary Lou Williams, who spent her childhood years in Pittsburgh. Just as Bearden's

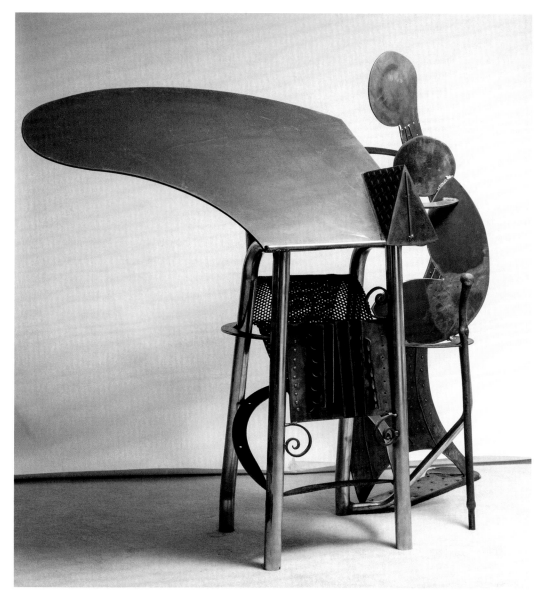

18–19. Ed Love, *The Piano Lesson: Homage to Romare Bearden*, 1994, chromed steel

The Love Family Private Collection.
© The Love Family Private Collection

Photo: Lluvia Higuera

20. Ed Love, *The Arc of the Good Ship Zong*, 1997, from *Passages from the Middle* series, chromed steel with chain

The Love Family Private Collection.
© The Love Family Private Collection

Photo: Lluvia Higuera

work was inspired by that of others in a variety of artistic fields, *Piano Lesson* inspired the play of the same title by playwright August Wilson, himself a Pittsburgh native."[30] Ed's sculpture is thus a discourse on the gendered nature of these transitions, as we see Mary Lou Williams teaching piano to a young child, passing on knowledge from one generation to another.

But Ed Love's sculpture also engages August Wilson's rendering of the theme in his play, which is less about the teaching of music than it is about the piano—as the embodiment of the history of a family that has come through slavery. In the play, a young man wants to sell the carved piano to buy property down south to get a new start in life, while his sister refuses to part with an heirloom that has the family's memories living within it. Wilson's play emphasized that the piano is the key, the history and destiny of a people that extends outward into the future, captured beautifully here in the sculpture by the way the piano lid seems to be moving out

into space. That Mary Lou Williams is teaching the lesson is suggested by the dress worn by the teacher, but even more, the energy with which this Black woman, one of the few successful jazz women pianists of the glory years of twentieth-century jazz, seems to cradle the young person leaning forward trying to learn to play. Indeed, the uncanny quality of the work is the way the figures and the piano seem to be moving in a dance to the music that comes from the piano. That is the fourth dimension, perhaps, caught by Ed in this sculpture—time, the sense of movement through space—which links all of these artists to a larger project of Black culture as a tradition to be handed down. Time is there in the composition, literally, in the metronome on the piano.[31]

The Piano Lesson also hints at how music functioned in Ed's sculptural practice. He played jazz music, especially Thelonious Monk, John Coltrane, and Ornette Coleman, in his studio not just to relax or enable his creative process but also to try and get the music into the sculpture. He succeeded beyond his norm here, as it seems we can hear cross-generational music coming out of *The Piano Lesson*. Jazz's knowledge now resides in Love's sculpture, as the family history resided in the piano in August Wilson's play.

Toward the end, Ed seemed to return to a Zen-like consciousness he had first explored while in the air force deployed in Japan. That acceptance of the passage that is everyone's journey into the middle of the earth was captured in a piece about one of the tragedies of the Atlantic slave trade's Middle Passage, *The Arc of the Good Ship Zong* (1997; fig. 20), which Ed constructed after reading about the notorious British vessel in my book *1001 Things Everyone Should Know about African American History*.[32] The captain of the ship had 122 Africans thrown into the sea to drown because he believed insurers would pay for dead but not sick slaves. The case became a tool for abolitionists to marshal opposition to the slave trade. Ed was moved by the way in which it symbolized the depths of inhumanity the slave trade embodied. Nevertheless, in this sculpture, he resists the tension to turn the story into visual agitprop. Indeed, rather than making a life-size slave ship, he reduces the ship to something diminutive: heavy, yes; awful, but not overblown. Something of a minimalism emerges in these late small sculptures, as if a counterpoint, spiritually, to the monumentalizing of earlier efforts. He also has reversed our notion of what the slave trade was by adorning the ship with pyramids. Rather than transporting bodies, the Atlantic slave trade transported culture, which survived the inhumanity of many a slave ship captain. Doomed as they were, those lost in the "passages from the middle" were trying to bring to the Americas a humane set of knowledges in art, music, science, mathematics, and philosophy that could, Locke and Love believed, bring freedom not just for Black people but for this Spaceship called Earth.

LOVING BLACKNESS:
JEFF DONALDSON IN WASHINGTON

Michael D. Harris

Taller than most men, Jeff Donaldson stood above the crowd in many ways, and his shadow still lingers. He died on a date that occurs only once every four years: February 29. While he lived, there was no doubt where he stood. My personal relationship with him as a graduate student, and then as a member of AfriCOBRA, from 1979 until his death in 2004, informs this essay. While offering glimpses into his personal outlook, my account explores Donaldson's intellectual and aesthetic evolution in Washington, DC, after he left Chicago.[1]

In 1970, when Donaldson became chair of the art department at Howard University, a seismic shift occurred, as though philosophical tectonic plates were moving. The more conventional Harlem Renaissance ideas of Howard art professors James A. Porter, James Lesesne Wells, and Lois Mailou Jones began to crumble. Perhaps the ideas of former Howard professor Alain Locke and his call in 1925 for African American artists to look to their ancestral heritage took on a bit more shine.[2] The tension of this shift may have been symbolically amplified by the legendary rift between Locke and the founding chair of the art department, James V. Herring. Their enmity was embodied by the oft-told story of Herring attending Locke's funeral in a white suit and muttering to his casket, "I told you I would outlive you!" before walking out.

Donaldson loved Blackness in the sense of bell hooks's 1992 essay "Loving Blackness as Political Resistance,"[3] where she argues, "In a white supremacist context 'loving Blackness' is rarely a political stance that is reflected in everyday life. When present it is deemed suspect, dangerous and threatening." hooks continues, suggesting:

> Racial integration in a social context where white supremacist systems are intact undermines marginal spaces of resistance by promoting the assumption that social equality can be attained without changes in the culture's attitudes about blackness and black people.[4]

Having grown up in the Jim Crow South in Pine Bluff, Arkansas, Donaldson learned models of resistance to white supremacy and violence from his own family. One story he enjoyed telling involved his mother responding to being called "aunt" by a white man. Donaldson recounted that she looked at this man slowly before replying: "I'm trying to see which of my sisters might be your mother."

Detail, fig. 9

During a video interview for the HistoryMakers Digital Archive of African American oral histories, Donaldson talked about his grandfather John Donaldson and the family's move from Alabama to Arkansas. First, he spoke of the legend of his grandfather killing a bear with two daggers in front of witnesses.[5] Donaldson continued:

> Later on, one of his sisters was assaulted and he and his brother took care of that guy, to the extent that he would never do that again. And the guy who had been his "owner"—quote, unquote—helped him to get out of Ar—Alabama. He and his brother. And they ended up in Arkansas. And his brother became a physician. Changed his name and became . . . a physician. But my grandfather didn't change his name and remained a farmer, kept the same name. He was a pretty tough guy.[6]

Donaldson moved from Chicago to Washington in 1970, after having participated in the conception and painting of the landmark outdoor mural in Chicago known as the *Wall of Respect* (1967); founding the Coalition of Black Revolutionary Artists, or COBRA, in 1968 (renamed AfriCOBRA the following year);[7] and then organizing the Conference on the Functional Aspects of Black Art (CONFABA) in 1970. The stated intention of AfriCOBRA was to create a community-based artist collective that reflected a unique Black aesthetic. Its principles were articulated in a manifesto, and the five founding members had doubled by the time of their two important Studio Museum in Harlem exhibitions *AfriCOBRA I* and *II* (1970 and 1971, respectively), both organized by Ed Spriggs, which gave them national attention (fig. 1).

In a 1970 essay, "Ten in Search of a Nation," Donaldson presented what might be considered an addendum to the AfriCOBRA manifesto:

> Our people are our standard for excellence. We strive for images inspired by African people—experience and images that African people can relate to directly without formal art training and/or experience. Art for people and not for critics whose peopleness is questionable. We try to create images that appeal to the senses—not to the intellect.[8]

In that essay and elsewhere, Donaldson listed a number of specific formal qualities, or principles, including shine, symmetry, and mimesis at midpoint, which acted as both guide to and explanation of the Black aesthetic that AfriCOBRA sought to create and visually articulate. One principle, shine, opened the list and informed the entire project:

> We want the things to shine, to have the rich luster of a just-washed 'Fro, of spit-shined shoes, of de-ashened elbows and knees and noses. The Shine who escaped the Titanic, the "li'l light of mine," patent leather, Dixie Peach, Bar-BQ, fried fish, cars, *ad shineum*![9]

Importantly, the essay was not an appeal for inclusion, acceptance, integration, or absorption into modernist notions of artists as individuals all alike in aesthetic expressiveness, following the historic argument of early African American art scholar James Porter, among others.[10] As was the case for most premodern African art, the work was doing something; it was a verb instead of a noun and connected to the communal experience. Robert Farris Thompson says, "Theories make sense of collisions of culture, ancient to modern. But the lived experiences of African and African American artists provide sources for understanding too." He continues:

1. Brochure for *AfriCOBRA I: Ten in Search of a Nation*, Studio Museum in Harlem, 1970

Collection of David Lusenhop

[T]heir lived experiences are equals to any ideology, anytime. Lived experiences stem from the people, choice memories of improvisation, choice memories of moral decision. They radiate common sense.[11]

So the response to differing experiences is interpreted, whether consciously or not, through the cultural syntax of African precolonial foundations and their rootedness in a spiritualized or inflected reality. Donaldson brought an aesthetic sensibility rooted in cultural practices that he experienced in Arkansas and Chicago and expanded into a larger vision of African epistemological and ontological modalities that suspended the impulse to pursue a mainstream (Eurocentric) artistic aspiration. Though he did not articulate it publicly, philosophically Donaldson chose Locke's idea of looking to his ancestral legacy—his African heritage and stylistic and cultural continuities—as an inspiration rather than seeking the validation of the larger society and art world of Eurocentric cultural production, which was at the heart of Howard University's curriculum before he arrived. He used his own painting and followed an aesthetic progression along a philosophical trajectory from resistance in Arkansas to community in Chicago to rhizomatic TransAfrican articulation in Washington. As his experience enlarged, so did his ideas and subject matter.

Perhaps as a way of validating his work's basis in Black lived experience, Donaldson liked to talk about how he showed his work, early in his career, in a lounge space in Chicago. Anonymously, he asked a patron sitting near him at the bar what he thought about the art on display. Donaldson proudly imitated the patron by stating, "Oh, we always could do that!" Art

to him and to AfriCOBRA was art with considerations of virtuosity and technique, but also dialogue with the Black masses, embedded in Black culture. It emerged from the experience of what Elizabeth Alexander calls the Black interior and the kinds of expression emerging from it. Rather than being trapped in the dynamics of race, Donaldson's perspective embraced the complexities of culture as an epistemological frame modified by experience. Alexander defines these interior spaces as "Black life and creativity behind the public face of stereotype and limited imaginations. The Black interior is a metaphysical space beyond the Black public everyday toward power and wild imagination that Black people ourselves know we possess but need to be reminded of." She suggests that tapping into this Black imaginary "helps us envision what we are not meant to envision: complex Black selves, real and enactable Black power, rampant and unfetishized Black beauty."[12]

Though aesthetic values and styles from Chicago's Black community had been incorporated into the AfriCOBRA manifesto, Donaldson, who was educated in African and African American art at Northwestern University and studied with eminent Yoruba and African art scholar Frank Willett, very early introduced Yoruba ideas, elements, and aesthetic references into his work and into AfriCOBRA. His painting *Wives of Shango* (1969), translated from a photograph of three women, transformed the subjects into both revolutionary agents and Yoruba icons (fig. 2). The women, each adorned with bandoliers of bullets, bushy Afros, and defiant expressions, are color coded in their dress to refer to the Yoruba *orisha* Oya, Oba, and Oshun. Their dress implies the activism and ideas of self-defense found in the words of Malcolm X and the Black Panther Party, active in the Chicago community.

Tuliza Fleming points out that Donaldson was also informed by Frantz Fanon's interpretation of the Black community as the equivalent of a colonized entity. She cites Fanon's argument that "the native man [or, as Donaldson interpreted it, artist] who writes for his people ought to use the past with the intention of opening the future, as an invitation to action and a basis for hope."[13] Fleming suggests that the diversity of character and personality embodied by the three *orisha* represent a principle of Fanon "that all Black people throughout the world, regardless of cultural differences, are connected through their struggle to liberate themselves from white oppression" and that this work presents a "symbolic unification of religious and ideological differences."[14] This might offer a glimpse into the "TransAfrican" ideas Donaldson began writing about during the late 1970s and kept promoting until the end of his life.

The term "TransAfrican" seems to have been a rearticulation of the larger global sense that Donaldson developed, which led to the embedding of Yoruba iconography and symbols in his paintings at the end of the 1960s, and later modified by exposure to international artists and communities once he moved to Washington. Donaldson first used the term in an essay published in *Black Collegian* in 1980,[15] and he reiterated it a final time in his essay for the catalog accompanying a Kerry James Marshall exhibition in Chicago in 2003. Donaldson chose to quote Locke for the epigraph of his essay:

> Between Africa and America, the Negro . . . has practically reversed himself. In his homeland, his dominant acts were the decorative and craft arts—sculpture, metal-working, weaving, etc. But in America, the interpretative emotion arts have been the Negro's chief forte, because his chief artistic expression has been in music, dance (pantomime), and folk poetry . . . the only channels left open.[16]

In May 1970 Donaldson organized the previously mentioned CONFABA at Northwestern University. The conference materials state:

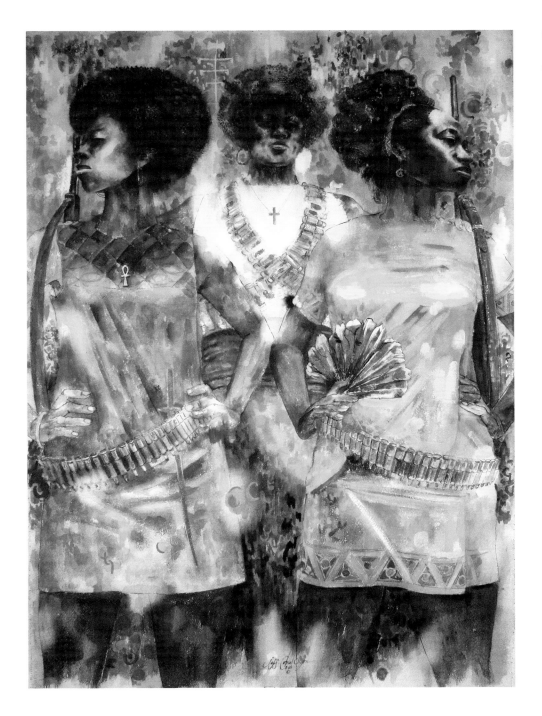

2. Jeff Donaldson, *Wives of Shango*, 1969, mixed media

Courtesy the artist and Kravets Wehby Gallery

When we addressed ourselves to the problem of the function of art, it was explicit that the function of art is to liberate man in the spiritual sense of the word, to provide more INTERNAL space. . . .

The heart of the Black Artist's ideology is the dedication of his art to the cultural liberation of his people. It is in this sense that Black art is decidedly functional, politically and spiritually, and it is not to be confused by the alienation[alienating?] concept of "art for art's sake" rather than art for people's sake.[17]

Barred from attending the conference by the US State Department, Elizabeth Catlett gave a telephone presentation (which Jeff Donaldson had taped) from her home in Mexico.[18] Among those in attendance were Margaret Burroughs, Aaron Douglas, Sylvia Boone, Larry Neal, Samella Lewis, Nelson Stevens, Ethiopian artist Skunder Boghossian, the members of AfriCOBRA, A. B. Spellman, Edmund Barry Gaither, Charles White, Sterling Stuckey, Dana Chandler, John Biggers, Lois Mailou Jones, Hughie Lee-Smith, Ed Spriggs, Floyd Coleman, Bernice Reagon, and David Driskell.[19] In 2003 Donaldson spoke about CONFABA, confirming the continuity of his outlook:

> You had musicians. You had political people. You had dramatists. Ron Walters was there. You had political focus to the whole thing. Gerald McWhorter was there. Larry Neal was there. That was the first time I met Jon Lockard. . . . Jon becomes important [because] wherever Jon went, he had a handful of students that he brought along with him. When we talk about "where do we go from here?" Jon has been doing that stuff ever since I've known him.[20]

Washington catalyzed a deeper, more African-based consciousness and sense of purpose in Donaldson. He had been able to build a community-conscious movement in Chicago, but his Pan-African, or Black Atlantic, outlook grew into a global consciousness (and web of relations) once he assumed the chair of the department of art and the directorship of the Howard University Gallery of Art in the fall of 1970. With Howard students protesting for a Black-centered curriculum in 1968 and the Washington uprising that followed the assassination of Rev. Dr. Martin Luther King Jr. that same year, the campus and the city supplied Donaldson with a nexus of things happening at the right time, even the wrong things, that turned his arrival at Howard that fall of 1970 into a moment of transformation. Donaldson entered a hothouse of Black consciousness among the students.

Current AfriCOBRA member Akili Ron Anderson and Chicago artist Joyce Owens joined the 1968 student protests at Howard. They received the support of new, young professors, such as Ed Love, Paul Carter Harrison, writer in residence Haki Madhubuti, and Acklyn Lynch (of Trinidadian birth). The students took over the fine arts building to protest the conservative curriculum and its Eurocentric foundations.[21] Anderson remembers that the arts program leaned toward integration and mainstream interest in music, theater, and visual art. Harrison said that he left Howard after the chair of the theater program told him that his shift from presenting five classic white-authored plays per year to three Black-authored plays could go no further and having five Black-authored plays produced in a year was not going to be tolerated. He transferred to the program at the University of Massachusetts Amherst when Lynch, who also left around 1970, helped organize the gathering of art, music, theater, and writing innovators there.[22]

When Donaldson had come to campus to interview for the job as chair of the art department, it was part of the shift toward an Afrocentric perspective and curriculum being pushed by the students. Shortly after he joined the faculty, jazz musician Donald Byrd came on board to teach music and, according to Anderson, a more unified arts front developed. Howard University had been pushed by the events of 1968 and the global awakening of Black consciousness among students toward a more African-centered vision in the arts. With students and new faculty members all leaning in the direction of an African-based consciousness of art and art instruction, Donaldson was buoyed by an emerging culture in the department he was asked to lead.

Donaldson often acknowledged the force of elements unspoken, unseen, or behind the scenes in his descriptions of events, as if he credited an invisible destiny that steered his fortunes and his career. If we listen carefully to his description of events and the fallout from the Wall

3. Brochure for *AfriCOBRA III*, University of Massachusetts Amherst, 1973

Collection of David Lusenhop

of Respect project during his video interview for the HistoryMakers project, he understood his hiring to run a previously conservative art department at Howard as the result of a confluence of political and spiritual forces. He spoke about J. Edgar Hoover's Cointelpro (Counterintelligence Program) and how it fragmented the Organization of Black American Culture (OBAC) arts collective in Chicago from which the *Wall of Respect* emerged:

> And what happened after that was really bizarre because all the—just about all the people that I've been mentioning were offered jobs someplace else. All the whole AACM went to New York. . . . I was offered a job here at Howard [University] and when I got here, I got a call from somebody who didn't identify themselves who said, "Are you satisfied now? And will you keep your big mouth shut? (pause) Do you like your job? You're making a lot of money? You got a good position?"[23]

James Phillips, a current faculty member at Howard University and a member of AfriCOBRA since the early 1970s, recalled hearing that Donaldson purged most of the white faculty from the art department once he arrived. He was instrumental in hiring Ethiopian Armenian painter Alexander "Skunder" Boghossian, and subsequently Phillips, as artist-in-residence. Phillips says that Donaldson became familiar with his work upon seeing it at the Studio Museum in Harlem in 1971 during an exhibition of the New York art collective Weusi, to which he belonged. Donaldson hired Tritobia Benjamin (who had attended CONFABA) and Ghanaian scholar Kojo Fosu to teach African American and African art history and added Winnie Owens-Hart to teach ceramics. Additionally, he brought in current or soon-to-be AfriCOBRA members Wadsworth Jarrell (who moved from Chicago) and Frank Smith (who moved from New York) to join the faculty. He tried to hire Nelson Stevens, but administrative delays caused Stevens instead to join the faculty at the University of Massachusetts Amherst, along with playwright Paul Carter Harrison and musicians Archie Shepp and Max Roach, among others, in that university's newly formed African American studies program (fig. 3).[24]

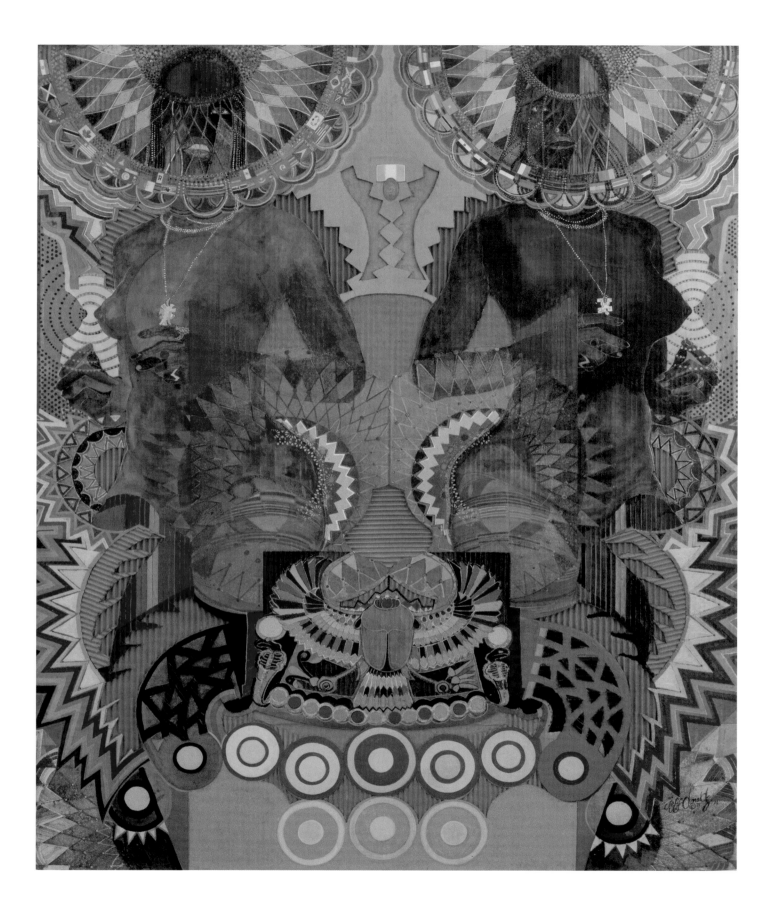

The combination of Donaldson's move to Washington, the aesthetic ideas and energy of Phillips, and the increasing focus on African ideas and imagery in the department shifted AfriCOBRA's aesthetic and imagery. The art became more abstract, perspective and space flattened, and canvases exploded with patterns and symbols. Contemporary African artists such as Boghossian influenced the work of AfriCOBRA artists as well as Donaldson's role as director of the US and Canada participation in the Second World Black and African Festival of Arts and Culture (FESTAC) in Lagos, Nigeria, in 1977.[25] A shift in focus toward African cultures, histories, aesthetic ideas, and use of symbols for AfriCOBRA and in Donaldson's own work took place at the same time that Howard University's art department welcomed Al Smith, Ed Sorrells-Adewale, and Owens-Hart and their focus on African cultural expression and the African diaspora. Two years after FESTAC, Owens-Hart returned to Nigeria for a year to study traditional pottery-making with the women of a small village near Ile-Ife, called Ipetumodu, while she taught at Obafemi Awolowo University in Ile-Ife.[26] The figure remained significant in the work of Stevens, Jarrell, Donaldson, and Gerald Williams, but now fused with African symbols and iconography it revealed a reality deeper than appearance for Black people that could be accessed through TransAfrican art.[27]

By the end of the 1970s, Donaldson's work had flattened the picture plane, eliminated any hints of perspective space, and gravitated toward symbolic imagery with a focus on African and African diaspora issues and perspectives. *Majorities*, a work formerly called *Afro Diaspo* (1977; fig. 4), is organized around two mirror-imaged women of African descent emerging from an Egyptian symbol and a series of circular or curved patterns with their heads framed by semicircles containing emblems of Black African nations on the right and majority Black populations in the Black Atlantic on the left. Textures and a spatial sense are derived from the corrugated cardboard interiors laid open in areas of the work, turning them from empty to variegated spaces. In the 1986 sketch made in preparation for turning the work into a serigraph (fig. 5), Donaldson calls it *Two for Cheikh*, possibly a nod to Senegalese scholar Cheikh Anta Diop, with whom he was photographed in 1975 while visiting Senegal. The sketch also reveals the design for a cat face embedded in the patterns of the work and not easily visible in the painting; the image of the winged scarab beetle becomes a necklace for the feline. His notations explain the symbolic imagery in the work and the significance of the flags, which indicate that "the sun never sets on the sons/daughters of Africa," an ironic re-rendering of the saying describing the global rule of the British empire.

Donaldson repeatedly returned to the notion of TransAfrican art, though his written descriptions of the concept are at times a bit vague.[28] His final iteration of the term was "TransAfrican art, a term that reflects the Pan-African perspective, the international scope, the non-African influences, and the dynamic progression of the style since the 1960s."[29] I interpret his intent (in a reading buttressed by personal conversations with him over the years) as similar to what Martinique scholar Édouard Glissant described as "rhizomatic thought." Glissant, an intellectual successor to negritude writer Aimé Césaire, also from Martinique, wrote of the rhizome root system when thinking about exile, a condition of early African descendants in both the Antilles and the United States. Glissant describes the rhizome as a resistant root system,

> a network spreading either in the ground or in the air, with no predatory roots taking over permanently. The notion of the rhizome maintains, therefore, the idea of rootedness but challenges that of a totalitarian root. Rhizomatic thought is the principle behind what I call the Poetics of Relation, in which each and every identity is extended through a relationship with the Other.[30]

Courtesy the artist and Kravets Wehby Gallery

5. Jeff Donaldson, sketch
for serigraph *Two for
Cheikh*, 1986

Collection of David Lusenhop

TransAfrican art simultaneously rooted and connected African diasporic peoples through symbolic form. Donaldson seemed to find this visual "poetics of relation" more palpable in the in-betweenness of French and African languages and forms. He spoke French fluently, perhaps from his time in France during his army service in the 1950s; from having studied French for the foreign-language requirements of his PhD; and from his early affinity for the work of Fanon. French also helped him advance his curatorial vision in AfriCOBRA. In 1987 he arranged for an AfriCOBRA exhibition in Fort-de-France, Martinique, and two years later brought the artist collective Groupe Fromajé from Martinique to exhibit alongside AfriCOBRA in the Howard University Gallery of Art. In his 1992 essay on TransAfrican art, Donaldson wrote about both groups and mentioned Groupe Bogolan Kasobané of Mali as examples of TransAfrican style producing "art which reflects social responsibility and technical skill . . . [in] works [that] clearly derive from the artists' immediate environment while maintaining a universal Africentric ambiance."[31] It is only in retrospect that I am struck by the large presence of Francophone thinkers and outlooks in Donaldson's ideas.

Donaldson was suggesting that a common root system underlay creative expression of the Black Atlantic world, a cultural logic that connected the varied local manifestations of Black culture from Lagos to Chicago to Salvador, Bahia. Historian Ras Michael Brown found BaKongo ideas and words in South Carolina Low Country histories as a means to maintain cultural continuities as well as spiritual and ancestral relationships, in their new, displaced

settings. Similarly, Donaldson injected Yoruba ideas into New World contemporary creative settings with works like *Wives of Shango*. Brown says that the range of what Kongo people did anywhere shows the potential of what they could have done everywhere. He also suggests that culture must be multigenerational.[32] This idea leads back to the ancestor and Africans displaced from Kongo attempting to relocate their ancestors, spirits, and relationship to the earth in the South Carolina Low Country during their enslavement, leading to the translation of the Central African BaKongo *simbi* spirit into *cymbee*.[33] For generations, African people in the diaspora have tried to apply old-world ideas, practices, words, symbols, and gestures to uses in their new circumstances. It became, in some ways, the use of an African cultural syntax for their new cultural and geographical lexicon.

This logic of shifting toward an African worldview expressed in creative variation is wonderfully articulated by Clyde Taylor in his 1982 essay "Salt Peanuts." Taylor argues that "the influence of Africa in African American oral culture must . . . be extricated from restrictive categories of Western thought." The rich improvisation of African oral communication and gesture needed to elude "the tendency of writing to fix or freeze speech has in the West extended toward the universe of human discourse itself." He continues: "These biases have made it difficult to understand how Africans in the Diaspora transmuted African oral tradition while no longer speaking African languages. . . . [T]he major linguistic transmissions from Africa were probably not words at all."[34] Imitation and emulation and a desire for inclusion in European modes of creativity and culture, in this sense, deny and disconnect those cultural gestures, intonations, and practices Donaldson and AfriCOBRA sought to tie into in Chicago, and expand upon once in Washington.

Taylor points out the tension and contention in the African and European cultural encounter and the motivation among the displaced Africans for retention and recovery:

> We find a driving search for forms of spiritual and human expression that could withstand the alienation of modern industrial culture and its inclination to transform human relations into commodity relations. Where the modernist ransacked every known past culture for esthetic and spiritual values in support of their mission, the quest of the Africans was more strictly directed towards the mainstays of their humanity that had been left behind in Africa.[35]

Representing creative, creolized fluidity, very early in his career Donaldson presented from his collection a Yoruba Gẹ̀lẹ̀dẹ́ mask wearing sunglasses as a symbol for AfriCOBRA (fig. 6). It appeared in the Studio Museum in Harlem 1970 exhibition brochure. This image would qualify as what Taylor called a "mythogram," "a visual symbolization in abbreviated form of familiar, traditional ritual and myth. In its concentrated form, such a sign would serve to reactivate mentally an entire myth and its appropriate ritualistic celebration, dance, music, sacrifice, and feast."[36] This symbol is consistent with Donaldson's ideas about visual expression as nonverbal communication. The sunglasses add a diasporic facet to the cultural iconography of the mask. In a 1988 interview with the author, he said, "I think [in] what we see as African art, there exists a whole system of communications that was sometimes graphic, and sometimes strictly oral."[37] We talked about the Gẹ̀lẹ̀dẹ́ mask and ceremony and Henry and Margaret Drewal's research on the subject:

> Everybody before [the Drewals] had said that Gẹ̀lẹ̀dẹ́ is for entertainment. The Gẹ̀lẹ̀dẹ́ mask is entertainment where men imitate and burlesque the gestures of women. [The Drewals] looked deeper and . . . discovered that Gẹ̀lẹ̀dẹ́, rather than being for entertainment, establishes a code of conduct that people should follow.[38]

6. Jeff Donaldson, Yoruba Gẹlẹdẹ mask for AfriCOBRA, c. 1980

Collection of David Lusenhop

As a mythogram, the Gẹlẹdẹ mask signifies, with ritual suggestion, the cultural and social intentions of AfriCOBRA, as well as the concentrated language of the use of symbols and gestures in the imagery of the group. It suggests that colorful or entertaining expression can convey serious ethics and meaningful codes beneath the spectacle.

In the early 1970s Donaldson's articulation of African implements, references, and symbolic colors with African American figures emerged from works such as *Wives of Shango*, where Africa appears as both adornment and TransAfrican rootedness. Donaldson's *Victory in the Valley of Eshu* (1971) prepared the ground for this more powerful articulation of the Africanness of Blackness with his picture of an elderly African American couple. The composition echoed the earnest couple in Grant Wood's *American Gothic* (1930), but Donaldson's version showed a male figure holding a Shango double-headed axe. Still, as with *Wives of Shango*, also from 1969, African Americans were depicted in clothing of the time with a few African elements deployed in the image and titles referring to Yoruba *orisha*. The figural images are natural in their roundness of form, though their spatial backgrounds are not distinct or emphasized. In *Wives*, a small symbol between the left and center heads suggests the metal staff of Osanyin, the *orisha* of healing. To the right there seems to be an image of a crowd of people in the distance. In both 1969 images, one of the women wears a necklace with an ankh symbol from Egypt, an image of life.

At the end of the 1970s, however, the transformation in Donaldson's art and cultural politics was complete. After FESTAC, Donaldson and AfriCOBRA were invited to exhibit at the United Nations, sealing the shift from Chicago's Black community, symbolized by the *Wall of Respect* mural at 43rd Street and Langley Avenue on the South Side, to a larger, global focus in line with Donaldson's TransAfrican ideas and the increased interaction available in Washington with artists, scholars, and people from Africa and throughout the African diaspora.

In 1979 Donaldson received a letter of invitation for the UN exhibition at the request of the Special Committee against Apartheid to commemorate the Soweto Massacre of 1976 (figs. 7 and 8). For that event, AfriCOBRA developed the theme So-We-Too to suggest African American solidarity with their struggle. Everyone in the group created a work from that theme, some using a limited palette with colors related to the land or the minerals in the land to reinforce the idea that the battle against apartheid and the liberation struggles in Angola, Mozambique, South Africa, and Zimbabwe were struggles for control of the land.[39] This theme extended for a time into a new name for AfriCOBRA going into the UN exhibition: AfriCOBRA/Farafindugu, adding a Malinke word suggesting a commitment to brotherhood and to the land.[40] In a statement at the time of the invitation, Donaldson wrote that AfriCOBRA "has consistently expressed, through visual arts, its solidarity with the Southern Africa liberation struggles, and has fostered the development of an Afro-American aesthetic which places the reunification of African people at the center of its focus."[41]

By the end of the 1980s, we can see how Donaldson's aesthetic ideas, African knowledge and experiences, and various artistic associations had moved from his more narrative explorations

7. David M. Sibeko, letter to Jeff Donaldson inviting AfriCOBRA to exhibit at the United Nations, June 4, 1979

Collection of David Lusenhop. Photo: Michael D. Harris

Pan Africanist Congress of Azania

Observer Mission to the United Nations

211 East 43rd Street
Suite 506
New York, NY 10017
Tel. (212) 986-7378

June 4, 1979

Jeff R. Donaldson, Ph.D.
Convenor
Africobra
Washington, D.C. 20001

Dear Brother Donaldson:

It was agreed by the United Nations Special Committee Against Apartheid at a meeting today to invite Africobra to come and display your works on Soweto on June 15 1979 during the Special Committee's solemn meeting to mark the International Day of Solidarity with the People of South Africa.

The works will be displayed inside the chamber where the meeting will be held at the UN. Arrangements for the issue of a press release to announce this feature of the Soweto Day commemoration activities at the UN will be made. Further the committee on exhibitions will be invited to review the work so that they may make a decision on the staging of an even bigger exhibition during the next General Assembly session of the UN which begins in September.

I sincerely look forward to seeing you on or about the 15th of June. In the meantime please send whatever press comments and other publicity material written specifically about your Soweto paintings and about Africobra's other work. Address these directly to:

 Mr. E.S. Reddy, Director
 Center Against Apartheid
 United Nations
 New York, N.Y. 10017

Send us a copy and do mention to Mr. Reddy that this is a follow-up of a discussion on this project, after it had been raised in today's meeting.

With warm fraternal greetings,

 Your brother always,

 David M. Sibeko
 Director of Foreign Affairs

of 1969. *One for Bear Den* (1991; fig. 9) is a tribute to Romare Bearden, who was Donaldson's adjunct thesis advisor during his dissertation work at Northwestern University. I have a video from a 1987 AfriCOBRA meeting in Donaldson's home and studio in Washington, where he explains some of the symbols in the work:

[I used] Egyptian hieratic lettering, and because the piece is dedicated to Romare Bearden, the piece is called, *Well, Play One for the Bear Den.* Romey was trained as a mathematician. So that's why it's there. It also, in my mind, does something visually in terms of the expression that comes from a musical instrument. Not to try to create notes but to create some kind of rhythmic pattern, or scheme, that deals with form. I also took that from Egypt as well as the woman [*inaudible*] from a tomb. And then from West Africa, the symbol here is one of the Adinkra

8. AfriCOBRA at the United Nations, New York, June 20, 1980; Donaldson's work is pictured at the far right corner

Collection of David Lusenhop

symbols from the Ashanti. This, as you know [*points to the pattern imposed on the woman's seat*], is from the BaKuba from Kongo. Of course, these [*pointing to the repeated papyrus symbols across the bottom*] come from Egypt again. And this [*points to the base area of the harp*] was inspired by the architecture of the Ndebele women of South Africa. So, what I tried to do is square the continent.[42]

The central figure as well as the harp were inspired by dynastic Egyptian imagery, and Ethiopian Amharic script flows across the top of the painting. The image is organized with horizontal rectangles at the top and a larger vertical rectangle framing the center and containing the figure. As had become the case with a good deal of AfriCOBRA work, once Frank Smith and James Phillips joined the group while at Howard in the mid-1970s, the picture plane flattened into a pattern-dominated space with foreground and background merging in syncopated relationships organized by forms, linear shapes and patterns, and color play unrelated to natural visual imagery or the use of chiaroscuro to solidify figural forms.

Phillips's *Flowers for Jeff* (2007; fig. 10) echoes and rhymes with *One for Bear Den*, both with pattern and floral symbols, as well as having a similar spatial organization, with two horizontal rectangles and one large vertical rectangle. Both paintings merge the foreground and background forms, symbols, and patterns, turning the surfaces into cloth-like sheets. Donaldson occasionally referred to the density of John Coltrane's late music performances and recordings as being like sheets of sound. He also linked that expression to the term *horror vacui* (fear of the void),[43] as an approach that was not present in AfriCOBRA work, particularly with the aesthetic turn away from more narrative imagery once the group, and he, were firmly

9. Jeff Donaldson, *One for Bear Den*, 1991, acrylic on canvas

Courtesy the artist and Kravets Wehby Gallery

established in Washington and the membership reconfigured. This approach, as had been the case for abstract expressionist painters, undermined the separation of figure/foreground from background, filling the picture plane with imagery and activity instead of pictorial illusion. Both Phillips and Donaldson use the figure as a point of departure, and, interestingly, the artistic elements of their imagery seem aligned despite the differences between the pictorial elements that each uses. Formally, images embed in and emerge from the painted surface. Donaldson and Phillips use carefully crafted shapes and patterns rather than painterly gestures accumulated on the surface. A mastery of painting is at the base of their works, manifested through the unique voice of each.

The stated thrust of Donaldson's aesthetic formulation is a combined technical excellence and a TransAfrican liberationist perspective. His work resists the modernist idea of art for art's sake (*l'art pour l'art*)[44] and expressively states the counter-notion of "art for people's sake."[45] This is important because it articulates a cultural view that leans toward a relational rather than an individualistic emphasis. Throughout his artistic and intellectual life, Donaldson worked toward and spoke about active, communal, and ancestral rooted art practice based inside the larger African experience both culturally and historically. This outlook functions as resistance to the worldview within which racism and slavery and white supremacy could function.

Donaldson's love of Blackness/Africanness grounded in his family history and resistance to oppression in the South informed his philosophical and political outlook for the rest of his life. He stated in an interview about the formation of AfriCOBRA:

> We don't accept the whole notion of being a victim of anything. We think that's demeaning. We think we are the masters of our own fate. So, the first thing we did was come together to see if there were any things we were all doing already in the work that would pull us together if we emphasized those things. We found a few of those things but then we decided that we really needed to do a lot of research on Africa and tried to do things that reflected that Afrocentric mode of expression. . . . Our American heritage is as significant as the African heritage.[46]

The unexplained aspect of the TransAfrican idea is, perhaps, an epistemological and ontological frame affecting how people of African cultural foundations experience and organize and articulate the world. It is here we find Robert Farris Thompson's idea that expression emerges from lived experience: "Lived experiences stem from the people, choice memories of improvisation, choice memories of moral decision."[47] It is phenomenological.

It is here where we find ourselves inside the Black Interior of Alexander and imagining Donaldson's expression of Shine as "patent leather, Dixie Peach, Bar-BQ, fried fish, cars . . ."[48]

It is here where we find Clyde Taylor's ideas of semantic, cultural, and spiritual retention or recovery of African fluidity.

It is here where we find the idiomatic aspects of African languages approximated with symbols and metaphors embedded like beads in the lives of people in the African diaspora.

In Washington, beginning in 1970, Jeff Donaldson found the space to evolve his outlook intellectually and aesthetically into a theory and practice of Black Atlantic continuities. Howard University offered the chance to try to realize and institutionalize his outlook. With the rhizomatic idea of rootedness and freedom from dominating narratives, it is here for awhile that a loving vision of Africans and their descendants was creatively celebrated through the force of personality. The experiment began with the *Wall of Respect* in Chicago and the subsequent founding of AfriCOBRA, and it found maturity in Washington.

In his life, in his art, in his aesthetic outlook, in his political and philosophical writing and expression, Jeff Donaldson consistently expressed his love of Blackness and African heritage. He practiced this in his art and writing, in his travel to Africa, and in choosing to work at Howard University, a Black institution of higher education. He attempted to institutionalize the study and appreciation of creative expression based in the lives of Black people globally. He did not often express anger and disdain for whites or take a position of Black victimhood, but often spoke of Black strength and beauty. And he loved being in witness and service to that. He loved saying, "Oh, we always could do that." And he did. From Arkansas to Chicago to Washington, he grew that fundamental, but the kernel was the same: Black love.

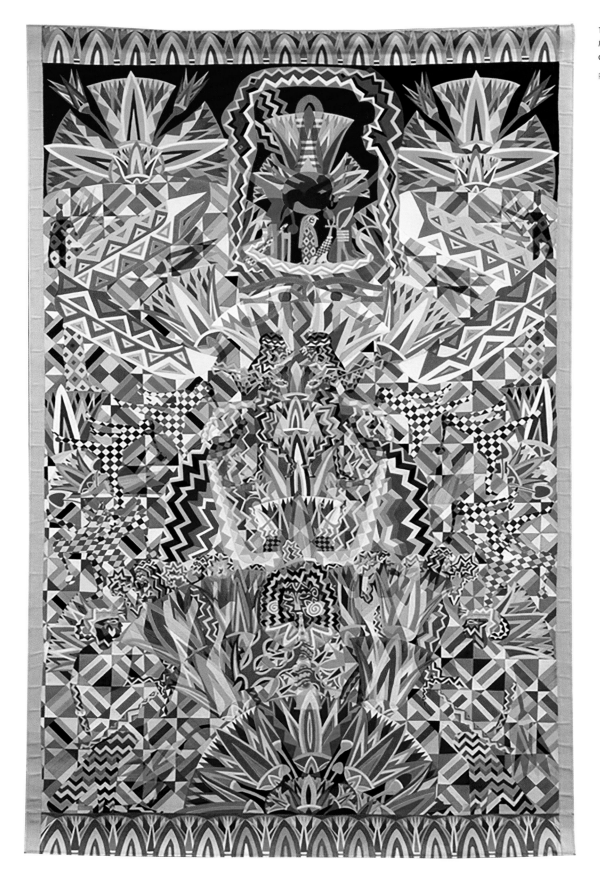

10. James Phillips, *Flowers for Jeff*, 2007, acrylic on canvas

Private collection

A CHOCOLATE CITY RECONSIDERED

Dedicated to David C. Driskell

Richard J. Powell

In 1975 the band Parliament recorded and released the album *Chocolate City* (fig. 1), a musical tribute to Washington, DC, the nation's capital *and* a predominately African American city. The album and title track took its name from the trope that had been colloquially used since the early 1970s, especially on Black AM radio stations in Washington to describe the District. Bobby "The Mighty Burner" Bennett, who was a DJ on WOL-AM, told the *Washington Post* that Chocolate City was "the expression of DC's classy funk and confident blackness."[1]

Parliament's "Chocolate City" (1975) has a mid-tempo, hard-disco funk beat with tight horn charts, an elastic bass, and an extended narrative track that begins with the unforgettable lines

> *Uh, what's happening CC?*
> *They still call it the White House*
> *But that's a temporary condition, too*
> *Can you dig it, CC?*

Although not as commercially successful as subsequent Parliament recordings, such as "Flash Light" and "Aqua Boogie," "Chocolate City" especially touched a deep, personal chord with the District's citizens not only by acknowledging their demographic distinction but also by referring to the city's cultural offerings and their broad national appeal.[2]

More or less coinciding with the release of *Chocolate City*, African Americans nationwide were beginning to recognize Washington's large Black population and increased national importance. In the March 1977 issue of *Essence*, the popular Black women's fashion and lifestyle magazine, a special multipage spread titled "Ease and Elegance" touted the District's growing significance and the many Black women, like *Washington Post* reporter Dorothy Gilliam and university professor and literary critic Eleanor W. Traylor, who contributed to its growing renown (fig. 2). "Washington is really two cities," the *Essence* article observed. "There is official Washington: the Washington of the capitol, the White House and picture postcard monuments; and there is Washington the city; the real Washington, over 75 percent Black with a Black municipal government—'Chocolate City.' . . . There's new energy revving up the nation's capital these days, a wind of change blowing through musty corridors."[3]

Detail, fig. 12

1. Album cover of Parliament,
Chocolate City (Casablanca, 1975)

Courtesy Republic Records and
Universal Music Group

What resided behind the playful banter and alluring rhythms in the song "Chocolate City" was an observation about a recent cultural sea change in a too-often-overlooked location in Black America. Premiering only a few months before America's bicentennial celebrations, "Chocolate City" heralded Washington as a Black capital whose status among other destinations in Black America had been steadily growing and solidifying over the years despite flying under the radar of many cultural critics and commentators. And clearly the myopia was triggered by racism—even at this auspicious, post-civil rights moment—and its insidious way of making what is front, center, and *Black* disappear.

Although "Chocolate City" called out Washington as a contemporary Black city, the reality was that, as early as the beginning of the twentieth century, the District had a large Black population, and, as early as 1957, African Americans in DC had surpassed the 50 percent threshold, making it the first large US city with a Black majority. With many whites fleeing to the Virginia and Maryland suburbs and many Blacks moving to the District in search of jobs in the rapidly expanding federal government, by the 1960s Washington's infamy as a bastion of segregation was rapidly disassembling, although there were still barriers to overcome in the areas of housing, education, economic opportunities, and voting rights.[4]

As the District's Black demographic grew, a confluence of events in the 1960s and early 1970s set the stage for Parliament's audacious musical decree of 1975. In 1961 Congress ratified the Twenty-Third Amendment, extending to DC residents the right to vote in presidential elections. Although the August 1963 March on Washington was an event of momentous proportions, it also had a profound psychological impact on and symbolism for the local African American population in the District.[5] Then came President Lyndon Johnson's decision in 1967 to replace the three-member board of commissioners that had run the capital since 1871 with a nine-member city council and an appointed "mayor-commissioner," who was the seasoned civil servant Walter E. Washington.

As the first African American mayor of a major American city, Walter Washington soon faced a huge crisis in DC with the riots of April 1968 following the assassination of the Rev. Dr. Martin Luther King Jr. The five days and four nights of rioting resulted in twelve deaths, thousands of people injured and arrested, and losses of property and potential business earnings estimated at more than one hundred million dollars. Nonetheless, autonomy for the District advanced. In the early 1970s two federal acts—the District of Columbia Delegate Act (1970) and the Home Rule Act (1973)—inspired Black Washingtonians to dream even bigger dreams, including to elect a Black mayor (which, with the already ensconced Walter Washington on the ballot, officially happened in 1975) and to attain full US Senate and House representation (which has yet to be achieved). This political momentum propelled local aspirations for Washington to become America's Black cultural center.[6]

"A chocolate city is no dream," Parliament asserted toward the end of its song, after advancing a litany of Black entertainers and cultural figures, including James Brown, Muhammad Ali,

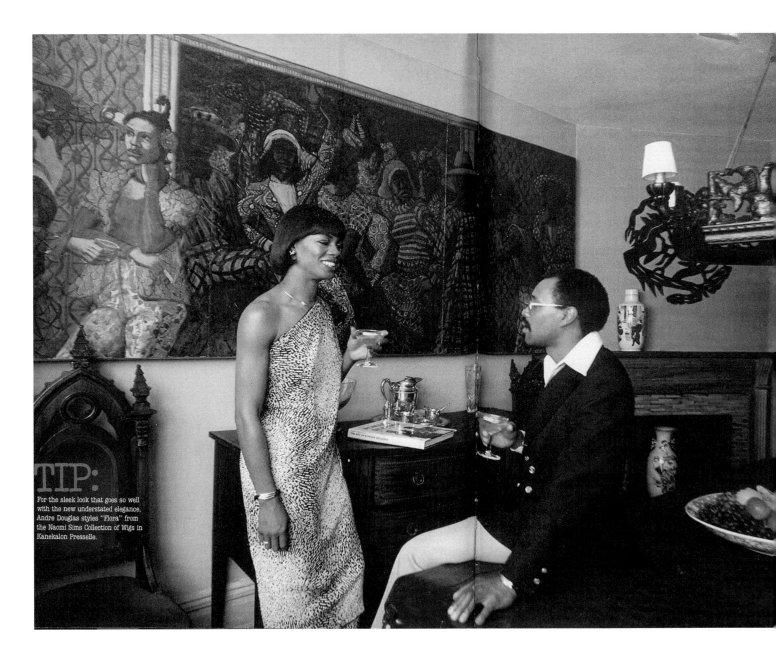

For the sleek look that goes so well with the new understated elegance, Andre Douglas styles "Flora" from the Naomi Sims Collection of Wigs in Kanekalon Presselle.

Reverend Ike, Richard Pryor, Stevie Wonder, and Aretha Franklin, who would all serve in its debut governing cabinet. Such hubris was part and parcel of a rehabilitated African American identity in the last quarter of the twentieth century: the years in which Washington would retool itself from a largely dependent status to not just a self-governing federal territory (under congressional oversight) but a bona fide Black cultural mecca.

On the subject of the city's scrappy African American presence in the face of being frequently rendered invisible, one should also consider a memorable scene from Hal Ashby's critically acclaimed comedy-drama film *Being There* (1979), based on the 1970 book of the same name by Polish American novelist Jerzy Kosiński. Near the beginning of the film, the protagonist—a socially challenged gardener played by the British film actor-comedian Peter Sellers—is evicted from his lifelong residence and workplace. Similar to a long-confined rocket-ship-encapsulated space explorer, he steps out of his refuge for the first time in many years, only to discover the

2. Ron Harris, photograph of Eleanor W. Traylor and Washington, DC, Arts Commissioner Larry Neal in Traylor's Washington home, with *The Party* (c. 1973–1975), a painting by Alfred Smith Jr., from *Essence* 7 (March 1977): 66–67

Courtesy Essence Communications

3. Film still from *Being There*, 1979, directed by Hal Ashby

Photograph courtesy MGM-United Artists and the British Film Institute Stills Archives

city's African American side (fig. 3). Film scholars have lauded Ashby's inspired decision (in consultation with the film's production designer, Michael Haller) to depart from the original story, placing the evicted gardener's sanctuary—a sequestered mansion from DC's ancien régime past—on a deteriorating, poverty-stricken block in the predominately African American Shaw neighborhood.[7] With Ashby's deft direction and Sellers's brilliant incarnation of the gardener, film audiences experience the inner-city streets through the evocative soundtrack of Eumir Deodato's jazz funk version of Richard Strauss's *Also sprach Zarathustra*, which happens to recall director Stanley Kubrick's 1968 science-fiction film *2001: A Space Odyssey*. It is not so much a step into postapocalyptic fear and urban loathing as it is an amiable tour through the Chocolate City, especially when Chance, the gardener, breaks into a serene smile when he stops to view an impromptu game of street basketball.

The smile that either the pick-up basketball game or, rather, the Chocolate City more generally, brings to Chance's face—and its intimations of a heartfelt, demonstrable jouissance—is this essay's main theme. It is an evidentiary, culture-specific joy that those who experienced Washington in the last quarter of the twentieth century intimately knew, whether it was manifested in the transformative acquisitions of African American art by the National Collection of Fine Arts (now the Smithsonian American Art Museum), the community of talented visual and theatrical artists that sprang out of Howard University's College of Fine Arts (now called the Chadwick A. Boseman College of Fine Arts), the growing admiration for the District's lively but mostly underground Black music scene, or the cultlike enthusiasm of the majority of the District's politically assertive Black masses for the flamboyant and controversial African American politician Marion Barry Jr. (fig. 4).[8] For other historical examples of Black joy in the Chocolate City, think of Elder Lightfoot Solomon Michaux and his "Happy Hour" broadcasts from his Church of God on Georgia Avenue. Or the audibly gleeful audience in the Ramsey Lewis Trio's 1965 hit song "The In Crowd," recorded live at the Bohemian Caverns on Eleventh Street NW. Or the famished but lighthearted regulars waiting in line for a vacant counter stool at Ben's Chili Bowl or at the Florida Avenue Grill. The Chocolate City "rose from the ashes of

4. Artist Mark Montgomery with Mayor Marion Barry Jr. at a City Hall art exhibition, Washington, DC, c. 1979–1980

© 2017 Richard J. Powell

1968 along with black Washington's hopes for self-determination," wrote historian Kenneth Carroll, reminding his readers about the "exclusive jurisdiction" of the US Congress over the District and the dispiriting riots of 1968, "whether [self-determination] took the form of home rule or statehood or something else," he wryly summarized.[9]

And it was a joy that made itself apparent in a grassroots African American cultural scene and the day-to-day existence of its average citizens, regardless of the District's political, infrastructural, and economic challenges during those years. It was a joy that emanated out of a community neither principally urbane and affluent nor predominately unrefined and disadvantaged. It was a community whose bloodlines reached back to Maryland, Virginia, the Carolinas, New Jersey, and Pennsylvania; to Trinidad, Jamaica, Nigeria, Ethiopia, and England; and, not surprisingly, to America's white ruling class and its unacknowledged mulatto progeny. It was also a colony of Black elites: federal bureaucrats, university intelligentsia, diplomats and deposed presidents in exile, preachers, and teachers. It was a populace of government workers and common laborers who, in spite of which political party was in power, trudged through January ice storms and sweltering August heat waves to keep the government running, their families fed, and their children clothed.

Longtime District resident and community activist Robert Robinson portrayed Washington somewhat differently:

> Washington, D.C., is best described . . . as a collection of small Southern towns. . . . It has these wonderful neighborhoods all over the city, a number of them in each ward, and they're all formed around small neighborhood business districts. . . . You could go from Brookland to Anacostia to Congress Heights to Deanwood and back over here to Foggy Bottom, and every neighborhood was different and specific and individual. . . . It had a very lively, vibrant atmosphere. There was clearly an African feel to Washington, D.C.[10]

Out of such heterogeneity, unsurprisingly, emerged aesthetic pleasure and Black artistic

5. Lois Mailou Jones, *Seventh Street Promenade*, 1943, transparent watercolor with graphite underdrawing on paper

Museum of Fine Arts, Boston, Gift of the Lois Mailou Jones Pierre-Noel Trust

Photograph © 2023 Museum of Fine Arts, Boston

6. Lois Mailou Jones, *1220 Quincy Street*, c. 1948–1953, oil on canvas

Smithsonian American Art Museum, Bequest of the artist

expression. The Washington-born Harlem Renaissance author Jean Toomer wrote eloquently in the 1920s about Seventh Street NW—DC's major thoroughfare through the Shaw neighborhood—likening it to an unstoppable river of "black reddish blood" and rhetorically asking, "Who set you flowing?"[11] In 1927 the native Washingtonian and legendary bandleader Duke Ellington recorded with his orchestra "Washington Wabble," a lively dance piece probably inspired by his musical bookings and synesthetic "people-watching" on and around Seventh and U Streets, DC's predominately African American entertainment corridor.[12] Years later, in the watercolor *Seventh Street Promenade* (1943; fig. 5), artist Lois Mailou Jones extended Toomer's and Ellington's impressions of Black Washington, her brushstrokes adeptly rendering tenement buildings, businesses, pedestrians, and pavement with both anecdotal specificity and ephemeral, fluid richness. Even when Jones turned her sybaritic sensibilities toward her own mid-twentieth-century Washington home in her painting *1220 Quincy Street* (c. 1948–1953; fig. 6)—portrayed at night under a heavy snowfall—the effects are exuberant, with aurora borealis–like illuminations bringing structure and form to Jones's middle-class, post–white flight Brookland neighborhood.[13]

But DC's delights are not always reducible to the city's diverse inhabitants and sensory effects. The World War II veteran and General Services Administration janitor James Hampton

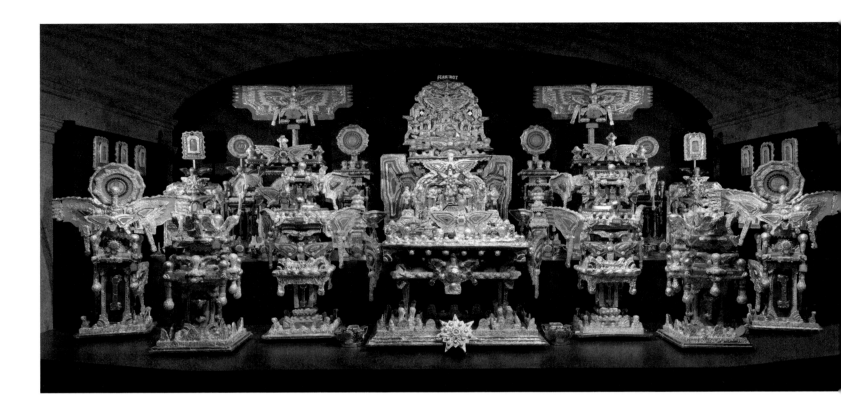

7. James Hampton, *The Throne of the Third Heaven of the Nations' Millennium General Assembly*, 1950–1964, mixed-media assemblage

Smithsonian American Art Museum, Gift of anonymous donors

found spiritual gratification and a materialized joy in his private shrine-assemblage *The Throne of the Third Heaven of the Nations' Millennium General Assembly*. Were it not for Hampton's death in 1964, he and *The Throne* would have potentially served his community's spiritual needs through weekly church services and evening revivals. But upon his death and the world's discovery of his devotional tabernacle, *The Throne* morphed into a critically acclaimed "outsider" masterpiece and, subsequently, began its new existence as a consummate, visionary expression in American art.[14] Created by the self-designated "St. James" and "Director of Special Projects for the State of Eternity" between 1950 and 1964 in a garage/former stable behind 1133 Seventh Street NW, *The Throne* comprises more than 180 pieces of discarded wooden furniture and cutout cardboard elements—cherubs, stars, angel wings, and heavenly bodies—covered in gold and silver foils and decorated with burned-out lightbulbs, thumbtacks, pushpins, flower vases, and jelly jars, all of which were lit by a dozen or so hanging lightbulbs (fig. 7). Constructed just blocks from the Federal Triangle and its majestic granite and marble buildings, *The Throne* was, in a sense, a counterstatement and a rejoinder—a scaled-down, sacralized version of the civic complex with a modest setting and scrapyard elements that fly in the face of its envisioned future as a spiritual seat and reminder of the second coming of Jesus Christ. Materially and metaphorically answering Hampton's solitary sign tacked onto his garage wall that read "Where there is no vision, the people perish," *The Throne* enshrined Black Washington as a wellspring for creative possibilities where, through God's divine grace, the discarded and forgotten entities—human as well as inorganic—are recycled, transformed, and imbued with the same light and joy that Toomer, Ellington, and Jones invoked in their respective works.[15]

When *The Throne* was officially acquired by the National Collection of Fine Arts in 1970, very few art critics regarded this institutional sanctioning as a significant event. More transformative in many people's opinions was the decision to place the highly regarded Washington

artist Sam Gilliam's *Carousel Form II* (1969) on the cover of the September/ October 1970 issue of *Art in America* (fig. 8). Accompanying art historian Barbara Rose's article on the question of contemporary art embodying a Black identity, Gilliam's artistic breakout from conventionally stretched easel paintings to draped and stained canvases was perceived as validation of Black artists forging racially opaque, innovative paths through the artistic mainstream.[16] Gilliam's visibility in the mid-to-late 1960s stands in sharp contrast to Jones's invisibility during the pre–civil rights era, which was necessitated by her having to use white friends as foils for submitting her landscapes to local art juries.[17]

Apart from generating hometown pride, Gilliam's success as an abstract painter who happened to be African American confirmed for many that DC's art scene had become less conservative, not only in terms of accepting more experimental approaches to art but also in accepting the work of accomplished Black artists and providing them with more professional opportunities. The Washington art scene in which Gilliam loomed essentially reflected his ecumenical sensibilities and those of his African American cohort, as well as the inclusionary beliefs of earlier generations of Black Washington artists, gallerists, and scholars.[18] As Keith Morrison noted in his 1985 study of the Black artistic presence in Washington at midcentury, Jeff Donaldson's appointment in 1970 as chair of the Howard University art department, with his unabashed Black cultural nationalist charisma, offset the open-ended, racially integrationist nature of Washington's Black art scene. This Chicago artist's emphatic racial sentiment and insurrectionary organizing skills catalyzed an Afrocentric approach to image making among Black Washington artists, providing the Chocolate City with an overtly African diasporic ambience and spiritual undergirding.[19]

The 1970s mainstream media was not entirely blind to the idea of a Chocolate City and its cultural and artistic renaissance in the making. In 1976, in the article "A Bright New 'School' With a Black Theme," *Washington Post* art critic Paul Richard noted that with the relatively recent arrivals in Washington of artists Donaldson, Valerie Maynard, James Phillips, Alfred Smith Jr., and others, the District's Black art scene was forever transformed, shifting in many people's minds from its recognizable Washington Color School referents in the paintings of Gilliam and Alma Thomas to the decidedly African visual aesthetics and Black subject matter found in much of the work emanating from Howard University's art department.[20] A few years later in *Art in America*, contributing editor David Tannous remarked on the considerable number of Black artists in "this largely black city . . . but you'd never know it from observing the crowd at a P Street opening, or from meeting the faculties of most of the area art schools. The Howard faculty includes some good artists," Tannous continues, "but by and large the Washington art world isn't much aware of the school's activities." Apparently Tannous was not aware either, considering his own pointed omissions from his article of any named Howard University art faculty or examples of their work.[21]

Richard's comparison of earlier, more established African American artists with successive Howard University–affiliated artists is interesting in that his critical antennae not only picked up on the stark differences between these two groups of Black Washington artists but also on the aesthetic continuums that, for example, linked the allover gestural statements in a Gilliam or Thomas canvas to the animated, comprehensive patterning in paintings by Donaldson (fig. 9),

8. Sam Gilliam, *Carousel Form II*, 1969, acrylic on canvas, on the cover of *Art in America* 58 (September/ October 1970)

© Sam Gilliam / Artists Rights Society (ARS), New York

Courtesy *Art in America*

9. Jeff Donaldson, *Eminence*, 1976, acrylic and mixed media on corrugated paper board

Collection of the Birmingham Museum of Art, Museum purchase in memory of Lillie Mae Harris Fincher with funds provided by the Sankofa Society, 2009.11. © Jeff Donaldson. Courtesy Jameela K. Donaldson

Photograph: Sean Pathasema

James Phillips, and Alfred Smith Jr. "It is a little strange," remarked Richard, "to find that Jeff Donaldson, the AfriCOBRA painter, the manifesto writer, the man who more than anyone helped form the Howard School, is an intimist of sorts." Describing at length Donaldson's highly detailed, cardboard-constructed collages inlaid with silver and gold foil, depicting iconic Black figures, Richard ultimately acknowledged the heterogeneity of the Howard School's style and, despite professed affinities for African designs and aesthetics, its marked modernity and fundamental Americanness.[22]

Another key figure making his artistic presence known in Washington at the time was artist, educator, and curator David C. Driskell, who settled in the area in 1977 to teach at the University of Maryland, College Park. Driskell was no stranger to the District's art community, having previously attended Howard University and Catholic University of America, along with maintaining professional and personal ties to DC's various art institutions and people. But his return (after years of teaching at Talladega College in Alabama and Fisk University in Nashville) was significant, bringing a high degree of art expertise to the District and signaling nationally Washington's growing cultural prominence and beehive-like energy swirling around Black artist groups and individuals. Driskell's centrality to an art history of the Chocolate City—from his up-close witnessing of the nascent iterations of racial/cultural distinctiveness issuing out of the legendary Barnett-Aden Gallery to his stewardship of innumerable artistic initiatives in

10. David C. Driskell, *Benin Head*, c. 1978, egg tempera on paper

Collection of Camille O. and William H. Cosby Jr.

the area, brought to great fruitfulness in the University of Maryland's visual arts and cultural center bearing his name—added a historical intelligence to the greater Washington Black art scene that merits its own scholarly consideration and critical reevaluation.[23]

Around the time Driskell returned to DC, he was deeply immersed in curating the landmark traveling exhibition *Two Centuries of Black American Art, 1750–1950* (1976–1977); in spite of undertaking this huge administrative endeavor he joined his fellow area artists in giving color, form, and a cerebral dimension to Washington's lately embraced African identity, as seen in the painting *Benin Head* (c. 1978; fig. 10). "By 1970 I had been to Africa for the first time," Driskell told art historian Julie L. McGee. "That visit reinforced for me the notion that the Black American experience was indeed relevant, while simultaneously driving home the importance and relevancy of the legacy of the ancestral arts of Africa in our culture."[24] Not only did Driskell's *Benin Head* pay homage to the African past and the distinctive, stylistic elements in the art of the Nigerian kingdom of Benin (examples of which could be seen at the Museum of African Art on Capitol Hill) but the painting's overall brown palette, subtle humanizing of a metal commemorative bust, and unsettling, shifting gaze introduced a psychological undercurrent: an emotional touch that, as in the work of several artists from the so-called Howard School, conceptually deconstructed and complicated the notion of the African diaspora. "There are African people in America," Howard University sculpture professor Ed Love told Richard,

WASHINGTON PROJECT FOR THE ARTS

FROM THE POTOMAC

TO THE ANACOSTIA

11. Sharon Farmer, *We're With It Washington*, 1985, gelatin silver print, cover of Richard J. Powell, *From the Potomac to the Anacostia: Art and Ideology in the Washington Area* (Washington, DC, 1989)

"and what we are producing is the visual evidence of our experience. . . . [Evidence] to convict something or to free something or to examine something."[25]

The artistic spores that blew across the Chocolate City's cultural landscape—where vibrant colors and rhythmic overtures to the District's various African American cadences subliminally correlated with collective social actions or a pleasure principle—were perhaps imperceptible, sub rosa seeds; and, yet, as seen in the 1977 *Essence* photograph of Eleanor Traylor and DC Arts Commissioner Larry Neal in Traylor's Washington townhouse, the aura of an erudite African vibration was pervasive in both institutional and domestic settings (see fig. 2). Traylor's home and its accoutrements (the mural-size painting *The Party* by Alfred Smith Jr., from about 1973 to 1975; the Gothic revival sanctuary chair; Traylor's chic, one-shoulder evening gown; *The Art of Romare Bearden* [1973] on the coffee table; and the Haitian cut-metal wall mount) imparted to the readers of *Essence* a sophisticated, multivocal Black world where, as embellished in Smith's painting depicting Black partygoers, the commingling of patterns and designs was analogous to the circulation of people and ideas across the Black cultural spectrum.[26]

A mixture of forces in the District—artistic, political, and market—had created by the mid-1970s a cultural milieu in which African American arts permeated the public sphere, so much so that, either as a conscious participant/observer or as an innocent bystander, one immediately sensed that Black art was more than decorative or entertaining. Rather (to paraphrase Sam Smith, the DC-based editor of the *Progressive Review*), art was pivotal in helping to construct DC's politics and social identity.[27] Several key arts organizations, like the DC Black Repertory Company (created and run by actor-director Robert Hooks), the Miya Gallery (started and directed by photographer and arts administrator Vernard Gray), and the Duke Ellington School for the Arts (established by community activist and arts patron Peggy Cooper Cafritz), flowered in this African American–centered, creative atmosphere, each contributing to the diffusion of the arts in every possible aspect of life in Washington.

Marion Barry Jr., Washington's mayor from 1979 until 1991 and from 1995 until 1999, made supporting the arts a signature of his administrations, which meant, among numerous things, making sure Washington's poorer neighborhoods had access to arts programs and the city's many cultural institutions. "Even in tough times," Barry often said, "we need to have a strong, participatory arts community."[28] This fervent belief that the arts should have a presence among all classes of the Black District was highlighted in the mid-1980s when, under Barry's directive (and championed by his highly influential arts and culture advisor Peggy Cooper Cafritz), the DC Commission on the Arts and Humanities mandated that, in order for the city's cultural institutions to receive grants totaling almost half a million dollars, they would have to provide increased opportunities to the less-privileged sectors of the city and promise to hire more minority artists, curators, and other arts professionals.[29] "Our goal is to make

Washington, D.C., the cultural capital of the nation," announced DC commission staff head Barbara R. Nicholson, clearly envisioning this objective not so much in the context of the federal city's tourism industry as in the framework of bolstering and advancing the city's lively African American arts scene and its creators.[30]

In subsequent years art in Washington continued to exude this *charmant noir*, or "chocolate" quality, although sifted through an Afro-Atlantic cultural sieve and presented by way of late twentieth-century postmodern formulae. In 1989 the Washington Project for the Arts (WPA), one of the District's premiere alternative art spaces during these years, probed Washington's artistic quintessence in the exhibition *From the Potomac to the Anacostia: Art and Ideology in the Washington Area* (fig. 11).[31] The exhibition (for which the author was the curator) included a diverse group of Washington-area artists, several of whom reflected a more complex, expressionistic side of the Chocolate City.[32] The work these artists created redefined art-historical conceptions like the Washington Color School and, as described by DC-based artists/theoreticians Donaldson and Morrison (especially in Morrison's 1979 essay "Art Criticism: A Pan-African Point of View"), many of the paintings, sculptures, and other works of art were anchored in semiotic imaging systems that had aesthetic links and conceptual parallels with selected genres of Black music and performing arts traditions.[33]

One of those painters, Simon Gouverneur, produced works that, although indebted to graph theory, combinatorics, and universal symbols, resonated strongly with this aforementioned aura of a studied cosmopolitanism and a systemic, decidedly non–New York School approach to painting and artistic content. Arriving in DC in 1980 for a teaching position at Howard University (recommended to him by Gilliam), Gouverneur rebelled against the more conventional paths that many DC artists followed by setting up a painting studio on Florida Avenue, wholly immersing himself in his work at the expense of his teaching, and developing a visual vocabulary of arcane signs, hieroglyphs, and cryptograms that he ingeniously incorporated into consistently formatted, high-key color canvases and other painted surfaces (fig. 12).[34] Art critic John Yau wrote that "Gouverneur rejected the widespread belief that a Black artist's primary task is to produce visual testimony to a personal or collective experience, which can be regarded as representative of Black culture. In its place," Yau continued, "Gouverneur sought to author a universal language of signs and symbols," placing his work within an "occult or hidden tradition in painting, which has its origins in spirituality."[35] When Gouverneur wrote in 1988 that "some day Washington will be able to make the distinction between art and ethnography and find the links between art and ontology," he was, in a sense, prophesying his own artistic legacy and the future critical undertakings that, despite his rejection of artistic communities based upon racial Blackness, would recognize the sacred geometries in both his art and in the freemasonry-inflected design for the District surveyed by Benjamin Banneker and others. "This will be a new day," Gouverneur idealistically concluded, not surprisingly echoing the utopian sentiments inherent in his fellow artist seer James Hampton's *The Throne of the Third Heaven of the Nations' Millennium General Assembly.*[36]

Coupling Gouverneur's 1980s abstractions and their place in a geomantic mysticism with Hampton's mid-twentieth-century art-assemblage-turned-spiritual-launching-pad is not a superficial parallel. Both men understood the importance of spirituality in artistic practice as revealing esoteric knowledge whose source, in no small measure, was deep-seated beliefs and compulsions, both local and far-flung, toward artifice, sophistry, and interiority. And both men exulted in self-imposed, creative seclusion and secrecy surrounding their iconographies, despite cursory similarities to the ideograms and symbols of the "global South" (for Gouverneur) and biblical references (for Hampton).[37]

12. Simon Gouverneur, *Flamma*, 1989, tempera on canvas

National Gallery of Art, Corcoran Collection (Gift of the artist)

Courtesy The Estate of Simon Gouverneur

That the Chocolate City was the ideal site for Hampton and Gouverneur's visual spirituality suggests that, despite the vast differences between their respective Washingtons, the District has been a mystical touchstone for receptive observers and petitioners, both in its part baroque/part sacred geometry and in its many religious societies and edifices. In the twenty-first century a number of artists from the Washington region, like Hampton and Gouverneur before them, became increasingly interested in pictorial retranscriptions of the metaphysical Washington. When appended to racialized experiences and environments, such preoccupations inadvertently revealed the subterranean patterns and inner workings of the Chocolate City and its Black citizens. "[The function of] art is to tell truth," Gouverneur stated of his particular interrogations in painting, "not because artists are the only truth tellers, but because art is the *rite* media [emphasis added] to tell truth."[38] This was another way for Gouverneur of articulating the same ontological proscription (and, as his use of the word *rite* suggests, art's sacred duty) that he frequently espoused, even while eschewing the racial and ethnographic in art.

Remarkably, DC-based artist Renée Stout discovered, in the tradition of Hampton's sculptural premillennialism, an infinite source of imagery via text, symbols, and African American metaphysics. As with much of Stout's art, her attention to minute details and notional realities carries this work beyond something folkloric or simulated; rather, its fidelity to cultural codes and,

at times, flashes of inscrutability make many of her creations examples of a conceptualism that, like Hampton's *The Throne*, defies commoditization and reductionism.[39] "Like *The Throne* itself," writes art historian Grey Gundaker, "Hampton's script [from his masterpiece's accompanying ceremonial notebook] challenges static and mutable orthodoxies while remaining faithful to Paul's sole description of 'The Third Heaven' in Second Corinthians 12:2–4."[40] One might add that the title for Hampton's notebook, *The Book of the 7 Dispensation* (c. 1945–1964; fig. 13), obliquely framed *The Throne*'s eschatological worldview as a sequential display of spiritual avatars (the names of biblical personae, liturgical components, and so on), not unlike Stout's *Fatima's Sign* (2002; fig. 14), a painting that invested the handwritten signboards on the exteriors of Washington's "herb shops" and storefront churches with a delineative flourish and pictorial agency.

 Fatima's Sign, which Stout located and contextualized in the heart of the Shaw neighborhood, abounds with references to the occult and the kinds of paraphernalia one usually encounters in such establishments. *Fatima's Sign* also resonates with the printed flyers and notices from psychics and "root doctors" that, similar to the advertisements featured for decades in the Baltimore and Washington editions of the *Afro-American* newspaper, listed ad infinitum the problems many impoverished Black urban dwellers experienced, along with bold assurances of herbal remedies. Stout's inventory of troubles, prophylactics, and prices—in the mode of

13. Front and back covers of James Hampton, *The Book of the 7 Dispensation*, c. 1945–1964, commercially printed ledger, cardboard, ink, and foil

Smithsonian American Art Museum, Gift of Harry Lowe

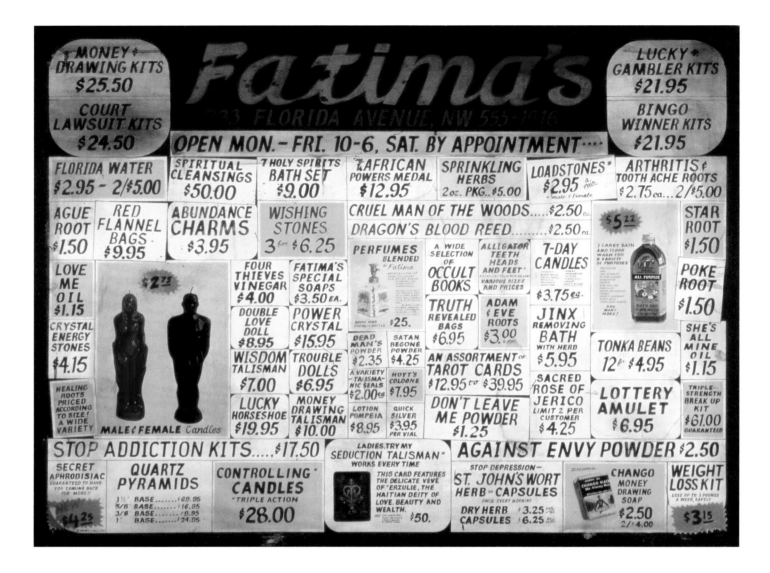

14. Renée Stout, *Fatima's Sign*, 2002,
acrylic and mixed media on wood

Belger Arts Center, Kansas City

Courtesy the artist and HEMPHILL
Fine Arts

self-effacing, amateur signage—provided an incisive social critique of the fantasies, phobias, and pecuniary costs that characterize Black working-class economies and that, like the metaphor of the Chocolate City itself, traffics in allegories of consumption, desire, and distaste.[41]

In an entirely different way the Washington-born and, since 2011, Chicago-based artist Jefferson Pinder has employed performance art and videos to explore the body's creative potential and to expose selected racial and class-conscious fault lines—inflection points where an understanding of Washington and its forms of bureaucracy poignantly zeroed in on what it means to live, work, and die in this irregular wedge of the Black diaspora. In a succession of memorable, DC-area-predicated pieces (especially in performances like *Mule*, *Marathon*, and *Lazarus*), Pinder paid tribute to the Black civil servant and his/her imperceptibility, the burdensome realities of the worker's daily commute, interracial misrecognition and empathy, and the Black bureaucrat's collective struggle. Themes like these could have easily succumbed to moral indignation and class-based grumbling, but in Pinder's critical discernments works of performance art such as *Ben-Hur* (fig. 15) not only filtered a narrative of slavish, entry-level grunt work through his referencing of the toga-and-chariot film of the same name. More philosophically,

it interrogated the personal stakes individuals have in a capitalist system of competitive labor and symbolic value. "Perhaps it's the combination of formality with brute force," explained Pinder about the appeal of his *Ben-Hur*. "Six black men literally work themselves to exhaustion on rowing machines. . . . The work starts off beautiful and choreographed but moves toward a deeply intense competition of who will be the last one rowing."[42] Spectacularly performed inside the Corcoran's grand, Beaux-Arts atrium (in a manner similar to the historic incursions of Washington artists Gilliam and Martin Puryear into the Corcoran's distinctive exhibition spaces), *Ben-Hur* asserted its lineage from these earlier African American inroads into racial equivocality and open-ended meanings in contemporary abstract art.[43]

15. Jefferson Pinder, *Ben-Hur*, 2012 performance at the Corcoran Gallery of Art, Washington, DC

Photograph courtesy the curator's office, Corcoran Gallery of Art.
Photo: Vincent Gallagos

"I'm grounded in this area," Pinder told a reporter about growing up in Silver Spring, Maryland, and being raised by parents who were federal and city employees. "My family," he continued, "goes back a *long* way."[44] This acknowledgment of family ties to place and its impact on a body-centric artist and maker of contemporary art actions brings us back to the song "Chocolate City" and its carefree but defiant claims for a special status among African American urban havens. When Parliament's George Clinton, the lead vocalist on "Chocolate City," sings

> There's a lot of chocolate cities, around
> We've got Newark, we've got Gary
> Somebody told me we got L.A.
> And we're working on Atlanta
> But you're the capital, CC

the other Parliament members respond to Clinton's call with assertions of superiority that resemble a contest in which one athlete extends and pushes *toward* and *past* another competitor for the proverbial win. Very much in the tradition of the folk raconteur and a prescient evocation of the DJ's braggadocio in subsequent rap and hip-hop music, Clinton's prerogatives for "Chocolate City," while casual and even playful at times, contained elements of a rapper's studied condescension and tenacious one-upmanship.[45]

That same declarative voice, demonstration of physical strength, and propulsive, in-your-face Black corporeality is not only present in Pinder's early twenty-first-century works but also vitally alive in his predecessors in a regional Black performance art scene. In the 1980s Baltimore's Joyce J. Scott and Washington's Sherman Fleming refuted this area's reputation as artistically conservative with coordinated, raucous art actions and physical exploits that contradicted the District's fabled decorum, diplomacy, and public overtures to respectability.[46]

Fleming—whose artistic *nom de guerre*, "RODFORCE," alluded to a visceral, masculine energy unconstrained by good manners or dignity—gave substance to his alias during these years in several pieces, such as *Cold Sweat* (1980), *Something Akin to Living* (1979), *Ax Vapor* (1987), and *Equestrian* (1987), to name a few. Fleming deployed his lithe, statuesque, and muscular body as an allegory pushed to its physical limits and beyond. In his *Fault: Axis for Light—* one of a series of performances collectively titled *States of Suspense*—he hung himself upside

16. Sherman Fleming, *Fault: Axis for Light*, 1986 performance at Yale Laundry, Washington, DC

Courtesy Sharon Farmer

down on a rigged rope from a high ceiling by his feet, but low enough for his hands to touch the floor, and for his body to either spin around or swing to and fro (fig. 16).[47] Operating between playfulness and precariousness, *Fault* brought into sharp focus Fleming's absorptions with "psycho-physical" behaviors, human vulnerability, and, as experienced by countless Black men in Washington, maintenance of one's equilibrium and sense of self under regimes of racism, inner-city violence, and deprecation.

In thinking about these works one cannot resist making connections between Fleming's endurance tests and the socioeconomic realities of Washington. "Washington is the nation's blank slate," wrote Fleming about his art's relationship to the District. "Its citizens are at once spectators and participants and disparate groups [joined] collectively in the exercise of power for the maintenance of selfhood, an identity always sought but seldom gained."[48] Art historian Kristine Stiles has drawn attention to the metaphorical dimensions of Fleming's art actions and, in the particular case of *Something Akin to Living* (a 1979 piece in which Fleming stands naked between two large architectural columns, supported by several dozen pieces of wood vertiginously wedged between the columns and his body), saw resonances between Fleming's tense, motionless figure, the "Doric columns of Washington, D.C.," and the all-too-human consequences of physical and psychological collapse as a result of institutional trauma and societal assaults.[49]

Another local source of artistic provocation and an alternative Black sensibility was the poet and artist Essex Hemphill (fig. 17). Unapologetically articulating a Black queer perspective in his writings and public performances, Hemphill led the effort in the 1980s in bringing the District's status as a gay capital to wider recognition, but with the District's African American LGBTQ community performing center stage in that national exposé. Hemphill's biographer, historian Martin Duberman, noted that Hemphill participated in and fostered "the black gay male and lesbian cultural flowering of the 1980s" (sometimes referred to as the "second Harlem Renaissance"). But, along with other Washington Black gay and lesbian artists, Hemphill made

the Chocolate City the location of a wholly original and spirited scene in that era's insurgent art universe.[50]

Hemphill's particular commitment to DC's Black gays and lesbians was neither exclusionary of, nor antithetical to, the District's Black community in general. He voiced his expanded conception of kinship (even when it was not always reciprocal) on countless occasions, and it was an underlying theme in much of his writing, whose story lines and points of view were frequently conceived and penned from a Black working-class perspective. For example, in Hemphill's "Visiting Hours" (1985), he speaks the unspoken—and uncensored—musings of a National Gallery of Art security guard: "I'm the host in the Capitol. I did Vietnam. My head is rigged with land mines, but I keep cool, waiting on every other Friday, kissing the Rose, catching some trim." Unlike Pinder's indefatigable, polyester-suit-clad civil servant personas in selected performances, Hemphill's guard is defiant, even recondite about his circumstances:

> Modigliani whispers to Matisse.
> Matisse whispers to Picasso.
> I kiss the Rose in my pocket
> And tip easy through this tomb of thieves.
>
> I'm weighted down with keys,
> Flashlight, walkie-talkie, a gun.
> I'm expected to die, if necessary,
> Protecting European artwork
> That robbed colour and movement
> From my life.[51]

17. Essex Hemphill, c. 1988
Courtesy Sharon Farmer

As part of the performance art program for the 1989 WPA exhibition *From the Potomac to the Anacostia*, Hemphill (with collaborators Wayson Jones and Ron Simmons) presented a number of Hemphill's "choreo-poems," which they consolidated into a series of public performances. Titling their program of performed poetry *From the Anacostia to the Potomac*, Hemphill reversed the exhibition's original titular sequencing of the city's two major rivers, consequently privileging in his performances DC's Black Southeast sector, demarcated by the Anacostia (where he grew up).

One of the poems Hemphill and Jones performed in *From the Anacostia to the Potomac* was "The Brass Rail," an ode to the legendary African American drag bar of the 1970s and 1980s at 811 Thirteenth Street NW. Some months later Hemphill and Jones's recitation of "The Brass Rail" was again heard, this time during the Washington premiere of the Black British film *Looking for Langston* (1989), directed by Isaac Julien (fig. 18).[52] In this impressionistic cinematic meditation on the African American author Langston Hughes, the Harlem Renaissance, and Black gay identities and desires, Julien made Hemphill's "The Brass Rail" the film's scenographic crescendo and an expository counterpoint to a stunning montage of jazz-age gay partygoers and marauding, bludgeon-wielding white skinheads and British police officers, all edited into a hallucinatory and kaleidoscopic climax. Visual crosscuts were overlaid with vocal crosscuts, layering Hemphill's lines from "The Brass Rail" onto lush, black-and-white cinematography in a Marvin Gaye–like, overlapping pattern analogous to intimate conversations where (as expressed

18. Isaac Julien, *La Rêve No. 1
(Looking for Langston Vintage
Series)*, 1989/2016

Courtesy the artist and Victoria Miro,
London

in the following poetic excerpt) independently voiced phrases and utterances elliptically roll
onto the beginnings and endings of each other:

> I saw you last night
> (Many occupants are never found)
> In the basement
> (Many canoes overturned)
> Of the Brass Rail.
> Your dark, diva's face
> (A leg)
> Lushing and laughing
> (I hear the sea)
> Your voice
> (Screaming)
> Falling from the air
> (Behind your eyes)
> Dancing with the boys on the edge of funk,
> (Twilight . . .)

Even without Julien's directorial hand and *Looking for Langston*'s crowning Chicago house
music soundtrack groove of Mr. Fingers's "Can You Feel It," Hemphill and Jones's mellifluous
voices—and their parallel, layered alliterations—carried this brazen cinematic moment and
transported the film's viewers across the Atlantic and back to the Chocolate City and its scenes
of Black pleasure and, ironically, Black dread and denial.

These conflicting emotions surrounding the Chocolate City were reflected in other social
oxymora in the final decades of the twentieth century. Much has already been written about

Washington's federal, relatively affluent, and overwhelmingly white demographic coexisting with a municipal, mostly working-class and poor Black population. During the 1980s Washington had one of the highest median income levels in the nation along with, ironically, an almost 20 percent poverty rate.[53] Mayor Barry's broadly reported political shortcomings and moral failures were not just examples of a leader's personal ruin; his infamous fall from respectability was collectively felt throughout the District and widely lamented. Although New York City and San Francisco experienced far greater casualties during the AIDS epidemic of the 1980s and 1990s than DC, the District was overwhelmingly affected by the disease, with more than 60 percent of its cases located squarely within the African American community, poet Essex Hemphill being one of those fatalities. "We have the very best of what black America has to offer and we also have the very worst," said the Black entrepreneur and media mogul Cathy Hughes in 1988.[54] And yet, paradoxically, these negatives were experienced simultaneously with what Kenneth Carroll called "a cultural muscularity," primarily in the arts and letters, through which the District metaphorically flexed its dark physique and enveloped itself in tributes to homegrown creativity, folkways, leisure, and spirituality.[55]

Poet, playwright, and essayist Jay Wright captured this rich yet quaking image of Washington in his poem "Benjamin Banneker Helps to Build a City" (1976). Toward the end of this lengthy poem Wright puts the eighteenth-century African American astronomer and surveyor of the soon-to-be District of Columbia on notice, recognizing Banneker's genius and prescience of mind and body while, in a few final, devastating word images, he places Banneker *and* himself among the powerless and fatalistic:

> I say your vision goes as far as this.
> And so you, Benjamin Banneker,
> walk gravely along these lines,
> the city a star, a body,
> the seed vibrating within you,
> and vibrating still,
> beyond your power,
> beyond mine.[56]

Was it this eloquent and emotional limbo around the District of Columbia and the contradictions of real, lived experiences within its boundaries that encouraged DJs and average citizens to begin calling Washington the Chocolate City in the first place? In equating "CC" with "DC," were they roguishly creating the metaphor of a confident, ripe-for-the-tasting, Black representational space that, like James Lesesne Wells's Depression-era *Barry Place* (1932; fig. 19), nonetheless belied an analogous sense of hunger, deprivation, and diminution? Or, taking cues from Lois Mailou Jones's *Jennie* (1943; fig. 20)—an enigmatic portrait of a Black woman scaling fish—was the Chocolate City a Black, brown, and beige confection between Baltimore and Richmond, whose cultural delights and defiant race pride clashed with its elitism, and whose developing sense of self throughout the latter half of the twentieth century and into the fin de siècle reaped a multitude of conflicting artistic statements?

Who would have thought that, beginning around 2011, the Chocolate City concept, while still relevant in terms of many of DC's artistic imperatives, would no longer represent the District's demographic difference? For the first time in half a century Washington lost its Black majority, largely because of gentrification, the soaring costs of housing in the District and the greater metropolitan area, and Black flight to the suburbs. Linking gentrification in Washington

19. James Lesesne Wells, *Barry Place*, 1932, linoleum cut

Courtesy Swann Auction Galleries

to perceived Black cultural forfeitures is unclear, argued arts administrator Kyle A. Jackson, even though it is unmistakable that the "Quiet Storm" of Black artistic effervescence and joy in the last quarter of the twentieth century occurred during a period of Black demographic and political dominance.[57] "The Parliament song 'Chocolate City' pinned a label on [Washington, DC]," stated poet E. Ethelbert Miller, who played a pivotal role in Washington's Black cultural renaissance. "Well," Miller quipped, "chocolate melts."[58] "The death of a Chocolate City," writes journalist Natalie Hopkinson about the collateral demise of go-go, an African American musical variant spawned in DC, "is just part of the global movement of voices from the margins to the center."[59]

Death knells for the Chocolate City have proliferated in the aftermath of Washington's announced population shift. And yet, like the recipients of many other African American requiems—the civil rights movement, rhythm and blues, or a vibrant Black culture persisting in an increasingly gentrified Harlem—Blackness rarely disappears in toto. Rather, it "hangs on,"

20. Lois Mailou Jones, *Jennie*, 1943, oil on canvas

Howard University Gallery of Art

seeping into the mainstream, and perseveres, albeit in a modified form. The Chocolate City's "unquantifiable richness," to quote Hopkinson, and that metaphor's allusions to something ambrosial, redolent, and epicurean reminds us of the more expressive elements in Washington's art portfolio.[60] In almost every instance, however, it is a fleeting, evanescent sweetness, couched in the bitter tastes of everyday realities that speak to the particular historical boundaries which have long defined this place and its striving, continually self-searching Black community.

NOTES

Introduction
Jeffrey C. Stewart

1 For a discussion of beauty in twentieth-century art, see David Konstan, "Chapter 24: Beauty," in *A Companion to Ancient Aesthetics*, ed. Pierre Destrée and Penelope Murray (Chichester, 2015), 366–380, and Jane Callister, "Introduction," in *Diabolical Beauty* (Santa Barbara, CA, 2001). I want to thank Vince Johnson, Monifa Love Asante, Fath Davis Ruffins, Ron Robinson, Hugo Hopping, Rose Cherubin, Melanee Harvey, Ruth Fine, Julia Elizabeth Neal, Julie Thatcher, and Helen Vendler for conversations and references that deepened my thinking on these topics. I also thank Ms. Neal for copyediting assistance on some of the essays in this volume.

2 Alain Locke, "Beauty Instead of Ashes," *The Nation* 126 (April 18, 1928): 432–434. Reprinted in Jeffrey C. Stewart, ed., *The New Negro Aesthetic: Selected Writings* (New York, 2022).

3 Isaiah 61:1–3, New International Version, https://www.biblegateway.com/passage/?search=Isaiah%2061%3A1-3&version=NIV.

4 See W. E. B. Du Bois, "The Criteria of Negro Art," *The Crisis* 32 (October 1926): 290–297.

5 See Constance Green, *Secret City: A History of Race Relations in the Nation's Capital* (Princeton, NJ, 2015). Also see Gillian Brockell, "The Deadly Race Riot 'Aided and Abetted' by the *Washington Post* a Century Ago," *Washington Post*, July 15, 2019.

6 Holland Cotter, "White House Art: Colors from a World of Black and White," *New York Times*, October 11, 2009.

7 Thomas Jefferson, *Notes on the State of Virginia*, 1785. All quotes in this passage are taken from chapter 14, "Laws." http://notes.scholarslab.org/milestones/laws.html.

8 See Patricia A. Morton, "National and Colonial: The Musée des Colonies at the Colonial Exposition, Paris, 1931," *The Art Bulletin* 80, no. 2 (June 1998): 357–377. I am indebted to Vince Johnson for bringing this information to my attention.

9 Text message from Vince Johnson, August 11, 2021.

10 Alain Locke, "Youth Speaks," *Survey Graphic* 53 (March 1, 1925): 660. For more on Locke's theory of art, see Jeffrey C. Stewart, *The New Negro: The Life of Alain Locke* (New York, 2018); and Stewart, *New Negro Aesthetic*.

11 Keith Morrison, "Art Criticism: A Pan-African Point of View," *New Art Examiner*, 1978, http://keithmorrison.com/?page_id=649; Keith Morrison, *Art in Washington and Its Afro-American Presence: 1940–1970* (Washington, DC, 1985), http://keithmorrison.com/?page_id=1228; manuel arturo abreu, "An Alternative History of Abstraction," May 16, 2020, YouTube video, https://www.youtube.com/watch?v=A8CeRo3lQQQ.

12 Dave Hickey, *The Invisible Dragon: Essays on Beauty* (Chicago, 1993; rev. ed., 2009). See also Callister, "Introduction."

13 Konstan, "Chapter 24: Beauty," 372.

14 David Dennis Jr., "The Defiance of Black Joy in an Especially Anti-Black Year," Level, December 9, 2020, https://level.medium.com/the-defiance-of-black-joy-in-an-especially-anti-black-year-8a0244f21da8.

15 The Blackbyrds, "Rock Creek Park, Official Video," 1975, YouTube video, https://www.youtube.com/watch?v=2wn167MG-x8; Tate Modern, "Soul of a Nation: Art in the Age of Black Power," https://www.tate.org.uk/whats-on/tate-modern/exhibition/soul-nation-art-age-black-power (accessed February 25, 2022).

16 "When you and I consult these hearts and mind of ours, what do we learn? That there actually exists a deeper beauty even than the beauty of death—the beauty of living." E. E. Cummings, "Armistice," E. E. Cummings Additional Papers, 1870–1969, MS Am 1892.6 (9), Houghton Library, Harvard College Library.

17 Elizabeth Alexander, *The Black Interior: Essays by Elizabeth Alexander* (St. Paul, MN, 2004).

18 Jeffreen M. Hayes, *AfriCOBRA: Messages to the People* (Miami, 2020), 14.

Visualizing a Legacy, Curating a Vision: The History of the Howard University Gallery of Art
Gwendolyn H. Everett

Epigraph: Jock Reynolds, preface to Keith Morrison, *Art in Washington and Its Afro-American Presence: 1940–1970* (Washington, DC, 1985).

1 James V. Herring, foreword to *Alma W. Thomas: A Retrospective Exhibition (1959–1966)* (Washington, DC, 1966).

2 Holland Cotter, "White House Art: Colors from a World of Black and White," *New York Times*, October 11, 2009.

3 Carol Kino, "Giving Alma Her Due," *Introspective Magazine*, April 27, 2015, https://www.1stdibs.com/introspective-magazine/alma-thomas-michael-rosenfeld-gallery/.

4 See Howard's history in Walter Dyson, *Howard University, the Capstone of Negro Education: A History, 1867–1940* (Washington, DC, 1941); and Rayford Logan, *Howard University: The First Hundred Years, 1867–1967* (New York, 1969).

5 See Tritobia Hayes Benjamin, "Howard University Gallery of Art," in *To Conserve a Legacy: American Art from Historically Black Colleges and Universities*, ed. Richard J. Powell and Jock Reynolds (Andover, MA, and New York, 1999), 24; and Tritobia Hayes Benjamin, "A Proud History in Profile: The Howard University Gallery of Art," in *A Proud Continuum: Eight Decades of Art at Howard University* (Washington, DC, 2005), 20.

6 Morrison, *Art in Washington and Its Afro-American Presence*, 12.

7 Morrison, *Art in Washington and Its Afro-American Presence*, 12.

8 Michael R. Winston, "On the Sesquicentennial of Howard University," *Howard Magazine* 26, no. 1 (Winter 2017): 4.

9 Winston, "On the Sesquicentennial of Howard University," 4.

10 Thomas C. Battle and Donna M. Wells, eds., *Legacy: Treasures of Black History* (Washington, DC, 2006), 121.

11 Dyson, *Howard University, the Capstone*, 287.

12 Dyson, *Howard University, the Capstone*, 290.

13 Scott W. Baker, "From Freedmen to Fine Artists," in *A Proud Continuum: Eight Decades of Art at Howard University* (Washington, DC, 2005), 2.

14 See Logan, *Howard University*, 69–187.

15 Dyson, *Howard University, the Capstone*, 104.

16 See "Andrew Rankin Memorial Chapel, Frederick Douglass Memorial Hall, and Founders Library," National Historic Landmark

Nominations, United States Department of the Interior, National Park Service, National Register of Historic Places Registration Form (2001), https://www.howard.edu/library/development /HistoricLandmarkNom.pdf, 6, and Howard University, "History and Legacy," Andrew Rankin Memorial Chapel, https://chapel.howard .edu/about/history-and-legacy (accessed March 30, 2020).

17 See Logan, *Howard University*, 505–506; Powell and Reynolds, and Baker, "From Freedmen to Fine Artists," 5–9.

18 James A. Porter, unpublished manuscript, Howard University Gallery of Art Archives. Various published and unpublished documents cite 1928 as the official founding date of the Gallery of Art, connecting it to a Howard University Board of Trustees action in that year approving the establishment of a gallery, though no documentation of such a board action has been located in Howard University Archives. The gallery formally opened to the public on April 7, 1930. I thank Lopez D. Matthews Jr., PhD, and Sonja N. Woods of the Moorland-Spingarn Research Center for their assistance.

19 Alonzo J. Aden, "The Gallery of Art at Howard University," *Southern Workman* 60, no. 7 (July 1931): 49.

20 On Avery Coonley (1870–1920) and his wife, Queene Ferry Coonley, as architectural patrons, see Texas Archival Resources Online, https://legacy.lib.utexas.edu/taro/utaaa/00102/aaa-00102 .html (accessed July 30, 2020).

21 Dyson, *Howard University, the Capstone*, 104.

22 Carol Duncan, "Art Museums and the Ritual of Citizenship," in *Exhibiting Cultures: The Poetics and Politics of Museum Display*, ed. Ivan Karp and Steven D. Lavine (Washington, DC, 1990), 91.

23 Ruby Moyse Kendrick, "Art at Howard University: An Appreciation," *The Crisis* (November 1932): 348.

24 Kendrick, "Art at Howard University," 348.

25 Benjamin, "A Proud History in Profile," 20.

26 Benjamin, "A Proud History in Profile," 20.

27 James V. Herring, "The American Negro as Craftsman and Artist," *The Crisis* (April 1942): 116–118. His version of the title uses "Calvary" rather than "Crucifixion."

28 James A. Porter, "The Fourth Generation: New Values," in *Modern Negro Art* (New York, 1969), 94.

29 Porter, "The Fourth Generation," 75–76.

30 Anna O. Marley, introduction to *Henry Ossawa Tanner: Modern Spirit*, ed. Anna O. Marley (Philadelphia, 2012), 40.

31 Marley, *Henry Ossawa Tanner: Modern Spirit*, 40.

32 Dewey F. Mosby, *Henry Ossawa Tanner* (Philadelphia, 1991), 288. Tanner's father, Bishop Benjamin T. Tanner, served on the board of trustees at Howard from 1897 to 1913.

33 Mosby, *Henry Ossawa Tanner*, 288.

34 Anacostia Neighborhood Museum, *The Barnett-Aden Collection* (Washington, DC, 1974), 11.

35 See Serwer and Francis essays in this volume.

36 Richard J. Powell, "Archibald Motley," in Powell and Reynolds, *To Conserve a Legacy*, 216.

37 David C. Driskell, "Face to Face with Archibald J. Motley Jr.," in *Archibald Motley: Jazz Age Modernist*, ed. Richard J. Powell (Durham, NC, 2014), 4.

38 Benjamin, "A Proud History in Profile," 20.

39 See Wofford essay in this volume.

40 Baker, "From Freedmen to Fine Artists," 11.

41 Benjamin, "Howard University Gallery of Art," 25.

42 James A. Porter, foreword to *New Vistas in American Art* (Washington, DC, 1961).

43 Porter, *New Vistas*, n.p.

44 Richard J. Powell, "To Conserve a Legacy: American Art from Historically Black Colleges and Universities," in Powell and Reynolds, *To Conserve a Legacy*, 106.

45 Julie McGee, *David C. Driskell: Artist and Scholar* (San Francisco, 2006), 70–73.

46 McGee, *David C. Driskell*, 73.

47 Floyd W. Coleman, "Visualizing Legacy: Selected Icons of African American Art," in *An Inside View: Highlights from the University's Collection, Howard University* (Washington, DC, 2002), n.p.

48 Sharon Patton, *African American Art* (Oxford, 1998), 215.

49 Alex Poinset, "The Metamorphosis of Howard University," *Ebony* 27, no. 2 (December 1971): 110–122.

50 Benjamin, "A Proud History in Profile," 21.

51 Baker, "From Freedmen to Fine Artists," 13.

52 Holland Cotter, "Skunder Boghossian, 65, Artist Who Bridged Africa and West," *New York Times*, May 18, 2003.

53 Baker, "From Freedmen to Fine Artists," 15.

54 Baker, "From Freedmen to Fine Artists," 16.

55 Helen Pettis, graduate of the class of 1959, funded the endowment with a generous donation in 2006.

56 Alumni and friends of the gallery, including Starmanda Bullock, who served as fourth chairman of the department of art, provided funding for the renovation project. A bronze plaque recognizing her support of the project was installed at the entrance to the gallery in 2009.

57 Tritobia Hayes Benjamin, "Director's Introduction and Acknowledgements," in *A Proud Continuum: Eight Decades of Art at Howard University* (Washington, DC, 2005), viii.

58 See *Journal of Blacks in Higher Education*, March 28, 2018, https://www.jbhe.com/2018/03/only-one-hbcu-on-the-list-of -the-50-most-amazing-college-museums/; Howard University Newsroom, April 16, 2015, https://www2.howard.edu/howards -gallery-art-among-top-50-united-states; CollegeRank.net; https:// www.collegerank.net/most-amazing-college-museums/44-howard -university-gallery-of-art/; College Values Online, "The Top 50 Most Impressive College Museums," https://www.collegevaluesonline .com/features/impressive-college-museums/; Layla Bermeo, "The 20 Best College Art Museums in the Country," Complex, http:// www.complex.com/style/2013/09/college-campus-art-museums /howard-university-gallery-of-art; Howard University Gallery of Art ranked number 8 in 2015 by collegerank.net, among the 50 Best College Museums in the country, http://www.collegerank.net /best-art-museums.

59 Howard University Gallery of Art, *Peter L. Robinson, Jr.: An American Colorist* (Washington, DC, 2016).

60 See *Peter L. Robinson, Jr.: An American Colorist*; and Tritobia Hayes Benjamin, "A Life in Art and Design: The Robinson Factor," in *Peter L. Robinson, Jr.: Explorations of Space and Color* (Washington, DC, 2003), 4–11.

61 Baker, "From Freedmen to Fine Artists," 2.

62 The gallery received a study collection of twelve Renaissance and baroque paintings and one Renaissance sculpture from the Samuel H. Kress Foundation in 1961. The Irving Gumbel Collection of prints by European master printmakers was donated in 1963. It includes approximately 350 works.

63 The concept of visual legacy builds on the analysis in Coleman, "Visualizing Legacy"; and Powell, "To Conserve a Legacy," 103–143. The university continues to expand its focus

and in 2021 reestablished the College of Fine Arts as the Chadwick A. Boseman College of Fine Arts under the leadership of Dean Phylicia Rashad.

Adaptable Legacies: Alain Locke's African Art Collection at Howard University
Tobias Wofford

1 Locke was on hiatus from Howard University following his dismissal in 1925 until he was reinstated in 1928. See H. U. Dismissal Correspondence, Box 2, Folders 20–22, Alain Locke Papers, Moorland-Spingarn Research Center, Manuscript Division, Howard University.

2 Dorothy B. Porter, "The African Collection at Howard University," *African Studies Bulletin* 2, no. 1 (January 1959): 20.

3 Mark Helbling, "African Art: Albert C. Barnes and Alain Locke," *Phylon* 43, no. 3 (1st quarter, 1982): 57–67.

4 See Alain Locke, "A Note on African Art," *Opportunity: Journal of Negro Life* 2, no. 17 (May 1924): 134–138; Albert C. Barnes, "The Temple," *Opportunity: Journal of Negro Life* 2, no. 17 (May 1924): 138–140; Paul Guillaume, "African Art at the Barnes Foundation," *Opportunity: Journal of Negro Life* 2, no. 17 (May 1924): 140–142. See also Alain Locke, ed., *The New Negro: An Interpretation* (New York, 1925).

5 Herskovits taught at Howard University in 1925 and contributed to Locke's *New Negro* anthology. See Melville J. Herskovits, "The Negro's Americanism," in Locke, *New Negro*, 353–360.

6 See Alain Locke, "The Legacy of the Ancestral Arts," in Locke, *New Negro*, 254–270.

7 While some have suggested that Issacs only provided financial assistance in acquiring the collection, Helen M. Shannon's account proposed that Isaacs played an active role in identifying the collection and bringing it to the United States. See Helen M. Shannon, "The Blondiau–Theatre Arts Collection of Primitive African Art," *Tribal Arts* 17, no. 66 (special issue no. 3, 2012): 50–55. See also Deborah A. Deacon, "African Art at the Schomburg Center for Research in Black Culture," *African Arts* 14, no. 2 (February 1981): 64–65, 88.

8 Shannon, "The Blondiau–Theatre Arts Collection."

9 Shannon, "The Blondiau–Theatre Arts Collection," 55.

10 Alain Locke, "Letter to the Editor," *The Nation* 124 (March 16, 1927): 290.

11 Shannon, "The Blondiau–Theatre Arts Collection," 53–55.

12 Mary Lou Hultgren, "Roots and Limbs: The African Art Collection at Hampton University Museum," in *Representing Africa in American Museums: A Century of Collecting and Display*, ed. Kathleen Bickford Berzock and Christa Clarke (Seattle, 2010), 49.

13 Deacon, "African Art at the Schomburg Center for Research in Black Culture," 64.

14 One such exhibition was *Man Ray, African Art, and the Modernist Lens,* at The Phillips Collection in Washington, DC, October 2009–January 2010, and the other was *African Art, New York, and the Avant-Garde* at the Metropolitan Museum of Art, New York, November 2012–September 2013. See Wendy A. Grossman, *Man Ray, African Art, and the Modernist Lens* (Minneapolis, 2009); Yaëlle Birro, "African Art, New York, and the Avant Garde," *African Arts* 46, no. 2 (Summer 2013): 88–97.

15 Birro, "African Art, New York, and the Avant Garde," 97.

16 Alain Locke, "Advance on the Art Front," *Opportunity: Journal of Negro Life* 17, no. 5 (May 1939): 133.

17 Richard J. Powell, "Re/Birth of a Nation," in *Rhapsodies in Black: Art of the Harlem Renaissance*, ed. Joanna Skipwith (Berkeley, CA, 1997), 14–33.

18 Theresa A. Leininger-Miller, *New Negro Artists in Paris: African American Painters and Sculptors in the City of Light, 1922–1934* (New Brunswick, NJ, 2001); Brent Hayes Edwards, *The Practice of Diaspora: Literature Translation and Practice of Black Internationalism* (Cambridge, MA, 2003).

19 Oral History Interview with Hale Woodruff, 1968 Nov. 18, Archives of American Art, Smithsonian Institution.

20 Alain Locke, "Impressions of Luxor," *Howard Alumnus* 2, no. 4 (May 1924): 74–78.

21 In chapter 4 of her book *Remaking Race and History*, Renée Ater explored the influence of Egyptian art on early twentieth-century Ethiopianism, especially as applied to Meta Vaux Warrick Fuller's *Ethiopia Awakening*. See Renée Ater, *Remaking Race and History: The Sculpture of Meta Warrick Fuller* (Berkeley, CA, 2011), 101–131.

22 Robert Vitalis, *White World Order, Black Power Politics: The Birth of American International Relations* (Ithaca, NY, 2015), 56.

23 Alain Locke, Undated Account Re: Abyssinia, Box 105, Folder 2, Alain Locke Papers, Moorland-Spingarn Research Center, Manuscript Division, Howard University.

24 "Memorandum on Department of African Studies at Howard University," Box 163, Folder 19, Alain Locke Papers, Moorland-Spingarn Research Center, Manuscript Division, Howard University.

25 Undated Memorandum Re: Proposal to Acquire a Collection of African Art, Box 163, folder 18, Alain Locke Papers, Moorland-Spingarn Research Center, Manuscript Division, Howard University.

26 Cora Mae Folsom as quoted in Hultgren, "Roots and Limbs: The African Art Collection at Hampton University Museum," 48.

27 Hultgren, "Roots and Limbs: The African Art Collection at Hampton University Museum," 49.

28 Keith Morrison, *Art in Washington and Its Afro-American Presence: 1940–1970* (Washington, DC, 1985).

29 Richard Long, interviewed by M. J. Hewitt, "Major Art Collections in Historically African American Institutions: An Interview with Richard A. Long," *International Review of African American Art* 11, no. 4 (1994): 9.

30 Morrison, *Art in Washington and Its Afro-American Presence*, 24.

31 Morrison, *Art in Washington and Its Afro-American Presence*, 14.

32 James V. Herring, ed., *Exhibition of African Negro Art: May 6–May 31, 1953* (Washington, DC, 1953).

33 Mary Beattie Brady to James Vernon Herring, July 11, 1950, Box 12, Jeff Donaldson Papers, c. 1960–2005, Archives of American Art, Smithsonian Institution.

34 Jeffrey C. Stewart, *The Critical Temper of Alain Locke: A Selection of His Essays on Art and Culture* (New York, 1983), 398.

35 Alain Locke, "The Negro in the Arts," in Stewart, *The Critical Temper of Alain Locke*, 475.

36 James Porter, "The Negro Artist and Racial Bias," *Art Front* 3 (June–July 1937): 8.

37 Morrison, *Art in Washington and Its Afro-American Presence*, 36.

38 Donald F. Davis reported that Porter's African art history course was a favorite among students. See Donald F. Davis, "James Porter of Howard: Artist, Writer"; *The Journal of Negro History* 70, no. 3/4 (Summer–Fall, 1985): 89–91.

39 *A Collection of African Negro Sculpture and Handicrafts from the Estate of Alain LeRoy Locke and Paintings and Prints by Nigerian Schoolboys, February–March, 1957* (Washington, DC, 1957).

40 According to the article, "Howard was found a 'natural' for preparing volunteers for Africa because of its extensive African studies program, its enrollment of some 20 African students and because of the fact that the majority of its regular students are Americans of African descent." See "Peace Corps Training at Howard," *Ebony*, November 1962, 69–77.

41 Morrison, *Art in Washington and Its Afro-American Presence*, 37–38.

42 Morrison, *Art in Washington and Its Afro-American Presenc*e, 43.

43 Donaldson wrote his dissertation on the 306 group in New York. See Jeff Donaldson, "Generation 306—Harlem, New York" (PhD diss., Northwestern University, 1974).

44 Formed in 1967, OBAC was pronounced "Oba-see," invoking the title of a Yoruba chief or ruler (*oba*). See Carole A. Parks, ed., *NOMMO: A Literary Legacy of Black Chicago (1967–1987)* (Chicago, 1987). Also see Kimberly M. Curtis, "Black Consciousness Is the Cornerstone of Liberation: The Black Arts Movement in African American Literature and Visual Culture, 1966–1976" (PhD diss., St. Louis University, 2007), 126–127.

45 See Jeff Donaldson, "Ten in Search of a Nation," *Black World*, October 1970, 80–89. See also Alice Thorson, "AfriCobra—Then and Now, An Interview with Jeff Donaldson," *New Art Examiner*, March 1990, 28.

46 Jeff Donaldson in *AFRI-COBRA III* (Amherst, 1973), n.p. (Donaldson's emphasis).

47 Jeff Donaldson Papers, 1918–2009, bulk 1966–2003, Archives of American Art, Smithsonian Institution.

48 Jeff Donaldson, introduction, *Howard University Art Faculty* (New York, 1972), n.p.

49 Morrison, *Art in Washington and Its Afro-American Presence*, 69.

50 Jeff Donaldson to Mark Fax, September 18, 1970, Box 5, Howard University Correspondence 1970–1985, Jeff Donaldson Papers, c. 1960–2005, Archives of American Art, Smithsonian Institution.

51 Donaldson, introduction, *Howard University Art Faculty*, n.p.

52 See Melanee Harvey, "James Phillips: A Retrospective," in *James Phillips: Swirling Complexity into Culture* (Adelphi, MD, 2017), 14; Morrison, *Art in Washington and Its Afro-American Presence*, 70.

53 Jeff Donaldson, "AfriCobra and TransAtlantic Connections," in *Seven Stories about Modern Art in Africa*, ed. Clémentine Deliss (Paris, 1995), 249–251.

54 *African Contemporary Art, April 30–July 31* (Washington, DC, 1977).

55 For an in-depth analysis of FESTAC see Andrew Apter, *The Pan-African Nation: Oil and the Spectacle of Culture in Nigeria* (Chicago, 2005).

56 Alex Poinsett, "Festac '77: Second World Black and African Festival of Arts and Culture Draws 17,000 Participants to Lagos," *Ebony*, May 1977, 33.

57 United States Zonal Committee, "Press Release Dated April 8, 1977," Box 37, Folder 10, Hoyt W. Fuller Collection, Robert Woodruff Library, Atlanta University Center, Atlanta, Georgia.

58 See: Jeff Donaldson, "TransAfrican Art: Origins and Development," in *Kerry James Marshall: One True Thing, Meditations on Black Aesthetics* (Chicago, 2003), 28–34.

"Art Means Integration": Duncan Phillips's Galvanizing Vision for The Phillips Collection
Elsa Smithgall

I thank Dorothy Kosinski, Evelyn Braithwaite, Karen Schneider, Danielle Grega, Michele DeShazo, Vivian Djen, Colleen Hennessey, and Laura Tighe for their input and generous assistance with this essay.

1 Duncan Phillips, *The Arts in War Time* (Washington, DC, 1942), The Phillips Collection Archives, Washington, DC, n.p. Italics in the original. Phillips presented his talk at the American Association of Museums conference on May 19, 1942, in Williamsburg, Virginia, and repeated it that year on a radio broadcast on May 26 and as a lecture at the Phillips on June 10.

2 Duncan Phillips, *A Collection in the Making: A Survey of the Problems Involved in Collecting Pictures, Together with Brief Estimates of the Painters in the Phillips Memorial Gallery* (Washington, DC, 1926), 6.

3 Phillips, *A Collection in the Making*, 6.

4 Edith Halpert to Alain Locke, June 9, 1941, folder 37, box 164–33, Alain LeRoy Locke Papers, Moorland-Spingarn Research Center, Howard University.

5 *Fortune*, November 1941, 102–109.

6 It is also possible that Phillips had first encountered the art of Jacob Lawrence in 1940, in a Library of Congress exhibition, *75 Years of Freedom: Commemoration of the 75th Anniversary of the Proclamation of the 13th Amendment of the Constitution of the United States* (Washington, DC, 1943). As an activist in touch with current affairs and himself chairman of the Public Works of Art Project for the Washington region, Phillips must have known about, if not attended, events around this commemorative event. Alain Locke and Holger Cahill, national director, Works Progress Administration Art Program, served on the advisory committees of the exhibition, which included four panels from Jacob Lawrence's thirty-one-panel series *The Life of Harriet Tubman* (1939–1940). It also included several works on loan from Howard University, including a drawing by James Lesesne Wells, a lithograph by Allan Rohan Crite, and an oil by Lois Mailou Jones—the latter two artists whose work Phillips would also add to his collection following his acquisition of Lawrence's *Migration Series*.

7 Duncan Phillips to Edith Halpert, January 2, 1942, reel 5496, frame 10, Downtown Gallery Records, Archives of American Art, Washington, DC. For more on the history of Halpert and Locke's organization of *American Negro Art* and role in the split acquisition of Jacob Lawrence's *Migration Series* by Duncan Phillips and Alfred H. Barr Jr., see Elsa Smithgall, "One Series, Two Places: Jacob Lawrence's Migration Series at The Museum of Modern Art and The Phillips Collection," in *Jacob Lawrence: The Migration Series*, ed. Leah Dickerman and Elsa Smithgall (New York, 2015), 32–45.

8 Edith Halpert to Duncan Phillips, February 5, 1942, reel 5496, frame 86, and Halpert to Phillips, February 21, 1942, reel 5496, frame 120, Downtown Gallery Records, Archives of American Art.

9 In a letter to Watkins, Wells thanks him for his interest in his work and mentions that he has learned that "Mr Phillips also liked my work and one painting to the extent that he planned to keep it and give $75 for it." James Lesesne Wells to C. Law Watkins, November 2, 1931, The Phillips Collection Archives. See also James Lesesne Wells to Minnie H. Byers, November 18, 1931, The Phillips Collection Archives.

10 See Joshua Pederson, "Letting Moses Go: Hurston and Reed, Disowning Exodus," *Twentieth-Century Literature* 58, no. 3 (Fall 2012): 439–461.

11 Phillips had been introduced to Crite's work years earlier in selecting his painting *Street Scene* for the *National Exhibition of Sketches, Oil Paintings, Water Colors and Graphics Arts: Federal Art Project, Works Progress Administration*, held at the Phillips Memorial Gallery June 15–July 5, 1936. Phillips acquired *Parade on Hammond Street* in 1942 from the Downtown Gallery, which the previous fall had featured two paintings by Crite, *Sawyer Street* (1939) and *Gossip* (n.d.), in its exhibition *American Negro Art*. It is possible that Halpert arranged the sale of *Parade on Hammond Street* with Grace Horne Galleries, Boston, whose label appears on the reverse of the painting.

12 Allan R. Crite to Mrs. Janice Miller, December 10, 1981, The Phillips Collection Research Files.

13 Soon after Duncan Phillips would have seen the Pippin in Halpert's *American Negro Art*, Halpert wrote to Robert Carlen: "Both Duncan Phillips and the Museum of Modern Art are interested in getting an important Pippin. After Albright [The Albright Gallery] gets through I can offer pictures to these two institutions. I shall let you know when the time is ripe." See Edith Halpert to Robert Carlen, January 14, 1942, reel 5496, frame 27, Downtown Gallery Records, Archives of American Art.

14 Duncan Phillips to Edith Halpert, December 4, 1943, reel 1960, frame 159, Phillips Collection Records 1920–1960, The Phillips Collection Archives.

15 Duncan Phillips, foreword to *The American Paintings of The Phillips Collection* (Washington, DC, 1944), n.p.; The Phillips Collection Archives.

16 Phillips, foreword to *American Paintings of The Phillips Collection*.

17 During this time, Phillips wrote to Halpert that he "miss[ed] our Jacob Lawrence unit" and asked the dealer to send Lawrence's "delightful" painting *The Libraries Are Appreciated* (1943) on approval. Phillips ultimately did not decide to acquire the painting. See Duncan Phillips to Edith Halpert, December 24, 1943, reel 1960, frame 763, and Duncan Phillips to Edith Halpert, April 14, 1944, reel 1962, frame 1243, Phillips Collection Records 1920–1960, The Phillips Collection Archives.

18 See *Three Negro Artists: Horace Pippin, Jacob Lawrence, Richmond Barthé, A Loan Exhibition of Painting and Sculpture at the Phillips Memorial Gallery* (Washington, DC, 1946), n.p. James W. Lane had advocated for the inclusion of a sculptor in the exhibition, suggesting both William Edmondson and Richmond Barthé. In a letter to Barthé, Lane informed the sculptor that Mr. and Mrs. Phillips "hope to be in New York on October 25th, and are looking forward to making the final choices then for the show." See James W. Lane to Richmond Barthé, October 11, 1946, The Phillips Collection Exhibition History File. On the heels of *Three Negro Artists*, James V. Herring assembled *Exhibition of Modern Sculpture* for the Howard University Gallery of Art (January–February 1947), in which Barthé was featured. Thanks to National Gallery of Art curator Charlie Brock and archivist Michele Willens for confirming information about Lane's role at the National Gallery of Art. Details about Lane's ties to the African American artistic community are yet to be fully explored.

19 According to the artist's catalogue raisonné, the Jacob Lawrence watercolor *The Blind Florist* (P46-17), now known as *Blind Flower Vendor*, is owned by Black Entertainment Television Holdings, Washington, DC.

20 Jane Watson Crane, "Exhibit Shows Negro Progress in Decade," *Washington Post*, January 5, 1947, L5. It is possible the exhibition to which Crane refers is *American Painting & Sculpture, 1862–1932*, held at the Museum of Modern Art, New York, October 31, 1932–January 31, 1933.

21 From 1935 to 1952 the Phillips held annual juried exhibitions to support local artists in the community. Lois Mailou Jones was featured in the exhibitions of 1941–1945. Until his death in 1945, The Phillips Collection's associate director, C. Law Watkins, joined Duncan and Marjorie Phillips as jurors, selecting the works from an open call for entries from any artist in greater Washington, which at times grew to over four hundred submissions. All works were for sale, and the museum took no commissions. For more on the history of these exhibitions, see Elsa Smithgall, "An Enduring Legacy: Engaging with DC's Art Community at the Phillips," in *Inside Outside, Upside Down* (Washington, DC, 2021), 12–14, https://issuu.com/thephillipscollection.org/docs/ioud_single_pages.

22 The South Carolina–born American artist Laura Glenn Douglas trained abroad with Fernand Léger and Hans Hoffmann and in the United States at the Corcoran School of Art and the Art Students League of New York. In 1942 she set up a studio in Washington and taught painting at the Phillips Gallery Art School. In the 1940s, Phillips acquired and regularly exhibited her work, including in a solo show in 1944.

23 Calfee was a teaching assistant to Watkins, director of the Phillips Gallery Art School; in 1945 Calfee joined Watkins on the faculty of American University. After Watkins died in 1945, Calfee took over his position as chair of the art department at American University, where he cofounded the Watkins Memorial Collection.

24 Leslie Judd Portner, "The Science of Color in Painting," *Washington Post*, March 29, 1953, L3.

25 See Alonzo J. Aden to Duncan Phillips, March 7, 1940, and April 11, 1940, The Phillips Collection Archives.

26 James Herring, *Contemporary American Art* (Washington, DC, 1940), n.p., Vertical Files, The Phillips Collection Archives.

27 Charles Seymour Jr., *American Paintings 1943–1948* (Washington, DC, 1948), n.p., Vertical Files, The Phillips Collection Archives.

28 Seymour, *American Paintings*.

29 David C. Driskell, interview by Donita M. Moorhus, December 23, 2008, 2 and 4, The Phillips Collection Oral History Program, The Phillips Collection Archives. In this interview Driskell recalled how the Barnett-Aden Gallery was "greatly influenced" by the intimate domestic setting of the Phillips and "sought to bring some of the same atmosphere to the African American community." He also spoke about how he found the Phillips a welcoming place for African Americans in an otherwise then highly segregated city.

30 Lois Mailou Jones to Duncan Phillips, March 10, 1946, Research Files, The Phillips Collection Archives.

31 Ultimately, James W. Lane wrote the foreword to the catalog for Lois Mailou Jones's 1946 exhibition. For the catalog, see Research Files, The Phillips Collection Archives.

32 Irene Rice Pereira's nephew recalled what it meant at that time for a white artist to exhibit in company with Black artists at Barnett-Aden Gallery: "I have often been asked why Pereira and [my mother, Juanita Guccione] are present in the Barnett-Aden Collection. The reason is that, having suffered the misogyny of the New York art scene, they were determined to stand shoulder to shoulder with their African American peers." Djelloul Marbrook, email to Elsa Smithgall, August 1, 2017.

33 See Keith Morrison, *Art in Washington and Its Afro-American Presence: 1940–1970* (Washington, DC, 1985), 31. See also Sandra Fitzpatrick and Maria R. Goodwin, *The Guide to Black Washington: Places and Events of Historical and Cultural Significance in the Nation's Capital* (New York, 1990), 95.

34 Morrison, *Art in Washington and Its Afro-American Presence*, 27 and 18n12.

35 David C. Driskell, interview with the author, July 25, 2017. Driskell recalled his meeting with Duncan Phillips at the Barnett-Aden Gallery around 1952 and noted Phillips's good friendship with Herring and his openness to engaging with the Black community at that time. "He was one of the few art people who left the cocoon and went out into the community." See also David C. Driskell, interview by Donita M. Moorhus, December 23, 2008, The Phillips Collection Oral History Program, The Phillips Collection Archives. Concurrent with the Barnett-Aden's regular displays of work by Cross, Pereira, and Stamos, the Phillips also showed their work frequently in hangs from the permanent collection and in special exhibitions. Phillips assembled an in-depth collection of works by Cross and Stamos, earning them a distinguished place as a so-called "unit" in the collection. For more on the important role Cross and Stamos played in the history of The Phillips Collection, see Erika D. Passantino, ed., *The Eye of Duncan Phillips: A Collection in the Making* (Washington, DC, 1999). In 1951 Phillips acquired a second work by Pereira, *Vertical Flow* (n.d.), and exhibited her works several times throughout the 1950s, including a solo show in 1952.

36 Frank Getlein, "Work of Foremost American Negro Artist at Phillips," *Sunday Star*, December 9, 1962.

37 The letter further explained: "They do not always hang continuously but there was a special request from the Howard University Art Department." See Marjorie Phillips to Thomas R. Barrett, chairman of the art department, St. Paul's School, July 24, 1969, Research Files, The Phillips Collection Archives. Given the strong visitation among younger people and the exceptionally long installation period, it seems likely that *The Migration Series* proved valuable as an educational tool for Howard University students. In a letter dated the same day, Marjorie turned down another request to borrow the panels, providing a similar reason, this one from the Federal City College of Washington, DC. "They are indeed a stunning group and we are proud to have them in The Collection. They . . . have caused so much interest especially among younger groups of visitors that I cannot grant your request to lend them." See Marjorie Phillips to Robert T. Jordan, July 24, 1969, Research Files, The Phillips Collection Archives.

38 *Paintings by Sam Gilliam*, exhibition brochure (Washington, DC, 1967), n.p., The Phillips Collection Archives.

39 Sam Gilliam, dialogue with Jerry Clapsaddle and Percy North, September 8, 1983, in *Abstractions from the Phillips Collection* (Fenwick Library Gallery, George Mason University, 1983–1984), n.p., The Phillips Collection Archives. For more on the history of Gilliams's contact with the Phillips in the 1950s and 1960s, see Sam Gilliam, interview by Donita M. Moorhus, October 28, 2010, transcript, The Phillips Collection Oral History Program, The Phillips Collection Archives.

40 Gilliam, dialogue with Clapsaddle and North, *Abstractions from the Phillips Collection*.

41 Benjamin Forgey, "Sam Gilliam Burst Forth at Phillips," *Sunday Star*, October 22, 1967, Exhibition History Files, The Phillips Collection Archives.

42 James McLaughlin, quoted in Paul Richard, "Horace Pippin: Self-Taught Master," *Washington Post*, February 26, 1977, E3.

43 Yvonne P. Carter and Georgia Jessup-Luck to Laughlin Phillips, June 15, 1979, Exhibition History Files, The Phillips Collection Archives.

44 Lois Mailou Jones to Laughlin Phillips, February 28, 1986, Registrar's File, The Phillips Collection.

45 Amy E. Schwartz, "Common Ground for Blacks and Whites," *Washington Post*, September 23, 1993.

46 See Peter T. Nesbett and Michelle DuBois, eds., *The Complete Jacob Lawrence*, 2 vols. (Seattle, 2000). The first volume is *Over the Line: The Art and Life of Jacob Lawrence*, and the second volume, *Jacob Lawrence: Paintings, Drawings, and Murals (1935–1999): A Catalogue Raisonné*, was adapted to serve jointly as the exhibition catalog. For transcripts and video clips of the two interviews with the artist commissioned by The Phillips Collection in 1992 and 2000, see the website *Jacob Lawrence: The Migration Series*, The Phillips Collection, http://lawrencemigration.phillipscollection.org. In 2015–2016 The Phillips Collection and the Museum of Modern Art collaborated with the Schomburg Center for Research in Black Culture to organize an exhibition that again reunited *The Migration Series*. See Leah Dickman and Elsa Smithgall, eds., *Jacob Lawrence: The Migration Series* (New York, 2015).

47 For more on The Phillips Collection's recent acquisitions, see Elsa Smithgall, ed., *Seeing Differently: The Phillips Collects for a New Century* (Washington, DC, 2021).

48 The mural commission was made possible through support from several DC partners: the late Toni A. Ritzenberg, Millennium Arts Salon, CulturalDC, International Arts and Artists, and the Cameroon American Council. The Phillips also commissioned five local playwrights to write one-act plays in response to *The Migration Series*: Norman Allen, Tearrance Arvelle Chisholm, Annalisa Dias, Jacqueline E. Lawton, and Laura Annawyn Shamas. The plays were developed in collaboration with dramaturge Otis Cortez Ramsey-Zöe and artistic producer Jacqueline E. Lawton and were read under the direction of Derek Goldman. Recordings of the readings of the plays are available at "The Migration Series on Stage," *Jacob Lawrence: The Migration Series*, The Phillips Collection, https://lawrencemigration.phillipscollection.org /immerse-yourself/videos.

From Theory to Practice: Lois Mailou Jones's and James Porter's American Modernisms

John A. Tyson

Lois Mailou Jones works illustrated in this essay are © Lois Mailou Jones Pierre-Noel Trust.

1 James A. Porter, manuscript of letter to Edward Alden Jewell, January 1929, 3. James A. Porter Papers, Stuart A. Rose Manuscript Archives and Rare Book Library, Emory University. Porter continues, "But from the standpoint of truth to American modes of being, feeling, acting and appearing our art must represent a homogenous greatness."

2 Flyer for *The World of Lois Mailou Jones* (September 6– October 15, 1995), University Art Gallery, Henry Clay Frick Fine Arts Building, University of Pittsburgh, exhibition organized and circulated by Meridian International Center, Washington, DC.

3 Paul Gilroy, *The Black Atlantic*: *Modernity and Double-Consciousness* (Cambridge, MA, 1993), 4; book jacket.

4 The department of art was founded in 1921.

5 James Herring to James Porter, July 20, 1927, Series 1 Correspondence and personal papers, 1913–1970, Box 1, Folder 1, James A. Porter Papers, Emory University.

6 Their work often appeared together in Harmon Foundation and Howard University Gallery of Art shows, including a tenth anniversary show at the Howard gallery, *Contemporary American Art* (1940), reported on in the *Washington Post*. See "Howard Shows Contemporary American Art: Three Professors' Paintings in Tenth Anniversary," *Washington Post*, April 7, 1940, L7.

7 The idea of art as locatable within a field—with its varying polarities—originates from James Meyer's important scholarship on minimalism. The "architecture" of Washington moderns can be viewed through Edward W. Said's call to "think contrapuntally," by considering "different experiences . . . as making up a set of . . . intertwined and overlapping histories," in order to "think through and interpret together experiences that are discrepant, each with its particular agenda and pace of development, its own internal formations, its internal coherence and system of external relationships, all of them co-existing and interacting with others." See Edward W. Said, *Culture and Imperialism* (New York, 1993), 34, 36.

8 In this sense modernism in DC resonates with the insights of Charles Baudelaire. See "The Painter of Modern Life" (1863) in *The Painter of Modern Life and Other Essays*, trans. and ed. Jonathan Mayne (New York, 1964), 15.

9 For a period critique of Barr's position in *Cubism and Abstract Art: Painting, Sculpture, Constructions, Photography, Architecture, Industrial Art, Theatre, Films, Posters, Typography* (New York, 1936) that brings up the problematics of purity, see Meyer Schapiro, "Nature of Abstract Art," *Marxist Quarterly* 1, no. 1 (January–March 1937): 77–98.

10 See Tirza True Latimer, "Discrepant Modernisms," *American Art* 30, no. 1 (Spring 2016): 2, 3.

11 See John A. Tyson, "The Washington Renaissance: Black Artists and Modern Institutions," in *The Routledge Companion to African American Art History*, ed. Eddie Chambers (New York and London, 2019), 120. Jeremy Braddock's *Collecting as Modernist Practice* (Baltimore, 2012) was influential in helping to develop my notion of modernism. Braddock argues that collecting—amassing, ordering, and anthologizing—is central to modernism. The notion of modernism being expressed in representation and presentation enables the consideration of curators, collectors, editors, etc., as producers of modern culture too.

12 Alain Locke, "Foreword," in *Contemporary Negro Art* (Baltimore, 1939), n.p. Indeed, Lois Mailou Jones's friend Edmund Barry Gaither affirms that "she never freed herself of the pressure to be in some way 'representative' of racial striving"; see "Reflections on a Friendship," in *Loïs Mailou Jones: A Life in Vibrant Color*, ed. Carla M. Hanzal (Charlotte, NC, 2009), 26.

13 See Langston Hughes, *The Big Sea* (New York, 1940), 218.

14 I refer to Edwin Rosskam's *Washington Nerve Center: The Face of America*, ed. Ruby Black (New York, 1939). For a further discussion of this photobook in relation to modernism in DC, see Charles Brock, "Toward a History of Modernism in Washington: The 1933 Display of Art by African Americans at the Smithsonian Institution's National Gallery of Art," *American Art* 33, no. 2 (Summer 2019): 4–10.

15 For more on this idea, see Braddock, *Collecting as Modernist Practice*, 1–28; and Latimer, "Discrepant Modernisms," 2, 3.

16 For more on the notion of unruly elements of modern culture that push against standard accounts of modernism, see Latimer, "Discrepant Modernisms," 2–6.

17 The prominent role of collective entities has been part of the city since it was designated a capital. The metropolis houses numerous government and nongovernment agencies (which are collective) and thus has a more institutional character than other cities.

18 Jones often had Céline Tabary drop off her work at the Corcoran because she believed it would not be shown if employees of the institution realized she was Black. See Betty LaDuke, "Lois Mailou Jones: The Grande Dame of African-American Art," *Woman's Art Journal* 8 (Fall/Winter 1987/1988): 28. For a discussion of the debate showing the work of Black artists in the Smithsonian in 1929, see "American Negro Artists (National Gallery of Art)," in "African American Contributions to the Smithsonian," Smithsonian Institution Archives, https://siarchives.si.edu/history/exhibits /African-Americans/african-american-contributions (accessed July 29, 2017). For more information about the Smithsonian National Gallery, see Michèle Gates Moresi, "Exhibiting the Negro: Art and Anthropology in the National Museum, 1929–33," *American Art* 33, no. 2 (Summer 2019): 17–23.

19 See "Survey of the Month: Lois Jones Exhibits in Paris," *Opportunity* 16, no. 1 (January 1938): 28.

20 Lane composed the text that accompanied Jones's 1948 solo painting show held at Banneker Junior High School in Washington, DC.

21 See David C. Driskell in the Artist Panel in this volume.

22 See Kathleen L. Wolgemuth, "Woodrow Wilson and Federal Segregation," *The Journal of Negro History* 44, no. 2 (April 1959): 158–173.

23 See Constance McLaughlin Green, "Chapter XI: A New Alignment, 1939–1945," in *Secret City: A History of Race Relations in the Nation's Capital* (Princeton, NJ, 1967), 250–273.

24 See Keith Morrison, *Art in Washington and Its Afro-American Presence: 1940–1970* (Washington, DC, 1985), ch. 2, part 2.

25 See Langston Hughes, "Our Wonderful Society: Washington," *Opportunity* 5 (August 1927): 227. Hughes's title is actually ironic. The salon was one of the few elements of Washington that he enjoyed. He found many Black Washingtonians overly concerned with posturing and lacking in intellectual rigor.

26 Although Barnett-Aden was a success as a domestic art space, it is important to remember that, like the salons, it in part emerged as a tactical response to racist structures in society that prevented Black artists and gallerists from access to spaces in the center of the city.

27 Alain Locke, "Beauty and the Provinces," *The Stylus* 2 (1929): 4.

28 These were *An Exhibition of Paintings and Sculptures by American Negro Artists* (May 16–May 29, 1929) and *An Exhibition of Paintings by American Negro Artists* (May 30–June 8, 1930).

29 See "American Negro Artists (National Gallery of Art, 1929–1930)," African American Contributions, Smithsonian Institution Archives, https://siarchives.si.edu/history/exhibits/African -Americans/american-negro-artists#c14 (accessed July 31, 2017).

30 See "Crowd Views Art of Negro: Paintings, Music, Books Included in Exhibit at Smithsonian," *Washington Post*, November 1, 1933, 8; and "8,000 View Works of Negro Artists in the National Gallery of Art," *Pittsburgh Courier*, November 11, 1933, 10.

31 "Howard Gallery Has Work by Porter, Wells: Two Negro Painters Are Given Exhibition until February 28," *Washington Post*, February 20, 1938, TT5.

32 Katrina Van Hook, "Art Critic Lauds Howard University and Asks: When Should Galleries Be Open?" *Washington Post*, April 28, 1946.

33 See Shirley Povich, "This Morning with Shirley Povich," *Washington Post*, June 19, 1944, 8.

34 Stanley Burnshaw to James A. Porter, June 22, 1943, Series 1 Correspondence and personal papers, 1913–1970, Box 2, Folder 2, James A. Porter Papers, Emory University.

35 Porter uses this exact phrase three times. See James A. Porter, *Modern Negro Art*, 2nd ed. (1943; repr., New York, 1969), 61, 90, 143.

36 Porter, preface to *Modern Negro Art*, n.p., my emphasis.

37 James Johnson Sweeney to James A. Porter, November 10, 1954, A letter of recommendation for the Belgian-American Foundation, Series 1 Correspondence and personal papers, 1913–1970, Box 4, Folder 1, James A. Porter Papers, Emory University.

38 Stanley Burnshaw to James A. Porter, June 22, 1943, Series 1 Correspondence and personal papers, 1913–1970, Box 2, Folder 2, James A. Porter Papers, Emory University. Burnshaw, Porter's editor, describes to him the telephone conversation he had with Barr.

39 The scope of Jones's influence was presented in the Mint Museum of Art's exhibition *Lois Mailou Jones and Her Former Students: An American Legacy* (October 31, 1998–January 4, 1999), which explored Jones's legacy as an artist and teacher.

40 See Seth Feman, "Student Art in the United States National Museum: Progressive Education on Display," *American Art* 33, no. 2 (Summer 2019): 27.

41 The many self-portraits in these shows—from Malvin Gray Johnson's to Fred Flemister's to Hale Woodruff's to Archibald Motley's—show these Black artists' augmented visuality and possible claims staked on the figure of the artist.

42 See Henri Lefebvre, "The Right to the City" (1968), in *Writings on Cities*, trans. and ed. Eleonore Kofman and Elizabeth Lebas (New York, 1996), 177. The Archives of American Art has photographic documentation of Jones leading students.

43 See Elizabeth McHenry, *Forgotten Readers: Recovering the Lost History of African American Literary Societies* (Durham, NC, 2002). Washington's salons were generally less wild than Carl Van Vechten's or A'Lelia Walker's more rowdy salons. In certain southern cities, libraries were not open to Blacks. The artist Alma Thomas, who was vice president of the Barnett–Aden Gallery, mentions that "at least Washington's libraries were open to negroes" on the first page of her untitled, unpaginated autobiography. See Box 2, Folder 7: Autobiographical Writings, circa 1960s–circa 1970s, Alma Thomas papers, circa 1894–2001, Archives of American Art, Smithsonian Institution, https://www.aaa.si.edu/collections/alma-thomas-papers-9241/subseries-3-1/box-2-folder-7 (accessed March 16, 2022). The Corcoran School had a reputation for being discriminatory at this time.

44 James A. Porter, "One Hundred Fifty Years of African American Art," in *Prints by American Negro Artists*, 2nd ed. (Los Angeles, 1967), 5, my emphasis.

45 Alain Locke, "The Legacy of the Ancestral Arts," in *The New Negro: Voices of the Harlem Renaissance*, ed. Alain Locke (New York, 1992), 254–268.

46 Porter seems to have viewed design as a necessary but more superficial quality of art. In a text he composed for a flyer that accompanied *Ten Hierographic Paintings by Sgt. Romare Bearden* (February 13–March 3, 1944) at Caresse Crosby's G Place Gallery, he writes: "One of the most frequent criticisms against American artists is they do not think. . . . But what seems like a valid excuse for condemnation may simply be one of the pitfalls of criticism; for the artist must by all means conceal the skeletal structure of his work under the more vocal essentials of design and surface."

47 Rosalind E. Krauss, *The Picasso Papers* (Cambridge, MA, 1998), 142.

48 Alain Locke, "Legacy of the Ancestral Arts," 266.

49 W. E. B. Du Bois, "The Talented Tenth," in *The Negro Problem: A Series of Articles by Representative Negroes of To-day* (New York, 1903), reproduced online at the Gilder Lehrman Center for the Study of Slavery, Resistance, and Abolition, Yale University, http://glc.yale.edu/talented-tenth-excerpts.

50 Other figures like the architects Hilyard Robinson and Paul Revere Williams, who was especially active in Los Angeles and worked on the LAX Theme Building (1961), have been to a certain extent overlooked by historians.

51 See "Lois M. Jones Paintings in Shaw Gallery," *Washington Post*, March 4, 1934.

52 For more on the men's relationship with African art, see Mark Helbling, "African Art: Albert C. Barnes and Alain Locke," *Phylon* 43, no. 1 (1st Quarter, 1982): 57–67; and Jeremy Braddock, "The Barnes Foundation, Institution of the New Psychologies," in Braddock, *Collecting as Modernist Practice*, 106–155.

53 Constance Porter Uzelac, "James Porter (1905–1970): The Father of African American Art History," in *James A. Porter: Spotlight on His Works on Paper* (Baltimore, 1998), 17.

54 Jeffrey C. Stewart, *The New Negro: The Life of Alain Locke* (New York, 2018), 761.

55 James A. Porter, "The Negro Artist and Racial Bias," *Art Front* (June–July 1937): 3.

56 See Porter, preface to *Modern Negro Art*, n.p.

57 Porter, *Modern Negro Art,* 125.

58 Porter, *Modern Negro Art,* 119.

59 See Van Wyck Brooks, "On Creating a Usable Past," *The Dial* 64, no. 11 (April 11, 1918): 337–341.

60 See Gaither, "Reflections on a Friendship," 22–24. While Jones did not explicitly cite Winold Reiss as an influence here, she was familiar with his illustrations. Works like Reiss's *Hot Chocolates* (1922) possess a not dissimilar kaleidoscopic sensibility and evoke the performing arts. For more on this work (and a related unfinished painting of the same title), see Jeffrey C. Stewart, "From Transnational to Transafrican: Winold Reiss and Romare Bearden," *NKA* 41 (November 2017): 30–42, 34–35.

61 See Richard Powell, *Black Art and Culture in the 20th Century* (London, 1997), 44–45.

62 Lois Mailou Jones, "On African Influence on African American Art," unpublished manuscript for presentation delivered at Leopold Sédar Senghor Foundation, 1970, in Lois Mailou Jones Papers, Box 215–218 Folder 3, Moorland-Springarn Research Center, Howard University, 6.

63 The Exposition Internationale du Surréalisme was held from January 17 to February 24, 1938.

64 A ProQuest search of the historical *New York Times* yields various hits for the term beginning in 1925.

65 See André Breton, *Manifestoes of Surrealism* (Ann Arbor, MI, 1969), 14.

66 Jones, "On African Influence on African American Art," 6, my emphasis.

67 The notion of Black people as alien beings is a motif that recurs in Afro-futurism as well.

68 The Blisses' collection of pre-Columbian art now at Dumbarton

Oaks was displayed at the National Gallery of Art from 1947 until 1962, first in the exhibition *Indigenous Art of the Americas: Collection of Robert Woods Bliss*.

69 See Braddock, *Collecting as Modernist Practice*.

70 See Henri Focillon, "Romanesque Mural Painting in France," Series 6, Box 76, Folder 18, Programs and brochures, artistic events, 1929–1955, James A. Porter Papers, Emory University.

71 See Duncan Phillips, "Goya to Daumier," notes taken during Henri Focillon's lecture at Phillips Memorial Gallery on April 18 (unpublished essay, 1940–1941), The Phillips Collection Archives, Washington, DC.

72 "Howard Gallery Has Work by Porter, Wells."

73 Porter may well have drawn from the conventions of studio photography, in which sitters appear against painted, flatter backgrounds. He was familiar with the work of the Scurlocks.

74 Porter recognizes the role of Van Vechten's infamous novel *N----- Heaven* (1926) as concretizing certain tropes about "urban Negroes as half-civilized and somewhat maudlin"; he saw portraiture as a potential corrective to dominant images of "Negro life." See Porter, *Modern Negro Art*, 112–113.

75 See James Smalls, "Féral Benga: African Muse of Modernism," *NKA* 41 (November 2017): 58. I developed a parallel argument about Porter's portrait for the iteration of this paper given at "The African American Art World in Twentieth-Century Washington, DC," on March 17, 2017.

76 For more on *Soldado Senegales*, see Nell Irvin Painter, *Creating Black Americans: African-American History and Its Meanings, 1619 to the Present* (New York, 2006), 182. It is notable that a Spanish-language title, rather than a French one, has stuck. This linguistic maneuver seems to further situate the sitter beyond the bounds of a particular nation-state—which are often shored up by a single national language.

77 Dana S. Hale, *Races on Display: French Representations of Colonized Peoples, 1886–1940* (Bloomington, IN, 2008), 95.

78 Lois Mailou Jones Scrap Books, A #1 to #5 01–567, Archives of American Art, Smithsonian Institution.

79 Porter discusses the importance of muralism for modern artists, mentioning Mexican muralists José Clemente Orozco and Diego Rivera, in *Modern Negro Art*, 116–118.

80 Given the growing interest in physical fitness at the time, these athletic bodies would have resonated as especially modern.

81 See "Island Scene She Had Known in Her Childhood First Moved Her to Try Her Hand at Painting," *Vineyard Gazette*, 1939, for a discussion of Jones and Tabary on the island. Clipping among Lois Jones scrapbooks on microfilm: Lois Mailou Jones Scrap Books, A #1 to #5 01–567, Archives of American Art, Smithsonian Institution.

82 Jeffrey C. Stewart points out the irony in this being visually advocated in a space segregated by both race and gender.

83 W. E. B. Du Bois, *The Souls of Black Folk*, rev. ed. (1903; repr., New York, 1989), 79.

84 See Lois Mailou Jones Scrap Books, A #1 to #5 01–567, Archives of American Art, Smithsonian Institution.

85 "YWCA Dedicates Mural Painted by Howard University Seniors," *Washington Times-Herald*, March 19, 1943. From James A. Porter Papers, Series 6, 74.1 Newspaper clippings, 1940–1949, Rose Library, Emory University.

86 For more on the murals and stained glass see *James A. Porter: Spotlight on His Works on Paper* (Baltimore, 1998), 16.

87 For more on this idea, see Michael Godby, ed., *The Lie of the Land: Representations of the South African Landscape* (Cape Town, 2010). Godby explores the way that representations of landscape are imbricated with power; they construct claims, the "lie of the land," that obfuscate the actual "lay of the land."

Frederick Douglass describes the obverse effect, the way myth can ideologically inflect the land:

> I am now as you will perceive by the date of this letter in Scotland, almost every hill, river, mountain and lake of which has been made classic by the heroic deeds of her noble sons. Scarcely a stream but has been poured into song, or a hill that is not associated with some fierce and bloody conflict between liberty and slavery. I had a view the other day of what are called the Grampian Mountains that divide eastern Scotland from the west. I was told that here the ancient crowned heads used to meet, contend and struggle in deadly conflict for supremacy, causing those grand old hills to run blood-warming cold steel in the others heart. My soul sickens at the thought, yet I see in myself all those elements of character which were I to yield to their promptings might lead me to deeds as bloody as those at which my soul now sickens and from which I now turn with disgust and shame.

Frederick Douglass to Francis Jackson, January 29, 1846, reproduced online "Letter to Francis Jackson (January 29, 1846)," The Gilder Lehrman Center for the Study of Slavery, Resistance, and Abolition, Yale University, http://glc.yale.edu/letter-francis-jackson-january-29-1846.

88 Charles H. Rowell, "An Interview with Lois Mailou Jones," *Callaloo* 12, no. 2 (Spring 1989): 357–378, http://xroads.virginia.edu/~ug01/westkaemper/callaloo/mailoujones.html.

89 Rowell, "Interview with Lois Mailou Jones," 357–378.

90 See Krista A. Thompson, "Preoccupied with Haiti: The Dream of Diaspora in African American Art, 1915–1942," *American Art* 21, no. 3 (2007): 74–97.

91 Thompson, "Preoccupied with Haiti," 74–97.

92 Beyond the article, the peasant motif would emerge in canvases by both Jones and Porter, setting their paintings into a broader "post-colonial community." One of Porter's major paintings, *On a Cuban Bus* (1943) employs a similar strategy to render a modern genre scene in Cuba. The inclusion of these subjects parallels developments in literature and art in the Anglophone Caribbean, which also focused on peasants and peasant life—figures who, like those in the colonies, did not have ownership of the land they occupied. See Glyne Griffeth, "Caribbean Voices and Competing Visions of Post-Colonial Community," in *The BBC and the Development of Anglophone Caribbean Literature, 1943–1958* (London, 2016), 71–109.

93 One particularly striking exploration of the importance of Martha's Vineyard for Black Americans was on display as part of the "Power of Place" section of the inaugural exhibition of the National Museum of African American History and Culture (NMAAHC).

94 The NMAAHC exhibition mentioned in the above note reproduced a sketch of this school from 1839.

95 Bliss, the award's namesake, was also (with his wife Mildred Barnes Bliss) the founder of Dumbarton Oaks.

96 Reginald Marsh to Lois Mailou Jones, October 23, 1944, Lois Mailou Jones Scrap Books, A #1 to #5 01–567, Archives of American Art, Smithsonian Institution.

97 See Rebecca Keegan VanDiver, "Routes to Roots: Loïs Mailou Jones's Engagement with Africa and the African Diaspora, 1938–70" (presentation, American Art in Dialogue with Africa and Its Diaspora Research Symposium, Smithsonian American Art Museum, Washington, DC, October 5, 2013); and Rebecca Keegan VanDiver, *Designing a New Tradition: Lois Mailou Jones and the Aesthetics of Blackness* (University Park, 2020).

98 See Hilyard Robinson, "An African Nation Approaches Its Centennial," *The Crisis* 53 (July 1946): 203.

99 See VanDiver, "Routes to Roots."

100 Gilroy, *The Black Atlantic*, 123.

101 See "Liberian Centennial Activities in Washington, D.C., July 1947," Library of Congress, http://www.loc.gov/pictures/item /2004681231/ (accessed July 31, 2017).

102 See W. E. B. Du Bois to Kwame Nkrumah, February 7, 1957, "WEB Du Bois Papers," University of Massachusetts, http://credo. library.umass.edu/view/full/mums312-b146-i353 (accessed July 31, 2017). Du Bois was unable to travel to Ghana until 1960 because the US government had seized his passport. He spent the final years of his life in that newly independent African nation.

103 Gilroy, *The Black Atlantic*, 123.

104 Gilroy, *The Black Atlantic*, 123.

105 These nations were, in 1970: Sudan, Kenya, Ethiopia, Congo, Nigeria, Ghana, the Ivory Coast, Liberia, Sierra Leone, and Senegal; in 1972: Sudan, Ethiopia, Kenya, Tanzania, Uganda, Zaire, Nigeria, Dahomey, and Ghana.

106 Various boxes of photos can be found in Jones's archives at the Moorland-Springarn Research Center at Howard University.

107 James A. Porter, *Contemporary Afro-American Art, First World Festival of Negro Arts: Colloquium on Negro Art* (New York, 1966), 452–453.

108 Porter, *Contemporary Afro-American Art*, 452–453.

109 See Clementine Deliss, ed., *Seven Stories about Modern Art in Africa* (London, 1995).

110 See Lois Mailou Jones, handwritten note, Box 215–218 Folder 2, Lois Mailou Jones Papers, Moorland-Springarn Research Center, Howard University.

111 Gilroy, *The Black Atlantic*, 40.

112 James A. Porter, foreword to *New Vistas in American Art* (Washington, DC, 1961), n.p.

113 Jeff Donaldson, *Retrospective Exhibition: Forty Years of Painting, 1932–1972* (Washington, DC, 1972), n.p.

The Museum of African Art and African American Art in 1960s Washington

Steven Nelson

Copyrighted images from the Eliot Elisofon Photographic Archives not specifically authorized by the copyright owner are reproduced under the provisions of fair use.

1 Warren M. Robbins to J. E. Slater, October 8, 1964, 6, Smithsonian Institution Archives, Accession 11-001, Robbins, Warren M. Robbins Papers (hereafter cited as Robbins Papers).

2 While Warren M. Robbins's achievements in founding the Museum of African Art and the Frederick Douglass Institute have had an extraordinary impact on the position and understanding of African art in the United States, his approach to women in the workplace was far less than honorable. Robbins often declared that other than work, pursuing women was his primary hobby, and the press routinely described him as a ladies' man. In a posthumous feature on Robbins, Elaine Sooy Goodman wrote, "He attracted an array of adoring young women willing to type his voluminous correspondence for a pittance and share his bed. Some became his protégés." Elaine Sooy Goodman, "Warren M. Robbins and the Founding of the National Museum of African Art," *Tribal Arts* 13, no. 2 (Spring 2009): 89. Decades of stories shared among scholars of African art history allege sexual harassment on his part.

3 Operation Crossroads Africa was considered a forerunner of the US Peace Corps.

4 Warren M. Robbins to J. E. Slater, October 8, 1964, Robbins Papers.

5 Penelope Lemov and Gail Werner, "Museum and Douglass Institute Are Booming," *New York Times*, June 29, 1969, xx23.

6 Ric Simmons, the Museum of African Art's property manager in the 1970s, told *Washington Post* staff writer Paul Richard that the furniture in the office "might not really have been Douglass's." See Paul Richard, "Double Vision: The Rival Legacies of Its First Two Leaders Shape the Museum of African Art's Future," *Washington Post*, December 15, 1996, G10.

7 Warren M. Robbins, "Prospectus for the Center for Cross-Cultural Communication, The Museum of African Art, and the Frederick Douglass Institute of Negro Arts & History," n.p., Robbins Papers.

8 Warren M. Robbins, manuscript draft on the history of the Museum of African Art, 1972, 4, Robbins Papers.

9 "Prospectus on the Center for Cross-Cultural Communication, The Museum of African Art, and the Frederick Douglass Institute of Negro Arts & History," n.p., Robbins Papers.

10 "Prospectus on the Center for Cross-Cultural Communication, The Museum of African Art, and the Frederick Douglass Institute of Negro Arts & History," n.p., Robbins Papers.

11 See, for example, excerpts from the "Prospectus of the Museum of African Art and the Frederick Douglass Institute," Robbins Papers.

12 Sarah Booth Conroy, "Raising the Roof for African Art," *Washington Post*, February 5, 1979, B1.

13 Ralph Linton, "'*Primitive*' Art," in Eliot Elisofon, *The Sculpture of Africa* (London, 1958), 9.

14 Melville J. Herskovits, *The Myth of the Negro Past* (1941; repr., Boston, 1990).

15 Herskovits, *The Myth of the Negro Past*, 32. Robbins includes this passage in a memo titled "Excerpts from *Myths of the Negro Past*, Melville Herskovits," Robbins Papers.

16 Warren M. Robbins, Transcript of Remarks at the Conference on Negro History and Culture, February 15, 1968, Robbins Papers, 4.

17 Herskovits, *The Myth of the Negro Past*, 32.

18 Frank Getlein, "Howard U.," *Sunday Star* (Washington, DC), November 25, 1962, F-7.

19 Warren M. Robbins to James Porter, [1962], James A. Porter Papers, 1867–2009, Stuart A. Rose Manuscript Archives and Rare Book Library, Emory University (hereafter cited as Porter Papers).

20 Warren M. Robbins to James Porter, [1962], Porter Papers.

21 Warren M. Robbins to James Porter, [1962], Porter Papers.

22 Warren M. Robbins to James Porter, [1962], Porter Papers.

23 For examples, see Warren M. Robbins to Josiah K. Lilly, December 31, 1963, and Warren M. Robbins to William J. Norton, February 4, 1964, Robbins Papers.

24 Warren M. Robbins to Edith Gregor Halpert, November 24, 1962, Robbins Papers.

25 Warren M. Robbins to James M. Nabrit Jr., February 23, 1963, Robbins Papers.

26 James Nabrit Jr. to Warren M. Robbins, March 8, 1963, Porter Papers. The James A. Porter Papers do not include responses from Porter to Robbins, and I was not granted access to Nabrit's correspondence at Howard University.

27 Warren M. Robbins to G. Mennen Williams, April 20, 1963, Robbins Papers.

28 Warren M. Robbins to Waldemar A. Nielsen, April 20, 1963, Robbins Papers.

29 Warren M. Robbins to Vincent Browne, November 15, 1963, Robbins Papers.

30 Warren M. Robbins to Vincent Browne, November 15, 1963, Robbins Papers.

31 Warren M. Robbins to Vincent Browne, November 15, 1963, Robbins Papers.

32 Warren M. Robbins to Vincent Browne, November 15, 1963, Robbins Papers.

33 Warren M. Robbins to Josiah K. Lilly, December 31, 1963, Robbins Papers.

34 Warren M. Robbins to James L. Kunen, December 31, 1963, Robbins Papers.

35 Warren M. Robbins to James Nabrit, January 24, 1964, Robbins Papers.

36 Warren M. Robbins to James Porter, April 21, 1964, Smithsonian Institution Archives, National Museum of African Art, Office of the Director, Records (hereafter cited as NMAfA Records).

37 Joseph H. Douglass, PhD, to James Nabrit, April 23, 1964, NMAfA Records.

38 James Nabrit to Warren M. Robbins, [1964], NMAfA Records.

39 Warren M. Robbins to James Porter, March 6, 1967, NMAfA Records. *Ten Afro-American Artists of the Nineteenth Century* was on view at the Howard University Gallery of Art from February 4 to March 30, 1967. Charles Wesley was an Americanist historian and close colleague of Porter at Howard.

40 Warren M. Robbins to James Nabrit, March 23, 1967, NMAfA Records.

41 James M. Nabrit to Warren Robbins, April 19, 1967, NMAfA Records.

42 See Alain Locke, "The Legacy of the Ancestral Arts," in *The New Negro*, ed. Alain Locke (New York, 1997), 254–257.

43 For more on the Howard University Gallery of Art and its audiences, see Keith Morrison, *Art in Washington and Its Afro-American Presence: 1940–1970* (Washington, DC, 1985).

44 Beth N. Rogers to James E. Cheek, July 9, 1969, NMAfA Records.

45 Robert Luck to Albert A. List, January 27, 1966, Smithsonian Institution, Archives of American Art, American Federation of Arts Records, 1895–1993, bulk 1909–1969 (hereafter cited as AFA Records).

46 Warren M. Robbins to James Nabrit, March 23, 1967, NMAfA Records.

47 James A. Porter to James E. Cheek, n.d., NMAfA Records.

48 Teixeira, "Museum of African Art," *The Hilltop*, May 24, 1968, 5.

49 Philip Stanford, "Warren Robbins and the Museum of African Art: Love Not All Requited," *Washington Post, Times Herald*, March 9, 1969, 15.

50 Stanford, "Warren Robbins and the Museum of African Art," 16. The *Afro-American Panorama* was published as a brochure and distributed to "10,000 teachers, administrators and other personnel of [Washington, DC's] public and parochial schools."

See "Publishing News," *Negro Digest* 18, no. 9 (July 1969): 50.

51 Stanford, "Warren Robbins and the Museum of African Art," 16.

52 Stanford, "Warren Robbins and the Museum of African Art," 15.

53 Stanford, "Warren Robbins and the Museum of African Art," 30.

54 Warren M. Robbins to Teixeira Nash, March 1, 1968, in Warren M. Robbins and Roulhac Toledano, "A Man for All Reasons: Letters of a Visionary," manuscript draft, 70.

55 Robbins's handwritten note from the late 1990s on the manuscript for his unpublished book "Before and After the Smithsonian, The Legacy of Warren Robbins, Founder, National Museum of African Art: A Biography of Letters and Essays," alleges that thirty years earlier Neal "helped himself to some pieces from the museum collection on his visit. We saw it, but did nothing." He further contended that Neal "had a drug habit to support." There seems to be no evidence supporting such claims. See "Before and After," ch. 11, "Civil Rights," n.p., unpublished manuscript, 1998–1999, Robbins Papers.

56 Warren M. Robbins, "Before and After," front matter, unpublished manuscript, 1998–1999, Robbins Papers.

57 Robbins and Toledano, "A Man for All Reasons," manuscript draft, 83.

58 James Porter, foreword to *New Vistas in American Art* (Washington, DC, 1961), n.p., Robbins Papers.

59 Keith Morrison, artist panel, "The African American Art World in Twentieth-Century Washington, DC," Wyeth Foundation for American Art Symposium, https://www.nga.gov/audio-video/video/wyeth-artist-panel.html.

60 Warren M. Robbins to Robert H. Luck, December 23, 1964, AFA Records.

61 Warren M. Robbins to René d'Harnoncourt, December 16, 1964, Robbins Papers.

62 US Congress, Senate, Committee on Labor and Public Welfare, *National Arts Legislation: Hearings before the Special Subcommittee on the Arts*, 88th Congress, 1st sess., 1963, 346.

63 Warren M. Robbins to René d'Harnoncourt, December 16, 1964, Robbins Papers.

64 In his correspondence with Norma Morgan, Hecht notes that he is interested in the watercolor "that hangs closest to the window in your livingroom." Henry H. Hecht Jr. to Norma Morgan, March 18, 1965, Robbins Papers.

65 Henry H. Hecht Jr. to Robert Luck, February 23, 1965, AFA Records.

66 Memo from Warren M. Robbins to Henry H. Hecht Jr., March 6, 1965, Robbins Papers.

67 Memo from Warren M. Robbins to Henry H. Hecht Jr., March 6, 1965, Robbins Papers.

68 Memo from Warren M. Robbins to Henry H. Hecht Jr., March 6, 1965, Robbins Papers.

69 Memo from Warren M. Robbins to Henry H. Hecht Jr., March 6, 1965, Robbins Papers.

70 Henry H. Hecht Jr. to Mary Daniel Reed, March 22, 1965, Robbins Papers. The recipient's name is Mary Reed Daniel. Hecht transposed her middle and last names in the letter.

71 Henry H. Hecht Jr. to Charles Alston, March 2, 1965, Robbins Papers.

72 Henry H. Hecht Jr. to Charles Alston, September 29, 1965, Robbins Papers.

73 Henry H. Hecht Jr. to Romare Bearden, March 2, 1965, and March 18, 1965, Robbins Papers.

74 Henry H. Hecht Jr. to Sam Gilliam, March 22, 1965, Robbins

Papers. A clip referring to Gilliam's work, which was on view at the Adams-Morgan Gallery, is included in the Robbins Papers: Wolf Von Eckardt, "Gallery Showing Symphony in Art," *Washington Post*, May 3, 1964, G8.

75 Henry H. Hecht Jr. to Robert Luck, March 6, 1965, AFA Records.

76 The American Federation of Arts, Catalog List, Museum Donor Program, 1964–1965, Museum of African Art Selection, 1965, AFA Records. It seems that along with the Mayhew painting, works by Emma Amos and Norman Lewis have also been lost.

77 Robert Luck to Albert A. List, January 27, 1966, AFA Records.

78 Warren M. Robbins to Mary Beattie Brady, July 22, 1966, Harmon Foundation Papers, 1929–1994, David C. Driskell Center Archives, University of Maryland (hereafter cited as Harmon Foundation Papers).

79 Warren M. Robbins to Mary Beattie Brady, July 22, 1966, Harmon Foundation Papers.

80 Warren M. Robbins to Mary Beattie Brady, July 22, 1966, Harmon Foundation Papers.

81 Warren M. Robbins to Mary Beattie Brady, September 22, 1966, Harmon Foundation Papers.

82 Warren M. Robbins to Mary Beattie Brady, October 17, 1966, Harmon Foundation Papers.

83 Warren M. Robbins to Mary Beattie Brady, October 17, 1966, Harmon Foundation Papers.

84 Warren M. Robbins to Mary Beattie Brady, July 22, 1966, Harmon Foundation Papers. Robbins claimed not to be happy with the artistic quality of the paintings he commissioned from Henry Dabs for the *Panorama of Negro History*.

85 Warren M. Robbins to Mary Beattie Brady, October 17, 1966, Harmon Foundation Papers.

86 Warren M. Robbins to Mary Beattie Brady, March 4, 1967, Harmon Foundation Papers.

87 Warren M. Robbins to Mary Beattie Brady, March 4, 1967, Harmon Foundation Papers.

88 Warren M. Robbins to Mary Beattie Brady, March 4, 1967, Harmon Foundation Papers.

89 Press release, "Five Nineteenth Century Afro-American Artists," 1979, Robbins Papers.

90 Morrison, *Art in Washington and Its Afro-American Presence*, 46.

91 Carroll Greene Jr. to Warren M. Robbins, June 29, 1966, NMAfA Records. In the letter Greene noted that the Kashey Gallery wanted $2,000 for the sculpture.

92 Carroll Greene, "The Negro Artist in America, Part I," *Journal*, United Church of Christ Council for Higher Education, 5, no. 1 (October 1966): 2.

93 Greene, "The Negro Artist in America, Part I," 3.

94 Greene, "The Negro Artist in America, Part I," 3.

95 See James A. Porter, *Modern Negro Art* (New York, 1969); and Cedric Dover, *American Negro Art* (New York, 1960).

96 Press release, "*Panorama of Negro History*," Museum of African Art / Frederick Douglass Institute of Negro Culture and History, n.d., Washington, DC, Robbins Papers.

97 Stand-alone photo, *Los Angeles Sentinel*, April 27, 1967, C4.

98 Warren M. Robbins to Marilyn Mikulsky, August 14, 1967, Robbins Papers.

99 Warren M. Robbins, "Introduction to the *Panorama of Negro History*," n.d., Robbins Papers.

100 Warren M. Robbins, foreword to *The Art of Henry O. Tanner (1859–1937)* (Washington, DC, 1969), 6.

101 Welcome to members of the College Art Association, February 1970, NMAfA Records.

102 "400 Works in African Art Exhibition at Smithsonian," *Baltimore Afro-American*, June 6, 1970, 19.

103 Romare Bearden et al., "The Black Artist in America: A Symposium," *The Metropolitan Museum of Art Bulletin* 27, no. 5 (January 1969): 256, 258.

104 Conroy, "Raising the Roof for African Art," B3.

105 Conroy, "Raising the Roof for African Art," B1.

106 See Richard, "Double Vision," G10.

107 Nancy Nooter, "Exhibition: Five 19th Century Afro-American Artists," press release draft, 1979, Robbins Papers.

108 Borrower's receipt from Museum of African Art to the National Collection of Fine Arts, 1975, Robbins Papers. The receipt also gives information about the works' condition at the time of transfer.

109 Bryna Freyer to Steven C. Newsome, February 19, 1999, courtesy Smithsonian Anacostia Community Museum.

110 See David Binkley et al., "Building a National Collection of African Art: The Life History of a Museum," in *Representing Africa in American Art Museums: A Century of Collecting and Display*, ed. Kathleen Bickford Berzock and Christa Clarke (Seattle, 2011), 265–288.

111 Richard, "Double Vision," G10.

DC's Black-Owned Art Galleries, 1960s to 1980s: Prequel to a Renaissance

Jacquelyn Serwer

Epigraph: Benjamin Forgey, "Washington's Bad Case of Cultural Amnesia: The Case for Rediscovering," *Washington Post*, April 24, 1988.

1 "Art Dealer and Gallery Owner Otto Veerhoff Dies at 83," *Washington Post*, July 26, 1990.

2 "Notes," *American Magazine of Art* 10, no. 9 (July 1919): 352.

3 Janet Gail Abbott, "The Barnett Aden Gallery: A Home for Diversity in a Segregated City" (PhD diss., Pennsylvania State University, 2008).

4 See Keith Morrison, *Art in Washington and Its Afro-American Presence: 1940–1970* (Washington, DC, 1985), 31–32.

5 Bill Alexander, "Black Art Galleries Turning Financial Corner," *Washington Post*, October 15, 1981.

6 Alexander, "Black Art Galleries."

7 Claudia Levy, "Art Dealer Thurlow Evans Tibbs Jr. Dies," *Washington Post*, January 17, 1997.

8 A portion of the collection was featured in the National Gallery of Art installation *The Evans-Tibbs Collection* in 2019.

9 Levy, "Art Dealer Thurlow Evans Tibbs Jr. Dies." There was an exhibition of the archives at the National Gallery of Art, *In the Library: The Evans-Tibbs Archive of African American Art*, January 21–April 12, 2019.

10 "The Smith-Mason Gallery," *DC Gazette*, January 5, 1971, 12.

11 "The Smith-Mason Gallery."

12 "Smithsonian Special Events for Black History Month," *Washington Afro-American*, February 1, 1983, which reported on Delilah Pierce's participation.

13 Alexander, "Black Art Galleries."

14 Alexander, "Black Art Galleries."

15 Alexander, "Black Art Galleries."

16 Alexander, "Black Art Galleries."

17 Alexander, "Black Art Galleries."

18 See Steven Nelson's essay on Warren Robbins and the Museum of African Art in this volume.

Venues Featuring African American Art in Washington, DC, c. 1940–2005

1 Program for The Opening of the Alma Thomas Memorial Gallery, Shaw Junior High School, 1982, Alma Thomas papers, box 3, folder 17, Archives of American Art.

2 Exhibition announcement for Elizabeth Catlett, *The Negro Woman*, Barnett-Aden Gallery, 1947.

3 Michael E. Ruane, "National Park Service to Go Ahead with Moving Archives from Bethune House," *Washington Post*, February 26, 2014.

4 Michael Kernan, "The Art of Balance," *Washington Post*, December 14, 1983.

5 Jo Ann Lewis, "Bringing New Art to Light," *Washington Post*, February 7, 1987.

6 Jo Ann Lewis, "Horizon's Highlights," *Washington Post*, July 3, 1982.

7 Bill Alexander, "Black Art Galleries Turning Financial Corner," *Washington Post*, October 15, 1981.

8 Correspondence from Jim Mayo to Dick Wolf, July 15, 1982, Box 19, Folder 3, Item 18, Capitol Hill Restoration Society, records, George Washington University Gelman Library.

9 Alexander, "Black Art Galleries Turning Financial Corner."

10 Museum and Galleries Listing, "Where to See & Buy Black Art," *Black Enterprise Magazine*, December 1980, 41.

11 Joshua N. Bedell v. Inver Housing, Inc., 506 A.2d 202 (1986).

12 Facebook page for NOA Gallery, Washington, DC, https://www.facebook.com/NOA-Gallery-197218820410091/.

13 Alexander, "Black Art Galleries Turning Financial Corner."

14 "New Art Gallery Opens," *Washington Sun*, June 20, 1991, Box 1, Folder 1, Parish Gallery records, Archives of American Art.

15 Alexander, "Black Art Galleries Turning Financial Corner."

16 Alexander, "Black Art Galleries Turning Financial Corner."

17 Alexander, "Black Art Galleries Turning Financial Corner."

The Evans-Tibbs Collection: A Legacy Project

Jacqueline Francis

I am grateful for the assistance of the archivists, curators, administrators, and registrars who provided information, materials produced for exhibitions, and records: Nancy Anderson and Harry Cooper (National Gallery of Art); Tad Bennicoff (Smithsonian Institution Archives); Margaret Bond (University of Kentucky Art Museum); Marisa Bourgoin (Archives of American Art, Smithsonian Institution); Michelle Burton (Haggerty Museum of Art, Marquette University); Linda E. Endersby (Museum of Art and Archaeology, University of Missouri); Jessica M. Estes and Beth Moore (Telfair Museums); Gwendolyn H. Everett (Howard University); Heather M. Ferguson (McNay Art Museum); Norma Hargraves (Arkansas Art Center); Deborah Tear Haynes (Hood Museum of Art, Dartmouth College); Karen Casey Hines and Joann Potter (Frances Lehman Loeb Art Center, Vassar College); Jarron L. Jewell (B. Davis Schwartz Memorial Library, Long Island University); Vada D. Komistra, Anna Tomlinson, and Anne H. Simmons (National Gallery of Art Library); Jennifer Morris (Anacostia Community Museum); Laurainne Ojo-Ohikuare (Gelman Library, George Washington University); Leah H. Reeder (Fort Wayne Museum of Art); Cathy Ricciardelli (Terra Foundation for American Art); Jen Rokoski (Center for Advanced Study in the Visual Arts, National Gallery of Art); Jonathan Frederick Walz (Columbus Museum); and Kay Wilson (Grinnell College Museum of Art).

1 The story of African American artists' practices often connects them to a larger, cultural whole, itself seen as unchanging. That is to say, historians have positioned Black Americans' visual production as a seamless continuation of West African ritual sculpture conventions; as a particularist form that is discrete from European and European American fine art traditions; or as a visual translation of popular African American expression in popular music and dance. For example, in the exhibition catalog for *African-American Artists, 1880–1987*, the SITES project director's acknowledgments hail "the emergence of African-American art as a distinct form of expression." Germaine Juneau, "Acknowledgments," *African-American Artists, 1880–1987: Selections from the Evans-Tibbs Collection* (Washington, DC, 1989), 11. The SITES contract with Tibbs, signed by Juneau and the collector, situates the exhibited work in majority and minority frameworks: it is seen as an outcome of an ethno-racial inheritance and the effect of national dominance. Germaine Juneau to Thurlow E. Tibbs Jr., Letter of Agreement, Smithsonian Institution Traveling Exhibition Service, August 18, 1988, 1, in "African-American Artists, 1880–1987, Evans-Tibbs Collection," Smithsonian Institution Traveling Exhibition Service Records, 1968–2010, Smithsonian Institution Archives, Washington, DC, Box 11-021.

2 Harriet O'Banion Kelley, "Tribute to Thurlow Tibbs," *International Review of African-American Art* 14, no. 1 (1997): 63.

3 In an article published in 1986, Tibbs stated, "In the late 1970s, just about a year after we got started, there were five commercial galleries dealing primarily with Afro-American artists." He added: "By 1981, there were 25, and it was exciting. There were shows all over the place. Most of them didn't survive the recession, or depression, depending on who you are. Now we are down to three, and they rarely mount regular exhibitions." In Eve M. Ferguson, "A Gem in the Inner City—'All Art Is but Imitation of Nature,' Seneca, *Epistle to Lucilius*," *Washington Informer* (October 1986), 52. Of Black-owned galleries during the late 1970s and early 1980s, David Driskell put the number at twenty-four. "Some were frame shops [and some were] airport art-gift shops [types of places]; but others were places of quality." David Driskell, interview with the author, December 18, 2016.

4 See John Tyson, "The Washington Renaissance: Black Artists and Modern Institutions," in *The Routledge Companion to African American Art History*, ed. Eddie Chambers (New York, 2019), 119–133.

5 Tonijala D. Penn, "A Finding Aid to the Edith T. Martin Papers," Anacostia Community Museum Archives, October 2007, 7.

6 It was reported in two historically African American weekly newspapers that "Naomi B. Aden, a teacher from Charleston, South Carolina," had bequeathed Bessie Potter Vonnoh's bronze *The Gift* to the Howard University Gallery of Art in 1932, in honor of her late daughter. "Howard University Gets Memorial Statuary," *New York Age*, September 10, 1932, 2. The same item appeared as "Howard U. Is Given Statue," *Pittsburgh Courier*, September 10, 1932, 5.

7 Jane Gail Abbott, "The Barnett Aden Gallery: A Home for Diversity in a Segregated City" (PhD diss., Pennsylvania State University, 2008), 103.

8 Adolphus Ealey, "Introduction," in *The Barnett-Aden Collection* (Washington, DC, 1974), 12.

9 David Driskell, interview with the author, December 18, 2016.

10 Ferguson, "Gem in the Inner City," 52.

11 Hiram Revels was elected to the US Senate to represent Mississippi in 1870. During the nineteenth century, Evans Tibbs's abolitionist forebears—her grandfather Henry Evans and great-uncle Wilson Bruce Evans—took part in the rescue of James Price, an enslaved Black man who successfully fled to Canada in 1858. At the turn of the century, Evans Tibbs's father, Dr. Wilson Bruce Evans, was the principal of Armstrong Manual Training School in Washington, DC, a high school built to provide vocational training to African Americans.

12 David Driskell, telephone interview with the author, December 18, 2016.

13 Sharon F. Patton, telephone interview with the author, December 27, 2016.

14 Jo-Ann Lewis, "The Collector and His Gold Mine," *Washington Post*, July 26, 1984.

15 K. Ross Toole, "E. S. Paxon: Neglected Artist of the West," *Montana Magazine of History* 4, no. 2 (Spring 1954): 26; "Elegant Terrorist," *Time*, February 8, 1954, 76; Leona E. Prasse, "An Exhibition of the Work of Rudy Pozzatti," *Bulletin of the Cleveland Museum of Art* 42, no. 9 (November 1955): 201–203; "Eskimo Carvings," *College Art Journal* 13, no. 2 (Winter 1954): 106; and Henry S. Francis, "Fall Exhibitions," *Bulletin of the Cleveland Museum of Art* 42, no. 9 (November 1955): 205.

16 In the book *The Barnett-Aden Collection*, published to accompany the exhibition, two sites were named for exhibition: the Anacostia Neighborhood Museum (January 20–May 6, 1974) and the Corcoran Gallery of Art (January 10–February 9, 1975). However, there is no documentation that Barnett-Aden holdings were ever displayed at the latter site.

17 Loan Agreement, Smithsonian Institution Traveling Exhibition Service, August 18, 1988, in "African-American Artists, 1880–1987, Evans-Tibbs Collection," Smithsonian Institution Traveling Exhibition Service Records, 1968–2010, Smithsonian Institution Archives, Washington, DC, Box 11-021.

18 Juneau to Tibbs, Letter of Agreement, 1.

19 Steve Cone, *Powerlines: Words That Sell Brands, Grip Fans, and Sometimes Change History* (New York, 2008), xvii, 64.

20 SITES support for museums included not only installation instructions and exhibition scripts but also guidelines for making their exhibitions accessible to the public—e.g., a brochure entitled "Do You Know What to Do When a Disabled Visitor Joins Your Museum Tour?"; a manual, *Part of Your General Public Is Disabled: A Handbook for Guides in Museums, Zoos, and Historic Houses*; and an instructional video, *Disabled Museum Visitors: Part of Your General Public*. In "African-American Artists, Evans-Tibbs Collection, Exhibition ID 446" folder, Smithsonian Fullerton Industrial Park Archives, Accession Number 00-069, Box 1.

21 The authorship of the SITES statement is undeclared. It may have been the outcome of Tibbs's conversations with Smithsonian administrators, or cowritten by Tibbs and/or the catalog contributors. The contrast between the Smithsonian's press release about the exhibition and the contract's fiery assertion is worth noting.

22 The exhibition's itinerary was as follows: Hood Museum of Art, Dartmouth College, Hanover, New Hampshire (January 21–March 12, 1989); Vassar Art Gallery, Vassar College, Poughkeepsie, New York (April 1–May 14, 1989); Afro-American Cultural Center, Charlotte, North Carolina (June 3–July 16, 1989); Patrick and Beatrice Haggerty Museum, Milwaukee (August 12–September 24, 1989); Marion Koogler McNay Art Museum, San Antonio (December 9, 1989–January 21, 1990); Nevada Institute of Contemporary Art, Las Vegas (February 3–March 4, 1990); Grinnell College, Iowa (April 7–May 21, 1990); Columbus Museum, Georgia (June 16–July 29, 1990); Arkansas Arts Center, Little Rock (August 18–September 30, 1990); Museum of Art and Archaeology, Columbia, Missouri (October 20–December 2, 1990); Edison Community College Gallery, Fort Myers, Florida (January 4–February 9, 1991); University of Kentucky Art Museum, Lexington (February 23–April 7, 1991); Terra Museum of American Art, Chicago (April 27–June 9, 1991); Telfair Academy of Arts and Sciences, Savannah (June 29–August 11, 1991); Fort Wayne Museum of Art, Indiana (August 31–October 13, 1991); Knoxville Museum of Art, Tennessee (November 2–December 15, 1991); Santa Fe Community College Art Gallery, New Mexico (January 11–February 23, 1992); Stedman Art Gallery, Rutgers University, Camden, New Jersey (March 14–April 26, 1992); Museum of African American History, Detroit (July 18–August 30, 1992); and Western Washington University, Bellingham (September 19–November 15, 1992).

23 G. Juneau, M. Menzel, and D. Cohen, "Exhibition Script—African American Artists 1880–1987: Selections from the Evans Tibbs Collection," 2, in "African-American Artists, 1880–1987, Evans-Tibbs Collection," Smithsonian Institution Traveling Exhibition Service Records, 1968–2010, Smithsonian Institution Archives, Washington, DC, Box 11-021.

24 Thurlow E. Tibbs Jr., "*The Music Lesson* (oil on canvas)/Robert Thompson (artist), Jan. 23, 1990," in "African-American Artist Selections from the Evans-Tibbs Collection," SITES Exhibition Records, c. 1977–1999, Accession No. 00-069, Box 1, Folder 446. In correspondence that SITES sent to Tibbs, project registrar Frederic P. Williams wrote that the collector had given the Smithsonian "quite the scare" triggering a "'shot heard' around the Institution." Frederic P. Williams, Smithsonian Institution Traveling Exhibition Service, Washington, DC, to Thurlow Tibbs, Washington, DC, September 21, 1990, in "African-American Artist Selections from the Evans-Tibbs Collection," SITES Exhibition Records, c. 1977–1999, Accession No. 00-069, Box 1, Folder 446.

25 Amid archived letters expressing satisfaction and delight about the exhibition was a lengthy complaint from Mort Sajadian, director of the Museum of Art and Archaeology at the University of Missouri. He stated that his staff received the exhibition checklist late and never received the Love-Tibbs interview video at all. He also noted discrepancies between some object labels printed for the walls and titles as published in the catalog, and he characterized the frames and mats for some artworks to be of poor quality. Lastly, he remarked that two works had been pulled from the exhibition—Thompson's *Music Lesson* and Ulysses Marshall's *Sunshine Meets the Man* (1980)—without advance notice. Sajadian to Anna R. Cohn, SITES Director, Washington, DC, December 21, 1990, in "African-American Artist Selections from the Evans-Tibbs Collection," SITES Exhibition Records, c. 1977–1999, Accession No. 00-069, Box 1, Folder 446.

26 Harriet Howard Heithaus, "African and American—Black Artists Find Ideas, in Culture, Class," *Fort Wayne Gazette*, August 29, 1991; "Afro-American Show a First for Museum," *Ledger* (Columbus, GA), June 14, 1990, in Smithsonian Institution Archives Fullerton, July 30, 1996, Accession Number 96-171, Smithsonian Institution

Traveling Exhibition Service, Public Relations Records (1983–1993), Location Box F07/13/14, Box 1 of 4.

27 Smith, Savannah, Georgia, to W. W. Law, Savannah, August 25, 1990, Archives of the Telfair Academy of Arts and Sciences, Incorporated, Savannah.

28 Smith to Law, August 25, 1990, and August 31, 1990, Archives of the Telfair Academy of Arts and Sciences, Incorporated, Savannah. African American historians of African American art Carroll Greene Jr. and Sharon F. Patton spoke at the Beach Institute during the exhibition run: Greene's lecture "Despite the Odds: Five African-American Artists of the Nineteenth Century" was held on November 13, 1990, and Patton's "From the Harlem Renaissance to Post Modernism," February 12, 1991. I thank Telfair registrar Beth Moore for making these relevant documents and images available to me.

29 Robert Baxter, "Camden Show Celebrates Century of Black Art—Arts Beat," *Courier Post*, March 22, 1992.

30 "Black Art Receives Its Due Respect," *San Antonio Reformer* 2, no. 9 (December 14–21, 1989): 1; Robert Baxter, "Camden Show Celebrates a Century of Black Art," *Courier-Post* [New Jersey], March 22, 1992; Dan R. Goddard, "McNay Exhibits Best of Afro-American Art," *San Antonio News*, December 10, 1989, 1H; and Regina Hackett, "A Century of African American Art Is Powerful Viewing," *Seattle Post-Intelligencer*, October 12, 1992, C1.

31 Eric Ries, "African American Art Highlighted in Telfair Show," *Savannah Morning News*, June 28, 2018, PD1.

32 Ries, "African American Art Highlighted in Telfair Show."

33 Quoted in Marcia Goren Weser, "Black Art in America: Exhibit Visiting the McNay Illustrates Artistic Changes Over the Past 100 Years," *San Antonio Light*, December 10, 1989.

34 Goren Weser, "Black Art in America"; Vivian Raynor, "It All Began with a Singer's Collection," *New York Times*, April 19, 1992.

35 Hackett, "Century of African American Art Is Powerful Viewing."

36 Edward J. Sozanski, "At Camden, a Century of Works by African Americans," *Philadelphia Inquirer*, March 27, 1992.

37 Cynthia Parks, "A Century of Works by African-Americans in Savannah Exhibit," *Florida Times-Union*, July 28, 1991.

38 Sharon F. Patton, telephone interview with author, December 27, 2016.

39 Renée Ater, telephone interview with the author, March 6, 2017.

40 Richard J. Powell, "From Renaissance to Realization, 1920–1950," in *African-American Artists, 1880–1987*, 42.

41 Powell, "From Renaissance to Realization," 50.

42 Sharon F. Patton, "The Search for Identity, 1950–1987," in *African-American Artists, 1880–1987*, 78.

43 Tibbs situated himself in the making of the exhibition as a legacy project. SITES documents indicate that the decision to title the exhibition *African-American Artists, 1880–1987: Selections from the Evans-Tibbs Collection* was made on November 8, 1988, supplanting *Emerging Legacy: A Collector's Perspective, Afro-American Artists from 1880–1987*. See Germaine Juneau, Memo to Everyone, Re: Exhibition Title Change, November 2, 1988. The "Emerging Legacy" title appears as a script for the exhibition's introductory wall panels; the typescript is presented on Evans-Tibbs Collection letterhead. The first paragraph concludes, "This collection covers a little over one hundred years of that history. That it was assembled by one young man in approximately eleven years is a tribute to determination and the power of the art itself." Both documents are found in the folder "SITES: Afro-American Artists, 1880–1987, Evans-Tibbs Collection," in Smithsonian Institution Archives Fullerton, February 13, 1995,

Records, Smithsonian Institution, Office of Exhibitions Central, Exhibition Records, 1986–1990, Location Box F06/12/06, Box 1 of 4.

Transblucency: Duke Ellington's *Black and Tan* as Celebration and Refusal

Robert G. O'Meally

1 My intention is to reclaim the word "institution" from those who use it merely to reify current agencies of oppression, always by definition hopelessly corrupt. I refer to the word's root meanings that suggest "statues" and "statutes": 360-degree art forms and higher laws that can guide us through our marred and clumsy world. "Hope and Memory have one daughter," writes W. B. Yeats, "and her name is Art, and she has built her dwelling far from the desperate field where men hang out their garments upon forked boughs to be banners of battle. O beloved daughter of Hope and Memory, be with me for a little." W. B. Yeats, "This Book," in *The Celtic Twilight* (1893). "Preface," *The Lesson of the Master, The Death of the Lion, The Next Time and Other Tales of Henry James,* vol. 15 of *The Novels and Tales of Henry James* (New York, 1909), x.

2 I quote indirectly Ralph Ellison's "Brave Words for a Startling Occasion" (1953), in *Shadow and Act* (New York, 1964), 105–106.

3 My discussion here is DC–centric in keeping with the conference for which it was first presented, a context that has proven revelatory for me. A fuller discussion of Ellington and Dudley Murphy's 1929 film *Black and Tan* could highlight other geographies: Paris or New York, certainly. But thinking back through the District, where I was born at Freedmen's Hospital (now part of Howard University Hospital) has reminded me how fertile a scene it was, how rich a place in must have been for my mother and grandparents, also born there, and for Ellington, whom certain of my family members recalled as "Eddie."

4 James Baldwin, "Sonny's Blues," *Partisan Review* 24, no. 3 (Summer 1957): 358. Baldwin's "Sonny's Blues" was first published in the *Partisan Review* issue in 1957 but reached much wider circulation when it appeared in book form as *Going to Meet the Man* (1963).

5 See for example Henry John Drewal, "Sensiotics, or the Study of the Senses in Material Culture and History in Africa and Beyond," in *The Oxford Handbook of History and Material Culture*, ed. Ivan Gaskell and Sarah Anne Carter (New York, 2020), 275–294.

6 Stanley Dance, *The World of Duke Ellington* (New York, 1970), 13.

7 Jacqui Malone, *Steppin' on the Blues: The Visible Rhythms of African American Dance* (Urbana, 1996), 142.

8 Thomas LeClair, "The Language Must Not Sweat: An Interview with Toni Morrison," *New Republic* 184 (March 21, 1981): 121.

9 Ralph Ellison, "Living with Music," in *Shadow and Act*, 189.

10 Ralph Ellison, *Juneteenth: A Novel* (New York, 2011), 20. Note that in Kenneth Burke's *Attitudes Toward History*, 2nd ed. (Boston, 1961), he differentiates between "bourgeois" individuality and multiple or corporate identities, which he terms "corporate," 89.

11 Richard J. Powell, "Paint That Thing! Aaron Douglas's Call to Modernism," *American Studies* 49, no. 12 (Spring/Summer 2008): 111.

12 See Carol J. Oja, *Making Music Modern: New York in the 1920s* (New York, 2000), 71 and pages following.

13 Dance, *World of Duke Ellington*, 17–18.

Sam Gilliam: Theater of Life

Adrienne Edwards

1 Jonathan P. Binstock, *Sam Gilliam: A Retrospective* (Berkeley, CA, 2005), 74.

2 Binstock, *Sam Gilliam*, 10.

3 Binstock, *Sam Gilliam*, 74–76.

4 Binstock, *Sam Gilliam*, 74–76.

5 Binstock, *Sam Gilliam*, 74–76.

6 Binstock, *Sam Gilliam*, 74.

7 Binstock, *Sam Gilliam*, 76.

8 Binstock, *Sam Gilliam*, 76.

9 Brian Massumi, *Semblance and Event: Activist Philosophy and the Occurrent Arts* (Cambridge, MA, 2011), 106.

10 Massumi, *Semblance and Event*, 107.

11 Massumi, *Semblance and Event*, 108.

12 Binstock, *Sam Gilliam,* 44.

13 Charmaine Picard, "In the Studio: Sam Gilliam," *Blouin Art + Auction*, December 17, 2015, 66.

14 David Driskell, *Contemporary Visual Expressions: The Art of Sam Gilliam, Martha Jackson-Jarvis, Keith Morrison, William T. Williams* (Washington, DC, 1987), 27.

15 Binstock, *Sam Gilliam*, 40.

16 Binstock, *Sam Gilliam,* 29.

17 Binstock, *Sam Gilliam*, 46.

18 Sam Gilliam with Annie Gawlak, "Solids and Veils," in "Constructive Painting," special issue, *Art Journal* 50, no. 1 (Spring 1991): 10.

19 Gilliam said, "Since 1968, I had been involved in a workshop situation that included both sculpture and painting, sponsored by the Washington Gallery of Modern Art. There, the other workshop members and I got into trouble when we repeated according to David Smith, there was no essential difference between painting and sculpture. In spite of the truth of the statement, there was a prevailing dictum to the contrary." Gilliam and Gawlak, "Solids and Veils," 10–11.

20 Gilliam and Gawlak, "Solids and Veils," 10.

21 Binstock, *Sam Gilliam*, 88.

22 Henry Geldzahler, "Jack Whitten: Ten Years, 1970–1980," in *Jack Whitten: Ten Years, 1970–1980* (New York, 1983), 9.

23 Jim Lewis, "Red Orange Yellow Green and Blue Period," *W Art*, December 2014–January 2015, 88.

24 Kellie Jones, *EyeMinded: Living and Writing Contemporary Art* (Durham, NC, 2011), 300.

25 Mary Schmidt Campbell, "Sam Gilliam: Journey toward Red, Black, and 'D,'" in *Red and Black to 'D': Paintings by Sam Gilliam* (New York, 1982), 9.

26 Massumi, *Semblance and Event,* 123. Italics in the original.

27 Massumi, *Semblance and Event*, 14.

28 Massumi, *Semblance and Event*, 14.

29 Massumi, *Semblance and Event*, 124.

30 Massumi, *Semblance and Event*, 114.

31 Massumi, *Semblance and Event*, 113. Italics in the original. Massumi's example for explicating affective attunement, through which the black work is considered here, is informed by Daniel Stern's *The Interpersonal World of the Infant*; he provides the example of the parental relationship to the child before the child has a sense of itself in which it learns to be soothed over time through a range of acts that the parent repeats, such as "from voice to ear, hand to back, hearing to touching," which are relationally connected, "whole-body experiences," and thereby linked affectively. (Quotations on 111.) For the purpose of art analysis, the parental relationship mirrors that of artists and the work of art they create: "the child's being vibrates with the parent's movement" (111).

32 "Russia Discovers Two Secret Paintings under Avant-Garde Masterpiece," *The Guardian*, November 13, 2015, https://www.theguardian.com/world/2015/nov/13/russia-malevich-black-square-hidden-paintings. See also Ivan Nechepurenko, "Examination Reveals a Mysterious Message on Malevich's 'Black Square' Painting," *ArtsBeat* (blog), *New York Times*, November 18, 2015, https://artsbeat.blogs.nytimes.com/2015/11/18/examination-reveals-a-mysterious-message-on-malevichs-black-square-painting/.

33 "Russia Discovers Two Secret Paintings under Avant-Garde Masterpiece."

34 "Russia Discovers Two Secret Paintings under Avant-Garde Masterpiece."

35 Binstock, *Sam Gilliam*, 113.

36 Binstock, *Sam Gilliam*, 113.

37 Binstock, *Sam Gilliam*, 113.

38 Binstock, *Sam Gilliam*, 113.

39 Campbell, "Sam Gilliam," 5.

40 See John Beardsley, "Sam Gilliam at 50," in *Modern Painters at the Corcoran: Sam Gilliam* (Washington, DC, 1983).

41 Beardsley, "Sam Gilliam at 50."

42 Campbell, "Sam Gilliam," 5. *The Arc Maker I and II* is unique in the Red and Black series because its arrangement is set and not negotiable.

43 Driskell, *Contemporary Visual Expressions*, 27.

44 Beardsley, "Sam Gilliam at 50."

45 Beardsley, "Sam Gilliam at 50," 151.

46 Gilles Deleuze and Félix Guattari, *What Is Philosophy?* (New York, 1994), 181.

47 Deleuze and Guattari, *What Is Philosophy?*, 181.

48 Deleuze and Guattari, *What Is Philosophy?*, 155.

49 Sianne Ngai, *Ugly Feelings* (Cambridge, MA, 2005), 93.

50 Ngai, *Ugly Feelings*, 94.

51 Ngai, *Ugly Feelings*, 95.

52 Ngai, *Ugly Feelings*, 95.

53 Frank B. Wilderson III, *Red, White and Black: Cinema and the Structure of U.S. Antagonisms* (Durham, NC, 2010), 42. Wilderson's thought is a vital contribution to Afro-Pessimism, theories informed by the critical and historical contributions of Frantz Fanon, Saidiya Hartman, Ronald Judy, Orlando Patterson, and Hortense Spillers, among others. Wilderson posits blackness as an ontology of slavery, measured solely in relation to the state, its apparatuses of power, and ultimately the structure of that power relation. For him, a black life is never a subject but rather a slave, given its originary social, economic, and political conditions in the United States, which is to say the absence of humanity and thereby any rights.

54 Massumi, *Semblance and Event*, 153.

55 Massumi, *Semblance and Event*, 155.

56 Elsa Honig Fine, *The Afro-American Artist: A Search for Identity* (New York, 1973), 225–226.

57 Wilderson, *Red, White and Black*, 55; emphasis added.

58 Massumi, *Semblance and Event*, 157.

59 Massumi, *Semblance and Event*, 157.

Alma Thomas's Washington, DC

Lauren Haynes

1 Eleanor Munro, "The Late Springtime of Alma Thomas," *Washington Post Magazine*, April 15, 1979.
2 Ian Berry and Lauren Haynes, "Alma Thomas," in *Alma Thomas*, ed. Ian Berry and Lauren Haynes (New York, 2016), 15.
3 Berry and Haynes, "Alma Thomas," 15.
4 "Unidentified Broadcast about Alma Thomas, Including a Biographical Account," Alma Thomas papers, 1894–2000, bulk 1936–1982, Archives of American Art, Smithsonian Institution, published in Berry and Haynes, *Alma Thomas*, 217. Biographical information about and several quotes from Thomas in this essay are drawn from this same interview, the transcript for which is archived with no date, location of interview, or interviewer name. Additional archival documents related to Thomas's career have been transcribed and published in Berry and Haynes, *Alma Thomas*.
5 "Unidentified Broadcast about Alma Thomas," 217.
6 "Unidentified Broadcast about Alma Thomas," 217.
7 "Unidentified Broadcast about Alma Thomas," 218.
8 "Unidentified Broadcast about Alma Thomas," 218.
9 "Unidentified Broadcast about Alma Thomas," 218.
10 Alma Thomas, "Artist Statement," 1972, published in Berry and Haynes, *Alma Thomas*, 216.
11 Thomas, "Artist Statement," 216.

Scurlock's Washington

Rhea L. Combs and Paul Gardullo

We are indebted to the assistance, hard work, and goodwill of many people from within and outside the Smithsonian in carrying out this project. Special thanks to Loren E. Miller of the National Museum of African American History and Culture (NMAAHC), whose support and dedication have been priceless. Additional gratitude to Douglas Remley at NMAAHC and to Maggie Wessling, formerly of NMAAHC and currently at the National Gallery of Art. Special recognition also to Kay Peterson and the staff at the Archives Center, National Museum of American History (NMAH); the National Portrait Gallery; and Lonnie G. Bunch III and Michelle Delaney, cocurator of the exhibition *The Scurlock Studio and Black Washington: Picturing the Promise* (Washington, DC, 2009).
1 Unless otherwise noted, all Scurlock images are scans of original Scurlock prints from Smithsonian collections. When a print was not available, a scan from an original Scurlock negative was used.
2 Nicole R. Fleetwood, *Troubling Vision: Performance, Visuality, and Blackness* (Chicago, 2011).
3 Jeffrey John Fearing, "African-American Image, History, and Identity in Twentieth-Century Washington, D.C., as Chronicled through the Art and Social Realism Photography of Addison N. Scurlock and the Scurlock Studios, 1904–1994" (PhD diss., Howard University, 2005), 67–70.
4 Deborah Willis, "The Sociologist's Eye: W. E. B. Du Bois and the Paris Exposition," in *A Small Nation of People: W. E. B. Du Bois and African American Portraits of Progress*, ed. David Levering Lewis (New York, 2003), 55.
5 Fearing, "African-American Image, History, and Identity," 65.
6 Peter Perl, "The Scurlock Look," *Washington Post Magazine*, December 2, 1990, 25, ProQuest Historical Newspapers.
7 Perl, "The Scurlock Look," 24–25.
8 Willis, "The Sociologist's Eye," 55.
9 Addison N. Scurlock, "Creating Business: A Paper Read before the February Meeting of the Local Negro Business League," *Negro Business League Herald* 1, no. 1 (April 1909): 7, Accessible Archive.
10 Perl, "The Scurlock Look," 25.
11 Perl, "The Scurlock Look," 24.
12 Jacqueline Trescott, "Love of the People, Control of the Craft: The Scurlocks' Heritage," *Washington Post*, June 13, 1976, K3, ProQuest Historical Newspapers.
13 W. Brian Piper, "'To Develop Our Business': Addison Scurlock, Photography, and the National Negro Business League, 1900–1920," *Journal of African American History* 101, no. 4 (Fall 2016): 436–468.
14 Perl, "The Scurlock Look," 27.
15 Esther Popel, "Flag Salute," *The Crisis* 47, no. 11 (November 1940): cover.
16 Trescott, "Love of the People, Control of the Craft," K3.
17 Blair A. Ruble, *Washington's U Street: A Biography* (Washington, DC, 2012).
18 Bruce D. Dickson Jr., *Archibald Grimké: Portrait of a Black Independent*, Southern Biography Series (Baton Rouge, 1993), quoted in Genny Beemyn, *A Queer Capital: A History of Gay Life in Washington, D.C.* (New York, 2015), 50.
19 Paul Gardullo et al., *The Scurlock Studio and Black Washington: Picturing the Promise* (Washington, DC, 2009), 30.
20 Trescott, "Love of the People, Control of the Craft," K3.
21 W. E. B. Du Bois, "The Conservation of Races," *The Crisis* 41, no. 6 (June 1934): 183.
22 Perl, "The Scurlock Look," 23.
23 Perl, "The Scurlock Look," 25.
24 Trescott, "Love of the People, Control of the Craft," K3.
25 Perl, "The Scurlock Look," 20–27.
26 All three Scurlock boys, Addison Jr., Robert, and George, showed an interest in photography. Addison Jr. served as president of Dunbar High's photography club and, like his younger brothers, attended college at Howard University. He died in 1933 from scarlet fever during his sophomore year in college.
27 Trescott, "Love of the People, Control of the Craft," K1, K3.
28 Jane Freundel Levey, "The Scurlock Studio," *Washington History* 1, no. 1 (Spring 1989): 102; and Jane Freundel Levey, "The Scurlock Studio," in *Visual Journal: Harlem and D.C. in the Thirties and Forties*, ed. Deborah Willis and Jane Lusaka (Washington, DC, 1996), 154.
29 Simeon Booker with Carol McCabe Booker, *Shocking the Conscience: A Reporter's Account of the Civil Rights Movement* (Jackson, MS, 2013).
30 Deborah Willis, "The Picture Maker," *Washington Post*, January 8, 1995, F1, F4, ProQuest Historical Newspapers.
31 Trescott, "Love of the People, Control of the Craft," K3.
32 Of the 1,590 businesses destroyed or damaged during the 1968 riots, 12 percent were African American–owned. The *Washington Post* reported that as a result of the riots and an increase in crime rates, white business owners decided to sell their stores, and African Americans increasingly bought them. As a result, the number of Black-owned businesses increased from 2,043 in 1967 to 2,393 in 1970. Minority-owned businesses increased in every industry, and their revenues grew 57 percent. "Negro Businesses Here Increase 16%: Whites Selling to Blacks," *Washington Post*,

February 23, 1970, B1, B6, ProQuest Historical Newspapers; Paul W. Valentine, "Riot Area Merchants Rebuild: Mixed Bag of Hope, Despair," *Washington Post*, April 8, 1970, C1, C3, ProQuest Historical Newspapers; "Census Finds Black-Owned Businesses Rose by 19% in 3 Years: Profits Not Disclosed," *New York Times*, December 10, 1974, 23, ProQuest Historical Newspapers; Claudia Levy, "Little Gain by Black Business: Black Business Profile Little Changed," *Washington Post*, December 15, 1974, G1, G4, ProQuest Historical Newspapers; and "Black-Owned Businesses Limited but Growing," *New Pittsburgh Courier*, January 4, 1975, 23, ProQuest Historical Newspapers.

33 The Corcoran Gallery of Art show was titled *The Historic Photographs of Addison N. Scurlock*, and the Chicago Black Women's Collaborative Inc. sponsored the 1981 exhibition, *The Scurlock Family Photographers: Twentieth Century Black Life and Leaders, 1900–1981*. Corcoran Gallery of Art, *The Historic Photographs of Addison N. Scurlock* (Washington, DC, 1976); Levey, "The Scurlock Studio," 102; and Black Women's Collaborative Inc., promotional postcard for *The Scurlock Family Photographers: Twentieth Century Black Life and Leaders, 1900–1981*, 1981, Box 3, Scurlock Family Archive (unprocessed), Collection of the Smithsonian National Museum of African American History and Culture, Gift of the Scurlock Family, Washington, DC.

34 Quoted in *Duke Ellington's Washington*, https://www.pbs.org/ellingtonsdc/transcripts.htm (accessed May 1, 2020).

35 The Scurlock Studio, "Our Obligation—as Portrait Photographers," brochure, c. 1942, negative, Box 3, Scurlock Family Archive (unprocessed), Collection of the Smithsonian National Museum of African American History and Culture, Gift of the Scurlock Family, Washington, DC.

36 Gloria Ricks, conversation with Paul Gardullo at the exhibition *The Scurlock Studio and Black Washington: Picturing the Promise*, National Museum of American History, Washington, DC, January 2009.

37 Gloria Ricks, conversation with Paul Gardullo.

Emancipation through Art: The New Negro, the Hueman, and the Social Sculpture of Ed Love

Jeffrey C. Stewart

1 Alain Locke, "Harlem," in *The New Negro Aesthetic: Selected Writings*, ed. Jeffrey C. Stewart (New York, 2022), 5.

2 "Harlem: Mecca of the New Negro," *Survey Graphic* 53 (March 1, 1925).

3 Alain Locke, "The American Negro as Artist," in Stewart, *New Negro Aesthetic*, 218–227. Also see Jeffrey C. Stewart, *The New Negro: The Life of Alain Locke* (New York, 2018), 648–655, 717–739, 773–784.

4 "In Memory of Ed Love," Florida State University Department of Art, January 12, 2017, http://art.fsu.edu/in-memory-of-ed-love/.

5 "In Memory of Ed Love."

6 See "Watts Towers of Simon Rodia State Historic Park," California Department of Parks and Recreation, http://www.parks.ca.gov/?page_id=613 (accessed September 24, 2017); Paul Richards, "Ed Love's Scrap Yard Spirits," *Washington Post*, September 15, 1986, https://www.washingtonpost.com/archive/lifestyle/1986/09/15/ed-loves-scrap-yard-spirits/3e734104-0724-4c40-b19e-f2e423d4a856/?utm_term=.e909c5030c62; Martha Schwendener, "Nancy Rubins: 'Our Friend Fluid Metal,'" *New York Times*, July 31, 2014, https://www.nytimes.com/2014/08/01/arts/design/nancy-rubins-our-friend-fluid-metal.html?mcubz=0&_r=0.

7 "Climbing Invisible Structures: Ritualized Disciplinary Practices in Social Life," *Nida Art Colony of Vilnius Academy of Arts*, February 5, 2017, http://nidacolony.lt/en/861-climbing-invisible-structures-part-4.

8 *Ed Love on Fire*, produced by Jeff Bieber, WETA TV, 1986.

9 For Locke's explication of the concept of generation in relation to artists, see Locke, "The American Negro as Artist," and "The Negro: 'New' or Newer: A Retrospective Review of the Literature of the Negro for 1938," in Stewart, *New Negro Aesthetic*, 329–354. For an excellent discussion of the philosophy of art of Howard's art department in the late 1970s and early 1980s, see Ed Love, "The Tenth Power: The Tenth Annual Art Faculty Exhibition, Howard University," *Sagala: A Journal of Art and Ideas* 2 (1981): 12–14, and other articles in this issue. As for the judgment of Howard's art faculty, the late professor Robert Farris Thompson put it this way: "I would argue that some of the richest minds in American art are on this [Howard's] faculty, united in teaching and making objects in which the civilizing strengths of nations disclose themselves. Of these great teacher-artists, I am privileged to study and consider one, Ed Love." Robert Farris Thompson, "Monuments to the Future: The Art of Ed Love," *New Directions* 14, no. 1, article 7 (January 1987): 28.

10 Neely Fuller Jr., *The United-Independent Compensatory Code/System/Concept: A Textbook/Workbook for Thought, Speech, and/or Action for Victims of Racism (White Supremacy)*, rev. ed. (1984).

11 I borrow this phrase from Jerome Rothenberg, ed., *Technicians of the Sacred: A Range of Poetries from Africa, America, Asia, and Oceania* (New York, 1968).

12 Love mentioned the "second why" in *Ed Love on Fire*.

13 Buckminster Fuller, *Operating Manual for Spaceship Earth* (privately pub., 1968), 36.

14 "For anybody, all people, on the planet, should be universal man and universal woman." Neely Fuller Jr., "Two Characteristics of Universal Man and Universal Woman," YouTube video, https://www.youtube.com/watch?v=T5GuCAhsxKc.

15 See "Osiris," *Ancient Egypt Online*, http://www.ancientegyptonline.co.uk/osiris.html (accessed September 21, 2017). See also Joshua J. Mark, "Horus," *Ancient History Encyclopedia*, https://www.ancient.eu/Horus/ (accessed September 21, 2017).

16 Charlene Villaseñor Black and Tim Barringer, "Decolonizing Art and Empire," *Art Bulletin* 104, no. 1 (March 2022): 7.

17 Ivan Van Sertima, "Trickster, the Revolutionary Hero," *Sagala: A Journal of Art and Ideas* 2 (1981): 4–6.

18 Robert Farris Thompson, *Flash of the Spirit: African and Afro-American Art & Philosophy* (New York, 1984).

19 Interview with Monifa Love Asante, August 2017. Amiri Baraka, *Black Magic: Poetry, Sabotage, Target Study, Black Art, 1961–1967*, 4th ed. (Indianapolis, 1969).

20 Fuller, *The United-Independent Compensatory Code/System/Concept*, 1.

21 Van Sertima, "Trickster, the Revolutionary Hero," 6.

22 Stuart Morgan, "Beuys, Joseph," in *Makers of Modern Culture*, vol. 1, ed. Justin Wintle (New York, 1981), 52. See also Tom Holert, "Learning Curve: Radical Art and Education in Germany," *Artforum* 46, no. 9 (May 2008), https://www.artforum.com/print/200805/learning-curve-radical-art-and-education-in-germany-19963.

23 There are other important differences as well, especially that Beuys never seems to confront who is included in or excluded from his utopian visions of a new, post–World War II world. His fictionalization of his role in the German air force is a case in point. He never publicly takes responsibility for his role in advancing a Nazi-driven war agenda that resulted in the murder of at least six million Jews. Was his guilt about that role driving him to "atone" by conceiving art as a political reconstruction or was he hiding how much his utopianism derived from aspirations for an ideal world that was first a Nazi imaginary? See Ulrike Knöfel, "Book Accuses Artist of Close Ties to Nazis," *Spiegel Online*, May 17, 2013, http://www.spiegel.de/international/germany/new-joseph-beuys-biography-discloses-ties-to-nazis-a-900509.html; Ulrike Knöfel, "New Letter Debunks More Wartime Myths," *Spiegel Online*, July 12, 2013, http://www.spiegel.de/international/germany/new-letter-debunks-myths-about-german-artist-joseph-beuys-a-910642.html; Jillian Steinhauer, "The Nazi Ties of Joseph Beuys," *Hyperallergic*, May 20, 2013, https://hyperallergic.com/71517/the-nazi-ties-of-joseph-beuys/; "Why Avant-Garde German Artist Joseph Beuys' Politics Remain Relevant to This Day," *Deutsche Welle*, May 19, 2017, http://www.dw.com/en/why-avant-garde-german-artist-joseph-beuys-politics-remain-relevant-to-this-day/a-38893951; Hannah Abdullah, "Kiefer and Beuys: Cathexis and Cartharsis," in *In Focus: Heroic Symbols 1969 by Anselm Kiefer*, ed. Christian Weikop, Tate Research Publication, 2016, http://www.tate.org.uk/research/publications/in-focus/heroic-symbols-anselm-kiefer/kiefer-and-beuys; Alex Allenchey, "What We Owe Postwar German Artists, From Joseph Beuys to Gerhard Richter," *Artspace*, March 29, 2013, http://www.artspace.com/magazine/art_101/art_market/postwargermany-5924.

24 Fuller, *The United-Independent Compensatory Code*, 5.

25 Interview with Monifa Love Asante, August 2017.

26 "In Memory of Ed Love," http://art.fsu.edu/in-memory-of-ed-love/.

27 See George Volsky, "Education: A School for the Arts Matures in Miami," *New York Times*, December 7, 1988.

28 Interview with Monifa Love Asante, June 17, 2017.

29 See Dar Davis, "The Evolution of Bumpers," *The Herald-Palladium*, November 21, 2010, http://www.heraldpalladium.com/features/the-evolution-of-bumpers/article_ec0f0ff1-0da3-5799-8022-be1149728104.html. Interview with Scott Love, September 17, 2017.

30 "The Art of Romare Bearden," National Gallery of Art (archived by Archive.org), https://web.archive.org/web/20170330203835/https://www.nga.gov/feature/bearden/170-130.htm (accessed June 27, 2019).

31 I am indebted to Marshanne K. Love for pointing out the metronome to me.

32 See Jeffrey C. Stewart, *1001 Things Everyone Should Know about African American History* (New York, 1996), 17. I am indebted to Monifa Love Asante for pointing out Ed's reading of this story in my book, and to Marta Reid Stewart for recommending I include Ed in my book (p. 295).

Loving Blackness: Jeff Donaldson in Washington

Michael D. Harris

1 Jeff could be fierce, difficult, unforgiving, and, at six feet six inches, imposing. He was a warrior but protective and welcoming for those with whom he shared affection, trust, purpose, and community. He was relentless in his commitment to the liberation of peoples of African descent, shortcomings and all.

2 See Alain Locke, "The Legacy of the Ancestral Arts," in *The New Negro: Voices of the Harlem Renaissance*, ed. Alain Locke (New York, 1992), 254–267.

3 bell hooks, "Loving Blackness as Political Resistance," in bell hooks, *Black Looks: Race and Representation* (Boston, 1992), 9–20.

4 hooks, "Loving Blackness," 10.

5 "Another time he was said to have gone into the woods—always with people around, and taunted and challenged a bear to charge him. And he had two daggers in his hands. And when the bear charged, he raised his arms so that the bear could hug him and then he comes down on both sides with the knife. And he never had to go back to the farm to work at all during any of those seasons after doing those kinds of things." Jeff Donaldson, *The HistoryMakers*, https://www.thehistorymakers.org/biography/jeff-donaldson-40. Interview recorded in 2001; transcription by The HistoryMakers, 1900 S. Michigan Avenue, Chicago, Illinois.

6 Donaldson, *HistoryMakers*.

7 Jeff recalled that a group of artists known as COBRA—Copenhagen, Brussels, and Amsterdam—already existed, so the group changed its name to African Commune of Bad Relevant Artists.

8 Jeff Donaldson, "Ten in Search of a Nation," *Black World* (October 1970): 80–86. Reprinted in *NKA: Journal of Contemporary African Art* 30 (Spring 2012): 76–83 (80).

9 Donaldson, "Ten in Search of a Nation" (reprint), 81.

10 James Porter argued against Alain Locke's 1925 call for artists to look to their African ancestral legacy and, to some extent, against W. E. B. Du Bois's 1926 essay "Criteria for Negro Art," which appeared in an NAACP *Crisis* editorial, saying that Negro artists should be unencumbered by such social imperatives and be free to express their individual, nonracial humanity. See James Porter, *Modern Negro Art* (Washington, DC, 1992 [1943]). See also Alain Locke, "The Legacy of the Ancestral Arts," in Locke, *New Negro*, 254–267.

11 Robert Farris Thompson, "Communiqué from Afro-Atlantis," in *NeoHooDoo: Art for a Forgotten Faith*, ed. Robert Farris Thompson (Houston, 2008), 68.

12 Elizabeth Alexander, *The Black Interior* (Saint Paul, MN, 2004), x.

13 Tuliza Fleming, "The Realization of an Aesthetic: Jeff Donaldson's Wives of Sango," The *International Review of African American Art* 29, no. 2 (2019): 11. Fleming cites Frantz Fanon, *The Wretched of the Earth* (New York, 1963), 222–223.

14 Fleming, "Realization of an Aesthetic," 9.

15 Jeff Donaldson, "Trans-African Art," *Black Collegian* (October/November 1980): 90–102.

16 Alain Locke, "The American Negro as Artist," *The American Magazine of Art* 23 (September 1931): 212. Cited from Jeff Donaldson, "TransAfrican Art: Origins and Development," in *Kerry James Marshall: One True Thing; Meditations on Black Aesthetics*

(Chicago, 2003), 28. In 2003, Donaldson invited Marshall to join AfriCOBRA and he accepted, but the process was interrupted by Donaldson's declining health and passing the next year.

17 Program for CONFABA, Northwestern University, Evanston, IL, May 1970. Published in Edmund Barry Gaither, "Heritage Reclaimed: An Historical Perspective and Chronology," in *Black Art—Ancestral Legacy: The African Impulse in African-American Art*, ed. Alvia Wardlaw (Dallas, 1989), 25.

18 Nelson Stevens, personal conversation, and confirmed in a telephone conversation, May 11, 2019.

19 For a detailed description of CONFABA and the list of participants, see Cherilyn C. Wright, "Reflections on CONFABA: 1970," *The International Review of African American Art* 15, no. 1 (1998): 36–44.

20 Jeff Donaldson, taped interview with the author and Murry DePillars, October 5, 2003, Washington, DC.

21 Akili Ron Anderson, telephone conversation with the author, September 24, 2019.

22 Paul Carter Harrison, conversation with the author, September 23, 2019, Atlanta, Georgia.

23 Jeff Donaldson, HistoryMakers video interview, 2001.

24 Personal conversation with James Phillips, September 8, 2019, and various conversations with Nelson Stevens and Paul Carter Harrison.

25 Ed Spriggs, who attended FESTAC, wrote to me that "Jeff took over 500 artists of all disciplines to Lagos, Nigeria. Of that number, 69 were visual artists, however the work of 108 artists were included in our exhibition including works by those who could not attend." Ed Spriggs, email to the author, June 22, 2013.

26 Owens says she met Agbo Folarin, a faculty member at the University of Ifẹ while at FESTAC, and he took her to the pottery village. She recounted, "I could have just dropped down dead because that was my life's dream, to go to Africa and do pottery." Winnie Owens-Hart, interview with the author. Tape recording, March 29, 1994, Washington, DC.

27 Akili Ron Anderson, Adger Cowans, Murry DePillars, and I became members of AfriCOBRA in 1978–1980. Kevin Cole joined in 2003, and Renée Stout became a member in 2017. Wadsworth Jarrell resigned in 1999, Donaldson passed in 2004, and DePillars passed in 2008.

28 In an essay from 1992, "TransAfrican Art: The Paris Connection" Donaldson wrote that TransAfrican art "is basically figurative but with an enormous variety of. . . . innovative approaches to rhythmic syncopated repetition of formal units (i.e., color areas, shapes, lines and motifs) often dominate the organizational patterns in this highly individualized and varied work." All these elements were used "to denote a sensibility, an attitude toward life, a mystique—indeed, a distinctive world view." Jeff Donaldson, "TransAfrican Art: The Paris Connection," in *Paris Connections: African and Caribbean Artists in Paris*, ed. Asake Bomani and Belvie Rooks (San Francisco, 1992), 20.

29 Donaldson, *Kerry James Marshall: One True Thing*, 29.

30 Édouard Glissant, *Poetics of Relation*, trans. Betsy Wing (Ann Arbor, 2010 [1997]), 11.

31 Donaldson, "TransAfrican Art."

32 Ras Michael Brown, lecture, Emory University, Atlanta, November 29, 2016.

33 See Ras Michael Brown, *African-Atlantic Cultures and the South Carolina Lowcountry* (New York, 2012). Central African BaKongo

nkisi nkondi nail figures are thought to be animated by spirits called *bisimbi* and many are named and some, such as Maabyala, have figures of wives and children carved to be associated with them. See Wyatt MacGaffey, "The Eyes of Understanding: Kongo Minkisi," in *Astonishment and Power* (Washington, DC, 1993).

34 Clyde Taylor, "Salt Peanuts: Sound and Sense in African/American Oral/Musical Creativity," *Callaloo*, no. 16 (October 1982): 2.

35 Taylor, "Salt Peanuts," 3.

36 Taylor, "Salt Peanuts," 3.

37 Jeff Donaldson, taped interview with the author, November 1988, Washington, DC.

38 Donaldson, interview with the author, 1988. In 1983 Henry and Margaret Drewal published *Gẹlẹdẹ: Art and Female Power among the Yoruba*, and Babatunde Lawal followed with *The Gẹlẹdẹ Spectacle: Art, Gender, and Social Harmony in an African Culture* in 1996.

39 Donaldson's international profile was more extensive than most knew. There are photos from 1974 showing him as a guest of Idi Amin in Uganda a few years before incriminating information led to Amin's downfall, followed by a special formal invitation to a diplomatic event in the United States with Amin in 1975. Another photo shows him with scholar Cheikh Anta Diop in Africa.

40 "Frank Smith posited the meaning of the Malinke word *Farafindugu* as 'the complex concept of Blackness, brother-hood and Black land.'" Kirstin L. Ellsworth, "Africobra and the Negotiation of Visual Afrocentrisms," *Civilisations* 58, no. 1 (2009): 21–38.

41 Jeff Donaldson, "AFRICOBRA/FARAFINDUGU," unpublished memo, 1979, Jeff Donaldson papers. Courtesy David Lusenhop.

42 Jeff Donaldson, private video, Washington, DC, 1987. Collection of and filmed by the author.

43 *Horror vacui* also suggests references to Arabesque decoration in Islamic art, dense carpet design, especially from North Africa, and illuminated manuscripts, all modes having a sense of the postmodern bypass of Western modernism and the pictorial space as a visual rather than symbolic space.

44 "Art for art's sake," the usual English rendering of the French expression from the early nineteenth century, *l'art pour l'art*, refers to a philosophy that the intrinsic value of art and the only "true" art is divorced from any didactic, moral, or utilitarian function. In a view that I share with Jeff Donaldson and expressed formally at CONFABA in 1970, art cannot be decontextualized (or, if you like, depoliticized) and self-contained. That position itself is a political one, functional only within a certain context or epistemological frame.

45 Donaldson, "Ten in Search of a Nation." This was also part of the statement emerging from the CONFABA conference convened by Donaldson at Northwestern University in 1970. See also Barry Gaither, "Heritage Reclaimed," 25.

46 Katy Mostoller, "Interview with Jeff Donaldson," 1997, 14–15. I'll Make Me a World Production Notes, Washington University Libraries, Department of Special Collections.

47 Thompson, "Communiqué from Afro-Atlantis," 68.

48 Donaldson, "Ten in Search of a Nation."

A Chocolate City Reconsidered

Richard J. Powell

1 Kenneth Carroll, "As Chocolate City Gathered Confidence after the Success of the Civil Rights Movement, D.C.'s Varied Black Communities Found a Common Anthem," *Washington Post*, February 1, 1998.

2 Parliament, "Chocolate City," Casablanca NBLP, 7014, 1975, LP album.

3 "Ease and Elegance," *Essence* 7 (March 1977): 60–67, 71

4 Constance McLaughlin Green, *The Secret City: A History of Race Relations in the Nation's Capital* (Princeton, NJ, 1967).

5 Green, *Secret City*, 3–12.

6 Thomas C. Battle, "Washington, D.C.," in *Encyclopedia of African-American Culture and History*, vol. 5, ed. Jack Salzman, David Lionel Smith, and Cornel West (New York, 1996).

7 "Ashby uses every device in his arsenal," writes film critic Christopher Beach about this particular passage, "mise-en-scène, editing, camera movement, and musical soundtrack—to heighten this sequence." Christopher Beach, "I Like to Watch: *Shampoo* and *Being There*," in *The Films of Hal Ashby* (Detroit, 2009), 113–114. "When I start preproduction," Ashby stated in a 1980 interview about *Being There*, "the person I work closest with is my production designer, Michael Haller. . . . [He] was so full of ideas—that's how the ghetto scene came about. He said, 'When I was in Washington, D.C., I was looking around the ghetto. It was real interesting.' I just flashed on that. I said, 'Oh God, Chance [the gardener, Peter Sellers's character] has just *got* to come out there.'" Jordan R. Young and Mike Bruns, "Hal Ashby: Satisfaction in *Being There*" (1980), republished in Nick Dawson, *Hal Ashby: Interviews* (Jackson, MS, 2010), 101.

8 Elizabeth Broun, "Introduction," in Richard J. Powell and Virginia M. Mecklenburg, *African American Art: Harlem Renaissance, Civil Rights Era and Beyond* (New York, 2012), 10–11; Blair A. Ruble, "Chocolate City," in *Washington's U Street: A Biography* (Washington, DC, 2010), 227–260; Kip Lornell, "Commentary—Beyond Category: Twentieth and Twenty-First Century Black Music Research and Recording in Washington, D.C.," *ARSC Journal* 40 (Spring 2009): 1–10; and Marion Barry Jr. and Omar Tyree, *Mayor for Life: The Incredible Story of Marion Barry, Jr.* (New York, 2014), 160.

9 Carroll, "As Chocolate City Gathered Confidence."

10 Interview with Robert Robinson, conducted by Richard Maulsby, August 21, 2015, https://archive.org/details/ms2342_s01_transcript_robert_robinson.

11 Jean Toomer, "Seventh Street," *Cane* (1923; repr., New York, 1969), 71–72.

12 Duke Ellington, *The Duke Ellington Centennial Edition*, RCA Victor, 09026-63386-2, 1999, CD box set.

13 Tritobia Hayes Benjamin, *The Life and Art of Lois Mailou Jones* (San Francisco, 1994), 49–52.

14 Ramon Geremia, "Tinsel, Mystery Are Sole Legacy of Lonely Man's Strange Vision," *Washington Post*, December 15, 1964; Godfrey Hodgson, "A Tinsel Heaven That Faith Built," *Washington Post*, December 20, 1964; Sarah Booth Conroy, "Laborer's Foil Shrine," *Washington Post*, December 21, 1971; and Lynda Roscoe Hartigan, *James Hampton: The Throne of the Third Heaven of the Nations' Millennium General Assembly* (Washington, DC, 1986), n.p.

15 Richard J. Powell, "Art, History and Vision," *Art Bulletin* 77 (September 1995): 379–382.

16 Barbara Rose, "Black Art in America," *Art in America* 58 (September/October 1970): cover, 54–67.

17 Charles Rowell, "An Interview with Lois Mailou Jones," *Callaloo* 12 (1989): 365–366.

18 Jonathan P. Binstock, *Sam Gilliam: A Retrospective* (Berkeley, CA, 2005), 65–74.

19 Keith Morrison, *Art in Washington and Its Afro-American Presence: 1940–1970* (Washington, DC, 1985), 51–73. Also see Paul Richard, "The Black Presence, Art and Integration," *Washington Post*, April 7, 1985.

20 Paul Richard, "A Bright New 'School' With a Black Theme," *Washington Post*, March 19, 1976. Paul Richard revisited the idea of a special artistic milieu at Howard University about a decade later: Paul Richard, "The Howard Dynamic," *Washington Post*, April 2, 1988.

21 David Tannous, "Capital Art: In the Major Leagues?" *Art in America* 66 (July/August 1978): 70–77.

22 Richard, "A Bright New 'School,'" 1976. That neither Paul Richard nor other art critics recognized the parallels between Donaldson's artistic media—metallic foils and corrugated cardboard—and James Hampton's *The Throne* speaks volumes to the inability of critics and historians at the time to seriously think about Washington, DC's Black Arts Movement and its connections with art and aesthetics within the Black vernacular tradition.

23 See Jessica May, ed., *David Driskell: Icons of Nature and History* (New York, 2021), and Julie L. McGee, "Offerings from the Studio, Heart, and Mind: David C. Driskell in Conversation with Julie L. McGee," in *Creative Spirit: The Art of David C. Driskell* (College Park, MD, 2011), 24–88.

24 McGee, "Offerings," 30.

25 Paul Richard, "Black Artists: Their Pride and Problems," *Washington Post*, March 15, 1981.

26 "Ease and Elegance," 65–67.

27 Sam Smith, "DC Diary: The 1970s," April 28, 2007, https://samsmithessays.blogspot.com/2007/04/uthor-in-appalling-1970s-wear-speaking.html.

28 Jacqueline Trescott, "D.C. Council Implored to Back Arts," *Washington Post*, February 24, 1994.

29 Len Tuck, "D.C. Grants $478,500 to Arts Groups," *Washington Post*, April 5, 1986.

30 Dorothy Gilliam, "Time to Bolster Black Culture," *Washington Post*, October 12, 1987.

31 Richard J. Powell, *From the Potomac to the Anacostia: Art and Ideology in the Washington Area* (Washington, DC, 1989), n.p.

32 Jane Addams Allen, "Paradoxes of D.C.," *Washington Times*, February 24, 1989.

33 Keith Morrison, "Art Criticism: A Pan-African Point of View," *New Art Examiner* 6 (February 1979): 4–7.

34 Andrea Pollan, "Simon Gouverneur: Plotting a Metaphysics of Mathart," *International Review of African-American Art* 19 (2004): 38–41.

35 John Yau, "Alone among the Living and the Dead," *Hyperallergic*, February 4, 2012, https://hyperallergic.com/46537/simon.gouverneur/.

36 Powell, *From the Potomac to the Anacostia*, n.p. Tragically, Simon Gouverneur would take his own life in his Florida Avenue studio in 1990, along with attempting to set the studio and its contents on fire. Fortunately, most of the contents of the studio were saved.

37 Jeffry Cudlin, "Mystic Logic: Works from the Estate of Simon Gouverneur," *Washington City Paper*, February 24, 2006, and Lynda Roscoe Hartigan, "Elijah Pierce and James Hampton: One Good Book Begets Another," *Folk Art* 19 (Summer 1994): 52–57.

38 Nord Wennerstrom, "Critic's Picks: Washington, DC, Simon Gouverneur," *Artforum*, https://www.artforum.com/picks/id=10411.

39 Mark Sloan, "Roots, Rattles and Bones," in *Tales of the Conjure Woman: Renée Stout* (Charleston, SC, 2013), 12–15.

40 Grey Gundaker and Judith McWillie, *No Space Hidden: The Spirit of African American Yard Work* (Knoxville, TN, 2005), 175.

41 Stephen Bennett Phillips and Michelle A. Owen-Workman, "Transcending Time," in *Readers, Advisors, and Storefront Churches: Renée Stout, A Mid-Career Retrospective* (Kansas City, MO, 2002), 64–71.

42 Jordana Moore Saggese, "Fade to Black: An Interview with Jefferson Pinder," *International Review of African American Art* 25 (2015): 45. See also Michael T. Martin and David Wall, "'Where Are You From?' Performing Race in the Art of Jefferson Pinder," *Black Camera* 2 (Winter 2010): 72–105.

43 The two art exhibitions at the Corcoran Gallery of Art referenced here are *Gilliam, Krebs, McGowin* (September 1969) and the installation of Martin Puryear's *Cedar Lodge* (1977) in his first major solo exhibition, July–September 1977. Binstock, *Sam Gilliam*, 51–56, and John Elderfield, *Martin Puryear* (New York, 2008), 19.

44 Blake Gopnik, "Folk Video Artist Jefferson Pinder Seeks to Cast off 'Black Art' Label," *Washington Post*, January 24, 2010. Italics in the original.

45 Parliament, "Chocolate City."

46 The Washington art scene's gradual shift, beginning in the 1980s, toward performance and conceptual art forms is well documented in Sidney Lawrence, "A Decade of Reckoning, 1980s, Part 1," in Jean Lawlor Cohen, Sidney Lawrence, and Elizabeth Tebow, *Washington Art Matters: Art Life in the Capital, 1940–1990* (Washington, DC, 2013), 128–156.

47 Pamela Sommer, "Mammoth Time," *Washington Post*, October 10, 1983.

48 Sherman Fleming, "Living in a City of Monuments, Or Why I No Longer Walk with an Erection," *Washington Review* 16 (February/March 1991): 6.

49 Kristine Stiles, "RODFORCE: Thoughts on the Art of Sherman Fleming," *High Performance* 10 (1987): 34–39. In a 2016 interview with Philadelphia art critic A. M. Weaver, Sherman Fleming discusses his affinities for Washington, where he lived from 1977 to 2000, and where Mayor Marion Barry Jr. loomed very large in his consciousness: https://www.theartblog.org/2016/12/sherman -fleming-talks-performance-and-black-masculinity-with-a-m -weaver/.

50 Martin Duberman, *Hold Tight Gently: Michael Callen, Essex Hemphill, and the Battlefield of AIDS* (New York, 2014), xi.

51 Essex Hemphill, "Visiting Hours," *Earth Life* (Washington, DC, 1988), 5–6.

52 *Looking for Langston*, directed by Isaac Julien (1989, Culver City: Strand Releasing, 2007), DVD.

53 Carol J. De Vita, Carlos A. Manjarrez, and Eric C. Twombly, "Poverty in the District of Columbia—Then and Now," *The United Planning Organization*, https://www.urban.org/research /publication/poverty-district-columbia-then-and-now.

54 Marianne Szegedy-Maszak, "D.C., The Other Washington," *New York Times Magazine*, November 20, 1988.

55 Carroll, "As Chocolate City Gathered Confidence."

56 Jay Wright, "Benjamin Banneker Helps to Build a City," in *Transfigurations: Collected Poems* (Baton Rouge, 2000), 107.

57 Kyle A. Jackson, "Gentrification and the Decline of African American Arts and Culture in Washington, D.C.," master's thesis, Drexel University, 2016, 59–62. "Quiet Storm" is a radio format of contemporary R&B, jazz-fusion, and Black pop music pioneered in the mid-1970s by a Howard University student, Melvin Lindsey,

when he was a DJ at Howard's radio station, WHUR-FM. This format, named after Smokey Robinson's 1976 album *A Quiet Storm*, quickly gained popularity throughout Washington, DC, prompting the media figure Cathy Hughes, then WHUR-FM's station manager, to bring it into the station's regular programming. Black radio industry reports of its broad appeal spawned a multitude of "Quiet Storm" programs nationally. Paul Farhi, "A Quiet Storm of Applause," *Washington Post*, August 18, 2006.

58 Carol Morello and Dan Keating, "Number of Black D.C. Residents Plummets as Majority Status Slips Away," *Washington Post*, March 24, 2011.

59 Natalie Hopkinson, *Go-Go Live: The Musical Life and Death of a Chocolate City* (Durham, NC, 2012), 160.

60 Hopkinson, *Go-Go Live*, x.

CONTRIBUTORS

Rhea L. Combs is director of curatorial affairs at the National Portrait Gallery. Prior to this, she was supervisory curator of film and photography and director of the Earl W. and Amanda Stafford Center for African American Media Arts at the National Museum of African American History and Culture.

Adrienne Edwards is Engell Speyer Family Curator and Director of Curatorial Affairs at the Whitney Museum of American Art. She was cocurator of *Whitney Biennial 2022: Quiet as It's Kept*.

Gwendolyn H. Everett is an associate professor in art history and associate dean for faculty affairs in the Chadwick A. Boseman College of Fine Arts at Howard University. Her areas of expertise are nineteenth- and twentieth-century American and African American art, museums, and cultural studies.

Jacqueline Francis is professor and chair of the graduate program in Visual and Critical Studies at California College of the Arts. She writes social histories of modern and contemporary art and visual culture of the United States, and she is particularly interested in the representation of ethno-cultural and racial identities and identifications.

Paul Gardullo is supervisory curator of history and director of the Center for the Study of Global Slavery at the National Museum of African American History and Culture. He was the cocurator of the museum's exhibition *The Scurlock Studio and Black Washington: Picturing the Promise* and editor of the companion volume.

Michael D. Harris was associate professor emeritus of art history in the Department of African American Studies at Emory University and the author of *Colored Pictures: Race and Visual Representation* (2003). Harris worked as a curator for the Harvey B. Gantt Center for African-American Arts and Culture, the National Museum of African Art, and Smithsonian Institution Traveling Exhibition Service. He also served as a curatorial consultant for the High Museum of Art. Harris was a practicing artist and a longtime member of AfriCOBRA whose work has been exhibited internationally.

Lauren Haynes is director of curatorial affairs and programs at the Queens Museum. Haynes is a specialist in contemporary art with a focus on artists of African descent.

Steven Nelson is dean of the Center for Advanced Study in the Visual Arts at the National Gallery of Art and professor emeritus of art history at the University of California, Los Angeles. His writings on the contemporary and historical arts, architecture, and urbanism of Africa and its diasporas; African American art history; and queer studies have appeared in numerous publications.

Robert G. O'Meally is the Zora Neale Hurston Professor of English and Comparative Literature at Columbia University, where he founded the Center for Jazz Studies. His new books are *Antagonistic Cooperation: Jazz, Collage, Fiction, and the Shaping of African American Culture* (2022) and *The Romare Bearden Reader* (2019).

Richard J. Powell is the John Spencer Bassett Distinguished Professor of Art and Art History at Duke University. Along with teaching courses in American art and the arts of the African diaspora, he has written on a range of topics, including the recent titles *Black Art: A Cultural History* (2021) and *Going There: Black Visual Satire* (2020).

Jacquelyn Serwer, now Curator Emerita at the Smithsonian Institution, was chief curator at the National Museum of African American History and Culture, where she played a critical role in building its foundational collection and served as the project manager and publications editor for its inaugural exhibition, *Let Your Motto Be Resistance: African American Portraits*. Formerly she served as chief curator at the Corcoran Gallery of Art and chief curator and curator of contemporary art at the Smithsonian American Art Museum.

Elsa Smithgall is chief curator at The Phillips Collection. Smithgall is a noted art historian and curator with a specialty in modern American and European art. She has curated major international traveling exhibitions and authored and edited numerous publications, including the museum's landmark centennial exhibition and accompanying catalog, *Seeing Differently: The Phillips Collects for a New Century* (2021).

Jeffrey C. Stewart is MacArthur Foundation Chair and Distinguished Professor of Black Studies at the University of California, Santa Barbara. With a PhD in American Studies from Yale University, Stewart has curated exhibitions at the National Portrait Gallery and Zimmerli Art Museum at Rutgers University. He is the author of *The New Negro: The Life of Alain Locke* (2018), which won the National Book Award for Nonfiction, Pulitzer Prize for Biography, and American Book Award. His most recent book is *The New Negro Aesthetic: Selected Writings* (2022).

John A. Tyson is an assistant professor of art history at the University of Massachusetts Boston. His scholarship focuses on modern American art in Washington, DC, and contemporary art. His recent publications respectively analyze Sol LeWitt's photobooks and Hans Haacke's artworks engaging weather. He is president of the Society of Contemporary Art Historians.

Tobias Wofford is an associate professor in the Department of Art History at Virginia Commonwealth University. His research explores the meeting of globalization and identity in the art of the African diaspora since the 1950s, as well as concepts of diversity and multiculturalism in art of the United States. Wofford is currently working on a book manuscript entitled "Visualizing Diaspora: Africa in African American Art." His research has been supported by the Terra Foundation for American Art, Getty Research Institute, Johns Hopkins University, and National Gallery of Art.

INDEX

Page numbers in **boldface** indicate illustrations. Titles of specific artworks, books, and performances will be found under the name of the artist, author, or performer.